∭∥₩₩₩₩₩₩₩₩₩₩ ∅ W9-BEL-729

WELLINGTON

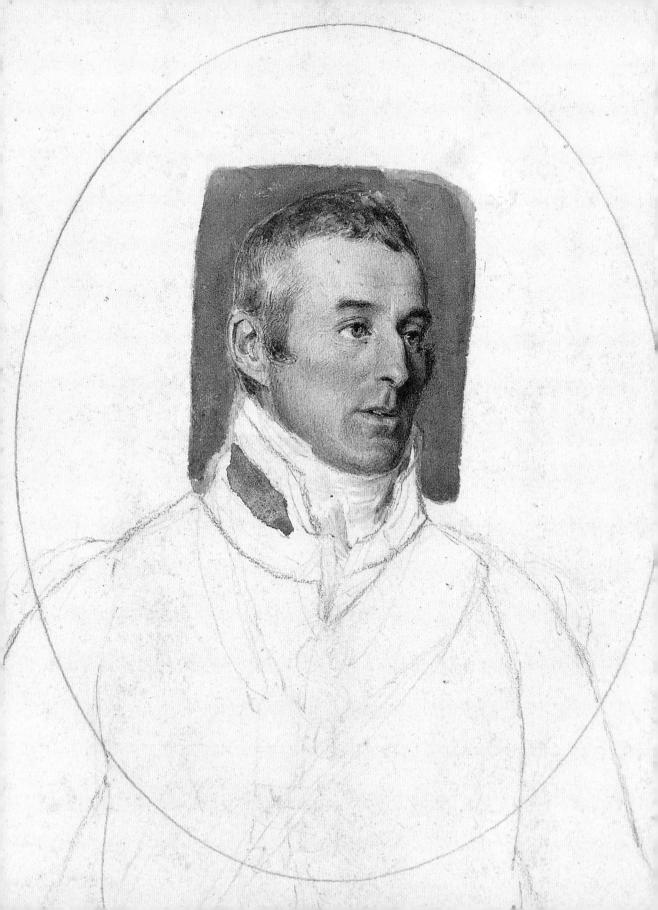

WELLINGTON TRIUMPHS, POLITICS AND PASSIONS

PAUL COX

WITH A FOREWORD BY WILLIAM HAGUE

NATIONAL PORTRAIT GALLERY, LONDON

Published in Great Britain by National Portrait Gallery Publications St Martin's Place, London WC2H 0HE

Published to accompany the exhibition Wellington: Triumphs, Politics and Passions at the National Portrait Gallery, London, from 12 March to 7 June 2015.

This exhibition has been made possible by the provision of insurance through the Government Indemnity Scheme. The National Portrait Gallery, London, would like to thank HM Government for providing Government Indemnity and the Department for Culture. Media and Sport and Arts Council England for arranging the indemnity.

Supported by the Wellington: Triumphs, Politics and Passions Exhibition Supporters Group

The National Portrait Gallery's Spring Season 2015 sponsored by Herbert Smith Freehills

For a complete catalogue of current publications, please write to the National Portrait Gallery at the address above, or visit our website at www.npg.org/publications

Copyright © 2015 National Portrait Gallery, London

The moral rights of the authors have been asserted. All rights reserved. No part of this publication may be reproduced, stored in a retrieval system or transmitted in any form or by any means, whether electronic or mechanical, including photocopying, recording or otherwise, without the prior permission in writing of the publisher.

ISBN 978 1 85514 499 6

A catalogue record for this book is available from the British Library.

10987654321

Printed in China

FSC[®] C104723 Managing Editor: Christopher Tinker Editor: Andrew Roff Copy-editor: Patricia Burgess

ΜΙΧ

Paper from onsible sources

Production Manager: Ruth Müller-Wirth Design: Will Webb

Special thanks are due to Ruth Slanev at the National Portrait Gallery and Mark Fairman of DL Imaging Ltd.

Every purchase supports the National Portrait Gallery, London

Page 2: Arthur Wellesley, 1st Duke of Wellington, by Thomas Heaphy, 1813–14 (detail of image on page 64, top left). Pages 16–17: Arthur Wellesley, 1st Duke of Wellington, by Francisco de Goya, 1812-14 (detail of image on page 27). Pages 54-5: The Battle of Waterloo, by George Jones, 1815 (detail of image on pages 84–5). Pages 92–3: Doing Homage, by 'Paul Pry' (William Heath), 1829 (detail of image on page 105).

Inside cover: The Funeral Procession of Arthur, Duke of Wellington, by Henry Alken and George Augustus Sala, 1853.

Inside front cover, left to right

1st row Panel 1: detachment of Life Guards, HRH the Duke of Cambridge commanding the troops. Panel 2: Rifle Brigade, 800 strong. Panel 3: Royal Marines, 600 strong. Panel 4: 33rd Regiment - The Duke's Own - 600 strong. Panel 5: band of the Coldstream and Fusilier Guards, battalion of the Scots Fusilier Guards. Panel 6: battalion of the Coldstream Guards, battalion of the Grenadier Guards. 2nd row Panel 7: commander of the Royal Artillery, band of the Royal Artillery. Panels 8-9: Royal Artillery, nine guns. Panel 10: HSH Prince Edward of Saxe Weimar, aide-de-camp. Panel 11: 17th Lancers, one squadron. Panel 12: 13th Light Dragoons, one squadron. 3rd row Panel 13: 8th Hussars (King's Royal Irish), one squadron. Panel 14: 2nd (Royal North British) Dragoons - 'Scots Greys' - one squadron. Panel 15: 6th Dragoon Guards (Carabiniers). Panels 16-18: Royal Horse Artillery, eight guns. 4th row Panel 19: state band, 1st Life Guards. Panel 20: Royal Horse Guards Blue, 2nd Life Guards, 1st Life Guards. Panel 21: marshalmen, Messenger of the College of Arms, eight conductors. Panel 22: 83 Chelsea Pensioners, denoting the Duke's age, twelve enrolled pensioners. Panels 23-4: infantry: one soldier from every regiment in Her Majesty's service; cavalry; an officer, sergeants of sappers, artillery and fusiliers, representing the East India Company's three presidencies, state band, thirteen trumpets and kettle drums. 5th row Panel 25: two pursuivants at arms, the standard or pennon, carried by a lieutenant colonel supported by two captains. Panel 26: members of the Duke's household, Lieutenant Colonel the Earl of Cardigan, aide-de-camp. Panel 27: deputations from public bodies, in twelve private carriages, two pursuivants at arms. Panel 28: band of the 6th Inniskilling Dragoons, the guidon carried by a lieutenant colonel supported by two captains. Panels 29-30: the Controller of the Household, the Physicians, the Chaplains of the Tower, of the Forces, London District and Chaplain-General of the Forces, the High Sheriff, County of Southampton, four coaches.

Inside back cover, left to right

1st row Panel 31: the Sheriffs of London. Panels 32-3: the Military Secretary, Companions of the Order of the Bath, Knights Commanders ditto, Knights Grand Cross ditto (one from each class, army and navy, Honourable East India Company and civil service), heralds, five coaches. Panel 34: state band, 2nd Life Guards, banner of Wellesley. Panels 35–6: the Speaker of the House of Commons (here followed 26 private carriages), the City Marshal, ward beadles. 2nd row Panel 37: the Lord Mayor of London. Panel 38: Assistant Quarter Master General, aides-decamp to deceased, Deputy Quarter Master General, Quarter Master General, Assistant Adjutant General, Deputy Adjutant General, Adjutant General, carriage of HRH Prince Albert with the Gentleman Usher, the Equerry, Groom of the Bedchamber. Panels 39–40: the Private Secretary, Treasurer and Lord of the Bedchamber to HRH Prince Albert, HRH Prince Albert attended by the Lord Chamberlain of HM Household, The Groom of the Stole to HRH and the Field Officer in Waiting, Norroy King of Arms, band of the Royal Horse Guards, the great banner. Panels 41-2: The batons of Spain, Russia, Prussia, Portugal, The Netherlands, Hanover, England, the coronet borne by Clarenceux King of Arms, eight coaches. 3rd row Panels 43-4: the pall-bearers, eight general officers, in two carriages, drummers of the Grenadier Guards, Life Guards. Panels 45-6: the funeral car drawn by twelve horses, ten bannerols borne by officers. Panels 47-8: the chief mourner, the Duke of Wellington, accompanied by his relations and friends, four coaches. 4th row Panels 49-50: the late Duke's horse led by his groom, private carriage of the late Duke, private carriage of the present Duke, band of the Royal Marines. Panels 50-2 and panels 53-4: one officer, one sergeant, one corporal and six privates from every regiment in HM service. Panel 54: band and pipers, 93rd Highlanders. 5th row Panels 55-6: carriage of HM The Queen and two of HM suite, three carriages of HRH the Duchess of Gloucester, HRH the Duchess of Kent and HRH the Duchess of Cambridge, Life Guards closing the procession.

CONTENTS

DIRECTORS' FOREWORD	6
CURATOR'S FOREWORD	8
THE DUKE OF WELLINGTON BY WILLIAM HAGUE	12
THE LAST GREAT ENGLISHMAN'	16
THE MOST DESPERATE BUSINESS' WELLINGTON IN THE ARMY	54
THE 'WATERLOO IDOL' DEFEATED WELLINGTON IN POLITICS	92
CHRONOLOGY	112
FURTHER READING	122
PICTURE CREDITS	122
NDEX	126

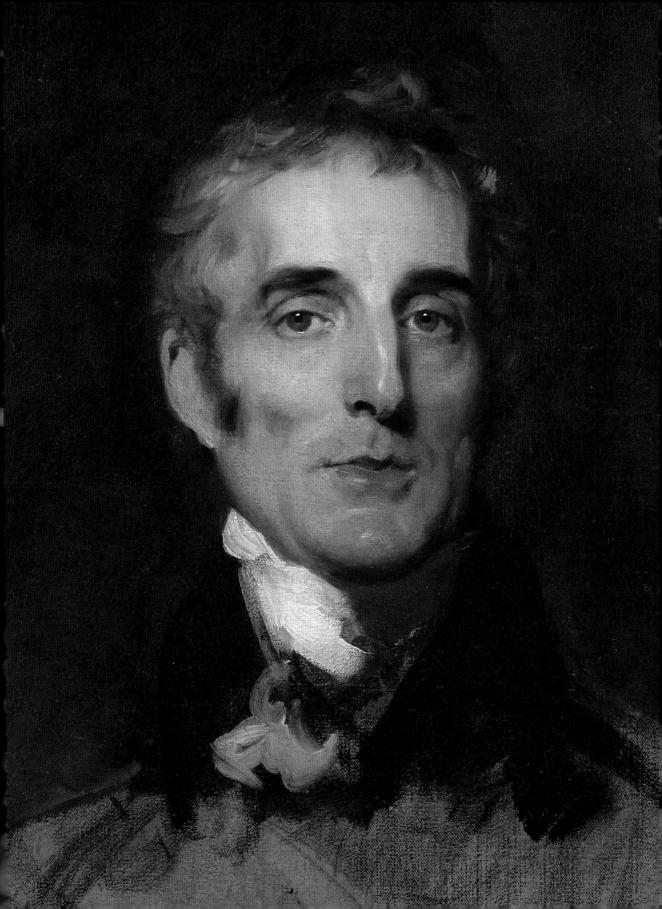

DIRECTORS' FOREWORD

• HE FIRST DUKE OF WELLINGTON makes a fitting subject for an exhibition at the National Portrait Gallery. A towering figure in British history and popular mythology, he was perhaps the greatest of national and military heroes, with a commanding presence in political and public life across several decades of the nineteenth century. He was a complex character, yet referred to by Lord Holland as possessing 'the ineffable charm of unassuming simplicity', so it is no surprise that, despite making the occasional protests, he sat for portraits on some 200 occasions. Whatever hesitations Wellington may have felt, images mattered in conveying his public persona: from the dashing young soldier depicted in oils by John Hoppner in the mid-1790s, to a daguerreotype taken towards the very end of his life, when Thomas Carlyle referred to him as 'truly a beautiful old man'. The earlier paintings include a portrait as poignant as that by Francisco de Goya, started in Madrid after the battle of Salamanca in 1812, but only completed in 1814. Alongside these are satirical prints of Wellington, made as policies were contested or he was seen as resisting political change. The great portraits painted by Sir Thomas Lawrence offer particular psychological insight, perhaps especially those commissioned by admirers who knew the Duke as a close friend rather than as a military commander or prime minister.

This exhibition, made in the 200th anniversary year of the battle of Waterloo, has been researched and selected by Paul Cox, Associate Curator, with close support from Lucy Peltz, Curator of Eighteenth-Century Portraits, and with the particular encouragement and advice of Charles Wellesley, Marquess of Douro. We are very grateful to them and to all our colleagues who have worked so hard to bring the exhibition and this publication to fruition, particularly Nick Budden, Robert Carr-Archer, Tarnya Cooper, Joanna Down, Neil Evans, Ian Gardner, Michelle Greaves, Justine McLisky, Ruth Müller-Wirth, Andrew Roff, Nicola Saunders, Jude Simmons, Fiona Smith, Liz Smith, Christopher Tinker, Sarah Tinsley, Ulrike Wachsmann, Helen Whiteoak and Rosie Wilson.

We should also like to thank all the many lenders to the exhibition, who have been so generous with loans, as well as William Hague, Leader of the House of Commons and First Secretary of State, for his foreword, and many supporters and advisors, especially our former Trustee Antonia, Lady Douro.

SANDY NAIRNE, former Director, PIM BAXTER, Deputy Director National Portrait Gallery, London

Detail of Arthur Wellesley, 1st Duke of Wellington, by Sir Thomas Lawrence, 1829 (page 36)

CURATOR'S FOREWORD

THE 200TH ANNIVERSARY of the battle of Waterloo falls on 18 June 2015. The historic encounter, at which an Anglo-Dutch army commanded by the Duke of Wellington defeated the French army of Napoleon Bonaparte, put an end to over twenty years of warfare in Europe. In 1915, British commemorations of the 100th anniversary were muted by wartime restrictions, as well as the fact that the enemies and allies of 1815 had been transposed: during the First World War Britain was fighting alongside France against an imperial Germany headed by Prussia, which had been an ally in 1815. In the relative peace of twenty-firstcentury Europe, with the belligerent nations of 100 and 200 years ago united within the European Union, it is possible to look more objectively at the events of 1815. The exhibition *Wellington: Triumphs, Politics and Passions* at the National Portrait Gallery is one of a number of commemorative events that will take place in 2015. These include a memorial service at St Paul's Cathedral, a re-enactment of the journey of Wellington's victory dispatch from Brussels to London, and exhibitions at museums and galleries throughout the country.

This book, and the exhibition it accompanies, examines the life of Arthur Wellesley, 1st Duke of Wellington – the man whose name is virtually synonymous in Britain with the downfall of Napoleon and the termination of the Napoleonic Wars. It looks not solely at his role in the battle of Waterloo, but at his life before 1815, during which he established his military reputation, and at the long political career he embarked on once his active duties as a soldier had come to an end. While many biographies of Wellington have been published over the years, this is the only account to explore and evaluate his life through the rich seam of portraiture and visual culture it inspired. In taking this approach, we necessarily owe much to the iconography of Wellington, prepared in 1935 by Lord Gerald Wellesley, later 7th Duke of Wellington, and John Steegman, a landmark work newly researched, expanded and updated in late 2014 by Charles Wellesley, Marquess of Douro.

For the exhibition, we are fortunate to have been able to assemble a number of fine portraits of the Duke, some of which have rarely been seen outside the family collection. Despite Wellington's oft-quoted antipathy to sitting for his portrait, the best depictions of him are both revealing and striking, and it is these that serve to structure the account of his life in the book's first chapter. The second chapter explores how Wellington's triumphs established his heroic status in the eyes of his contemporaries. It also considers the impact of Wellington and his victories on artistic production in a variety of media, with a particular focus on the commemorative and decorative works produced in the aftermath of his final victory at Waterloo. The third and final chapter considers Wellington's political career as a diplomat, a Tory Member of Parliament and as prime minister. It is, perhaps, not surprising that he was a passionate defender of the existing political order, or that, having fought against the armies of Revolutionary and Napoleonic France, he supported the return of Louis XVIII, despite reservations about the King's personality and competence. Likewise, Wellington's intractable opposition to political reform in Britain reflected his passionate belief in the existing social order and the institution of monarchy at the head of religious and political life. These strongly held beliefs cost him his prime ministership and resulted in the dramatic loss of the status he had achieved after Waterloo. Some aspects of the Duke's personality can be difficult to like, but it is impossible not to admire a man who adhered to his convictions so strongly, regardless of the professional and personal cost. I suspect few modern politicians would do the same.

Assembling an exhibition such as this would not be possible without the support of a great number of organisations and individuals. Lord Douro in particular has been unstinting in his generosity, both by offering to lend portraits, and in allowing access to the family's collections at Stratfield Saye and Apsley House.

An early discussion with John Cooper, former Head of Education at the National Portrait Gallery, was tremendously helpful in confirming my ideas about the exhibition's direction. In addition, Jane Branfield, Archivist at Stratfield Saye, Alice Crossland, Researcher for the Stratfield Saye Preservation Trust, Pip Dodd, Curator of Fine and Decorative Art at the National Army Museum, Kate Heard, Senior Curator of Prints and Drawings at the Royal Collection, Professor Andrew Lambert of King's College London, Chris McCarthy, Parliamentary Assistant to The Rt. Hon. William Hague, Josephine Oxley, Keeper of the Wellington Collection at Apsley House, and Dr John Peaty have all supplied valuable information and assistance.

At the National Portrait Gallery, Sandy Nairne, Jacob Simon, Tarnya Cooper and Sarah Tinsley have all offered tremendous encouragement since the first outline plan was drafted. I am grateful to Robin Francis, Head of Archive & Library, and all my immediate colleagues, who have tolerated my periodic absences from the department's activities over the last five years. I would also like to thank colleagues who have brought their professional skills to bear on the project, especially Nick Budden, Natalia Calvocoressi, Emma Cavalier, James Cunningham-Graham, Liz Dewar, Andrea Easey, Ian Gardner, Michelle Greaves, Victoria Miller, Andrew Roff, Jude Simmons and Ulrike Wachsmann; curatorial interns Juliet Chippindale, Rosie Razzal and Amanda Hilliam all provided valuable research assistance.

I wish to thank particularly Lucy Peltz, Curator of Eighteenth-Century Portraits, with whom I have worked closely. Her enthusiasm for the project has been inspiring, she has acted as a mentor and a guide to the mechanics of producing an exhibition at the National Portrait Gallery, and she has also generously read and suggested amendments to the catalogue essays.

Finally, my special thanks go to Eleanor Ghey, both for her personal support during work on the exhibition and book, and for the intelligently critical eye with which she has read my texts.

PAUL COX Associate Curator National Portrait Gallery, London

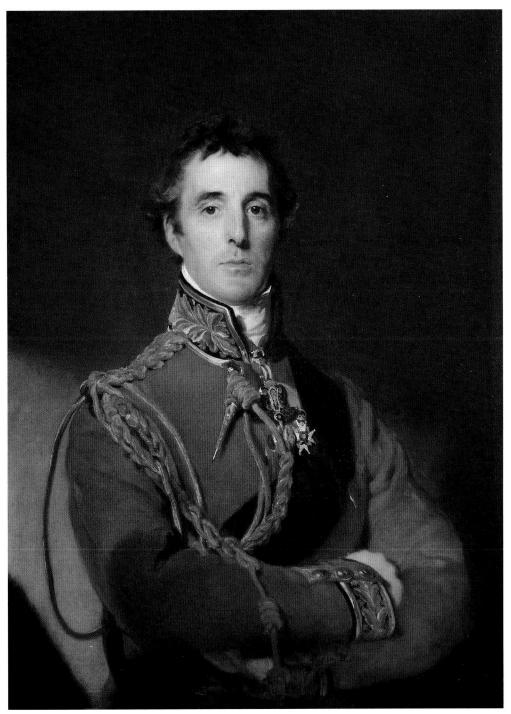

Arthur Wellesley, 1st Duke of Wellington, by Sir Thomas Lawrence, 1817–18

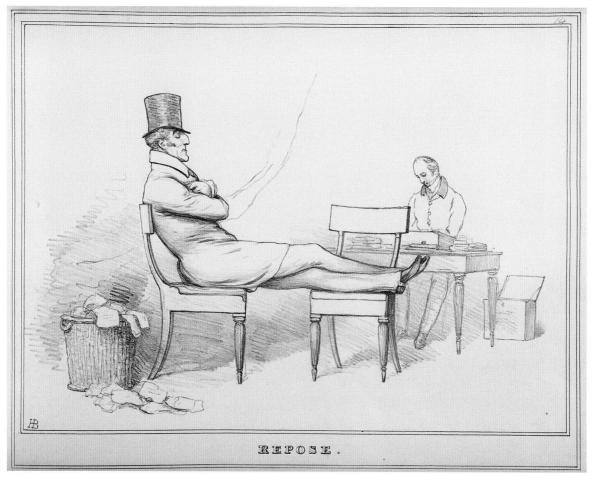

Repose, by 'HB' (John Doyle), July 1829

The print's title implies rest after labour – it was published shortly after the passage of the Roman Catholic Relief Act. However, the issue of political reform, which brought down Wellington's government, awaited him.

THE DUKE OF WELLINGTON BY THE RT. HON. WILLIAM HAGUE

T IS NOT THE HABIT of the British to accept generals, even the giants among them, as political leaders. In Britain there has been no Eisenhower in the twentieth century, no cadre of Grants and Shermans before that; no de Gaulle has been called on to restore political leadership and order. The long absence of civil conflict, the early development of parliamentary democracy, and the general aversion to possessing a large standing army have all joined with the healthy British scepticism towards the amassing of authority to make the combination in one person of leading political and military roles rare indeed.

Yet the Duke of Wellington, despite becoming in every other respect the personification of British values, habits, power and duty, comprehensively defied this unwritten rule. Most obviously known to history for his extraordinary generalship, he went on to serve in Cabinets for some eighteen years, briefly becoming foreign secretary and presiding for nearly three years in 10 Downing Street as prime minister.

Furthermore, he held such offices while largely keeping his reputation and standing intact. On his death it was written that 'one can hardly realise to oneself the idea of England without the Duke of Wellington', and the size of the crowds mourning him as his body lay in state led to several people being killed in the crush.

What was it about the Duke that made him such a unique figure in his country's history? And what were the reasons that he alone was able to make the transition from presiding over the battlefield to doing so in the Cabinet Room instead?

First was the sheer extent of his military renown, which went far beyond anything seen in previous decades or the two centuries that have since followed. In an age when victory still depended overwhelmingly on the commander on the spot, his tactical brilliance, his mastery of logistics and terrain, and his ability to make a ramshackle force into a disciplined army were essential instruments in the defeat of Napoleon after a quarter-century of warfare. By the time of his victory at Salamanca his reputation was rivalling that of Marlborough; after Waterloo he was regarded not merely as the greatest general in Britain, but anywhere in the world. And since he had held together disparate international coalitions in the field, and seamlessly moved on to govern occupied France, it was clear that effective politics had assisted his success in war.

Second, he had arrived at this pinnacle of fame and reputation at the age of forty-six, and would outlive the political leaders who shared in his success. They needed his standing to give weight to their governments at a time of immense economic and social strain, and once they left the scene – Castlereagh due to suicide, Liverpool to a stroke, Canning to exhaustion and death – the one figure who represented continuity and safety was Wellington.

Third, while in common with almost all military men he found politics exasperating – remarking after chairing his first Cabinet meeting as prime minister that it was 'An extraordinary affair. I gave them their orders and they wanted to stay and discuss them.' – he retained a sharp political eye honed by his earlier need to manage critical media and parliamentary attack on his management of a long, difficult and initially unproductive war in the Peninsula. Inevitably on the wrong side of public opinion on many occasions, with the mob trying to drag him from his horse at the height of the controversy over Queen Caroline in 1820, he ensured he retained sufficient dignity, and a dislike of 'factious opposition' even when he was in opposition himself, not to descend to being just another politician.

And fourth and decisively, the sense of duty that he coupled with ambition was genuine and shone through. Deeply conservative himself, he nevertheless was crucial in persuading other powerful conservative forces, the monarchy and the Tory party, to support or be reconciled to essential reform. No one in the country could manage George IV – 'the worst man I fell in with in my life' – so successfully; Wellington was able to push through the long-disputed Catholic emancipation, and ultimately allowed through the Great Reform Act he hated rather than tip the country into chaos or revolution.

It is this combination of circumstances and abilities that makes the Duke of Wellington a unique and compelling figure, and a hugely influential political leader at a formative time in the modern government of Britain. For him, the country made an exception. And for him, it was right to do so.

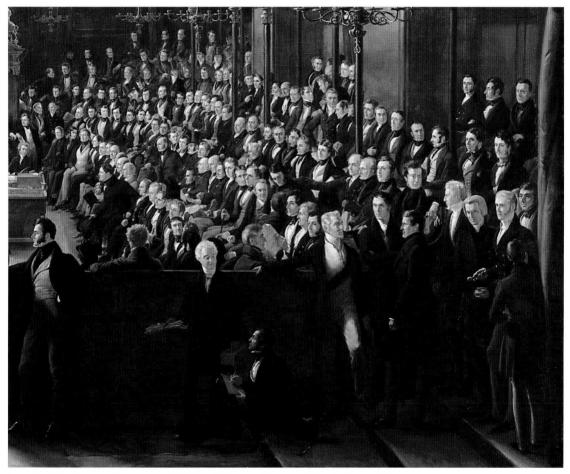

Detail of *The House of Commons, 1833*, by Sir George Hayter, 1833–43 (page 109) Wellington, wearing the Order of the Golden Fleece on a red ribbon, has his back to the Commons chamber. He is said to have remarked on seeing the first reformed House of Commons, 'I have never seen so many bad hats in all my life.'

'THE LAST GREAT ENGLISHMAN' THE LIFE OF WELLINGTON

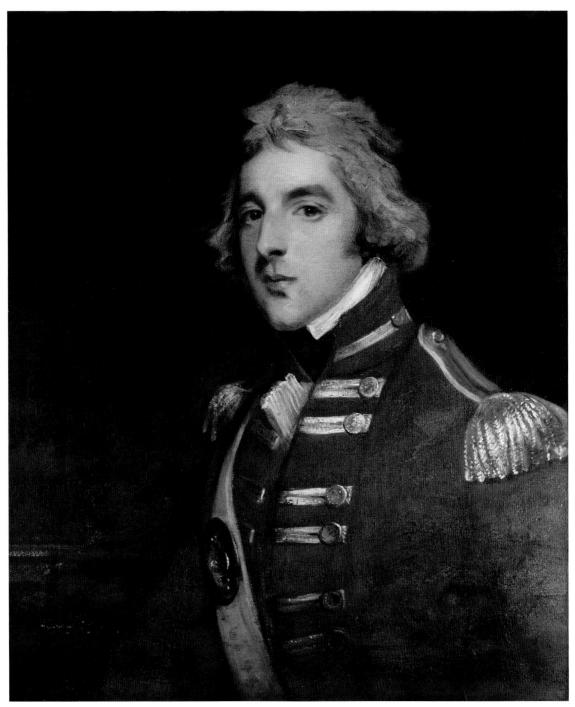

Arthur Wellesley, 1st Duke of Wellington, by John Hoppner, c. 1795

THE DUKE OF WELLINGTON is a name that needs little introduction, yet his life is hardly known to modern audiences. Although Arthur Wellesley, 1st Duke of Wellington, professed to hate sitting for his portrait – complaining that no one had 'sacrificed his time ... to the Artists to the same degree that I have' – he was portrayed over 200 times.¹ This iconography stretches from a late eighteenthcentury painting of him as a young military man full of potential and promise, to a daguerreotype of an aged statesman, the hero of Waterloo, saviour of nations and ex-prime minister, taken on his seventy-fifth birthday. This early photograph depicts a man who had lived through and shaped a climactic and tumultuous period in British and world history – a career captured by artists and explored in this book.

The first oil portrait of the future Duke of Wellington was painted by John Hoppner in the mid-1790s, when Arthur Wesley, as he was then known, was around twenty-six years old (opposite). Although elegantly posed in the distinctive all-red uniform of the 33rd Regiment, with the loosely styled and powdered hair fashionable in that decade, the fresh-faced complexion, slightly parted lips and the almost quizzical position of the head suggest the hesitancy of a young man about to commit himself to a career. He had recently gained the command of his regiment, and for the near future at least a life in the army was in prospect. So, we might ask, what was his background, what had been his experience of life thus far and what could he reasonably expect from the future at this point? Arthur Wesley was born in Ireland in 1769, the third surviving son of Garrett Wesley, 1st Earl of Mornington and his wife Anne Hill (following the example of his older brother Richard [opposite], Arthur would change his surname in 1798 to the earlier form of Wellesley). 'The Wesleys were a Protestant family of English origin but, unlike others of the ruling class, they were not especially active in Ireland's administration. Arthur's father was more interested in music than politics. He was appointed professor of music at Trinity College, Dublin and his elevation to the Irish peerage in 1760 appears to have been due to his musical achievements. Equally, in his management of the family estate at Dangan in County Meath he concentrated more on the aesthetics of landscape than agricultural productivity and the family fortune suffered accordingly.²

As a boy, Arthur was considered dull and unintelligent in comparison with his brothers. They had excelled in their studies at Eton, but Arthur was a poor scholar and was removed from the school, even though his two younger brothers stayed. After some time with a tutor in England, he went to live with his widowed mother in Brussels. He was later sent to the Royal Academy of Equitation at Angers in France to prepare him for the military career that was all his mother felt he was fit for. She referred to him as her 'awkward son Arthur ... food for powder and nothing more'.³

The academy was less a military college than a finishing school for gentlemen, where dancing, fencing and horsemanship featured heavily on the curriculum. The instruction in French grammar, mathematics and military fortification would, however, be of future use. Whatever the military benefit of his period at Angers, by the time he returned to England in 1786, Arthur was no longer a disappointment, but a confident young man. More significantly still, he appeared resolved on a military career and allowed his older brother Richard to use his influence to obtain him a commission in the army.

In this period, when commissions and promotions in the army were typically bought and sold, an officer rising in rank could sell his existing commission to an eligible junior officer. Connections could also smooth this process and in March 1787 Richard, then serving as a junior lord of the Treasury, obtained Arthur's first commission as an ensign (the lowest ranking officer) in the 73rd Highland Regiment of Foot. Over the next six years, his name was on the books of five further regiments, yet his active participation in their affairs is unlikely. In April 1793 he purchased the rank of major in the 33rd Regiment. This was the regiment with

Richard, Marquess Wellesley, by John Hoppner, mid-1790s

which he saw his first military action and it was renamed by Queen Victoria the 33rd (the Duke of Wellington's) Regiment in 1853, the year after his death.

Arthur's desire to become a major coincided with his more active participation in politics. He had replaced his older brother William as Member of Parliament for the Ulster borough of Trim in 1790, but only in 1793 started to speak in the Irish Parliament. He was also now courting the young and attractive 'Kitty' Pakenham, daughter of the late Lord Longford, and was preparing to ask for her hand in marriage. Kitty's father had died in 1792, so it was to her brother Tom, younger than both Kitty and Arthur himself, that the suitor had to make his request. This was to no avail: Tom turned Arthur down. The Wesleys now had many debts and Arthur could clearly not afford to keep Kitty on his income. His rank of major at the age of twenty-four was unimpressive when Tom's younger brother, Ned, had had this rank bought for him at the age of seventeen.

This rejection was a turning point in Arthur's life, when he determined to take his military career seriously. Although he had inherited a talent for music from his father, in a grand and emphatic gesture he burnt his violin, resolving never to play again. He purchased the rank of lieutenant-colonel and thereby became commander of the 33rd – Hoppner's portrait shows him in the uniform of this rank – and he applied himself to the detailed business of regimental affairs. With some disappointment, Wesley assumed that his regiment was unlikely to see active service. However, in the summer of 1794 it was sent to reinforce the Duke of York's army, then fighting alongside Austrian allies against the forces of Revolutionary France in Flanders. Shortly before he set sail for the Continent, he wrote to Kitty to let her know that should any change in his circumstances cause her brother to review his decision, 'my mind will still remain the same'.⁴ His commitment to this sentiment was to affect his future life profoundly.

During the campaign in Flanders, Arthur saw his first action at the battle of Boxtel. Although he performed well, he was left disillusioned by the poor command and even worse resources of the army. He was later to recall that this campaign had taught him 'what one ought not to do'.⁵ In the spring of 1796 the 33rd Regiment was ordered to set sail for India, where the future Duke of Wellington's military career began to attract notice.

Wellesley participated in the defeat of Tipu Sultan of Mysore (opposite) in southern India in 1799 and successfully commanded an army against the Maratha Confederacy in central India in 1803. Both had threatened the expansion of the East

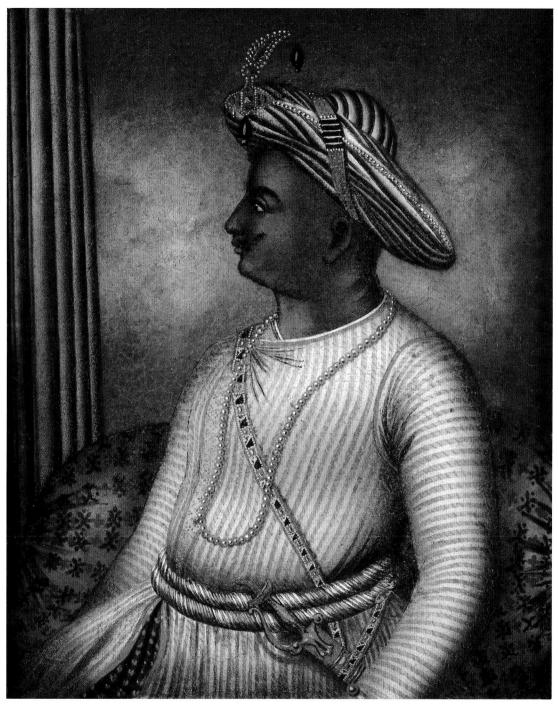

Tipu Sultan, attributed to F. Cherry, 1792

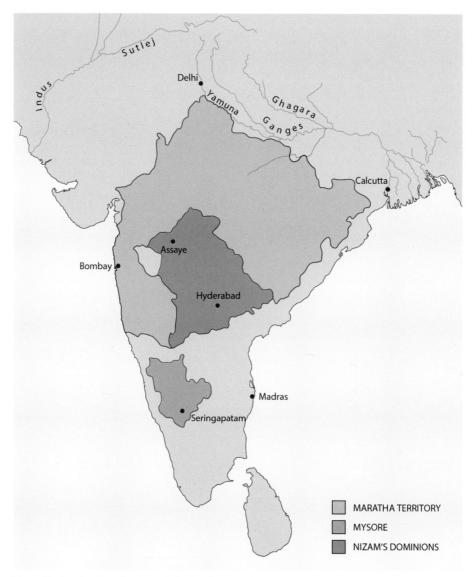

Map of India, showing the sites of the battles at Seringapatam and Assaye

India Company, by this time a *de facto* arm of the British government. Wellington recalled in later life that his greatest military achievement had been the battle of Assaye, a victory against a far larger enemy force during the Maratha campaign.⁶ He had ordered a brilliant manoeuvre to bring about the coup, but, not for the last time, expressed melancholy at a victory gained at such a heavy cost in casualties (above).⁷

Major-General the Hon. Arthur Wellesley being received in Durbar at the Chepauk Palace Madras by Azim al-Daula, Nawab of the Carnatic, by George Chinnery, 1805

Arthur Wellesley's Indian career was undoubtedly boosted by the appointment of his brother Richard as Governor-General of India the year after he arrived. That Richard's secretary was their younger brother Henry meant that there were simultaneously three Wellesleys serving in important Indian offices. This occasionally resulted in Arthur being placed ahead of officers with more legitimate claims. Although the charge of favouritism was probably justified, at one point Arthur and Richard did fall out when an important appointment was awarded to another officer.

Wellesley's military reputation was established in India. He was promoted to major-general in 1802, although only within the Indian army, but this was confirmed in 1806 after his return to England. A watercolour by George Chinnery (above) records a ceremonial event he attended less than a month before departing, where he is shown being presented to Azim al-Daula, Nawab of the Carnatic. The purpose of the drawing is unknown, but it is likely to have been a preparatory design for an oil painting to commemorate this occasion. Wellesley's placement at the focal point of the composition reveals the artist's awareness of the status and reputation he had achieved among his colleagues in India.

THE PENINSULAR WAR

From 1808 to 1814 during the Peninsular War, an Anglo-Portuguese army fought alongside its Spanish allies to liberate first Portugal and then Spain – the Iberian Peninsula – from French rule. Wellesley first fought the French in the Peninsula in 1808, and was in command of the Anglo-Portuguese army from 1809. He was elevated to the peerage as Baron Douro and Viscount Wellington in 1809, to the Earldom of Wellington in February 1812, and later that year to marquess in recognition of his victory at Salamanca in Spain, one of his most successful battles. A particularly revealing portrait of Wellington was painted during this period. Francisco de Goya's painting (opposite), commenced in 1812 but given its current form in 1814, records his war-weary appearance on arrival in Madrid. His triumphal entry into the Spanish capital followed his Salamanca victory, but his men were exhausted. Occupying the city not only allowed the army time to rest, but also gave a political boost to the government in England, which had been under attack by the opposition over its conduct of the war.

When the newly elevated Wellington began sitting to Goya, his uniform was decorated by the stars on his left breast and the Peninsular Medal on a ribbon around his neck. However, the Spanish government awarded him the Order of the Golden Fleece after his victory at Salamanca and the portrait was soon altered to include the order's insignia, which includes a representation of the Golden Fleece sought by the hero Jason in Greek myth, hanging from a red ribbon around Wellington's neck. This modification was unsurprising given the unprecedented honour of his admission to the order, which had never before been granted to a non-Catholic or non-royal recipient. It represented Spain's gratitude to Wellington and he was justly proud of it: almost all subsequent official portraits include this decoration, even when no others are visible. Wellington finally returned to Madrid in 1814, after being awarded the Military Gold Cross by the British government, and Goya again

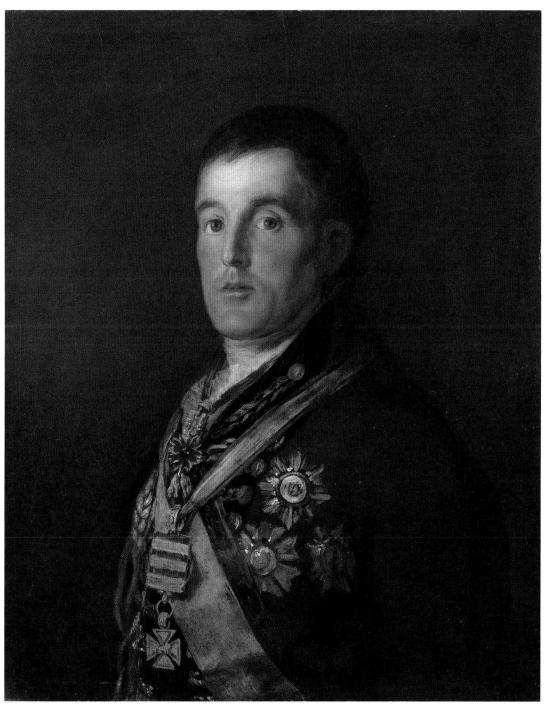

Arthur Wellesley, 1st Duke of Wellington, by Francisco de Goya, 1812–14

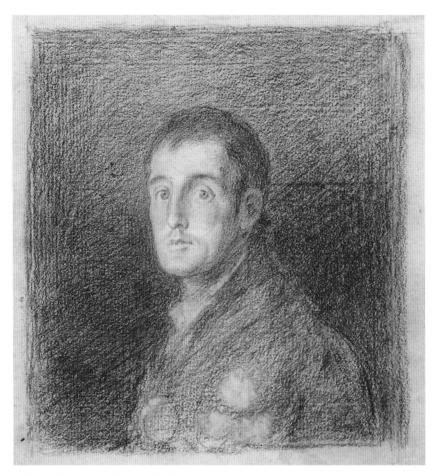

Arthur Wellesley, 1st Duke of Wellington, by Francisco de Goya, c. 1812

revisited the portrait, painting over the Peninsular Medal to show the Gold Cross suspended from its ribbon below the Golden Fleece.⁸

In addition to the international honours on his chest, Goya's portrait succeeds in conveying a sense of the inner man that no other portrait of Wellington ever achieved. A small related drawing (above) makes this clear. In this portrait Wellington's sunken eyes and weary expression reflect the exhaustion shared by the general and his army after a long season of sieges and lengthy manoeuvres. Some of the melancholy, fatigue and horror witnessed made its way into the finished portrait, revealing the reality of war behind the glittering splendour of a public façade. Goya was, of course, examining this brutal reality at the time with his series of etchings known as the *Disasters of War* (1810–20).

By the time this portrait was painted, Wellington's personal circumstances had also changed. After his return from India in 1805, he had renewed his acquaintance with Kitty (overleaf). The couple had not seen each other for over eleven years, nor written since his departure for Flanders. However, once he was back in England, Lady Olivia Sparrow, a mutual friend, acted as an intermediary. She wrote to Arthur that Kitty remained fond of him and persuaded him of his duty to marry her. She also communicated the contents of Arthur's letters to Kitty who, to her credit, detected in them a lack of conviction and felt that Arthur should at least meet her before renewing his proposal. During Arthur's absence abroad, convinced that their relationship had reached an end, she had become engaged to another man. She had broken this off, however, possibly after Lady Olivia had shown her a letter from Arthur in which he declared his continuing fondness for her. The emotional stress placed upon her by this romantic upheaval and the conflicting desires of her family and friends had then caused her to suffer a nervous breakdown, from which she had only partially recovered. She urged caution on Arthur, but he wrote proposing marriage. Even in her letter of acceptance, she let him know that she felt uneasy about making a commitment before they had met, but Arthur travelled to Ireland and they met less than a week before they were to be married in 1806.

Arthur did indeed find her changed: he is said to have remarked ungallantly to his brother that 'she has grown ugly, by Jove!'⁹ Why he pursued this marriage after such an interval can only be guessed. Perhaps it was to expunge the humiliation of his earlier rejection, or perhaps the promise made in his final letter before leaving for Flanders made it a matter of honour. Whatever the reason, the marriage was never happy. It is telling that the drawing of Kitty by the eminent portrait painter Thomas Lawrence (overleaf) was commissioned not by her husband, but her sister.¹⁰ It shows a woman of beauty, but the pose, with Kitty's hand fingering the collar of her dress, suggests nervousness, and her heavy lidded eyes a note of sadness. Only six months after the wedding, evidence can be found of what Wellington would call 'domestic annoyances' over his perception of her mismanagement of the household budget.¹¹ Kitty gave birth to their first son, Arthur, in February 1807 and Charles was to follow in January 1808 (page 31). Wellesley then left to consolidate his military reputation in the Peninsular War, first for three months in 1808 and then, without a break, from 1809 to 1814.

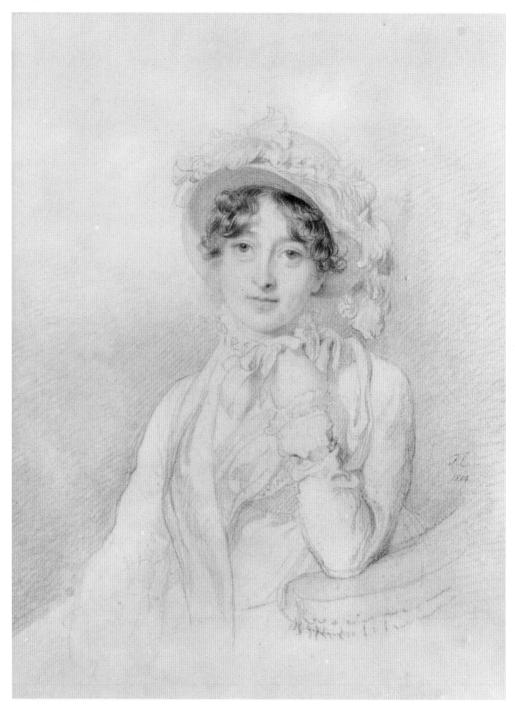

Catherine ('Kitty') Pakenham, Duchess of Wellington, by Sir Thomas Lawrence, 1814

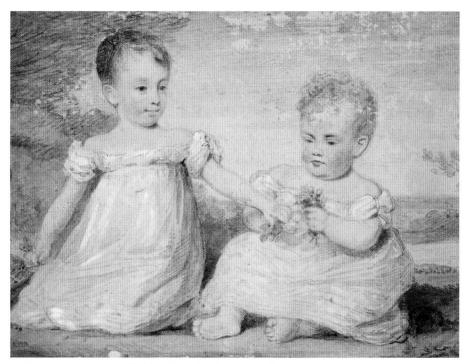

Wellington's sons Arthur (left) and Charles, by Henry Edridge, c. 1808

WATERLOO

Of the seven oil portraits of the Duke of Wellington painted by Thomas Lawrence, the half-length in military uniform is perhaps the best-known of all images of Wellington, having formed the basis of the portrait on Britain's £5 note from 1971 to 1991 (page 11). Recent research by the Marquess of Douro has dated the portrait to 1817 or after, just two years after Wellington's final military triumph. The supreme air of self-confidence expressed by the pose and facial expression reflects the elevated international status accorded the Duke after his defeat of Napoleon. Lawrence's portrait has been described as steering 'adroitly between extremes of grandeur and ordinariness', perhaps reflecting the Duke's desire to maintain the public image of an uncomplicated soldier in the face of the hero worship to which he was subjected.¹² The armies of Napoleonic France had suffered enormous defeats at the battles of Leipzig in Germany and Vitoria in Spain in 1813 and although Napoleon fought on, his downfall was inevitable and he abdicated in April 1814. He was exiled by the victorious allies to the Mediterranean island of Elba, off the west coast of Italy. Throughout Europe there was a feeling that the long war was now over and the Continent could look forward to a period of peace and rebuilding. Amid the international celebration, Wellington received his final step in the peerage, when the Prince Regent created him Duke of Wellington in May 1814 as an acknowledgement of his part in Napoleon's defeat.

The situation was not so straightforward, however. Napoleon managed to escape from exile and return to power in France in 1815. The Congress of Vienna, then in session, declared Napoleon an outlaw and agreed a treaty in which the great European powers – Austria, Great Britain, Prussia and Russia – would assemble armies to defeat Napoleon's forces and restore the legitimate king to the French throne. With the other allies yet to arrive from the east, an Anglo-Dutch army under Wellington and a Prussian army under Field Marshal Blücher decisively defeated Napoleon's army at the interlinked battles of Waterloo and Wavre on 18 June 1815. Again, Wellington expressed his misgivings about a battle won with such heavy casualties: 'Nothing except a battle lost can be half so melancholy as a battle won.'¹³

After this final defeat, Napoleon abdicated yet again. He was exiled by the British government to the distant British territory of St Helena in the South Atlantic. Although there was now no likelihood of a resumption of war in Europe and little prospect of his further active employment as a soldier, Wellington had one final military command. The Treaty of Paris decreed that France was to be occupied for a period of five years by an allied force of 150,000 men, until financial reparations were completed. Reflecting his newly elevated position on the world stage, the Duke of Wellington was appointed commander-in-chief. The French population resented the occupation, so to strengthen the newly formed French government Wellington brokered bank loans to enable the treaty obligations to be fulfilled early and the occupying force was wound up in 1818. To mark this final duty and to acknowledge the importance of his role in the removal from Europe of the Napoleonic threat, Austria, Prussia and Russia made Wellington a field marshal in their armies. Each presented him with the ceremonial baton associated with this rank – Portugal and Spain had already awarded him this honour during his active

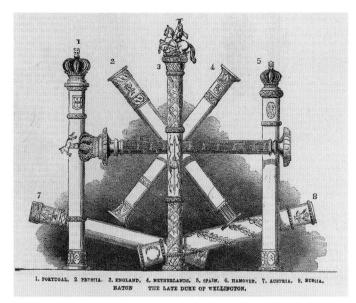

Wellington's field marshal's batons. An illustration published in the *Illustrated London News* at the time of his funeral, 1852

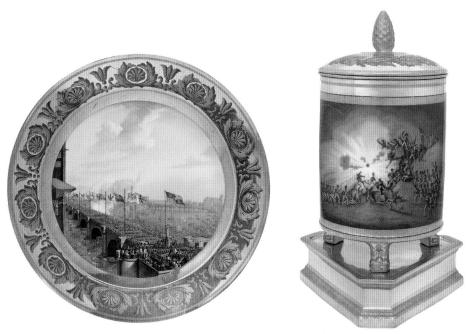

Dessert plate from the Saxon porcelain service, with a design showing the opening of Waterloo Bridge and (right) ice pail from the Prussian service, with a design showing the storming of Ciudad Rodrigo, c. 1819

military career (previous page, top). More personal gifts were the lavish porcelain table services commissioned by the kings of Austria, France, Saxony and Prussia (previous page, bottom). Of these, the most celebrated is the Prussian porcelain service, made up of 470 pieces decorated with scenes commemorating Wellington's life and exploits. This was commissioned in 1817 from the Royal Porcelain Factory in Berlin and forms one of their most elaborate productions. The porcelain services and a silver table centrepiece commissioned by the King of Portugal were used during the annual celebratory Waterloo banquets at Apsley House, Wellington's grand home at Hyde Park Corner in London (below).

The British government voted Wellington the vast sum of £600,000 (about £25 million today) to buy an estate. The site Wellington chose was Stratfield Saye near Basingstoke in Hampshire, which was bought for less than half this sum in 1817. Although plans were drawn up to demolish the existing house and build a spectacular palace, this was never realised and the existing house, with its comfortable domestic atmosphere, was to become Kitty's favourite residence. In 1818 Wellington also bought Apsley House from his older brother as his London home.

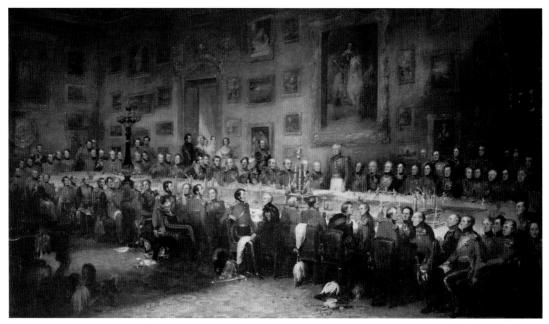

The Waterloo Banquet, 1836, by William Salter, 1840

POLITICAL CAREER AND LATER LIFE

Over the next decade, Wellington operated as government adviser or representative on a number of domestic and international matters. He was involved in the delicate negotiations between the Prince Regent and the Prince's estranged wife, Queen Caroline. He also represented British interests at the Congress of Verona in 1822, one of a series of conferences on European affairs after the Napoleonic Wars. Finally, soon after the death of the Prime Minister Lord Liverpool in 1828, Wellington was seen by the Tory party as the natural choice to lead them and became prime minister.

Thomas Lawrence's unfinished portrait (overleaf) was painted during this important period in Wellington's political career. It was commissioned by the immensely wealthy Sarah, Countess of Jersey, but remained unfinished on Lawrence's death. Nonetheless, the artist has captured in Wellington's face a feeling of sensitivity appropriate in a portrait made for one of Wellington's most devoted friends. Lady Jersey was a leading social and political hostess of her day. Initially dedicating her social gatherings to the cause of the Whig party, in the late 1820s she switched her allegiance to the Tories, with Wellington and Sir Robert Peel becoming her particular favourites. She believed herself to be one of Wellington's confidantes, but he justifiably mistrusted her ability to keep a secret: earlier in life her loquacity had earned her the nickname 'Silence' among her acquaintances.¹⁴

As prime minister, and later as leader of the Tory party in opposition, Wellington became embroiled in the divisive political questions of Catholic emancipation and parliamentary reform. These created a conflict between his commitment to serving his country and his own conservative political beliefs. His intransigent opposition to the Reform Bill, intended to provide greater political enfranchisement, resulted in his becoming a hate-figure among certain sections of the population: the iron shutters fitted to the windows of Apsley House to protect him from stones thrown by the mob at this time are probably the origin of his nickname 'The Iron Duke'.¹⁵

This was the most eventful period of Wellington's political career. After the fall of Lord Melbourne's Whig ministry in 1834, he became a caretaker prime minister for less than a month while Sir Robert Peel was abroad. He later assisted Peel to pass a bill repealing the Corn Laws, which set trade restrictions on imported grain, against the instincts of the right wing of his party. The resulting split in the party caused the defeat of the government in a subsequent vote and Wellington's active political career was essentially brought to an end.

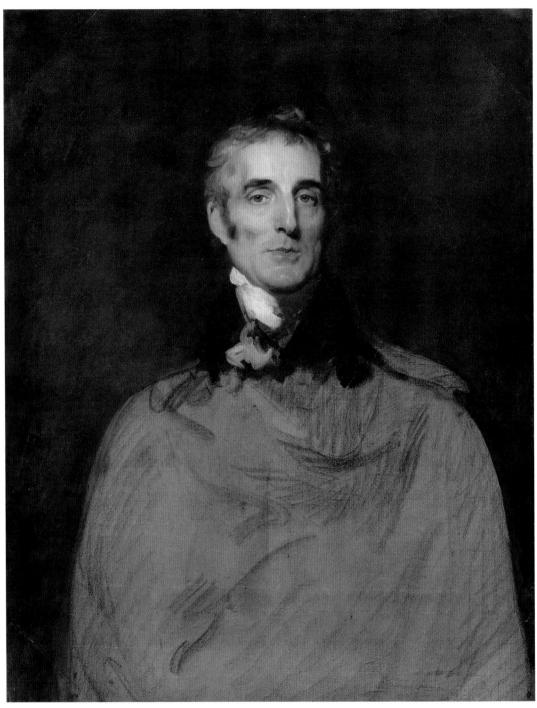

Arthur Wellesley, 1st Duke of Wellington, by Sir Thomas Lawrence, 1829

The most remarkable and unexpected portrait of the Duke of Wellington is an early photograph, a daguerreotype, taken on his seventy-fifth birthday in 1844 (page 39). Essentially a modern image of a man wearing a dark jacket, white waistcoat and shirt not dissimilar to those worn on formal occasions today, the contrast with the eighteenth-century portrait by Hoppner is dramatic and forcibly reminds us of Wellington's long career. His openness to the new technique of photography is not uncharacteristic. Although suspicious of the potential drain on the public purse from new technologies such as railways and military inventions, he was quite ready to adopt innovations of personal benefit. He had central heating and flushing toilets installed at Stratfield Saye and owned a variety of unusual waterproof garments to protect him from the British weather. By the time this photograph was taken, he had withdrawn from party politics and adopted a role as an elder statesman, providing advice to the Queen and government when required. He also became an unwilling adviser to the general public, who felt entitled to write to him on a variety of topics, perhaps because of his many years at the centre of the public life of the country. To cope with his enormous postbag he used pre-printed reply slips to respond to the most common subjects of correspondence, including approaches from military inventors (overleaf).

Wellington held a number of non-governmental posts throughout his career. He had been made commander-in-chief of the army in 1827, but had to give up the role in 1828 on being appointed prime minister. He was appointed to the former position again in 1842 and the conservative influence he exerted over the army until his death was partially responsible for its poor performance in the Crimean War in 1854. He was made Constable of the Tower of London and Lord Lieutenant of Hampshire, but it was his appointment as Lord Warden of the Cinque Ports in 1829 that gave him the most personal satisfaction. This post was accompanied by the residence of Walmer Castle on the Kent coast, which became Wellington's favourite home outside London.

Lineter ment mesey lout Pulso ha hand leter 10 how hunout me nauli touch in mane min ment unhull er heuce

Lithographic standard letter written by Wellington, c. 1830s

The letter reads:

London

FM [Field Marshal] The Duke of Wellington presents his Compliments to [correspondent's name]. The Duke has nothing to say to inventions. He has no power or authority to incur one Shilling of Expense on any account whatever, or to order or authorise such expense or to adopt any plan or improvement of armament or equipment which can occasion expense. It is useless therefore for inventors to apply to him [correspondent's name] must address the Master General of the Ordnance.

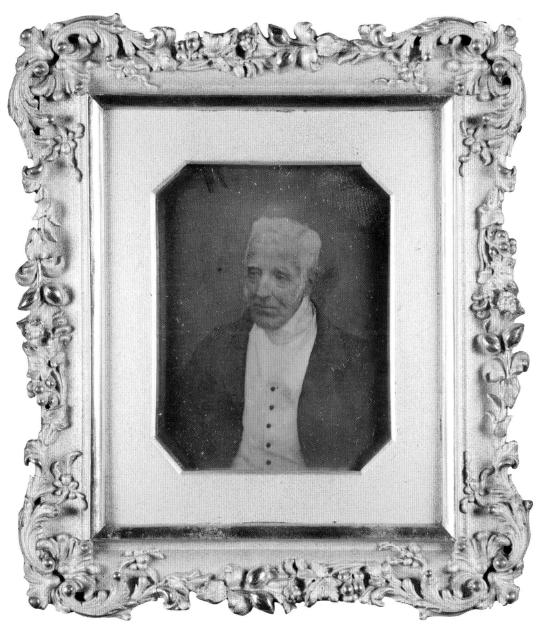

Arthur Wellesley, 1st Duke of Wellington, daguerreotype by Antoine Claudet, 1844

PRIVATE LIFE

The Duke favoured Walmer Castle because life at Stratfield Saye was difficult due to his poor relationship with Kitty. When Wellington was in residence she often invited people whom he disliked or barely knew, making the time he spent there uncomfortable. There were also many disagreements over Kitty's management of the household, her pursuit of information about Wellington's whereabouts from his servants, and even complaints over her dress and appearance, which he felt were

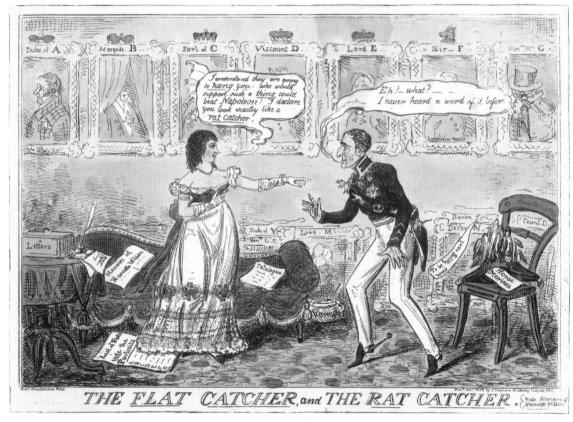

The Flat Catcher, and the Rat Catcher, by Robert Cruikshank, 1825

The speech reads:

Harriette Wilson: I understand they are going to hang you. Who would suppose such a thing could beat Napoleon; I declare you look exactly like a rat catcher. Wellington: Eh? What? I never heard a word of it before.

not sufficiently elegant for her station in life. Whatever had been Wellington's motives for pursuing the marriage, his conduct within it does not paint him in a favourable light. Despite his antipathy, though, Kitty was devoted to her husband, and he softened towards her at the time of her final illness. As she lay dying in April 1831, Wellington spent long periods at her bedside at Apsley House, displaying uncharacteristic patience. Kitty was comforted to find on Wellington's arm a bracelet she had given him many years before, which she would have found, he told a friend, at any time in the previous twenty years had she looked. He was to reflect that it was strange that two people who had

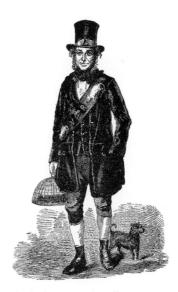

Jack Black, rat-catcher, illustration from Henry Mayhew's London Labour and the London Poor, 1851

lived together for half a lifetime could 'only understand one another at the end'.¹⁶ The Duke had certainly been unfaithful. There were rumours of affairs in India and the Peninsula both before and after their marriage. More infamously, he had become involved with the London courtesan Harriette Wilson in the early 1800s (opposite). When she was writing her memoirs in the 1820s, Wilson's publisher, Joseph Stockdale, wrote to Wellington and many of the other individuals mentioned, offering to remove his name from the book for a payment of £200. Wellington's response is famously reputed to have been 'Publish and be damned!' Wilson's book appeared in 1825 and went through a number of editions in quick succession. The revelation of the affair was not salacious, yet it shocked Wellington's friends. Harriette made a number of allegations of boorish conduct and poor conversation, which ring true, but her assertion that he visited her wearing the sash of the Order of the Bath, which she felt resembled the sash associated with London rat-catchers (above), is harder to believe.

Other liaisons included those in 1814, when Wellington was British ambassador in Paris, with the singer Giuseppina Grassini and the actress Marguerite Weimer, known as Mademoiselle Georges (page 43). Both of these had previously been mistresses of Napoleon, but Mlle Georges let it be known that the Duke was by far the more impressive lover.¹⁷ A more significant affair took place in the early 1820s with the society beauty Lady Charlotte Greville. It greatly upset her family, and her son Charles took his own revenge by writing an anonymous letter, falsely accusing Wellington's friend Harriet Arbuthnot (page 44) of being in love with him and alleging that they were constantly to be found in 'holes and corners'.¹⁸

Wellington's relationship with Harriet Arbuthnot is an example of the type of female friendship he came to value. An intelligent woman, with a lively fascination for politics and the connections to satisfy this interest, she was the second wife of the Tory politician Charles Arbuthnot (page 45). With her, Wellington was able to talk about politics and current affairs in a way he felt he could not with his wife. Their close friendship, conducted openly in public, attracted comment and even the Prime Minister Sir Robert Peel believed their relationship to be sexual. It is clear, however, from Harriet's diaries (not published until 1950) that the friendship was platonic and that both she and her husband were Wellington's close and intimate friends. When Harriet died in 1834, both men were devastated and Charles Arbuthnot went to live with Wellington at Apsley House, remaining as his companion until his own death in 1850.

In 1820 the Arbuthnots commissioned a portrait of Wellington by Thomas Lawrence (page 46). Although closely related to the earlier half-length in format, it shows the sitter in a far more personal light. Where the earlier picture conveys a stern military self-confidence, strengthened by its low viewpoint, the eye-level view of the Arbuthnots' portrait gets us much closer to the real man. But even in this private portrait, the Order of the Golden Fleece is included to signal his international reputation and military achievement. Harriet herself noted in her diary that all other pictures of Wellington 'depict him as a hero', whereas her portrait shows 'the softness and sweetness of countenance which characterises him when he is in the private society of his friends'.¹⁹

Another relationship that sheds light on Wellington's character in his later years was his friendship with the heiress Angela Burdett-Coutts (page 47). Daughter of the radical politician Sir Francis Burdett and granddaughter of the banker Thomas Coutts, Angela inherited Coutts's banking fortune on the death of his second wife in 1837, becoming the richest heiress in England. This background of radical politics and great wealth inspired in Burdett-Coutts a spirit of philanthropy and she sought to use her fortune for charitable purposes. After the death of both her parents in

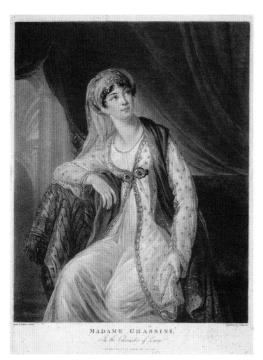

Giuseppina Grassini, by Samuel William Reynolds after Elisabeth-Louise Vigée-Le Brun, 1806

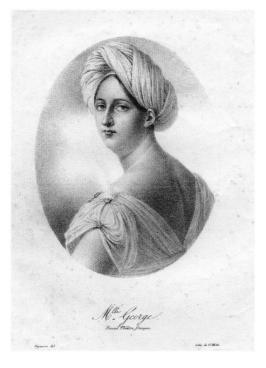

Mademoiselle Georges, by Charles Etienne Pierre Motte and Pierre Roch Vigneron, c. 1813–18

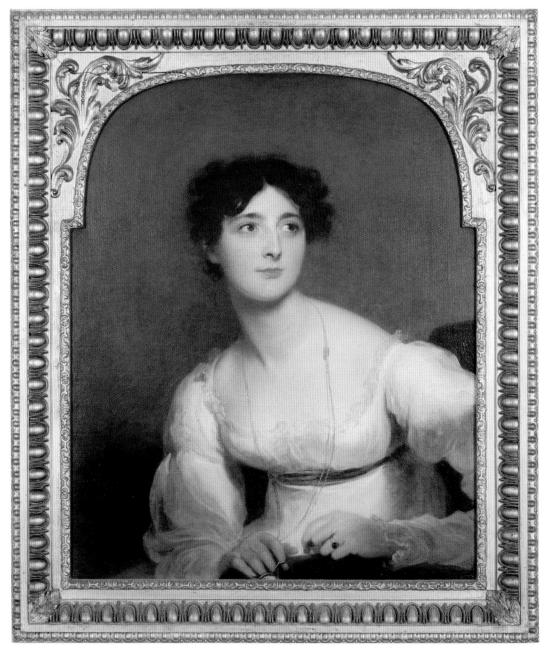

Harriet Arbuthnot, by Sir Thomas Lawrence, 1817

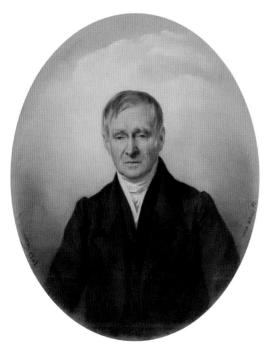

Charles Arbuthnot, by Jules-Jean Baptiste Dehaussy, 1848

1844, she and Wellington became close friends – she lived in Piccadilly, not far from Apsley House – and he advised her on both the management and the disbursement of her wealth.

Surviving letters confirm that the relationship was an extremely close and loving one and Burdett-Coutts, in a highly unconventional move, proposed marriage to Wellington in 1847 when she was thirty-two and he seventy-seven. He refused her gently, stressing the difficulties of the great age gap, and they were to remain intimate friends until his death in 1852. Indeed, after that, his family treated her almost as his widow. She certainly attended the funeral alongside other members of the family and was the only woman to whom Wellington's son gave a death mask. She, in her turn, commissioned a posthumous portrait by Robert Thorburn depicting the Duke in the library at Stratfield Saye (page 48). In this he is shown, as was his habit, opening his morning letters in the presence of his grandchildren and giving them the covers to play with. The frail, white-haired and slightly stooped figure is echoed in contemporary popular ceramic pieces (page 49), reflecting a softening of public attitudes towards him in the years following his divisive political career.

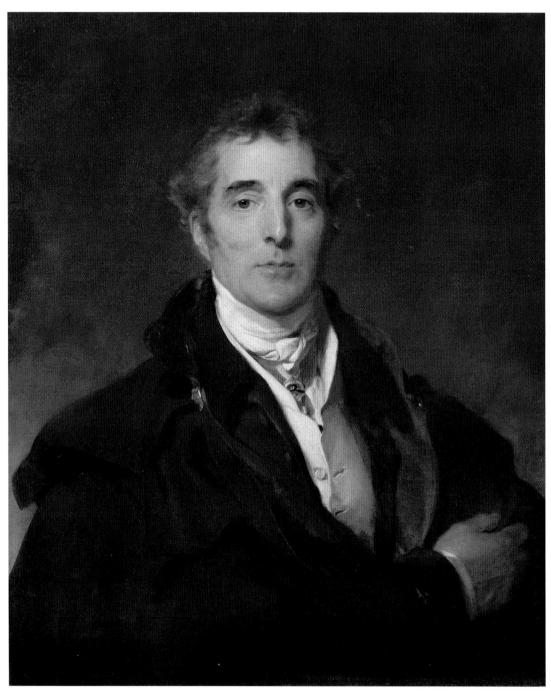

Arthur Wellesley, 1st Duke of Wellington, by Sir Thomas Lawrence, c. 1821

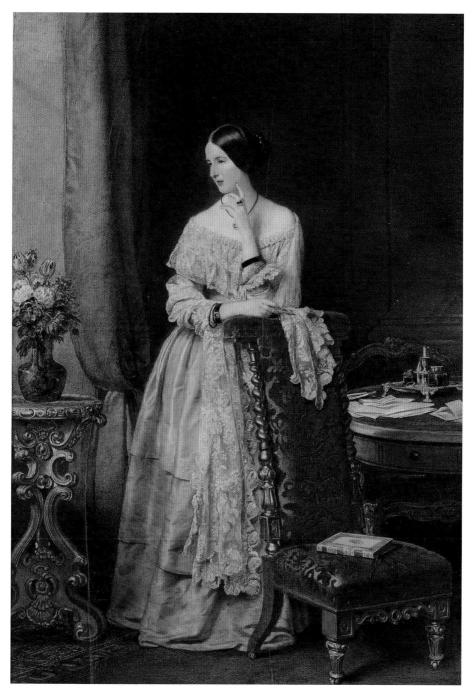

Angela Burdett-Coutts, Baroness Burdett-Coutts, by Sir William Charles Ross, c. 1847

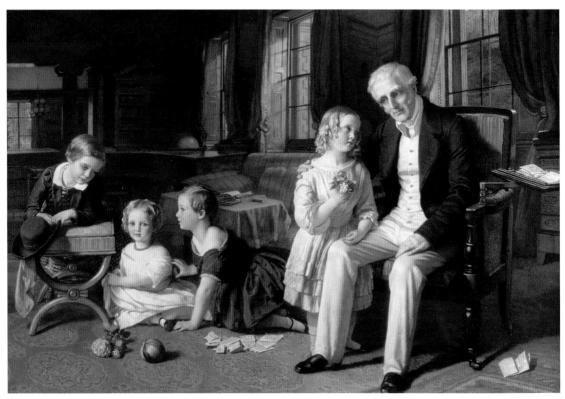

The Duke of Wellington Playing with His Grandchildren, by Robert Thorburn, 1852

DEATH AND LEGACY

The Duke of Wellington died at Walmer Castle on 14 September 1852. By that time the resentment he had incurred among large sections of society while in government had largely been forgotten, and the nation mourned the man that the poet Alfred, Lord Tennyson described in his *Ode on the Death of the Duke of Wellington* as 'The last great Englishman'. His body was laid in state at the Royal Hospital Chelsea, where the crowds were so great that a number of visitors were crushed to death. There then followed the grandest of state funerals. The procession in which the coffin was conveyed to St Paul's Cathedral included soldiers from every regiment in the army and was watched by a crowd estimated at a million and a half people. The funeral carriage itself (page 51), which can be seen today at Stratfield Saye, was not well received: commentators thought it over-ornate and ugly and its enormous size dwarfed the coffin. At over 18 tons in weight, it sank into the mud at one point in its journey and sailors had to relieve the exhausted horses to pull it the last part of the distance. A final indignity occurred when the mechanism designed to lower the coffin failed to work, delaying the funeral ceremony in St Paul's by an hour. What

did move onlookers was the simple sight of Wellington's horse, led by his groom, with the Duke's empty boots reversed in the stirrups (overleaf).

An enormous range of commercial souvenirs was produced after Wellington's death, indicating the national outpouring of grief, gratitude and respect and the market this generated. Britain's manufacturing industry had been celebrated only the year before with the Great Exhibition and was perfectly placed to capitalise on the demand for such items. Official memorials include the monument by the sculptor Alfred Stevens in St Paul's Cathedral (page

> The Duke of Wellington, Staffordshire earthenware figure, *c*. 1852

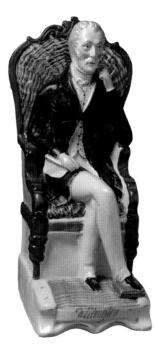

⁵²). Wellington's name is also preserved in more than sixty street names in Greater London alone, as well as in the names of towns and cities around the world. In more than merely these physical symbols, however, the Duke of Wellington lived on in nineteenth-century Britain as an example of the sort of life to be aspired to. In the days after his death, newspapers were almost unanimous in their emphasis on 'duty' to crown and country as the defining characteristic of the Duke's life.²⁰ Biographies followed this lead: in her 1853 book *The Patriot Warrior: An Historical Sketch of the Life of the Duke of Wellington, for Young Persons*, Marie Atkinson Maurice encouraged her readers to 'be more resolute in the performance of every duty, and more earnest in fulfilling ... the work given to them'.²¹ This was indeed a trait that Wellington identified, describing himself on more than one occasion as the 'retained servant' of the sovereign.²²

Wellington's death also represented the passing of an age. He died as the quintessential Victorian, but his death was a reminder of the time forty years earlier during which he gained his heroic reputation. The crowds at his funeral had been swelled by great advances in communication. The proliferation of newspapers spread the news of his death throughout the country, while the recently developed railway network enabled many of those inspired by the newspaper coverage to travel to London to attend.²³ The powdered eighteenth-century elegance represented by Wellington's first portrait had truly been replaced by the machine age of the daguerreotype.

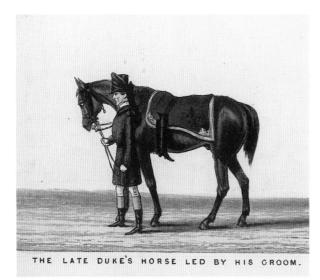

Detail from *The Funeral Procession of Arthur, Duke of Wellington*, by Henry Alken and George Augustus Sala, 1853. Wellington's groom leads his horse, with his boots reversed in the stirrups.

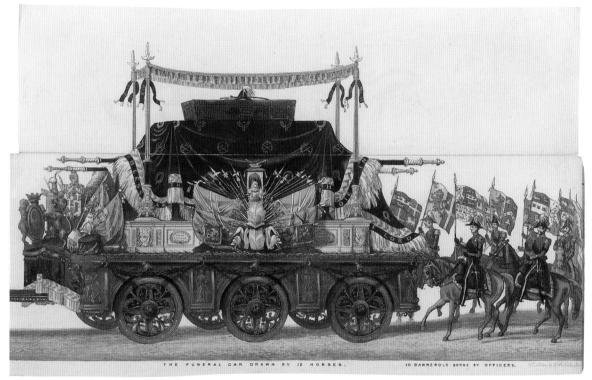

Detail from *The Funeral Procession of Arthur, Duke of Wellington*, by Henry Alken and George Augustus Sala, 1853. This small section of the hand-colour etching and aquatint, which measures 20.6 metres (67 feet) long, shows the elaborate funeral carriage. (The entire procession is reproduced on the inside cover of this catalogue.)

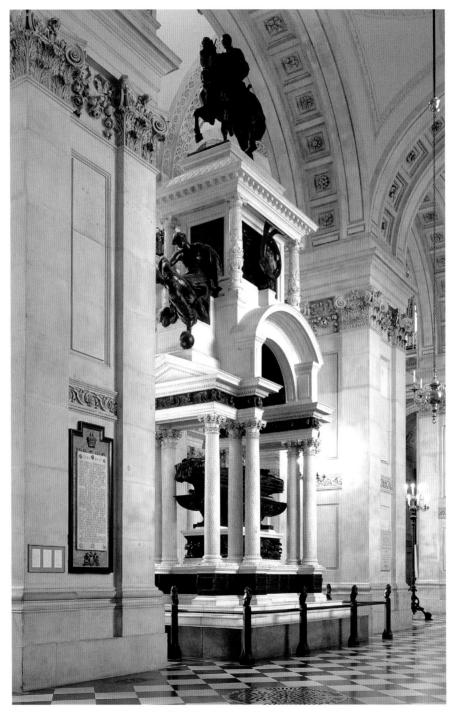

Wellington's monument in St Paul's Cathedral, by Alfred Stevens, made at various stages between *c*. 1856 and 1912.

- Quoted in Christopher Hibbert, Wellington: A Personal History (Addison-Wesley, Reading, Massachusetts, 1997), p.328; the iconography in the entry for Wellington in Richard Walker, Regency Portraits (National Portrait Gallery, London, 1985), pp.533–42 lists over 200 portraits.
- 2 For general biographical information on the 1st Duke of Wellington see Elizabeth Longford's two-volume work Wellington: The Years of the Sword (Weidenfeld & Nicolson, London, 1969) and Wellington: Pillar of State (Weidenfeld & Nicolson, London, 1972) and Hibbert, op. cit.; Rory Muir has drawn on a tremendous amount of new material for his two-volume work, only the first part of which, Wellington: The Path to Victory, 1769–1814 (Yale University Press, New Haven and London, 2013) was published at the time of writing; an excellent starting point is Norman Gash, 'Wellesley, Arthur, First Duke of Wellington (1769–1852)', Oxford Dictionary of National Biography (Oxford University Press, Oxford, 2004).
- 3 Longford, op. cit., Sword, p.19.
- 4 Ibid., p.113.
- 5 Ibid., p.37.
- 6 The 7th Duke of Wellington (ed.), The Conversations of the First Duke of Wellington with George William Chad (Saint Nicolas Press, Cambridge, 1956), p.20.
- 7 Longford, op. cit., Sword, p.93.
- 8 Neil Maclaren, National Gallery Catalogues: The Spanish School, 2nd edn, rev. Allan Braham (National Gallery, London, 1970), pp.16–23.

- 9 Longford, op. cit., Sword, p.122.
- 10 Michael Levey, Sir Thomas Lawrence (Yale University Press, New Haven and London, for the Paul Mellon Centre for Studies in British Art, 2005), p. 187.
- 11 Longford, op. cit., Sword, p.124.
- 12 Levey, op. cit., p.26.
- 13 Hibbert, op. cit., p.185.
- 14 K.D. Reynolds, 'Villiers, Sarah Sophia Child-, Countess of Jersey (1785–1867)', Oxford Dictionary of National Biography (Oxford University Press, Oxford, 2004).
- 15 Hibbert, op. cit., p.326n.
- 16 Longford, op. cit., Pillar, p.267.
- 17 Longford, op. cit., Sword, p.375.
- 18 Longford, op. cit., Pillar, p.85.
- 19 Harriet Arbuthnot, *The Journal of Mrs Arbuthnot*, ed. Francis Bamford and the Duke of Wellington (Macmillan, London, 1950), Vol. 1, p.59.
- 20 Peter Sinnema, The Wake of Wellington: Englishness in 1852 (Ohio University Press, Athens, Ohio, 2006), pp.41–3.
- 21 Ibid., p.40.
- 22 Longford, op. cit., Pillar, pp.364, 366.
- 23 R.E. Foster, "Bury the Great Duke": thoughts on Wellington's passing', Wellington Studies, Vol. 5, ed. C.M. Woolgar (University of Southampton, Southampton, Hampshire, 2013).

'THE MOST DESPERATE BUSINESS' WELLINGTON IN THE ARMY

Anther March 140

and filler to an address of

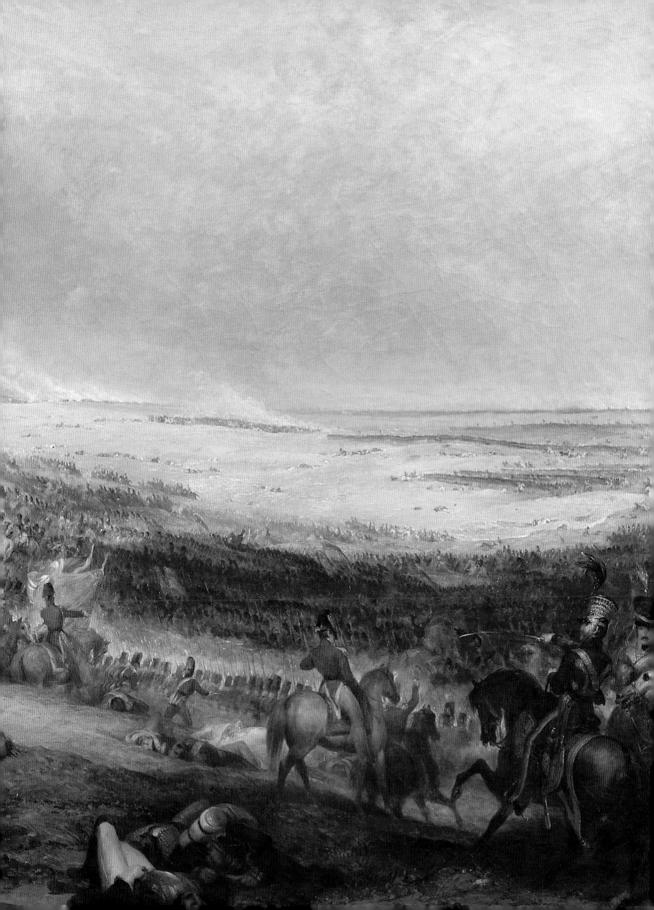

T HE PORTRAIT of the future Duke of Wellington by John Hoppner (page 18) shows him at the start of his active military life in the mid-1790s. Just over twenty years later he attained heroic status after commanding the allied troops that defeated Napoleon's army at the battle of Waterloo in 1815, putting an end to two decades of warfare across Europe. There are many fine and exhaustive studies of Wellington's military career, with which this essay is not intended to compete; instead it will examine a mixture of fine and popular art and other expressions of visual culture to explore Wellington's identity, status and reception among contemporary audiences.

While his victory at Assaye in India in 1803 brought him widespread fame, his reputation was firmly established during the Peninsular War (1808–14), which arose after Napoleon ordered an invasion of Portugal in 1807. The Portuguese royal family fled to Brazil, while the Spanish King abdicated after the French army had occupied northern Spain en route to Portugal. Before Napoleon's brother Joseph could be crowned as the new King of Spain, popular insurrections spread throughout the country and later extended to Portugal. With both countries in turmoil, the British government saw an opportunity to assist Portugal, a long-time ally, and, more importantly, to strike at Napoleon's forces within continental Europe. An expeditionary force under Wellington – then still Sir Arthur Wellesley – was sent to Portugal and landed in August 1808.

PORTUGAL, SPAIN AND FRANCE: THE PENINSULAR WAR

Initially operating under more senior generals, Wellesley was in sole command from 1809 onwards and remained in the Iberian Peninsula continuously until the end of the war in 1814. There soon developed a demand among the British public for images of the countries in which the British army was engaged. Sometimes these images came from within the army itself. For example, the Reverend William Bradford was a military chaplain who landed in Portugal a few days after the first victory of the war at Vimeiro. Between 1809 and 1810 he published *Sketches of the Country, Character and Costume in Portugal and Spain* in twenty-four parts, with coloured aquatints showing the local sights and inhabitants. Later prints in the series included a range of Portuguese, Spanish and French military uniforms, reflecting the increased fashion for and interest in all things military. The set proved popular, with a number of further English and French editions being published, the last

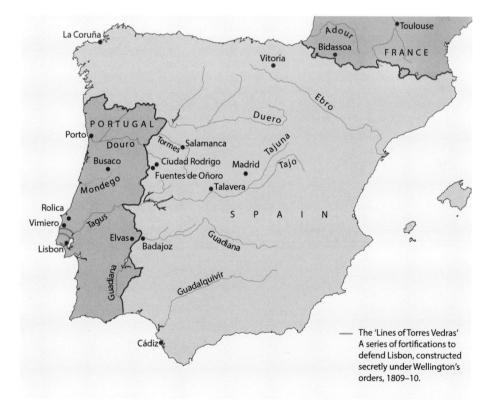

Map of Portugal, Spain and southern France, showing principal towns and sites of battles

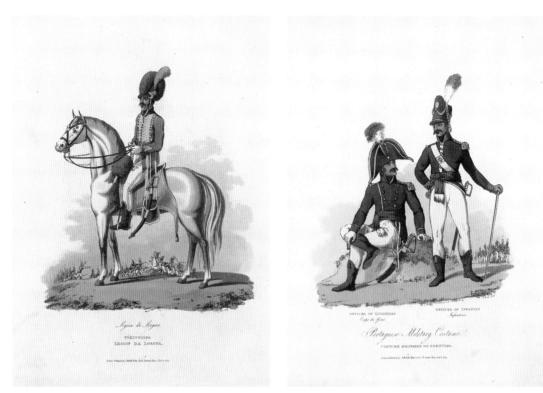

Portuguese Legion da Lorgna from Sketches of the Country, Character and Costume in Portugal and Spain, by John Heaviside Clark after Reverend William Bradford, 1809

Portuguese Military Costume: Officer of Engineers and Officer of Infantry from Sketches of the Country, Character and Costume in Portugal and Spain, by John Heaviside Clark after Reverend William Bradford, 1809

appearing in 1823. These two prints from Bradford's *Sketches* (above) show uniforms of Portuguese cavalry and infantrymen, who were combined with British troops to form an Anglo-Portuguese army. Through necessity, the expanded Portuguese army was equipped with uniforms supplied by British contractors and many items of dress and equipment closely resembled their British counterparts. Conversely, when the British army's own uniform was redesigned in 1812, the headdress adopted was based on the distinctively shaped Portuguese 'barretina' worn by the infantry officer on the right.

As the war progressed, publications featuring images of individual battles proliferated. These could also provide an intimate picture of the daily life of the British soldiers and, again, the suggestion of eyewitness testimony was particularly

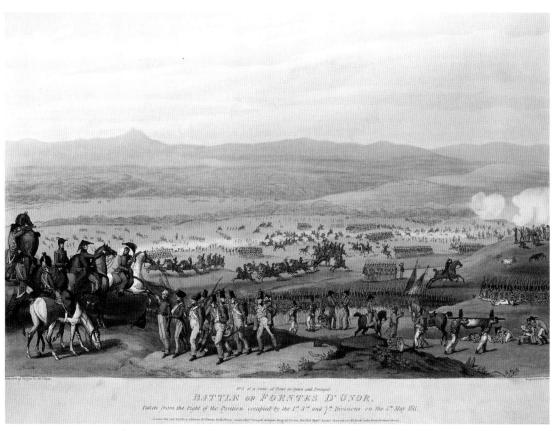

Battle of Foentes D'Onor [Fuentes de Oñoro], by Charles Turner after Thomas Staunton St Clair, 1812

valued. In 1812 a consortium of leading London publishers issued *Views of the Principal Occurrences of the Campaigns in Spain and Portugal*, a series of coloured prints based on sketches by Major Thomas Staunton St Clair, a serving infantry officer. In fact, the prints reflect only St Clair's experiences of the events in which his regiment was involved and therefore fail to deliver a record of the 'Principal Occurrences' that the title promised. His illustration of the 1811 battle of Fuentes de Oñoro (above), although not one of the landmark engagements of the war, captures unusual details that only an onlooker could have recorded. The seated regiment of soldiers to the right awaiting orders and the wounded soldiers receiving medical attention just below them suggest direct observation. Even the caption confirms that the drawing was made near the position of the 3rd Division of the army, which

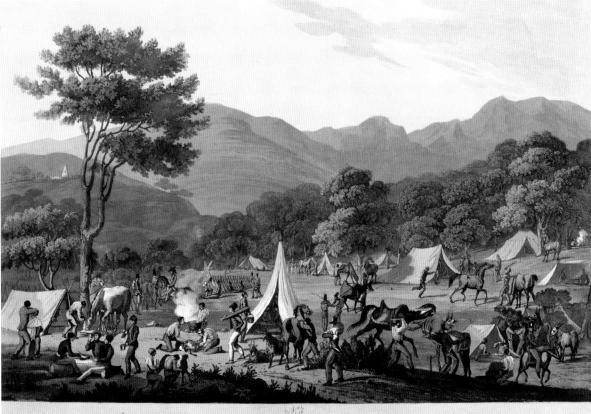

TROOPS BEFOLLORD near the Vidlage of SILLA FELIAR, on the Evening of the 19 th 1811. thering the various occupations of an Estimational

Troops Bevouack'd near the Village of Villa Velha, by Charles Turner after Thomas Staunton St Clair, 1813

included the artist's own 94th Regiment. Wellesley, who had by this time been elevated to the peerage as Viscount Wellington, is shown prominently to the left, dispatching a messenger with orders. This composition reveals that it was necessary for generals in this period to put themselves at risk by operating in close proximity to their soldiers. They needed to observe the activity on the battlefield and be in a position to issue swift orders, usually by messenger, but sometimes in person. Given this proximity to battle, on several occasions members of Wellington's staff were killed or wounded close to him. Wellington more than once expressed his belief that the 'finger of God' was responsible for sparing his life.'

The British public were not only interested in battles, they were also curious about the soldiers' daily lives. This followed a change in the way Britain's army was perceived. Prior to the war the army was looked on with a measure of contempt. In the absence of a police force, it had been used in Britain to control public order and its wartime expansion resulted in increased taxation. Its Peninsular victories raised the army in the public's estimation, however, and created a new interest in military activities. Another of St Clair's prints shows a more routine aspect of the war (opposite). This lively and light-hearted camp scene communicated to the print-buying public an idea of the everyday life of the ordinary soldier. Unlike the French army, which conscripted soldiers of all classes, the British army was made up of 'volunteers' likely to have enlisted from financial necessity. Wellington's attitude to his soldiers is difficult to pin down: he has been justifiably criticised for referring to the enlisted men in his army as the 'scum of the earth', largely because of their social origins.² Despite this provocative statement, he was nevertheless proud of their abilities and achievements. When the allied sovereigns gathering in Paris after Waterloo remarked on the small stature of the British soldiers, Wellington is said to have responded that they would 'find none who fight so well'.³

Visual records of Wellington's campaigns were made for personal reasons as well as for publication. Lieutenant Edmund Wheatley kept a diary to be read by his sweetheart when the war was over. A draughtsman of some skill, he also sketched the people and places he encountered. Wheatley's portrait of the 'drunken face' of his friend Henry Llewellyn, for example, is placed opposite a drawing of a windmill, which appeared to be bulletproof, having survived heavy cannon fire. He concludes, ironically, that he and his comrades later took it down for want of firewood (overleaf).⁴

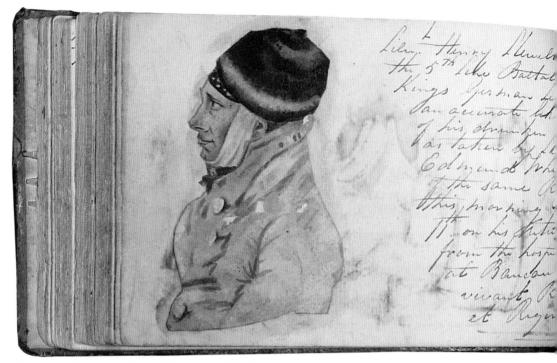

Pages from the diary of Edmund Wheatley, 1812-17

Edmund Wheatley, self-portrait, c. 1830

The diary reads:

Lieut. Henry Llewellyn of the 5th Line Battalion Kings German Legion an accurate likeness of his drunken face as taken by Lieut. Edmund Wheatley of the same Regt this morning April 11th on his return from the hospital at Baucaut [Boucau] – vivant Rex et Regina

The windmill near St Etienne bomb & ball proof – which stood the cannonading of Bayonne without any impressions being made upon it – which on a working party at this window in the night of the 9th of April a cannon ball entered the door & took off the left knee of private Ludolph of the light company.

We were at last compelled to take it down for want of fire wood.

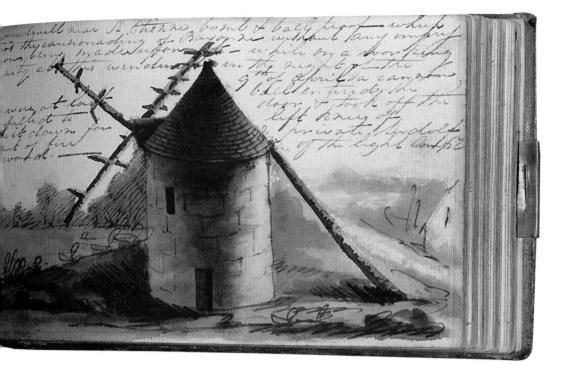

Professional artists also travelled to the Peninsula to record people and events and to consolidate on the commercial opportunities the war presented. Although this long predates the concept of the official 'war artist', some were given unofficial military help. The watercolourist Thomas Heaphy, for example, appears to have been encouraged by a staff officer to visit Wellington's military headquarters in Spain in 1813.⁵ While there, he painted small whole-length watercolour portraits of a number of Wellington's officers, although some demurred at his price of fifty guineas, which included ten guineas danger money after Heaphy had narrowly escaped capture by the French.⁶ He also brought home sketches (pages 64–7) from which to paint a large group portrait. When the war was over and artist and potential sitters had returned to England, there was a clamour to be included in the picture, which Heaphy had announced was to be engraved for publication. The result was an implausibly overcrowded composition, which lost almost all sense of the authenticity that sketching on the spot might have provided (page 68). The print's title highlights the Duke of Wellington, but the additional portraits reflect

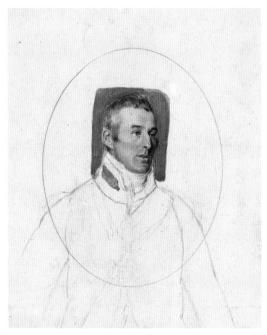

Arthur Wellesley, 1st Duke of Wellington, by Thomas Heaphy, 1813–14

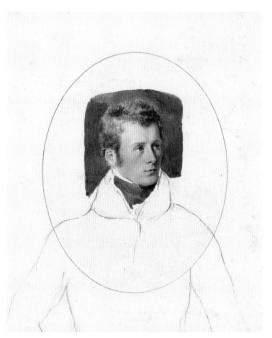

Charles Gordon-Lennox, 5th Duke of Richmond and Lennox, by Thomas Heaphy, 1813–14

Don Pablo Morillo, Comte de Cartagena, by Thomas Heaphy, c. 1813–14

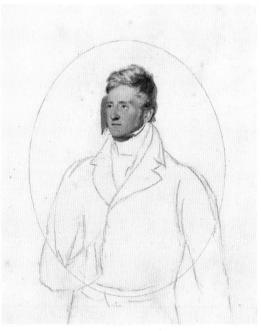

Fitzroy James Henry Somerset, 1st Baron Raglan, by Thomas Heaphy, 1813–14

PLOP / KALIL JOHNSK KAR

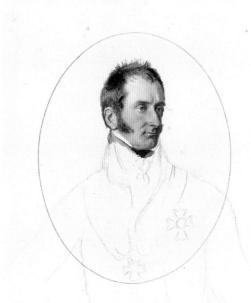

Lord Robert Edward Somerset, by Thomas Heaphy, 1813

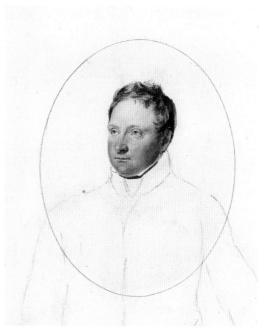

Rowland Hill, 1st Viscount Hill, by Thomas Heaphy, 1813

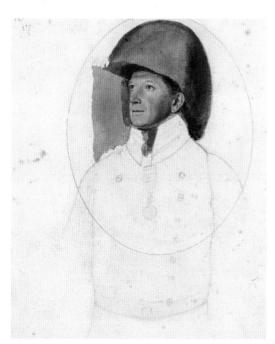

Sir Charles Alten, Count von Alten, by Thomas Heaphy, 1813–14

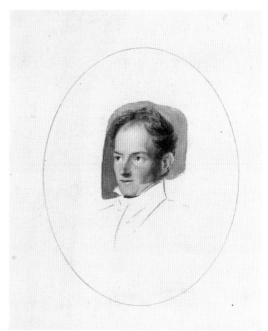

Sir Edward Barnes, by Thomas Heaphy, 1813–14

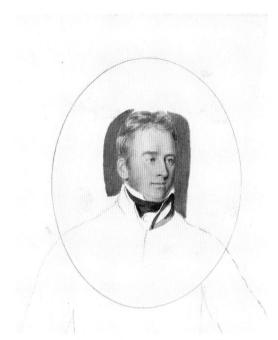

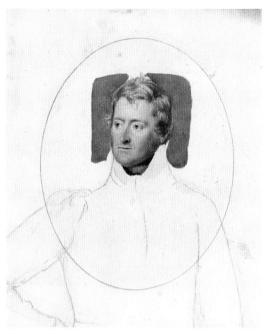

Sir Frederic Ponsonby, by Thomas Heaphy, 1813–14

Sir George Scovell, by Thomas Heaphy, 1813–14

Sir Hew Dalrymple Ross, by Thomas Heaphy, 1813–14

Sir James McGrigor, 1st Bt, by Thomas Heaphy, 1813–14

Sir John Fox Burgoyne, 1st Bt, by Thomas Heaphy, 1813–14

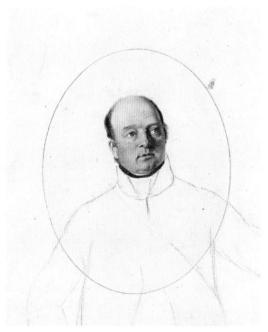

William Carr Beresford, Viscount Beresford, by Thomas Heaphy, 1813–14

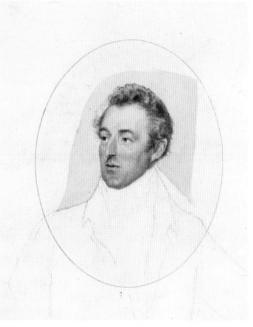

Arthur Wellesley, 1st Duke of Wellington, by Thomas Heaphy, 1813–14

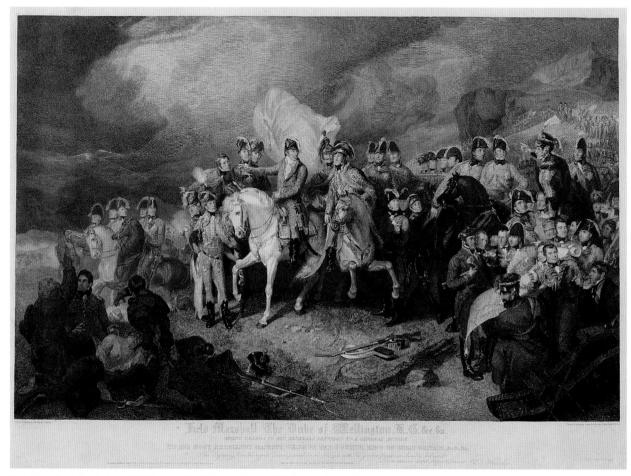

Field Marshall the Duke of Wellington KG Giving Orders to His Generals Previous to a General Action, by Anker Smith after Thomas Heaphy, 1822

the contribution made by his officers, who also formed a large part of the market for Heaphy's print. Heaphy unsuccessfully attempted to sell his painting to King George IV, the Tsar of Russia and the Prince of Orange. Its whereabouts is now unrecorded and it is known only from the engraving.⁷

There is every indication that Denis Dighton, a professional artist whose brother was serving in Wellington's army, also travelled to the Peninsula. In addition to a number of battle paintings, he produced several hundred watercolour studies, as well as portraits of Spanish guerrilla leaders apparently drawn from life (overleaf). Unlike Heaphy, Dighton does not appear to have intended to capitalise on his efforts through print publication. Instead he was commissioned directly by the Prince Regent, who was fascinated, if not obsessed, by military culture. It is likely that Dighton's work was intended to provide the future king with a visual record of the Napoleonic wars.⁸ These watercolours represent, therefore, another facet of the Prince's interest in the wars, which found its greatest artistic fruition in Thomas Lawrence's commission to paint the portraits of the allied sovereigns in the Waterloo Chamber at Windsor Castle.

During the war in Spain, a great contribution was made by bands of ordinary citizens, who harassed the French army and disrupted their supply convoys and messengers. These bands were organised according to regulations issued by the Spanish government and their activities became known as the *guerrilla*, or 'little war', giving us the modern name for such informal forces. Dighton's watercolour of a Spanish general officer of cavalry, accompanied by guerrillas (overleaf), contrasts the official military dress of the mounted general on the left with the less formal attire of the standing guerrilla leader who, other than a military hat and sword, appears to be wearing his civilian clothing. The ornate uniform of the two mounted soldiers holding lances has not been identified and may even be Dighton's fanciful invention, intended to exoticise the Spanish army and pander to the Prince Regent's well-known interest in uniform.

Wellington was promoted to field marshal, the army's highest rank, after his troops won the battle of Vitoria against a French army led by Joseph Bonaparte, King of Spain, in June 1813. This decisive victory was the turning point of the Peninsular War, although there were further difficult battles to be fought even after the army crossed into southern France. In April 1814, after Russian, Prussian and Austrian armies had invaded France from the east, Napoleon abdicated and was exiled by the allied powers to Elba.

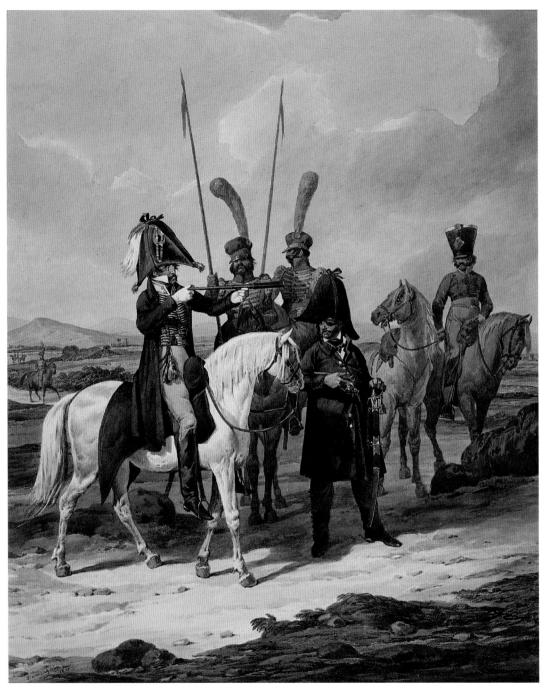

Spanish Army. General Officer of Cavalry with Guerrillas and Lancers, by Denis Dighton, 1815

THE WATERLOO CAMPAIGN

Despite the real international hope that hostilities were over, Napoleon escaped from exile and returned to France in 1815; the European powers immediately mobilised against him. A Prussian army commanded by Field Marshal Blücher and an Anglo-Dutch army under Wellington were gathered in the Netherlands, where Napoleon (page 73) was expected to make his first attack. The campaign that followed was the only one in which Wellington and Napoleon actively commanded armies against each other. While Napoleon had led an army into Spain in 1808 during the Peninsular War, this was during a period when Wellington had been recalled to England. His lack of direct experience led Napoleon to underestimate Wellington's abilities in 1815. Ignoring his success in Portugal and Spain, Napoleon asserted that Wellington was 'a *bad* general and that the English are *bad* troops'.⁹

Wellington's army numbered about 89,000 men, just over a third of whom were British. Most of the British troops were inexperienced, as many of the highly trained Peninsular regiments had been sent to the war in America in 1814, while others were disbanded. The remainder of the army was made up of German, Dutch and Belgian soldiers. Many of the Belgians had served in Napoleon's army while Belgium had been annexed to France, so their loyalty in this campaign was far from guaranteed. Command of the allied troops in the Netherlands had originally been given to the Prince of Orange (page 74, left), son of the recently crowned King William I. The youthful Prince had served as an aide-de-camp to Wellington in the Peninsula and although he was considered brave, he had little experience of military command. Wellington assumed overall command on his arrival and the Prince was left in charge of a single corps. In command of the allied cavalry was Henry Paget, Earl of Uxbridge (later Marquess of Anglesey) (overleaf). Wellington had wanted Stapleton Cotton, Lord Combermere, in this role, as had been the case in the Peninsula, but Paget was appointed by the Prince Regent and the Duke of York. Wellington claimed that Paget's elopement with his sister-in-law some six years earlier had not affected his preference.¹⁰ The other commander facing Napoleon was Field Marshal Blücher (page 74, right), at the head of the Prussian army. Seventy-two years old in 1815, he had been a soldier in the Prussian army since 1760. His force was just over 122,500 strong, but it included many militia troops who were not full-time soldiers. Although an unsophisticated general, Blücher was courageous and had the ability to inspire his men, who nicknamed him Alte Vorwärts (Old Forwards) because of his straightforward style

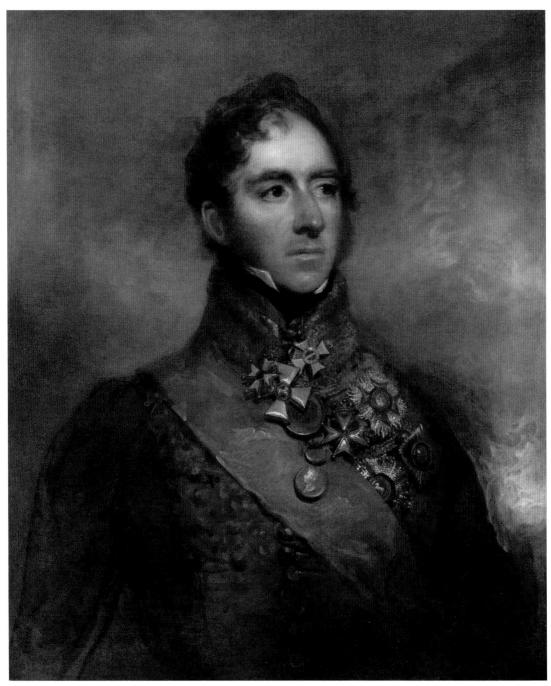

Henry William Paget, 1st Marquess of Anglesey, attributed to George Dawe, c. 1817

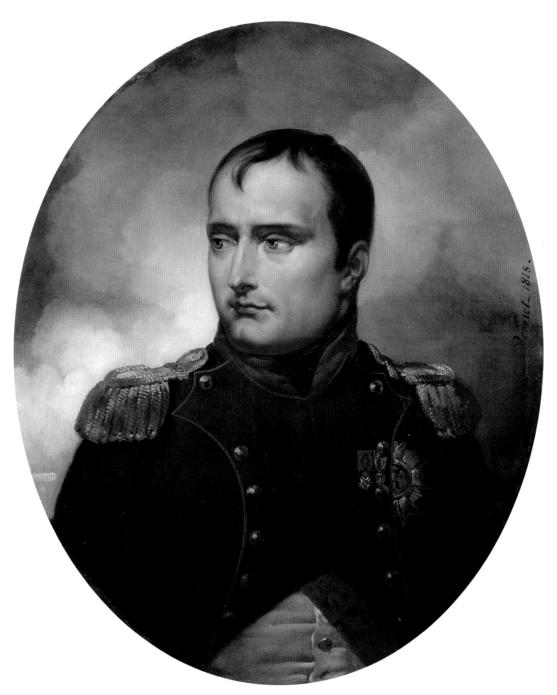

The Emperor Napoleon I, by Emile-Jean-Horace Vernet, 1815

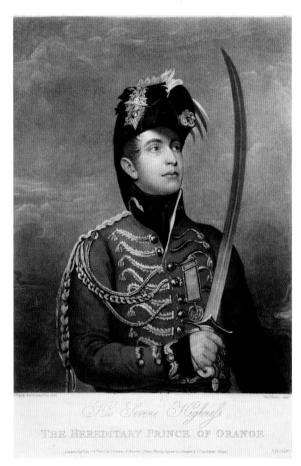

The Hereditary Prince of Orange, William II, by Charles Turner after John Singleton Copley, 1813

Field Marshal Blücher, by Charles Turner after F.J. Bosio, 1814

of command. His was a well-known name in England as he had visited the country after Napoleon's first abdication in 1814. He had been enthusiastically received by the British, who mobbed him at public events. The Prince Regent had also assured Blücher of his friendship and given him a miniature containing the Prince's portrait; this jewel can be seen in many of Blücher's own portraits (opposite).

The Anglo-Dutch and Prussian armies faced Napoleon's force, which consisted of 128,000 soldiers, most of whom were veterans of Napoleon's earlier campaigns. In short, Napoleon's army was stronger than each of the Anglo-Dutch and Prussian armies individually, but weaker than the two together. His strategy, therefore, was to defeat each of them in turn before they could be combined against him. The resulting campaign would comprise two pairs of linked battles (see map, below)."

Wellington heard the news that Napoleon had crossed the border into Belgium during the evening of 15 June, while he and many other British officers were attending a ball hosted by the Duchess of Richmond in Brussels. Napoleon proceeded to attack

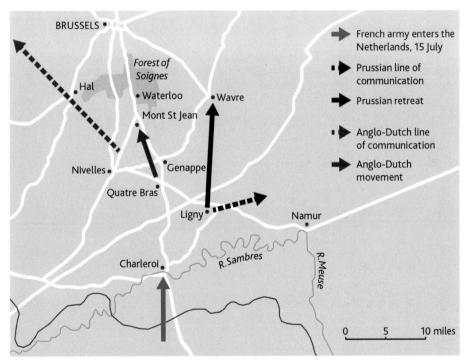

Map of the area south of Brussels showing the sites of battles in the Waterloo campaign

the Prussians at Ligny and sent part of his army under Marshal Ney against the Anglo-Dutch at Quatre Bras on 16 June; with these battles he hoped to drive the two armies apart. Retreating armies tend to move along their 'lines of communication', in other words the routes along which they have previously travelled and on which they have established supply bases. If Napoleon had achieved his aim then the Prussians would have moved eastwards away from the Anglo-Dutch army, which in turn would have travelled north-west, but although the Prussians suffered a severe defeat at Ligny they retreated almost due north, in the direction of Wavre. The outcome of Quatre Bras was inconclusive, but Wellington was also forced to retire because of the Prussian movement. He did so in a northerly direction towards the village of Mont St Jean, which is situated on a ridge and would therefore give him a tactical advantage against an army attacking from the south. He sent a messenger to Blücher to inform him of his intention to halt there and fight the French, provided the Prussians could send reinforcements.

The two battles of Wavre and Waterloo took place on 18 June. Wellington's army occupied a strong position on the ridge at Mont St Jean, with two groups of buildings to its front: the farms of La Haye Sainte and Château de Hougoumont (pages 78–9). Allied soldiers were stationed at each and both sets of buildings have been accorded a special status by British historians since that time. The battle started at about 11.30am with an artillery bombardment of the British position and a French attack on Hougoumont. The fighting at the farm lasted all day, with French soldiers actually entering the courtyard at one point. However, the position was never taken by the French and occupied the attention of troops who would have been of more use to Napoleon elsewhere on the battlefield.

At around 2.00pm French infantry, supported by cavalry, attacked the centre of the Anglo-Dutch position. This was resisted by two cavalry charges, the first defeating the French cavalry and the second falling on the undefended flank of the French infantry. Fighting was fierce and two of the prized French eagle standards were captured (opposite). The British cavalry's triumph was turned to disaster, however, as they charged on through the French lines, emboldened by their success, but increasingly disorganised and exhausted. They were ultimately defeated by previously unengaged French cavalry and at a stroke around half of the allied cavalry was lost.

The next French attack, two hours later, was a cavalry charge on the right of Wellington's position. So many men and horses were involved that they were

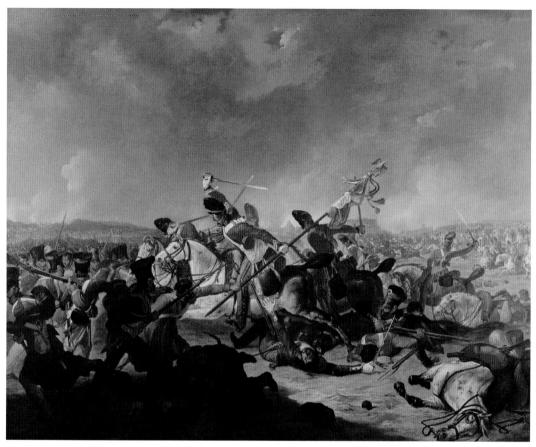

The Battle of Waterloo: The Charge of the Second Brigade of Cavalry, by Denis Dighton, 1815–17

unable to manoeuvre, and Wellington's infantry successfully defended themselves by changing formation.

At 4.30pm cannon fire from the east was heard, as the Prussians, who had themselves been fighting at Wavre, approached. Nevertheless the Anglo-Dutch position was increasingly weakened, with La Haye Sainte falling to the French at 6.00pm. An hour later Napoleon ordered his final attack, sending forwards his remaining infantry, including his elite guard troops. As they reached the crest of the ridge, the British Guards, who had been lying down to avoid artillery bombardment, stood up and fired at the head of the dense French formation, while another British infantry regiment moved around in order to fire into their flank. The heavy casualties forced the attackers to flee and astonishment at their defeat

Château de Hougoumont, Field of Waterloo, by Denis Dighton, 1815

caused the remainder of the French army to disintegrate. The battle of Waterloo, which Wellington described to his brother as 'the most desperate business I ever was in', had been won.¹² He later met Blücher, whose army had been fighting to reach him all day, near an inn named the Belle Alliance. Blücher suggested that they gave this name to the battle, but Wellington insisted on calling it Waterloo, after the village three miles to the north, which had been the site of his headquarters the night before, a name that would also be easier for the British public to pronounce.

The swiftness of the Waterloo campaign, which was measured in days and weeks rather than the years of the Peninsular War, meant that artists had little opportunity to produce images while events were unfolding. However, within days of the battle, the site had become a tourist attraction and artists as well as sightseers arrived on the scene. Among these was the painter Denis Dighton, who made sketches from

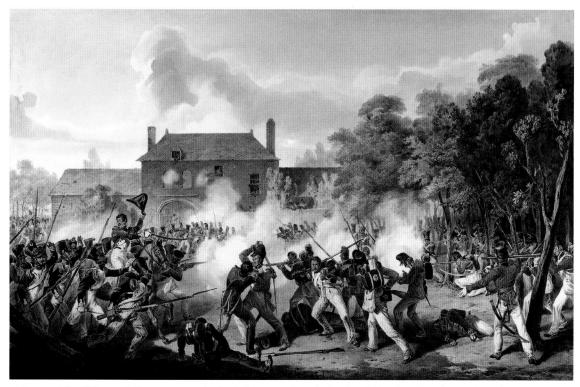

Defence of the Château de Hougoumont, by the Coldstream Guards, Battle of Waterloo 1815, by Denis Dighton, c. 1815

which he produced finished battle scenes. He was also moved to record the grisly work of clearing the battlefield. His sketch of the farm at Château de Hougoumont, for example (opposite), shows the damage done to the buildings themselves, but also the melancholy sight of soldiers' bodies, stripped of clothing, being buried in mass graves. The farm door and even the roadway are still marked with blood.

The contrast between the sketch and Dighton's completed painting (above) could not be greater. In the latter he shows the repulse of a French attack outside the south gate of the farm by soldiers of the British Foot Guards. While the central scene is of bloody hand-to-hand combat, the image of French soldiers advancing in packed lines to attack the British Guards in their smart and colourful uniforms communicates a message of military glory in which the gruesome reality of battle is minimised. Despite its large size, the picture has more in common with prints

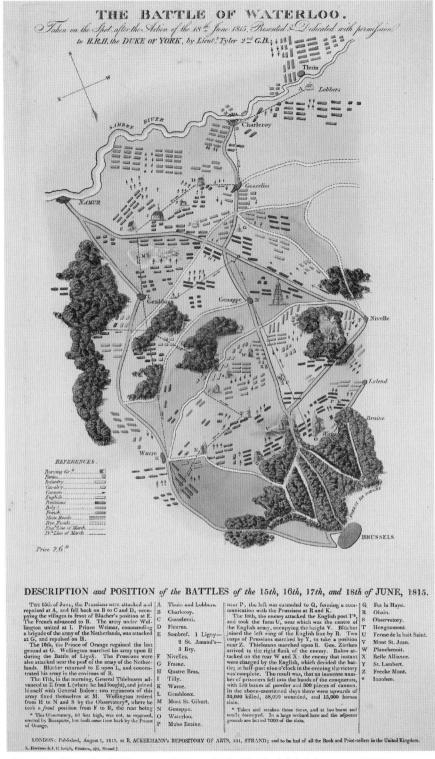

The Battle of Waterloo, by Lieutenant Tyler, published by Rudolph Ackermann, 1815

depicting individual incidents than the larger dramatised battle paintings that would become more fashionable in the later nineteenth century.

One aspect of the battle that could be swiftly recorded by the soldiers themselves was the countryside over which the campaign was fought. Officers were expected to be able to sketch simple maps as part of their duties and examples were swiftly sent to England to be engraved and published. A map by a Lieutenant Tyler (opposite) was issued as an attractive hand-coloured engraving at the beginning of August, just six weeks after news of the battle reached England. Like a number of these maps, it is inverted, with the south appearing at the top of the page so that the terrain is seen from the British point of view. Although entitled *The Battle of Waterloo*, the map shows the area over which all four battles were fought and its simple pictorial style makes it easy to understand by those unused to studying more formal military maps.

COMMEMORATING WATERLOO

The final defeat of Napoleon at Waterloo stimulated the production of a wide range of commemorative artworks at all levels of the market. In 1815 the British Institution, which had been formed in 1805 to promote the fine arts, announced prizes to be awarded for pictures 'illustrative of or connected with the successes of the British army' in the wars.¹³ The first prize went to James Ward, better known as an animal painter, for his oil sketch for *The Triumph of Arthur Wellesley, 1st Duke of Wellington and the Allies* (overleaf). He was given a commission for 1,000 guineas to produce a full-sized version of this allegorical picture. Among Ward's many figures are Wellington and Britannia in the chariot of war, which crushes Opposition and Tumult. Even at the time, Ward's complex allegory was difficult to decipher and the picture needed to be accompanied by several paragraphs of explanatory text in a catalogue.

An unexpected second prize was awarded to the artist and former soldier George Jones. Jones's picture, like those of many of the other entrants, was a depiction of the battle of Waterloo itself. Jones had served in the army of occupation in Paris and visited the battlefield, subsequently publishing *The Battle of Waterloo, described by eyewitnesses* in 1817. This was illustrated with his own maps and drawings. His prize-winning battle scene in oils successfully combines an accurate rendering of the battlefield's topography with an artistic and highly dramatic composition.

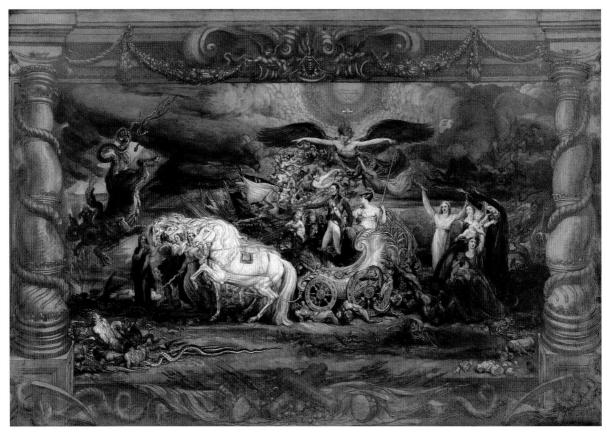

Sketch for The Triumph of Arthur Wellesley, 1st Duke of Wellington and the Allies, by James Ward, 1816

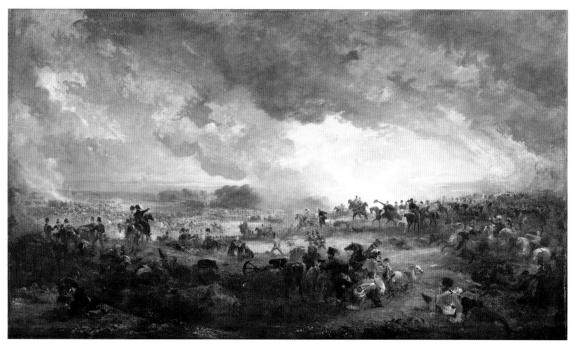

The Battle of Waterloo, by George Jones, c. 1820

Furthermore, it creates a sense of narrative by focusing on the figure of the Duke of Wellington, depicting him at the crucial moment when, with a wave of his hat, he ordered a general advance to pursue the disintegrating French army (above).

The British Institution's membership consisted of connoisseurs rather than artists and the organisation presented itself as an arbiter of taste. The selection of Ward's picture reflected its desire to commemorate Wellington's victory through the traditional artistic conventions of allegorical 'history painting'. This was considered to be of higher artistic status than battle painting, which retained the documentary or illustrative qualities of the military or topographical sketch as opposed to the creative abstraction valued in the academic tradition. Battle painting was also considered to be 'un-English' through its association with militaristic regimes such as France, where it had been elevated under Napoleon to an equal status with traditional history painting.

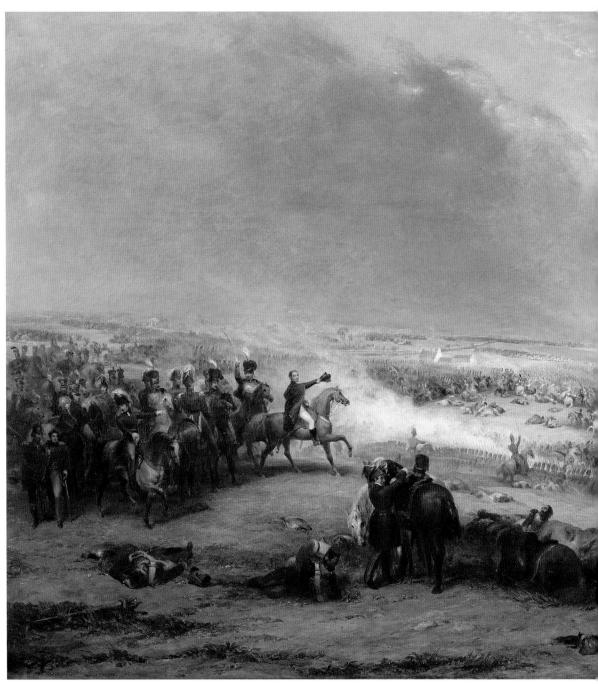

The Battle of Waterloo, 1815, by George Jones, exhibited 1853

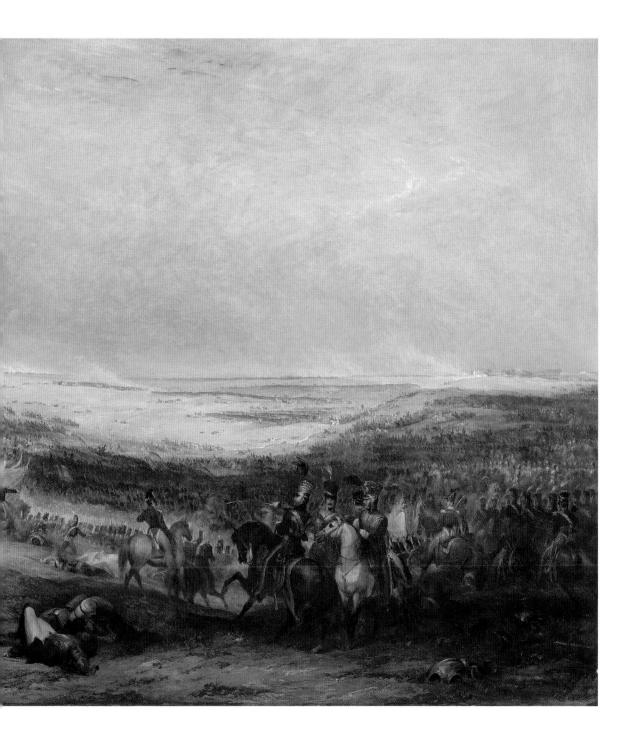

Waterloo Medal, by Benedetto Pistrucci (Obverse and reverse shown above and opposite), 1819–49

By awarding a second prize to a more innovative composition, the British Institution's directors acknowledged the existence of alternative, indeed conflicting, artistic approaches to the commemoration of military victory. In fact, the use of the word 'illustrative' in the prize announcement seemed to invite the submission of such paintings.¹⁴ Jones's approach ultimately experienced far more success. His picture was purchased for the Royal Hospital Chelsea, where it still hangs, and he subsequently painted so many variants on the theme – the last being exhibited at the Royal Academy in 1853 (pages 84–5) – that he gained the nickname 'Waterloo' Jones. James Ward's composition is now known only through the sketch. The finished picture was also presented to the hospital, but was so large that it proved impossible to hang properly and no longer survives.

Victory at Waterloo was not commemorated just by pictures. Of the many medals that were issued, the most ambitious was the Waterloo Medal. This was commissioned in 1819 at the suggestion of the Prince Regent from Benedetto Pistrucci, one of the

foremost medallists of his generation. The Prince's intention had been to issue gold medals to the allied sovereigns and their generals, but disputes over payment delayed completion of the work until 1849, by which time most of the potential recipients had died. Furthermore, the ambitious size of the medal (13.4cm in diameter) meant that the dies could not be hardened for striking, and only impressions in gutta percha, a rubber-like material, and silver and bronze electrotypes were produced (above). Despite the ultimate failure of the commission, the medal is nevertheless considered Pistrucci's masterpiece. The obverse features the conjoined laureate heads of the allied sovereigns, while the reverse shows classically garbed equestrian portraits of Wellington and Blücher. Both designs are surrounded by classical figures expressive of victory and the resolution of strife.¹⁵ The prominent placement of Blücher contributed to the failure of the medal once completed, as by the 1840s a standard British historical narrative had developed, which gave sole credit for the Waterloo victory to Wellington's army and reduced or ignored the Prussian contribution.

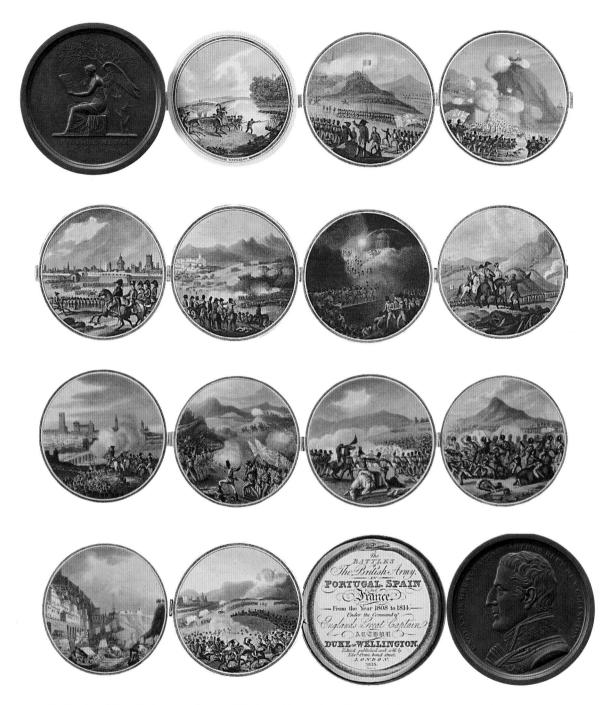

The Battles of the British Army in Portugal, Spain and France from the year 1808 to 1814, box medal designed by I. Porter, prints made by Edward Orme, *c*. 1815

A mcdal with a different purpose was the unusual box medal issued by the engraver and publisher Edward Orme (opposite). Combining the skills of medallist and printmaker, it comprises a shallow bronze container decorated with a portrait of Wellington on the obverse, with a winged figure of Victory on the reverse inscribing a tablet with the words 'RECORD OF BRITISH VALOUR'. Inside are thirteen printed discs, linked by a silk ribbon, illustrating the achievements of Wellington's army during the Peninsular War and at Waterloo. Its title, *The Battles of the British Army in Portugal, Spain and France from the year 1808 to 1814*, suggests that the set was conceived after the initial termination of the war, although the presence of a disc for Waterloo confirms that it was completed only after the ultimate conclusion of hostilities in 1815. A commercial product aimed at the middle ground of the market, Orme's medal is but one illustration of the demand for souvenirs commemorating Wellington's recent military success and the resulting peace.¹⁶

Indeed, commemorative and celebratory goods appeared in every imaginable material, ceramic being a particular favourite. An earthenware 'Waterloo' jug (overleaf, top) may in fact have been hastily produced to serve a market hungry for Waterloo souvenirs by adapting a pre-existing design. The equestrian figure in British general's uniform is identified as the Duke by the letters WN and the date 1815, although on another, slightly smaller example, a similar figure is clearly identified as George III.¹⁷ Whatever its origins, when sold in the aftermath of the battle, the jug, with its patriotic oak leaf and acorn border and martial trophies of war on the reverse, offered the purchaser an opportunity to share in the sense of British achievement after the battle.

Another jug more definitely associated with the battle bears recognisable portraits of Wellington and Blücher inscribed with their names. It also communicates more explicitly the expected benefits of the victory, with the inscription 'Peace & Plenty' beneath cornucopias symbolising prosperity and clasped hands and a winged caduceus (the staff carried by Mercury in Greek mythology) symbolising peace (overleaf, bottom).

The importance of the battle of Waterloo remains a subject of debate, especially among historians of other nations. Some consider it merely a postscript to the campaigns of 1813–14, with Napoleon's defeat after his return to power seeming inevitable.¹⁸ Whatever the truth behind these opinions, Napoleon was finally conquered by what was seen in Britain as a British army commanded by the Duke of Wellington. This gave the nation a new sense of self-confidence on the European

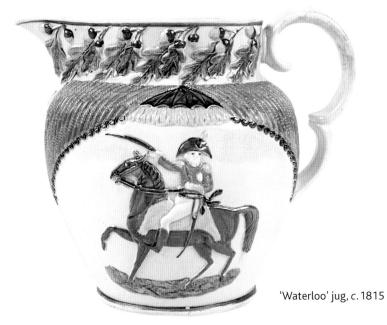

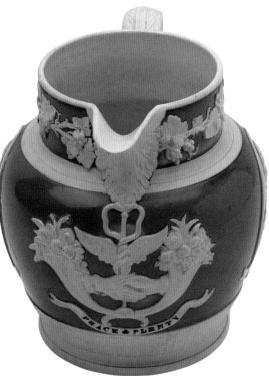

'Peace & Plenty' jug, c. 1815

political stage and led to the outpouring of commemorative artworks celebrating the battle and Wellington's part in it. It is true that the British army was not to be involved in another major European war until 1914. However, while 'Peace & Plenty' may have been the expectation of the producers and purchasers of the jug, post-war manufacturing and agricultural slumps combined with vast numbers of dispossessed army veterans to produce successive phases of unemployment and popular unrest. The result was a background of political instability against which Wellington would pursue the next stage of his career.

- Elizabeth Longford, Wellington: The Years of the Sword (Weidenfeld & Nicolson, London, 1969), pp.330, 490.
- 2 Ibid., pp.321-2.
- 3 General Cavalié Mercer, Journal of the Waterloo Campaign (Peter Davies Ltd, London, 1927), p.299.
- 4 Christopher Hibbert (ed.), The Wheatley Diary: A Journal and Sketch-book kept during the Peninsular War and the Waterloo Campaign (Windrush Press, Moreton-in-Marsh, Glos., 1997).
- 5 Rory Muir, Wellington: The Path to Victory, 1769–1814 (Yale University Press, New Haven and London, 2013), p.504.
- 6 Sir George Larpent (ed.), *The Private Journal of F.S. Larpent, Esq.*, 3 vols (Richard Bentley, London, 1853), Vol. 2, p. 125.
- 7 Richard Walker, *Regency Portraits* (National Portrait Gallery, London, 1985), Vol. I, pp.630–2.
- Jenny Spencer-Smith, 'Dighton, Denis (1791–1827)', Oxford Dictionary of National Biography (Oxford University Press, Oxford, 2004).
- 9 Henry Houssaye, 1815: Waterloo (Adam & Charles Black, 1900), p.178.
- 10 Longford, op. cit., p.399.
- David Chandler, Waterloo: The Hundred Days (Osprey, London, 1980), pp.52–70.

- 12 Longford, op. cit., p.490.
- 13 Thomas Smith, Recollections of the British Institution (Simpkin & Marshall; Edward Stanford, London, 1860), pp.70–1.
- 14 Analysis of the effect of the British Institution competition, as well as a discussion of the less wellknown artists contributing entries, can be found in chapter 1 of J.W.M. Hichberger, Images of the Army: The Military in British Art, 1815–1914 (Manchester University Press, Manchester, 1988), pp.10–35.
- 15 Laurence Brown, British Historical Medals 1760–1960, Vol. I (Seaby Publications Ltd., London, 1980), pp.208–12.
- 16 Ibid., pp.206-7.
- 17 John Lewis and Griselda Lewis, Pratt Ware: 1780–1840 (Antique Collectors Club, Woodbridge, Suffolk, 1984), p.172.
- 18 This opinion was expressed by the speakers at the 2013 conference Waterloo: The Battle that Forged a Century, at King's College, London, during the session chaired by Professor Andrew Lambert on 'Prussia, Russia and Central Europe', with Dr Michael V. Leggiere, Professor Alan Sked and Dr Alexander Mikaberidze.

THE WATERLOO'IDOL' DEFEATED WELLINGTON IN POLITICS

Multiplin

T HE DUKE OF WELLINGTON'S life appears at first glance to divide neatly into two halves: the first portion spent pursuing a military career, during which he rose to the most senior rank in the British army; the second in politics, when he again rose to the highest office, this time of prime minister. The historian Norman Gash reminds us that these facts should not blind us to the exceptional nature of this transition. It had not been common in Britain for high-ranking soldiers to have a second successful career in politics. In fact, Wellington is the only professional soldier in modern history to have headed the British government.' Additionally, the division is not as neat as it appears because Wellington had been elected to the House of Commons in both Ireland and Britain many years before entering the Cabinet in 1818. This chapter explores Wellington's life in politics, focusing on the two major political issues that served to define his career. It also considers the effect on Wellington's reputation of his political actions, as well as looking at his representation in the political caricatures that provided a visual commentary on the politics of the late Georgian and early Victorian eras.

FROM BACKBENCHES TO CABINET OFFICE

Arthur Wesley's first entry into politics came in 1790, when his oldest brother Richard decided that he should take over as Member of Parliament for the Irish borough of Trim from his older brother William, who was moving to Westminster. Although this seat was within the control of the family, he still had to go through the process of an election, which took place shortly before his twenty-first birthday. Having not yet reached his majority, he was, strictly speaking, not yet eligible to stand for election or to sit in parliament. This situation was far from unusual, however, and although there were appeals against his election, they were ultimately dismissed. Wesley's maiden speech, made in January 1792, contained a prophetic foretaste of the political issue that would later challenge his abilities as prime minister. Although employed as an aide-de-camp to the Lord Lieutenant of Ireland, and therefore unlikely to be expressing his own political views, he referred approvingly to new legislation removing some of the laws barring Catholics from public office in Ireland.²

Wesley's activity in the Irish House of Commons was terminated by his decision to focus on his developing military career. In 1794 his regiment was sent to the war in Flanders, and in 1796 he set sail for India. He returned to England as Sir Arthur Wellesley in 1805, having established his military reputation. He learned on the way home that his brother Richard, Marquess Wellesley, who was serving as Governor-General of India, had been recalled by the government. His handling of the war with the Maratha Confederacy had been criticised, and allegations of corruption would follow. Arthur lobbied the government on his brother's behalf, and in April 1806 was elected as Member of Parliament for Rye in Sussex. He had stood for this seat with the express purpose of defending his brother's reputation in the House of Commons. He was active at Westminster, making a number of speeches in Richard's defence, and thereby bringing his own name to the attention of ministers. In future years Wellington acknowledged the contribution that his time in parliament had made to his progression within the army.³

Wellesley lost his Rye seat when parliament was dissolved in October 1806, but transferred to Mitchell in Cornwall – a 'rotten borough' that would be disenfranchised by the Reform Act of 1832 – and soon after to Newport on the Isle of Wight. In March 1807 he accepted the position of Chief Secretary for Ireland with a proviso indicating his future career intentions: he agreed on the condition that the position would not jeopardise any future offers of employment in the army. His duties principally concerned honours and appointments, including the distribution of offices, titles and pensions to potential political allies. This was particularly pressing given the forthcoming general election. Wellesley was probably pleased to replace these responsibilities with a role in the expedition to Copenhagen in 1807 to prevent the Danish fleet from falling under Napoleon's influence. He resumed his Dublin position after returning from Denmark, but this portion of his political and administrative career was brought to a close when he was given the command of a force sent to fight Napoleon's armies in the Iberian Peninsula in the summer of 1808. The Peninsular War, and later the Waterloo campaign and its aftermath, then kept him out of active British politics for over ten years.

Arthur Wellesley, by now Duke of Wellington, returned to England at the end of 1818, three years after Waterloo. He and Lord Castlereagh, the Foreign Secretary (opposite), had represented Britain at the second peace congress at Aix-la-Chapelle (present-day Aachen) in October and November. The congress terminated the allied occupation of France, of which Wellington had been commander-in-chief, and redefined the post-war relationships of the European powers. Earlier, in 1814, he had served briefly as British ambassador to France after the first defeat of Napoleon, until threats to his life led to his recall and a role representing Britain at the Congress of Vienna. This conference met to settle post-war European boundaries in the hope of a long-term peace, but was in session when Napoleon's escape from Elba led to the Waterloo campaign. Other than these diplomatic positions, and the necessity of negotiating with domestic and foreign governments while on campaign, Wellington's career since 1808 had been exclusively military.

Earlier British military heroes, such as James Wolfe at Quebec and Horatio Nelson at Trafalgar, had died at their moment of supreme military glory, allowing them to be memorialised in art and literature with their posthumous reputations largely untarnished. The difficult question for the British government, headed by Prime Minister Lord Liverpool (page 98), was what to do with such an illustrious living military personality. Wellington's international fame and prestige were virtually without precedent, and for him to remain within the army in a purely military capacity would have appeared insufficient recognition of this status. The solution was to invite him into government, but this was not an offer that he accepted without hesitation. It took Castlereagh to persuade him with the argument that refusal would strengthen the hand of the opposition. Wellington declared after accepting that he had seen the negative effect of a 'factious opposition' during his

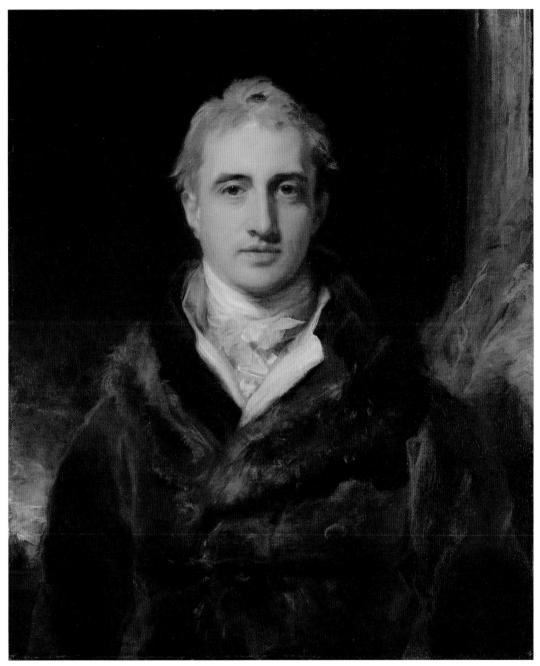

Robert Stewart, 2nd Marquess of Londonderry (Lord Castlereagh), by Sir Thomas Lawrence, 1809–10

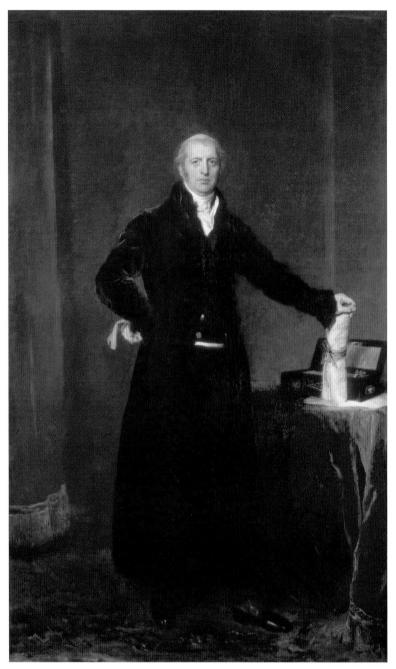

Robert Jenkinson, Lord Liverpool, by Sir Thomas Lawrence, exhibited 1827

time in the Peninsula.⁴ He would also have been more likely to accept persuasion from Castlereagh, who had supported him in parliament during the Peninsular War in the face of Whig criticism. An appropriate role in the Cabinet was found when Lord Mulgrave offered to give up the position of Master-General of the Ordnance to make way for him.

As Master-General, Wellington was responsible for the army's artillery, engineers and fortifications. The post was entirely suited to his experience, and he was additionally employed by the government in a variety of other negotiations. An early task was to negotiate with Queen Caroline's representatives during the abortive parliamentary divorce proceedings encouraged by King George IV (page 117, bottom). Then, after Castlereagh's suicide, Wellington replaced him at the Congress of Verona in 1822.

Castlereagh was succeeded as foreign secretary by George Canning (overleaf). It was as a result of Canning's foreign policies that a rift developed between him and Wellington. For example, Canning was sympathetic to the South American states that wished to break away from Spanish and Portuguese rule. Wellington, on the other hand, had an instinctive respect for the royal authority represented by the existing arrangements. Furthermore, he felt it wrong to support such movements abroad while suppressing similar aspirations for Irish independence. An additional disagreement with Canning was over the issue of Catholic emancipation – the removal of the restrictions preventing Catholics from participation in public life, particularly in government, which had been in place since the Reformation in the sixteenth century. Although Lord Liverpool had become prime minister in 1812 on the understanding that his Cabinet would remain neutral on the issue, Canning was openly sympathetic to Catholic emancipation, despite the threat this posed to the government's authority.

In the light of this visible split, it was inevitable that people assumed Wellington held opposite views to Canning on all the burning questions of the day. On the Catholic issue even his political colleagues failed to understand his actual position. For example, in 1825 he drafted a plan to legalise the Catholic Church's relationship with the British government through an agreement with the Pope. Although this plan was never enacted, it is clear that Wellington was not, as the Tories resisting Catholic emancipation supposed, entirely opposed to some form of settlement.

Lord Liverpool suffered a stroke in 1827, which ended his prime ministership. To many, Canning and Wellington were the leading candidates to replace him,

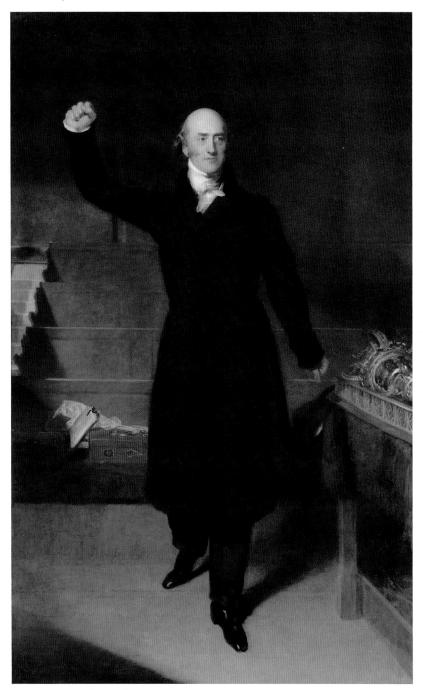

George Canning, by Sir Thomas Lawrence, 1825

but Wellington refused to have his name put forward. In fact, he proposed alternatives, but also warned the King that choosing Canning would weaken the government. When George IV finally selected Canning, Wellington refused to serve in his Cabinet, resigning his position as Master-General of the Ordnance. He also resigned as commander-in-chief of the army, a position usually reserved for a member of the royal family, but which had been given to him on the death of the Duke of York at the beginning of the year. Six other ministers resigned alongside Wellington, leading to accusations that he was leading a 'cabal' against the King and the new Prime Minister.' Both the satirical and the traditional press were highly critical. A statue of Achilles, the hero of the Trojan War, had recently been erected near Wellington's home at Apsley House to commemorate his victories during the Napoleonic Wars. Caricatures were published comparing Wellington with Achilles sulking in his tent after being slighted by the Greek commander Agamemnon (below).

Achilles in the Sulks after his Retreat, or, The Great Captain on the Stool of Repentance!! Satirical print, published by George Humphrey, 1827

The inscription, a quotation from Alexander Pope's translation of Homer's *lliad*, reads:

here for brutal courage far renowned, I live an idle burden to the ground, (others in counsil famed for nobler skill. More useful to preserve than I to kill;)

The letter on the table reads: His M-j-sty accepts the resignation of his Grace the Duke of W-ll-ngt-n with the same regret that it is communicated

<u>Aleilles</u> in the Seilles for his <u>Repeat</u> or . The <u>Great Capitatin</u> on the Scool of <u>Repentance</u>!! "here for batal courses for remoned, <u>(athere</u> in coursed from the skill fline an ille busien to the ground, <u>Item unfit to process</u> the <u>J</u> to <u>kill</u>;) is a nu

PRIME MINISTERIAL UPS AND DOWNS

The antipathy between the two men continued throughout Canning's tenure as prime minister until, having suffered from poor health for some time, Canning died in August 1827. He was followed as prime minister by Viscount Goderich, who had acted as the government's leader in the House of Lords. Goderich led a coalition of Whigs and liberal Tories that proved weak and lost power after five months. In January 1828, George IV appointed the Duke of Wellington as Goderich's successor on the understanding that, like his predecessor Lord Liverpool, his government would be neutral on the issue of Catholic emancipation.

Whatever Wellington's hopes and intentions, he became embroiled in two major, divisive political questions. These would cause his wish to serve his country and sovereign to come into conflict with his own conservative and reactionary political opinions. They also alienated him from large sections of his own party. Despite his assurance to the King, the first of these issues was indeed that of Catholic emancipation. Wellington's family background in Ireland, as well as the fact that he had seen at first hand the contribution made by Irish Catholic soldiers to the British army, perhaps made him more than usually accepting of the need for a relaxation of the laws that restricted Catholics' rights to hold public office or positions in parliament. Impetus was given to the cause in Westminster when Daniel O'Connell (opposite), leader of the campaigning Catholic Association, was elected for County Clare in July 1828. This was a contentious moment, as British law forbade him as a Catholic from sitting in parliament although not from standing for election. Wellington feared the emergence of disorder if O'Connell's electoral achievement was repeated by other would-be Catholic Members of Parliament, thereby depriving Irish voters of representation in parliament. In consequence, he obtained permission from the King to allow the government to abandon its previous neutrality and debate the issue, in the hope of reaching a settlement. After much persuasion, including the threat of his own resignation, he ensured the passage of a bill removing the restrictions on Catholics serving in government. This made him unpopular with the King, with a large part of the general public, and with the right wing of his own party - the 'Ultra-Tories'.

Wellington's political career was conducted during the high point of graphic satire in Britain, when a constant flow of prints critiqued contemporary events. He was the butt of satire as a result of his stance on Catholic emancipation more than

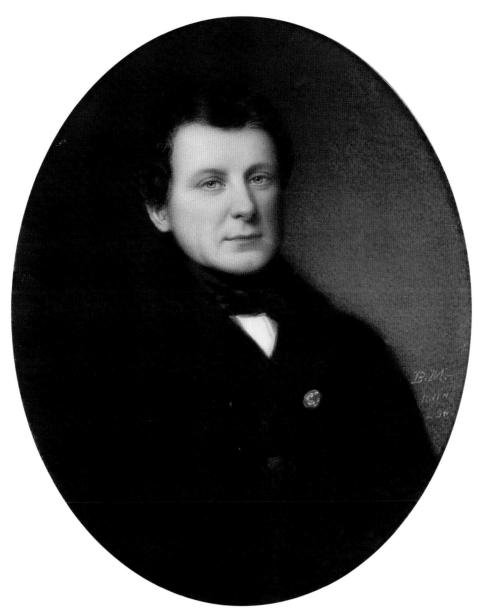

Daniel O'Connell, by Bernard Mulrenin, 1836

on any other issue.⁶ The prints ranged from complex illustrations with extensive text, from which the viewer could enjoy teasing out the satirist's intention, to striking graphic images, such as William Heath's *Doing Homage* (opposite), that communicated their point simply and directly. Published under Heath's pseudonym Paul Pry, *Doing Homage* shows the Duke of Wellington holding a rosary and kneeling to kiss the Pope's foot, while Robert Peel, who had originally declared an anti-Catholic position, awaits his turn. Heath's lampooning of Wellington followed an ironic change of career: he is thought to have been a soldier and certainly earned a living illustrating the military books that enjoyed a vogue during and after the Napoleonic Wars, including *The Wars of Wellington* (1819). However he was forced to turn to satire in the 1820s when the demand for such military publications slowed.⁷

At the same time as promoting the Catholic emancipation bill, Wellington had been instrumental in the foundation of King's College London, with its close links to the Church of England. King's was founded in response to the creation of London University (now University College London), with its deliberately secular agenda, in 1826. The Ultra-Tory Earl of Winchilsea published a letter suggesting that Wellington had deliberately associated himself with King's College in order to obscure his real opinions on the Catholic question. Insulted, Wellington challenged Winchilsea to a duel, which the two fought at Battersea. Although both men deliberately aimed to miss, the danger to which the Prime Minister had apparently subjected himself attracted much attention. The event was the subject of caricatures, such as William Heath's etching The Field of Battersea (page 106). In this print it is difficult to know exactly where Heath's sympathies lie, as he seems to ridicule both parties equally. Wellington is shown clad in a monk's robe with a rosary hanging from his belt, his distinctive profile turned into a lobster's claw – 'lobster', from its colour, was a derogatory term for a British soldier. Lord Winchilsea is represented with exaggerated thinness to present less of a target and complains that he will be tainted with popery should he be hit by one of Wellington's bullets. Wellington wrote to the Duke of Buckingham a month after the duel that it had been deliberately undertaken to further his purpose in introducing the legislation.⁸ Whatever the truth of this, it was a convincing demonstration of the strength of the Duke's feelings on the issue, and convinced many moderate Tories of the folly of the Ultra-Tories' inflexible position.

The second contentious political issue in which Wellington was involved was reform of the House of Commons. In the early nineteenth century, parliament

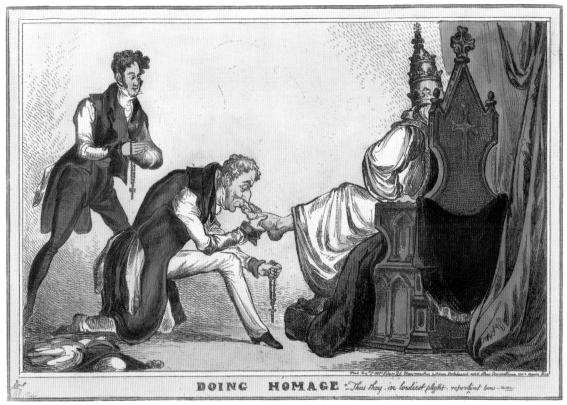

Doing Homage, by 'Paul Pry' (William Heath), 1829 The subtitle 'Thus they in lowliest plight, repentant bow' misquotes Milton's *Paradise Lost*.

The Field of Battersea, by 'Paul Pry' (William Heath), 1829

The speech reads:

Wellington (left): I used to be a good shot, but have been out of practice for some years.

Winchilsea (right): I'll make myself up small. Gad if he should hit me, I might be tainted with some of his popery, won't give him more than one chance.

The sign reads: BATTERSEA SHOOTING GROUNDS GRAND PIGEON MATCH

operated under a system largely devised during the Middle Ages. The populations of electoral boroughs that had once been important had in some cases dwindled almost to nothing, yet they still returned Members of Parliament to the House of Commons. Conversely, new cities such as Birmingham and Manchester, whose populations had grown dramatically with the rise of industry and manufacturing, remained unrepresented. Furthermore, the small size of some electorates enabled voters to be bribed or otherwise persuaded by local landowners to vote for particular candidates: these were known as 'pocket' boroughs, as they were essentially 'in the pocket' of the proprietor. There had been calls for parliamentary reform to redress these imbalances since the previous century, but in the 1820s, partly as a result of the growing middle classes, momentum had grown until some measure of change was felt to be inevitable.

Wellington, nonetheless, was implacably opposed to any reform of the existing system. In this case he appears to have placed his own deeply held convictions above the good of the country and the will of the electorate. His belief that reform was equivalent to revolution brought about through force of law reflected his innate conservative instincts. It would have been reinforced by his lengthy experience fighting the forces of Revolutionary and Napoleonic France. A statement he made in the House of Lords in November 1830, to the effect that the existing parliamentary system was perfect, and that he would resist any change to it, was so uncompromising that it alienated many even in his own party. This speech was followed a few days later by the government's defeat in the House of Commons over a minor financial matter, essentially a vote of no confidence, with a number of the Ultra-Tories still smarting over Catholic emancipation voting against. A reform bill was due to be debated the day after this setback, and rather than risk the defeat of an already weakened government on this important subject, Wellington and his colleagues resigned. Once again, Wellington's difficulties were mocked by caricaturists. A Regular Turn Out by 'A. Sharpshooter' - probably the caricaturist John Phillips - was published just a week after the government's resignation (overleaf). It shows a muscular John Bull, representing the will of the British electorate, sweeping Wellington and his anti-reform colleagues from power. One of the outgoing ministers cries, 'Oh! This cursed 29!!!', a reference to the twenty-nine votes that had defeated the government, but perhaps most telling is the Duke of Wellington's complaint that John Bull is treating his 'Waterloo Idol' roughly. It is clear that the heroic status accorded him after his victory at Waterloo had by this time virtually disappeared.

A Regular Turn Out; or, Cleansing the Augean Stable, by 'A. Sharpshooter' (John Phillips), 1830

The speech reads:

John Bull (left): I'm determined to have a clean house, I'll be bamboozled no longer. Away ye Varlets, with your trickery and your plots and your intrigue. Reform shall be the order of the day, Reform – thorough Reform. Attorney General James Scarlett (middle): This is assault and battery, mind that. Wellington (on all fours): What. treat your Waterloo idol in this way, Johnny? Outgoing minister (right): Oh! this cursed 29!!!

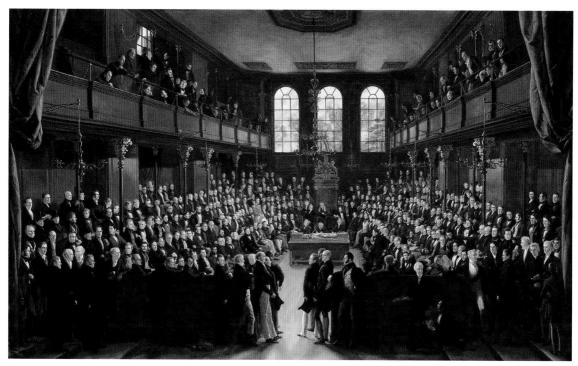

The House of Commons, 1833, by Sir George Hayter, 1833–43 Hayter's picture shows the opening of the first reformed parliament in the House of Commons.

Wellington's resignation enabled the Whig Charles, Lord Grey to form a government, and in 1832 the Great Reform Act was finally passed under his prime ministership, despite Wellington and his followers' resistance. The new enlarged and redistributed House of Commons was represented by George Hayter in a great work of celebration and it is telling that Wellington is shown in the foreground with his back to the Members (above). During this period of opposition, Wellington became particularly unpopular. There were rumours of plots to assassinate him, and the London mob, angered at his continued intransigence over reform, twice broke the windows of Apsley House. A caricature published in 1832, *Bombarding the Barricades or the Storming of Apsley House* (overleaf), reflects this mood. With a distinctly military theme, it shows the leading reformists besieging Apsley House, but unlike *A Regular Turn Out*, with its unequivocally pro-reform message, it offers a less positive view of the Reform Bill. Wellington's brother Richard, Marquess

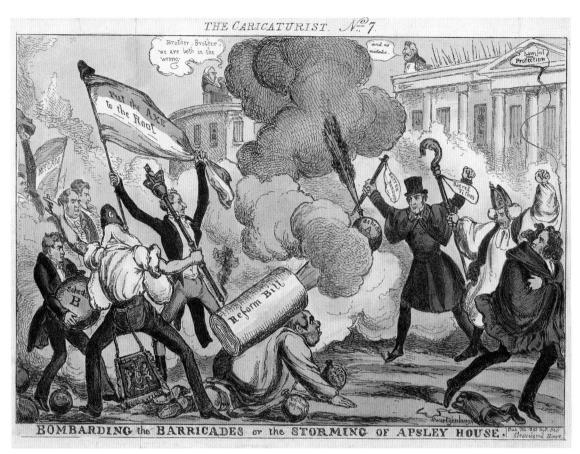

Bombarding the Barricades or the Storming of Apsley House, published by J. Bell, 1832

The speech reads:

Richard, Marquess Wellesley (left): *Brother, Brother, we are both in the wrong.* Wellington (right): *And no mistake*.

Wellesley, a supporter of reform, cries to Wellington from the roof of a neighbouring house, 'Brother, Brother, we are both in the wrong,' to which Wellington, shown in profile backed by bayonets on the roof of Apsley House, responds, 'And no mistake.' Furthermore, the figure of John Bull is this time subservient, supporting the Reform Bill cannon on his back so it can be fired by Lord Chancellor Henry Brougham. Although the print communicates a generally positive view of the reformers' actions, their characterisation as French Revolutionaries, with tricolours and caps of Liberty, was provocative. It seems clear that even individual commentators, such as the artist behind this print, could have mixed feelings on the subject.

Wellington's remaining political career was to be less eventful. He acted as caretaker prime minister for less than a month in 1834, before Sir Robert Peel, who was abroad, could return and form a Cabinet. A more significant service to the country, Wellington believed, was his ability in the mid-1840s to persuade the landowning Tories in the House of Lords to allow the passage of Peel's bill repealing the Corn Laws. These imposed such steep duties on imported grain that they essentially prevented imports from reaching the country, even in times of dire need. Despite disagreeing with Peel over the measure, Wellington felt that good government was more important than the Corn Laws themselves. Again, however, the result was the alienation of the Ultra-Tories and the defeat of the government in a subsequent vote.

The Duke of Wellington's life in politics was controversial and not entirely successful. The high office he achieved in government would have been impossible without the reputation forged by his glittering military career, but the qualities that made him a successful military commander did not suit him to political leadership. As a general, he was used to issuing orders and having them carried out without question, but as prime minister he found his 'orders' were questioned and debated, a process he interpreted as hostility or disloyalty. Nevertheless, his autocratic nature and persuasiveness, combined with an unreformed political system susceptible to such pressure, enabled him to push through the Catholic emancipation legislation against considerable opposition. The irony that this achievement split his party, and thus hastened the decline of the system that he later fought so strongly to defend, has not been lost on historians.⁹

- Norman Gash, 'The Duke of Wellington and the Prime Ministership, 1824–1830', Wellington: Studies in the Military and Political Career of the First Duke of Wellington, ed. Norman Gash (Manchester University Press, Manchester, 1990), p.117.
- 2 Rory Muir, Wellington: The Path to Victory, 1769–1814 (Yale University Press, New Haven and London, 2013), pp.22–3.
- 3 Ibid., pp.180-1.
- 4 Elizabeth Longford, Wellington: Pillar of State (Weidenfeld & Nicolson, London, 1972), p.57.

5 Ibid., p.138.

- 6 Edward du Cann, The Duke of Wellington and His Political Career after Waterloo: The Caricaturists' View (Antique Collectors' Club, Woodbridge, Suffolk, 2000), p.89.
- 7 Simon Heneage, 'Heath, William [Paul Pry] (1794/5– 1840)', Oxford Dictionary of National Biography (Oxford University Press, Oxford, 2004).
- 8 Longford, op. cit., pp. 189–90.
- 9 Gash, op. cit., pp. 128-9.

CHRONOLOGY

1769

Arthur Wesley is born in Dublin, 1 May, the third surviving son of Garret Wesley, 1st Earl of Mornington, and his wife Anne Hill.

Napoleon Bonaparte is born in Ajaccio, Corsica, 15 August.

1781

Arthur is sent to school at Eton with his younger brother, Gerald.

Lord Mornington dies, leaving the family in reduced financial circumstances.

1784

Arthur is removed from Eton to make way for his more gifted younger brother, Henry.

1786

Arthur is sent to Monsieur de Pignerolle's Academy of Equitation in France in preparation for a military career.

1787

With the help of his older brother Richard, later Marquess Wellesley, Arthur receives his first commission as ensign in the 73rd Highland Regiment of Foot.

1789

Outbreak of the French Revolution.

1790

Arthur succeeds his brother William as MP for Trim in Ulster, Ireland.

Anne Hill, Countess of Mornington, by Robert Healy, 1760

Garret Wesley, 1st Earl of Mornington, by an unknown artist, *c*. 1760

Arthur Wesley silhouette, by an unknown artist, c. 1780

Arthur courts Kitty Pakenham, daughter of the Earl of Longford.

1793

After holding commissions in six different regiments, Arthur Wesley transfers to the 33rd Regiment, later renamed The Duke of Wellington's.

His marriage proposal to Kitty Pakenham is rejected by her younger brother Tom, by this time the head of Kitty's family.

Again with Richard's assistance, Arthur purchases the rank of lieutenant-colonel and thereby the command of his regiment.

Revolutionary France declares war on Britain.

1794

Wesley's regiment is sent to the war in Flanders. He has his first experience of combat during the inconclusive battle of Boxtel in presentday Holland.

1796

Frustrated by the poor management of the campaign in Flanders, Wesley unsuccessfully attempts to obtain a civil position. He and his regiment are ordered to India.

1797

Arthur's eldest brother, Richard Wellesley, is appointed Governor-General of India.

1798

Following his older brother's example, Arthur changes his surname from Wesley to Wellesley, a form used by the family in the past.

1799

Arthur Wellesley commands the army of the Nizam of Hyderabad in the war against Tipu Sultan of Mysore, who is suspected of plotting with the French. He is appointed governor of Tipu's capital Seringapatam after its capture.

A Mysorean Soldier with a Rocket, by Robert Home, c. 1792

1802

The Treaty of Amiens temporarily ends hostilities between France and Britain.

Wellesley is promoted to major-general and commands in the war against the Maratha Confederacy in India.

Britain again declares war against France.

1804

Wellesley is appointed to the Order of the Bath.

Napoleon is crowned emperor of France.

1805

Wellesley returns to Britain.

Nelson dies at the battle of Trafalgar.

1806

Wellesley marries Kitty Pakenham.

He is elected as MP for Rye, entering parliament with the intention of defending his brother Richard against charges of maladministration in India.

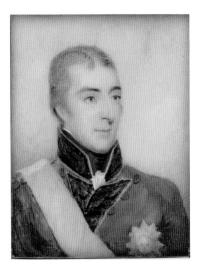

Arthur Wellesley, 1st Duke of Wellington, after Robert Home, 1804

Napoleon Bonaparte's Continental System forbids European trade with Britain.

Prime Minister William Pitt dies.

1807

Wellesley is appointed Chief Secretary for Ireland.

Arthur and Kitty's first son, Arthur Richard, is born.

Wellesley takes part in the military expedition to Denmark and the siege of Copenhagen. Wellesley's horse, Copenhagen, is born.

1808

Kitty gives birth to Charles, the couple's second son.

Wellesley heads an expeditionary force to Portugal. He commands at the battles of Roliça and Vimeiro against the French, but afterwards two senior generals arrive to take charge. Wellesley and his superiors are recalled to a court of enquiry into the generous terms of an armistice signed with the French.

1809

Wellesley returns to the Iberian Peninsula in command of a force given the task of defending Portugal. The army retakes Oporto from the French, moves into Spain and fights the battle of Talavera, forcing the French to retreat. Despite this victory, a second French army forces the British to return to Portugal.

He is raised to the peerage as Viscount Wellington of Talavera.

1810

A French army, originally to have been commanded by Napoleon, is led by Marshal André Masséna into Portugal. Wellington's Anglo-Portuguese army retreats, stopping to fight at Busaco. On reaching the defensive 'Lines of Torres Vedras', Masséna's army declines to attack.

1811

The Prince of Wales is appointed regent when King George III becomes so ill he can no longer rule.

The French army retreats to Spain. Wellington's armies unsuccessfully attempt to take the Spanish border fortresses of Ciudad Rodrigo and Badajoz from the French in order to stop access to Portugal. The French-held Portuguese fortress of Almeida is attacked en route to Ciudad Rodrigo. The battle of Fuentes de Oñoro is fought when the French attempt to relieve Almeida. The fortress falls to Wellington's army, but the French troops escape.

1812

Additional artillery, combined with a reduction in the size of the French force, enables Wellington's army to capture Ciudad Rodrigo. Encouraged by this success, he orders an assault on Badajoz, which is taken with heavy casualties. Wellington's army enters Spain and is victorious against the French at the battle of Salamanca, considered one of the most skilful of his victories.

He is raised in the peerage to Marquess of Wellington.

His army occupies Madrid, where he is painted by Goya.

He becomes generalissimo of the Spanish armies.

The French forces concentrate and Wellington is forced to retreat to Ciudad Rodrigo.

Napoleon invades Russia.

America declares war on Britain.

1813

Wellington's command of the Spanish armies, as well as a reduction in French forces to replace losses in Russia, enables him to take the offensive. He moves northwards into Spain from Portugal, threatening the French lines of communication. At the battle of Vitoria the French army of Napoleon's brother King Joseph is crushingly defeated. The ceremonial baton of Marshal Jourdan is captured and sent to the Prince Regent, who appoints Wellington field marshal.

Wellington's army crosses the Bidassoa river into France.

Napoleon's army is defeated at Leipzig in presentday Germany during the battle known as the 'battle of the Nations'.

1814

The armies of the European powers enter Paris and Napoleon abdicates.

The final battle of the Peninsular War is fought at Toulouse.

Napoleon is exiled to the Mediterranean island of Elba.

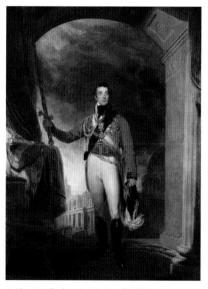

Arthur Wellesley, 1st Duke of Wellington, by Sir Thomas Lawrence, 1814–15

Wellington receives his final rank in the peerage, becoming Duke of Wellington. He returns to England to see his wife and sons for the first time in five years and is received as a hero by the public. He carries the sword of state in a thanksgiving ceremony at St Paul's Cathedral (previous page).

He is appointed ambassador to France, purchasing the residence of Napoleon's sister in the rue du Faubourg St-Honoré, which houses the British Embassy to this day.

1815

Wellington represents Britain at the Congress of Vienna, convened to decide the political boundaries of post-Napoleonic Europe.

Napoleon escapes from Elba and lands in France; the Congress declares him an outlaw.

The Anglo-Dutch army under Wellington and Field Marshal Blücher's Prussian army defeat Napoleon's forces at the battles of Waterloo and Wavre, south of Brussels.

Napoleon abdicates again and is exiled to St Helena in the South Atlantic.

Wellington is appointed Commander-in-Chief of the Army of Occupation of France.

1816

An arson attempt is made on Wellington's Paris house.

1817

Wellington brokers loans to the French government to facilitate the early repayment of the reparations demanded by the allied powers.

1818

An attempt is made on Wellington's life in Paris by André Cantillon, a veteran of Napoleon's army. The occupation force in France is wound up. Wellington is appointed Master-General of the Ordnance in the Cabinet of Tory Prime Minister Lord Liverpool (below).

The Master General of the Ordinance (Arthur Wellesley, 1st Duke of Wellington), by Richard Dighton, 1818

1819

A number of protestors are killed when cavalry break up a peaceful demonstration at St Peter's Field, Manchester. The massacre is referred to as 'Peterloo', in reference to Wellington's victory at Waterloo (opposite, top).

1820

The Prince Regent succeeds to the throne as George IV.

Wellington acts for the government in the negotiations between George IV and his estranged wife Queen Caroline (opposite, below).

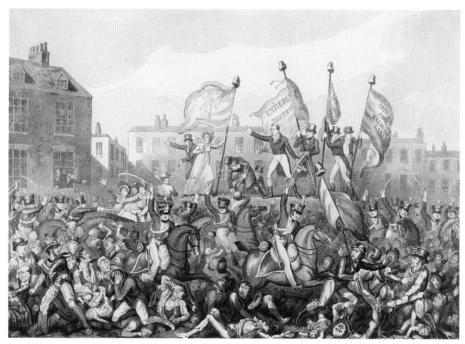

Detail of Peterloo Massacre (or Battle of Peterloo), published by Richard Carlile, 1819

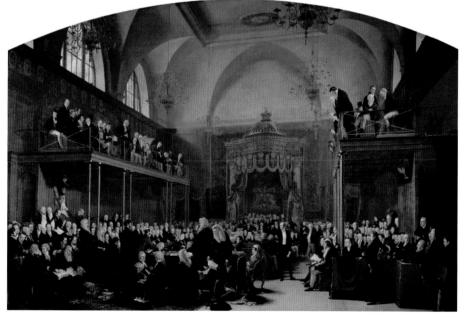

The Trial of Queen Caroline, by Sir George Hayter, 1820–3

The Duke of Wellington Showing George IV the Battlefield of Waterloo, by Benjamin Robert Haydon, c. 1844. Wellington is on the left and George IV is on the right.

1821

Napoleon dies in exile on St Helena. He leaves a legacy to Cantillon, the would-be assassin of Wellington, in his will.

Wellington visits the battlefield of Waterloo with George IV (above).

1822

Following an explosion at a weapons test he attends while Master-General of the Ordnance, Wellington suffers permanent loss of hearing in his left ear.

1823

Daniel O'Connell forms the Catholic Association to campaign for the right of Catholics to enter parliament.

1827

Wellington is appointed commander-in-chief of the army (right).

George Canning's appointment as prime minister results in Wellington's resignation from Cabinet. Canning dies after four months in office.

1828

Wellington is appointed prime minister and must therefore resign command of the army.

Daniel O'Connell is elected MP for County Clare, but, as a Catholic, the law forbids him from taking his seat in parliament.

A Wellington Boot or the Head of the Army, by 'Paul Pry' (William Heath), 1827

Wellington is appointed Lord Warden of the Cinque Ports, with which comes the residence of Walmer Castle in Kent.

He fights a duel with Lord Winchilsea over the issue of Catholic emancipation. With Wellington's backing, a bill is passed, allowing the admission of Roman Catholics to parliament. This alienates the Ultra-Tories (extreme right-wingers) and thus splits the Tory party.

1830

Wellington makes such an uncompromising speech against reform of the House of Commons that the government is defeated on a vote of no confidence. He and his Cabinet resign. Lord Grey forms a Whig government with the aim of seeing through reform legislation.

George IV dies; William IV succeeds to the throne.

1831

In opposition, Wellington's continuing resistance to parliamentary reform results in a dramatic loss of popularity. His London home, Apsley House, is stoned by the mob (below, left).

Kitty Wellington dies.

Anne, Countess of Mornington, Wellington's mother, dies in her ninetieth year.

Taking an Airing in Hyde Park (Arthur Wellesley, 1st Duke of Wellington), by 'HB' (John Doyle), 1833

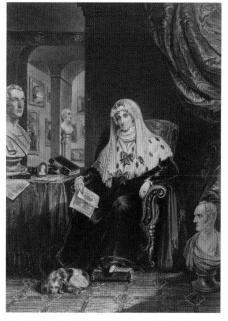

Anne Wellesley (née Hill), Countess of Mornington, by Thomas Hodgetts after Priscilla Anne Fane, Countess of Westmorland, 1839

The Great Reform Bill becomes law under Lord Grey's government.

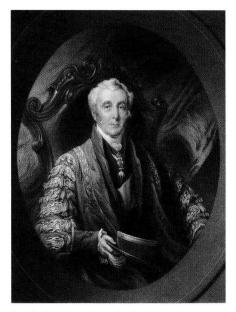

Detail of *His Grace the Duke of Wellington in His Robes as Chancellor of the University*, by George Henry Phillips after Henry Perronet Briggs, 1841

1834

Wellington is appointed Chancellor of the University of Oxford (above).

William IV dismisses the Whig government and offers the prime ministership to Wellington. Wellington refuses, but acts as caretaker prime minister until Sir Robert Peel returns from abroad.

1835

The Tory government falls and Wellington becomes leader of the opposition in the House of Lords.

1837

William IV dies; Queen Victoria succeeds to the throne.

1841

Peel becomes prime minister again and Wellington is appointed a minister without portfolio.

1845

The potato famine devastates Ireland.

Peel attempts to repeal the Corn Laws. Wellington persuades the House of Lords to support the Prime Minister, but Peel is then defeated on a separate issue in the Commons and resigns. Wellington's active political career is now essentially at an end.

1848

Revolution in France leads to a wave of uprisings across Europe.

In his capacity as Commander-in-Chief of the Army, Wellington supervises military preparation in anticipation of a mass Chartist meeting planned for Kennington Common. The meeting is peaceful and smaller than anticipated and the troops are not called upon.

1850

Wellington is appointed Ranger of the Royal Parks, which means he is responsible for security at the forthcoming Great Exhibition, the brainchild of Prince Albert.

The First of May 1851, by Franz Xaver Winterhalter, 1851

The Great Exhibition opens in Hyde Park on 1 May, the Duke of Wellington's birthday and that of his godson, Prince Arthur. His initial doubts about the project soften and he makes a number of visits to the exhibition, commemorated by Winterhalter's painting (left).

1852

Wellington dies at Walmer Castle in September. According to Queen Victoria's wishes, his funeral is delayed for two months until Parliament resumes. The funeral procession to St Paul's Cathedral attracts a million and a half spectators (below).

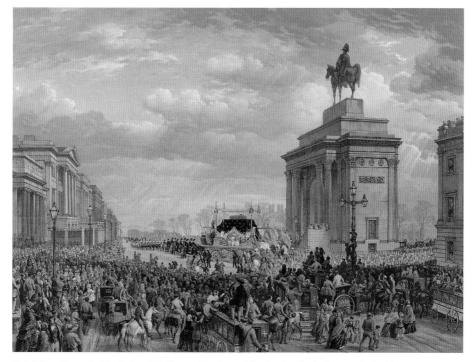

Detail from Funeral of the Duke of Wellington: The Funeral Car Passing the Archway at Apsley House, 18 November 1852, by Thomas Picken after Louis Haghe, 1853

FURTHER READING

General biography

Christopher Hibbert, *Wellington: A Personal History* (Addison-Wesley, Reading, Massachusetts, 1997)

Elizabeth Longford, *Wellington: The Years of the Sword* (Weidenfeld & Nicolson, London, 1969)

Elizabeth Longford, *Wellington: Pillar of State* (Weidenfeld & Nicolson, London, 1972)

Rory Muir, *Wellington: The Path to Victory,* 1769–1814 (Yale University Press, New Haven and London, 2013)

Eliza Pakenham, *Soldier, Sailor: An Intimate Portrait* of an Irish Family (Weidenfeld & Nicolson, London, 2007)

E.A. Smith, *Wellington and the Arbuthnots: A Triangular Friendship* (Alan Sutton Publishing Ltd, Stroud, Gloucestershire, 1994)

Charles Wellesley, Marquess of Douro, *Wellington Portrayed* (Unicorn Press Ltd, London, 2014)

Military career and the battle of Waterloo

Mark Adkin, The Waterloo Companion: The Complete Guide to History's Most Famous Land Battle (Aurum Press, London, 2001)

David Chandler, *Waterloo: The Hundred Days* (Osprey, London, 1980)

Richard Holmes, *Wellington: The Iron Duke* (HarperCollins, London, 2002)

Peter Snow, To War with Wellington: From the Peninsula to Waterloo (John Murray, London, 2010)

Political career and caricature

Edward du Cann, The Duke of Wellington and His Political Career after Waterloo: The Caricaturists' View (Antique Collectors' Club, Woodbridge, Suffolk, 2000)

Norman Gash (ed.), Wellington: Studies in the Military and Political Career of the First Duke of Wellington (Manchester University Press, Manchester, 1990)

PICTURE CREDITS

The National Portrait Gallery would like to thank the copyright holders for granting permission to reproduce works illustrated in this book. Every effort has been made to contact the holders of copyright material, and any omission will be corrected in future editions if the publisher is notified in writing. Dimensions are given height x width in millimetres and are all as framed unless otherwise stated. *An asterisk denotes works included in the exhibition *Wellington: Triumphs, Politics and Passions.* The National Portrait Gallery would like to thank the lenders of these works.

Front cover flap: Arthur Wellesley, 1st Duke of Wellington Published by Richard Evans, 1815 Hand-coloured etching, 235 x 293 © National Portrait Gallery, London (NPG D4731)

 Inside cover: The Funeral Procession of Arthur, Duke of Wellington
 Henry Alken and George Augustus Sala, 1853
 Hand-coloured etching and aquatint, 229 x 20608
 National Portrait Gallery
 National Portrait Gallery, London
 (NPG D42981) * Page 11 Arthur Wellesley, 1st Duke of Wellington Sir Thomas Lawrence, 1817–18 Oil on canvas, 915 x 710 The Wellington Collection, Apsley House, London (English Heritage)

Page 12: Repose 'HB' (John Doyle), July 1829 Lithograph, 286 x 412 © National Portrait Gallery, London (NPC D40949)

* Page 18: Arthur Wellesley, 1st Duke of Wellington John Hoppner, c. 1795 Oil on canvas, 890 x 675 Wellington Collection, Stratfield Saye House © Stratfield Saye Preservation Trust

- * Page 21: Richard, Marquess Wellesley John Hoppner, mid-1790s Oil on canvas, 770 x 620 Wellington Collection, Stratfield Saye House © Stratfield Saye Preservation Trust
- * Page 23: Tipu Sultan Attributed to F. Cherry, 1792 Oil on canvas, 265 x 230 The British Library
 © The British Library Board
- * Page 25: Major-General the Hon. Arthur Wellesley being received in Durbar at the

Chepauk Palace Madras by Azim al-Daula, Nawab of the Carnatic George Chinnery, 1805 Watercolour, 254 x 508 The British Library © The British Library Board

* Page 27: Arthur Wellesley, 1st Duke of Wellington, Francisco de Goya, 1812–14 Oil on mahogany, 643 x 524 The National Gallery, London. Bought with aid from the Wolfson Foundation and a special Exchequer grant, 1961

Page 28: Arthur Wellesley, 1st Duke of Wellington Francisco de Goya, c. 1812 Red and black chalk and graphite on paper, 235 x 177 © The Trustees of the British Museum

* Page 30: Catherine ('Kitty') Pakenham, Duchess of Wellington Sir Thomas Lawrence, 1814 Black and red chalk on paper, 345 x 273 Wellington Collection, Stratfield Saye House © Stratfield Saye Preservation Trust

Page 31: Wellington's sons Arthur (left) and Charles Henry Edridge, c. 1808 Pencil and watercolour on paper, 125 x 170 Wellington Collection, Stratfield Saye House © Stratfield Saye Preservation Trust

Page 33 top: Wellington's field marshal's batons. An illustration published in the *Illustrated London News* at the time of his funeral, 1852 National Portrait Gallery Library

- * Bottom, left: Dessert plate from the Saxon porcelain service, with a design showing the opening of Waterloo Bridge Meissen Porcelain Manufactory, c. 1819 235 diameter The Wellington Collection, Apsley House, London (English Heritage)
- * Bottom, right: Ice pail from the Prussian percelain service, with a design showing the storming of Ciudad Rodrigo Berlin Porcelain Manufactory, c. 1819 356 height, 159 diameter The Wellington Collection, Apsley House, London (English Heritage)

Page 34: The Waterloo Banquet, 1836 William Salter, 1840 Oil on canvas, 1875 x 3275 Wellington Collection, Stratfield Saye House © Stratfield Saye Preservation Trust

* Page 36: Arthur Wellesley, 1st Duke of Wellington Sir Thomas Lawrence, 1829 Oil on canvas, 965 x 762 Lent by Mr and Mrs Timothy Clode, 2014 © Timothy Clode Collection. National Portrait Gallery, London (NPG L257) Page 38: Lithographic standard letter written by Wellington, c. 1830s Ink on paper, 190 x 123 Wellington Collection, Stratfield Saye House © Stratfield Saye Preservation Trust

- * Page 39: Arthur Wellesley, 1st Duke of Wellington Antoine Claudet, 1844 Daguerreotype, 70 × 55 Wellington Collection, Stratfield Saye House © Stratfield Saye Preservation Trust
- * Page 40: The Flat Catcher, and the Rat Catcher Robert Cruikshank, 1825 Hand-coloured etching, 239 x 336 Andrew Edmunds, London

Page 41: Jack Black, rat-catcher, illustration from Henry Mayhew's London Labour and the London Poor, 1851

Page 43 top: Giuseppina Grassini Samuel William Reynolds after Elisabeth-Louise Vigée-Le Brun, 1806 Line engraving, 221 x 143 National Portrait Gallery, Given by Henry Witte Martin, 1861 © National Portrait Gallery, London (NPG D37808)

Bottom: Mademoiselle Georges Charles Etienne Pierre Motte and Pierre Roch Vigneron, c. 1813–18 Lithograph, 277 x 212 National Portrait Gallery, Given by Henry Witte Martin, 1861 © National Portrait Gallery, London (NPG D42331)

- Page 44: Harriet Arbuthnot Sir Thomas Lawrence, 1817 Oil on canvas, 762 x 635 Private collection
- * Page 45: Charles Arbuthnot Jules-Jean Baptiste Dehaussy, 1848 Bodycolour on card, 315 x 250 Private collection

Page 46: Arthur Wellesley, 1st Duke of Wellington Sir Thomas Lawrence, c. 1821 Oil on canvas, 762 x 648 Private Collection/Photo © Christie's Images/Bridgeman Images

* Page 47: Angela Burdett-Coutts, Baroness Burdett-Coutts Sir William Charles Ross, c. 1847 Watercolour on ivory, 419 x 292 National Portrait Gallery, Transferred from Tate Gallery, 1957 © National Portrait Gallery, London (NPC 2057)

* Page 48: The Duke of Wellington Playing with His Grandchildren Robert Thorburn, 1852 Watercolour on ivory, 600 x 810 Wellington Collection, Stratfield Saye House © Stratfield Saye Hreservation Trust Page 49: The Duke of Wellington, Staffordshire earthenware figure, c. 1852 Moulded lead-glazed earthenware enamelled in colours, 305 x 124 x 170 © Victoria and Albert Museum, London

* Pages 50–1: Details from The Funeral Procession of Arthur, Duke of Wellington Henry Alken and George Augustus Sala, 1853 Hand-coloured etching and aquatint, 229 x 20608 National Portrait Gallery © National Portrait Gallery. London (NPG D42981)

Page 52: Wellington's monument in St Paul's Cathedral Alfred Stevens, c. 1856–1912 Photograph © the Chapter of St Paul's Cathedral

- * Page 58 left: Portuguese Legion da Lorgna from Sketches of the Country, Character and Costume in Portugal and Spain John Heaviside Clark after Reverend William Bradford, 1809 Hand-coloured aquatint, 328 x 239 On loan from The British Museum, London 1873, 0308.332
 © The Trustees of The British Museum, London
- Right: Portuguese Military Costume: Officer of Engineers and Officer of Infantry from Sketches of the Country, Character and Costume in Portugal and Spain John Heaviside Clark after Reverend William Bradford, 1809 Hand-coloured aquatint, 332 x 237 On loan from The British Museum, London 1873,0308.329
 The Trustees of The British Museum, London
- * Page 59: Battle of Foentes D'Onor [Fuentes de Oñoro] Charles Turner after Thomas Staunton St Clair, 1812 Aquatint, 335 x 500 Courtesy of the Council of the National Army Museum, London
- * Page 60: Troops Bevouack'd near the Village of Villa Velha Charles Tumer after Thomas Staunton St Clair, 1813 Aquatint, 335 x 500 Courtesy of the Council of the National Army Museum, London
- * Pages 62–3 top: Pages from the diary of Edmund Wheatley, 1812–17 Diary, 100 x 167 x 28 Private Collection
- * Bottom: Edmund Wheatley Self-portrait, c. 1830 Sepia watercolour on card, 155 x 128 Private collection
- * Page 64 top, left: Arthur Wellesley, 1st Duke of Wellington Thomas Heaphy, 1813–14 Pencil and watercolour on paper,

190 x 161 © National Portrait Gallery, London (NPG 1914(18))

- Top, right: Charles Gordon-Lennox, 5th Duke of Richmond and Lennox
 Thomas Heaphy, 1813–14
 Pencil and watercolour on paper, 191 x 162
 © National Portrait Gallery, London (NPG 1914(12))
- * Bottom, left: Don Pablo Morillo, Comte de Cartagena Thomas Heaphy, c. 1813–14 Pencil and watercolour on paper, 238 x 199 © National Portrait Gallery, London (NPG 1914(23))
- * Bottom, right: Fitzroy James Henry Somerset, 1st Baron Raglan Thomas Heaphy, 1813–14 Pencil and watercolour on paper, 213 x 184 © National Portrait Gallery, London (NPG 1914(11))
- Page 65 top, left: Lord Robert Edward Somerset
 Thomas Heaphy, 1813
 Pencil and watercolour on paper, 194 x 162
 © National Portrait Gallery, London (NPG 1914(15))
- Top, right: Rowland Hill, 1st Viscount Hill Thomas Heaphy, 1813
 Pencil and watercolour on paper, 191 x 162
 National Portrait Gallery, London (NPG 1914(6))
- * Bottom, left: Sir Charles Alten, Count von Alten Thomas Heaphy, 1813–14 Pencil and watercolour on paper, 203 x 165 © National Portrait Gallery, London (NPG 1914(1))
- Bottom, right: Sir Edward Barnes Thomas Heaphy, 1813–14
 Pencil and watercolour on paper, 191 x 159
 National Portrait Gallery, London (NPG 1914(2))
- * Page 66 top, left: Sir Edward Pakenham Thomas Heaphy, 1813–14 Pencil and watercolour on paper, 191 x 159 © National Portrait Gallery, London (NPG 1914(9))
- Top, right: Sir Frederic Ponsonby Thomas Heaphy, 1813–14
 Pencil and watercolour on paper, 184 x 162
 National Portrait Gallery, London (NPG 1914(10))
- * Bottom, left: Sir George Scovell Thomas Heaphy, 1813–14 Pencil and watercolour on paper,

191 x 162 © National Portrait Gallery, London (NPG 1914(14))

- * Bottom, right: Sir Hew Dalrymple Ross Thomas Heaphy, 1813–14 Pencil and watercolour on paper, 191 x 152 © National Portrait Gallery, London (NPG 1914(13))
- Page 67 top, left: Sir James McGrigor, 1st Bt
 Thomas Heaphy, 1813–14
 Pencil and watercolour on paper, 194 x 162
 © National Portrait Gallery, London (NPG 1914(8))
- Top, right: Sir John Fox Burgoyne, 1st Bt Thomas Heaphy, 1813–14
 Pencil and watercolour on paper, 191 x 159
 © National Portrait Gallery, London (NPG 1914(5))
- * Bottom, left: William Carr Beresford, Viscount Beresford Thomas Heaphy, 1813–14 Pencil and watercolour on paper, 195 x 161 © National Portrait Gallery, London (NPG 1914(4))

Bottom, right: Arthur Wellesley, 1st Duke of Wellington Thomas Heaphy, 1813–14 Pencil and watercolour on paper, 194 x 160 © National Portrait Gallery, London (NPG 1914(17))

- * Page 68: Field Marshall the Duke of Wellington KG Giving Orders to His Generals Previous to a General Action Anker Smith after Thomas Heaphy, 1822 Line and stipple engraving, 720 x 1023 (paper size) National Portrait Gallery, acquired Unknown source, 1925
- * Page 70: Spanish Army. General Officer of Cavalry with Guerrillas and Lancers Denis Dighton, 1815 Watercolour, 570 x 480 Royal Collection Trust/© Her Majesty Queen Elizabeth II 2015
- * Page 72: Henry William Paget, 1st Marquess of Anglesey Attributed to George Dawe, c. 1817 Oil on canvas, 762 x 635
 © National Portrait Gallery, London (NPG 1581)
- * Page 73: The Emperor Napoleon I Emile-Jean-Horace Vernet, 1815 Oil on canvas, 724 x 597 The National Gallery, London. Presented by the Duke of Leinster, 1889
- * Page 74 left: The Hereditary Prince of Orange, William II Charles Turner after John Singleton Copley, 1813

Mezzotint and etching, 354 x 234 On loan from The British Museum, London 1902,1011.5746 © The Trustees of The British Museum, London

 Page 74 right: Field Marshal Blücher Charles Turner after F.J. Bosio, 1814 Mezzotint, 496 x 375
 On Ioan from The British Museum, London 1891,0414.481
 The Trustees of The British Museum, London

Page 77: The Battle of Waterloo: The Charge of the Second Brigade of Cavalry Denis Dighton, 1815–17 Oil on canvas, 1215 x 1523 Royal Collection Trust/© Her Majesty Oueen Elizabeth II 2014

- * Page 78: Château de Hougoumont, Field of Waterloo Denis Dighton, 1815 Watercolour, 300 x 400 Royal Collection Trust/© Her Majesty Queen Elizabeth II 2015
- * Page 79: Defence of the Château de Hougoumont, by the Coldstream Guards, Battle of Waterloo 1815 Denis Dighton, c. 1815 Watercolour, 649 x 1001 Courtesy of the Council of the National Army Museum, London
- * Page 80: The Battle of Waterloo Lieutenant Tyler, published by Rudolph Ackermann, 1815 Hand-coloured etching, 470 x 286 Royal Collection Trust/© Her Majesty Queen Elizabeth II 2015
- * Page 82: The Triumph of Arthur Wellesley, 1st Duke of Wellington and the Allies James Ward, 1816 Oil on canvas, 914 x 1340 The Royal Hospital Chelsea

Page 83: *The Battle of Waterloo* George Jones, c. 1820 Oil on canvas, 3040 x 4210 The Royal Hospital Chelsea

- * Pages 84–5: The Battle of Waterloo, 1815 George Jones, exhibited 1853 Oil on canvas, 1110 x 2102 Royal Scottish Academy of Art and Architecture Image: Andy Phillipson, courtesy of the Royal Scottish Academy
- Pages 86–7: Waterloo Medal Benedetto Pistrucci, 1819–49
 Bronze electrotype, 134 diameter
 On loan from The British Museum, London
 M.9354
 © The Trustees of The British Museum, London
- * Page 88: The Battles of the British Army in Portugal, Spain and France from the year 1808 to 1814 Box medal designed by I. Porter, prints made by Edward Orme, c. 1815

Copper alloy and paper, 74 diameter On Ioan from The British Museum, London M.6585 © The Trustees of The British Museum, London

- * Page 90 top: 'Waterloo' jug Staffordshire, c. 1815 Pearlware, relief-moulded and underglaze painted, 170 x 200 x 150 Courtesy of The Potteries Museum & Art Gallery, Stoke-on-Trent
- * Bottom: 'Peace & Plenty' jug, c. 1815 Stoneware, 190 x 160 x 100 Courtesy of the Council of the National Army Museum, London

Page 97: Robert Stewart, 2nd Marquess of Londonderry (Lord Castlereagh) Sir Thomas Lawrence, 1809–10 Oil on canvas, 743 x 616 © National Portrait Gallery, London (NPG 891)

Page 98: Robert Jenkinson, Lord Liverpool Sir Thomas Lawrence, exhibited 1827 Oil on canvas, 2337 x 1422 Given by an anonymous donor through The Art Fund, 1918 © National Portrait Gallery, London (NPG 1804)

Page 100: George Canning Sir Thomas Lawrence, 1825 Oil on canvas, 2381 x 1473 Given by Henry George Charles Lascelles, 6th Earl of Harewood, 1919 © National Portrait Gallery, London (NPG 1832)

Page 101: Achilles in the Sulks after his Retreat, or, The Great Captain on the Stool of Repentance!! Published by George Humphrey, 1827 Hand-coloured etching on paper, 351 x 248 © The Trustees of the British Museum

Page 103: Daniel O'Connell Bernard Mulrenin, 1836 Watercolour and bodycolour on ivory, 155 x 133 oval © National Portrait Gallery, London (NPG 208)

- * Page 105: Doing Homage 'Paul Pry' (William Heath), 1829 Hand-coloured etching, 239 x 336 Andrew Edmunds, London
- * Page 106: The Field of Battersea 'Paul Pry' (William Heath), 1829 Hand-coloured etching, 239 x 336 Andrew Edmunds, London
- * Page 108: A Regular Turn Out; or, Cleansing the Augean Stable
 *A. Sharpshooter' (John Phillips), 1830
 Hand-coloured etching, 248 x 350
 On Ioan from The British Museum, London
 1868,0808.9265
 © The Trustees of The British Museum, London

Page 109: The House of Commons, 1833 Sir George Hayter, 1833–43 Oil on canvas, 3460 x 5420 x 135 Given by HM Government, 1858 © National Portrait Gallery, London (NPG 54)

* Page 110: Bombarding the Barricades or the Storming of Apsley House Published by J. Bell, 1832 Hand-coloured etching, 247 x 337 On loan from The British Museum, London 1985,0119.238 © The Trustees of The British Museum, London

Page 112 left: Anne Hill, Countess of Mornington Robert Healy, 1760 Brown and white chalk on paper, 581 x 444 Wellington Collection, Stratfield Saye House © Stratfield Saye Preservation Trust

Right: Garret Wesley, 1st Earl of Mornington Unknown artist, c. 1760 Oil on canvas, 1175 x 975 Wellington Collection, Stratfield Saye House © Stratfield Saye Preservation Trust

Page 113 left: Arthur Wesley silhouette Unknown artist, c. 1780 Ink on paper, 95 x 75 Wellington Collection, Stratfield Saye House © Stratfield Saye Preservation Trust

Right: A Mysorean Soldier with a Rocket Robert Home, c. 1792 Watercolour on paper, 102 x 158 © Victoria and Albert Museum, London

Page 114: Arthur Wellesley, 1st Duke of Wellington After Robert Home, 1804 Watercolour and bodycolour on ivory, 86 x 67 Given by Edward Cock, 1885 © National Portrait Gallery, London (NPG 741)

Page 115: Arthur Wellesley, 1st Duke of Wellington Sir Thomas Lawrence, 1814–15 Oil on canvas, 3171 x 2256 Royal Collection Trust/© Her Majesty Queen Elizabeth II 2014

Page 116: The Master General of the Ordinance (Arthur Wellesley, 1st Duke of Wellington) Richard Dighton, 1818 Hand-coloured etching, 328 x 204 (paper size) © National Portrait Gallery, London (NPG D4721)

Page 117 top: Detail of Peterloo Massacre (or Battle of Peterloo) Published by Richard Carlile, 1819 Aquatint and etching, 421 x 489 (paper size) Given by Andrew Edmunds, 2011 © National Portrait Gallery, London (NPG D42256)

Bottom: *The Trial of Queen Caroline* Sir George Hayter, 1820–3 Oil on canvas, 2330 x 3562 Given by The Art Fund, 1912 © National Portrait Gallery, London (NPG 99)

* Page 118 top: The Duke of Wellington Showing George IV the Battlefield of Waterloo Benjamin Robert Haydon, c. 1844 Oil on canvas, 700 x 895 Wellington Collection Stratfield Saye House © Stratfield Saye Preservation Trust

* Bottom: A Wellington Boot or the Head of the Army 'Paul Pry' (William Heath), 1827 Hand-coloured etching, 350 x 250 Andrew Edmunds, London

Page 119 left: *Taking an Airing in Hyde Park* (Arthur Wellesley, 1st Duke of Wellington) 'HB' (John Doyle), 1833 Lithograph, 415 x 286 overall © National Portrait Gallery, London (NPG D41202)

Right: Anne Wellesley (née Hill), Countess of Mornington Thomas Hodgetts after Priscilla Anne Fane, Countess of Westmorland, 1839 Mezzotint, 600 × 449 (paper size) © National Portrait Gallery, London (NPG D39043)

Page 120: Detail of *His Grace the Duke of Wellington in His Robes as Chancellor of the University* George Henry Phillips after Henry Perronet Briggs, 1841 Mezzotint, 686 x 504 (paper size) © National Portrait Gallery, London (NPG D37579)

Page 121 top: The First of May 1851 Franz Xaver Winterhalter, 1851 Oil on canvas, 1067 x 1295 Royal Collection Trust/© Her Majesty Queen Elizabeth II 2014

Bottom: Detail from Funeral of the Duke of Wellington: The Funeral Car Passing the Archway at Apsley House, 18 November 1852 Thomas Picken after Louis Haghe, 1853 Lithograph, 500 x 650

London Metropolitan Archives, City of London

INDEX

Note: page references in *italics* refer to captions.

Achilles in the Sulks after his Retreat 101 Alken, Henry, The Funeral Procession of Arthur, Duke of Wellington 49, 50, 51 Alten, Sir Charles Alten, Count von 65 Anglesey, Henry William Paget, 1st Marguess of 71, 72 Arbuthnot, Charles 42, 45 Arbuthnot, Harriet 42, 44 Barnes, Sir Edward 65 Battle of Foentes D'Onor (Turner after St Clair) 59, 59 Battle of Waterloo, The (Dighton) 77 Battle of Waterloo, 1815, The (Jones, exhibited 1853) 84, 86 Battle of Waterloo, The (Jones, c.1820) 81-3, 83, 86 Battle of Waterloo, The (Tyler) 80, 81 Battles of the British Army (box medal) 88.89 Beresford, William Carr Beresford, Viscount 67 Blücher, Field Marshal 71, 74, 75, 78, 87, 89, 116 Bombarding the Barricades or the Storming of Apsley House 109, 110 Bosio, F.J., portrait of Field Marshal Blücher 74 Bradford, William, Sketches of the Country, Character and Costume in Portugal and Spain 57-8.58 Briggs, Henry Perronet, His Grace the Duke of Wellington in His Robes as Chancellor of the University 120 Burdett-Coutts, Angela, Baroness 42-5,47 Burgoyne, Sir John Fox 67

Canning, George 99, 100, 101, 102 Cantillon. André 116 Carlile, Richard, Peterloo Massacre (or Battle of Peterloo) 117 Caroline, Queen 33, 99, 116 Cartagena, Don Pablo Morillo, Comte de 64 Castlereagh, Lord, Robert Stewart (2nd Marguess of Londonderry) 14, 96, 97, 99 Château de Hougoumont, Field of Waterloo (Dighton) 76, 78, 79 Cherry, F., portrait of Tipu Sultan 23 Chinnery, George, Major-General the Hon. Arthur Wellesley being received in Durbar 25-6, 25 Clark, John Heaviside, illustrations 58, 58 Claudet, Antoine, daguerreotype of Wellington 37, 39 Copley, John Singleton, portrait of the Prince of Orange, William II 74 Cruikshank, Robert, The Flat Catcher, and the Rat Catcher 40 Dawe, George, portrait of Henry William Paget, 1st Marquess of Anglesey 72 Defence of the Château de Hougoumont (Dighton) 76, 79, 79 Dehaussy, Jules-Jean Baptiste, portrait of Charles Arbuthnot 45 Dighton, Denis 69, 76, 78-9 The Battle of Waterloo 77 Château de Hougoumont, Field of Waterloo 76, 78, 79

Defence of the Château de Hougoumont 76, 79, 79 Spanish Army 69, 70 Dighton, Richard, The Master General of the Ordinance 116 Doing Homage (Heath) 104, 105 Doyle, John ('HB'), cartoons 12, 119 Duke of Wellington Playing with His Grandchildren, The (Thorburn) 45, 48 Duke of Wellington Showing George IV the Battlefield of Waterloo, The (Haydon) 118

Edridge, Henry, portrait of Wellington's sons Arthur and Charles 31

- Field Marshall the Duke of Wellington KG Giving Orders to His Generals (Smith after Heaphy) 68 Field of Battersea, The (Heath) 104, 106 First of May 1851, The (Winterhalter) 121, 121
- Flat Catcher, and the Rat Catcher, The (Cruikshank) 40
- Funeral of the Duke of Wellington (Picken after Haghe) 121
- Funeral Procession of Arthur, Duke of Wellington, The (Alken and Sala) 49, 50, 51
- George IV 32, 33, 69, 71, 75, 86, 99, 101, 102, 115, 116, *118*, 119 Georges, Mademoiselle 41–2, *43* Goderich, Viscount 102 Goya, Francisco de 28 portraits of Wellington 26–8, *27, 28* Grassini, Giuseppina 41–2, *43* Greville, Lady Charlotte 42 Grey, Charles, Lord 107, 119, 120

Haghe, Louis, Funeral of the Duke of Wellington 121

Haydon, Benjamin Robert, The Duke of Wellington Showing George IV the Battlefield of Waterloo 118 Hayter, Sir George The House of Commons, 1833 15,109 The Trial of Queen Caroline 117 portrait of Wellington 115 Healy, Robert, portrait of Anne Hill, Countess of Mornington 112 Heaphy, Thomas 63-9 Field Marshall the Duke of Wellington KG Giving Orders to His Generals Previous 68 sketches 64–7 Heath, William ('Paul Pry'), cartoons 104, 105, 106, 118 Hill, Rowland Hill, 1st Viscount 65 His Grace the Duke of Wellington in His Robes as Chancellor of the University (Phillips after Briggs) 120 Hodgetts, Thomas, portrait of Anne Wellesley (née Hill), Countess of Mornington 119 Home, Robert Mysorean Soldier with a Rocket, A 113 of Wellington 114 Hoppner, John, portraits Richard, Marquess Wellesley 21 of Wellington 18, 19, 22, 56 House of Commons, 1833. The (Hayter) 15, 109

Jack Black, rat-catcher 41 Jersey, Sarah, Countess of 35 Jones, George 81, 86 The Battle of Waterloo, 1815 (exhibited 1853) 84, 86 The Battle of Waterloo (c.1820) 81–3, 83, 86 Joseph Bonaparte 56, 115 jugs 89, 90, 91

Lawrence, Sir Thomas, portraits Catherine ('Kitty') Pakenham, Duchess of Wellington 29, *30* George Canning 100 Harriet Arbuthnot 44 Robert Jenkinson, Lord Liverpool 98 Robert Stewart, 2nd Marquess of Londonderry (Lord Castlereagh) 97 of Wellington 1814–15 115 1815–16 11, 31 c. 1821 42, 46 1829 7, 35, 36 Liverpool, Robert Jenkinson, Lord 14, 33, 96, 98, 99, 116

Major-General the Hon. Arthur Wellesley being received in Durbar (Chinnery) 25-6, 25 Master General of the Ordinance, The (Dighton) 116 McGrigor, Sir James, 1st Bt 67 Mornington, Anne Wellesley (née Hill), Countess of 20, 112, 112, 119, 119 Mornington, Garrett Wesley, 1st Earl of 20, 112, 112 Motte, Charles Etienne Pierre, portrait of Mademoiselle Georges 43 Mulrenin, Bernard, portrait of Daniel O'Connell 103 Mysorean Soldier with a Rocket, A (Robert Home) 113

Napoleon Bonaparte 32, 56, 69, 71, 73, 75–7, 83, 89, 112, 114–15, 116, 118

O'Connell, Daniel 102, *103*, 118 Orme, Edward, *The Battles of the British Army* (box medal) 88, 89

Pakenham, Sir Edward (Ned) 22, 66 Pakenham, Thomas 22 Peel, Sir Robert 35, 42, 104, 111, 120 Peninsular War 26–9, 56–69, 114–15 Peterloo Massacre (or Battle of Peterloo) (Carlile) 117 Phillips, George Henry, His Grace the Duke of Wellington in His Robes as Chancellor of the University 120 Phillips, John, A Regular Turn Out 107, 108
Picken, Thomas, Funeral of the Duke of Wellington 121
Pistrucci, Benedetto, Waterloo Medal 86–7, 86
Ponsonby, Sir Frederic 66
Portuguese Military Costume (Clark after Bradford) 58, 58

Raglan, Fitzroy James Henry Somerset, 1st Baron 64 Regular Turn Out, A (John Phillips) 107, 108 Repose (Doyle) 12 Richmond and Lennox, Charles Gordon-Lennox, 5th Duke of 64 Ross, Sir Hew Dalrymple 66 Ross, Sir William Charles, portrait of Angela Burdett-Coutts, Baroness Burdett-Coutts 47

Sala, George Augustus, The Funeral Procession of Arthur, Duke of Wellington 49, 50, 51 Scovell, Sir George 66 Sketches of the Country, Character and Costume in Portugal and Spain (Bradford) 57-8, 58 Salter, William, Waterloo Banquet, 1836. The 34 Smith, Anker, Field Marshall the Duke of Wellington KG Giving Orders to His Generals 68 Somerset, Lord Robert Edward 65 Spanish Army (Dighton) 69, 70 Sparrow, Lady Olivia 29 St Clair, Thomas Staunton Battle of Foentes D'Onor 59, 59 Troops Bevouack'd near the Village of Villa Velha 60, 61 Stevens, Alfred, Wellington's monument 49-50, 52

Taking an Airing in Hyde Park (Doyle) 119 Tennyson, Alfred, Lord 49 Thorburn, Robert, The Duke of Wellington Playing with His Grandchildren 45, 48 Tipu Sultan 22, 23 Trial of Queen Caroline, The (Hayter) 117 Triumph of Arthur Wellesley, 1st Duke of Wellington and the Allies, The (Ward) 81-3, 82 Troops Bevouack'd near the Village of Villa Velha (Turner after St Clair) 60.61 Turner, Charles, works Battle of Foentes D'Onor 59 Field Marshal Blücher 74 The Hereditary Prince of Orange, William II 74 Troops Bevouack'd near the Village of Villa Velha 60, 61 Tyler, Lieutenant, Battle of Waterloo, The 80, 81

Vernet, Emile-Jean-Horace, portrait of The Emperor Napoleon I 73 Victoria, Queen 22, 37, 120, 121 Vigée-Le Brun, Elisabeth-Louise, portrait of Giuseppina Grassini 43 Vigneron, Pierre Roch, portrait of Mademoiselle Georges 43

Wales, Prince of (Prince Regent) 32, 33, 69, 71, 75, 86, 99, 101, 102, 115, 116, 118, 119 Ward, James, Sketch for The Triumph of Arthur Wellesley, 1st Duke of Wellington and the Allies 81–3, 82 Waterloo 31-4, 71-91, 116 Waterloo Banquet, 1836, The (Salter) 34 Waterloo Medal (Pistrucci) 86-7, 86 Wellesley (Wesley) family 20, 25, 95, 112, 113 Wellesley, Arthur Richard (later 2nd Duke of Wellington) 29, 31, 114 Wellesley, Charles 29, 31, 114 Wellesley, Richard, Marguess 20, 21, 25, 95, 109, 112, 113, 114

Wellington, Arthur Wellesley, 1st Duke of military career early 20-2, 112-13 India 22-6, 56, 113 Peninsular War 22-6, 56-69, 114-15 Waterloo 31-4, 71-81, 116 personal life early 20, 112 marriage and family 22, 29, 40-1, 113, 114, 116 relationships 41–5 later and death 37, 49-50, 121 political career 35–7, 111 early 22, 95, 112 government 96-9, 101, 107, 116, 118, 119 in opposition 109-10 prime minister 102-7, 111, 118 portraits of daguerreotype 37, 39 The Duke of Wellington Playing with His Grandchildren (Thorburn) 45, 48 The Duke of Wellington Showing George IV the Battlefield of Waterloo (Haydon) 118 Field Marshall the Duke of Wellington KG Giving Orders to His Generals (Smith after Heaphy) 68 by Goya 26-8, 27, 28 by Hayter 115 by Heaphy 64, 67 His Grace the Duke of Wellington in His Robes as Chancellor of the University (Phillips after Briggs) 120 after Home 114 by Hoppner 18, 19, 22, 56 by Lawrence 7, 11, 31, 35, 36, 42, 46, 115

Major-General the Hon. Arthur Wellesley being received in Durbar (Chinnery) 25-6, 25 silhouette 113 Triumph of Arthur Wellesley, 1st Duke of Wellington and the Allies, The (Ward) 81-3.82 images of 45, 49, 87, 89, 90 satire 118, 119 standard letter 37, 38 Wellington, Catherine ('Kitty') Wellesley (née Pakenham), Duchess of 22, 29, 30, 34, 40-1, 113, 114, 119 Wellington Boot or the Head of the Army, A (Heath) 118 Wellington's monument (Stevens) 49-50.52 Wheatley, Edmund 61 diary pages 62 self-portrait 62 William II, Prince of Orange 71, 74 William IV 119, 120 William Reynolds, Samuel, portrait of Giuseppina Grassini 43 Wilson, Harriette 40–1 Winchilsea, Lord 104, 106, 119 Winterhalter, Franz Xaver, The First of May 1851 121, 121

York, Duke of 22, 71, 101

Medical Genetics

Medical Genetics

Third Edition

Lynn B. Jorde, PhD

Professor, Department of Human Genetics University of Utah Health Sciences Center Salt Lake City, Utah

John C. Carey, MD

Professor, Division of Medical Genetics Department of Pediatrics University of Utah Health Sciences Center Salt Lake City, Utah

Michael J. Bamshad, MD

Associate Professor, Department of Pediatrics University of Utah Health Sciences Center Salt Lake City, Utah

Raymond L. White, PhD

Director, Ernest Gallo Clinic and Research Center University of California, San Francisco San Francisco, California

An Affiliate of Elsevier

11830 Westline Industrial Drive St. Louis, Missouri 63146

MEDICAL GENETICS Copyright 2003, Elsevier (USA). All rights reserved.

ISBN 0-323-02025-9

No part of this publication may be reproduced or transmitted in any form or by any means, electronic or mechanical, including photocopy, recording, or any information storage and retrieval system, without permission in writing from the publisher.

Permissions may be sought directly from Elsevier Inc.'s Rights Department in Philadelphia, PA, USA: phone: (+1) 215 238 7869, fax: (+1) 215 238 2239, e-mail: healthpermissions@elsevier.com. You may also complete your request on-line via the Elsevier Science homepage (http://www.elsevier.com), by selecting "Customer Support" and then "Obtaining Permissions."

Notice

Medical genetics is an ever-changing field. Standard safety precautions must be followed, but as new research and clinical experience broaden our knowledge, changes in treatment and drug therapy may become necessary or appropriate. Readers are advised to check the most current product information provided by the manufacturer of each drug to be administered to verify the recommended dose, the method and duration of administration, and contraindications. It is the responsibility of the treating physician, relying on experience and knowledge of the patient, to determine dosages and the best treatment for each individual patient. Neither the Publisher nor the author assumes any liability for any injury and/or damage to persons or property arising from this publication.

The Publisher

First Edition 1995. Second Edition 2000.

Library of Congress Cataloging-in-Publication Data

Publishing Director; Medical Textbooks: William Schmitt Acquisitions Editor: Jason Malley Developmental Editor: Donna L. Morrissey Project Managers: Mary Anne Folcher, Linda Van Pelt

RT/QWD

Printed in the United States of America.

Last digit is the print number: 9 8 7 6 5 4 3 2

To our families

Eileen and Alton Jorde Leslie, Patrick, and Andrew Carey Jerry and Joanne Bamshad Joan, Juliette, and Jeremy White

Foreword

J.B.S. Haldane titled an anthology of some of his more dyspeptic writings, "Everything Has a History," and this is clearly applicable to the field of medical genetics. More than 200 years ago scientists such as Buffon, Lamarck, Goethe, and Kielmeyer reflected on how the developmental history of each organism related to the history of life on Earth. Based on these ideas, the discipline of biology was born in 18th-century Europe, enjoyed adolescence as morphology and comparative anatomy in the 19th century, and reached adulthood in the 20th century as the field of genetics. However, the late 19th century definition of genetics (heredity) as the science of variation (and its causes) is still valid. Thus, human genetics is the science of human variation, medical genetics the science of abnormal human variation, and clinical genetics that branch of medicine that cares for individuals and families with abnormal variation of structure and function.

In the late 19th and early 20th centuries, the unity of morphology-based science was gradually replaced by a pluralistic view of biology that splintered the field into many different, and often rivalrous, disciplines. However, thanks to the application of novel molecular biological methods to the analysis of development and to the understanding of the materials of heredity (i.e., genes), the various branches of biology are being reunited. This new discipline, termed molecular morphology, may be defined as the study of the form, formation, transformation, and malformation of living organisms. Indeed, ignorant as they may be of the traditional methods of historiography, geneticists have developed their own brilliant and highly effective methods. Consequently, they have achieved a perspective remarkably longer and much better documented than that of historians. This nearly 4-billion-year perspective unites living organisms into a single web of life related to each other in unbroken descent to a common ancestor. This makes the phylogenetic (i.e., the genetic relationships of different species to one another) and the ontogenetic (i.e., the genetic basis for the development of individual organisms) perspectives of development not only complementary but inseparable. Thus, it is now possible to effectively explore a key question of biology of the 19th and 20th centuries: What is the relationship between evolution and development?

In 1945 the University of Utah established the Laboratory for the Study of Hereditary and Metabolic Disorders (later called the Laboratory of Human Genetics). Here, an outstanding group of scientists performed pioneering studies on clefts of lips and palate, muscular dystrophy, albinism, deafness, hereditary polyposis of the colon (Gardner syndrome), and familial breast cancer. These predecessors would be enormously proud of their current peers at the University of Utah, whose successes have advanced knowledge in every aspect of the field of genetics.

In their attempts to synthesize the story of genetics and its applications to human variability, health and disease, development, and cancer, the authors of this text have succeeded admirably. This concise, well written and illustrated, carefully edited and indexed book is highly recommended to undergraduate students, new graduate students, medical students, genetic counseling students, nursing students, and students in the allied health sciences. Importantly, it is also a wonderful text for the practicing physician (primary care providers and specialists) who wants an authoritative introduction to the basis and principles of modern genetics as applied to human health and development. This text, by distinguished and internationally respected colleagues and friends who love to teach, is a joy to read in its expression of enthusiasm and of wonder, which Aristotle said was the beginning of all knowledge.

Einstein once said, "The most incomprehensible thing about the world is that it is comprehensible." When I began to work in the field of medical genetics, the gene was widely viewed as incomprehensible. Indeed, some scientists, such as Goldschmidt, cast doubt on the very existence of the gene, although the great American biologist E.B. Wilson had predicted its chemical nature more than 100 years previously. In this text, genes and their function in health and disease are made comprehensible in a manner that should have wide appeal to all.

> JOHN OPITZ, MD Salt Lake City, Utah

Preface

Medical genetics is a rapidly progressing field. No textbook can remain factually current for long, so we have attempted to emphasize the central principles of genetics and their clinical application. In particular, this textbook integrates recent developments in molecular genetics with clinical practice.

This new edition maintains the format and presentation that were well received in the first and second editions. Basic principles of molecular biology are introduced early in the book so that they can be discussed and applied in subsequent chapters. The chapters on autosomal and X-linked disorders include updated discussions of topics such as genomic imprinting, anticipation, and expanded trinucleotide repeats. The chapter on cytogenetics highlights important molecular advances in this area, including fluorescence in situ hybridization, comparative genomic hybridization, and the use of subtelomeric probes. Gene mapping and cloning, a central focus of modern medical genetics, is treated at length, and recent advances based on completion of the human genome project are discussed. Chapters are included on the rapidly developing fields of immunogenetics and cancer genetics. Considerable discussion is devoted to the genetics of common adult diseases, such as heart disease, diabetes, stroke, and hypertension. The book concludes with chapters on genetic diagnosis (again emphasizing current molecular approaches such as microarray analysis), gene therapy, and clinical genetics and genetic counseling.

As in the second edition, a Web site is available to provide access to continually changing information in medical genetics (http://evolve.elsevier.com/Jorde/). The Web site includes downloadable versions of all of the figures in the textbook, many additional patient photographs, hyperlinks to other relevant sites, and a battery of test questions and answers. The symbol www will be found throughout the text next to topics that are supplemented by information on the Web page.

Several pedagogical aids are incorporated in this book:

Clinical Commentary boxes present detailed cover-

age of the most important genetic diseases and provide examples of modern clinical management.

- Mini-summaries, highlighted in a second color, are placed on nearly every page to help the reader understand and summarize important concepts.
- Study questions, provided at the end of each chapter, assist the reader in review and comprehension.
- A detailed glossary is included at the end of the book.
- Key terms are emphasized in boldface.
- Important references are listed at the end of each chapter.

Many major additions have been incorporated into this revision:

- All chapters have been thoroughly updated, with special attention given to rapidly changing topics such as genetic diagnosis, gene therapy, gene cloning, cancer genetics, and the genetics of other common diseases.
- The scientific and societal implications of the Human Genome Project are discussed in greater detail, and a section on ethical, legal, and social issues in genetics has been added to Chapter 14.
- Thirty-nine new clinical photographs and figures have been added or updated.
- To facilitate the creation of illustrations for teaching purposes, all images on the Web site (including line drawings from the textbook) can now be down-loaded.
- An expanded comprehensive index includes all text citations of all diseases.

This textbook evolved from courses we teach for medical students, nursing students, and graduate and undergraduate students in human genetics. These students are the primary audience for this book, but it should also be useful for students in genetic counseling and biology and for house staff, physicians, and other health care professionals who wish to become more familiar with medical genetics. х

ACKNOWLEDGMENTS

Many of our colleagues have generously donated their time and expertise in reading and commenting on portions of this book. We extend our sincere gratitude to Arthur Brothman, PhD; Peter Byers, MD; William Carroll, MD; Debbie Dubler, BS; Ruth Foltz, MS; Sandra Hasstedt, PhD; Susan Hodge, PhD; Rajendra Kumar-Singh, PhD; James Kushner, MD; Jean-Marc Lalouel, MD, DSc; Claire Leonard, MD; Mark Leppert, PhD; William McMahon, MD; James Metherall, PhD; Shige Sakonju, PhD; Gary Schoenwolf, PhD; Carl Thummel, PhD; Thérèse Tuohy, PhD; Scott Watkins, MS; John Weis, PhD; H. Joseph Yost, PhD; Maxine J. Sutcliffe, PhD; Leslie R. Schover, PhD; and Craig Smith, medical student. In addition, a number of colleagues provided photographs; they are acknowledged individually in the figure captions. We wish to thank Peeches Cedarholm, RN, Karin Dent, MS, Bridget Kramer, RN, and Ann Rutherford, BS, for their help in obtaining and organizing the photographs. The karyotypes in Chapter 6 were provided by Arthur Brothman, PhD, and Bonnie Issa, BS. The illustrations were originally created by Carol Cassidy. Our editors at Elsevier, Donna Morrissey and Jason Malley, offered ample encouragement and understanding. Finally, we wish to acknowledge the thousands of students with whom we have interacted during the past two decades. Teaching involves communication in both directions, and we have undoubtedly learned as much from our students as they have learned from us.

> Lynn B. Jorde John C. Carey Michael J. Bamshad Raymond L. White

Contents

- 1 Background and History 1 What is Medical Genetics? 1 Why Is a Knowledge of Medical Genetics Important for Today's Health Care Practitioner? 1 A Brief History 1 Types of Genetic Diseases 3 The Clinical Impact of Genetic Disease 4
- 2 Basic Cell Biology: Structure and Function of Genes and Chromosomes 6
 DNA, RNA, and Proteins: Heredity at the Molecular Level 6
 The Structure of Genes and the Genome 17
 The Cell Cycle 22
- Genetic Variation: Its Origin and Detection 29 Mutation: The Source of Genetic Variation 29 Detection and Measurement of Genetic Variation 41
- 4 Autosomal Dominant and Recessive Inheritance 57
 Basic Concepts of Formal Genetics 57
 Autosomal Dominant Inheritance 63
 Autosomal Recessive Inheritance 65
 Factors That May Complicate Inheritance
 Patterns 68
 Consanguinity in Human Populations 83
- 5 Sex-Linked and Mitochondrial Inheritance 88 X Inactivation 88 Sex-Linked Inheritance 90 Sex-Limited and Sex-Influenced Traits 101 Mitochondrial Inheritance 101

- 6 Clinical Cytogenetics: The Chromosomal Basis of Human Disease 107
 Cytogenetic Technology and Nomenclature 107
 Abnormalities of Chromosome Number 111
 Chromosome Abnormalities and Pregnancy Loss 120
 Abnormalities of Chromosome Structure 122
 Chromosome Abnormalities and Clinical Phenotypes 130
 Cancer Cytogenetics 132
 Chromosome Instability Syndromes 133
- 7 Biochemical Genetics: Disorders of Metabolism 136
 Variants of Metabolism 136
 Defects of Metabolic Processes 139
 Pharmacogenetics 155
- 8 Gene Mapping and Cloning 160 Genetic Mapping 161 Physical Mapping and Cloning 174
- 9 Immunogenetics 193
 The Immune Response: Basic Concepts 193
 Immune Response Proteins: Genetic Basis of Structure and Diversity 198
 The Major Histocompatibility Complex 200
 The ABO and Rh Blood Groups 205
 Immunodeficiency Diseases 206
- 10 Developmental Genetics 209
 Development: Basic Concepts 209
 Genetic Mediators of Development: The Molecular Toolbox 210

 Pattern Formation 216

- 11 Cancer Genetics 228

 Causes of Cancer 229
 Cancer Genes 230
 Major Classes of Cancer Genes 232
 Identification of Inherited Cancer Genes 238
 Molecular Basis of Cancer 246
 Is Genetic Inheritance Important in Common Cancers? 246
- Multifactorial Inheritance and Common Diseases 248
 Principles of Multifactorial Inheritance 248
 Nature and Nurture: Disentangling the Effects of Genes and Environment 255
 The Genetics of Common Diseases 258
- 13 Genetic Testing and Gene Therapy 278 Population Screening for Genetic Disease 278 Molecular Tools for Screening and Diagnosis 284

Prenatal Diagnosis of Genetic Disorders and Congenital Defects 288 Fetal Treatment 295 Gene Therapy 296

 14 Clinical Genetics and Genetic Counseling 305 The Principles and Practice of Clinical Genetics 305
 Dysmorphology and Clinical Teratology 316 Bioethics and Medical Genetics 321

Answers to Study Questions 327

Glossary 339

Index 353

CHAPTER

Background and History

Genetics is playing an increasingly important role in the practice of clinical medicine. Medical genetics, once largely confined to relatively rare conditions seen by only a few specialists, is now becoming a central component of our understanding of most major diseases. These include not only the pediatric diseases, but also common adult diseases such as heart disease, diabetes, many cancers, and many psychiatric disorders. Because all components of the human body are influenced by genes, genetic disease is relevant to all medical specialties. Today's health care practitioners must understand the science of medical genetics.

WHAT IS MEDICAL GENETICS?

Medical genetics involves any application of genetics to medical practice. It thus includes studies of the inheritance of diseases in families, mapping of disease genes to specific locations on chromosomes, analyses of the molecular mechanisms through which genes cause disease, and the diagnosis and treatment of genetic disease. As a result of rapid progress in molecular genetics, gene therapy the insertion of normal genes into patients in order to correct genetic disease—is now possible. Medical genetics also includes genetic counseling, which involves the communication of information regarding risks, prognoses, and treatments to patients and their families.

WHY IS A KNOWLEDGE OF MEDICAL GENETICS IMPORTANT FOR TODAY'S HEALTH CARE PRACTITIONER?

There are several answers to this question. Genetic diseases make up a large proportion of the total disease burden in both pediatric and adult populations (Table 1-1). This proportion will continue to grow as our understanding of the genetic basis of disease grows. In addition, modern medicine is placing increasing emphasis on the importance of prevention. Because genetics provides a basis for understanding the fundamental biological makeup of the organism, it naturally leads to a better understanding of the disease process. In many cases this knowledge can lead to actual prevention of the disorder. It also leads to more effective disease treatment. Prevention and effective treatment are among the highest goals of medicine. The chapters that follow provide many examples of the ways in which genetics contributes to these goals. But first, this chapter reviews the foundations upon which current practice is built.

A BRIEF HISTORY

The inheritance of physical traits has been a subject of curiosity and interest for thousands of years. The ancient Hebrews and Greeks, as well as later medieval scholars, described many genetic phenomena and proposed theories to account for them. Many of these theories were incorrect. Gregor Mendel (Fig. 1-1), an Austrian monk

FIGURE 1.1 ■ Gregor Johann Mendel (From Raven PH, Johnson GB [1992] Biology, 3rd ed. Mosby, St Louis. With permission of McGraw-Hill, New York.)

TABLE 1.1 🔳 A Partial List of Some Important Genetic Diseases

Disease	Approximate prevalence		
Chromosome Abnormalities			
Down syndrome	1/700 to 1/1,000		
Klinefelter syndrome	1/1,000 males		
Trisomy 13	1/10,000		
Trisomy 18	1/6,000		
Turner syndrome	1/2,500 to 1/10,000 females		
<i>Single-Gene Disorders</i> Adenomatous polyposis coli	1/6,000		
Adult polycystic kidney disease	1/1,000		
α_1 -Antitrypsin deficiency	1/2,500 to 1/10,000 Caucasians		
Cystic fibrosis			
Duchenne muscular dystrophy	1/2,000 to 1/4,000 Caucasians		
	1/3,500 males 1/500		
Familial hypercholesterolemia			
Fragile X syndrome	1/4,000 males; 1/8,000 females		
Hemochromatosis (hereditary)	1/300 Caucasians are homozygotes; approximately 1/1,000 to 1/2,000 are affected		
Hemophilia A	1/5,000 to 1/10,000 males		
Hereditary nonpolyposis colorectal cancer	Up to 1/200		
Huntington disease	1/20,000 Caucasians		
Marfan syndrome	1/10,000 to 1/20,000		
Myotonic dystrophy	1/7,000 to 1/20,000 Caucasians		
Neurofibromatosis type 1	1/3,000 to 1/5,000		
Osteogenesis imperfecta	1/5,000 to 1/10,000		
Phenylketonuria	1/10,000 to 1/15,000 Caucasians		
Retinoblastoma	1/20,000		
Sickle cell disease	1/400 to 1/600 African-Americans; up to 1/50 in central Africa		
Tay-Sachs disease	1/3,000 Ashkenazi Jews		
Thalassemia	1/50 to 1/100 (South Asian and circum-Mediterranean population		
Multifactorial Disorders Congenital malformations			
Cleft lip with or without cleft palate	1/500 to 1/1,000		
Club foot (talipes equinovarus)	1/1,000		
Congenital heart defects	1/200 to 1/500		
Neural tube defects (spina bifida, anencephaly)	1/200 to 1/1,000		
Pyloric stenosis	1/300		
Adult diseases			
Alcoholism	1/10 to 1/20		
Alzheimer disease	1/10 (Americans older than 65 years of age)		
Bipolar affective disorder	1/100 to 1/200		
Cancer (all types)	1/3		
Diabetes (types I and II)	1/10		
Heart disease or stroke	1/3 to 1/5		
Schizophrenia	1/100		
Mitochondrial disease Kaerns-Sayre syndrome	Rare		
	Rare		
Leber hereditary optic neuropathy (LHON)			
Mitochondrial encephalopathy, lactic acidosis, and stroke-like	Rare		
episodes (MELAS) Myoclonic epilepsy and ragged red fiber disease (MERRF)	Rare		

2

who is usually considered to be the "father" of genetics, advanced the field significantly by performing a series of cleverly designed experiments on living organisms (garden peas). He then used this experimental information to formulate a series of fundamental principles of heredity.

Mendel published the results of his experiments in 1865 in a relatively obscure journal. It is one of the ironies of biological science that his discoveries, which still form the foundation of genetics, received virtually no recognition for 35 years. At about the same time, Charles Darwin formulated his theories of evolution, and his cousin, Francis Galton, performed an extensive series of family studies (concentrating especially on twins) in an effort to understand the influence of heredity on various human traits. Neither scientist was aware of Mendel's work.

Genetics as it is known today is largely the result of research performed during the 20th century. Mendel's principles were independently rediscovered in 1900 by three different scientists working in three different countries. This was also the year in which Landsteiner discovered the ABO blood group. In 1902, Archibald Garrod described alkaptonuria as the first "inborn error of metabolism." In 1909, Johannsen coined the term **gene** to denote the basic unit of heredity.

The next several decades were a period of considerable experimental and theoretical work. Several organisms, including *Drosophila* (fruit flies) and *Neurospora* (bread mold) served as useful experimental systems in which to study the actions and interactions of genes. For example, H. J. Muller demonstrated the genetic consequences of ionizing radiation in the fruit fly. During this period, much of the theoretical basis of population genetics was developed by three central figures: Ronald Fisher, J. B. S. Haldane, and Sewall Wright. In addition, the modes of inheritance of several important genetic diseases, including phenylketonuria, sickle cell disease, Huntington disease, and cystic fibrosis, were established. In 1944, Oswald Avery showed that genes are composed of **deoxyribonucleic acid (DNA)**.

Probably the most significant achievement of the 1950s was the specification of the physical structure of DNA by James Watson and Francis Crick in 1953. Their seminal paper, which was only one page in length, formed the basis for what is now known as **molecular genetics** (the study of the structure and function of genes at the molecular level). Another significant accomplishment in that decade was the correct specification of the number of human chromosomes. Since the early 1920s, it had been thought that humans had 48 chromosomes in each cell. Only in 1956 was the correct number, 46, finally determined. The ability to count and identify chromosomes led to a flurry of new findings in cytogenetics, including the discovery in 1959 that Down syndrome is caused by an extra copy of chromosome 21.

Technological developments since 1960 have brought about significant achievements at an ever-increasing rate. The most spectacular advances have occurred in the field of molecular genetics. During the past two decades, thousands of genes have been mapped to specific chromosome locations. The Human Genome Project, a large collaborative venture begun in 1990, provided the complete human DNA sequence in the year 2003 (the term genome refers to all of the DNA in an organism). Important developments in computer technology have helped to decipher the barrage of data being generated by this and related projects. In addition to mapping genes, molecular geneticists have pinpointed the molecular defects underlying a number of important genetic diseases. This research has contributed greatly to our understanding of the ways in which gene defects can cause disease, opening paths to more effective treatment and potential cures. The next decade promises to be a time of great excitement and fulfillment.

TYPES OF GENETIC DISEASES

Each human is estimated to have approximately 30,000 to 40,000 different genes. Alterations in these genes, or in combinations of them, can produce genetic disorders. These disorders are classified into several major groups:

- 1. Chromosome disorders, in which entire chromosomes (or large segments of them) are missing, duplicated, or otherwise altered. These disorders include diseases such as Down syndrome and Turner syndrome.
- 2. Disorders in which single genes are altered; these are often termed "mendelian" conditions, or **single-gene disorders**. Well-known examples include cystic fibrosis, sickle cell disease, and hemophilia.
- 3. **Multifactorial disorders**, which result from a combination of multiple genetic and environmental causes. Many birth defects, such as cleft lip and/or cleft palate, as well as many adult disorders, including heart disease and diabetes, belong in this category.
- 4. **Mitochondrial disorders**, a relatively small number of diseases caused by alterations in the small cytoplasmic mitochondrial chromosome.

Table 1-1 provides some examples of each of these types of diseases.

Of these major classes of diseases, the single-gene disorders have probably received the greatest amount of attention. These disorders are classified according to the manner in which they are inherited in families: autosomal dominant, autosomal recessive, or X-linked. These modes of inheritance are discussed extensively in Chapters 4 and 5. The first edition of McKusick's *Mendelian Inheritance in Man*, published in 1966, listed only 1,368 autosomal traits and 119 X-linked traits.

FIGURE 1.2 Continuum of genetic diseases. Some diseases (e.g., cystic fibrosis) are strongly determined by genes, whereas others (e.g., infectious diseases) are strongly determined by environment.

Today, the online version of McKusick's compendium lists more than 14,000 entries, of which more than 13,000 are autosomal, 788 are X-linked, 43 are Y-linked, and 60 are in the mitochondrial genome. Most of these traits are genetic diseases, and disease-causing mutations have thus far been identified for approximately 1,500 of them. With continued advances, these numbers are certain to increase.

Although some genetic disorders, particularly the single-gene conditions, are strongly determined by genes, many others are the result of multiple genetic and nongenetic factors. One can therefore think of genetic diseases as lying along a continuum (Fig. 1-2), with disorders such as cystic fibrosis and Duchenne muscular dystrophy situated at one end (strongly determined by genes) and conditions such as measles situated at the other end (strongly determined by environment). Many of the most prevalent disorders, including many birth defects and common diseases such as diabetes, hypertension, heart disease, and cancer, lie somewhere in the middle of the continuum. These diseases are the products of varying degrees of both genetic and environmental influences.

THE CLINICAL IMPACT OF GENETIC DISEASE

Genetic diseases are sometimes perceived as being so rare that the average health care practitioner will seldom encounter them. That this is far from the truth is becoming increasingly evident as knowledge and technology progress. Less than a century ago, diseases of largely nongenetic causation (i.e., those caused by malnutrition, unsanitary conditions, and pathogens) accounted for the great majority of deaths in children. During the 20th century, however, public health vastly improved. As a result, genetic diseases have come to account for an everincreasing proportion of deaths among children in developed countries. For example, the percentage of pediatric deaths due to genetic causes in various hospitals in the United Kingdom increased from 16.5% in 1914 to 50% in 1976 (Table 1-2).

In addition to contributing to a large proportion of childhood deaths, genetic diseases also account for a large share of admissions to pediatric hospitals. For example, a survey of Seattle hospitals showed that 27% of all pediatric inpatients presented with a genetic disorder, and a survey of admissions to a major pediatric hospital in Mexico showed that 37.8% involved a disease that was either genetic or "partly genetic."

Another way to assess the importance of genetic diseases is to ask, "What proportion of individuals in the population will be diagnosed with a genetic disorder?" This is not as simple a question as it may seem. A variety of factors can influence the answer. For example, some diseases are found more frequently in certain ethnic groups. Cystic fibrosis is especially common among Europeans, whereas sickle cell disease is especially common among Africans. Some diseases are more common

TABLE 1.2 Percentages of Childhood Deaths in United Kingdom Hospitals Attributable to Nongenetic (e.g., Infectious) and Cenetic Causes

Cause	London 1914	London 1954	Newcastle 1966	Edinburgh 1976
Nongenetic	83.5	62.5	58.0	50.0
Genetic Single gene Chromosomal	2.0	12.0	8.5 2.5	8.9 2.9
Multifactorial	14.5	25.5	31.0	38.2

From Rimoin DL, Connor JM, Pyeritz RE, Korf BR (2002) Emery and Rimoin's Principles and Practice of Medical Genetics. Churchill Livingstone, London.

in older individuals. For example, colon cancer, breast cancer, and Alzheimer disease are caused by dominant genes in a small proportion (5% to 10%) of cases but are not usually manifested until later in life. The prevalence estimates for these genetic diseases would be higher in an older population. Variations in diagnostic and recording practices can also cause prevalence estimates to vary. Accordingly, the prevalence figures shown in Table 1-3 are given as rather broad ranges. Keeping these sources of variation in mind, it is notable that 3% to 7% of the population will at some point be diagnosed with a recognizable genetic disease. This tabulation does not include most cases of the more common adult diseases, such as heart disease, diabetes, and cancer. But it is known that these diseases also have genetic components. If such diseases are included, the clinical impact of genetic disease is considerable indeed.

SUGGESTED READINGS

- Baird PA, Anderson TW, Newcombe HB, Lowry RB (1988) Genetic disorders in children and young adults: a population study. Am J Hum Genet 42:677-693
- Dunn LC (1965) A Short History of Genetics. McGraw-Hill, New York

TABLE 1.3 Approximate Prevalence of Genetic Disease in the General Population		
Type of genetic disease	Lifetime prevalence per 1,000 persons	
Autosomal dominant Autosomal recessive	3 to 9.5 2 to 2.5	
V 1:11	05 to 2	

Autosomal recessive	2 to 2.5
X-linked	0.5 to 2
Chromosome disorder*	6 to 9
Congenital malformation [†]	20 to 50
Total	31.5 to 73

*The upper limit of this range is obtained when newer chromosome banding techniques are used (see Chapter 6).

^t"Congenital" means "present at birth." Most congenital malformations are thought to be multifactorial and therefore probably have both genetic and environmental components.

- McKusick VA (2000) History of medical genetics. In: Rimoin DL, Connor JM, Pyeritz RE, Korf BR (eds) Emery and Rimoin's Principles and Practice of Medical Genetics. Vol. 1. Churchill Livingstone, London, pp 3-36
- Passarge E (1995) Color Atlas of Genetics. Georg Thieme Verlag, Stuttgart
- Peltonen L, McKusick VA (2001) Genomics and medicine: dissecting human disease in the postgenomic era. Science 291:1224-1229
- Rimoin DL, Connor JM, Pyeritz RE, Korf BR (2002) Emery and Rimoin's Principles and Practice of Medical Genetics. Churchill Livingstone, London
- Scriver CR, Sly WS, Childs G, Beaudet AL, Valle D, Kinzler KW, Vogelstein B (2001) The Metabolic and Molecular Bases of Inherited Disease, 8th ed. McGraw-Hill, New York
- Seashore MS, Wappner RS (1996) Genetics in Primary Care and Clinical Medicine. Appleton & Lange, Stamford, CT
- Watson JD, Crick FHC (1953) Molecular structure of nucleic acids: a structure for deoxyribose nucleic acid. Nature 171:737

INTERNET RESOURCES*

Dolan DNA Learning Center, Cold Spring Harbor Laboratory (a useful online resource for learning and reviewing basic principles)

http://www.dnalc.org/

Genetic Science Learning Center (another useful resource for learning and reviewing basic genetic principles) http://gslc.genetics.utah.edu/

Landmarks in the History of Genetics http://cogweb.ucla.edu/EP/DNA_bistory.html

National Human Genome Research Institute Educational Resources

http://www.genome.gov/Education

Online Mendelian Inheritance in Man (OMIM) (a comprehensive catalog and description of single-gene conditions)

http://www3.ncbi.nlm.nih.gov/Omim/

University of Kansas Medical Center Genetics Education Center (a large number of links to useful genetics education sites)

http://www.kumc.edu/gec/

*Please note that these addresses may change. Updated addresses are given at our Web site,

http://medgen.genetics.utah.edu

CHAPTER 2

Basic Cell Biology: Structure and Function of Genes and Chromosomes

All genetic diseases involve defects at the level of the cell. For this reason, one must understand basic cell biology to understand genetic disease. Errors can occur in the replication of genetic material or in the translation of genes into proteins. Such errors commonly produce single-gene disorders. In addition, errors that occur during cell division can lead to disorders involving entire chromosomes. To provide the basis for understanding these errors and their consequences, this chapter focuses on the processes through which genes are replicated and translated into proteins, as well as the process of cell division.

In the 19th century, microscopic studies of cells led scientists to suspect that the nucleus of the cell (Fig. 2-1) contains the important mechanisms of inheritance. They found that chromatin, the substance that gives the nucleus a granular appearance, is observable in the nuclei of nondividing cells. Just before a cell undergoes division, the chromatin condenses to form discrete, dark-staining bodies called chromosomes (from the Greek word for "colored bodies"). With the rediscovery of Mendel's breeding experiments at the beginning of the 20th century, it soon became apparent that chromosomes contain genes. Genes are transmitted from parent to offspring and are considered to be the basic unit of inheritance. It is through the transmission of genes that physical traits such as eye color are inherited in families. Diseases can also be transmitted through genetic inheritance.

Physically, genes are composed of **deoxyribonucleic** acid (DNA). DNA provides the genetic "blueprint" for all proteins in the body. Thus, genes ultimately influence all aspects of body structure and function. The human is estimated to have 30,000 to 40,000 structural genes (genes that code for ribonucleic acid [RNA] or proteins). An error (or **mutation**) in one of these genes often leads to a recognizable genetic disease. To date, more than 14,000 single-gene traits have been identified, most of which represent disease conditions.

Genes, the basic unit of inheritance, are contained in chromosomes and consist of DNA. Each human **somatic cell** (cells other than the **gametes**, or sperm and egg cells) contains 23 pairs of different chromosomes, for a total of 46. One member of each pair is derived from the individual's father, and the other member is derived from the mother. One of the chromosome pairs consists of the **sex chromosomes**. In normal males, the sex chromosomes are a Y chromosome inherited from the father and an X chromosome inherited from the mother. Two X chromosomes are found in normal females, one inherited from each parent. The other 22 pairs of chromosomes are termed **autosomes**. The members of each pair of autosomes are said to be **homologs**, or **homologous**, because their DNA is very similar. The X and Y chromosomes are not homologs of one another.

Somatic cells, having two of each chromosome, are termed **diploid** cells. Human gametes have the **haploid** number of chromosomes, 23. The diploid number of chromosomes is maintained in successive generations of somatic cells by the process of **mitosis**, whereas the haploid number is obtained through a process known as **meiosis**. Both of these processes are discussed in detail later in this chapter.

Somatic cells are diploid, having 23 pairs of chromosomes (22 pairs of autosomes and one pair of sex chromosomes). Gametes are haploid and have a total of 23 chromosomes.

DNA, RNA, AND PROTEINS: HEREDITY AT THE MOLECULAR LEVEL

DNA

COMPOSITION AND STRUCTURE OF DNA

The DNA molecule has three basic components: the pentose sugar, deoxyribose; a phosphate group; and four types of nitrogenous **bases** (so named because they can combine with hydrogen ions in acidic solutions). Two of the bases, **cytosine** and **thymine**, are single carbon-nitrogen rings called **pyrimidines**. The other two bases,

FIGURE 2.1 The anatomy of the cell.

adenine and **guanine**, are double carbon-nitrogen rings called **purines** (Fig. 2-2). The four bases are commonly represented by their first letters: C, T, A, and G.

One of the contributions of Watson and Crick in the mid-20th century was to demonstrate how these three components are physically assembled to form DNA. They proposed the now-famous **double helix** model, in which DNA can be envisioned as a twisted ladder with chemical bonds as its rungs (Fig. 2-3). The two sides of the ladder are composed of the sugar and phosphate components, held together by strong phosphodiester bonds. Projecting from each side of the ladder, at regular intervals, are the nitrogenous bases. The base projecting from one side is bound to the base projecting from the other side by relatively weak hydrogen bonds. The paired nitrogenous bases therefore form the rungs of the ladder.

Figure 2-3 illustrates the chemical bonds between

bases and shows that the ends of the ladder terminate in either 3' or 5'. These labels are derived from the order in which the five carbon atoms composing deoxyribose are numbered. Each DNA subunit, consisting of one deoxyribose, one phosphate group, and one base, is called a **nucleotide**.

Different sequences of nucleotide bases (e.g., ACCAAGTGC) specify different proteins. Specification of the body's many proteins must require a great deal of genetic information. Indeed, each haploid human cell contains approximately 3 billion nucleotide pairs, more than enough information to specify the composition of all human proteins.

The most important constituents of DNA are the four nucleotide bases: adenine, thymine, cytosine, and guanine. DNA has a double helix structure.

7

FIGURE 2.2 Chemical structure of the four bases, showing hydrogen bonds between base pairs. Three hydrogen bonds are formed between cytosine-guanine pairs, and two bonds are formed between adenine-thymine pairs.

DNA COILING

Textbook illustrations usually depict DNA as a double helix molecule that continues in a long, straight line. However, if the DNA in a cell were actually stretched out in this way, it would be about 2 meters in length. To package all of this DNA into a tiny cell nucleus, it is coiled at several levels. First, the DNA is wound around a histone protein core to form a nucleosome (Fig. 2-4). About 140 to 150 DNA bases are wound around each histone core, and then 20 to 60 bases form a "spacer" element before the next nucleosome complex. The nucleosomes in turn form a helical solenoid: each turn of the solenoid includes about six nucleosomes. The solenoids themselves are organized into chromatin loops, which are attached to a protein scaffold. Each of these loops contains approximately 100,000 base pairs (bp), or 100 kilobases (kb), of DNA. The end result of this coiling and looping is that the DNA, at its maximum stage of condensation, is only about 1/10,000 as long as it would be if it were fully stretched out.

DNA is a tightly coiled structure. This coiling occurs at several levels: the nucleosome, the solenoid, and 100-kb loops.

REPLICATION OF DNA

As cells divide to make copies of themselves, identical copies of DNA must be made and incorporated into the

FIGURE 2.3 The DNA double helix, with sugar-phosphate backbone and nitrogenous bases.

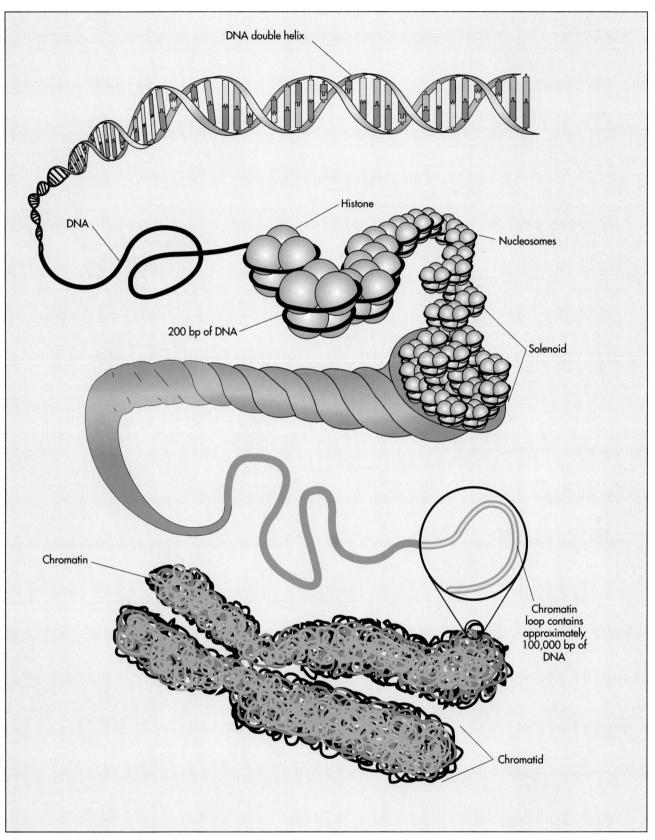

FIGURE 2.4
Patterns of DNA coiling. DNA is wound around histones to form nucleosomes. These are organized into solenoids, which in turn make up the chromatin loops.

new cells. This is essential if DNA is to serve as the fundamental genetic material. DNA replication consists basically of the breaking of the weak hydrogen bonds between the bases, which leaves a single DNA strand with each base unpaired. The consistent pairing of adenine with thymine and guanine with cytosine, known as complementary base pairing, is the key to accurate replication. The principle of complementary base pairing dictates that the unpaired base will attract a free nucleotide only if that nucleotide has the proper complementary base. For example, a portion of a single strand with the base sequence ATTGCT will bond with a series of free nucleotides with the bases TAACGA. The single strand is said to be a template upon which the complementary strand is built. When replication is complete, a new double-stranded molecule identical to the original is formed (Fig. 2-5).

Several different enzymes are involved in DNA replication. One enzyme unwinds the double helix, one holds the strands apart, and others perform other distinct functions. **DNA polymerase** is one of the key replication enzymes. It travels along the single DNA strand, adding free nucleotides to the 3' end of the new strand. Nucleotides can be added only to the 3' end of the strand, so replication always proceeds from the 5' to the 3' end. When referring to the orientation of sequences along a gene, the 5' direction is termed "upstream," and the 3' direction is termed "downstream."

In addition to adding new nucleotides, DNA polymerase performs part of a **proofreading** procedure, in which a newly added nucleotide is checked to make certain that it is in fact complementary to the template base. If it is not, the nucleotide is excised and replaced with a correct complementary nucleotide base. This process substantially enhances the accuracy of DNA replication. When a DNA replication error is not successfully repaired, a mutation has occurred. As will be seen in Chapter 3, many such mutations cause genetic diseases.

DNA replication is critically dependent on the principle of complementary base pairing. This allows a single strand of the doublestranded DNA molecule to form a template for the synthesis of a new, complementary strand.

The rate of DNA replication in humans, about 40 to 50 nucleotides per second, is comparatively slow. In bacteria the rate is much higher, reaching 500 to 1,000 nucleotides per second. Given that some human chromosomes have as many as 250 million nucleotides, replication would be an extraordinarily time-consuming process if it proceeded linearly from one end of the chromosome to the other (for a chromosome of this size, a single round of replication would take almost 2 months). Instead, replication begins at many different points along the chromosome, termed replication origins. The resulting multiple separations of the DNA strands are called replication bubbles (Fig. 2-6). By occurring simultaneously at many different sites along the chromosome, the replication process can proceed much more quickly.

Replication bubbles allow DNA replication to take place at multiple locations on the chromosome, greatly speeding the replication process.

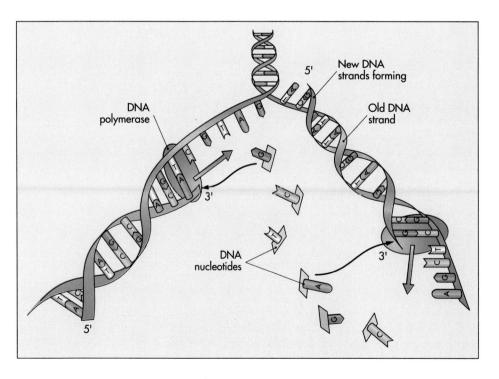

FIGURE 2.5 ■ DNA replication. The hydrogen bonds between the two original strands are broken, allowing the bases in each strand to undergo complementary base pairing with free bases. This process, which proceeds in the 5' to 3' direction on each strand, forms two new double strands of DNA.

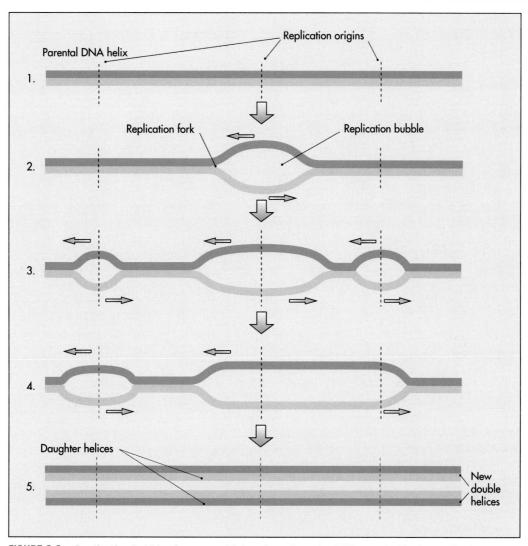

FIGURE 2.6
Replication bubbles form at multiple points along the DNA strand, allowing replication to proceed more rapidly.

From Genes to Proteins

While DNA is formed and replicated in the cell nucleus, protein synthesis takes place in the cytoplasm. The information contained in DNA must be transported to the cytoplasm and then used to dictate the composition of proteins. This involves two processes, transcription and translation. Briefly, the DNA code is transcribed into messenger RNA, which then leaves the nucleus to be translated into proteins. These processes, summarized in Fig. 2-7, are discussed at length later in this chapter. Transcription and translation are both mediated by ribonucleic acid (RNA), a type of nucleic acid that is chemically similar to DNA. Like DNA, RNA is composed of sugars, phosphate groups, and nitrogenous bases. It differs from DNA in two ways: the sugar is ribose instead of deoxyribose, and uracil rather than thymine is one of the four bases. Uracil is structurally similar to thymine, so, like thymine, it can pair with adenine. Another difference between RNA and DNA is that,

whereas DNA usually occurs as a double strand, RNA usually occurs as a single strand.

DNA sequences encode proteins through the processes of transcription and translation. These processes both involve RNA, a single-stranded molecule that is similar to DNA except that it has a ribose sugar rather than deoxyribose and a uracil base rather than thymine.

TRANSCRIPTION

Transcription is the process by which an RNA sequence is formed from a DNA template (Fig. 2-8). The type of RNA produced by the transcription process is termed **messenger RNA (mRNA)**. To initiate mRNA transcription, one of the **RNA polymerase** enzymes (RNA polymerase II) binds to a **promoter** site on the DNA (a promoter is a nucleotide sequence that lies just upstream

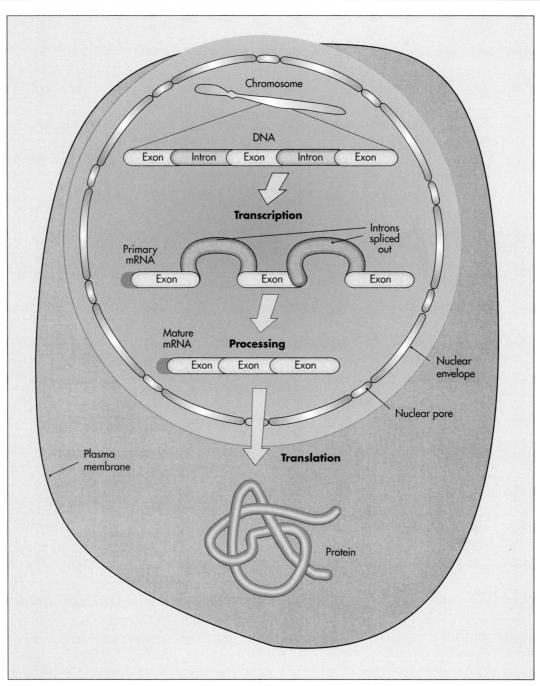

FIGURE 2.7 \blacksquare A summary of the steps leading from DNA to proteins. Replication and transcription occur in the cell nucleus. The mRNA is then transported to the cytoplasm, where translation of the mRNA into amino acid sequences composing a protein occurs.

of a gene). The RNA polymerase then pulls a portion of the DNA strands apart from one another, exposing unattached DNA bases. One of the two DNA strands provides the template for the sequence of mRNA nucleotides. Although either DNA strand could in principle serve as the template for mRNA synthesis, only one is chosen to do so in a given region of the chromosome. This choice is determined by the promoter sequence, which orients the RNA polymerase in a specific direction along the DNA sequence. Because the mRNA molecule can be synthesized only in the 5' to 3' direction, the promoter, by specifying directionality, determines which DNA strand serves as the template. This template DNA strand is also known as the **antisense** strand. RNA polymerase moves in the 3' to 5' direction along the DNA template strand, assembling the complementary mRNA strand from 5' to 3' (see Fig. 2-8). Because of complementary base pairing, the mRNA nucleotide sequence is

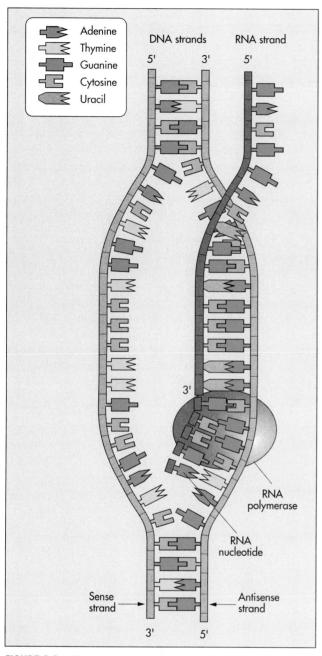

FIGURE 2.8 Transcription of DNA to mRNA. RNA polymerase II proceeds along the DNA strand in the 3' to 5' direction, assembling a strand of mRNA nucleotides that is complementary to the DNA template strand.

identical to that of the DNA strand that does *not* serve as the template—the **sense strand**—except, of course, for the substitution of uracil for thymine.

Soon after RNA synthesis begins, the 5' end of the growing RNA molecule is "capped" by the addition of a chemically modified guanine nucleotide. This 5' cap appears to help prevent the RNA molecule from being degraded during synthesis, and later it helps to indicate the starting position for translation of the mRNA molecule into protein. Transcription continues until a group of bases called a **termination sequence** is reached. Near

this point, a series of 100 to 200 adenine bases are added to the 3' end of the RNA molecule. This structure, known as the **poly-A tail**, may be involved in stabilizing the mRNA molecule so that it is not degraded when it reaches the cytoplasm. RNA polymerase usually continues to transcribe DNA for several thousand additional bases, but the mRNA bases that are attached after the poly-A tail are eventually lost. Finally, the DNA strands and the RNA polymerase separate from the RNA strand, leaving a transcribed single mRNA strand. This mRNA molecule is termed the **primary transcript**.

In some human genes, such as the one that can cause Duchenne muscular dystrophy, several different promoters exist and are located in different parts of the gene. Thus, transcription of the gene can start in different places, resulting in the production of somewhat different proteins. This allows the same gene sequence to code for variations of a protein in different tissues (e.g., muscle tissue versus brain tissue).

In the process of transcription, RNA polymerase II binds to a promoter site near the 5' end of a gene on the sense strand and, through complementary base pairing, helps to produce an mRNA strand from the antisense DNA strand.

TRANSCRIPTION AND THE REGULATION OF GENE EXPRESSION

Some genes—a fairly small proportion—are transcribed in all cells of the body. These **housekeeping genes** encode products that are required for a cell's maintenance and metabolism. Most genes, however, are transcribed only in specific tissues at specific points in time. Therefore, in most cells, only a small proportion of genes are actively transcribed. This specificity explains why there is a large variety of different cell types making different protein products, even though almost all cells have exactly the same DNA sequence. For example, the globin genes are transcribed only in the progenitors of red blood cells (where they help to form hemoglobin), and the lowdensity lipoprotein receptor genes are transcribed only in liver cells.

Many different proteins participate in the process of transcription. Some of these proteins are required for the transcription of all structural genes; they are termed **general transcription factors**. Others, labeled **specific transcription factors**, have more specialized roles, activating only certain genes at certain stages of development. A key transcriptional element is RNA polymerase II, which was described previously. Although this enzyme plays a vital role in initiating transcription by binding to the promoter region, it cannot locate the promoter region on its own. Furthermore, it is incapable of producing significant quantities of mRNA by itself. Effective transcription requires the interaction of a large complex of approximately 50 different proteins. These include general (basal) transcription factors, which bind to RNA polymerase and to specific DNA sequences in the promoter region (sequences such as TATA and others needed for transcription initiation). The general transcription factors allow RNA polymerase to bind to the promoter region so that it can function effectively in transcription (Fig. 2-9).

The transcriptional activity of specific genes can be greatly increased by interaction with sequences called enhancers, which may be located thousands of bases upstream or downstream of the gene. Enhancers do not interact directly with genes. Instead, they are bound by a class of specific transcription factors, termed activators. Activators bind to a second class of specific transcription factors, called co-activators, which in turn bind to the general transcription factor complex described previously (see Fig. 2-9). This chain of interactions, from enhancer to activator to co-activator to the general transcription complex and finally to the gene itself, increases the transcription of specific genes at specific points in time. Whereas enhancers help to increase the transcriptional activity of genes, other DNA sequences, known as silencers, help to repress the transcription of genes through a similar series of interactions.

Mutations in enhancer, silencer, or promoter sequences, as well as mutations in the genes that encode transcription factors, can lead to faulty expression of vital genes and consequently to genetic disease. Many examples of such diseases are discussed in the following chapters.

Transcription factors are required for the transcription of DNA to mRNA. General transcription factors are used by all genes, and specific transcription factors help to initiate the transcription of genes in specific cell types at specific points in time. Transcription is also regulated by enhancer and silencer sequences, which may be located thousands of bases away from the transcribed gene.

The large number and complexity of transcription factors allow for fine-tuned regulation of gene expression. But how do the transcription factors locate specific DNA sequences? This is achieved by **DNA-binding motifs**: configurations in the transcription-factor protein that allow it to fit snugly and stably into a unique portion of the DNA double helix. Several examples of these binding motifs are listed in Table 2-1, and Fig. 2-10 illustrates the binding of one such motif to DNA. Each major motif contains many variations that allow specificity in DNA binding.

FIGURE 2.9 Key elements of transcription control include general (basal) transcription factors and specific enhancers and silencers. The activity of enhancers is mediated by activators and co-activators, which are specific transcription factors. (Adapted from Tjian R [1995] Molecular machines that control genes. Sci Am 272:54–61)

Motif	Description	Human disease examples
Helix-turn-helix	Two α helices are connected by a short chain of amino acids, which constitute the "turn." The carboxyl-terminal helix is a recognition helix that binds to the DNA major groove.	Homeodomain proteins (HOX): mutations in humar HOXD13 and HOXA13 cause synpolydactyly and hand-foot-genital syndrome, respectively.
Helix-loop-helix	Two α helices (one short and one long) are connected by a flexible loop. The loop allows the two helices to fold back and interact with one another. The helices can bind to DNA or to other helix-loop-helix structures.	Mutations in the <i>TWIST</i> gene cause Saethre- Chotzen syndrome (acrocephalosyndactyly type III)
Zinc finger	Zinc molecules are used to stabilize amino acid structures (e.g., α helices, β sheets), with binding of the α helix to the DNA major groove.	<i>BRCA1</i> (breast cancer gene); <i>WT1</i> (Wilms tumor gene); <i>GL13</i> (Greig syndrome gene); vitamin D receptor gene (mutations cause rickets)
Leucine zipper	Two leucine-rich α helices are held together by amino acid side chains. The α helices form a Y-shaped structure whose side chains bind to the DNA major groove.	<i>RB1</i> (retinoblastoma gene); <i>JUN</i> and <i>FOS</i> oncogenes
β Sheets	Side chains extend from the two-stranded β sheet to form contacts with the DNA helix.	<i>TBX</i> family of genes: <i>TBX5</i> (Holt-Oram syndrome); <i>TBX3</i> (ulnar-mammary syndrome)

TABLE 2.1 The Major Classes of DNA-Binding Motifs Found in Transcription Factors

FIGURE 2.10 \blacksquare A helix-loop-helix motif binds tightly to a specific DNA sequence.

An intriguing type of DNA-binding motif is contained in the high-mobility group (HMG) class of proteins. These proteins are capable of bending DNA and may facilitate interactions between distantly located enhancers and the appropriate basal factors and promoters (see Fig. 2-9).

Transcription factors contain DNA-binding motifs that allow them to interact with specific DNA sequences. In some cases, they may bend DNA so that distant enhancer sequences can interact with target genes.

Gene activity can also be related to patterns of chromatin coiling or condensation (the term **chromatin** refers to the combination of DNA and the histone proteins around which the DNA is wound). Highly condensed chromatin regions, termed **heterochromatin**, are typically characterized by **histone acetylation** (the attachment of acetyl groups to lysine residues in the histones), a process that is thought to bring about condensation. Condensation makes these chromatin regions relatively inaccessible to transcription factors and thus transcriptionally inactive. In contrast, **euchromatin** is decondensed or "open," less acetylated, and transcriptionally more active.

Heterochromatin, which is highly condensed and acetylated, tends to be transcriptionally inactive, whereas euchromatin, which is less condensed and less acetylated, tends to be transcriptionally active.

GENE SPLICING

The primary mRNA transcript is exactly complementary to the base sequence of the DNA template. In eukaryotes,* an important step takes place before this RNA transcript leaves the nucleus. Sections of the RNA are removed by nuclear enzymes, and the remaining sections are spliced together to form the functional mRNA that will migrate to the cytoplasm. The excised sequences are called introns, and the sequences that are left to code for proteins are called exons (Fig. 2-11). Only after gene splicing is completed does the mature transcript move out of the nucleus into the cytoplasm. Some genes contain alternative splice sites, which allow the same primary transcript to be spliced in different ways, ultimately producing different protein products from the same gene. Errors in gene splicing, like replication errors, are a form of mutation that can lead to genetic disease.

^{*}Eukaryotes are organisms that have a defined cell nucleus, as opposed to **prokaryotes**, which lack a defined nucleus.

Introns are spliced out of the primary mRNA transcript before the mature transcript leaves the nucleus. Exons contain the mRNA that specifies proteins.

THE GENETIC CODE

Proteins are composed of one or more **polypeptides**, which are in turn composed of sequences of **amino acids**. The body contains 20 different types of amino acids, and the amino acid sequences that make up polypeptides must in some way be designated by the DNA after transcription into mRNA.

Because there are 20 different amino acids and only 4 different RNA bases, a single base could not be specific for a single amino acid. Similarly, specific amino acids could not be defined by couplets of bases (e.g., adenine followed by guanine, or uracil followed by adenine) because only 16 (4×4) different couplets are possible. If triplet sets of bases are translated into amino acids, however, 64 ($4 \times 4 \times 4$) combinations can be achieved—more than enough to specify each amino acid. Conclusive proof that amino acids are specified by these triplets of bases, or **codons**, was obtained by manufacturing synthetic nucleotide sequences and allowing them to direct the formation of polypeptides in the laboratory. The cor-

FIGURE 2.11 Gene splicing. Introns are precisely removed from the primary mRNA transcript to produce a mature mRNA transcript. Consensus sequences mark the sites at which splicing occurs.

respondence between specific codons and amino acids, known as the **genetic code**, is shown in Table 2-2.

Of the 64 possible codons, 3 signal the end of a gene and are known as **stop codons**. These are UAA, UGA, and UAG. The remaining 61 codons all specify amino acids. This means that most amino acids can be specified by more than one codon, as Table 2-2 shows. The genetic code is thus said to be "degenerate." While a given amino acid may be specified by more than one codon, each codon can designate only one amino acid.

Individual amino acids, which compose proteins, are encoded by units of three mRNA bases, termed codons. There are 64 possible codons and only 20 amino acids, so the genetic code is degenerate.

A significant feature of the genetic code is that it is universal: virtually all living organisms use the same DNA codes to specify amino acids. One known exception to this rule occurs in **mitochondria**, cytoplasmic organelles that are the sites of cellular respiration (see Fig. 2-1). The mitochondria have their own extranuclear DNA molecules.

First position (5' end)	Second position			Third position - (3' end)	
(J eliu) ↓	U	С	А	G	- (5 enu) ↓
U	Phe	Ser	Tyr	Cys	U
U	Phe	Ser	Tyr	Cys	С
U	Leu	Ser	STOP	STOP	Α
U	Leu	Ser	STOP	Trp	G
С	Leu	Pro	His	Arg	U
С	Leu	Pro	His	Arg	С
С	Leu	Pro	Gln	Arg	Α
С	Leu	Pro	Gln	Arg	G
Α	Ile	Thr	Asn	Ser	U
Α	Ile	Thr	Asn	Ser	С
Α	Ile	Thr	Lys	Arg	Α
А	Met	Thr	Lys	Arg	G
G	Val	Ala	Asp	Gly	U
G	Val	Ala	Asp	Gly	С
G	Val	Ala	Glu	Gly	Α
G	Val	Ala	Glu	Gly	G

*Examples: UUG is translated into leucine; UAA is a stop codon; GGG is translated into glycine. Under some circumstances the UGA codon can specify an amino acid called selenocysteine, which is often termed the "21st" amino acid.

Ala, Alanine; Arg, arginine; Asn, asparagine; Asp, aspartic acid; Cys, cysteine; Gln, glutamine; Glu, glutamic acid; Gly, glycine; His, histidine; Ile, isoleucine; Leu, leucine; Lys, lysine; Met, methionine; Phe, phenylalanine; Pro, proline; Ser, serine; Thr, threonine; Trp, tryptophan; Tyr, tyrosine; Val, valine. Several codons of mitochondrial DNA encode different amino acids than do the same nuclear DNA codons.

TRANSLATION

Translation is the process in which mRNA provides a template for the synthesis of a polypeptide. mRNA cannot, however, bind directly to amino acids. Instead, it interacts with molecules of transfer RNA (tRNA), which are cloverleaf-shaped RNA strands of about 80 nucleotides. As Fig. 2-12 illustrates, each tRNA molecule has a site at the 3' end for the attachment of a specific amino acid by a covalent bond. At the opposite end of the cloverleaf is a sequence of three nucleotides called the anticodon. The tRNA molecule picks up the amino acid that is complementary to the anticodon sequence. The anticodon then undergoes complementary base pairing with an appropriate codon in the mRNA, and the attached amino acid is transferred to the polypeptide chain being synthesized. In this way, mRNA specifies the sequence of amino acids by acting through tRNA.

The cytoplasmic site of protein synthesis is the **ribosome**, which consists of roughly equal parts of enzymatic proteins and **ribosomal RNA (rRNA)**. The function of

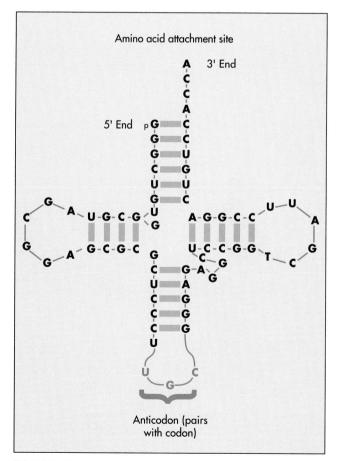

FIGURE 2.12 ■ The structure of a tRNA molecule. In two dimensions, the tRNA has a cloverleaf shape. Note the 3' site of attachment for an amino acid. The anticodon pairs with a complementary mRNA codon.

rRNA is to help bind mRNA and tRNA to the ribosome. During translation, depicted in Fig. 2-13, the ribosome first binds to an initiation site on the mRNA sequence. This site consists of a specific codon, AUG, which specifies the amino acid methionine (this amino acid is usually removed from the polypeptide before the completion of polypeptide synthesis). The ribosome then binds the tRNA to its surface so that base pairing can occur between tRNA and mRNA. The ribosome moves along the mRNA sequence, codon by codon, in the usual 5' to 3' direction. As each codon is processed, an amino acid is translated by the interaction of mRNA and tRNA.

In this process, the ribosome provides an enzyme that catalyzes the formation of covalent peptide bonds between the adjacent amino acids, resulting in a growing polypeptide. When the ribosome arrives at a stop codon on the mRNA sequence, translation and polypeptide formation cease. The amino (NH₂) terminus of the polypeptide corresponds to the 5' end of the mRNA strand, and the carboxyl (COOH) terminus corresponds to the 3' end. After synthesis is completed, the mRNA, the ribosome, and the polypeptide separate from one another. The polypeptide is then released into the cytoplasm.

In the process of translation, the mRNA sequence serves as a template to specify sequences of amino acids. These sequences, which form polypeptides, are assembled by ribosomes. The tRNA and rRNA molecules interact with mRNA in the translation process.

Before a newly synthesized polypeptide can begin its existence as a functional protein, it often undergoes further processing, termed **posttranslational modification**. These modifications can take a variety of forms, including cleavage into smaller polypeptide units or combination with other polypeptides to form a larger protein. Other possible modifications include the addition of carbohydrate side chains to the polypeptide. Such modifications may be needed, for example, to produce proper folding of the mature protein or to stabilize its structure. An example of a clinically important protein that undergoes considerable posttranslational modification is type I collagen (Clinical Commentary 2-1).

Posttranslational modification consists of various chemical changes that occur in proteins shortly after they are translated.

THE STRUCTURE OF GENES AND THE GENOME

Some aspects of gene structure, such as the existence of introns and exons, have already been touched on. Alterations of different parts of genes can have quite distinct consequences in terms of genetic disease. It is therefore necessary to describe more fully the details of gene structure. A schematic diagram of gene structure is given in Fig. 2-14.

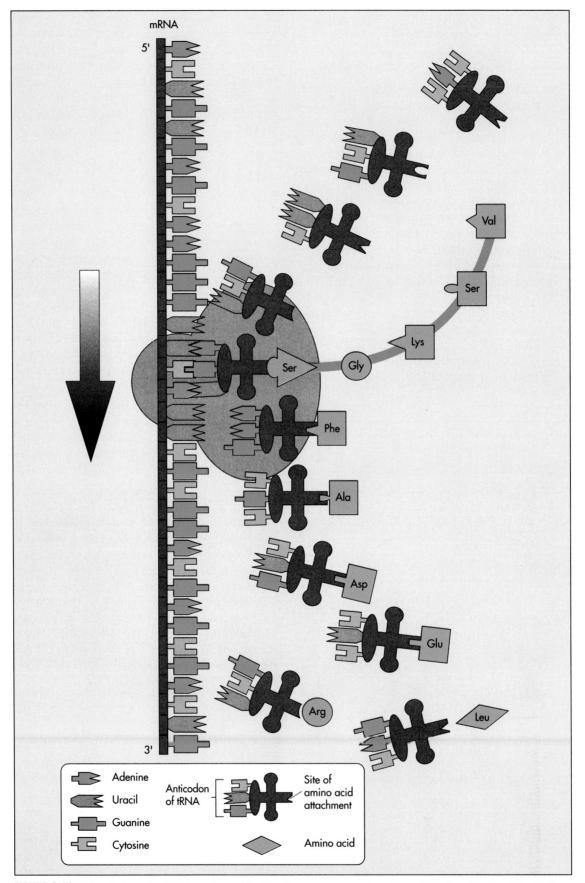

FIGURE 2.13 Translation of mRNA to amino acids. The ribosome moves along the mRNA strand in the 5' to 3' direction, assembling a growing polypeptide chain. In this example the mRNA sequence GUG AGC AAG GGU UCA has assembled five amino acids (Val, Ser, Lys, Gly, and Ser, respectively) into a polypeptide.

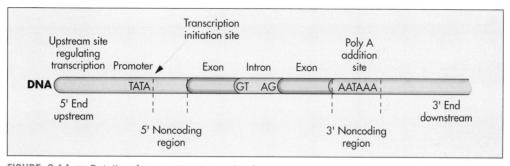

FIGURE 2.14 Details of gene structure, showing promoter and upstream regulation (enhancer) sequences and a poly-A addition site.

CLINICAL COMMENTARY 2.1

Osteogenesis Imperfecta, An Inherited Collagen Disorder

As its name implies, osteogenesis imperfecta is a disease caused by defects in the formation of bone. This disorder, sometimes known as "brittle bone disease," affects approximately 1 in 10,000 individuals in all ethnic groups. www

Nearly all cases of osteogenesis imperfecta are caused by defects in type I collagen, a major component of bone that provides much of its structural stability. The function of collagen in bone is analogous to that of the steel bars incorporated in reinforced concrete. This is an especially apt analogy because the tensile strength of collagen fibrils is roughly equivalent to that of steel wires.

When type I collagen is improperly formed, the bone loses much of its strength and fractures easily

FIGURE 2.15 A, A stillborn infant with type II osteogenesis imperfecta (the perinatal lethal form). The infant had a type I procollagen mutation and short, slightly twisted limbs. **B**, Radiograph of an infant with type II osteogenesis imperfecta. Note rib fractures (observable as "beads" on the ribs).

CLINICAL COMMENTARY 2.1

Osteogenesis Imperfecta, An Inherited Collagen Disorder-cont'd

TABLE 2.3 🔳 Subtypes of Osteogenesis Imperfecta

Type Disease features

- I Mild bone fragility, blue sclerae, hearing loss in 50% of patients, normal stature, few bone deformities
- II Most severe form, with extreme bone fragility, long bone deformities, compressed femurs; lethal in the perinatal period (most die of respiratory failure)
- III Severe bone fragility, very short stature, variably blue sclerae, progressive bone deformities, dentinogenesis imperfecta common
- IV Short stature, normal sclerae, mild to moderate bone deformity, hearing loss in some patients, dentinogenesis imperfecta common; bone fragility is variable

(Fig. 2-15). Patients with osteogenesis imperfecta may suffer hundreds of bone fractures, or they may experience only a few, making this disease highly variable in its expression (the reasons for this variability are discussed in Chapter 4). In addition to bone fractures, patients may have short stature, hearing loss, abnormal tooth development (dentinogenesis imperfecta), bluish sclerae, and various bone deformities. Osteogenesis imperfecta is commonly classified into four types, as shown in Table 2-3. There is currently no cure for this disease, and management consists primarily of the repair of fractures and, in some cases, the use of external or internal bone support (e.g., surgically implanted rods). New, yet unproven, approaches include the use of bisphosphonates to decrease bone resorption and human growth hormone to facilitate growth. Physical rehabilitation also plays an important role in clinical management.

Type I collagen is a trimeric protein (i.e., having three subunits) with a triple helix structure (Fig. 2–16). It is formed from a precursor protein, type 1 procollagen. Two of the three subunits of type 1 procollagen, labeled pro α 1(I) chains, are encoded by a gene on chromosome 17 that is about 18,000 base pairs (18 kb) in length. The third subunit, the pro α 2(I) chain, is encoded by a 38-kb gene on chromosome 7. Each of these genes contains more than 50 exons. After transcription and splicing, the mature mRNA formed from each gene is only 5 to 7 kb in length. The mature mRNAs proceed to the cytoplasm, where they are translated into polypeptide chains by the ribosomal machinery of the cell.

At this point, the polypeptide chains undergo a series of posttranslational modifications. Many of the proline and lysine **residues**^{*} are hydroxylated (i.e., hydroxyl

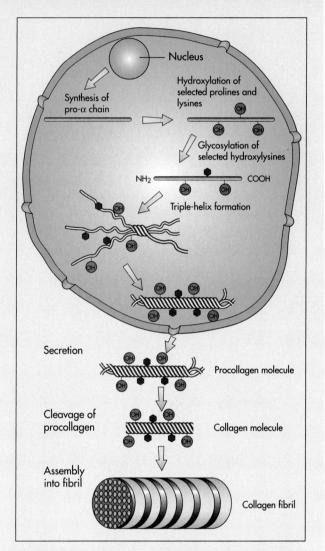

FIGURE 2.16 The process of collagen fibril formation. After the pro- α polypeptide chain is formed, a series of posttranslational modifications takes place, including hydroxylation and glycosylation. Three polypeptide chains assemble into a triple helix, which is secreted outside the cell. Portions of each end of the procollagen molecule are cleaved, resulting in the mature collagen molecule. These molecules then assemble into collagen fibrils.

groups are added) to form hydroxyproline and hydroxylysine, respectively. The three polypeptides, two $pro\alpha 1(I)$ chains and one $pro\alpha 2(I)$ chain, begin to associate with one another at their COOH termini. This association is stabilized by sulfide bonds that form

^{*}A residue is an amino acid that has been incorporated into a polypeptide chain.

CLINICAL COMMENTARY 2.1

Osteogenesis Imperfecta, An Inberited Collagen Disorder—cont'd

between the chains near the COOH termini. The triple helix then forms, in zipper-like fashion, beginning at the COOH terminus and proceeding toward the NH₂ terminus. Some of the hydroxylysines are glycosylated (i.e., sugars are added), a modification that commonly occurs in the rough endoplasmic reticulum (see Fig. 2–1). The hydroxyl groups in the hydroxyprolines help to connect the three chains by forming hydrogen bonds, which stabilize the triple helix. Critical to proper folding of the helix is the presence of a glycine in every third position of each polypeptide. This occurs because every third residue must fit into the center of the helix, and only glycine is small enough to do so.

Once the protein has folded into a triple helix, it moves from the endoplasmic reticulum to the Golgi apparatus (see Fig. 2–1) and is secreted from the cell. Yet another modification then takes place: the procollagen is cleaved by proteases near both the NH₂ and the COOH termini of the triple helix, removing some amino acids at each end. These amino acids performed essential functions earlier in the life of the protein (e.g., helping to form the triple helix structure, helping to

Introns and Exons

The intron-exon structure of genes, discovered in 1977, is one attribute that distinguishes eukaryotes from prokaryotes. Introns form the major portion of most eukaryotic genes. As noted previously, introns are spliced out of the mRNA before it leaves the nucleus. This splicing must be under very precise control, or there would be an intolerable amount of variation in the amino acid sequences produced from mRNA. Enzymes that carry out splicing are directed to the appropriate locations by DNA sequences known as **consensus sequences** (so named because they are common in all eukaryotic organisms), which are situated adjacent to each exon.

Because most eukaryotic genes are composed primarily of introns, it is natural to ask whether introns might have some function. At present, this is largely material for speculation. One interesting hypothesis is that introns, by lengthening genes, encourage the shuffling of genes when homologous chromosomes exchange material during meiosis (see later discussion). It has also been suggested that introns evolved to modify the amount of time required for DNA replication and transcription. thread the protein through the endoplasmic reticulum) but are no longer needed. This cleavage results in the mature protein, type I collagen. The collagen then assembles itself into fibrils, which react with adjacent molecules outside the cell to form the covalent crosslinks that impart tensile strength to the fibrils.

The path from the DNA sequence to the mature collagen protein involves many steps. The complexity of this path provides many opportunities for mistakes (in replication, transcription, translation, or posttranslational modification) that can cause disease. One common mutation produces a replacement of glycine with another amino acid. Because only glycine is small enough to be accommodated in the center of the triple helix structure, substitution of a different amino acid causes instability of the structure and thus poorly formed fibrils. This type of mutation is seen in most cases of type II osteogenesis imperfecta. Other mutations can cause excess posttranslational modification of the polypeptide chains, again producing abnormal fibrils. Other examples of disease-causing mutations are provided in the suggested readings at the end of this chapter.

Surprisingly, at least a few introns contain transcribed genes that are apparently unrelated to the gene in which the introns are contained. For example, introns of the human neurofibromatosis type 1 (*NF1*) gene contain three genes that are transcribed in the direction opposite that of the *NF1* gene itself. These genes appear to have no functional relationship to the *NF1* gene. Similar gene inserts have been found within the factor VIII gene on the human X chromosome.

Types of DNA

While most of the emphasis in genetics is given to the DNA that encodes proteins, it is important to note that fewer than 5% of the 3 billion nucleotide pairs in the human genome actually perform this role. Most of our genetic material has no known function. To better understand the nature of all types of DNA, we will briefly review the several categories into which it is classified. (Fig. 2-17).

The first and most important class of DNA is termed **single-copy DNA**. As the name implies, single-copy DNA sequences are seen only once (or possibly a few times) in the genome. Single-copy DNA comprises about 45% of the genome and includes the protein-coding genes. However, protein-coding DNA represents only a small proportion of all single-copy DNA, most of which is found in introns or in DNA sequences that lie between genes.

The intron-exon structure is a key feature of most eukaryotic genes. The function of introns, if any, is currently unknown.

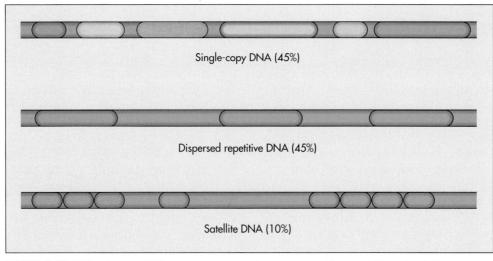

FIGURE 2.17 Single-copy DNA sequences are unique and are dispersed throughout the genome. Satellite DNA sequences are repetitive elements that occur together in clusters. Dispersed repeats are similar to one another but do not cluster together.

The remaining 55% of the genome consists of **repetitive DNA**, sequences that are repeated over and over again in the genome, often thousands of times. There are two major classes of repetitive DNA, **dispersed repetitive DNA** and **satellite DNA**. Satellite repeats are clustered together in certain chromosome locations, where they occur in tandem (i.e., the beginning of one repeat occurs immediately adjacent to the end of another). Dispersed repeats, as the name implies, tend to be scattered singly throughout the genome; they do not occur in tandem.

The term "satellite" is derived from the fact that these sequences, because of their composition, can easily be separated by centrifugation in a cesium chloride density gradient. The DNA appears as a "satellite," separate from the other DNA in the gradient. This term is not to be confused with the "satellites" that can be observed microscopically on certain chromosomes (see Chapter 6). Satellite DNA comprises approximately 10% of the genome and can be further subdivided into several categories. α -Satellite DNA occurs as tandem repeats of a 171-bp sequence that can extend to several million base pairs or longer. This type of satellite DNA is found near the centromeres of chromosomes. Minisatellites are blocks of tandem repeats (each 14 to 500 bp long) whose total length is much smaller, usually a few thousand base pairs. A final category, microsatellites, are smaller still: the repeat units are 1 to 13 bp long, and the total length of the array is usually less than a few hundred base pairs. Minisatellites and microsatellites are of special interest in human genetics because they vary in length among individuals, making them highly useful for gene mapping (see Chapter 8). A minisatellite or microsatellite is found at an average frequency of one per 2 kb in the human genome; altogether they comprise about 3% of the genome.

Dispersed repetitive DNA makes up about 45% of the genome, and these repeats fall into several major cat-

egories. The two most common categories are short interspersed elements (SINEs) and long interspersed elements (LINEs). Individual SINEs range in size from 90 to 500 bp, whereas individual LINEs can be as large as 7,000 bp. One of the most important types of SINEs is termed the "Alu repeat." These repeat units, which are about 300 bp long, contain a DNA sequence that can be cut by the Alu restriction enzyme (see Chapter 3 for further discussion). The Alu repeats are a family of genes, meaning that all of them have highly similar DNA sequences. About 1 million Alu repeats are scattered throughout the genome; they thus constitute approximately 10% of all human DNA. A remarkable feature of Alu sequences, as well as some LINEs, is that some of them can generate copies of themselves, which can then be inserted into other parts of the genome. This insertion can sometimes interrupt a protein-coding gene, causing genetic disease (examples will be discussed in Chapter 4).

There are several major types of DNA, including single-copy DNA, satellite DNA, and dispersed repetitive DNA. The latter two categories are both classes of repeated DNA sequences. Less than 5% of human DNA actually encodes proteins.

THE CELL CYCLE

During the course of development, each human progresses from a single-cell **zygote** (an egg cell fertilized by a sperm cell) to a marvelously complex organism containing approximately 100 trillion (10¹⁴) individual cells. Because few cells last for an individual's entire lifetime, new ones must be generated to replace those that die. Both of these processes—development and replacement—require the manufacture of new cells. The cell division processes that are responsible for the creation of new diploid cells from existing ones are termed mitosis (nuclear division) and cytokinesis (cytoplasmic division). Before dividing, a cell must duplicate its contents, including its DNA; this occurs during interphase. The alternation of mitosis and interphase is referred to as the cell cycle.

As Fig. 2-18 shows, a typical cell spends most of its life in interphase. This portion of the cell cycle is divided into three phases, G1, S, and G2. During G1 ("gap 1," the interval between mitosis and the onset of DNA replication), synthesis of RNA and proteins takes place. DNA replication occurs during the S (synthesis) phase. During G2 (the interval between the S phase and the next mitosis), some DNA repair takes place, and the cell prepares for mitosis. By the time G2 has been reached, the cell contains two identical copies of each of the 46 chromosomes. These identical chromosomes are referred to as sister chromatids. Sister chromatids often exchange material during or after the S phase, a process known as sister chromatid exchange.

The cell cycle consists of the alternation of cell division (mitosis and cytokinesis) and interphase. DNA replication and protein synthesis take place during interphase.

The length of the cell cycle varies considerably from one cell type to another. In rapidly dividing cells such as those of epithelial tissue (found, for example, in the lining of the intestines and in the lungs), the cycle may be completed in fewer than 10 hours. Other cells, such as those of the liver, may divide only once each year or so. Some cell types, such as skeletal muscle cells and neurons, largely

GAP SYNTHESIS INTERPHASE

FIGURE 2.18 Major phases of the mitotic cell cycle, showing the alternation of interphase and mitosis (division).

lose their ability to divide and replicate in adults. Although all stages of the cell cycle have some variation in length, the great majority of variation is due to differences in the length of the G1 phase. When cells stop dividing for a long period, they are often said to be in the G0 stage.

Cells divide in response to important internal and external cues. Before the cell enters mitosis, for example, DNA replication must be accurate and complete and the cell must have achieved an appropriate size. The cell must respond to extracellular stimuli that require increased or decreased rates of division. Complex molecular interactions mediate this regulation. Among the most important of the molecules involved are the cyclin-dependent kinases (CDKs), a family of kinases that phosphorylate other regulatory proteins at key stages of the cell cycle. In order to carry out this function, the CDKs must form complexes with various cyclins, proteins that are synthesized at specific cell-cycle stages and are then degraded when CDK action is no longer needed. The cyclins and CDKs, as well as the many proteins that interact with them, are subjects of intense study because of their vital role in the cell cycle and because their malfunction can lead to cancer (see Chapter 11).

The length of the cell cycle varies in different cell types. Critical to regulation of the cell cycle are CDKs, which phosphorylate other proteins, and cyclins, which form complexes with CDKs. Faulty regulation of the cell cycle can lead to cancer.

Mitosis

Although mitosis usually requires only 1 to 2 hours to complete, this portion of the cell cycle involves many critical and complex processes. Mitosis is divided into several phases (Fig. 2-19). During prophase, the first mitotic stage, the chromosomes become visible under a light microscope as they condense and coil (chromosomes are not clearly visible during interphase). The two sister chromatids of each chromosome lie together, attached at a point called the centromere. The nuclear membrane, which surrounds the nucleus, disappears during this stage. Spindle fibers begin to form, radiating from two centrioles located on opposite sides of the cell. The spindle fibers become attached to the centromeres of each chromosome and eventually pull the two sister chromatids in opposite directions.

The chromosomes reach their most highly condensed state during metaphase, the next stage of mitosis. Because they are highly condensed, they are easiest to visualize microscopically during this phase. For this reason, clinical diagnosis of chromosome disorders is usually based on metaphase chromosomes. During metaphase the spindle fibers begin to contract and pull the centromeres of the chromosomes, which are now arranged along the middle of the spindle (the **equatorial plane** of the cell).

During anaphase, the next mitotic stage, the cen-

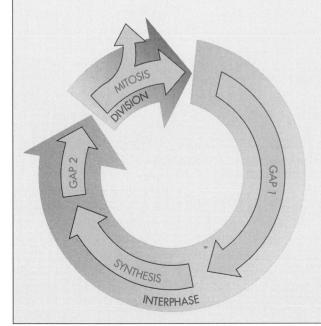

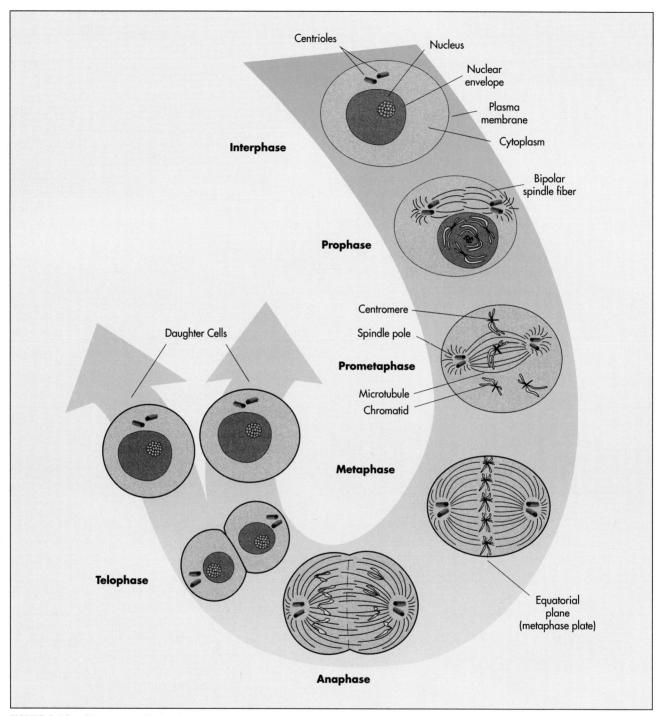

FIGURE 2.19 The stages of mitosis, during which two identical diploid cells are formed from one original diploid cell.

tromere of each chromosome splits, allowing the sister chromatids to separate. The chromatids are then pulled by the spindle fibers, centromere first, toward opposite sides of the cell. At the end of anaphase, the cell contains 92 separate chromosomes, half lying near one side of the cell and half near the other side. If all has proceeded correctly, the two sets of chromosomes are identical.

Telophase, the final stage of mitosis, is characterized by the formation of new nuclear membranes around each of the two sets of 46 chromosomes. Also, the spindle fibers disappear, and the chromosomes begin to decondense. Cytokinesis usually occurs after nuclear division and results in a roughly equal division of the cytoplasm into two parts. With the completion of telophase, two diploid **daughter cells**, both identical to the original cell, have been formed.

Mitosis is the process through which two identical diploid daughter cells are formed from a single diploid cell.

Meiosis

When an egg cell and a sperm cell unite to form a zygote, their chromosomes are combined into a single cell. Because humans are diploid organisms, there must be a mechanism to reduce the number of chromosomes in gametes to the haploid state. Otherwise the zygote would have 92, instead of the normal 46, chromosomes. The primary mechanism by which haploid gametes

are formed from diploid precursor cells is termed meiosis.

Two cell divisions occur during meiosis. Each meiotic division has been divided into stages with the same names as those of mitosis, but the processes involved in some of the stages are quite different (Fig. 2-20). During meiosis I, often called the **reduction division stage**, two haploid cells are formed from a diploid cell. These diploid cells are

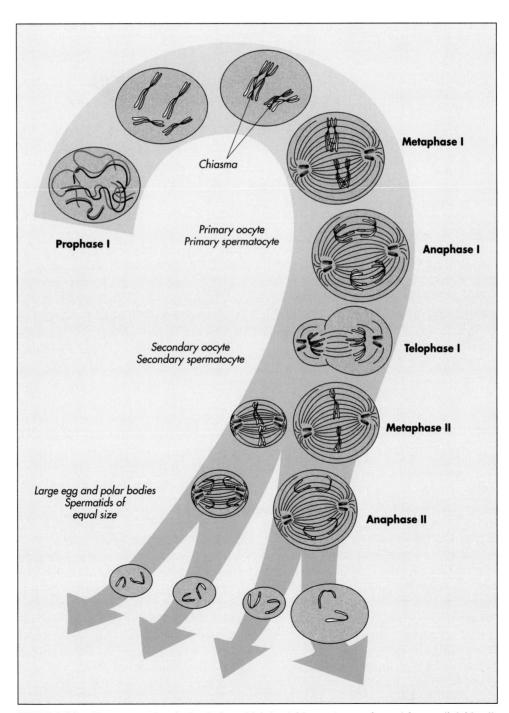

FIGURE 2.20 The stages of meiosis, during which haploid gametes are formed from a diploid cell. For brevity, prophase II and telophase II are not shown. Note the relationship between meiosis and spermatogenesis and oogenesis.

the **oogonia** in females and the **spermatogonia** in males. After meiosis I, a second meiosis, the **equational division**, takes place, during which each haploid cell is replicated.

The first stage of meiosis is interphase I. During this phase, as in mitotic interphase, important processes such as replication of chromosomal DNA take place. The second phase of meiosis I, prophase I, is quite complex and includes many of the key events that distinguish meiosis from mitosis. Prophase I begins as the chromatin strands coil and condense, causing them to become visible as chromosomes. During a process called synapsis, the homologous chromosomes pair up, side by side, lying together in perfect alignment (in males, the X and Y chromosomes, being mostly nonhomologous, line up end to end). This pairing of homologous chromosomes is an important part of the cell cycle that does not occur in mitosis. As prophase I continues, the chromatids of the two chromosomes intertwine. Each pair of intertwined homologous chromosomes is called a bivalent (indicating two chromosomes in the unit) or a tetrad (indicating four chromatids in the unit).

A second key feature of prophase I is the formation of chiasmata (plural of chiasma), cross-shaped structures that mark attachments between the homologous chromosomes (Fig. 2-21). Each chiasma indicates a point at which the homologous chromosomes exchange genetic material. This process, called crossing over, produces chromosomes that consist of combinations of parts of the original chromosomes. This chromosomal "shuffling" is important because it greatly increases the possible combinations of genes in each gamete and thereby increases the number of possible combinations of human traits. Also, as discussed in Chapter 8, this phenomenon is critically important in assessing the order of genes along chromosomes. At the end of prophase I, the bivalents begin to move toward the equatorial plane, a spindle apparatus begins to form in the cytoplasm, and the nuclear membrane dissipates.

Metaphase I is the next phase. Like mitotic metaphase, this stage is characterized by the completion of spindle formation and alignment of the bivalents, which are still attached at the chiasmata, in the equatorial plane. The two centromeres of each bivalent now lie on opposite sides of the equatorial plane.

During **anaphase I**, the next stage, the chiasmata disappear and the homologous chromosomes are pulled by the spindle fibers toward opposite poles of the cell. The key feature of this phase is that, unlike the corresponding phase of mitosis, *the centromeres do not duplicate and divide*, so that only half of the original number of chromosomes migrates toward each pole. The chromosomes migrating toward each pole thus consist of one member of each pair of autosomes and one of the sex chromosomes.

The next stage, **telophase I**, begins when the chromosomes reach opposite sides of the cell. The chromosomes uncoil slightly, and a new nuclear membrane begins to form. The two daughter cells each contain the

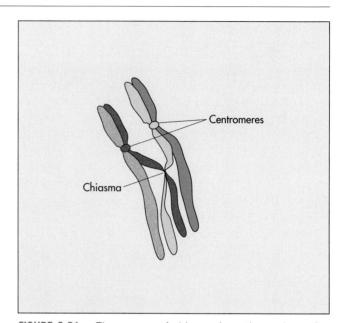

FIGURE 2.21 ■ The process of chiasma formation and crossing over results in the exchange of genetic material between homologous chromosomes.

haploid number of chromosomes, and each chromosome has two sister chromatids. In humans, cytokinesis also occurs during this phase. The cytoplasm is divided approximately equally between the two daughter cells in the gametes formed in males. In those formed in females, nearly all of the cytoplasm goes into one daughter cell, which will later form the egg. The other daughter cell becomes a **polar body**, a small, nonfunctional cell that eventually degenerates.

Meiosis I (reduction division) includes a prophase I stage in which homologous chromosomes line up and exchange material (crossing over). During anaphase I the centromeres do not duplicate and divide. Consequently only one member of each pair of chromosomes migrates to each daughter cell.

The equational division, meiosis II, then begins with interphase II. This is a very brief phase. The important feature of interphase II is that, unlike interphase I and mitotic interphase, *no replication of DNA occurs*. **Prophase** II, the next stage, is quite similar to mitotic prophase, except that the cell nucleus contains only the haploid number of chromosomes. During prophase II the chromosomes thicken as they coil, the nuclear membrane disappears, and new spindle fibers are formed. This is followed by **metaphase II**, during which the spindle fibers pull the chromosomes into alignment at the equatorial plane.

Anaphase II then follows. This stage resembles mitotic anaphase in that the centromeres split and each carries a single chromatid toward a pole of the cell. The chromatids have now separated, but, because of chiasma formation and crossing over, the newly separated sister chromatids may not be identical (see Fig. 2-20).

Telophase II, like telophase I, begins when the chromosomes reach opposite poles of the cell. There they begin to uncoil. New nuclear membranes are formed around each group of chromosomes, and cytokinesis occurs. In gametes formed in males, the cytoplasm is again divided equally between the two daughter cells. The end result of male meiosis is thus four functional daughter cells, each of which has an equal amount of cytoplasm. In female gametes, unequal division of the cytoplasm again occurs, forming the egg cell and another polar body. The polar body formed during meiosis I sometimes undergoes a second division, so three polar bodies may be present when the second stage of meiosis is completed.

Meiosis is a specialized cell division process in which a diploid cell gives rise to haploid gametes. This is accomplished by combining two rounds of division with only one round of DNA replication.

Most chromosome disorders are caused by errors that occur during meiosis. Gametes can be created that contain missing or additional chromosomes or chromosomes with altered structures. In addition, mitotic errors that occur early in the life of the embryo can affect enough of the body's cells to produce clinically significant disease. Mitotic errors occurring at any point in one's lifetime can, under some circumstances, cause cancer. Cancer genetics is discussed in Chapter 11, and chromosome disorders are the subject of Chapter 6.

The Relationship Between Meiosis and Gametogenesis

The stages of meiosis can be related directly to stages in gametogenesis, the formation of gametes (see Fig. 2-20). In mature males, the seminiferous tubules of the testes are populated by spermatogonia, which are diploid cells. After going through several mitotic divisions, the spermatogonia produce primary spermatocytes. Each primary spermatocyte, which is also diploid, undergoes meiosis I to produce a pair of secondary spermatocytes, each of which contains 23 doublestranded chromosomes. These undergo meiosis II, and each produces a pair of spermatids that contain 23 single-stranded chromosomes. The spermatids then lose most of their cytoplasm and develop tails for swimming as they become mature sperm cells. This process, known as spermatogenesis, continues throughout the life of the mature male.

Oogenesis, the process by which female gametes are formed, differs in several important ways from spermatogenesis. Whereas the cycle of spermatogenesis is constantly recurring, much of female oogenesis is completed before birth. Diploid oogonia divide mitotically to produce primary oocytes by the third month of fetal development. More than 6 million primary oocytes are formed during gestation, and they are suspended in prophase I by the time of birth. Meiosis continues only when a mature primary oocyte is ovulated. In meiosis I, the primary oocyte produces one secondary oocyte (containing the cytoplasm) and one polar body. The secondary oocyte then emerges from the follicle and proceeds down the fallopian tube, with the polar body attached to it. Meiosis II begins only if the secondary oocyte is fertilized by a sperm cell. If this occurs, one haploid mature ovum, containing the cytoplasm, and another haploid polar body are produced. The polar bodies eventually disintegrate. About 1 hour after fertilization, the nuclei of the sperm cell and ovum fuse, forming a diploid zygote. The zygote then begins its development into an embryo through a series of mitotic divisions.

In oogenesis, one haploid ovum and three haploid polar bodies are produced meiotically from a diploid oogonium. In contrast to spermatogenesis, which continues throughout the life of the mature male, the first phase of oogenesis is completed before the female is born; oogenesis is then halted until ovulation occurs.

SUGGESTED READINGS

- Alberts B, Johnson A, Lewis J, et al (2002) Molecular Biology of the Cell, 4th ed. Garland Science, New York
- Berger SL (2002) Histone modifications in transcriptional regulation. Curr Opin Genet Dev 12:142-148
- Byers PH (2000) Osteogenesis imperfecta: perspectives and opportunities. Curr Opin Pediatr 12:603-609
- Cook PR (1999) The organization of replication and transcription. Science 284:1790-1795
- Forsberg EC, Bresnick EH (2001) Histone acetylation beyond promoters: long-range acetylation patterns in the chromatin world. Bioessays 23:820-830
- Johnson CA (2000) Chromatin modification and disease. J Med Genet 37:905-915
- Lander ES, Linton LM, Birren B, Nusbaum C, Zody MC, Baldwin J, Devon K, Dewar K, Doyle M, et al (2001) Initial sequencing and analysis of the human genome. Nature 409:860-921
- Lee B, Amon A (2001) Meiosis: how to create a specialized cell cycle. Curr Opin Cell Biol 13:770-777
- Lemon B, Tjian R (2000) Orchestrated response: a symphony of transcription factors for gene control. Genes Dev 14:2551-2569
- Lewin B (1999) Genes VII. Oxford University Press, Oxford

In spermatogenesis, each diploid spermatogonium produces four haploid sperm cells.

- Mitchison TJ, Salmon ED (2001) Mitosis: a history of division. Nat Cell Biol 3:E17-E21
- Woodcock CL, Dimitrov S (2001) Higher-order structure of chromatin and chromosomes. Curr Opin Genet Dev 11:130-135

INTERNET RESOURCES

Cell Division Web site (contains numerous links to Web sites on various aspects of cell division, including mitosis, chromosomes, and cytokinesis)

STUDY QUESTIONS

1. Consider the following double-stranded DNA sequence:

5'-CAG AAG AAA ATT AAC ATG TAA-3' 3'-GTC TTC TTT TAA TTG TAC ATT-5'

If the bottom strand serves as the template, what is the mRNA sequence produced by transcription of this DNA sequence? What is the amino acid sequence produced by translation of the mRNA sequence?

2. Arrange the following terms according to their hierarchical relationship to one another: genes, chromosomes, exons, codons, nucleotides, genome.

meiosis.html Tutorial on DNA structure, replication, transcription, and translation

http://www.emc.maricopa.edu/faculty/farabee/BIOBK/BioBook

http://www.ncc.gmu.edu/dna/

Meiosis tutorial (illustrated)

http://www.nature.com/celldivision/links/

- 3. Less than 5% of human DNA encodes proteins. Furthermore, in a given cell type only 10% of the coding DNA actively encodes proteins. Explain these statements.
- 4. What are the major differences between mitosis and meiosis?
- 5. The human body contains approximately 10¹⁴ cells. Starting with a single-cell zygote, how many mitotic cell divisions, on average, would be required to produce this number of cells?
- 6. How many mature sperm cells will be produced by 100 primary spermatocytes? How many mature egg cells will be produced by 100 primary oocytes?

CHAPTER 🚽

Genetic Variation: Its Origin and Detection

Humans display a remarkable degree of genetic variation. This is seen in traits such as height, blood pressure, and skin color. Included in the spectrum of genetic variation are disease states, such as cystic fibrosis or type 1 neurofibromatosis (see Chapter 4). This aspect of genetic variation is the focus of medical genetics.

All genetic variation originates from the process known as **mutation**, which is defined as a change in DNA sequence. Mutations can affect either **germline** cells (cells that produce gametes) or **somatic** cells (all cells other than germline cells). Mutations in somatic cells can lead to cancer and are thus of significant concern. However, this chapter is directed primarily to germline mutations, because they can be transmitted from one generation to the next.

As a result of mutations, a gene may differ among individuals in terms of its DNA sequence. The differing sequences are referred to as alleles. A gene's location on a chromosome is termed a locus (from the Latin word for "place"). For example, it might be said that an individual has a certain allele at the β -globin locus on chromosome 11. If an individual has the same allele on both members of a chromosome pair, he or she is said to be a homozygote. If the alleles differ in DNA sequence, the individual is a heterozygote. The alleles that are present at a given locus are referred to as the individual's genotype. Some loci (plural of locus) vary considerably among individuals. If a locus has two or more alleles whose frequencies each exceed 1% in a population, the locus is said to be polymorphic ("many forms"). The polymorphic locus is often termed a polymorphism.

In this chapter, we examine mutation as the source of genetic variation. We discuss the types of mutation, the causes and consequences of mutation, and the biochemical and molecular techniques that are now used to detect genetic variation in human populations.

MUTATION: THE SOURCE OF GENETIC VARIATION

Types of Mutation

Some mutations consist of an alteration of the number or structure of chromosomes in a cell. These major chromosome abnormalities can be observed microscopically and are the subject of Chapter 6. Here, the focus is on mutations that affect only single genes and are not microscopically observable. Most of our discussion centers on mutations that take place in coding DNA or in regulatory sequences, since mutations that occur in other parts of the genome usually have no clinical consequences.

One important type of single-gene mutation is the base-pair substitution, in which one base pair is replaced by another.* This can result in a change in the amino acid sequence. However, because of the redundancy of the genetic code, many of these mutations do not change the amino acid sequence and thus have no consequence. Such mutations are called silent substitutions. Nonsilent base-pair substitutions consist of two basic types: missense mutations, which produce a change in a single amino acid, and nonsense mutations, which produce one of the three stop codons (UAA, UAG, or UGA) in the messenger RNA (mRNA) (Fig. 3-1). Because the stop codons terminate translation of the mRNA, nonsense mutations result in a premature termination of the polypeptide chain. Conversely, if a stop codon is altered so that it encodes an amino acid, an abnormally elongated polypeptide is produced. Alterations of amino acid sequences can have profound consequences, and many of the serious genetic diseases discussed later are the result of such alterations.

^{*}In molecular genetics, base-pair substitutions are also termed **point mutations.** However, the latter term was used in classical genetics to denote any mutation small enough to be unobservable under a microscope.

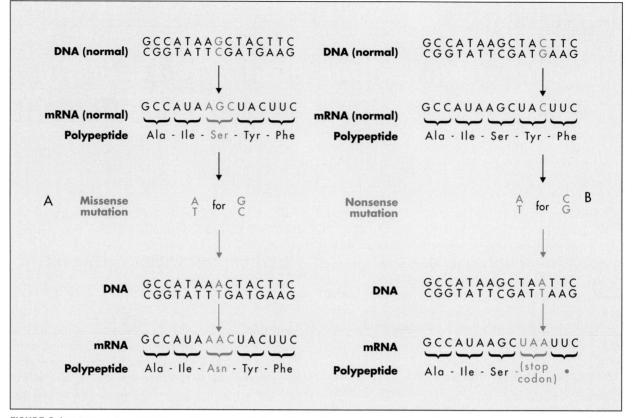

FIGURE 3.1 \blacksquare Base pair substitution. Missense mutations (A) produce a single amino acid change, whereas nonsense mutations (B) produce a stop codon in the mRNA. Stop codons terminate translation of the polypeptide.

A second major type of mutation consists of **deletions** or insertions of one or more base pairs. These mutations, which can result in extra or missing amino acids in a protein, are often detrimental. An example of such a mutation is the 3-bp deletion that causes most cases of cystic fibrosis seen in Europeans (see Chapter 4). Deletions and insertions tend to be especially harmful when the number of missing or extra base pairs is not a multiple of three. Because codons consist of groups of three base pairs, such insertions or deletions can alter all of the downstream codons. This is termed a frameshift mutation (Fig. 3-2). For example, the insertion of a single base (an A in the second codon) would convert a DNA sequence read as 5'-ACT GAT TGC GTT-3' to 5'-ACT GAA TTG CGT-3'. This would change the amino acid sequence from Thr-Asp-Cys-Val to Thr-Glu-Leu-Arg. Frequently, a frameshift mutation produces a stop codon downstream of the insertion or deletion, resulting in a truncated polypeptide.

On a larger scale, **duplications** of whole genes can also lead to genetic disease. A good example is given by Charcot-Marie-Tooth disease. This disorder, named after the three physicians who described it more than a century ago, is a peripheral nervous system disease that leads to progressive atrophy of the distal limb muscles. It affects approximately 1 in 2,500 individuals and exists in

FIGURE 3.2 Frameshift mutations result from the addition or deletion of a number of bases that is not a multiple of three. This alters all of the codons downstream from the site of insertion or deletion.

several different forms. About 70% of patients who have the most common form (type 1) display a 1.5 million-bp duplication on one copy of chromosome 17. As a result, they have three, rather than two, copies of the genes in this region. One of these genes, PMP22, encodes a peripheral myelin protein. The increased dosage of the gene product contributes in some way to the demyelination that is characteristic of this form of the disorder. Interestingly, a deletion of this same region produces a distinct disease, hereditary neuropathy with liability to pressure palsies (paralysis). Because either a reduction (to 50%) or an increase (to 150%) in the gene product produces disease, this gene is said to display dosage sensitivity. Point mutations in PMP22 itself can produce yet another disease, Dejerine-Sottas syndrome (characterized by distal muscle weakness, sensory alterations, muscular atrophy, and enlarged spinal nerve roots). www

Other types of mutation can alter the regulation of transcription or translation. A **promoter mutation** can decrease the affinity of RNA polymerase for a promoter site, often resulting in reduced production of mRNA. The final result is decreased production of a protein. Mutations of transcription factor genes or enhancer sequences can have similar effects.

Mutations may also interfere with the splicing of introns as mature mRNA is formed from the primary mRNA transcript. Splice site mutations, those that occur at intron-exon boundaries, alter the splicing signal that is necessary for proper excision of an intron. Splice site mutations may occur at the GT sequence that always defines the 5' splice site (the donor site) or at the AG sequence that defines the 3' splice site (the acceptor site). They may also take place in the sequences that lie near the donor and acceptor sites. When such mutations occur, the excision is often made within the next exon, at a splice site located in the exon. These splice sites, whose DNA sequences differ slightly from those of normal splice sites, are ordinarily unused and "hidden" within the exon. They are thus termed cryptic splice sites. The use of a cryptic site for splicing results in partial deletion of the exon or, in other cases, the deletion of an entire exon. As Fig. 3-3 shows, splice site mutations can also result in the abnormal inclusion of part or all of an intron in the mature mRNA. Finally, a mutation may occur at a cryptic splice site, causing it to appear as a normal splice site and thus to compete with the normal splice site.

Several types of DNA sequences are capable of propagating copies of themselves; these copies are then inserted in other locations on chromosomes (examples include the SINE and *Alu* repeats, discussed in Chapter 2). Such insertions can cause frameshift mutations. Until recently, it was not clear whether this phenomenon, which has been well documented in experimental animals such as fruit flies, occurred in humans. The insertion of **mobile elements** has now been shown to cause isolated cases of type 1 neurofibromatosis, Duchenne muscular dystrophy, β -thalassemia, familial breast cancer, familial polyposis (colon cancer), and hemophilia A and B (clotting disorders) in humans.

The final type of mutation to be considered here affects tandem repeated DNA sequences (see Chapter 2) that occur within or near certain disease-related genes. The repeat units are usually 3 bp long, so a typical example would be CAGCAGCAG. A normal individual has a relatively small number (e.g., 20 to 30) of these tandem repeats at a specific chromosome location. Occasionally, the number of repeats increases dramatically during meiosis or possibly during early fetal development, so that a newborn may have hundreds or even thousands of repeats. When this occurs in certain regions of the genome, it causes genetic disease. Like other mutations, these **expanded repeats** can be transmitted to the patient's offspring. More than a dozen genetic diseases are now known to be caused by expanded repeats (see Chapter 4).

Mutations are the ultimate source of genetic variation. Some mutations result in genetic disease, but others have no physical effects. The principal types of mutations are missense, nonsense, frameshift, promoter, and splice site mutations. Mutations can also be caused by the random insertion of mobile elements, and some genetic diseases are known to be caused by expanded repeats.

Molecular Consequences of Mutation

It is useful to think of mutations in terms of their effects on the protein product. Broadly speaking, mutations can produce either a **gain of function** or a **loss of function** of the protein product. Gain-of-function mutations occasionally result in a completely novel protein product. More commonly, they result in overexpression of the product or inappropriate expression (i.e., in the wrong tissue or in the wrong stage of development). Gain-offunction mutations produce **dominant** disorders.* Charcot-Marie-Tooth disease, mentioned previously, can result from overexpression of the protein product and is considered a gain-of-function mutation. Huntington disease, to be discussed in Chapter 4, is another example.

Loss-of-function mutations are often seen in **recessive** diseases. In such diseases, the mutation results in the loss of 50% of the protein product (e.g., a metabolic enzyme), but the 50% that remains is sufficient for normal function. The heterozygote is thus unaffected, but the homozygote is affected. In some cases, however, 50% of the gene's protein product is not sufficient for normal function **(haploinsufficiency)**, and a dominant disorder can result. Haploinsufficiency is seen, for example, in the autosomal dominant disorder known as familial hypercholesterolemia (see Chapter 12). In this disease, a single

^{*}The terms "dominant" and "recessive" are discussed fully in Chapter 4. Briefly, a dominant disease is caused by a single copy of a mutation (i.e., heterozygotes are affected), whereas a recessive disease requires that both copies of the allele be mutated (i.e., only homozygotes are affected).

FIGURE 3.3 \blacksquare **A**, Normal splicing. **B**, Splice site mutation. The donor sequence, GT, is replaced with AT. This results in an incorrect splice that leaves part of the intron in the mature mRNA transcript. In another example of splice site mutation **(C)**, a second GT donor site is created within the first intron, resulting in a combination of abnormally and normally spliced mRNA products.

copy of a mutation (heterozygosity) reduces the number of low-density lipoprotein (LDL) receptors by 50%. Cholesterol levels in heterozygotes are approximately double those of normal homozygotes, resulting in a substantial increase in the risk of heart disease. As with most disorders involving haploinsufficiency, the disease is more serious in affected homozygotes (who have few if any functional LDL receptors) than in heterozygotes. Both haploinsufficiency and gain-of-function mutations are examples of dosage sensitivity, mentioned previously.

A **dominant negative** mutation results in a protein product that is not only nonfunctional but also inhibits the function of the protein produced by the normal allele in the heterozygote. Typically, dominant negative mutations are seen in genes that encode multimeric proteins (i.e., proteins composed of two or more subunits). Type I collagen (see Chapter 2), which is composed of three helical subunits, is an example of such a protein. An abnormal helix created by a single mutation may combine with the other helices, distorting them and producing a seriously compromised triple helix protein.

Mutations can result in either a gain of function or a loss of function of the protein product. Gain-of-function mutations are sometimes seen in dominant diseases. Loss of function is seen in (1) recessive diseases; (2) diseases involving haploinsufficiency, in which 50% of the gene product is insufficient for normal function; and (3) dominant negative mutations, in which the abnormal protein product interferes with the normal protein product.

Clinical Consequences of Mutation: The Hemoglobin Disorders

Genetic disorders of human hemoglobin are the most common group of single-gene diseases: an estimated 7% of the world's population carries one or more mutations of the genes involved in hemoglobin synthesis. Because almost all of the types of mutation described in this chapter have been observed in the hemoglobin disorders, these disorders serve as an important illustration of the clinical consequences of mutation.

The hemoglobin molecule is a tetramer composed of four polypeptide chains, two labeled α and two labeled β . The β chains are encoded by a gene on chromosome 11, and the α chains are encoded by two genes on chromosome 16 that are very similar to one another. A normal individual has two normal β genes and four normal α genes (Fig. 3-4). Ordinarily, tight regulation of these genes ensures that roughly equal numbers of α and β chains are produced. Each of these **globin** chains is associated with a **heme** group, which contains an iron atom and binds with oxygen. This property allows hemoglobin to perform the vital function of transporting oxygen in erythrocytes (red blood cells).

FIGURE 3.4 The α -globin gene cluster on chromosome 16 and the β -globin gene cluster on chromosome 11. The β -globin cluster includes the ε -globin gene, which encodes embryonic globin, and the γ -globin genes, which encode fetal globin. The $\psi\beta$ gene is not expressed. The α -globin cluster includes the ζ -globin gene, which encodes embryonic α -globin.

The hemoglobin disorders can be classified into two broad categories: *structural abnormalities*, in which the hemoglobin molecule is altered, and *thalassemias*, a group of conditions in which either the α - or the β -globin chain is structurally normal but reduced in quantity. Another condition, hereditary persistence of fetal hemoglobin (HPFH), occurs when fetal hemoglobin, encoded by the α -globin genes and by two β -globin-like genes called $^{A}\gamma$ and $^{C}\gamma$ (see Fig. 3-4), continues to be produced after birth (normally, γ -chain production ceases and β -chain production begins at the time of birth). HPFH does not cause disease but instead can compensate for a lack of normal adult hemoglobin.

A large array of different hemoglobin disorders have been identified. The discussion that follows is a greatly simplified presentation of the major forms of these disorders. The hemoglobin disorders, the mutations that cause them, and their major features are summarized in Table 3-1.

Disease	Mutation type	Major disease features
Sickle cell disease	β-globin missense mutation	Anemia, tissue infarctions, infections
HbH disease	Deletion or abnormality of three of the four α -globin genes	Moderately severe anemia, splenomegaly
Hydrops fetalis (Hb Barts)	Deletion or abnormality of all four α -globin genes	Severe anemia or hypoxemia, congestive heart failure; stillbirth or neonatal death
β^0 -Thalassemia	Usually nonsense, frameshift, or splice site donor or acceptor mutations; no β-globin produced	Severe anemia, splenomegaly, skeletal abnormalities, infections; often fatal during first decade if untreated
β⁺-Thalassemia	Usually missense, regulatory, or splice site consensus sequence or cryptic splice site mutations; small amount of β-globin produced	Features similar to those of $\beta^0\text{-thalassemia}$ but often somewhat milder

SICKLE CELL DISEASE

Α

The most important of the structural hemoglobin abnormalities is sickle cell disease, a disorder that affects approximately 1 in 400 to 1 in 600 African-American births. It is even more common in parts of Africa, where it can affect up to 1 in 50 births, and it is also seen occasionally in Mediterranean and Middle Eastern populations. Sickle cell disease is caused by a single missense mutation that effects a substitution of valine for glutamic acid at position 6 of the β -globin polypeptide chain. In homozygous form, this amino acid substitution alters the characteristics of the hemoglobin molecule such that the erythrocytes assume a characteristic "sickle" shape under conditions of low oxygen tension (Fig. 3-5A). These conditions are experienced in capillaries, the tiny vessels whose diameter is smaller than that of the erythrocyte. Normal erythrocytes (see Fig. 3-5B) can squeeze through capillaries, but sickled erythrocytes are less flexible and are unable to do so. In addition, the abnormal erythrocytes tend to stick to the vascular endothelium (the inner lining of blood vessels). The resultant vascular obstruction produces localized hypoxemia (lack of oxygen), painful sickling "crises," and infarctions of various tissues, including bone, spleen, kidneys, and lungs (an infarction is tissue death due to hypoxemia). Premature destruction of the sickled erythrocytes decreases the number of circulating erythrocytes and the hemoglobin level, producing **anemia**. The spleen becomes enlarged (splenomegaly), but infarctions eventually destroy this organ, producing some loss of immune function. This contributes to the recurrent bacterial infections (especially pneumonia) that are commonly seen in individuals with sickle cell disease and frequently cause death. In North America, it is estimated that the life expectancy of individuals with sickle cell disease is reduced by about 30 years. www

Sickle cell disease, which causes anemia, tissue infarctions, and multiple infections, is the result of a single missense mutation that produces an amino acid substitution in the β-globin chain.

FIGURE 3.5 Erythrocytes from patients with sickle cell disease assume a characteristic shape under conditions of low oxygen tension (A). Compare with normal erythrocytes (B).

THALASSEMIA

The term thalassemia is derived from the Greek word thalassa ("sea"). This refers to the fact that thalassemia was first described in populations living near the Mediterranean Sea, although it is also common in portions of Africa, the Mideast, India, and Southeast Asia. Thalassemia can be divided into two major groups, α thalassemia and β -thalassemia, depending on the globin chain that is reduced in quantity. When one type of chain is decreased in number, the other chain type, unable to participate in normal tetramer formation, tends to form molecules consisting of four chains of the excess type only (these are termed homotetramers, in contrast to the heterotetramers normally formed by α and β chains). In α -thalassemia, the α -globin chains are deficient, so the β chains (or γ chains in the fetus) are found in excess. They form homotetramers that have a greatly reduced oxygen-binding capacity, producing hypoxemia. In β -thalassemia, the excess α -chains form homotetramers that precipitate and damage the cell membranes of red blood cell precursors (i.e., the cells that form circulating erythrocytes). This leads to premature erythrocyte destruction and anemia. www

Most cases of α -thalassemia are caused by deletions of the α -globin genes. The loss of one or two of these genes has no clinical effect. The loss or abnormality of three of the α genes produces moderately severe anemia and splenomegaly (HbH disease). Loss of all four α genes, a condition seen primarily among Southeast Asians, produces hypoxemia in the fetus and *hydrops fetalis* (a condition in which there is a massive buildup of fluid). Severe hypoxemia invariably causes stillbirth or neonatal death.

The α -thalassemia conditions are usually caused by deletions of α -globin genes. The loss of three of these genes leads to moderately severe anemia, and the loss of all four is fatal.

Individuals with a β -globin mutation in one copy of chromosome 11 (heterozygotes) are said to have βthalassemia minor, a condition that involves little or no anemia and does not ordinarily require clinical management. Those in whom both copies of the chromosome carry a B-globin mutation develop either B-thalassemia major (also called Cooley's anemia) or the less serious condition, B-thalassemia intermedia. B-globin may be completely absent (β^0 -thalassemia), or it may be reduced to about 10% to 30% of the normal amount (β^+ thalassemia). Typically, β^0 -thalassemia produces a more severe disease phenotype, but because disease features are caused by an excess of α -globin chains, individuals with β^0 -thalassemia are less severely affected when they also have α -globin mutations that reduce the quantity of α globin chains.

 β -globin is not produced until after birth, so the effects of β -thalassemia major are not seen clinically until

the age of 2 to 6 months. These patients develop severe anemia. If the condition is left untreated, substantial growth retardation can occur. The anemia causes bone marrow expansion, which in turn produces skeletal changes, including a protuberant upper jaw and cheekbones and thinning of the long bones (making them susceptible to fracture). Splenomegaly (Fig. 3-6) and infections are common, and patients with untreated β thalassemia major often die during the first decade of life. β -thalassemia can vary considerably in severity, depending on the precise nature of the responsible mutation.

In contrast to α -thalassemia, gene deletions are relatively rare in B-thalassemia. Instead, most cases are caused by single-base mutations. Nonsense mutations, which result in premature termination of translation of the β -globin chain, usually produce β^0 -thalassemia. Frameshift mutations also typically produce the β^0 form. In addition to mutations in the β -globin gene itself, alterations in regulatory sequences are often seen. B-globin transcription is regulated by a promoter, two enhancers, and an upstream region known as the locus control region (LCR) (see Fig. 3-4). Mutations in these regulatory regions usually result in reduced synthesis of mRNA and a reduction, but not complete absence, of β -globin $(\beta^+$ -thalassemia). Several types of splice site mutations have also been observed. If a point mutation occurs at a donor or acceptor site, normal splicing is destroyed completely, producing β^0 -thalassemia. Mutations in the

FIGURE 3.6 A child with β -thalassemia major who has severe splenomegaly.

surrounding consensus sequences usually produce β^+ thalassemia. Mutations also occur in the cryptic splice sites found in introns or exons of the β -globin gene, causing these sites to be available to the splicing mechanism. These additional splice sites then compete with the normal splice sites, producing some normal and some abnormal β -globin chains. The result is usually β^+ thalassemia.

Many different types of mutations can produce β-thalassemia conditions. Nonsense, frameshift, and splice site donor and acceptor mutations tend to produce more severe disease. Regulatory mutations and those involving splice site consensus sequences and cryptic splice sites tend to produce less severe disease.

More than 300 different β -globin mutations have been reported. Consequently, most patients with β thalassemia are not "homozygotes" in the strict sense: they usually have a *different* β -globin mutation on each copy of chromosome 11 and are termed **compound heterozygotes**. Even though the mutations differ, each of the two β -globin genes is altered, producing a disease state. It is common to apply the term "homozygote" loosely to compound heterozygotes.

Patients with sickle cell disease or β-thalassemia major are sometimes treated with blood transfusions and with chelating agents that remove excess iron introduced by the transfusions. Prophylactic administration of antibiotics and antipneumococcal vaccination are used to diminish bacterial infections in patients with sickle cell disease, and analgesics are administered for pain relief during sickling crises. Bone marrow transplantation, which provides donor stem cells that produce genetically normal erythrocytes, has been performed on patients with severe β-thalassemia or sickle cell disease. However, it is often impossible to find a suitably matched donor, and the mortality rate from this procedure is still fairly high (approximately 5% to 30%, depending on the severity of disease and the age of the patient). A lack of normal adult β -globin can be compensated by reactivating the genes that encode fetal β -globin (the γ -globin genes, discussed previously). Agents such as hydroxyurea and butyrate can reactivate these genes and are being investigated. Also, the hemoglobin disorders are possible candidates for gene therapy (see Chapter 13).

Causes of Mutation

A large number of agents are known to cause **induced mutations**. These mutations, which are attributed to

known environmental causes, can be contrasted with **spontaneous mutations**, which arise naturally during the process of DNA replication. Agents that cause induced mutations are known collectively as **mutagens**. Animal studies have shown that **radiation** is an important class of mutagen (Clinical Commentary 3-1). **Ionizing radiation**, such as that produced by x-rays and nuclear fallout, can eject electrons from atoms, forming electrically charged ions. When these ions are situated within or near the DNA molecule, they can promote chemical reactions that change DNA bases. Ionizing radiation can also break the bonds of double-stranded DNA. This form of radiation can reach all cells of the body, including the germline cells.

Nonionizing radiation does not form charged ions but can move electrons from inner to outer orbits within an atom. The atom becomes chemically unstable. Ultraviolet (UV) radiation, which occurs naturally in sunlight, is an example of nonionizing radiation. UV radiation causes the formation of covalent bonds between adjacent pyrimidine bases (i.e., cytosine or thymine). These **pyrimidine dimers** (a dimer is a molecule having two subunits) are unable to pair properly with purines during DNA replication; this results in a base pair substitution (Fig. 3-7). Because UV radiation is absorbed by the epidermis, it does not reach the germ line but can cause skin cancer (Clinical Commentary 3-2).

A variety of chemicals can also induce mutations, sometimes because of their chemical similarity to DNA bases. Because of this similarity, these base analogs, such as 5-bromouracil, can be substituted for a true DNA base during replication. The analog is not exactly the same as the base it replaces, so it can cause pairing errors during subsequent replications. Other chemical mutagens, such as acridine dyes, can physically insert themselves between existing bases, distorting the DNA helix and causing frameshift mutations. Still other mutagens can directly alter DNA bases, causing replication errors. An example of the latter is nitrous acid, which removes an amino group from cytosine, converting it to uracil. Although uracil is normally found in RNA, it mimics the pairing action of thymine in DNA. Thus, it pairs with adenine instead of guanine, as the original cytosine would have done. The end result is a base pair substitution.

Hundreds of chemicals are now known to be mutagenic in laboratory animals. Among these are nitrogen mustard, vinyl chloride, alkylating agents, formaldehyde, sodium nitrite, and saccharin. Some of these chemicals are much more potent mutagens than others. Nitrogen mustard, for example, is a powerful mutagen, whereas saccharin is a relatively weak one. Although some mutagenic chemicals are produced by humans, many occur

CLINICAL COMMENTARY 3.1 The Effects of Radiation on Mutation Rates

Because mutation is a rare event, occurring less than once per 10,000 genes per generation, it is difficult to measure directly in humans. The relationship between radiation exposure and mutation is similarly difficult to assess. For a person living in a developed country, a typical lifetime exposure to ionizing radiation is about 6 to 7 rem.* About one third of this amount is thought to originate from medical and dental x-ray procedures.

Unfortunate situations have arisen in which specific human populations have received much larger radiation doses. The most thoroughly studied such population consists of the survivors of the atomic bomb blasts that occurred in Hiroshima and Nagasaki, Japan, at the close of World War II. Many of those who were exposed to high doses of radiation died from radiation sickness. Others survived, and many of the survivors produced offspring.

To study the effects of radiation exposure in this population, a large team of Japanese and American scientists conducted medical and genetic investigations of some of the survivors. A significant number of those exposed developed cancers and chromosome abnormalities in their somatic cells, probably as a consequence of radiation exposure. To assess the effects of radiation exposure on the subjects' germ lines, the scientists compared the offspring of those who suffered substantial radiation exposure with the offspring of those who did not. While it is difficult to establish radiation doses with precision, there is no doubt that, in general, those who were situated closer to the blasts suffered much higher exposure levels. It is estimated that the exposed group received roughly 30 to 60 rem of radiation, many times the average lifetime radiation exposure.

In a series of more than 76,000 offspring of these individuals, researchers assessed a large number of factors, including stillbirths, chromosome abnormalities, birth defects, cancer before 20 years of age, death before age 26 years, and various measures of growth and development (e.g., intelligence quotient). There were no statistically significant differences between the offspring of individuals who were exposed to radiation and the offspring of those who were not exposed. In addition, direct genetic studies of mutations have been carried out using minisatellite polymorphisms and protein electrophoresis, a technique that detects mutations that lead to amino acid changes (discussed elsewhere in this chapter). Parents and offspring were compared to determine whether germline mutations had occurred at various loci. The numbers of mutations detected in the exposed and unexposed groups were statistically equivalent.

More recently, studies of those who were exposed to radiation from the Chernobyl nuclear power plant accident have demonstrated a significant increase in thyroid cancers among children exposed to radiation. This reflects the effects of somatic mutations. The evidence for increased frequencies of germline mutations, however, remains unclear. A number of other studies of the effects of radiation on humans have been reported, including investigations of those who live near nuclear power plants. The radiation doses received by these individuals are substantially smaller than those of the populations discussed previously, and the results of these studies are equivocal.

It is remarkable that, even though there was substantial evidence for radiation effects on somatic cells in the Hiroshima-Nagasaki studies, no detectable effect could be seen for germline cells. What could account for this? It is likely that DNA repair is at least in part responsible. Also, we must recognize that, even with a large sample of individuals who received relatively high doses of radiation, increased mutation levels are difficult to detect.

These results argue that radiation danger should not be taken lightly. Above-ground nuclear testing in the American Southwest has produced increased rates of leukemia and thyroid cancer in a segment of the population. Radon, a radioactive gas that is produced by the decay of naturally occurring uranium, can be found at dangerously high levels in some homes and poses a risk for lung cancer. Any unnecessary exposure to radiation, particularly to the gonads or to developing fetuses, should be avoided if at all possible.

^{*}A rem is a standard unit for measuring radiation exposure. It is roughly equal to 0.01 joule of absorbed energy per kilogram of tissue.

FIGURE 3.7 Pyrimidine dimers originate when covalent bonds form between adjacent pyrimidine (cytosine or thymine) bases. This deforms the DNA, interfering with normal base pairing (A). The defect is repaired by removal and replacement of the dimer and bases on either side of it, with the complementary DNA strand used as a template (B).

naturally in the environment (e.g., aflatoxin B1, a common contaminant of foods).

Many substances in the environment are known to be mutagenic, including ionizing and nonionizing radiation and hundreds of different chemicals. These mutagens are capable of causing base substitutions, deletions, and frameshifts. Ionizing radiation can induce double-stranded DNA breaks. Some mutagens occur naturally, while others are generated by humans.

DNA Repair

Considering that 3 billion DNA base pairs must be replicated in each cell division, and considering the large number of mutagens to which we are exposed, DNA replication is surprisingly accurate. A primary reason for this accuracy is the process of **DNA repair**, which takes place in all normal cells of higher organisms. Several dozen enzymes are involved in the repair of damaged DNA. They collectively recognize an altered base, excise it by cutting the DNA strand, replace it with the correct base (determined from the complementary strand), and reseal the DNA. It is estimated that these repair mechanisms correct 99.9% of initial errors.

Because DNA repair is essential for the accurate repli-

cation of DNA, defects in DNA repair systems can lead to many types of disease. For example, inherited mutations in genes responsible for **DNA mismatch repair** result in the persistence of cells with replication errors (i.e., mismatches) and can lead to some types of cancers (see Chapter 11). A compromised ability to repair **double-stranded DNA breaks** can lead to ovarian and/or breast cancer. **Nucleotide excision repair** is necessary for the removal of larger changes in the DNA helix (e.g., pyrimidine dimers); defects in excision repair lead to a number of diseases, of which xeroderma pigmentosum is an important example (see Clinical Commentary 3-2).

DNA repair helps to ensure the accuracy of the DNA sequence by correcting replication errors (mismatches), repairing doublestranded DNA breaks, and excising damaged nucleotides.

Mutation Rates

How often do spontaneous mutations occur? At the nucleotide level, the mutation rate is usually estimated to be about 10^{-9} per base pair per cell division (this figure represents mutations that have escaped the process of DNA repair). At the level of the gene, the mutation rate

CLINICAL COMMENTARY 3.2

Xeroderma Pigmentosum: A Disease of Faulty DNA Repair

An inevitable consequence of exposure to UV radiation is the formation of potentially dangerous pyrimidine dimers in the DNA of skin cells. Fortunately, a highly efficient system of enzymes usually repairs these dimers in normal individuals. Among those affected with the rare disease xeroderma pigmentosum (XP), this system does not work properly, and the resulting replication errors lead to base pair substitutions in skin cells. Varying substantially in severity, XP usually begins within the first 10 years of life. The skin is dry and scaly (xeroderma), and extensive freckling and abnormal skin pigmentation (pigmentosum) are followed by numerous skin tumors (Fig. 3-8). Neurological abnormalities are seen in some cases. It is estimated that the risk of skin tumors in individuals with XP is elevated approximately 1,000-fold. These cancers are concentrated primarily in sun-exposed parts of the body. Patients are advised to avoid sources of UV light (e.g., sunlight), and cancerous growths are removed surgically. Patients with XP can develop severe malignancies that sometimes result in death before 20 years of age.

Several different repair enzymes are involved in correcting pyrimidine dimers. They include helicases that unwind the double-stranded DNA helix, an endonuclease that cuts the DNA at the site of the dimer, an exonuclease that removes the dimer and nearby nucleotides, a polymerase that fills the gap with DNA bases (using the complementary DNA strand as a template), and a ligase that rejoins the corrected portion of DNA to the original strand. An inherited mutation in any of the seven repair enzyme genes can produce XP.

XP involves two distinct classes of mutations. The repair-enzyme mutations occur in the germ line and

FIGURE 3.8 A child with xeroderma pigmentosum, showing the multiple skin tumors characteristic of this disease. (From Raven PH, Johnson GB [1992] Biology, 3rd ed. Mosby, St Louis. With permission of McGraw-Hill, New York.)

therefore can be transmitted from one generation to the next. Because they result in deficient DNA repair, they in turn permit skin cell mutations to persist, resulting in tumors. The skin cell mutations themselves cannot, of course, be inherited.

Although XP is probably the best known disease that results from deficient DNA repair, it is not the only one. Other examples are given in Table 3-2.

Disease	Features	Type of repair defect
Xeroderma pigmentosum	Skin tumors, photosensitivity, cataracts, neurological abnormalities	Nucleotide excision repair defects, including mutations in helicase and endonuclease genes
Cockayne syndrome	Reduced stature, skeletal abnormalities, optic atrophy, deafness, photosensitivity, mental retardation	Defective repair of UV-induced damage in transcriptionally active DNA; considerable etiological and symptomatic overlap with xeroderma pigmentosum and trichothiodystrophy
Fanconi anemia	Anemia; leukemia susceptibility; limb, kidney, and heart malformations; chromosome instability	As many as eight different genes may be involved, but their exact role in DNA repair is not yet known
Bloom syndrome	Growth deficiency, immunodeficiency, chromosome instability, increased cancer incidence	Mutations in the reqQ helicase family
Werner syndrome	Cataracts, osteoporosis, atherosclerosis, loss of skin elasticity, short stature, diabetes, increased cancer incidence; sometimes described as "premature aging"	Mutations in the reqQ helicase family
Ataxia telangiectasia	Cerebellar ataxia, telangiectases,* immune deficiency, increased cancer incidence, chromosome instability	Normal gene product is likely to be involved in halting the cell cycle after DNA damage occurs
Hereditary nonpolyposis colorectal cancer	Proximal bowel tumors, increased susceptibility to several other types of cancer	Mutations in any of six DNA mismatch-repair genes

TABLE 3.2 🔳 Examples of Diseases That Are Caused by a Defect in DNA Repair

*Telangiectases are vascular lesions caused by the dilatation of small blood vessels. This typically produces discoloration of the skin.

FIGURE 3.9 Cytosine methylation. The addition of a methyl group (CH_3) to a cytosine base forms 5-methylcytosine. The subsequent loss of an amino group (deamination) forms thymine. The result is a cytosine \rightarrow thymine substitution.

is quite variable, ranging from 10^{-4} to 10^{-7} per locus per cell division. There are at least two reasons for this large range of variation.

- 1. Genes vary tremendously in size. The somatostatin gene, for example, is quite small, containing 1,480 bp. In contrast, the gene responsible for Duchenne muscular dystrophy (DMD) spans more than 2,000,000 bp. As might be expected, larger genes present larger "targets" for mutation and usually experience mutation more frequently than do smaller genes. The DMD gene, as well as the genes for hemophilia A and type 1 neurofibromatosis, are all very large and have high mutation rates.
- 2. It is well established that certain nucleotide sequences are especially susceptible to mutation. These are termed **mutation hot spots**. The bestknown example is the two-base (dinucleotide) sequence CG. In mammals, about 80% of CG dinucleotides are methylated: a methyl group is attached to the cytosine base. The methylated cytosine, 5-methylcytosine, easily loses an amino group, converting it to thymine. The end result is a mutation from cytosine to thymine (Fig. 3-9). Surveys of mutations in human genetic diseases have shown that the mutation rate at CG dinucleotides is about 12 times higher than at other dinucleotide sequences. Mutation hot spots, in the form of CG dinucleotides, have been identified in a number of important human disease genes, including the procollagen genes responsible for osteogenesis imperfecta (see Chapter 2). Other disease examples are discussed in Chapters 4 and 5.

Mutation rates also vary considerably with the age of the parent. Some chromosome abnormalities increase dramatically with maternal age (see Chapter 6). In addition, single-gene mutations can increase with paternal age. This increase is seen in several single-gene disorders, including Marfan syndrome and achondroplasia. As Fig. 3-10 shows, the risk of producing a child with Marfan syndrome is approximately five times higher for a male older than 40 years of age than for a male in his 20s. This paternal age effect is usually attributed to the fact that the stem cells giving rise to sperm cells continue to divide throughout life, allowing a progressive buildup of DNA replication errors.

Mutation rates vary substantially in different parts of the genome. Large genes, because of their size, are generally more likely to experience mutations than are small genes. Mutation hot spots, particularly methylated CG dinucleotides, are also known to occur. For some single-gene disorders, there is a substantial increase in mutation risk with advanced paternal age.

FIGURE 3.10 Paternal age effect. For some single-gene disorders, the risk of producing a child with the condition (Y axis) increases with the father's age (X axis).

For centuries, humans have been intrigued by the differences that can be seen among individuals. Attention was long focused on observable differences such as skin coloration or body shape and size. Only in the 20th century did it become possible to examine variation in genes, the consequence of mutations accumulated through time. The evaluation and measurement of this variation in populations and families are important for mapping genes to specific locations on chromosomes, a key step in determining gene function (see Chapter 8). The evaluation of genetic variation also provides the basis for much of genetic diagnosis, and it is highly useful in medical forensics. In this section, several key approaches to detecting genetic variation in humans are discussed in historical sequence.

Blood Groups

Several dozen **blood group** systems have been defined on the basis of antigens located on the surfaces of erythrocytes. Some are involved in determining whether a given individual can receive a blood transfusion from a given donor. Because individuals differ extensively in terms of blood groups, these systems provided an important early means of assessing genetic variation.

Each of the blood group systems is determined by a different gene or set of genes. The various antigens that can be expressed within a system are the result of different DNA sequences in these genes. Two blood group systems that have special medical significance, the ABO and Rh systems, are discussed here.

THE ABO SYSTEM

Human blood transfusions were carried out as early as 1818, but they were often unsuccessful. After transfusion, some recipients suffered a massive, sometimes fatal, hemolytic reaction. In 1900 Karl Landsteiner discovered that this reaction was caused by the ABO antigens located on erythrocyte surfaces. The ABO system consists of two major antigens, labeled A and B. Individuals can have one of four blood types: those with blood type A carry the A antigen on their erythrocytes, those with type B carry the B antigen, those with type AB carry both A and B, and those with type O carry neither antigen. Each individual has antibodies that react against any antigens that are not found on their own red blood cell surfaces. For example, a person with type A blood has anti-B antibodies, and transfusing type B blood into this individual would provoke a severe antibody reaction. It is straightforward to determine ABO blood type in the laboratory by mixing a small sample of a person's blood with solutions containing different antibodies and observing which combinations cause the clumping that is characteristic of an antibody-antigen interaction.

The ABO system, which is encoded by a single gene on chromosome 9, consists of three primary alleles, labeled I^{A} , I^{B} , and I^{O} . (There are also subtypes of both the I^{A} and I^{B} alleles, but they are not addressed here.) Individuals with the I^{A} allele have the A antigen on their erythrocyte surfaces (blood type A), while those with I^{B} have the B antigen on their cell surfaces (blood type B). Those with both alleles express both antigens (blood type AB), and those with only two copies of the I^{O} allele have neither antigen (type O blood). Because the I^{O} allele produces no antigen, individuals who are $I^{A}I^{O}$ or $I^{B}I^{O}$ heterozygotes have blood types A and B, respectively (Table 3-3).

Because populations vary substantially in terms of the frequency with which the ABO alleles occur, the ABO locus was the first blood group system to be used extensively in studies of genetic variation among individuals and populations. For example, early studies showed that the A antigen is relatively common in western European populations, while the B antigen is especially common among Asians. Neither antigen is common among Native South American populations, the great majority of whom have blood type O.

THE RH SYSTEM

Like the ABO system, the Rh system is defined on the basis of antigens that are present on erythrocyte surfaces. This system is named after the rhesus monkey, the experimental animal in which it was first isolated by Landsteiner in the late 1930s. It is typed in the laboratory by a procedure similar to the one described for the ABO system. The Rh system varies considerably among individuals and populations and thus has been another highly useful tool for assessing genetic variation. Recently, the molecular basis of variation in both the ABO and the Rh systems has been elucidated (for further details, see the suggested readings at the end of this chapter).

The ABO and Rh systems are both of key importance in determining the compatibility of blood transfusions and tissue grafts. Some combinations of these systems

TABLE 3.3 Relationship Between ABO Genotype and Blood Type				
Genotype	Blood type	Antibodies present		
$I^A I^A$	A	Anti-B		
$I^A I^O$	A	Anti-B		
$I^B I^B$	В	Anti-A		
$I^{B}I^{O}$	В	Anti-A		
$I^A I^B$	AB	None		
$I^{O}I^{O}$	0	Anti-A and anti-B		

can produce maternal-fetal incompatibility, sometimes with serious results for the fetus. These issues are discussed in detail in Chapter 9.

The blood groups, of which the ABO and Rh systems are examples, have provided an important means of studying human genetic variation. Blood group variation is the result of antigens that occur on the surface of erythrocytes.

Protein Electrophoresis

Although the blood group systems have been a useful means of measuring genetic variation, their number is quite limited. **Protein electrophoresis**, developed first in the 1930s and applied widely to humans in the 1950s and 1960s, increased the number of detectable polymorphic systems considerably. This technique makes use of the fact that a single amino acid difference in a protein (the result of a mutation in the corresponding DNA sequence) can cause a slight difference in the electrical charge of the protein

An example is the common sickle cell disease mutation discussed earlier. The replacement of glutamic acid with valine in the β-globin chain produces a difference in electrical charge because glutamic acid has two carboxyl groups, whereas valine has only one carboxyl group. Electrophoresis can be used to determine whether an individual has normal hemoglobin (HbA) or the mutation that causes sickle cell disease (HbS). The hemoglobin is placed in an electrically charged gel composed of starch, agarose, or polyacrylamide (Fig. 3-11A). The slight difference in charge resulting from the amino acid difference causes the HbA and HbS forms to migrate at different rates through the gel. The protein molecules are allowed to migrate for several hours and are then stained with chemical solutions so that their positions can be seen (Fig. 3-11B). From the resulting pattern it can be determined whether the individual is an HbA homozygote, an HbS homozygote, or a heterozygote having HbA on one chromosome and HbS on the other.

Protein electrophoresis has been used to detect amino acid variation in hundreds of human proteins. However, silent substitutions, which do not alter amino acids, cannot be detected by this approach. In addition, some amino acid substitutions do not alter the electrical charge of the protein molecule. For these reasons, it is estimated that protein electrophoresis detects only about one third of the mutations that occur in coding DNA. Single-base substitutions in noncoding DNA are not usually detected by protein electrophoresis.

Protein electrophoresis detects variations in genes that encode certain serum proteins. These variations are observable because proteins with slight differences in their amino acid sequence migrate at different rates through electrically charged gels.

FIGURE 3.11 The process of protein electrophoresis. A tissue sample is loaded in the slot at the top of the gel, and an electrical current is run though the gel (**A**). After staining, distinct bands, representing molecules with different electrical charges and therefore different amino acid sequences, are visible. HbA homozygotes show a single band closer to the positive pole, whereas HbS homozygotes show a single band closer to the negative pole (**B**). Heterozygotes, having both alleles, show two bands.

Detection of Variation at the DNA Level

It is estimated that variation in human DNA occurs at an average of 1 in every 300 to 500 bp. Thus, approximately 10 million polymorphisms may exist among the 3 billion base pairs that comprise the human genome. Since there are only 100 or so blood group and protein electrophoretic polymorphisms, these approaches have detected only a tiny proportion of human DNA variation. Yet the assessment of this variation is critical to gene mapping and genetic diagnosis (see Chapters 8 and 13). Fortunately, molecular techniques developed during the past 20 years enable the detection of thousands of new polymorphisms at the DNA level. These techniques, which have revolutionized both the practice and the potential of medical genetics, are discussed next.

RESTRICTION FRAGMENT LENGTH POLYMORPHISMS

An early approach to the detection of genetic variation at the DNA level took advantage of the existence of bacterial enzymes known as **restriction endonucleases** or **restriction enzymes**. These enzymes are produced by various bacterial species to "restrict" the entry of foreign DNA into the bacterium by cutting, or cleaving, the DNA at specifically recognized sequences. These sequences are referred to as **restriction sites** or **recognition sites**. For example, the intestinal bacterium *Escherichia coli* produces a restriction enzyme, called *Eco*RI, that recognizes the DNA sequence GAATTC. Each time this sequence is encountered, the enzyme cleaves the sequence between the G and the A. This produces DNA **restriction fragments**.

Now imagine a region of DNA that is several thousand bases long and includes three recognition sites for EcoRI. Suppose that a polymorphism exists within the middle restriction site (e.g., some individuals might have the sequence GAATTT instead of the GAATTC sequence recognized by EcoRI). The enzyme will not cleave the GAATTT sequence, but it will cleave the normal restriction sites that are located on either side of the polymorphic sequence. As a result, the specific DNA fragment produced in the individual who lacks the restriction site will be longer than in the individual who has it (Fig. 3-12). If these differing lengths could be visualized directly, it would be possible to observe DNA sequence differences among individuals (i.e., DNA polymorphism).

A series of steps has been devised that permits this visualization (Fig. 3-13). First, DNA is extracted from a tissue sample, usually blood. Then the DNA is exposed to a restriction enzyme such as EcoRI. This process is termed a restriction digest. The digest typically produces more than 1 million DNA fragments. To assess length variation, these fragments are subjected to gel electrophoresis. This procedure is similar to the protein electrophoresis described previously, except that the DNA fragments migrate down the gel according to size rather than electrical charge. The smaller fragments migrate more quickly than the larger ones. The DNA is denatured (i.e., converted from a double-stranded to a single-stranded form) by exposing it to alkaline chemical solutions. In order to fix the positions of the DNA fragments permanently, they are transferred from the gel to a solid membrane, such as nitrocellulose (this is termed a Southern transfer, after the man who invented the process in the mid-1970s). At this point, the solid membrane, often called a "Southern blot," contains many thousands of fragments arrayed according to their size. If we looked at all of these fragments at once, it would be impossible to distinguish one from another because of their large number. How do we pick out specific DNA fragments?

Here, it is possible to exploit the principle of complementary DNA base pairing. A **probe** is constructed using recombinant DNA techniques (Box 3-1). This probe consists of a small piece of single-stranded human DNA (a few kilobases [kb] in length) that has been inserted into a vector such as a phage, plasmid, or cosmid. The probe is labeled, often with a radioactive isotope. The blot is exposed to thousands of copies of the labeled probe, which under proper conditions will undergo complementary base pairing only with the appropriate singlestranded DNA fragments on the blot (a large number of

FIGURE 3.12 Cleavage of DNA by the *Eco*RI restriction enzyme. In **B**, the enzyme cleaves the three GAATTC recognition sequences, producing two smaller fragments. In **A**, the middle sequence is GAATTT instead of GAATTC, so it cannot be cleaved by the enzyme. The result is a single, longer fragment.

FIGURE 3.13 ■ The RFLP process. DNA is extracted from blood samples from subjects A, B, and C. The DNA is digested by a restriction enzyme and then loaded on a gel. Electrophoresis separates the DNA fragments according to their size. The DNA is denatured and transferred to a solid membrane, where it is hybridized with a radioactive probe. Exposure to x-ray film (autoradiography) reveals specific DNA fragments (bands) of different sizes in individuals A, B, and C.

BOX 3.1

Genetic Engineering, Recombinant DNA, and Cloning

In the last two decades, most of the lay public has acquired at least a passing familiarity with the terms "recombinant DNA," "cloning," and "genetic engineering." Indeed, these techniques lie at the heart of what is often called the "new genetics."

Genetic engineering refers to the laboratory alteration of genes. A number of alterations can be made. One that is of special importance in medical genetics is the manufacturing of **clones**. Briefly, a clone is an identical copy of a DNA sequence. The following description outlines one approach to the artificial cloning of human genes.

Our goal is to insert a human DNA sequence into a rapidly reproducing organism so that copies (clones) of the DNA can be made quickly. One system commonly used for this purpose is the **plasmid**, which is a small, circular, self-replicating piece of DNA that resides in many bacteria. Plasmids can be removed from bacteria or inserted into them without seriously disrupting bacterial growth or reproduction.

To insert human DNA into the plasmid, we need a way to cut DNA into pieces so that it can be manipulated. Restriction enzymes, discussed earlier in the text, perform this function efficiently. The DNA sequence recognized by the restriction enzyme EcoRI, GAATTC, has the convenient property that its complementary sequence, CTTAAG, is the same sequence, except backwards. Such sequences are called palindromes. When plasmid or human DNA is cleaved with EcoRI, the resulting fragments have "sticky ends" (Fig. 3-14). If human DNA and plasmid DNA are both cut with this enzyme, both types of DNA fragments contain exposed ends that can undergo complementary base pairing with one another. Then, when the human and plasmid DNA are mixed together, they recombine (hence the term recombinant DNA). The resulting plasmids contain human DNA inserts. The plasmids are inserted back into bacteria, where they reproduce rapidly through natural cell division. The human DNA sequence, which is reproduced along with the other plasmid DNA, is thus cloned.

The plasmid is referred to as a **vector**. Several other types of vectors may also be used as cloning vehicles, including **bacteriophages** (viruses that infect bacteria), **cosmids** (phage-plasmid hybrids capable of carrying relatively large DNA inserts), **yeast artificial chromosomes** (YACs; vectors that are inserted into yeast cells and that behave much like ordinary yeast chromosomes), **bacterial artificial chromosomes** (BACs), and, most recently, **human artificial chromosomes** (see Chapters 8 and 13). While plasmids and bacteriophages can accommodate only relatively small inserts (about 10 and 20 kb, respectively), cosmids can carry inserts of approximately 50 kb, and YACs can carry inserts up to 1,000 kb in length.

Cloning is typically used to create the thousands of copies of human DNA needed for Southern blotting and other experimental applications. In addition, this approach is now being used to produce genetically engi-

FIGURE 3.14 Recombinant DNA technology. Human and circular plasmid DNA are both cleaved by a restriction enzyme, producing sticky ends (1-3). This allows the human DNA to anneal and recombine with the plasmid DNA. Inserted into the plasmid DNA, the human DNA is now replicated when the plasmid is inserted into the *Escherichia coli* bacterium (4).

neered therapeutic products, such as insulin, interferon, human growth hormone, clotting factor VIII (used in the treatment of hemophilia A, a coagulation disorder), and tissue plasminogen activator (a blood clot-dissolving protein that helps to prevent heart attacks and strokes). When these genes are cloned into bacteria or other organisms, the organism produces the human gene product along with its own gene products. In the past, these products were obtained from donor blood or from other animals; the processes of obtaining and purifying them were slow and costly. Genetically engineered gene products are rapidly becoming a cheaper and more efficient alternative. probe copies is required so that a strong signal can be visualized). Because it is only a few kb in size, the probe identifies a specific portion of the DNA, usually just one or two fragments. To visualize the position of the hybridized probe, the blot is exposed to x-ray film, which darkens at the probe's position due to the emission of radioactive particles from the labeled probe. These darkened positions are usually referred to as "bands," and the film is termed an **autoradiogram** (Fig. 3-15).

The term **restriction fragment length polymorphisms** (usually abbreviated RFLPs) should now be selfexplanatory. These are *polymorphisms* that are revealed by variation in the *lengths* of *restriction fragments*.

RFLPs result from variations in DNA sequence at specific restriction sites. These variations produce different DNA fragment lengths, which are sorted by electrophoresis and visualized through the use of labeled probes.

The RFLP process can be illustrated using the example of sickle cell disease. As discussed previously, normal individuals have glutamic acid at position 6 of the β -globin polypeptide. Glutamic acid is encoded by the DNA sequence GAG. The sickle cell mutation results in the sequence GTG at this site instead of GAG, causing valine to be substituted for glutamic acid. The restriction enzyme *Mst*II recognizes the DNA sequence CCT-NAGG (the N signifies that the enzyme will recognizes and cleaves the DNA sequence of the "normal" chromosome at this site, as well as at the restriction sites on either side of it (Fig. 3-16). The result is two DNA fragments, one 1,100 bp long and another only 200 bp long.

FIGURE 3.15 An autoradiogram, showing the positions of a 4.1-kb band and a 3.3-kb band. Each lane represents DNA from a subject in the family whose pedigree is shown above the autoradiogram.

In chromosomes that have the valine substitution, *Mst*II cannot recognize the sequence, so the sickle cell DNA is not cleaved at that site. However, the restriction sites flanking the site of interest, which do not vary, are still cleaved. The result is a single DNA fragment that is longer than the long fragment produced from the normal chromosome (i.e., 1,300 bp instead of 1,100 bp). Because

FIGURE 3.16 Cleavage of β -globin DNA by the *Mst*II restriction enzyme. The sickle cell mutation removes an *Mst*II recognition site, producing a longer, 1.3-kb fragment. The normal DNA sequence includes the restriction site (i.e., the sequence CCTGAG instead of CCTGTG), so a shorter, 1.1-kb fragment is produced. Therefore, on the autoradiogram, sickle cell homozygotes have a single 1.3-kb band, normal homozygotes have a single 1.1-kb band, and heterozygotes have both the 1.1-kb and the 1.3-kb bands. Note that the banding pattern here, based on DNA sequence differences, resembles the banding pattern shown in Fig. 3-11, which is based on hemoglobin amino acid sequences detected by protein electrophoresis.

shorter fragments migrate farther on a gel, the two fragment sizes can easily be distinguished after hybridization of the blot with a probe containing DNA from the β globin gene. In this case, the RFLP approach permits direct detection of the mutation causing the disease. In current practice, more efficient methods are now used to test for sickle cell mutations (see Chapter 13). However, the approach outlined here remains useful in detecting many polymorphisms and disease-causing mutations.

There are several thousand known restriction enzymes, most of which recognize a distinct DNA sequence. In addition, thousands of different probes have been created, each representing a different small piece of the human DNA sequence. By combining these various probes and enzymes, researchers have identified thousands of polymorphic sites in the human genome. These polymorphisms were instrumental in localizing many important disease genes, including those for cystic fibrosis, Huntington disease, and type 1 neurofibromatosis (see Chapter 8).

TANDEM REPEAT POLYMORPHISMS

The approach just described usually detects the presence or absence of a restriction site; such polymorphisms are often termed restriction site polymorphisms (RSPs). These polymorphisms have only two possible alleles, placing a limit on the amount of genetic diversity that can be seen. More diversity could be observed if a polymorphic system had many alleles, rather than just two. A variation on the RFLP approach has provided just such a system. This particular variation exploits the minisatellites that exist throughout the genome. As discussed in Chapter 2, minisatellites are regions in which the same DNA sequence is repeated over and over again, in tandem. The genetic variation measured is the number of repeats in a given region, which varies substantially from individual to individual-hence the term variable number of tandem repeats, or VNTRs.

VNTRs are detected using an approach similar to that used for conventional RFLPs. DNA is digested with a restriction enzyme, and the fragments are electrophoresed, denatured, and transferred to a solid medium. The principal difference is that special probes are used that hybridize only to a given minisatellite region. Whereas RSPs reveal polymorphisms because of the presence or absence of a restriction site, VNTRs reveal polymorphisms because of different numbers of repeats located between two restriction sites (Fig. 3-17). The number of tandem repeats can vary considerably in populations: a minisatellite region could have as few as 2 or 3 repeats or as many as 20 or more. These polymorphisms can therefore reveal a high degree of genetic variation. This is especially useful for mapping genes by the process of linkage analysis, discussed in Chapter 8.

VNTRs are a form of RFLP that arise from variation in the number of tandem repeats in a DNA region. Because VNTR loci can have many different alleles, they are especially useful in medical genetics and other applications.

Just as minisatellite regions can vary in length, microsatellites can also vary in length as a result of differing numbers of repeats (see Chapter 2). Each microsatellite repeat is substantially smaller than a minisatellite repeat (typically 2, 3, or 4 bp in length). These are referred to as dinucleotide, trinucleotide, and tetranucleotide repeats, respectively, and they are known collectively as short tandem repeats. A short tandem repeat may occur in tandem as many as several hundred times, and this number varies considerably among individuals (and usually between the two homologous chromosomes of an individual). These short tandem repeat polymorphisms (STRPs) differ from the VNTRs just discussed in terms of their size and also in that they are not defined by restriction sites flanking the repeat region. Instead, the polymerase chain reaction technique, discussed next, is used to isolate them. Like VNTRs, STRPs are highly useful for gene mapping. They are more abundant than VNTRs, more evenly distributed in the genome, and easier to assay in the laboratory. Thus, they have become the polymorphism of choice in most gene mapping studies. Both types of polymorphisms are useful in forensic

FIGURE 3.17 VNTR polymorphisms. Bands of differing length, A and B, are created by different numbers of tandem repeats in the DNA on two different chromosomes. Restriction sites are found on either side of the repeat region, and a radioactively labeled probe hybridizes to the DNA, allowing the different fragment lengths to be visualized on an autoradiogram.

applications, such as paternity testing and the identification of criminal suspects (Box 3-2).

DNA AMPLIFICATION USING THE POLYMERASE CHAIN REACTION

The RFLP and VNTR approaches, which have been useful in many applications, originally depended on Southern blotting and cloning procedures. These techniques suffer from certain limitations. Cloning is timeconsuming, often requiring a week or more of laboratory time. In addition, the standard Southern blotting approach requires relatively large amounts of purified DNA, usually several micrograms (up to 1 ml of fresh blood would be needed to produce this much DNA). A newer approach to making copies of DNA, the **polymerase chain reaction** (PCR), has made the detection of genetic variation at the DNA level much more efficient. Essentially, PCR is an artificial means of replicating a short, specific DNA sequence (several kb or less) very quickly, so that millions of copies of the sequence are made.

DNA Profiles in The Forensic Setting

Because of the large number of polymorphisms observed in the human genome, it is virtually certain that each of us is genetically unique (with the exception of identical twins). It follows that genetic variation could be used to identify individuals, much as a conventional fingerprint does. Because DNA can be found in any tissue sample, including blood, semen, and even hair,* genetic variation could have substantial potential in forensic applications (e.g., criminal cases, paternity suits, identification of accident victims). VNTRs and STRPs, with their many alleles, are very useful in establishing a highly specific **DNA profile**.

The principle underlying a DNA profile is quite simple. If we examine enough polymorphisms in a given individual, the probability that any other individual in the population has the same allele at each examined locus becomes extremely small. DNA left at the scene of a crime in the form of blood or semen, for example, can be typed for a series of VNTRs, and/or STRPs. Because of the extreme sensitivity of the PCR approach, even a tiny, several-year-old sample can yield enough DNA for laboratory analysis (although extreme care must be taken to avoid contamination when using PCR with such samples). The detected alleles are then compared with the alleles of a suspect (Fig. 3-18). If the alleles in the two samples match, the suspect is implicated.

A key question is whether another person in the general population might have the same alleles as the suspect. Could the DNA profile then falsely implicate the wrong person? In criminal cases, the probability of obtaining an allele match with a random member of the population is calculated. Because of the high degree of allelic variation in VNTRs and STRPs, the probability is usually very small. A set of just four VNTR loci typically provides random match probabilities of about 1 in 1 million. The use of 13 STRPs, which is now common practice, yields random match probabilities in the neighborhood of 1 in 1 trillion. Provided that a large enough number of loci are used under well-controlled laboratory conditions, and provided that the data are collected and evaluated carefully, DNA profiles can furnish highly useful forensic evidence.

FIGURE 3.18 DNA profiles. The autoradiogram shows that the band pattern of DNA from suspect A does not match the DNA taken from the crime scene (C), whereas the band pattern from suspect B does match. In practice, several such VNTRs or STRPs are assayed to reduce the possibility of a false match. (Courtesy Jay Henry, Criminalistics Laboratory, Department of Public Safety, State of Utah.)

Although we tend to think of such evidence in terms of identifying the guilty party, it should be kept in mind that when a match is not obtained, a suspect may be exonerated. It has been reported that, among the rape cases in which DNA profiles were used, approximately one third of the suspects were freed because their DNA did not match that of the evidentiary sample. In addition, "post-conviction" DNA testing has resulted in the release of a number of individuals who were wrongly imprisoned. Thus, DNA profiles can also benefit those who are falsely accused.

^{*}Even fingerprints left at a crime scene sometimes contain enough DNA for PCR amplification and DNA profiling.

The PCR process, summarized in Fig. 3-19, requires four components:

- 1. Two **primers**, each consisting of 15 to 20 bases of DNA. These small DNA sequences are termed **oligonucleotides** (*oligo* meaning "a few"). The primers correspond to the DNA sequences immediately adjacent to the sequence of interest (such as a sequence that contains a tandem repeat polymorphism or a mutation that causes disease). The oligonucleotide primers are synthesized using a laboratory instrument.
- DNA polymerase. A thermally stable form of this enzyme, initially derived from the bacterium *Thermus aquaticus*, performs the vital process of DNA replication (here termed **primer extension**).
- 3. A large number of free DNA nucleotides.
- 4. Genomic DNA from an individual. Because of the extreme sensitivity of PCR, the quantity of this DNA can be very small.

The genomic DNA is first heated to a relatively high temperature (approximately 95°C) so that it denatures and becomes single-stranded. It is then is exposed to large quantities of primers, which hybridize, or anneal, to the appropriate complementary bases in the genomic DNA as it is cooled to an annealing temperature of approximately 35° to 65°C. The DNA is then heated to an intermediate temperature (70° to 75°C). In the presence of a large number of free DNA bases, a new DNA strand is synthesized by the DNA polymerase at this temperature, extending from the primer sequence. The newly synthesized DNA consists of a double strand that has the 5' end of the primer at one end, followed by the bases added through primer extension by DNA polymerase. This double-stranded DNA is heated to a high temperature again, causing it to denature. The heating-cooling cycle is then repeated. Now, the newly synthesized DNA serves as the template for further synthesis. As the cooling-heating cycles are repeated, the primerbounded DNA products are amplified geometrically: the number of copies doubles in each cycle (i.e., 2, 4, 8, 16, and so on). This is why the process is termed a "chain reaction." Typically, the cycles are repeated 20 to 30 times, producing millions of copies of the original DNA. In summary, the PCR process consists of three basic steps: DNA denaturing at high temperature, primer hybridization at a low temperature, and primer extension at an intermediate temperature. The result is a product that consists almost entirely of a defined DNA sequence.

Because each heating-cooling cycle requires only a few minutes or less, a single molecule of DNA can be amplified to make millions of copies in only a few hours. Because the procedure is simple and entirely self-contained, inexpensive machines have been developed to automate it completely. Once the DNA is amplified, it can be analyzed in a variety of ways.

PCR has several advantages over older techniques. First, it can be used with extremely small quantities of

FIGURE 3.19 The PCR process. Genomic DNA is first heated and denatured to form single strands. In the annealing phase, the DNA is cooled, allowing hybridization with primer sequences that flank the region of interest. Then the reaction is heated to an intermediate primer extension temperature, in which DNA polymerase adds free bases in the 3' direction along each single strand, starting at the primer. Blunt-ended DNA fragments are formed, and these provide a template for the next cycle of heating and cooling. Repeated cycling produces a large number of DNA fragments bounded on each end by the primer sequence.

DNA (usually nanogram amounts, as opposed to the micrograms required for cloning). The amount of DNA in a several-year-old blood stain, a single hair, or even the back of a licked postage stamp is often sufficient for analysis. Second, because it does not require gene cloning, the procedure is much faster than older techniques. The genetic diagnosis of sickle cell disease, which required a week or longer with older techniques, can be done in a single day with PCR. Finally, because PCR can make large quantities of very pure DNA, it is less often necessary to use radioactive probes to detect specific DNA sequences or mutations. Instead, safer, nonradioactive substances, such as biotin, can be used.

PCR does have some disadvantages. First, primer synthesis obviously requires knowledge of the DNA sequence flanking the DNA of interest. If no sequence information is available, other techniques must be used. Second, the extreme sensitivity of PCR makes it susceptible to contamination in the laboratory. A number of precautions are commonly taken to guard against contamination. Finally, because it is difficult to apply PCR to sequences longer than a few kb, it cannot be used to detect larger deletions (i.e., it is difficult or impossible to amplify the longer, normal sequence). Southern blotting techniques are typically used instead.

Because PCR is such a powerful and versatile technique, it is now used extensively in genetic disease diagnosis, forensic medicine, and evolutionary genetics. It has supplanted the Southern blotting technique in many applications and is now used to assay RFLPs and VNTRs. PCR is so sensitive that it has been used to analyze DNA from ancient mummies and even from several Neandertal specimens more than 30,000 years old. Analysis of these specimens showed that modern humans are genetically quite distinct from Neandertals and are thus unlikely to have descended directly from them.

PCR provides a convenient and efficient means of making millions of copies of a short DNA sequence. Heating-cooling cycles are used to denature DNA and then build new copies of a specific, primer-bounded sequence. Because of its speed and ease of use, this technique is now widely used for assessing genetic variation, for diagnosing genetic diseases, and for forensic purposes.

DNA SEQUENCING

In many genetic studies, a primary goal is to determine the actual array of DNA base pairs that makes up a gene or part of a gene. Such a **DNA sequence** can indicate a great deal about the nature of a specific mutation, the function of a gene, and the gene's degree of similarity to other known genes. We will first discuss a technique that has been widely used to determine DNA sequences.

The **dideoxy method** of DNA sequencing, invented by Frederick Sanger, makes use of chain-terminating dideoxynucleotides. These are chemically quite similar to ordinary deoxynucleotides, except that they are missing one hydroxyl group. This prevents the subsequent formation of phosphodiester bonds with free DNA bases. Thus, although dideoxynucleotides can be incorporated into a growing DNA helix, no additional nucleotides can be added once they are included. Four different dideoxynucleotides are used, each corresponding to one of the four nucleotides (A, C, G, and T). The single-stranded DNA whose sequence we wish to determine is mixed with radioactively labeled primers, DNA polymerase, ordinary nucleotides, and one type of dideoxynucleotide (Fig. 3-20). The primer hybridizes to the appropriate complementary position in the single-stranded DNA, and DNA polymerase adds free bases to the growing DNA molecule, as in the PCR process. At any given position, either an ordinary nucleotide or the corresponding dideoxynucleotide may be incorporated into the chain; this is a random process. However, once a dideoxynucleotide is incorporated, the chain is terminated. The procedure thus yields DNA fragments of varying length, each ending with the same dideoxynucleotide. The DNA fragments can be separated according to length by electrophoresis, as discussed previously. Four different sequencing reactions are run, one for each base. The fragments obtained from each reaction are electrophoresed side by side on the same gel, so that the position of each fragment can be compared. Since each band corresponds to a DNA chain that terminates with a unique base, the DNA sequence can be read by observing the order of the bands on the gel after autoradiography (the radioactive primer indicates the position of the fragment on the film). Several hundred base pairs can usually be sequenced in one reaction series.

DNA sequencing can be accomplished using the dideoxy method. This method depends on the fact that dideoxynucleotides behave in a fashion similar to ordinary deoxynucleotides, except that, once incorporated into the DNA chain, they terminate the chain. They thus mark the positions of specific bases.

It should be apparent that this method of sequencing DNA is a relatively slow, laborious, and error-prone process. More recently, strategies for **automated DNA sequencing** using fluorescent, chemiluminescent, or colorimetric detection systems have been developed. The use of fluorochrome-labeled primers or dideoxynucleotides has become the most popular method, partly because it can easily be adapted for rapid automation.

Typically, a DNA template is sequenced using a method similar to the primer extension step in PCR. Each of the four different nucleotides can be labeled with a fluorochrome that emits a distinct spectrum of light. The fluorochrome-labeled reaction products are electrophoresed through a very thin polyacrylamide gel; as they migrate past a window, they are excited by a beam of light from a laser. The emitted light is captured by a digital camera for translation into an electronic signal, and a

FIGURE 3.20 DNA sequencing by the dideoxy method. Labeled primer is added to the single-stranded DNA whose sequence is unknown. DNA polymerase adds free bases to the single strand, using complementary base pairing. Four different reactions are carried out, corresponding to the four dideoxynucleotides (ddATP, ddCTP, ddGTP, and ddTTP). Each of these terminates the DNA sequence whenever it is incorporated in place of the normal deoxynucleotide (dATP, dCTP, dGTP, and dTTP), dCTP, dGTP, and dTTP, corresponding to the bases A, C, G, and T, respectively). The process results in fragments of varying length, which can be separated by electrophoresis. The position of each fragment is indicated by the emission of radioactive particles from the label, which allows the DNA sequence to be read directly.

composite gel image is generated. This gel image is analyzed to produce a graph in which each of the four different nucleotides is depicted by a different-colored peak (see Color Plate). Approximately 500 bp of DNA from up to 96 individuals can be analyzed on a single gel in 2 to 4 hours. Automated sequencers can also be adapted to assay STRPs, single-nucleotide polymorphisms, and other types of polymorphisms.

In another approach to automated sequencing, DNA samples are eletrophoresed in thin glass tubes (termed

capillaries) rather than polyacrylamide gels. Because these tubes are very thin, relatively little heat is generated during electrophoresis. As a consequence, **capillary sequencing** is very rapid, allowing 96 samples to be sequenced for approximately 600 bp in 15 minutes. By using computers and advanced automated technology, approaches such as these have greatly increased the potential speed of DNA sequencing. These techniques have permitted the completion of the entire 3-billion-bp human DNA sequence.

The Causes of Genetic Variation

Although mutation is the ultimate source of genetic variation, it cannot alone account for the substantial differences in the incidence of many genetic diseases among different ethnic groups. Why, for example, is sickle cell disease seen in approximately 1 of every 600 African-Americans, but almost never in northern Europeans? Why is cystic fibrosis 40 times more common in Europeans than in Asians? Although mutation is the process that introduces diseases into populations, several evolutionary factors, including natural selection, genetic drift, and gene flow, determine how common the disease genes become in a population. These forces change **gene frequencies** in populations (a gene frequency is defined as the proportion of a population's chromosomes that have a specific allele, a concept discussed further in Chapter 4).

Natural selection is often described as the "editor" of genetic variation. It increases the population frequency of favorable mutations (i.e., those who carry the mutation will produce more surviving offspring), and it decreases the frequency of genes that are unfavorable in a given environment (i.e., gene carriers produce fewer surviving offspring). Typically, disease mutations are continually introduced into a population through the error processes described earlier, while natural selection removes the mutations. Certain environments, however, may result in a selective advantage for a disease mutation. Sickle cell disease again provides an example. As discussed previously, individuals who are homozygotes for the sickle cell mutation are much more likely to die

early. Heterozygotes ordinarily have no particular advantage or disadvantage. However, it has been shown that sickle cell heterozygotes have a distinct survival advantage in environments in which Plasmodium falciparum malaria is common (e.g., west-central Africa) (Fig. 3-21). Because the malaria parasite does not survive well in the erythrocytes of sickle cell heterozygotes, these individuals are less likely to succumb to malaria than are normal homozygotes, conferring a selective advantage on the sickle cell gene in this environment. While there is selection against the gene in sickle cell homozygotes, there is selection for the gene in heterozygotes. The result is that the disease gene persists at a relatively high frequency in many African populations. In nonmalarial environments (e.g., northern Europe), the sickle-cell mutation has no advantage, so natural selection acts strongly against it by eliminating homozygotes. This example illustrates the concept that variation in genetic disease incidence among populations can be caused by natural selection operating differentially in different environments.

Genetic drift is another force that can cause disease genes to vary in frequency among populations. To understand the process of genetic drift, consider a coin-tossing exercise in which 10 coins are tossed. Because "heads" and "tails" are equally likely, the expected number of heads and tails in this exercise would be 5 each. However, it is intuitively clear that, by chance, a substantial departure from this expectation could be observed. It would not be surprising to

The Causes of Genetic Variation—cont'd

see 7 heads and 3 tails in 10 throws, for example. However, if 1,000 coins are tossed, the degree of departure from the expected proportion of 50% heads and 50% tails is much smaller. A reasonable outcome of 1,000 throws might be 470 heads and 530 tails, but it would be quite unlikely to obtain 700 heads and 300 tails. Therefore, there is less random fluctuation in larger samples.

The same principle applies to gene frequencies in populations. In a very small population, a gene frequency can deviate substantially from one generation to the next, but this is unlikely in a large population. Thus, genetic drift is greater in smaller populations. As a result, genetic diseases that are otherwise uncommon may be seen fairly frequently in a small population. For example, Ellis-van Creveld syndrome, a rare disorder that involves reduced stature, polydactyly (extra digits), and congenital heart defects, is seen with greatly elevated frequency among the Old Order Amish population of Pennsylvania. The Amish population was founded in the United States by about 50 couples. Because of this small population size, there was great potential for genetic drift, resulting in increased frequencies of certain disease-causing alleles .

It is common to observe the effect of genetic drift in small, isolated populations throughout the world. Even relatively large populations may have experienced drift effects in the recent past if they underwent severe population bottlenecks or were established by a small number of founders (**founder effect**). For example, more than 30 otherwise rare genetic diseases are found with elevated frequency in

Automated DNA sequencing, using fluorescent labels and laser detection, greatly increases the speed and efficiency of the sequencing process.

DETECTION OF MUTATIONS AT THE DNA LEVEL

The detection of mutations or polymorphisms in DNA sequences is often a critical step in understanding how a gene causes a specific disease. New molecular methods have spawned a number of techniques for detecting DNA sequence variation. The Southern blotting approach permits the detection of relatively large deletions; those smaller than 50 bp cannot be seen on Southern blots because of the limited resolution of this technique. Mutations that alter a restriction site can also be recognized with the Southern blotting approach, but most mutations do not occur at a known restriction site. After a specific region of DNA has been amplified by PCR, it can be sequenced directly with the technique described previously. Mutations are then detected by comparing the DNA sequence of a patient with that of an unaffected individual.

Although direct sequencing is a useful and accurate

Finland's population, which is thought to have been founded primarily by a small number of individuals some 100 generations ago. Phenylketonuria and cystic fibrosis, which are common in other Caucasian populations, are relatively rare in Finland, illustrating the fact that genetic drift can both increase and decrease the frequency of disease genes. Several genetic diseases (e.g., torsion dystonia, Tay-Sachs disease, Gaucher disease) occur with increased frequency in the Ashkenazi Jewish population (see Chapter 7); this may be the result of population bottlenecks that have occurred in the history of this population.

Gene flow occurs when populations exchange migrants who mate with one another. Through time, gene flow between populations tends to make them genetically more similar to one another. One reason why sickle cell disease is less common among African-Americans than in many African populations is because of gene flow between African-Americans and Caucasians in North America (this same process is likely to have increased the frequency of cystic fibrosis in the African-American population). In addition, because *P. falciparum* malaria is not found in North America, the African-American population does not experience selection in favor of the sickle cell mutation.

The forces of mutation, natural selection, genetic drift, and gene flow interact in complex and sometimes unexpected ways to influence the distribution and prevalence of genetic diseases in populations. The study of the ways in which these processes influence genetic evolution is referred to as **population genetics**.

means of detecting mutations, it can be very time-consuming. Other techniques provide a more rapid approach to surveying large numbers of patients for mutations. These techniques can indirectly indicate the existence and location of a mutation, after which the DNA in the indicated region can be sequenced to identify the specific mutation (Table 3-4).

Two approaches to be mentioned here make use of the fact that, under certain conditions, mutations alter the mobility of DNA fragments in gel electrophoresis. **Denaturing gradient gel electrophoresis** (DGGE) employs a gel in which there is an increasing gradient of a denaturing factor, such as temperature. In **single-strand conformation polymorphism** (SSCP) analysis, alteration of the secondary structure of a DNA segment by a mutation in DNA sequence changes the rate of migration of a single-stranded DNA segment in a nondenaturing gel. Using either of these techniques, sequence differences between a patient's DNA and that of a normal control can be identified (Fig. 3-22). Once a difference is detected, the patient's DNA can be sequenced to determine the precise nature of the mutation.

Another mutation-detection approach employs chemicals or enzymes that cleave DNA when there is a mis54

Technique	Brief description	Application
Southern blotting	Digestion of test DNA with restriction enzyme; resolution of fragments with agarose gel electrophoresis; transfer of DNA to nylon membrane and hybridization of labeled probe to DNA fragments	Detection of insertions, deletions, rearrangements; ordering of DNA fragments into physical map
Direct DNA sequencing	Determination of linear order of nucleotides of test DNA; specific nucleotide detected by chemical cleavage, dideoxy-chain termination, or fluorochrome dye	Detection of insertions, deletions, point mutations, rearrangements
Single-strand conformational polymorphism (SSCP) analysis	Differential electrophoretic mobility of single- stranded test DNA with different secondary structures (conformations) through a nondenaturing gel	Detection of small insertions or deletions, point mutations
Denaturing gradient gel electrophoresis (DGGE) analysis	Migration of DNA duplexes through an electrophoretic gel with increasing amounts of a denaturant (e.g., chemical, temperature) until DNA strands separate; resolution of alleles by PAGE	Detection of small insertions or deletions, point mutations
DNA mismatch cleavage	Hybridization of a labeled probe to test DNA; cleavage of DNA at site of base-pairing mismatch	Detection of small insertions or deletions, point mutations
Allele-specific oligonucleotide (ASO) hybridization	Preferential hybridization of labeled probe to test DNA with uniquely complementary base composition	Detection of alleles of known composition
Mass spectrometry	Detection of physical mass of sense and antisense strands of test DNA	Detection of small insertions or deletions, point mutations
DNA microarray hybridization	Hybridization of test DNA to arrays of oligonucleotides ordered on silicone chip or glass slide	Detection of test DNA of known composition
Protein truncation	Test DNA used to make complementary DNA (cDNA) by RT-PCR with 5' primer containing T7 promoter; cDNA translated and product resolved by SDS-PAGE	Detection of frameshift, splice site, or nonsense mutations that truncate the protein product

TABLE 3.4 🔳 Methods of Mutation Detection

PAGE, Polyacrylamide gel electrophoresis; RT-PCR, reverse transcriptase-polymerase chain reaction; SDS, sodium dodecyl sulfate.

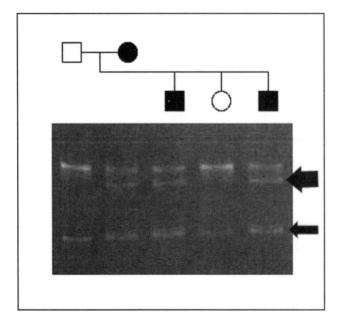

FIGURE 3.22 Single-stranded conformational polymorphism (SSCP) analysis is a method used to rapidly screen a region of DNA for differences among individuals. Depending on its nucleotide sequence, the conformation of each DNA strand varies in a nondenaturing gel, altering its mobility through the gel. This permits differentiation between a normal allele (*small arrow*) and a mutant allele (*large arrow*) in this family with an autosomal dominant disorder.

FIGURE 3.23 Schematic diagram of a microarray. Oligonucleotides are placed or synthesized on a chip. They are then exposed to labeled DNA from a subject. Hybridization will occur only if the oligonucleotide contains a DNA sequence that is complementary to that of the subject's DNA. The fluorescent label marks the location of the complementary oligonucleotide sequence on the chip.

match between two otherwise complementary hybridized DNA sequences (i.e., one strand contains the normal sequence, while the other strand contains an altered base). This **mismatch cleavage** produces fragments of differing lengths that can then be detected on a gel. The mismatch cleavage method has been adapted for use with automated sequencers, greatly increasing the efficiency and speed of this method.

A great deal of progress is now being made in fabricating **DNA microarrays** (also known as **DNA chips**) and using them for detection of mutations (Fig. 3-23 and Color Plate). To make a DNA microarray, oligonucleotides are robotically placed on a small glass slide. A single slide (1 cm^2) can contain hundreds of thousands of different oligonucleotides. These oligonucleotides consist of normal DNA sequences as well as DNA sequences that contain known disease-causing mutations. Fluorescently labeled DNA from a subject is hybridized with the oligonucleotides on the slide to determine whether the DNA hybridizes with the normal or with the mutationcontaining oligonucleotides, and the pattern of hybridization signals is analyzed by a computer.

Another application of DNA microarrays is to determine which genes are being expressed (i.e., transcribed) in a given tissue sample (e.g., from a tumor). mRNA from the tissue is extracted and used as a template to form a complementary DNA sequence, which is then hybridized on the slide with oligonucleotides representing many different genes. The pattern of positive hybridization signals indicates which genes are expressed in the tissue sample. The DNA microarray approach offers the extraordinary speed, miniaturization, and accuracy of computer-based mutation analysis. Tests for specific mutations, an important aspect of genetic diagnosis, are discussed further in Chapter 13. Many techniques can be used to detect mutations at the DNA sequence level. These include Southern blotting, direct DNA sequencing, and electrophoretic techniques such as denaturing gradient gel electrophoresis, single-strand conformation polymorphism analysis, and mismatch cleavage analysis. In addition, DNA microarrays are used in mutation detection and gene expression analysis.

SUGGESTED READINGS

- Aitman TJ (2001) DNA microarrays in medical practice. BMJ 323:611-615
- Berneburg M, Lehmann AR (2001) Xeroderma pigmentosum and related disorders: defects in DNA repair and transcription. Adv Genet 43:71-102
- Chance PF (2001) Molecular basis of hereditary neuropathies. Phys Med Rehabil Clin North Am 12:277-291
- Crow JF (2000) The origins, patterns and implications of human spontaneous mutation. Nat Rev Genet 1:40-47
- Emanuel BS, Shaikh TH (2001) Segmental duplications: an "expanding" role in genomic instability and disease. Nat Rev Genet 2:791-800
- Graham CA, Hill AJ (2001) Introduction to DNA sequencing. Methods Mol Biol 167:1-12
- Green ED (2001) Strategies for the systematic sequencing of complex genomes. Nature Rev Genet 2:573-583
- Heller C (2001) Principles of DNA separation with capillary electrophoresis. Electrophoresis 22:629-643.
- Kwok P-Y (2001) Methods for genotyping single nucleotide polymorphisms. Annu Rev Genomics Hum Genet 2:235-258
- Lindahl T, Wood RD (1999) Quality control by DNA repair. Science 286:1897-1905
- Mentzer WC, Kan YW (2001) Prospects for research in hematologic disorders: sickle cell disease and thalassemia. JAMA 285:640-642

56

- Moses RE (2001) DNA damage processing defects and disease. Annu Rev Genomics Hum Genet 2:41-68
- Mouro I, Colin Y, Cherif-Zahar B, Cartron J, Le Van Kim C (1993) Molecular genetic basis of the human Rhesus blood group system. Nat Genet 5:62-65
- Neel JV (1995) New approaches to evaluating the genetic effects of the atomic bombs. Am J Hum Genet 57:1263-1266.
- Olivieri NF (1999) The β-thalassemias. N Engl J Med 341:99-109
- Robertson KD, Wolffe AP (2000) DNA methylation in health and disease. Nat Rev Genet 1:11-19
- Steinberg MH (1999) Management of sickle cell disease. N Engl J Med 340:1021-1030
- Strachan T, Read AP (1999) Human Molecular Genetics, 2nd ed. Wiley-Liss, New York
- Syvanen AC (2001) Accessing genetic variation: genotyping single nucleotide polymorphisms. Nat Rev Genet 2:930-942
- Tefferi A, Bolander ME, Ansell SM, Wieben ED, Spelsberg TC

(2002) Primer on medical genomics. Part III: Microarray experiments and data analysis. Mayo Clin Proc 77:927-940

- Weatherall DJ (2001) Phenotype-genotype relationships in monogenic disease: lessons from the thalassaemias. Nat Rev Genet 2:245-255
- Yamamoto F, Clausen H, White T, Marken J, Hakomori S (1990) Molecular genetic basis of the histo-blood group ABO system. Nature 345:229-233

INTERNET RESOURCES

- DNA Chips (basic tutorial illustrating technology and applications of DNA microarrays) http://science-education.nih.gov/newsnapshots/TOC_Chips/ toc_chips.html
- Sickle Cell Information Center

http://www.scinfo.org/

STUDY QUESTIONS

1. In the following list, the normal amino acid sequence is given first, followed by sequences that are produced by different types of mutations. Identify the type of mutation most likely to cause each altered amino acid sequence.

Arg
Гhr
Arg

- 2. Missense and transcription (promoter, enhancer, transcription factor) mutations often produce milder disease conditions than do frameshift, donor/acceptor site, and nonsense mutations. Using the globin genes as examples, explain why this is so.
- Individuals who have mutations that lower their production of both α- and β-globin often present with milder disease symptoms than do those who

have mutations lowering the production of only one type of chain. Why?

- 4. Outline the major differences between RSPs, VNTRs, and STRPs. Which of these three types of polymorphism is represented in the autoradiogram in Fig. 3-24?
- 5. α_1 -Antitrypsin deficiency is a disease that arises when both copies of the α_1 -antitrypsin gene are altered by mutations. Liver disease, chronic emphysema, and pulmonary failure can result. One of the mutations that causes α_1 -antitrypsin deficiency occurs in exon 3 of the gene and destroys a recognition site for the restriction enzyme *Bst*EII. RFLP analysis was performed on three members of a family, producing the autoradiogram in Fig. 3-25. Determine the disease status of each individual.

Thalassemia (information on thalassemias and their management) http://sickle.bwh.harvard.edu/menu_thal.html

CHAPTER 4

Autosomal Dominant and Recessive Inheritance

Many important and well-understood genetic diseases are the result of a mutation in a single gene. The 2003 on-line edition of McKusick's *Mendelian Inheritance in Man* (http://www3.ncbi.nlm.nih.gov/Omim/) lists more than 14,000 known **single-gene**, or **monogenic**, traits defined thus far in the human. Of these, more than 13,000 are located on autosomes, 788 are located on the X chromosome, and 43 are located on the Y chromosome. Single-gene traits have been the focus of much of the progress made thus far in medical genetics. In many cases these genes have been mapped to specific chromosome locations, cloned, and sequenced. Such research has led to new and exciting insights not only in genetics but also in the basic pathophysiology of disease.

In this chapter we focus on single-gene disorders caused by mutations on the autosomes. (Single-gene disorders caused by mutations on the sex chromosomes are the subject of Chapter 5). We discuss the patterns of inheritance of these diseases in families, as well as factors that complicate these patterns. When appropriate, the molecular basis for genetic disease processes is addressed. We also discuss the risks of transmitting single-gene diseases to one's offspring, since this is usually an important concern for at-risk couples.

BASIC CONCEPTS OF FORMAL GENETICS

Gregor Mendel's Contributions

Monogenic traits are also known as **mendelian** traits, after Gregor Mendel, the 19th-century Austrian monk who deduced several important genetic principles from his well-designed experiments with garden peas. Mendel studied seven traits in the pea, each of which is determined by a single gene. These traits included attributes such as height (tall versus short plants) and seed shape (rounded versus wrinkled). The variation in each of these traits is caused by the presence of different alleles at individual loci.

Two central principles emerged from Mendel's work.

The first is the **principle of segregation**, which states that sexually reproducing organisms possess genes that occur in pairs and that only one member of this pair is transmitted to the offspring (i.e., it segregates). The prevalent thinking during Mendel's time was that hereditary factors from the two parents are "blended" in the offspring. In contrast, the principle of segregation states that genes remain intact and distinct. An allele for "rounded" seed shape can be transmitted to an offspring in the next generation, which can, in turn, transmit the same allele to its own offspring. If, instead of remaining distinct, genes were somehow blended in offspring, it would be impossible to trace genetic inheritance from one generation to the next. Thus, the principle of segregation was a key development in modern genetics.

Mendel's **principle of independent assortment** was his second great contribution to genetics. This principle states that genes at different loci are transmitted independently. Consider the two loci mentioned previously. One locus can have either the "rounded" or the "wrinkled" allele, and the other can have either the "tall" or the "short" allele. In a reproductive event, a parent transmits one allele from each locus to its offspring. The principle of independent assortment dictates that the allele transmitted at one locus ("rounded" or "wrinkled") has no effect on which allele is transmitted at the other locus ("tall" or "short").

Mendel's experiments also showed that the effects of one allele may mask those of another. He performed **crosses** (matings) between pea plants homozygous for the "tall" gene (i.e., having two identical copies of an allele which we will label H) and plants homozygous for the "short" gene (having two copies of an allele labeled b). This cross, which can produce only heterozygous (Hb) offspring, is illustrated in the **Punnett square** shown in Fig. 4-1. Mendel found that the offspring of these crosses, even though they were heterozygotes, were all tall. This reflects the fact that the H allele is **dominant**, while the b allele is **recessive** (it is conventional to label the dominant allele in upper case and the recessive allele in lower case). The term "recessive" comes from a

FIGURE 4.1 ■ Punnett square illustrating a cross between *HH* and *hh* homozygote parents.

FIGURE 4.2 ■ Punnett square illustrating a cross between two *Hh* heterozygotes.

Latin root meaning "to hide." This describes the behavior of recessive alleles well: in heterozygotes, the consequences of a recessive allele are hidden. Whereas a dominant allele exerts its effect in both the homozygote (*HH*) and the heterozygote (*Hb*), the presence of the recessive allele is detected only when it occurs in homozygous form (*bb*). Thus, short pea plants can be created only by crossing parent plants that each carry at least one *b* allele. An example would be a heterozygote × heterozygote cross, shown in Fig. 4-2.

The principle of segregation describes the behavior of chromosomes in meiosis. The genes on chromosomes segregate during meiosis, and they are transmitted as distinct entities from one generation to the next. When Mendel performed his critical experiments, he had no direct knowledge of chromosomes, meiosis, or genes (indeed, the latter term was not coined until 1909, long after Mendel's death). Although his work was published in 1865 and cited occasionally, its fundamental significance was unrecognized for several decades. Yet Mendel's research, which was eventually replicated by other researchers at the turn of the 20th century, forms the foundation of much of modern genetics.

Mendel's key contributions were the principles of segregation and independent assortment and the definitions of dominance and recessiveness.

Basic Concepts of Probability

Risk assessment is an important part of medical genetics. For example, the physician or genetic counselor commonly informs couples about their risk of producing a child with a particular genetic disorder. In order to understand how such risks are estimated, some basic concepts of probability must be presented. A **probability** is defined as the proportion of times that a specific outcome occurs in a series of events. Thus, we may speak of the probability of obtaining a 4 when a die is tossed, or the probability that a couple will produce a son rather than a daughter. Because probabilities are proportions, they lie between 0 and 1, inclusive.

During meiosis, one member of a chromosome pair is transmitted to each sperm or egg cell. The probability that a given member of the pair will be transmitted is 1/2, and the probability that the other member of the pair will be transmitted is also 1/2. (Note that the probabilities of all possible events must add to 1 for any given experiment.) Since this situation is directly analogous to coin tossing, in which the probabilities of obtaining heads or tails are each 1/2, we will use coin tossing as our illustrative example.

When a coin is tossed repeatedly, the outcome of each toss has no effect on subsequent outcomes. Each event (toss) is said to be **independent**. Even if we have obtained 10 heads in a row, the probability of obtaining heads or tails on the next toss remains 1/2. Similarly, the probability that a parent will transmit one of the two alleles at a locus is independent from one reproductive event to the next.

The independence principle allows us to deduce two fundamental concepts of probability, the **multiplication rule** and the **addition rule**. The multiplication rule states that if two trials are independent, then the probability of obtaining a given outcome in both trials is the product of the probabilities of each outcome. For example, we may wish to know the probability that an individual will obtain heads on both tosses of a fair coin. Because the tosses are independent events, this probability is given by the product of the probabilities of obtaining heads in each individual toss: $1/2 \times 1/2 = 1/4$. Similarly, the probability of obtaining two tails in a row is $1/2 \times 1/2 = 1/4$.

The multiplication rule can be extended for any number of trials. Suppose that a couple wants to know the probability that all three of their planned children will be girls. Since the probability of producing a girl is approximately 1/2, and since reproductive events are independent of one another, the probability of producing three girls is $1/2 \times 1/2 \times 1/2 = 1/8$. However, if the couple has already produced two girls and *then* wants to know the probability of producing a third girl, it is simply 1/2. This is because the previous two events are no longer probabilities; they have actually occurred. Because of independence, these past events have no effect on the outcome of the third event.

The addition rule states that if we want to know the probability of either one outcome or another, we can simply add the respective probabilities together. For example, the probability of getting two heads in a row is $1/2 \times 1/2$, or 1/4, and the probability of getting two tails in a row is the same. The probability of getting either two heads or two tails in a total of two tosses is the sum of the probabilities: 1/4 + 1/4 = 1/2. As another example, imagine that a couple plans to have three children, and they have a strong aversion to having three children all of the same sex. They can be reassured somewhat by knowing that the probability of producing three girls or three boys is only 1/8 + 1/8, or 1/4. The probability that they will have some combination of boys and girls is 3/4, because the sum of the probabilities of all possible outcomes must add to 1.

Basic probability enables us to understand and estimate genetic risks. The multiplication rule is used to estimate the probability that two events will occur together. The addition rule is used to estimate the probability that one event or another will occur.

Gene and Genotype Frequencies

The prevalence of many genetic diseases varies considerably from one population to another. For example, cystic fibrosis, a severe respiratory disorder (Clinical Commentary 4-1), is quite common among Caucasians, affecting approximately 1 in every 2,500 births. It is much rarer in Asian populations. As discussed in Chapter 3, sickle cell disease is common among African-Americans, affecting approximately 1 in 600 births. Yet it is almost never seen among individuals of northern European descent. The concepts of **genotype frequency** and **gene frequency** help us to measure and understand population variation in disease genes.

Imagine that we have typed 200 individuals in a population for the MN blood group. This blood group, which is encoded by a locus on chromosome 2, has two major alleles, labeled M and N. In the MN system, the effects

of both alleles can be observed in the heterozygote. M and N are therefore said to be **codominant**: the heterozygote can be distinguished from both homozygotes. Any individual in the population can have one of three possible genotypes (recall from Chapter 3 that the genotype is one's genetic makeup at a locus): he or she could be homozygous for M (genotype MM), heterozygous (MN), or homozygous for N(NN). After typing each person in our sample, we find the following distribution of genotypes: MM, 64; MN, 120; NN, 16. The genotype frequency is obtained simply by dividing each genotype count by the total number of subjects. The frequency of MM is 64/200, or 0.32; the frequency of MN is 120/200, or 0.60; and the frequency of NN is 16/200, or 0.08. The sum of these frequencies must, of course, equal 1.

The gene frequency for each allele, M and N, can be obtained here by the process of **gene counting**. Each MM homozygote has two M alleles, while each heterozygote has one M allele. Similarly, NN homozygotes have two N alleles, and heterozygotes have one N allele. In the example described, there are

 $(64 \times 2) + 120 = 248 M$ genes $(16 \times 2) + 120 = 152 N$ genes

In total, there are 400 genes at the MN locus (i.e., twice the number of subjects, since each subject has two alleles). To obtain the frequency of M, we divide the number of M alleles by the total number of alleles at that locus: 248/400 = 0.62. Likewise, the frequency of N is 152/400, or 0.38. The sum of the two frequencies must equal 1.

Gene and genotype frequencies specify the proportions of each allele and each genotype, respectively, in a population. Under simple conditions these frequencies can be estimated by direct counting.

The Hardy-Weinberg Principle

The example given for the *MN* locus presents an ideal situation for gene frequency estimation, since, because of codominance, the three genotypes can easily be distinguished and counted. What happens when one of the homozygotes is indistinguishable from the heterozygote (i.e., when there is dominance)? Here the basic concepts of probability can be used to specify a predictable relationship between gene frequencies and genotype frequencies.

Imagine a locus that has two alleles, labeled A and a. Suppose that, in a population, we know the frequency of allele A, which we will call p, and the frequency of allele a, which we will call q. From these data, we wish to determine the expected population frequencies of each genotype, AA, Aa, and aa. We will assume that individuals in the population mate at random with regard to their genotype at this locus (**random mating** is also referred to

-

CLINICAL COMMENTARY 4.1

Cystic Fibrosis

Cystic fibrosis (CF) is one of the most common singlegene disorders in North America, affecting approximately 1 in 2,000 to 1 in 4,000 Caucasian newborns. It is less common in other ethnic groups. The prevalence among African-Americans is about 1 in 15,000 births, and it is less than 1 in 30,000 among Asian-Americans. Approximately 30,000 Americans suffer from this disease. www

CF was first identified as a distinct disease entity in 1938, and its earlier name was "cystic fibrosis of the pancreas." This refers to the fibrotic lesions that develop in the pancreas, one of the principal organs affected by this disorder (Fig. 4-3A,B). Approximately 85% of CF patients have pancreatic insufficiency (i.e., the pancreas is unable to secrete digestive enzymes, resulting in chronic malnutrition). The intestinal tract is also affected, and approximately 10% to 20% of newborns with CF have meconium ileus (a thick plug that blocks the colon). The sweat glands of CF patients are abnormal, resulting in high levels of chloride in the sweat. This is the basis for the sweat chloride test, commonly used in the diagnosis of this disease. More than 95% of males with CF are sterile due to absence or obstruction of the vas deferens. The most serious problem facing CF patients is obstruction of the lungs by heavy, thick mucus. Because this mucus cannot be cleared effectively, the lungs are highly susceptible to infection by bacteria such as Staphylococcus aureus and Pseudomonas aeruginosa. Chronic obstruction and infection lead to destruction of the lung tissue, resulting eventually in death from pulmonary disease in more than 90% of CF patients (see Fig. 4-3 C,D).

As a result of improved antibiotics, aggressive chest physical therapy, and pancreatic enzyme replacement therapy, the survival rate of CF patients has improved substantially during the past three decades. Median survival time is now slightly more than 30 years of age. This disease has highly variable expression, with some patients experiencing relatively little respiratory difficulty and nearly normal survival. Others have much more severe respiratory problems and may survive for only a few years.

The gene responsible for CF was mapped to chromosome 7q in 1985 by investigators in London, Toronto, and Salt Lake City, and it was cloned 4 years later by investigators in Michigan and Toronto. It is a large gene, spanning 250 kb and including 27 exons. This gene encodes a protein product labeled the "cystic fibrosis transmembrane regulator" (CFTR). CFTR forms cyclic AMP-regulated chloride ion channels that span the membranes of specialized epithelial cells, such as those that line the bowel and lung. In addition, CFTR is involved in regulating the transport of sodium ions across epithelial cell membranes.

The fact that CFTR is involved in sodium and chloride transport helps us to understand the multiple effects of mutations at the CF locus. Defective ion transport results in salt imbalances, depleting the airway of water and producing the thick, obstructive secretions seen in the lungs. The pancreas is also obstructed by thick secretions, leading to fibrosis and pancreatic insufficiency. The chloride ion transport defect explains the abnormally high concentration of chloride in the sweat secretions of CF patients: chloride is secreted instead of being reabsorbed by the sweat gland.

DNA sequence analysis has revealed more than 1,000 different mutations at the CF locus. The most common of these is a three-base deletion that results in the loss of a phenylalanine molecule at position 508 of the CFTR protein. This mutation is labeled " Δ F508" (i.e., deletion of phenylalanine at position 508). Δ F508 accounts for nearly 70% of all CF mutations. This mutation, along with several dozen other relatively common ones, is assayed in the genetic diagnosis of CF (see Chapter 13).

FIGURE 4.3 A, Normal pancreas. B, Pancreas from a cystic fibrosis patient, showing infiltration of fat and fibrotic lesions.

Cystic Fibrosis—cont'd

Identification of the specific mutation or mutations that are responsible for CF in a patient can be useful in predicting the course of the disease. For example, the most severe classes of mutations (of which Δ F508 is an example) result in a complete lack of chloride ion channel production or in channels that cannot migrate to the cell membrane. Patients homozygous for these mutations nearly always have pancreatic insufficiency. In contrast, other mutations (e.g., R117H, a missense mutation) result in ion channels that do proceed to the cell membrane but respond poorly to cyclic AMP and consequently do not remain open as long as they should. The phenotype is thus milder: patients who have this mutation are less likely to have pancreatic insufficiency. Patients with other "mild" CFTR mutations tend to have less severe pulmonary disease. The severity of CFTR mutations also helps to determine the probability that a male patient will have congenital bilateral absence of the vas deferens (CBAVD): only those males with very mild mutations escape this condition. The correlation between genotype and phenotype is far from perfect, however, indicating that additional factors (possibly other loci and environmental factors) must influence the expression of the disease. In general, there is a reasonably good correlation between genotype and pancreatic function and a more variable relationship between genotype and pulmonary function.

The ability to identify CFTR mutations has led to a series of population surveys among individuals who have one (heterozygous) or two (homozygous) CFTR mutations but who do not have cystic fibrosis. These surveys demonstrate that such individuals have increased risks for a number of disease conditions, including CBAVD, bronchiectasis (chronic dilatation of the bronchi and abnormal mucus production), and pancreatitis (pancreatic inflammation).

In addition to enhancing our understanding of the pathophysiology of CF, cloning of the CF gene has opened the possibility of gene therapy (see Chapter 13). Research in experimental systems has shown that insertion of normal CF genes into cells with defective chloride ion transport can correct the defect. This and other research findings have led to the initiation of clinical trials in which normal CF genes are inserted into adenoviruses or similar vectors, which then may be introduced into the lungs of CF patients. It is hoped that the adenoviruses will insert the normal gene into airway epithelial cells, inducing normal chloride channel function in these cells. Although there are many difficulties (e.g., the adenoviruses themselves can produce lung infections), gene therapy could eventually lead to a cure for this usually fatal disease.

FIGURE 4.3, cont'd C, Normal lung tissue. **D**, Lung tissue from a cystic fibrosis patient, showing extensive destruction as a result of obstruction and infection. (Courtesy Dr. Edward Klatt, Florida State University School of Medicine.)

С

D

62

as **panmixia**). Thus, the genotype has no effect on mate selection. If men and women mate at random, then the assumption of independence is fulfilled. This allows us to apply the addition and multiplication rules to estimate genotype frequencies.

Suppose that the frequency, *p*, of allele *A* in our population is 0.7. This means that 70% of the sperm cells in the population must have allele *A*, as must 70% of the egg cells. Since the sum of the frequencies *p* and *q* must be 1, 30% of the egg and sperm cells must carry allele *a* (i.e., q = 0.30). Under panmixia, the probability that a sperm cell carrying *A* will unite with an egg cell carrying *A* is given by the product of the gene frequencies: $p \times p = p^2 = 0.49$ (multiplication rule). This is the probability of producing an offspring with the *AA* genotype. Using the same reasoning, the probability of producing an offspring with the *aa* genotype is given by $q \times q = q^2 = 0.09$.

What about the frequency of heterozygotes in the population? There are two ways a heterozygote can be formed. Either a sperm cell carrying A can unite with an egg carrying a, or a sperm cell carrying a can unite with an egg carrying A. The probability of each of these two outcomes is given by the product of the gene frequencies, pq. Since we want to know the overall probability of obtaining a heterozygote (i.e., the first event or the second), we can apply the addition rule, adding the probabilities to obtain a heterozygote frequency of 2pq. These operations are summarized in Fig. 4-4. The relationship between gene frequencies and genotype frequencies was established independently by two men, Godfrey Hardy and Wilhelm Weinberg, and is termed the **Hardy-Weinberg principle**.

As already mentioned, this principle can be used to estimate gene and genotype frequencies when dominant homozygotes and heterozygotes are indistinguishable. This is often the case for recessive diseases such as cystic fibrosis. Only the affected homozygotes, with genotype aa, are distinguishable. The Hardy-Weinberg principle tells us that the frequency of *aa* should be q^2 . For cystic fibrosis in the Caucasian population, $q^2 = 1/2,500$ (i.e., the prevalence of the disease among newborns). To estimate q, we take the square root of both sides of this equation: $q = \sqrt{1/2,500} = 1/50 = 0.02$. Since p + q = 1, p = 0.98. We can then estimate the genotype frequencies of AA and Aa. The latter genotype, which represents heterozygous carriers of the disease allele, is of particular interest. Because p is almost 1.0, we can simplify the calculation by rounding p up to 1.0 without a significant loss of accuracy. We then find that the frequency of heterozygotes is 2pq = 2q= 2/50 = 1/25. This tells us something rather remarkable about cystic fibrosis and about recessive diseases in general. While the incidence of affected homozygotes is only 1 in 2,500, heterozygous carriers of the disease gene are much more common (1 in 25 individuals). The vast majority of recessive disease alleles, then, are effectively "hidden" in the genomes of heterozygotes.

FIGURE 4.4 The Hardy-Weinberg principle. The population frequencies of genotypes *AA*, *Aa*, and *aa* are predicted on the basis of gene frequencies (p and q). It is assumed that the gene frequencies are the same in males and females.

relationship between gene frequencies and genotype frequencies. It is useful in estimating gene frequencies from disease prevalence data and in estimating the incidence of heterozygous carriers of recessive disease genes.

The Concept of Phenotype

The term "genotype" has been defined as an individual's genetic constitution at a locus. The **phenotype** is what is actually observed physically or clinically. Genotypes do not uniquely correspond to phenotypes. Individuals with two different genotypes, a dominant homozygote and a heterozygote, may have the same phenotype. An example is cystic fibrosis. Conversely, the same genotype may produce different phenotypes in different environments. An example is the recessive disease phenylketonuria (PKU), which is seen in approximately 1 of every 10,000 Caucasian births. Mutations at the locus encoding the metabolic enzyme phenylalanine hydroxylase render the homozygote unable to metabolize the amino acid phenylalanine. While babies with PKU are normal at birth, their metabolic deficiency produces a buildup of phenylalanine and various toxic metabolites. This is highly destructive to the central nervous system, and it eventually produces severe mental retardation. It has been estimated that babies with untreated PKU lose, on average, 1 to 2 IQ points per week during the first year of life. Thus, the PKU genotype can produce a severe disease phenotype. However, it is easy to screen for PKU at birth (see Chapter 13), and the disease can be avoided by initiating a low-phenylalanine diet within 1 month after birth. The individual still has the PKU genotype, but the phenotype of mental retardation has been profoundly altered by environmental modification. www

Under panmixia, the Hardy-Weinberg principle specifies the

This example shows that the phenotype is the result of the *interaction* of genotype and environmental factors. It should be emphasized that "environment" can include the genetic environment (i.e., genes at other loci whose products may interact with a specific gene or its product).

The phenotype, which is physically observable, results from the interaction of genotype and environment.

Basic Pedigree Structure

The **pedigree** is one of the most commonly used tools in medical genetics. It illustrates the relationships among

FIGURE 4.5 Basic pedigree notation.

family members, and it shows which family members are affected or unaffected by a genetic disease. Typically, an arrow denotes the **proband**, the first individual diagnosed in the pedigree. The proband is sometimes also referred to as the **index case** or **propositus** (**proposita** for a female). Fig. 4-5 describes the features of pedigree notation.

When discussing relatives in families, one often refers to degrees of relationship. First-degree relatives are those who are related at the parent-offspring or sibling (brother and sister) level. Second-degree relatives are those who are removed by one additional generational "step" (e.g., grandparents and their grandchildren, uncles or aunts and their nieces or nephews). Continuing this logic, third-degree relatives would include, for example, one's first cousins, great-grandchildren, and so on.

AUTOSOMAL DOMINANT INHERITANCE

Characteristics of Autosomal Dominant Inheritance

Autosomal dominant diseases are seen in roughly 1 of every 200 individuals (see Table 1-4 in Chapter 1). Individually, each autosomal dominant disease is rather rare in populations, however, with the most common ones having gene frequencies of about 0.001. For this reason, matings between two individuals who are both affected by the same autosomal dominant disease are uncommon. Most often, affected offspring are produced by the union of a normal parent with an affected heterozygote. The Punnett square in Fig. 4-6 illustrates such a mating. The affected parent can pass either a disease gene or a normal gene to his or her children. Each

FIGURE 4.6 Punnett square illustrating the mating of an unaffected individual (*aa*) with an individual who is heterozygous for an autosomal dominant disease gene (*Aa*). The genotypes of affected offspring are shaded.

event has a probability of 0.5. Thus, on the average, half of the children will be heterozygotes and will express the disease, while half will be normal homozygotes.

Postaxial polydactyly, the presence of an extra digit next to the fifth digit (Fig. 4-7), can be inherited as an autosomal dominant trait. Let A symbolize the gene for polydactyly, and let a symbolize the normal allele. An idealized pedigree for this disease is shown in Fig. 4-8. This pedigree illustrates several important characteristics of autosomal dominant inheritance. First, the two sexes exhibit the trait in approximately equal proportions, and males and females are equally likely to transmit the trait to their offspring. This reflects the fact that this is an autosomal disease (as opposed to a disease caused by an X chromosome mutation, in which these proportions typically differ). Second, there is no skipping of generations: if an individual has polydactyly, one parent must also have it. This leads to a vertical transmission pattern, in which the disease phenotype is usually seen in one generation after another. Also, if neither parent has the trait, none of the children will have it. Third, father-son transmission of the disease gene is observed. Although father-son transmission is not required to establish autosomal dominant inheritance, its presence in a pedigree excludes certain other modes of inheritance (particularly X-linked inheritance; see Chapter 5). Finally, as we have already seen, an affected heterozygote transmits the trait to approximately half of his or her children. However, since gamete transmission, like coin tossing, is subject to chance fluctuations, it is possible that all or none of the children of an affected parent will have the trait. When large numbers of matings of this type are studied, the proportion of affected children will closely approach 1/2. www

tions, and roughly equal numbers of affected males and females. Father-son transmission may be observed.

Recurrence Risks

Parents at risk for producing children with a genetic disease are often concerned with the question: What is the chance that our future children will have this disease? When one or more children have already been born with a genetic disease, the parents are given a recurrence risk. This is the probability that subsequent children will also have the disease. When the parents have not yet had children but are known to be at risk for having children with a genetic disease, an occurrence risk can be given. If one parent is affected by an autosomal dominant disease (heterozygote) and the other is normal, the occurrence and recurrence risks for each child are 1/2. It is important to keep in mind that each birth is an independent event, as in the coin-tossing examples. Thus, even if the parents have already had a child with the disease, their recurrence risk remains 1/2. Even if they have had several children, all affected (or all unaffected) by the disease, the law of independence dictates that the probability that their next child will have the disease is still 1/2. Although this concept may seem intuitively obvious, it is frequently misunderstood by the lay population. Further aspects of communicating risks to families are discussed in Chapter 14.

The recurrence risk for an autosomal dominant disorder is 50%. Because of independence, this risk remains constant no matter how many affected or unaffected children are born.

FIGURE 4.7 \blacksquare Postaxial polydactyly. An extra digit is located next to the fifth digit.

FIGURE 4.8 A pedigree illustrating the inheritance pattern of postaxial polydactyly, an autosomal dominant disorder. Affected individuals are represented by shading.

Autosomal dominant inheritance is characterized by vertical transmission of the disease phenotype, a lack of skipped genera-

FIGURE 4.9 Punnett square illustrating the mating of two heterozygous carriers of an autosomal recessive gene. The genotype of the affected offspring is shaded.

AUTOSOMAL RECESSIVE INHERITANCE

Like autosomal dominant diseases, autosomal recessive diseases are fairly rare in populations. As shown previously, heterozygous carriers for recessive disease genes are much more common than affected homozygotes. Consequently, the parents of individuals affected with autosomal recessive diseases are usually both heterozygous carriers. As the Punnett square in Fig. 4-9 demonstrates, one fourth of the offspring of two heterozygotes will be normal homozygotes, half will be phenotypically normal heterozygous carriers, and one fourth will be homozygotes affected with the disease (on average).

Characteristics of Autosomal Recessive Inheritance

Fig. 4-10 is a pedigree showing the inheritance pattern of an autosomal recessive form of albinism that results from mutations in the gene that encodes tyrosinase, a tyrosinemetabolizing enzyme.* The resulting tyrosinase deficiency creates a block in the metabolic pathway that normally leads to the synthesis of melanin pigment. Consequently, the affected individual has very little pigment in the skin, hair, and eyes (see Color Plate). Because melanin is also required for the normal development of the optic fibers, albinos may also display nystagmus (rapid uncontrolled eye movement), strabismus (deviation of the eye from its normal axis), and reduced visual acuity. The pedigree demonstrates most of the important criteria for distinguishing autosomal recessive inheritance. These criteria, along with those of autosomal dominant inheritance, are summarized in Table 4-1.

First, unlike autosomal dominant diseases, in which

^{*}This form of albinism, termed "tyrosinase-negative" oculocutaneous albinism (OCA1), is distinguished from a second, milder form termed "tyrosinase-positive" oculocutaneous albinism (OCA2). The latter form is typically caused by mutations in a gene on chromosome 15 (the "P" gene) whose protein product is thought to affect pH levels in melanosomes.

FIGURE 4.10 Pedigree showing the inheritance pattern of tyrosinase-negative albinism, an autosomal recessive disease. Consanguinity in this pedigree is denoted by a double bar connecting the parents of the affected individuals.

Attribute	Autosomal dominant	Autosomal recessive
Usual recurrence risk	50%	25%
Transmission pattern	Vertical; disease phenotype seen in generation after generation	Horizontal; disease phenotype seen in multiple siblings, but usually not in earlier generations
Sex ratio	Equal number of affected males and females (usually)	Equal number of affected males and females (usually)
Other	Father-son transmission of disease gene is possible	Consanguinity is sometimes seen, especially for rare recessive diseases

TABLE 4.1 A Comparison of the Ma	r Attributes of Autosomal Dominant and Autoson	al Recessive Inheritance Patterns

the disease phenotype is seen in one generation after another, autosomal recessive diseases are usually observed in one or more siblings but not in earlier generations. Second, as in autosomal dominant inheritance, males and females are affected in equal proportions. Third, on average, one fourth of the offspring of two heterozygous carriers will be affected with the disorder. Finally, **consanguinity** is present more often in pedigrees involving autosomal recessive diseases than in those involving other types of inheritance (see Fig. 4-10). The term *consanguinity* (Latin, "with blood") refers to the mating of related individuals. It is sometimes a factor in recessive disease because related individuals are more likely to share the same disease genes. Consanguinity is discussed in greater detail later in this chapter. www

Autosomal recessive inheritance is characterized by clustering of the disease phenotype among siblings, but the disease is not usually seen among parents or other ancestors. Equal numbers of affected males and females are usually seen, and consanguinity may be present.

Recurrence Risks

As already discussed, the most common mating type seen in recessive disease involves two heterozygous carrier parents. This reflects the relative commonness of heterozygous carriers and the fact that many autosomal recessive diseases are severe enough that affected individuals are less likely to become parents.

The Punnett square in Fig. 4-9 demonstrates that one fourth of the offspring from this mating will be homozygous for the disease gene and therefore affected. The recurrence risk for the offspring of carrier parents is then 25%. As before, these are *average* figures. In any given family chance fluctuations are likely, but a study of a large number of families would yield a figure quite close to this proportion.

Occasionally, a carrier of a recessive disease gene mates with an individual who is homozygous for the disease gene. In this case, roughly half of their children will be affected, and half will be heterozygous carriers. The recurrence risk is 50%. Because this pattern of inheritance mimics that of an autosomal dominant trait, it is sometimes referred to as **quasidominant** inheritance. With studies of extended pedigrees in which carrier matings are observed, quasidominant inheritance can be distinguished from true dominant inheritance.

When two individuals affected by a recessive disease mate, all of their children must also be affected. This observation helps to distinguish recessive from dominant inheritance, since two parents who are both affected by a dominant disease will almost always both be heterozygotes, and thus one fourth of their children will be unaffected.

The recurrence risk for autosomal recessive diseases is usually 25%. Quasidominant inheritance, with a recurrence risk of 50%, is seen when an affected homozygote mates with a heterozygote.

"Dominant" Versus "Recessive": Some Cautions

The preceding discussion has treated dominant and recessive disorders as though they belong in rigid categories. However, these distinctions are becoming less strict as our understanding of these diseases increases. Many (probably most) of the so-called dominant diseases are actually more severe in affected homozygotes than in heterozygotes. An example is achondroplasia, an autosomal dominant disorder in which heterozygotes have reduced stature (Fig. 4-11). Heterozygotes enjoy a nearly normal life span, estimated to be only 10 years less than average. Affected homozygotes are much more severely affected and usually die in infancy from respiratory failure (see Chapter 10 for further discussion of achondroplasia). www

Although heterozygous carriers of recessive disease genes are clinically normal, the effects of recessive genes can often be detected in heterozygotes because they result in reduced levels of enzyme activity. This is usually the basis for biochemical carrier detection tests (see

FIGURE 4.11 Achondroplasia. This girl has short limbs relative to trunk length. She also has a prominent forehead, low nasal root, and redundant skin folds in the arms and legs.

Chapter 13). A useful and valid way to distinguish dominant and recessive disorders is that heterozygotes are clinically affected in most cases of dominant disorders, whereas they are almost always clinically normal in recessive disorders.

While the distinction between dominant and recessive diseases is not rigid, a dominant disease allele will produce disease in a heterozygote, whereas a recessive disease allele will not.

Another caution is that a disease may be inherited in autosomal dominant fashion in some cases and in autosomal recessive fashion in others. Familial isolated growth hormone deficiency (IGHD), another disorder that causes reduced stature, is one such disease. DNA sequencing of a pituitary growth hormone gene on chromosome 17 (GH1) has revealed a number of different mutations that can produce IGHD. *Recessive* IGHD can be caused by nonsense and splice site mutations that apparently alter the protein product (pituitary growth hormone) such that it cannot proceed to the secretory granules of the cell (cytoplasmic structures that secrete growth hormone and other products from the cell). Because they have one normal chromosome, heterozygotes still produce half of the normal amount of growth hormone. This is sufficient for normal stature. Homozygotes for these mutations produce no GH1 product and have reduced stature.

How, then, can a mutation at this locus produce *dominant* inheritance? In one form of dominantly inherited IGHD, a splice site mutation deletes the third exon of the *GH1* gene, producing a protein product that does proceed to the secretory granules. Here, the abnormal GH1 product encoded by the mutated chromosome is thought to form disulfide bonds with the normal product encoded by the normal chromosome. Acting as a dominant negative (see Chapter 3), the abnormal molecules disable the normal growth hormone molecules, resulting in greatly reduced production of GH1 product and thus reduced stature.

Another example is given by β -thalassemia, a condition discussed in Chapter 3. Although the great majority of B-thalassemia cases occur as a result of autosomal recessive mutations, a small proportion inherited in autosomal dominant fashion. Some of these are caused by nonsense or frameshift mutations that terminate translation in exon 3 or in downstream exons. The resulting messenger RNA (mRNA) proceeds to the cytoplasm and produces unstable *β*-globin chains. In heterozygotes, these abnormal chains exert a dominant negative effect on the normal β -globin chains produced by the normal allele (see Chapter 3). In contrast, frameshift or nonsense mutations that result in termination of translation in exons 1 or 2 of the gene result in very little abnormal mRNA in the cytoplasm, leaving the product of the normal allele intact. Hence, the heterozygote is unaffected.

These examples illustrate some of the complexities involved in applying the terms "dominant" and "recessive." They also show how molecular analysis of a gene can help to explain important disease features.

In some cases, a disease may be inherited in either autosomal dominant or autosomal recessive fashion, depending on the nature of the mutation that alters the gene product.

A final caution is that the terms "dominant" and "recessive," strictly speaking, apply to traits, not genes. To see why, consider the sickle cell mutation, discussed in Chapter 3. Homozygotes for this mutation develop sickle cell disease. Heterozygotes, who are said to have sickle cell *trait*, are usually clinically normal. However, a heterozygote has an increased risk for splenic infarctions at very high altitude. Is the mutant gene then dominant or recessive? Clearly, it makes more sense to refer to sickle cell *disease* as recessive and sickle cell *trait* as dominant. Nonetheless, it is common (and often convenient) to apply the terms "dominant" and "recessive" to genes.

FACTORS THAT MAY COMPLICATE INHERITANCE PATTERNS

The inheritance patterns described previously for postaxial polydactyly and albinism are quite straightforward. However, many autosomal diseases display more complex patterns. Some of these complexities are described next.

New Mutation

If a child has been born with a genetic disease and there is no history of the disease in the family, it is possible that the disease is the product of a new mutation (this is especially likely if the disease in question is autosomal dominant). That is, the gene transmitted by one of the parents underwent a change in DNA resulting in a mutation from a normal to a disease-causing allele. The genes at this locus in the parent's other germ cells would still be normal. In this case the recurrence risk for the parents' subsequent offspring would not be elevated above that of the general population. However, the offspring of the affected child may have a substantially elevated occurrence risk (e.g., it would be 50% for an autosomal dominant disease). A large proportion of the observed cases of many autosomal dominant diseases are the result of new mutations. For example, it is estimated that 7/8 of all cases of achondroplasia are caused by new mutations, while only 1/8 are transmitted by achondroplastic parents. This is primarily because the disease tends to limit the potential for reproduction. In order to provide accurate risk estimates, it is essential to know whether an observed case is due to an inherited disease gene or a new mutation. This can be done only if an adequate family history has been taken.

New mutations are a frequent cause of the appearance of a genetic disease in an individual with no previous family history of the disorder. The recurrence risk for the individual's siblings is very low, but it may be substantially elevated for the individual's offspring.

Germline Mosaicism

Occasionally, two or more offspring may present with an autosomal dominant or X-linked disease when there is no family history of the disease. Since mutation is a rare event, it is unlikely that this situation would be due to multiple mutations in the same family. The mechanism most likely to be responsible is termed **germline mosaicism** (mosaicism describes the presence of more than one genetically distinct cell line in the body). During the embryonic development of one of the parents, a mutation occurred that affected all or part of the germ line but few or none of the somatic cells of the embryo (Fig. 4-12). Thus, the parent carries the mutation in his or her germ line but does not actually express the disease because the mutation is absent in other cells of the body. As a result, the parent can transmit the mutation to multiple offspring. Although this phenomenon is relatively rare, it can have significant effects on recurrence risks when it does occur.

Germline mosaicism has been studied extensively in the lethal perinatal form of osteogenesis imperfecta (OI type II; see Chapter 2), which is caused by mutations in the type 1 procollagen genes. The fact that unaffected parents sometimes produced multiple offspring affected with this disease led to the conclusion that type II OI was an autosomal recessive trait. This was disputed by studies in which the polymerase chain reaction (PCR) technique was used to amplify DNA from the sperm of a father of two children with type II OI. This DNA was compared with DNA extracted from his somatic cells (skin fibroblasts). Although procollagen mutations were not detected in the fibroblast DNA, they were found in

FIGURE 4.12 A mutation occurs in one cell of the developing embryo. All descendants of that cell have the same mutation, resulting in mosaicism. If the first mutated cell is part of the germline lineage, then germline mosaicism results.

approximately 1 of every 8 sperm cells. This was a direct demonstration of germline mosaicism in this individual. Although germline mosaicism has thus been demonstrated for type II OI, most non-inherited cases (approximately 95%) are thought to be caused by isolated new mutations, and a few cases of true autosomal recessive inheritance have also been documented.

Other diseases in which germline mosaicism has been observed include achondroplasia, neurofibromatosis type 1, Duchenne muscular dystrophy, and hemophilia A. Germline mosaicism is relatively more common in the latter two diseases, both of which are discussed further in Chapter 5. It has been estimated that germline mosaicism accounts for up to 15% of Duchenne muscular dystrophy cases and 20% of hemophilia A cases in which there is no previous family history.

Germline mosaicism occurs when all or part of a parent's germ line is affected by a disease mutation but the somatic cells are not. It elevates the recurrence risk for future offspring of the mosaic parent.

Reduced Penetrance

Another important characteristic of many genetic diseases is reduced **penetrance**: an individual who has the genotype for a disease may not exhibit the disease phenotype at all, even though he or she can transmit the disease gene to the next generation. Retinoblastoma, a malignant eye tumor (Clinical Commentary 4-2), is a good example of an autosomal dominant disorder in which reduced penetrance is seen. The transmission pattern of this disorder is illustrated in Fig. 4-13. Family studies have shown that about 10% of the **obligate car**- **riers** of the retinoblastoma susceptibility gene (i.e., those who have an affected parent and affected children and therefore must themselves carry the gene) do not have the disease. The penetrance of the gene is then said to be 90%. Penetrance rates are usually estimated by examining a large number of families and determining what proportion of the obligate carriers (or obligate homozygotes, in the case of recessive disorders) develop the disease phenotype. www

Reduced penetrance describes the situation in which individuals who have a disease-causing genotype do not develop the disease phenotype.

Age-Dependent Penetrance

While some genetic diseases are expressed at birth or shortly afterward, many others do not become apparent until well into adulthood. A delay in the age of onset of a genetic disease is known as age-dependent penetrance. One of the best-known examples is Huntington disease, a neurological disorder whose main features are progressive dementia and increasingly uncontrollable movements of the limbs (Clinical Commentary 4-3). The latter feature is known as "chorea" (from the Greek word for dance, khoreia), and the disease is sometimes called Huntington chorea. This autosomal dominant disorder is named after Dr. George Huntington, who first described the disease in 1872. Symptoms are not usually seen until age 30 years or later (Fig. 4-15). Thus, those who develop the disease often have children before they are aware that they carry the gene. If the disease were present at birth, nearly all affected persons would die before reaching reproductive age, and the frequency of the gene in the

FIGURE 4.13 Pedigree illustrating the inheritance pattern of retinoblastoma, a disorder with reduced penetrance. The unaffected obligate carrier is lightly shaded, and affected individuals are heavily shaded.

1 -

CLINICAL COMMENTARY 4.2

Retinoblastoma

Retinoblastoma (Fig. 4-14) is the most common childhood eye tumor, affecting approximately 1 in 20,000 children. The tumor begins during embryonic development, when retinal cells are actively dividing and proliferating. It nearly always presents clinically by the age of 5 years.

Approximately 40% of retinoblastoma cases are familial (the remainder are sporadic and are not transmitted from one generation to the next). Before this gene was mapped to chromosome 13 and subjected to molecular analyses in the early 1980s, the cause of reduced penetrance in familial retinoblastoma was the subject of much speculation. The ability to examine changes in DNA near the disease gene finally explained the mechanism responsible for the reduced penetrance. Briefly, an affected individual will transmit the disease gene to half of his or her children, on average. Thus, the offspring inherits a mutation on one member of the chromosome 13 pair in every cell of his or her body. However, this is not sufficient to cause tumor formation (if it were, every cell in the body would give rise to a tumor). A second event must occur in the same region of the normal, homologous chromosome 13 in a developing retinal cell of the fetus to initiate a tumor (this "two-hit" process is discussed further in Chapter 11). The second event, which can be considered a somatic mutation, has a relatively low probability of occurring. However, there are at least 1 million retinal cells in the developing fetus, each representing a potential "target" for the event. Usually, a fetus who has inherited a copy of the retinoblastoma disease gene will experience a second "hit" in several different retinal cells, giving rise to several tumors. Familial retinoblastoma is thus usually multifocal (consisting of several tumor foci) and bilateral (affecting both eyes). Since the second hits are random events, a small proportion of individuals who

inherit the disease allele never experience a second hit in any retinal cell. They do not develop a retinoblastoma. The requirement for a second hit thus explains the reduced penetrance seen in this disorder.

The retinoblastoma gene has been cloned and sequenced, and the function of its gene product, pRb, has been studied extensively. A major function of pRb, when hypophosphorylated, is to bind and inactivate E2F, a nuclear transcription factor. The cell requires active E2F to proceed from the G1 to the S phase of mitosis. By inactivating E2F, pRb applies a "brake" to the cell cycle. When cell division is required, pRb is phosphorylated by cyclin-dependent kinases (see Chapter 2). Consequently, E2F is released by pRb and thus activated. A mutation in pRb can cause permanent loss of the E2F-binding capacity, and the cell, having lost its brake, will undergo uncontrolled proliferation leading to a tumor. Because of its controlling effect on the cell cycle, the Rb gene belongs to a class of genes known as tumor suppressors (see Chapter 11).

If untreated, retinoblastomas can grow to considerable size. Fortunately, these tumors are now usually detected and treated before they become large. If found early enough through ophthalmological examination, the tumor may be treated successfully with radiation, cryotherapy (freezing), or laser photocoagulation. In more advanced cases, enucleation (removal) of the eye is necessary. Because individuals with familial retinoblastoma have inherited a chromosome 13 mutation in all cells of their body, they are also susceptible to other types of cancers later in life. In particular, about 15% of those who inherit the mutation later develop osteosarcomas (malignant bone tumors). Careful monitoring for subsequent tumors and avoidance of agents that could produce a second hit (e.g., radiation) are thus important aspects of management for the patient with familial retinoblastoma.

FIGURE 4.14 Bilateral retinoblastoma, showing presence of neoplastic tissue. (From Rosai J [1996] Ackerman's Surgical Pathology, 8th ed. Mosby, St Louis.)

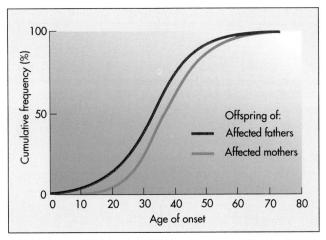

FIGURE 4.15 Distribution of the age of onset for Huntington disease. The age of onset tends to be somewhat earlier when the affected parent is the father. (Data from Conneally PM [1984] Am J Hum Genet 36:520.)

population would be much lower. Delaying the age of onset of the disease thus reduces natural selection against a disease gene, increasing its frequency in a population. Age-dependent penetrance can cause difficulties in deducing the mode of inheritance of a disease because it is not possible to determine until later in life whether an individual carries the disease gene. www

A person whose parent has Huntington disease has a 50% chance of inheriting the disease gene. Until recently, this individual would be confronted with a torturous question: Should I have children, knowing that there is a 50% chance that I might have this disease gene and pass it to half of my children? With the identification of the mutation responsible for Huntington disease, it is now possible for at-risk individuals to know with a high degree of certainty whether they carry a disease-causing allele.

As mentioned previously, a number of important genetic diseases exhibit age-dependent penetrance. These include hemochromatosis, a potentially fatal recessive disorder of iron storage (see Chapter 7); familial Alzheimer disease (see Chapter 12); and many inherited cancers, including autosomal dominant breast cancer.*

Variable Expression

A similar complication is variable expression. Here, the penetrance may be complete, but the severity of the disease can vary greatly. A well-studied example of variable expression in an autosomal dominant disease is neurofibromatosis type 1, or von Recklinghausen disease (after the German physician who described the disorder in 1882). Clinical Commentary 4-4 provides further discussion of this disorder. A parent with mild expression of the disease—so mild that he or she is not aware of it—can transmit the gene to a child, who may have severe expression. As with reduced penetrance, variable expression provides a mechanism for disease genes to survive at higher frequencies in populations. www

It should be emphasized that penetrance and expression are distinct entities. Penetrance is an all-or-none phenomenon: one either has the disease phenotype or does not. Variable expression refers to the *extent* of expression of the disease phenotype.

The causes of variable expression usually are not known. Environmental effects can sometimes be responsible: in the absence of a certain environmental factor, the gene is expressed with diminished severity or not at all. Another possible cause is the interaction of other genes, called modifier genes, with the disease gene. An example of a human modifier gene is a locus on chromosome 19 that appears to influence whether meconium ileus develops in individuals with cystic fibrosis (see Clinical Commentary 4-1). Finally, as the molecular basis of mutation becomes better understood, it is clear that some cases of variable expression are caused by different types of mutations (i.e., different alleles) at the same disease locus. This is termed allelic heterogeneity. In some cases, clinically distinct diseases may be the result of allelic heterogeneity, as in the β -globin mutations that can cause either sickle cell disease or various βthalassemias.

Osteogenesis imperfecta is one disease in which genetic studies have helped to explain variable expression. Mutations that affect amino acids near the carboxyl terminal of the procollagen molecule generally cause more severe consequences than do mutations affecting the molecule near its amino terminal. It is also well documented that affected members of the same family, having the same mutation, can nevertheless manifest large differences in disease severity. This may be a consequence of different genetic "backgrounds" (i.e., modifier genes) in related individuals. And nongenetic events, such as an accidental bone fracture, can influence the severity of the disorder. Once a fracture occurs, casting and immobilization lead to a loss of bone mass, which further predisposes the patient to future fractures. Thus, a chance environmental event (e.g., trauma leading to a fracture in a baby during delivery) can cause a significant increase in severity of expression. Osteogenesis imperfecta thus provides examples of each factor thought to influence variable expression: environmental events, modifier genes, and allelic heterogeneity.

Age-dependent penetrance is observed in many genetic diseases. It complicates the interpretation of inheritance patterns in families.

^{*}Epidemiological studies indicate that about 5% of breast cancer cases in the United States are caused by genes inherited in autosomal dominant fashion. See Chapters 11 and 12 for further discussion.

Huntington Disease

Huntington disease (HD) affects approximately 1 in 20,000 persons of European descent. It is substantially less common among Japanese and Africans. The disorder usually presents between the ages of 30 and 50 years, although it has been observed as early as 2 years of age and as late as 80 years of age.

HD is characterized by a progressive loss of motor control and by psychiatric problems, including dementia and affective disorder. There is a substantial loss of neurons in the brain, detectable by imaging techniques such as magnetic resonance imaging (MRI). Decreased glucose uptake in the brain, an early sign of the disorder, can be demonstrated by positron-emission tomography (PET). Although many parts of the brain are affected, the area most noticeably damaged is the corpus striatum. In some patients the disease leads to a loss of 25% or more of total brain weight (Fig. 4-16).

The clinical course of HD is protracted. Typically, the interval from initial diagnosis to death is approximately 15 years. As in many neurological disorders, patients with HD experience difficulties in swallowing; aspiration pneumonia is the most common cause of death. Cardiorespiratory failure and subdural hematoma (due to head trauma) are other frequent causes of death. The suicide rate among HD patients is several times higher than that in the general population. Treatment includes the use of drugs such as benzodiazepines to help control the choreic movements. Affective disturbances, which are seen in nearly half of the patients, are sometimes controlled with antipsychotic drugs and tricyclic antidepressants. Although these drugs help to control some of the symptoms of HD, there is currently no way to alter the outcome of the disease.

HD is notable in that affected homozygotes appear to display exactly the same clinical course as heterozygotes (in contrast to most dominant disorders, in which homozygotes are more severely affected). This attribute, and the fact that mouse models in which one copy of the gene is inactivated are perfectly normal, support the hypothesis that the mutation causes a gain of function (see Chapter 3). In more than 95% of cases, the mutation is inherited from an affected parent. HD has the distinction of being the first genetic disease mapped to a specific chromosome using an RFLP marker. James Gusella and colleagues mapped the disease gene to a region on the distal short arm of chromosome 4 in 1983.

After 10 years of work by a large number of investigators, the disease gene was cloned. DNA sequence analysis showed that the mutation is a CAG expanded repeat (see Chapter 3) located within the coding portion of the gene. The normal repeat number ranges from 10 to 26. Individuals with 27 to 35 repeats are unaffected but are more likely to transmit a still larger number of repeats to their offspring. The inheritance of 36 or more copies of the repeat can produce disease, although incomplete penetrance of the disease phenotype is seen in those who have 36 to 41 repeats. As in many disorders caused by trinucleotide repeat expansion, a larger number of repeats is correlated with earlier age of onset of the disorder. Also, there is a tendency for greater repeat expansion when the father, rather than the mother, transmits the disease gene. This helps to explain the difference in ages of onset for maternally and paternally transmitted disease seen in Fig. 4-15. In particular, 80% of cases with onset before 20 years of age (termed "juvenile Huntington disease") are paternally transmitted, and these cases are accompanied by especially large repeat expansions. It remains to be seen why the degree of repeat instability in the HD gene is greater in paternal transmission than in maternal transmission.

Cloning of the HD gene led quickly to the identification of the gene product, huntingtin. This protein is involved in the transport of vesicles in cellular secretory pathways. In addition, there is evidence that huntingtin is necessary for the normal production of brain-derived neurotrophic factor. The CAG repeat expansion produces a lengthened series of glutamine residues near huntingtin's amino terminal. Although the precise role of the expanded glutamine tract in disease causation is unclear, recent studies show that it leads to a buildup of toxic protein aggregates within and near neuronal nuclei. This buildup is associated with the early neuronal death that is characteristic of HD.

FIGURE 4.16 Cross section of the brain of an adult with Huntington disease, illustrating marked striatal atrophy. (Courtesy Dr. Jeanette Townsend, University of Utah Health Sciences Center.)

Neurofibromatosis: A Disease with Highly Variable Expression

Neurofibromatosis type 1 (NF1) (Fig. 4-17) is one of the most common autosomal dominant disorders, affecting approximately 1 in 3,000 individuals. It offers a good example of variable expression in a genetic disease. Some patients have only a few café-au-lait spots (from the French for "coffee with milk," describing the color of the hyperpigmented skin patches), Lisch nodules (benign growths on the iris), and perhaps neurofibromas (nonmalignant peripheral nerve tumors). These individuals are often unaware that they have the condition. Other patients have a much more severe expression of the disorder, including hundreds to thousands of neurofibromas, optic gliomas (benign tumors of the optic nerve), learning disabilities, hypertension, scoliosis (lateral curvature of the spine), and malignancies (e.g., malignant peripheral nerve sheath tumors, which can arise from plexiform neurofibromas). Fortunately, about two thirds of patients have only a mild cutaneous involvement. Fewer than 10% develop malignancies as a result of the disorder. Expression can vary significantly within the same family: a mildly affected parent can produce a severely affected offspring.

been developed. Two or more of the following must be present:

- 1. Six or more café-au-lait spots greater than 5 mm in diameter in prepubertal subjects and greater than 15 mm in postpubertal subjects
- 2. Freckling in the armpits or groin area
- 3. Two or more neurofibromas of any type or one plexiform neurofibroma (i.e., an extensive growth that occurs along a large nerve sheath)
- 4. Two or more Lisch nodules
- 5. Optic glioma
- 6. Distinctive bone lesions, particularly an abnormally formed sphenoid bone or tibial pseudarthrosis*
- 7. A first-degree relative diagnosed with neurofibromatosis using the previous six criteria

^{*}Pseudarthrosis may occur when a long bone, such as the tibia, undergoes a loss of bone cortex, leading to weakening and fracture. Abnormal callus formation causes a "false joint" in the bone, leading to the term ("arthron" = ioint).

café-au-lait spot can be seen in the right upper abdomen. B, In a second patient with NF1, a large plexiform neurofibroma hangs from the lower right back, causing considerable inconvenience and discomfort. (The term plexiform is from the Latin plexus = "braid," describing the complex, tangled structure of these tumors). The patient's condition was substantially improved by surgical removal of the tumor. Approximately 25% of NF1 patients develop plexiform neurofibromas. (B, Courtesy Dr. David Viskochil, University of Utah Health Sciences Center.)

B

Neurofibromatosis: A Disease with Highly Variable Expression—cont'd

Although NF1 has highly variable expression, the penetrance of this gene is virtually 100%. It has one of the highest known mutation rates, about 1 in 10,000 per generation. Approximately 50% of NF1 cases are the result of new mutations. In 1987 the gene was mapped to chromosome 17q by researchers in Salt Lake City, and it was isolated and cloned 3 years later. It is a large gene, spanning approximately 350 kb of DNA. Its large size, which presents a sizable "target" for mutation, may help to account for the high mutation rate. The gene encodes a 13-kb mRNA transcript, and the gene product, termed neurofibromin, acts as a tumor suppressor (see Chapter 11).

A mutation in the *NF1* gene that occurs during embryonic development will affect only some cells of the individual, resulting in somatic mosaicism. In this case, the disease features may be confined to only one part of the body (segmental neurofibromatosis).

Neurofibromatosis type 2 (NF2) is much rarer than NF1 and involves *café-au-lait* spots and bilateral acoustic

Pleiotropy and Heterogeneity

Genes that have more than one discernible effect on the body are said to be pleiotropic. A good example of a gene with pleiotropic effects is given by Marfan syndrome. First described in 1896 by Antoine Marfan, a French pediatrician, this autosomal dominant disorder affects the eye, the skeleton, and the cardiovascular system (Clinical Commentary 4-5). All of the observed features of Marfan syndrome are caused by unusually stretchable connective tissue. The gene for Marfan syndrome has been mapped to chromosome 15q, and it has been demonstrated that mutations in the gene encoding fibrillin, a component of connective tissue, are responsible for the multiple defects seen in this disorder. We have already discussed several other single-gene diseases in which pleiotropy is seen, including cystic fibrosis, in which sweat glands, lungs, and pancreas can be affected; osteogenesis imperfecta, in which bones, teeth, and sclerae can be affected; and albinism, in which pigmentation and optic fiber development are affected. www

neuromas (tumors affecting the eighth cranial nerve). It does not, however, involve true neurofibromas. The term "neurofibromatosis type 2" is thus a misnomer. The NF2 gene was mapped to chromosome 22 and subsequently cloned.

Mild cases of neurofibromatosis may involve very little clinical management. However, surgery may be required if malignancies develop or if benign tumors interfere with normal function. Scoliosis, tibial pseudarthrosis, and/or tibial bowing, seen in fewer than 5% of cases, may require orthopedic management. Hypertension may develop and is often secondary to a pheochromocytoma or a stenosis (narrowing) of the renal artery. The most common clinical problems in children are learning disabilities (seen in about 50% of individuals with NF1), short stature, and optic gliomas (which can lead to vision loss). Close follow-up can help to detect these problems and minimize their effects.

Just as a single gene may have multiple effects, a single disease phenotype may be caused by mutations at different loci in different families. The causation of the same disease phenotype by mutations at distinct loci is termed locus heterogeneity (compare with allelic heterogeneity, discussed in the previous section). A good example is adult polycystic kidney disease (APKD), an autosomal dominant disorder in which a progressive accumulation of renal cysts is seen. Patients may also develop liver cysts, hypertension, cerebral aneurysms, and cardiac valvular defects. Occurring in about 1 of every 1,000 Caucasians, this disorder is responsible for 8% to 10% of end-stage renal disease in North America. APKD can be caused by mutations in genes on either chromosome 16 (PKD1) or chromosome 4 (PKD2).* Both of these genes encode membrane-spanning glycoproteins that interact with one another and may be involved in cellular signaling. (When this signaling goes awry, it is thought that cellular growth regulation is compromised, resulting in cyst formation.) In one family, the disease may be caused by a PKD1 mutation, whereas in another family it may be caused by a PKD2 mutation. The disease states produced by mutations in these two genes may be clinically indistinguishable.

Osteogenesis imperfecta provides a second example of locus heterogeneity. Recall from Chapter 2 that the subunits of the procollagen triple helix are encoded by two

Variable expression of a genetic disease may be caused by environmental effects, modifier genes, or allelic heterogeneity.

Genes that exert effects on multiple aspects of physiology or anatomy are pleiotropic. Pleiotropy is a common feature of human genes.

^{*}There is also evidence for a third, as yet unidentified, gene for autosomal dominant APKD, and a gene that can cause autosomal recessive polycystic kidney disease has recently been identified on the short arm of chromosome 6.

CLINICAL COMMENTARY 4.5 Marfan Syndrome: An Example of Pleiotropy

Marfan syndrome (Fig. 4-18) is an autosomal dominant condition seen in approximately 1 of every 10,000 North Americans. It is characterized by defects in three major systems: ocular, skeletal, and cardiovascular. The ocular defects include myopia, which is present in most patients with Marfan syndrome, and displaced lens (ectopia lentis), which is observed in about half of the patients. The skeletal defects include

A

dolichostenomelia (unusually long and slender limbs), pectus excavatum ("hollow chest"), pectus carinatum ("pigeon chest"), scoliosis, and arachnodactyly (literally "spider fingers," denoting the characteristically long, slender fingers). Marfan patients also typically exhibit joint hypermobility. The most life-threatening defects are those of the cardiovascular system. Most patients with Marfan syndrome develop prolapse of

FIGURE 4.18 A, A young man with Marfan syndrome, showing characteristically long limbs and narrow face. **B**, Arachnodactyly in an 8-year-old girl with Marfan syndrome.

75

A.

CLINICAL COMMENTARY 4.5 Marfan Syndrome: An Example of Pleiotropy—cont'd

the mitral valve, a condition in which the cusps of the mitral valve protrude upward into the left atrium during systole. This can result in mitral regurgitation (leakage of blood back into the left atrium from the left ventricle). Mitral valve prolapse, however, is seen in 1% to 3% of the general population and is often of little consequence. Much more serious is dilatation (widening) of the ascending aorta, which is seen in 90% of Marfan patients. As dilatation increases, the aorta becomes susceptible to dissection or rupture, particularly when cardiac output is high (as in heavy exercise or pregnancy). As the aorta widens, the left ventricle enlarges, and cardiomyopathy (damage to the heart muscle) ensues. The end result is congestive heart failure, a frequent cause of death among Marfan syndrome patients.

All of these defects involve excessively "stretchy" connective tissue. The role of connective tissue is apparent for defects such as aortic dilatation and detached lens. Its role in skeletal defects is mediated by the periosteum, the connective tissue that covers bone and provides an oppositional force in normal bone growth. When the periosteum is more elastic than it should be, overgrowth of bone occurs, resulting in skeletal defects.

What is the basis of the connective tissue disorder? Answers are being provided by the discovery that patients with Marfan syndrome have mutations of the chromosome 15 gene that encodes fibrillin, a connective tissue protein. Fibrillin, a major component of microfibrils, is found in the aorta, the suspensory ligament of the lens, and the periosteum. The location of the gene product and its role as a component of connective tissue nicely explain the pleiotropic effects that cause disturbances in the eye, the skeleton, and the cardiovascular system.

Several hundred different fibrillin mutations have been identified in Marfan syndrome patients. Most of these are missense mutations, but frameshifts and nonsense mutations producing a truncated fibrillin protein are also seen. In many cases, the missense mutations produce a more severe disease phenotype because of a dominant negative effect (i.e., the abnormal fibrillin proteins bind to and disable many of the normal fibrillin proteins produced by the normal allele in a heterozygote). A severe neonatal form of the disease is produced by mutations in exons 24 to 32. At least one Marfan syndrome compound heterozygote has been reported. This infant, who inherited a disease-causing allele from each of its affected heterozygous parents, had severe congestive heart failure and died from cardiac arrest at the age of 4 months.

Specific mutations in the fibrillin gene can cause familial arachnodactyly (with no other symptoms of Marfan syndrome), while others can cause familial ectopia lentis. Mutations in a second fibrillin gene, located on chromosome 5, cause a disease called "congenital contractural arachnodactyly." This condition shares many of the skeletal features of Marfan syndrome but does not involve cardiac or ocular defects.

Treatment for Marfan syndrome includes regular ophthalmological examinations and, for individuals with aortic dilatation, the avoidance of heavy exercise and contact sports. In addition, β -adrenergic blockers (e.g., propranolol) can be administered to decrease the strength and abruptness of heart contractions. This reduces stress on the aorta. In some cases, the aorta and aortic valve are surgically replaced with a synthetic tube and artificial valve. With such treatment, individuals with Marfan syndrome can now look forward to nearly normal life spans.

A number of historical figures are thought to have possibly had Marfan syndrome, including Niccolo Paganini, the violinist, and Sergei Rachmaninoff, the composer and pianist. Most controversial is the proposal that Abraham Lincoln may have had Marfan syndrome. He had skeletal features consistent with the disorder, and examination of his medical records has shown that he may well have had aortic dilatation. Some have suggested that he was in congestive heart failure at the time of his death and that, had he not been assassinated, he still would not have survived his second term of office. Lincoln has no living descendants who could be evaluated for Marfan syndrome. However, samples of his blood, bone, and hair have been preserved. Once the specific mutations for Marfan syndrome are better characterized, it may be possible, using the polymerase chain reaction, to amplify DNA from these specimens. DNA sequencing could then be used to determine whether Lincoln had Marfan syndrome.

While this may seem like a silly exercise to some, it should be pointed out that genetic diseases such as Marfan syndrome are frequently viewed as serious impediments to success. To find that one of the greatest Presidents in United States history had this disorder would be an eloquent reply.

FIGURE 4.19 Structure of the triple helix type 1 collagen protein. The two α 1 chains are encoded by a gene on chromosome 17, and the α 2 chain is encoded by a gene on chromosome 7.

genes, one on chromosome 17 and the other on chromosome 7 (Fig. 4-19). A mutation occurring in either of these genes can alter the normal structure of the triple helix, resulting ultimately in osteogenesis imperfecta. Table 4-2 lists some additional examples of diseases in which there is locus heterogeneity.

A disease that can be caused by mutations at different loci in different families is said to exhibit locus heterogeneity.

Genomic Imprinting

Mendel's experimental work with garden peas established that the phenotype is the same whether a given allele is inherited from the mother or the father. Indeed, this principle has been part of the central dogma of genetics. Recently, however, it has become increasingly apparent that this principle does not always hold. A striking example is provided by a deletion of 3 to 4 million base pairs (Mb) on the long arm of chromosome 15. When this deletion is inherited from the father, the child manifests a disease known as Prader-Willi syndrome. The disease phenotype includes short stature, hypotonia (poor muscle tone), small hands and feet, obesity, mild to moderate mental retardation, and hypogonadism (Fig. 4-20A). When the deletion is inherited from the mother, the child develops Angelman syndrome, which is characterized by severe mental retardation, seizures, and an ataxic gait (Fig. 4-20B). Both diseases are seen in about 1 of every 15,000 individuals, and in both about 70% of the cases are caused by chromosome deletions. In most instances, the deletions that cause Prader-Willi and Angelman syndromes are microscopically indistinguishable. www

What could cause these differences? The 3- to 4-Mb portion of chromosome 15 that is deleted in both syndromes is known as the "critical region." Within this region several genes are transcriptionally active only on the chromosome inherited from the father, and they are inactive on the chromosome inherited from the mother. Similarly, other genes are transcriptionally active only on the chromosome inherited from the mother and are inactive on the chromosome inherited from the father. Thus, there are several genes in the critical region that are active on only one chromosome (Fig. 4-20C). If the single active copy of one of these genes is lost through a chromosome deletion, then no gene product is produced at all, and disease results. The differential activation of genes, depending on the parent from which they are inherited, is known as genomic imprinting. The transcriptionally inactive genes are said to be "imprinted."

Molecular analysis using many of the tools and techniques outlined in Chapter 3 (microsatellite polymorphisms, cloning, and DNA sequencing) has identified several specific genes in the critical region of chromosome 15. The Angelman syndrome gene encodes a protein involved in ubiquitin-mediated protein degradation during brain development (consistent with the

Disease	Description	Chromosomes on which known loci are located
Retinitis pigmentosa	Progressive retinopathy and loss of vision (see Chapter 8)	More than 20 chromosome regions identified
Osteogenesis imperfecta	Brittle bone disease	7, 17
Charcot-Marie-Tooth disease	Peripheral neuropathy	1, 5, 8, 10, 11, 17, 19, X
Familial Alzheimer disease	Progressive dementia	1, 10, 12, 14, 19, 21
Familial melanoma	Autosomal dominant melanoma (skin cancer)	1, 9
Hereditary nonpolyposis colorectal cancer	Autosomal dominant colorectal cancer	2p, 2q, 3, 7
Autosomal dominant breast cancer	Predisposition to early-onset breast and ovarian cancer	13, 17
Tuberous sclerosis	Seizures, facial angiofibromas, hypopigmented macules, mental retardation, multiple hamartomas	9, 16
Adult polycystic kidney disease	Accumulation of renal cysts leading to kidney failure	4, 16

TABLE 4.2 Some Examples of Diseases in Which There is Locus Heterogeneit	V
--	---

FIGURE 4.20 Illustration of the effect of imprinting on chromosome 15 deletions. **A**, Inheritance of the deletion from the father produces Prader-Willi syndrome (note the inverted V-shaped upper lip, small hands, and truncal obesity). **B**, Inheritance of the deletion from the mother produces Angelman syndrome (note the characteristic posture).

mental retardation and ataxia observed in this disorder). In brain tissue, this gene is active only on the chromosome inherited from the mother; thus, a maternally inherited deletion removes the single active copy of this gene. Several genes appear to be involved in Prader-Willi syndrome, and they are active only on the chromosome inherited from the father. One of these genes, *SNRPN*, encodes a small nuclear riboprotein that is expressed in the brain.

Several mechanisms in addition to chromosome deletions can cause Prader-Willi and Angelman syndrome. One of these is uniparental disomy, a condition in which the individual inherits two copies of a chromosome from one parent and none from the other (see Chapter 6 for further discussion). When two copies of the maternal chromosome 15 are inherited, Prader-Willi syndrome results because no active paternal genes are present in the critical region. Conversely, disomy of the paternal chromosome 15 produces Angelman syndrome. Point mutations in the identified Angelman syndrome gene can also produce disease. Finally, about 1% of cases of Prader-Willi syndrome result from a small deletion of the region that contains an imprinting center on chromosome 15. This is the DNA sequence that apparently helps to set

FIGURE 4.20, cont'd C, Pedigrees illustrating the inheritance pattern of this deletion and the activation status of genes in the critical region. AS, Angelman syndrome; PWS, Prader-Willi syndrome.

and reset the imprint itself. Box 4-1 presents clinical issues of Prader-Willi syndrome from the perspective of a patient's family.

A second example of imprinting in the human is given by Beckwith-Wiedemann syndrome, a disorder that involves large size for gestational age, large tongue, omphalocele (an abdominal wall defect), and a predisposition to Wilms tumor, a kidney cancer (see Chapter 14). As with Angelman syndrome, a minority of Beckwith-Wiedemann syndrome cases are caused by the inheritance of two copies of a chromosome from the father and no copy of the chromosome from the mother (uni-

BOX 4.1

A Mother's Perspective of Prader-Willi Syndrome

We have a 3 1/2-year-old son, John, who has Prader-Willi syndrome. Months before John was born, we were concerned about his well-being because he wasn't as active in utero as his older siblings had been. At the first sight of John, the doctors suspected that things "weren't quite right." John opened his eyes but made no other movements. He couldn't adequately suck, he required supplemental oxygen, and he was "puffy." He remained hospitalized for nearly 3 weeks. The next 3 years were filled with visits to occupational therapists, physical therapists, home health care aides, early childhood service providers, and speech therapists.

From the day John was born, we searched diligently for a diagnosis. His father insisted that we need only love and help him. However, I wanted specifics on how to help him and knowledge from other parents who might have traveled a similar path. After extensive testing and three "chromosome checks," John was diagnosed with Prader-Willi syndrome (PWS). We were glad to be provided with some direction and decided that we would deal with further challenges as they came upon us. We used what we learned about PWS to get started helping John reach his potential. We were not going to worry about all the potential problems John could have because of his PWS.

John attends a special education preschool at the local

elementary school 4 days a week. The bus ride takes about 5 minutes, but it is long enough for John to very much anticipate it each day. If he is ill, we have to tell him that the bus is broken. He attends a Sunday school class with children of a similar age. He misbehaves by saying "hi" and "bye" very loudly to each participant. He receives speech therapy once a week, and I spend at least 30 minutes each day with John, practicing speech, cognitive, and play skills. John has not yet experienced the feeding difficulties commonly observed in children with PWS. However, excessive eating and weight gain are more common in older children with PWS.

Compared with other 3-year-old children, John struggles with speech and motor developmental milestones. Yet, he loves to play with his siblings and their friends and to look at books. In fact, we struggle to keep people from doing too many things for John because they might prevent him from attaining the same goal independently. We feel very privileged to have him in our family.

Our expectations for John are that he achieves everything that is possible for him plus a little bit more. Indeed, some of his care providers are already impressed with his capabilities. I hope that his success is partly a result of the care and support that we have given to him. Moreover, I hope that John continues to overcome the daily challenges that face him. 80

parental disomy, in this case affecting chromosome 11). Some genes on chromosome 11 are imprinted, including insulin-like growth factor 2 (IGF2). This gene is imprinted (inactive) on the maternally derived chromosome and active only on the paternal chromosome. Normally, then, an individual has only one active copy of this gene. When two copies of the paternal chromosome are inherited, the active IGF2 gene is present in double dose. Two active copies can also result from a loss of the maternal imprint, activating the maternally inherited gene. It is thought that increased levels of the growth factor gene lead to the overgrowth features of Beckwith-Wiedemann syndrome and to Wilms tumor. In contrast to Prader-Willi and Angelman syndromes, which are produced by a missing gene product, Beckwith-Wiedemann syndrome is caused, at least in part, by overexpression of a gene product. www

The molecular basis of imprinting remains unclear. In the genes known to be imprinted in mice or humans, of which there are now more than 40, there is a strong association between methylation and transcriptional inactivation. The attachment of methyl groups to DNA may inhibit the binding of proteins that promote transcription. It is not yet known, however, whether methylation is the primary imprinting signal or whether it serves merely to maintain the imprinting signal once it has been established by other mechanisms (e.g., histone acetylation and alteration in chromatin structure).

Some disease genes may be expressed differently when inherited from one sex versus the other. This is genomic imprinting. It is associated with, and possibly caused by, methylation of DNA.

Anticipation and Repeat Expansion

Since the early part of the 20th century, it has been observed that some genetic diseases seem to display an earlier age of onset and/or more severe expression in the more recent generations of a pedigree. This pattern is termed **anticipation**, and it has been the subject of considerable controversy and speculation. Many researchers believed that it was an artifact of better observation and clinical diagnosis in more recent times: a disorder that previously may have remained undiagnosed until age 60 years might now be diagnosed at age 40 simply because of better diagnostic tools. Others, however, believed that anticipation could be a real biological phenomenon, although evidence for the actual mechanism remained elusive.

Recently, molecular genetics has provided good evidence that anticipation does in fact have a biological basis. This evidence has come, in part, from studies of myotonic dystrophy, an autosomal dominant disease that involves progressive muscle deterioration (Fig. 4-21). Seen in approximately 1 in 8,000 individuals, myotonic dystrophy is the most common muscular dystrophy that affects adults. In addition to affecting skeletal muscles,

FIGURE 4.21 A three-generation family affected with myotonic dystrophy. The degree of severity increases in each generation. The grandmother (*right*) is only slightly affected, but the mother (*left*) has a characteristic narrow face and somewhat limited facial expression. The baby is more severely affected and has the facial features of children with neonatal-onset myotonic dystrophy, including an open, triangle-shaped mouth. The infant has more than 1,000 copies of the trinucleotide repeat, whereas the mother and grandmother each have approximately 100 repeats.

this disorder produces cardiac arrhythmias (abnormal heart rhythms), testicular atrophy, and cataracts. The disease-causing gene, which has been mapped to chromosome 19 and subsequently cloned, encodes a protein kinase. www

Analysis of the gene has produced some interesting results. The disease mutation is an expanded CTG trinucleotide repeat (see Chapter 3) that lies in the 3' untranslated portion of the gene (i.e., a region transcribed into mRNA but not translated into protein). The *number* of these repeats is strongly correlated with severity of the disease. Unaffected individuals typically have 5 to 30 copies of the repeat. Those with 50 to 100 copies may be mildly affected or have no symptoms. Those with full-blown myotonic dystrophy have anywhere from 100 to several thousand copies of the repeat sequence. The number of repeats often increases with succeeding generations: a mildly affected parent with 80 repeats may produce a severely affected offspring who has more than 1,000 repeats (Fig. 4-22). Many families have now been documented in which the number of repeats increases through successive generations, accompanied by increasing severity of the disorder. There is thus strong evidence that expansion of this trinucleotide repeat is the cause of anticipation in myotonic dystrophy.

How does a mutation in the 3' untranslated portion of the gene produce the many disease features of myotonic dystrophy? Mouse models of this disease indicate that the expanded repeat decreases production of the protein product (a protein kinase), which results in cardiac conduction defects that produce arrhythmias. In addition, the mutation alters the mRNA transcript such that it remains in the nucleus and interacts with RNA-binding proteins to block their normal activity. This produces myotonic myopathy. Finally, the mutation may interfere (by altering chromatin structure) with a downstream transcription-factor gene, *SIX5*, resulting in cataract formation. Thus, analysis of the disease-causing mutation and its effect on nearby genes helps to explain the pleiotropy observed in myotonic dystrophy.

FIGURE 4.22 A, Myotonic dystrophy pedigree illustrating anticipation. In this case, the age of onset for family members affected with an autosomal dominant disease is lower in more recent generations. **B**, An autoradiogram from a Southern blot analysis of the myotonic dystrophy gene in three individuals. Individual A is homozygous for a 4- to 5-repeat allele and is normal. Individual B has one normal allele and one disease allele of 175 repeats; this individual has myotonic dystrophy. Individual C is also affected with myotonic dystrophy and has one normal allele and a disease-causing allele of approximately 900 repeats. (B, Courtesy Dr. Kenneth Ward and Dr. Elaine Lyon, University of Utah Health Sciences Center.)

Disease	Description	Repeat sequence	Normal range, abnormal range	Parent in whom expansion usually occurs	Location of expansion
Category 1					
Huntington disease	Loss of motor control, dementia, affective disorder	CAG	6–34; 36–100 or more	More often through father	Exon
Spinal and bulbar muscular atrophy	Adult-onset motor-neuron disease associated with androgen insensitivity	CAG	11–34; 40–62	More often through father	Exon
Spinocerebellar ataxia type 1	Progressive ataxia, dysarthria, dysmetria	CAG	6–39; 41–81	More often through father	Exon
Spinocerebellar ataxia type 2	Progressive ataxia, dysarthria	CAG	15–29; 35–59		Exon
Spinocerebellar ataxia type 3 (Machado– Joseph disease)	Dystonia, distal muscular atrophy, ataxia, external ophthalmoplegia	CAG	13–36; 68–79	More often through father	Exon
Spinocerebellar ataxia type 6	Progressive ataxia, dysarthria, nystagmus	CAG	4–16; 21–27	_	Exon
Spinocerebellar ataxia type 7	Progressive ataxia, dysarthria, retinal degeneration	CAG	7–35; 38–200	More often through father	
Spinocerebellar ataxia type 17	Progressive ataxia, dementia, bradykinesia, dysmetria	CAG	29-42; 47-55	_	Exon
Dentatorubral– pallidoluysian atrophy/Haw River syndrome	Cerebellar atrophy, ataxia, myoclonic epilepsy, choreoathetosis, dementia	CAG	7–25; 49–88	More often through father	Exon
<i>Category 2</i> Pseudoachondroplasia/ multiple epiphyseall dysplasia	Short stature, joint laxity, degenerative joint disease	GAC	5; 6–7	_	Exon
Oculopharyngeal muscular dystrophy	Proximal limb weakness, dysphagia, ptosis	GCG	6; 7–13	—	Exon
Cleidocranial dysplasia	Short stature, open skull sutures with bulging calvaria, clavicular hypoplasia, shortened fingers, dental anomalies	GCG, GCT, GCA	17; 27 (expansion observed in one family)	_	Exon
Synpolydactyly	Polydactyly and syndactyly	GCG, GCT, GCA	15; 22–25	—	Exon
<i>Category 3</i> Myotonic dystrophy (DM1; chromosome 19)	Muscle loss, cardiac arrhythmia, cataracts, frontal balding	CTG	5–37; 100 to several thousand	Either parent, but expansion to congenital form through mother	3' untranslated region
Myotonic dystrophy (DM2; chromosome 3)	Muscle loss, cardiac arrhythmia, cataracts, frontal balding	CCTG	<75; 75–11,000	—	3' untranslate region
Friedreich ataxia	Progressive limb ataxia, dysarthria, hypertrophic cardiomyopathy, pyramidal weakness in legs	GAA	7–22; 200–900 or more	Disorder is autosomal recessive, so disease alleles are inherited from both parents	Intron
Fragile X syndrome (FRAXA)	Mental retardation, large ears and jaws, macroorchidism in males	CGG	6–52; 200–2000 or more	Exclusively through mother	5' untranslated region
Fragile site (FRAXE)	Mild mental retardation	GCC	6–35; >200	More often through mother	5' untranslate region
Spinocerebellar ataxia type 8	Adult-onset ataxia, dysarthria, nystagmus	CTG	16–37; 107–127	More often through mother	3' untranslate region
Spinocerebellar ataxia type 12	Ataxia, eye movement disorders; variable age at onset	CAG	7–28; 66–78	_	5' untranslate region
Progressive myoclonic epilepsy type 1	Juvenile-onset convulsions, myoclonus, dementia	12-bp repeat motif	2-3; 30-75	Autosomal recessive inheritance so transmitted by both parents	5' untranslated region

TABLE 4.3 Disease Associated with Repeat Expansions

Recently, a locus on chromosome 3 was discovered in which a 4-bp (CCTG) expanded repeat can also cause myotonic dystrophy. Again, the repeat is located in the 3' untranslated region of the gene. The phenotype associated with the chromosome 3 mutation is highly similar to that of the chromosome 19 mutation, although it sometimes is less severe. Myotonic dystrophy thus illustrates several important genetic principles: anticipation, pleiotropy, and locus heterogeneity.

As discussed in Clinical Commentary 4-3, trinucleotide repeat expansion is also associated with anticipation in Huntington disease. It has also been observed in the fragile X syndrome, a leading genetic cause of mental retardation to be discussed in Chapter 5. Repeat expansions have now been identified as a cause of more than 20 genetic diseases (Table 4-3), and anticipation is observed in most of these diseases.

As more repeat expansion diseases have been identified, some general patterns have begun to emerge. These diseases can be grouped into three categories, as indicated in Table 4-3. The first category consists of neurological diseases, such as Huntington disease and most of the spinocerebellar ataxias, that are caused by a CAG repeat expansion in a protein-coding portion of the gene. The repeats generally expand in number from a normal range of 10 to 35 to a disease-causing range of approximately 50 to 100. Expansions tend to be larger when transmitted through the father than through the mother, and the mutations have a gain-of-function effect. The second group consists of phenotypically more diverse diseases in which the expansions are again small in magnitude and are found in exons. The repeat sequence is heterogeneous, however, and anticipation is not a typical feature. The third category includes fragile X syndrome, myotonic dystrophy, two of the spinocerebellar ataxias, juvenile myoclonic epilepsy, and Friedreich ataxia. The repeat expansions are typically much larger than in the first two categories: the normal range is generally 5 to 50 trinucleotides, but the disease-causing range can vary from 200 to several thousand trinucleotides. The repeats are located outside the protein-coding regions of the gene in all of these disorders, and the mutations usually have a loss-of-function effect. Repeat expansions are often larger when they are transmitted through the mother. Anticipation is seen in most of the diseases in categories 1 and 3.

CONSANGUINITY IN HUMAN POPULATIONS

Although consanguinity is relatively rare in Western populations, it is common in many populations of the world. For example, first-cousin unions are seen in 20% to 50% of marriages in many countries of the Mideast, and uncle-niece and first-cousin marriages are common in some parts of India. Because relatives more often share disease genes inherited from a common ancestor, consanguineous unions are more likely to produce offspring affected by autosomal recessive disorders. It is possible to quantify the proportion of genes shared by a pair of relatives by estimating the **coefficient of relationship** (Box 4-2). Estimation of this quantity shows, for example, that siblings share 1/2 of their genes on average, first cousins share 1/8, first cousins once removed share 1/16, second cousins share 1/32, and so on.*

Consanguinity and the Frequency of Recessive Diseases

Recall that about 1 in 25 Caucasians is a heterozygous carrier of the cystic fibrosis gene. A man who carries this gene thus has a 1 in 25 chance of meeting another carrier if he mates with somebody in the general population. He only triples his chance of meeting another carrier if he mates with a first cousin, who has a 1/8 chance of carrying the same gene. In contrast, a carrier of a relatively rare recessive disease, such as classical galactosemia (a metabolic disorder discussed in Chapter 7), has only a 1/170 chance of meeting another carrier in the general population. Because he shares 1/8 of his genes with his first cousin, the chance that his first cousin also has the galactosemia gene is still 1/8. With this rarer disease, a carrier is 21 times more likely to mate with another carrier in a first-cousin marriage than in a marriage with an unrelated individual. This illustrates an important principle: the rarer the recessive disease, the more likely that the parents of an affected individual are consanguineous.

This principle has been substantiated empirically. A French study showed that the frequency of first-cousin marriages in that country was less than 0.2%. Among patients with cystic fibrosis, a relatively common recessive disorder, 1.4% were the offspring of first-cousin matings. This percentage rose to 7.1% for cystinosis and 12.5% for achromatopsia, both of which are less common recessive disorders.

Consanguinity increases the chance that a mating couple will both carry the same disease gene. It is seen more frequently in

Anticipation refers to progressively earlier or more severe expression of a disease in more recent times. Expansion of DNA repeats has been shown to cause anticipation in some genetic diseases. These diseases can be divided into three major categories, depending on the size of the expansion, the location of the repeat, the phenotypic consequences of the expansion, the effect of the mutation, and the parent in whom large expansions typically occur.

^{*}First cousins are the offspring of two siblings and thus share a set of grandparents. A first cousin once removed is the offspring of one's first cousin. Second cousins are the offspring of two different first cousins and thus share a set of greatgrandparents.

BOX Measurement of Consanguinity: The Coefficient of Relationship 4.2

To determine the possible consequences of a consanguineous mating, it is useful to know what proportion of genes are shared by two related individuals. The coefficient of relationship is a measure of this proportion. Clearly, individuals who are more closely related must share a greater proportion of their genes. To begin with a simple example, an individual receives half of his or her genes from each parent. Thus, the coefficient of relationship between a parent and offspring is 1/2. This also means that the probability that the parent and offspring share a given gene (for example, a disease allele) is 1/2.

To continue with a more complex example, suppose that a man is known to be a heterozygous carrier for galactosemia, a relatively rare autosomal recessive metabolic disorder. If he mates with his first cousin, what is the probability that she also carries this disease gene? We know that this probability must be higher than that of the general population, because first cousins share one set of grandparents. There is thus a possibility that the grandparent who transmitted the galactosemia gene to the known carrier also transmitted it to the carrier's cousin. The coefficient of relationship specifies this probability. A pedigree for a firstcousin mating is shown in Fig. 4-23A. The male carrier is labeled A, and his female cousin is labeled E. Since we are interested only in the family members who are related to both the man and his cousin, the pedigree is condensed, in Fig. 4-23B, to include only those individuals who form a "path" between the man and his cousin.

To estimate the coefficient of relationship, we begin with the carrier and ascend the pedigree. We know that there is a probability of 1/2 that the known carrier inherited the gene from the parent in the path (labeled B). There is also a probability of 1/2 that he inherited the gene from his other parent, who is not related to his cousin and is thus not included in the diagram. By similar reasoning, the probability that individual B inherited the disease gene from his parent, individual C, is also 1/2. The probability that individual C in turn passed on the disease gene to his offspring, D, is 1/2, and the probability that D passed the disease gene to E is also 1/2. Thus, for E to share a disease gene with A, each of these four events must have taken place. The multiplication rule dictates that, to find the probability that all four events have taken place, we take the product of all four probabilities. Since each of these probabilities is 1/2, the result is $(1/2)^4 = 1/16$.

If individuals A and E shared only one grandparent, the coefficient of relationship would be 1/16. But, as with most first cousins, they share a common grandfather and grandmother. Thus, there are two paths through which the disease gene could have passed. To obtain the probability that the gene passed through the second path, we use the same procedure as in the previous paragraph and obtain a probability of 1/16. Now we need to estimate the probability that the gene went through either the first path or the second (i.e., through one grandparent or the other). The addition rule states that we can add these two probabilities together to get the overall probability that A and E share a disease gene: 1/16 + 1/16 = 1/8. The probability that the carrier's cousin shares his disease allele, as a result of their descent from a common set of grandparents, is thus 1/8. This is the coefficient of relationship for first cousins.*

It should be recognized that individual E could also inherit a disease allele from an ancestor not included in either of these paths. However, for disease alleles, which are relatively rare in populations, this probability is small and can usually be disregarded.

The rules for calculating the coefficient of relationship can be summarized as follows:

- 1. Each individual can appear in a route only once.
- 2. Always begin with one individual, proceed up the pedigree to the common ancestor, then down the pedigree to the other individual.
- 3. The coefficient of relationship for one route is given by $(1/2)^{n-1}$, where n is the number of individuals in the route.
- 4. If there are multiple routes (i.e., multiple common ancestors), the probabilities estimated for each route are added together.

*A related quantity, frequently used in population genetics, is the **inbreeding coefficient**. This coefficient is the probability that an individual is homozygous at a locus as a result of consanguinity in his or her parents. For a given type of mating, the inbreeding coefficient of an individual always equals the parents' coefficient of relationship multiplied by 1/2 (e.g., the inbreeding coefficient for the offspring of a first-cousin mating is 1/16).

FIGURE 4.23 A, Pedigree for a first-cousin mating. B, The pedigree is condensed to show only those individuals who are related to both of the first cousins.

		1.0 Cousin		1.5 Cousin*		2.0 Cousin		Unrelated	
Population	Mortality type	%	N	%	N	%	N	%	N
Amish (Old Order)	Prereproductive	14.4	$1,218^{+}$			13.3	6,064	8.2	17,200
Bombay, India	Perinatal	4.8	3,309	2.8	176	0	30	2.8	35,620
France (Loir-et-Cher)	Prereproductive	17.7	282	6.7	105	11.7	240	8.6	1,117
Fukuoka, Japan	0 to 6 y	10.0	3,442	8.3	1,048	9.2	1,066	6.4	5,224
Hirado, Japan	Prereproductive	18.9	2,301	15.3	764	14.7	1,209	14.3	28,569
Kerala, India	Prereproductive	18.6	391	_		11.8	34	8.7	770
Punjab, Pakistan	Prereproductive	22.1	3,532	22.9	1,114	20.1	57	16.4	4,731
Sweden	Prereproductive	14.1	185	13.7	227	11.4	79	8.6	625
Utah Mormons	Prereproductive	22.4	1,048	15.3	517	12.2	1,129	13.2	302,454

TABLE 4.4 🔳 Mortality Levels Among Cou	ousin and Unrelated Control I	Marriages in S	Selected Human F	opulations
--	-------------------------------	----------------	------------------	------------

Modified from Jorde LB (1997). In: Delbecco R (ed.) Encyclopedia of Human Biology. Vol 4. Academic Press, San Diego.

*First cousins once removed.

[†]Includes 1.5 cousins.

pedigrees involving rare recessive diseases than in those involving common recessive diseases.

Health Consequences of Consanguinity

It has been estimated that each person carries the equivalent of one to five recessive genes that would be lethal to offspring if matched with another copy of the gene (i.e., homozygosity). It would therefore be expected that matings between relatives would more often produce offspring with genetic diseases. In fact, most empirical studies do show that mortality rates among the offspring of first-cousin marriages are substantially greater than those of the general population (Table 4-4). Similarly, the prevalence of genetic disease is roughly twice as high among the offspring of first-cousin marriages as among the offspring of unrelated individuals. First-cousin marriages are illegal in most states of the United States. Marriages between closer relatives (except double first cousins, who share both sets of grandparents) are prohibited throughout the United States.

Very few data exist for matings between first-degree relatives (defined as **incest**). The limited data indicate that the proportion of abnormal offspring produced by incestuous matings is very high: between 1/4 and 1/2. Mental retardation is particularly common among these offspring. Because of small sample sizes in these studies, it is difficult to separate the effects of genetics from those of a substandard environment. It is likely that the problems experienced by the offspring of incestuous matings are caused by both genetic and environmental influences. At the population level, consanguinity increases the frequency of genetic disease and mortality. The closer the degree of consanguinity, the greater the increase.

SUGGESTED READINGS

- Arnaout MA (2001) Molecular genetics and pathogenesis of autosomal dominant polycystic kidney disease. Annu Rev Med 52:93-123
- Bittles A (2001) Consanguinity and its relevance to clinical genetics. Clin Genet 60:89-98
- Cummings CJ, Zoghbi HY (2000) Fourteen and counting: unraveling trinucleotide repeat diseases. Hum Mol Genet 9:909-916
- Gutmann DH (2001) The neurofibromatoses: when less is more. Hum Mol Genet 10:747-755
- Hanel ML, Wevrick R (2001) The role of genomic imprinting in human developmental disorders: lessons from Prader-Willi syndrome. Clin Genet 59:156-164
- Jorde LB (1997) Inbreeding in human populations. In: Dulbecco R (ed) Encyclopedia of Human Biology. Vol. 5. Academic Press, New York, pp 1-13
- Margolis RL, McInnis MG, Rosenblatt A, Ross CA (1999) Trinucleotide repeat expansion and neuropsychiatric disease. Arch Gen Psychiatry 56:1019-1031
- Mickle JE, Cutting GR (2000) Genotype-phenotype relationships in cystic fibrosis. Med Clin North Am 84:597-607
- Nadeau JH (2001) Modifier genes in mice and humans. Nature Rev Genet 2:165-174
- Nevins JR (2001) The Rb/E2F pathway and cancer. Hum Mol Genet 10:699-703
- Nicholls RD, Knepper JL (2001) Genome organization, function, and imprinting in Prader-Willi and Angelman syndromes. Annu Rev Genomics Hum Genet 2:153-175
- North K (2000) Neurofibromatosis type 1. Am J Med Genet 97:119-127

Procter AM, Phillips JA 3rd, Cooper DN (1998) The molecular genetics of growth hormone deficiency. Hum Genet 103:255-272

Pyeritz RE (2000) The Marfan syndrome. Annu Rev Med 51:481-510

Ranum LP, Day JW (2002) Dominantly inherited, non-coding microsatellite expansion disorders. Curr Opin Genet Dev 12:266-271

Richards RI (2001) Dynamic mutations: a decade of unstable expanded repeats in human genetic disease. Hum Mol Genet 10:2187-2194

Robinson PN, Booms P, Katzke S, Ladewig M, Neumann L, Palz M, Pregla R, Tiecke F, Rosenberg T (2002) Mutations of FBN1 and genotype-phenotype correlations in Marfan syndrome and related fibrillinopathies. Hum Mutat 20:153-161

Scriver CR, Waters PJ (1999) Monogenic traits are not simple: lessons from phenylketonuria. Trends Genet 15:267-272

Sturm RA, Teasdale RD, Box NF (2001) Human pigmentation genes: identification, structure and consequences of polymorphic variation. Gene 277:49-62

- Tapscott SJ, Thornton CA (2001) Reconstructing myotonic dystrophy. Science 293:816-817
- Trottier Y, Mandel JL (2001) Huntingtin: profit and loss. Science 293:445-446
- Zheng L, Lee WH (2001) The retinoblastoma gene: a prototypic and multifunctional tumor suppressor. Exp Cell Res 264:2-18

- Zielenski J (2000) Genotype and phenotype in cystic fibrosis. Respiration 67:117-133
- Zlotogora J (1998) Germ line mosaicism. Hum Genet 102:381-386

INTERNET RESOURCES

Cystic Fibrosis Mutation Database (also contains links to other useful cystic fibrosis Web sites)

http://www.genet.sickkids.on.ca/cftr/

Eye Cancer Network: retinoblastoma (descriptions, photographs, and useful links) http://www.eyecancer.com/conditions/Retinal%20Tumors/retino.

http://www.ejecumer.com/comations/Kermai/6201umors/retime. html

National Center for Biotechnology Information: Genes and Disease (brief summaries of many of the genetic diseases discussed in this text)

http://www.ncbi.nlm.nih.gov/books/bv.fcgi?call=bv.View.. ShowTOC&rid=gnd.TOC&depth=2

National Institute of Neurological Diseases and Stroke: Huntington Disease Information Page

http://www.ninds.nih.gov/health_and_medical/disorders/ huntington.htm

National Neurofibromatosis Foundation (many useful links to online resources)

http://www.nf.org/

National Marfan Foundation (basic information about Marfan syndrome, with links to other sites) http://www.marfan.org/

STUDY QUESTIONS

1. Using protein electrophoresis, 100 members of a population were studied to determine whether they carry genes for normal hemoglobin (*HbA*) or sickle hemoglobin (*HbS*). The following genotypes were observed:

HbA/HbA	88
HbA/HbS	10
Hbs/Hbs	2

What are the gene frequencies of *HbA* and *HbS*? What are the observed genotype frequencies? Assuming Hardy-Weinberg proportions, what are the *expected* genotype frequencies?

- 2. Approximately 1 in 10,000 Caucasians is born with PKU. What is the frequency of the disease gene? What is the frequency of heterozygous carriers in the population?
- **3.** A man who has achondroplasia marries a phenotypically normal woman. If they have four children, what is the probability that none of their children will be affected with this disorder? What is the probability that *all* of them will be affected?
- 4. The estimated penetrance for familial retinoblastoma is approximately 90%. If a man has had

familial retinoblastoma and mates with a woman who does not have a retinoblastoma mutation, what is the risk that their offspring will develop retinoblastoma?

- **5.** A 30-year-old woman had a sister who died from infantile Tay-Sachs disease, an autosomal recessive disorder that is fatal by age 6 years. What is the probability that this woman is a heterozygous carrier of the Tay-Sachs gene?
- 6. Consider a woman who is a known heterozygous carrier of a mutation that causes PKU (autosomal recessive). What is the probability that her two grandchildren, who are first cousins, are *both* heterozygous carriers of this PKU causing allele?
- 7. It is possible to create a zygote from two copies of the maternal genome alone. In amphibians, the zygote will develop and mature into an adult without fertilization by a sperm cell (this process is known as parthenogenesis). The same experiment has been attempted in mice, but it always results in early prenatal death. Explain this.
- 8. Two mating individuals, labeled A and B in Fig. 4-24, share a single great-grandparent. What

STUDY QUESTIONS—cont'd

FIGURE 4.24 Diagram for study question 8.

is their coefficient of relationship? Suppose that one member of this couple is a heterozygous carrier for PKU. What is the probability that this couple will produce a child affected with PKU?

- **9.** A suspect in a rape case has been typed for three VNTR (variable number of tandem repeats) systems. His alleles match those of the evidentiary sample (semen taken from the rape victim) for each system. He is a heterozygote for the first two systems and a homozygote for the third. The allele frequencies for system 1 in the general population are 0.05 and 0.10. For system 2, they are 0.07 and 0.02. For system 3, the allele frequency in the general population is 0.08. What is the probability that a random individual in the general population would match the evidentiary sample?
- 10. A man implicated in a paternity suit has had his DNA tested to establish whether or not he is the father of the baby. Four microsatellite polymorphisms were tested for him, the mother, and the baby. The baby's alleles and his match for all four loci. The frequencies of these alleles in the general population are 0.05, 0.01, 0.01, and 0.02. What is the probability that someone else in the general population could be the father of the baby?

Sex-Linked and Mitochondrial Inheritance

The previous chapter dealt with disease genes located on the 22 autosomes. In this chapter we discuss disease genes located on the sex chromosomes and in the mitochondria. The human X chromosome is a large chromosome, containing about 5% of the nuclear genome's DNA (approximately 160 million base pairs, or 160 Mb). More than 700 coding genes have been localized to the X chromosome. Diseases caused by genes on this chromosome are said to be **X-linked**. Most X-linked diseases are recessive, although there are also a few X-linked dominant diseases. In contrast to the X chromosome, the Y chromosome is quite small (70 Mb) and contains very few genes. More than a dozen diseases are now known to be caused by mutations in mitochondrial DNA; these are discussed at the end of this chapter.

X INACTIVATION

It has long been known that human females have two X chromosomes while males have only one. It has also long been known that the X chromosome contains many important protein-coding genes. Thus, females have two copies of each X-linked gene, while males have only one copy. Yet males and females do not differ in terms of the products (e.g., enzyme levels) encoded by most of these genes. What could account for this?

In the early 1960s Mary Lyon hypothesized that one X chromosome in each somatic cell of the female is inactivated. This would result in **dosage compensation**, an equalization of X linked gene products in males and females. The **Lyon hypothesis** stated that X inactivation occurs early in female embryonic development and that the X chromosome contributed by the father is inactivated in some cells, whereas in other cells the X chromosome contributed by the mother is inactivated. Each cell chooses one of the two X chromosomes at random to be inactivated, so the maternally and paternally derived X chromosomes will each be inactivated in about half of the embryo's cells. Thus, inactivation, like gamete transmission, is analogous to a coin-tossing experiment. Once an

88

X chromosome is inactivated in a cell, it will remain inactive in all descendants of that cell. X inactivation is therefore said to be randomly determined, but *fixed*. As a result of X inactivation, all normal females have two distinct populations of cells: one population has an active paternally derived X chromosome, and the other has an active maternally derived X chromosome. (Figure 5-1 provides a summary of this process.) With two populations of cells, females are mosaics (see Chapter 4) for the X chromosome. Males, having only one copy of the X chromosome, are not mosaics but are **hemizygous** for the X chromosome (*hemi* = "half").

The Lyon hypothesis states that one X chromosome in each cell is randomly inactivated early in the embryonic development of females. This ensures that females, who have two copies of the X chromosome, will produce X-linked gene products in quantities roughly similar to those produced in males (dosage compensation).

The Lyon hypothesis relied on several pieces of evidence, most of which were derived from animal studies. First, it was known that females are typically mosaics for some X-linked traits while males are not. For example, female mice that are heterozygous for certain X-linked coat-color genes exhibit a dappled coloring of their fur, whereas male mice do not. A similar example is given by the "calico cat." These female cats have alternating black and orange patches of fur that correspond to two populations of cells: one that contains X chromosomes in which the "orange" allele is active and one that contains X chromosomes in which the "black" allele is active. Male cats of this breed do not exhibit alternating colors. A final example, seen in humans, is X-linked ocular albinism. This is an X-linked recessive condition characterized by a lack of melanin production in the retina and by ocular problems such as nystagmus (rapid involuntary eye movements) and decreased visual acuity. Males who inherit the mutation show a uniform lack of melanin in their retinas, while female heterozygotes exhibit alternating patches of pigmented and nonpigmented tissue (see Color Plate 3).

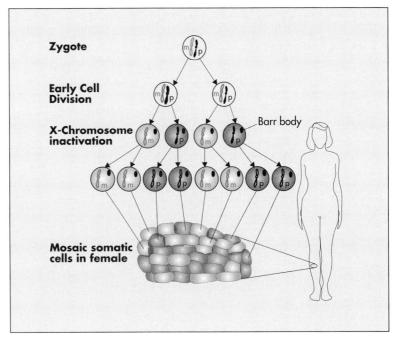

FIGURE 5.1 The X inactivation process. The maternal (m) and paternal (p) X chromosomes are both active in the zygote and in early embryonic cells. X inactivation then takes place, resulting in cells having either an active paternal X or an active maternal X chromosome. Females are thus X chromosome mosaics, as shown in the tissue sample at the bottom of the figure.

The Lyon hypothesis was also supported by biochemical evidence. The enzyme glucose-6-phosphate dehydrogenase (G6PD) is encoded by a gene on the X chromosome and is present in equal quantities in males and females (dosage compensation). In females who are heterozygous for two common G6PD alleles (labeled Aand B), some skin cells produce only the A variant of the enzyme and others produce only the B variant. This is further proof of X chromosome mosaicism in females.

Finally, cytogenetic studies in the 1940s showed that interphase cells of female cats often contained a densely staining chromatin mass in their nuclei (Fig. 5-2). These masses were never seen in males. They were termed **Barr bodies**, after Murray Barr, one of the scientists who described them. Barr and his colleague, Ewart Bertram, hypothesized that the Barr body represented a highly condensed X chromosome. It is now known that Barr and Bertram were correct, and that the inactive X chromosome is observable as a Barr body in the somatic cells of normal females. Its condensed state reflects the fact that its DNA is replicated later in the S phase than that of other chromosomes.

The Lyon hypothesis is supported by cytogenetic evidence: Barr bodies, which are inactive X chromosomes, are seen only in cells with two or more X chromosomes. It is also supported by biochemical and animal studies that revealed mosaicism of X-linked traits in female heterozygotes.

Further study has largely verified the Lyon hypothesis. Messenger RNA (mRNA) is transcribed from only one X chromosome in each somatic cell of a normal female. The inactivation process takes place within approximately 7 to 10 days after fertilization, when the embryonic inner-cell mass contains no more than a few dozen cells. Inactivation is initiated in a single 1-Mb region on the X chromosome long arm, termed the **X inactivation center**, and then spreads along the chromosome. Although inactivation is random among cells that make up the embryo itself, only the paternally derived X chromosome is inactivated in cells that will become extraembryonic tissue (e.g., the placenta). X inactivation is permanent for all somatic cells in the

FIGURE 5.2 ■ A Barr body, which is the inactive X chromosome, is visible as a densely staining chromatin mass in the interphase nucleus of a normal female's somatic cell. DNA-based tools have now supplanted Barr body assays as a means of sex determination.

female, but the inactive X chromosome must become reactivated in the female's germ line so that each egg cell will receive one active copy of the chromosome.

An important implication of the Lyon hypothesis is that the number of Barr bodies in somatic cells is always one less than the number of X chromosomes. Normal females have one Barr body in each somatic cell, while normal males have none. Females with Turner syndrome (see Chapter 6), having only one X chromosome, have no Barr bodies. Males with Klinefelter syndrome (two X chromosomes and a Y chromosome) have one Barr body in their somatic cells, and females who have three X chromosomes per cell have two Barr bodies in each somatic cell. This pattern leads to another question: if the extra X chromosomes are inactivated, why aren't people with extra (or missing) X chromosomes phenotypically normal?

The answer to this question is that X inactivation is incomplete. Some regions of the X chromosome remain active in all copies. In particular, the tips of the short and long arms of the X chromosome do not undergo inactivation. The tip of the short arm of the X chromosome is highly homologous to the distal short arm of the Y chromosome (see Chapter 6). Other regions that escape inactivation include those that contain the genes for steroid sulfatase, the Xg blood group, and Kallman syndrome (a disorder that causes hypogonadism and an inability to perceive odor). Recent studies indicate that about 15% of the genes on the X chromosome may escape inactivation; relatively more genes on the short arm of the X escape inactivation than on the long arm. Some of the X-linked genes that escape inactivation have homologs on the Y chromosome, preserving equal gene dosage in males and females. Thus, having extra (or missing) copies of active portions of the X chromosome contributes to phenotypic abnormality.

X inactivation is random, fixed, and incomplete. The last fact helps to explain why, despite X inactivation, most individuals with abnormal numbers of sex chromosomes are not phenotypically normal.

The X inactivation center contains at least one gene required for inactivation, *XIST*. As expected, *XIST* is transcribed only on the inactive X chromosome, and its 17-kb mRNA transcripts are detected in normal females but not in normal males. The RNA transcript, however, is not translated into a protein. Instead, it remains in the nucleus and coats the inactive X chromosome. This coating process may act as a signal that leads to other aspects of inactivation, including late replication and condensation of the inactive X chromosome.

Methylation and histone deacetylation are additional features of the inactive X chromosome. Many CG dinucleotides in the 5' regions of genes on the inactive X are heavily methylated, and the administration of demethylating agents, such as 5-azacytidine, can partially reactivate an inactive X chromosome in vitro. However, methylation does not appear to be involved in spreading the inactivation signal from the inactivation center to the remainder of the X chromosome. It is more likely to be responsible for maintaining the inactivation of a specific X chromosome in a cell and all of its descendants.

The XIST gene is located in the X inactivation center and is required for X inactivation. It encodes an RNA product that coats the inactive X chromosome. X inactivation is also associated with methylation of the inactive X chromosome, a process that may help to ensure the long-term stability of inactivation.

SEX-LINKED INHERITANCE

Sex-linked genes are those that are located on either the X or the Y chromosome. Because only a few dozen genes are known to be located on the human Y chromosome, our attention will be focused mostly on X-linked diseases.

X-Linked Recessive Inheritance

A number of well-known diseases and traits are caused by X-linked recessive genes. These include hemophilia A (Clinical Commentary 5-1), Duchenne muscular dystrophy (Clinical Commentary 5-2), and red-green color blindness (Box 5-1). The inheritance patterns and recurrence risks for X-linked recessive diseases differ substantially from those for diseases caused by autosomal genes.

Because females inherit two copies of the X chromosome, they can be homozygous for a disease allele at a given locus, heterozygous, or homozygous for the normal allele at the locus. In females, an X-linked recessive trait behaves much like an autosomal recessive trait. However, only one X chromosome is active in an individual somatic cell. This means that about half of the cells in a heterozygous female will express the disease allele and half will express the normal allele. Thus, as with autosomal recessive traits, the heterozygote will produce about 50% of the normal level of the gene product. Ordinarily this is sufficient for a normal phenotype. The situation is different for males, who are hemizygous for the X chromosome. If a male inherits a recessive disease gene on the X chromosome, he will be affected by the disease because the Y chromosome does not carry a normal allele to compensate for the effects of the disease gene.

An X-linked recessive disease with gene frequency q will be seen in a proportion q of males. This is because a male, having only one X chromosome, will manifest the disease if his X chromosome contains the disease-causing mutation. Females, needing two copies of the mutant allele to express the disease, will have a disease frequency of only q^2 , as in autosomal recessive diseases. For example, hemophilia A ("classical" hemophilia; see Clinical Commentary 5-1) is seen in about 1 of every 10,000

CLINICAL COMMENTARY 5.1

Hemophilia A

Hemophilia A, or "classical" hemophilia, affects approximately 1 in 5,000 to 1 in 10,000 males worldwide. It is the most common of the severe bleeding disorders and has been recognized as a familial disorder for centuries. The Talmud states that boys whose brothers or cousins bled to death during circumcision are exempt from the procedure (this may well be the first recorded example of genetic counseling). Queen Victoria carried the gene for hemophilia A, transmitting it to one son and two carrier daughters. They in turn transmitted the gene to many members of the royal families of Germany, Spain, and Russia (Fig. 5-3). One of the males affected by the disease was the Tsarevitch Alexis of Russia, the son of Tsar Nicholas II and Alexandra. Grigori Rasputin, the so-called "mad monk," had an unusual ability to calm the Tsarevitch during bleeding episodes, probably through hypnosis. As a result, he came to have considerable influence in the royal court, and some historians believe that his destabilizing effect helped to bring about the 1917 Bolshevik revolution. (Recently, the Russian royal family was again touched by genetics. Using the polymerase chain reaction, autosomal DNA microsatellites and mitochondrial DNA sequences were assayed in the remains of several bodies exhumed near Yekaterinburg, the reputed murder site of the royal family. Analysis of this genetic variation and comparison with living maternal relatives showed that the bodies were indeed those of the Russian royal family.)

Hemophilia A is caused by deficient or defective factor VIII, a key component of the clotting cascade. Fibrin formation is affected, resulting in prolonged and often severe bleeding from wounds and hemorrhages in the joints and muscles. Bruising is frequently seen. Hemarthroses (bleeding into the joints) are common in joints such as the ankles, knees, hips, and elbows (Fig. 5-4). They are often painful, and repeated episodes can lead to destruction of the synovium and diminished joint function. Intracranial bleeding is also quite common, and, before the advent of effective treatment for bleeding episodes, it was the leading cause of death among hemophiliacs. It should be emphasized that platelet activity is normal in hemophiliacs, so minor lacerations and abrasions do not usually lead to excessive bleeding. www

Hemophilia A varies considerably in its severity, and this variation is correlated directly with the level of factor VIII. About half of hemophilia A patients fall into the "severe" category, with factor VIII levels that are less than 1% of normal. These individuals experience relatively frequent bleeding episodes, often several per month. Moderate hemophiliacs (1% to 5% of normal factor VIII) generally have bleeding episodes only after mild trauma and typically experience one to several episodes per year. Mild hemophiliacs have 5% to 25% of the normal factor VIII level and usually

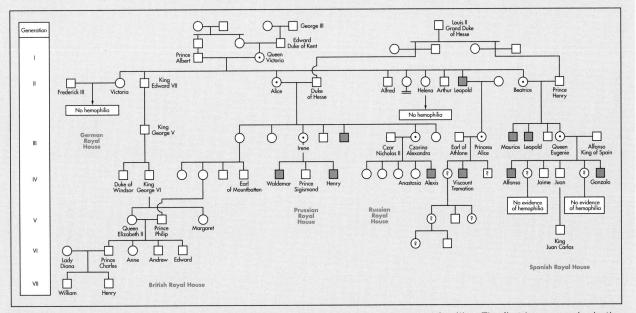

FIGURE 5.3 A pedigree showing the inheritance of hemophilia A in the European royal families. The first known carrier in the family was Queen Victoria. Note that all of the affected individuals are male. (Modified from Raven PH, Johnson GB [1992] Biology, 3rd ed. Mosby, St Louis. With permission of McGraw-Hill, New York.)

92

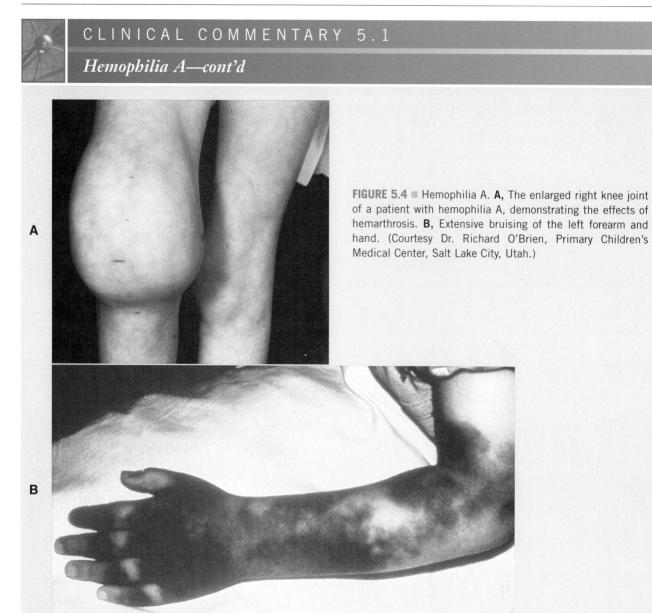

experience bleeding episodes only after surgery or relatively severe trauma.

Until the early 1960s, hemophilia A was often fatal by about 20 years of age. Then it became possible to purify factor VIII from donor plasma. Factor VIII is usually administered at the first sign of a bleeding episode and is a highly effective treatment. Prophylactic factor VIII administration in severe hemophiliacs is effective in avoiding loss of joint function. By the 1970s, the median age at death of hemophiliacs had increased to 68 years. The major drawback of donor-derived factor VIII was the fact that, because a typical infusion contained plasma products from hundreds or thousands of different donors, it was frequently contaminated by viruses. Consequently, hemophiliacs often suffered from hepatitis B and C. More seriously, human immunodeficiency virus (HIV) can be transmitted in this manner, and it is estimated that half of American hemophiliacs treated with donor-derived factor VIII between 1978 and 1985 became infected with HIV. Acquired immune deficiency syndrome (AIDS) accounted for nearly half of deaths among American hemophiliacs from 1979 to 1998, and it resulted in a decrease in the median age at death to 49 years in the 1980s. Donor blood has been screened for HIV since 1985, and heat treatment of donor-derived factor VIII kills HIV and hepatitis B virus, nearly eliminating the threat of infection. Consequently, AIDS mortality among hemophiliacs has decreased markedly since 1995.

The factor VIII gene has been mapped to the distal long arm of the X chromosome and cloned. It contains 186 kb of DNA and 26 exons. The 9-kb mRNA transcript encodes a mature protein consisting of 2,332 amino acids. Cloning and sequencing of the gene has led to a number of insights. Patients with nonsense

CLINICAL COMMENTARY 5.1

Hemophilia A—cont'd

mutations usually develop severe hemophilia, while those with missense mutations usually have relatively mild disease. This is expected because nonsense mutations produce a truncated protein, while missense mutations produce a single amino acid substitution without a dominant negative effect. Many of the point mutations take place at CG sequences, which are hot spots for mutation (see Chapter 3). About 45% of severe cases of hemophilia A are caused by a chromosome inversion (see Chapter 6) that disrupts the factor VIII gene. An additional 5% of patients have deletions, which usually lead to relatively severe disease.

Cloning of the factor VIII gene has enabled the production of human factor VIII using recombinant DNA techniques. Extensive clinical testing showed that recombinant factor VIII works as effectively as the donor-derived form, and it was approved for commercial use in 1994. Recombinant factor VIII has, of course, the advantage that there is no possibility of viral contamination. However, as with other forms of factor VIII, recombinant factor VIII generates antifactor VIII antibody production in approximately 10% to 15% of patients. (This response is most common in patients who have no native factor VIII production.)

There are two other major bleeding disorders, hemophilia B and von Willebrand disease. Hemophilia B, sometimes called "Christmas disease,"* is also an X-linked recessive disorder and is caused by a deficiency of clotting factor IX. It is less severe than hemophilia A, and it is only about one fifth as common. The factor IX gene has also been cloned, and it consists of 34 kb of DNA and eight exons. The disorder can be treated with donor-derived factor IX. von Willebrand disease is an autosomal dominant disorder that is highly variable in expression. While it may affect as many as 1% of Caucasians, it reaches severe expression in fewer than 1 in 10,000. The von Willebrand factor, which is encoded by a gene on chromosome 12, acts as a carrier protein for factor VIII. In addition, it binds to platelets and to damaged blood vessel endothelium, thus promoting the adhesion of platelets to damaged vessel walls.

*"Christmas" was the name of the first reported patient.

males. Thus, in a collection of 10,000 male X chromosomes, one chromosome would contain the disease-causing mutation (q = 0.0001). Affected female homozygotes are almost never seen, since $q^2 = 0.00000001$, or 1 in 100,000,000. This example shows that, in general, males are more frequently affected with X-linked recessive diseases than are females, with this difference becoming more pronounced as the disease becomes rarer.

Because females have two copies of the X chromosome and males have only one (hemizygosity), X-linked recessive diseases are much more common among males than among females.

Pedigrees for X-linked recessive diseases display several characteristics that distinguish them from pedigrees for autosomal dominant and recessive diseases (Fig. 5-5).

FIGURE 5.5 A pedigree showing the inheritance of an X-linked recessive trait. Solid symbols represent affected individuals, and dotted symbols represent heterozygous carriers.

As just mentioned, the trait is seen much more frequently in males than in females. Since a father can transmit only a Y chromosome to his son, X-linked genes are not passed from father to son. (In contrast, father-son transmission can be observed for autosomal disease genes.) An X-linked disease allele can be transmitted through a series of phenotypically normal heterozygous females, causing the appearance of "skipped" generations. The gene is passed from an affected father to all of his daughters, who, as carriers, transmit it to approximately half of their sons, who are affected.

X-linked recessive inheritance is characterized by an absence of father-son transmission, "skipped" generations when genes are passed through female carriers, and a preponderance of affected males.

The most common mating type involving X-linked recessive genes is the combination of a carrier female and a normal male. The carrier mother will transmit the disease gene to half of her sons and half of her daughters. As Fig. 5-6 shows, half of the daughters of such a mating will be carriers, while half will be normal (on the average). Half of the sons will be normal, while half, on average, will have the disease.

The other common mating type is an affected father and a normal mother (Fig. 5-7). Here, all of the sons must be normal, since the father can transmit only his Y chromosome to them. Because all of the daughters must receive the father's X chromosome, they will all be heterozygous carriers. None of the children will manifest the disease, however. Since the father must transmit his X chromosome to his daughters and cannot transmit it to his sons, these risks, unlike those in the previous

FIGURE 5.6 Punnett square representation of the mating of a heterozygous female who carries an X-linked recessive disease gene with a normal male. X_1 , chromosome with normal allele; X_2 , chromosome with disease allele.

FIGURE 5.7 Punnett square representation of the mating of a normal female with a male who is affected by an X-linked recessive disease. X_1 , chromosome with normal allele; X_2 , chromosome with disease allele.

paragraph, are exact figures rather than probability estimates.

A much less common mating type is that of an affected father and a carrier mother (Fig. 5-8). Half of the daughters will be heterozygous carriers, while half, on average, will be homozygous for the disease gene and thus affected. Half of the sons will be normal, and half will be affected. Note that it may appear that father-son transmission of the disease has occurred, but the affected son has actually received the disease allele from his mother.

Recurrence risks for X-linked recessive disorders are more

FIGURE 5.8 Punnett square representation of the mating of a carrier female with a male affected with an X-linked recessive disease. X_1 , chromosome with normal allele; X_2 , chromosome with disease allele.

complex than for autosomal disorders. The risk depends on the genotype of each parent and the sex of the offspring.

Occasionally, females who inherit only a single copy of an X-linked recessive disease gene can be affected with the disease. Imagine a female embryo that has received a normal factor VIII gene from one parent and a mutated factor VIII gene from the other. Ordinarily, X inactivation will result in approximately equal numbers of cells having active paternal and maternal X chromosomes. In this case, the female carrier would produce about 50% of the normal level of factor VIII and would be phenotypically normal. However, because X inactivation is a random process, it will occasionally result in a heterozygous female in whom nearly all of the active X chromosomes happen to be the ones carrying the disease mutation. These females exhibit the disorder and are termed manifesting heterozygotes. Because such females usually maintain at least a small proportion of active normal X chromosomes, they tend to be relatively mildly affected. For example, approximately 5% of females who are heterozygous for hemophilia A have factor VIII levels low enough to be classified as mild hemophiliacs.

Because X inactivation is a random process, some female heterozygotes may experience inactivation of most of the normal X chromosomes in their cells. These manifesting heterozygotes are usually mildly affected.

Less commonly, females having only a single X chromosome (Turner syndrome) have been seen with Xlinked recessive diseases such as hemophilia A. Females can also be affected with X-linked recessive diseases as a result of translocations or deletions of X chromosome material (see Chapter 6). These events are rare.

X-Linked Dominant Inheritance

X-linked dominant diseases are fewer in number and prevalence than are X-linked recessive diseases. An example of an X-linked dominant disease is hypophosphatemic rickets, a disease in which the kidneys are impaired in their ability to reabsorb phosphate. This results in abnormal ossification, with bending and distortion of the bones. Another example is incontinentia pigmenti type 1, a disorder characterized by abnormal skin pigmentation, conical or missing teeth, and ocular and neurological abnormalities. This disorder is seen only in females. It is thought that hemizygous males are so severely affected that they do not survive to term. Heterozygous females, having one normal X chromosome, tend generally to have milder expression of Xlinked dominant traits (just as heterozygotes for most autosomal dominant disease genes are less severely affected than are homozygotes).

X-linked dominant inheritance is also observed in Rett

syndrome, a neurodevelopmental disorder seen in 1/10,000 to 1/15,000 females and in a smaller proportion of males (some males are lost before term, while others survive). Rett syndrome is characterized by autistic behavior, mental retardation, seizures, and gait ataxia. Most cases of this disease are caused by mutations in a gene, *MECP2*, whose protein product binds to methylated CG sequences found in the 5' regions of other genes. After binding to these sequences, the protein helps to bring about repression of the transcription of the downstream genes. Loss-of-function mutations in *MECP2* result in the inappropriate expression of genes that appear to be involved in brain development. www

Figure 5-9 illustrates a pedigree for X-linked dominant inheritance. As with autosomal dominant diseases, an individual need inherit only a single copy of an Xlinked dominant disease gene to manifest the disorder. Because females have two X chromosomes, either of which can potentially carry the disease gene, they are about twice as commonly affected as males (unless the disorder is lethal in males, as in incontinentia pigmenti). Affected fathers cannot transmit the trait to their sons. All of their daughters must inherit the disease gene, so all are affected. Affected females are usually heterozygotes and thus have a 50% chance of passing the disease allele to their daughters and sons. The characteristics of Xlinked dominant and X-linked recessive inheritance are summarized in Table 5-1.

X-linked dominant diseases display characteristic patterns of inheritance. They are about twice as common in females as in males, skipped generations are uncommon, and father-son transmission is not seen.

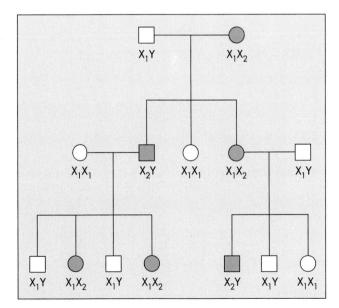

FIGURE 5.9 Pedigree demonstrating the inheritance of an X-linked dominant trait. X_1 , chromosome with normal allele; X_2 , chromosome with disease allele.

CLINICAL COMMENTARY 5.2

Duchenne Muscular Dystrophy

Muscular dystrophy, defined as a progressive weakness and loss of muscle, exists in dozens of different forms. Of these, Duchenne muscular dystrophy (DMD), named after the French neurologist who provided the first comprehensive description in 1868, is the most severe and the most common. It affects approximately 1 of every 3,500 males, a prevalence figure that is similar among all ethnic groups studied thus far.

The symptoms of DMD are usually seen before the age of 5 years, with parents often noticing clumsiness and muscle weakness. Pseudohypertrophy of the calves, the result of infiltration of muscle by fat and connective tissue, is often seen early in the course of the disease. All skeletal muscle degenerates eventually (Fig. 5-10), and most patients with DMD are confined to a wheelchair by 11 years of age. The heart and respiratory musculature become impaired, and death usually results from respiratory or cardiac failure. Survival beyond age 25 years is uncommon. Despite much effort, there is no effective treatment for this disease. www

As muscle cells die, the enzyme creatine kinase (CK) leaks into the bloodstream. Serum CK assays show that in DMD patients, CK is elevated at least 20 times above the upper limit of the normal range. This elevation can be observed presymptomatically (i.e., before clinical symptoms such as muscle wasting are seen). Other diagnostic tools include electromyography, which reveals reduced action potentials, and muscle biopsy (Fig. 5-11).

Female heterozygous carriers of the *DMD* gene are usually free of disease, although 8% to 10% have some degree of muscle weakness. In addition, serum CK exceeds the 95th percentile in approximately two thirds of heterozygotes.

FIGURE 5.10 A patient with late-stage Duchenne muscular dystrophy, showing severe muscle loss.

Until the *DMD* gene was isolated and cloned in 1986, little was known about the mechanism responsible for muscle deterioration. Cloning of the gene and identification of its protein product have advanced our knowledge tremendously. The *DMD* gene covers

FIGURE 5.11 Transverse section of gastrocnemius muscle from (A) a normal boy and (B) a boy with Duchenne muscular dystrophy. Normal muscle fiber is replaced with fat and connective tissue.

В

CLINICAL COMMENTARY 5.2

Duchenne Muscular Dystrophy—cont'd

approximately 2.5 Mb of DNA, making it by far the largest gene known in the human. It contains 79 exons that produce a 14-kb mRNA transcript (because of this gene's huge size, transcription of an mRNA molecule may take as long as 24 hours). The mRNA is translated into a mature protein of 3,685 amino acids. The protein product, named dystrophin, was unknown before the cloning of the DMD gene. Dystrophin accounts for only about 0.002% of a striated muscle cell's protein mass and is localized on the cytoplasmic side of the cell membrane. While its function is still being explored, it is likely to be involved in maintaining the structural integrity of the cell's cytoskeleton. The amino terminus of the protein binds F-actin, a key cytoskeletal protein. The carboxyl terminus of dystrophin binds a complex of glycoproteins, known as the dystroglycan-sarcoglycan complex, that spans the cell membrane and binds to extracellular proteins (Fig. 5-12). Dystrophin thus links these two cellular components and plays a key role in maintaining the structural integrity of the muscle cell. Lacking dystrophin, the muscle cells of the DMD patient gradually die as they are stressed by muscle contractions.

The large size of the DMD gene helps to explain its high mutation rate, about 10^{-4} per locus per generation. As with neurofibromatosis type 1, the DMD gene presents a large target for mutation. A slightly altered form of the DMD gene product is normally found in brain cells. Its absence in DMD patients helps to explain why approximately 25% have an intelligence quotient (IQ) below 75. In brain cells the transcription initiation site is further downstream in the gene, and a different promoter is used. Thus, the mRNA transcript and the resulting gene product differ from the gene product found in muscle cells. Several additional promoters have also been found, providing a good example of a single gene that can produce different gene products as a result of modified transcription.

Becker muscular dystrophy (BMD), another Xlinked recessive dystrophic condition, is less severe than the Duchenne form. The progression is also much slower, with onset at 11 years of age, on average. One study showed that, while 95% of DMD patients are confined to a wheelchair before 12 years of age, 95% of those with BMD become wheelchair bound after 12 years of age. Some never lose their ability to walk. BMD is considerably less common than DMD, affecting about 1 in 18,000 male births.

For some time, it was known that the *BMD* gene was located close to *DMD* on the X chromosome. It was unclear, however, whether the two diseases were caused by distinct loci or by different mutations at the same locus. Cloning of the gene showed that the two diseases are in fact caused by different mutations at the same locus and thus represent another example of allelic heterogeneity. Both diseases usually result from deletions (65% of DMD cases and 85% of BMD

FIGURE 5.12 The amino terminus of the dystrophin protein binds to F-actin in the cell's cytoskeleton, and its carboxyl terminus binds to elements of the dystroglycan-sarcoglycan complex. The latter complex of glycoproteins spans the cell membrane and binds to proteins in the extracellular matrix, such as laminin.

1º

CLINICAL COMMENTARY 5.2

Duchenne Muscular Dystrophy—cont'd

cases) or duplications (6% to 7% of DMD and BMD cases). But, whereas the great majority of DMD deletions and duplications produce frameshifts, the majority of BMD mutations are in-frame alterations (i.e., a multiple of three bases is deleted or duplicated). One would expect that a frameshift, which is likely to alter the protein substantially (see Chapter 3), would produce a more severe disease than would an in-frame alteration.

The consequences of these different mutations can be observed in the gene product. While dystrophin is absent in almost all DMD patients, it is usually present in reduced quantity (or as a shortened form of the protein) in BMD patients. Thus, a dystrophin assay can help to distinguish between the two diseases. It also helps to distinguish both diseases from other forms of muscular dystrophy, since several of these forms (e.g., various limb-girdle muscular dystrophies) result from mutations in genes that encode proteins of the dystroglycan-sarcoglycan complex, whereas dystrophin appears to be affected only in BMD and DMD.

Precise identification of the *DMD* gene has led to animal models for the disease (a mouse model and a dog model). Animal research is contributing considerably to our understanding of the human form of the disease. In addition, work is progressing on gene therapy for DMD (see Chapter 13). However, because all muscles of the body, including the heart, are affected, this type of therapy faces formidable challenges.

Attribute	X-linked dominant	X-linked recessive
Recurrence risk for heterozygous female × normal male mating	50% of sons affected; 50% of daughters affected	50% of sons affected; 50% of daughters heterozygous carriers
Recurrence risk for affected male × normal female mating	0% of sons affected; 100% of daughters affected	0% of sons affected; 100% of daughters heterozygous carriers
Transmission pattern	Vertical; disease phenotype seen in generation after generation	Skipped generations may be seen, representing transmission through carrier females
Sex ratio	Twice as many affected females as affected males (unless disease is lethal in males)	Much greater prevalence of affected males; affected homozygous females are rare
Other	Male-male transmission not seen; expression is less severe in female heterozygotes than in affected males	Male-male transmission not seen; manifesting heterozygotes may be seen in females

TABLE 5.1 Comparison of the Major Attributes of X-Linked Dominant and X-Linked Recessive Inheritance Patterns*

*Compare with the inheritance patterns for autosomal diseases shown in Table 4-1 (Chapter 4).

The Fragile X Story: Molecular Genetics Explains a Puzzling Pattern of Inheritance

Since the 19th century, it has been observed that there is an approximate 25% excess of males among the institutionalized mentally retarded. This excess is partly explained by several X-linked conditions that cause mental retardation. The fragile X syndrome is the most common of these, accounting for approximately 40% of all cases of X-linked mental retardation. The fragile X syndrome is in fact the single most common inherited cause of mental retardation (Down syndrome, to be discussed in Chapter 6, accounts for a larger proportion of cases of mental retardation, but it usually occurs as a new mutation and is thus not inherited). In addition to mental retardation, fragile X syndrome is characterized by a distinctive facial appearance, with large ears and long face (Fig. 5-13), hypermobile joints, and macroorchidism (increased testicular volume) in postpubertal males. The degree of mental retardation tends to be milder and more variable in females than in males. The term "fragile X" is derived from the fact that the X chromosomes of affected individuals, when cultured in a medium that is deficient in folic acid, sometimes exhibit breaks and gaps near the tip of the long arm (Fig. 5-14). www

Although the presence of a single fragile X mutation is sufficient to cause disease in either males or females, the prevalence of this condition is higher in males (1/4,000)than in females (1/8,000). The lower degree of penetrance

prominent jaws, and large ears and the similar characteristics of children from different ethnic groups: Caucasian (A), Asian (B), and Hispanic (C).

Α

in females, as well as variability in expression, reflects the effects of the normal X chromosome and variation in patterns of X-inactivation. Males who have affected descendants but are not affected themselves are termed "normal transmitting males." In the mid-1980s, studies of fragile X pedigrees revealed a perplexing pattern: the mothers of transmitting males had a much lower proportion of affected sons than did the daughters of these males (Fig. 5-15). Daughters of transmitting males were never affected with the disorder, but *their* sons could be affected. This pattern, dubbed the "Sherman paradox," appeared to be inconsistent with the rules of X-linked inheritance.

в

С

Many mechanisms were proposed to explain this pattern, including autosomal and mitochondrial modifier loci. Resolution of the Sherman paradox came only with the cloning of the disease gene, labeled FMR1. DNA sequence analysis showed that the 5' untranslated region of the gene contains a CGG repeat unit that is present in 6 to 50 copies in normal individuals. Those with fragile X syndrome have 230 to 1,000 or more CGG repeats (a "full mutation"). An intermediate number of repeats, ranging approximately from 50 to 230 copies, is seen in normal transmitting males and their female offspring. When these female offspring transmit the gene to their offspring, there is sometimes an expansion from this "premutation" of 50 to 230 repeats to the full mutation of more than 230 repeats. These expansions do not occur in male transmission. Furthermore, premutations tend to become larger in successive generations, and larger premutations are more likely to expand to a full mutation. These findings explain the Sherman paradox. They show why males with the premutation cannot transmit the disease to their daughters, and they explain why grandsons and great-grandsons of transmitting males are more likely to be affected by the disorder.

Measurement of mRNA transcribed from FMR1 has shown that the highest mRNA expression levels are in the brain, as would be expected. Individuals with normal and premutation FMR1 genes both produce mRNA (in fact, mRNA production is elevated in those with premutations). However, those with full mutations have no FMR1 mRNA in their cells, indicating that transcription of the gene has been eliminated. The CGG repeat is heavily methylated in those with the full mutation, as is a series of CG sequences 5' of the gene. The degree of methylation is correlated with severity of expression of the disorder. These correlations indicate that methylation may influence the transcription of FMR1. A small proportion of individuals with fragile X syndrome (less than 5%) do not have an expansion of the CGG repeat but instead have other loss-of-function mutations in FMR1.

The protein product of *FMR1*, FMRP, binds to RNA and is capable of shuttling back and forth between the nucleus and the cytoplasm. It appears that this protein

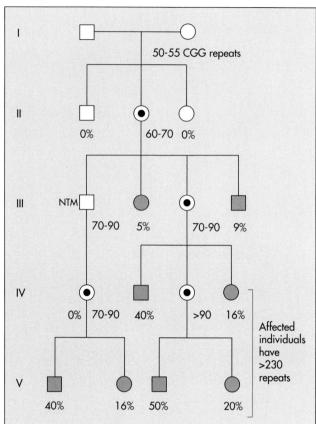

FIGURE 5.15 A pedigree showing the inheritance of the fragile X syndrome. Females who carry a premutation (50 to 230 CGG repeats) are dotted. Affected individuals are represented by solid symbols. A normal transmitting male, who carries a premutation of 70 to 90 repeat units, is designated NTM. Note that the number of repeats increases each time the mutation is passed through another female. Also, only 5% of the NTM's sisters are affected, and only 9% of his brothers are affected, but 40% of his grandsons and 16% of his granddaughters are affected. This is the Sherman paradox.

may be involved in transporting mRNA from the nucleus to the cytoplasm, and it may also be involved in regulating the translation of mRNA.

Further study of this region has revealed the presence of another fragile site distal to the fragile X site. This site, termed FRAXE, is also associated with an expansion of a CGG trinucleotide repeat in the 5' region of a gene (labeled FMR2), subsequent hypermethylation, and a phenotype that includes mental retardation. Unlike fragile X syndrome, the CGG repeat at this locus can expand when transmitted through either males or females.

Cloning of the *FMR1* gene and the identification of a repeat expansion have already explained a great deal about the inheritance and expression of the fragile X syndrome. These advances have also improved diagnostic accuracy for the condition, since cytogenetic analysis of chromosomes often fails to identify fragile X heterozygotes. In contrast, DNA diagnosis, which consists of

measurement of the length of the CGG repeat sequence and the degree of methylation of *FMR1*, is very accurate.

Y-Linked Inheritance

Although it consists of approximately 70 Mb of DNA, the Y chromosome contains relatively few genes. Only a few dozen Y-linked, or **holandric**, genes have been identified. These include the gene that initiates differentiation of the embryo into a male (see Chapter 6), several genes that encode testis-specific spermatogenesis factors, and a minor histocompatibility antigen (termed HY). Several housekeeping genes are located on the Y chromosome, and they all have inactivation-escaping homologs on the X chromosome. Transmission of Y-linked traits is strictly from father to son (Fig. 5-16).

SEX-LIMITED AND SEX-INFLUENCED TRAITS

Confusion sometimes exists regarding traits that are *sex-linked* and those that are **sex-limited** or **sex-influenced**. A sex-limited trait occurs in only one of the sexes—due, for instance, to anatomical differences. Inherited uterine or testicular defects would be examples. A good example of a sex-influenced trait is male-pattern baldness, which occurs in both males and females but much more commonly in males. Contrary to oft-stated belief, male-pattern baldness is not X-linked. It is thought to be inherited as an autosomal dominant trait in males, whereas in females it is inherited as an autosomal recessive trait. Female heterozygotes can transmit the trait to their off-spring but do not manifest it. Females display the trait

only if they inherit two copies of the gene. Even then, they are more likely to display marked thinning of the hair, rather than complete baldness.

MITOCHONDRIAL INHERITANCE

The great majority of genetic diseases are caused by defects in the nuclear genome. However, a small but significant number of diseases are the result of mitochondrial mutations. Because of the unique properties of the mitochondria, these diseases display characteristic modes of inheritance and a large degree of phenotypic variability.

Each human cell contains several hundred or more mitochondria in its cytoplasm. Through the complex process of oxidative phosphorylation, these organelles produce adenosine triphosphate (ATP), the energy source essential for cellular metabolism. Mitochondria are thus critically important for cell survival.

The mitochondria have their own DNA molecules. They occur in several copies per organelle and consist of 16,569 base pairs arranged on a double-stranded circular molecule (Fig. 5-18). The mitochondrial genome encodes two ribosomal RNAs, 22 transfer RNAs (tRNAs), and 13 polypeptides involved in oxidative phosphorylation (another 90 or so nuclear DNA genes also encode polypeptides that are transported into the mitochondria to participate in oxidative phosphorylation). Transcription of mitochondrial DNA (mtDNA) takes place in the mitochondrion, independently of the nucleus. Unlike nuclear DNA, mtDNA contains no introns. Because it is located in the cytoplasm, mtDNA is inherited exclusively through the maternal line

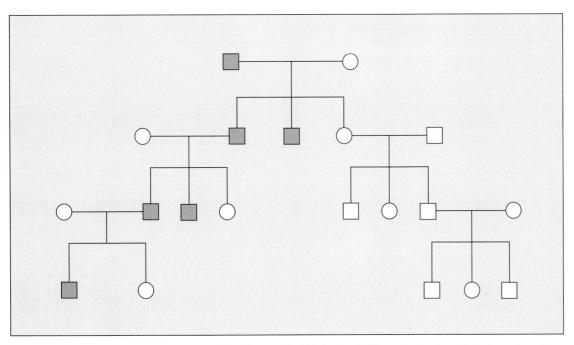

FIGURE 5.16 Pedigree demonstrating the inheritance of a Y-linked trait. Transmission is exclusively male-male.

BOX

5.1

Color Vision: Molecular Biology and Evolution

Human vision depends on a system of retinal photoreceptor cells, about 95% of which are termed **rod cells**. They contain the light-absorbing protein **rhodopsin** and allow us to see in conditions of dim light. In addition, the retina contains three classes of **cone cells**, which contain light-absorbing proteins (opsins) that react to the three primary colors—red, green, and blue. Color vision depends on the presence of all four of these cell types. Since three major colors are involved, normal color vision is said to be **trichromatic**.

There are many recognized defects of human color vision. The most common of these involve red and green color perception and have been known since 1911 to be inherited in X-linked recessive fashion. Thus, they are much more common in males than in females. Various forms of "red-green colorblindness" are seen in about 8% of Caucasian males, 4% to 5% of Asian males, and 1% to 4% of African and Native American males. Among Caucasian males, 2% are **dichromatic**: they are unable to perceive one of the primary colors, usually red or green. The inability to perceive green is termed **deuteranopia**, while the inability to perceive red is termed **protanopia**. About 6% of Caucasian males can detect green and red, but with altered perception of the relative shades of these colors. These are respectively termed **deuteranomalous** and **protanomalous** conditions.

It should be apparent that dichromats are not really color blind, since they can still perceive a fairly large array of different colors. True colorblindness (**monochromacy**, the ability to perceive only one color) is much less common, affecting approximately 1 in 100,000 individuals. There are two major forms of monochromatic vision. **Rod monochromacy** is an autosomal recessive condition in which all visual function is carried out by rod cells. **Blue cone monochromacy** is an X-linked recessive condition in which both the red and green cone cells are absent.

Cloning of the genes responsible for color perception has revealed a number of interesting facts about both the biology and the evolution of color vision in humans. About 15 years ago, Jeremy Nathans and colleagues reasoned that the opsins in all four types of photoreceptor cells might have similar amino acid sequences because they carry out similar functions. Thus, the DNA sequences of the genes encoding these proteins should also be similar. But none of these genes had been located, and the precise nature of the protein products was unknown. How could they locate these genes? Fortunately, the gene encoding rhodopsin in cattle had been cloned. Even though humans and cattle are separated by millions of years of evolution, their rhodopsin proteins still share about 40% of the same amino acid sequence. Thus, the cattle (bovine) rhodopsin gene could be used as a probe to search for a homolog in the human genome. A portion of the bovine rhodopsin gene was converted to single-strand form, radioactively labeled, and hybridized with human DNA (much in the same way that a probe is used in Southern blotting [see Chapter 3]). Low-stringency hybridization conditions were used: temperature and other conditions were manipulated so that complementary base pairing would occur despite some sequence differences

between the two species. In this way, the human rhodopsin gene was identified and mapped to chromosome 3.

The next step was to use the human rhodopsin gene as a probe to identify the cone cell opsin genes. Each of the cone cell opsin amino acid sequences shares 40% to 45% similarity with the human rhodopsin amino acid sequence. By probing with the rhodopsin gene, the gene for blue-sensitive opsin was identified and mapped to chromosome 7. This gene was expected to map to an autosome because variants in blue sensitivity are inherited as an autosomal recessive trait. The genes for the red- and green-sensitive opsins were also identified in this way and, as expected, were found to be on the X chromosome. The red and green genes are highly similar, sharing 98% of their DNA sequence.

Initially, many investigators expected that people with color vision defects would display the usual array of deletions and missense and nonsense mutations seen in other disorders. But further study revealed some surprises. It was found that the red and green opsin genes are located directly adjacent to one another on the distal long arm of the X chromosome and that normal individuals have one copy of the red gene but can have one to several copies of the green gene. The multiple green genes are 99.9% identical in DNA sequence, and the presence of multiple copies of these genes has no effect on color perception. However, when there are no green genes, deuteranopia is produced. Individuals who lack the single red gene have protanopia. The unique aspect of these deletions is that they are the result of unequal crossover during meiosis (Fig. 5-17). Unlike ordinary crossover, in which equal segments of chromosomes are exchanged (see Chapter 2), unequal crossover results in a loss of chromosome material on one homolog and a gain of material on the other. Unequal crossover seems to be facilitated by the high similarity in DNA sequence among the red and green genes: it is relatively easy for the cellular machinery to make a "mistake" in deciding where the crossover should occur. Thus, a female with one red gene and two green genes could produce one gamete containing a red gene with one green gene and another gamete containing a red gene with three green genes. Unequal crossover could also result in gametes with no copies of a gene, producing protanopia or deuteranopia.

Unequal crossover also explains protanomalous and deuteranomalous color vision. Here, crossover takes place *within* the red or green genes (see Fig. 5-17), resulting in new chromosomes with hybrid genes (e.g., a portion of the red gene fused with a portion of the green gene). The relative proportion of red and green components of these **fusion genes** determines the extent and nature of the red-green anomaly.

Since the opsin genes have DNA sequence similarity and perform similar functions, they are members of a gene family, much like the globin genes (see Chapter 3). This suggests that they evolved from a single ancestral gene that, through time, duplicated and diverged to encode different but related proteins. Evidence for this process is provided by comparing these genes in humans and other species. Because the X-linked red and green opsin genes share the

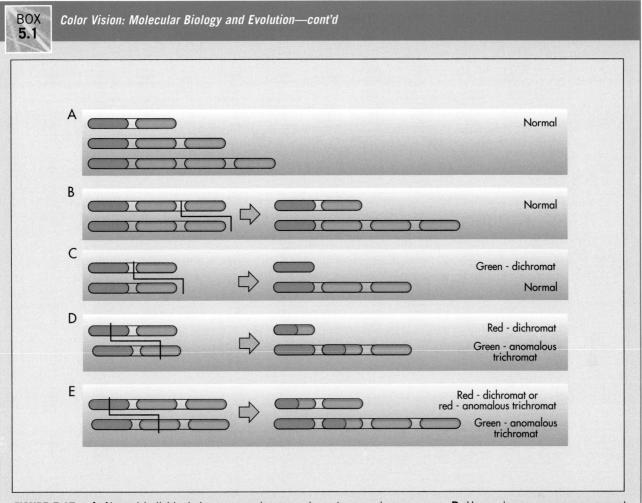

FIGURE 5.17 A, Normal individuals have one red gene and one to several green genes. B, Unequal crossover causes normal variation in the number of green genes. C, Unequal crossover can produce a green dichromat with no green genes (deuteranopia). D, Unequal crossover that occurs *within* the red and green genes can produce a red dichromat (protanopia) or a green anomalous trichromat (deuteranomaly). E, Crossovers within the red and green genes can also produce red anomalous trichromats (protanomaly). The degree of red and green color perception depends on where the crossover occurs within the genes. (Modified from Nathans J, Merbs SL, Sung C, et al. [1989] The genes for color vision. Sci Am 260:42-49.)

greatest degree of DNA sequence similarity, we would expect that these two genes would be the result of the most recent duplication. Indeed, humans share all four of their opsin genes with apes and Old World monkeys, but the less closely related New World monkeys have only a single opsin gene on their X chromosomes. It is therefore likely that the red-green duplication occurred sometime after the split of the New and Old World monkeys, which took place about 30 to 40 million years ago. Similar comparisons date the split of the X-linked and autosomal cone opsin genes to approximately 500 million years ago. And finally, comparisons with the fruit fly, *Drosophila melanogaster*, indicate that the split between the rod and cone visual pigment genes may have occurred as much as 1 billion years ago.

(Fig. 5-19). Males inherit their mtDNA from their mothers. They do not pass it to their offspring, however, because sperm cells contain only a small number of mtDNA molecules, which are not incorporated into the developing embryo.

The mutation rate of mtDNA is about 10 times higher than that of nuclear DNA. This is caused by a lack of DNA repair mechanisms in the mtDNA and possibly also by damage from free oxygen radicals released during the oxidative phosphorylation process.

Since each cell contains a *population* of mtDNA molecules, a single cell can harbor some molecules that have an mtDNA mutation and other molecules that do not. This heterogeneity in DNA composition, termed **heteroplasmy**, is an important cause of variable expression in mitochondrial diseases. The larger the proportion of

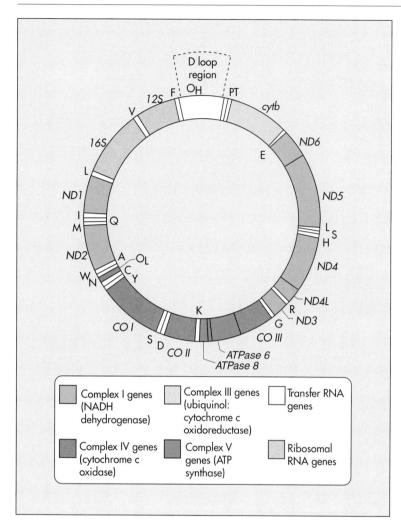

FIGURE 5.18 ■ The circular mitochondrial DNA genome. Locations of protein-encoding genes (for reduced nicotinamide adenine dinucleotide [NADH] dehydrogenase, cytochrome c oxidase, cytochrome c oxidoreductase, and ATP synthase) are shown, as are the locations of the two ribosomal RNA genes and 22 transfer RNA genes (designated by single letters). The replication origins of the heavy (OH) and light (OL) chains and the noncoding D loop (also known as the control region) are shown. (Modified from Wallace DC [1992] Mitochondrial genetics: a paradigm for aging and degenerative diseases? Science 256:628-632.)

FIGURE 5.19 A pedigree showing the inheritance of a disease caused by a mitochondrial DNA mutation. Only females can transmit the disease mutation to their offspring. Complete penetrance of the disease-causing mutation is shown in this pedigree, but heteroplasmy often results in incomplete penetrance for mitochondrial diseases.

mutant mtDNA molecules, the more severe the expression of the disease. As cells divide, changes in the proportion of mutant alleles can occur through chance variation (identical in concept to genetic drift, discussed in Chapter 3) or because of a selective advantage (e.g., deletions produce a shorter mitochondrial DNA mole-

cule that can replicate more quickly than a full-length molecule).

Each tissue type requires a certain amount of mitochondrially produced ATP for normal function. Although some variation in ATP levels may be tolerated, there is typically a threshold level below which cells

104

begin to degenerate and die. Organ systems with large ATP requirements and high thresholds tend to be the ones most seriously affected by mitochondrial diseases. For example, the central nervous system consumes about 20% of the body's ATP production and therefore is often affected by mtDNA mutations.

Like the globin disorders, mitochondrial disorders can be classified according to the type of mutation that causes them. Missense mutations in protein-coding mtDNA genes cause one of the best-known mtDNA diseases, Leber hereditary optic neuropathy (LHON). This disease is characterized by rapid loss of vision in the central visual field as a result of optic nerve death. Vision loss typically begins in the third decade of life and is usually irreversible. Heteroplasmy is rare in LHON, so expression tends to be relatively uniform and pedigrees for this disorder usually display a clear pattern of mitochondrial inheritance.

Single-base mutations in a tRNA gene can result in myoclonic epilepsy with ragged-red fiber syndrome (MERRF), a disorder characterized by epilepsy, dementia, ataxia (uncoordinated muscle movement), and myopathy (muscle disease). MERRF is heteroplasmic and thus highly variable in its expression. Another example of a mitochondrial disease caused by a single-base tRNA mutation is mitochondrial encephalomyopathy and stroke-like episodes (MELAS). Like MERRF, MELAS is heteroplasmic and highly variable in expression. www

The final class of mtDNA mutations consists of duplications and deletions. These can produce Kearns-Sayre disease (muscle weakness, cerebellar damage, and heart failure), Pearson syndrome (infantile pancreatic insufficiency, pancytopenia, and lactic acidosis), and chronic progressive external ophthalmoplegia (CPEO). To date, the disease-causing mutations seen in mtDNA include more than 50 point mutations and more than 100 deletions or duplications.

Mitochondrial mutations are also involved in some common human diseases. A mitochondrial deletion causes a form of deafness, and the MELAS mutation is seen in 1% to 2% of individuals with non-insulin-dependent diabetes mellitus. Mitochondrial defects may also be associated with some cases of Alzheimer disease. It has also been suggested that mtDNA mutations, whichaccumulate through the life of an individual as a result of free radical formation, could contribute to the aging process.

The mitochondria, which produce ATP, have their own unique DNA. Mitochondrial DNA is maternally inherited and has a high mutation rate. A number of diseases are known to be caused by mutations in mitochondrial DNA.

SUGGESTED READINGS

- Avner P, Heard E (2001) X-chromosome inactivation: counting, choice and initiation. Nat Rev Genet 2:59-67
- Brockdorff N (2002) X-chromosome inactivation: closing in on proteins that bind Xist RNA. Trends Genet 18:352-358
- Emery AE (2002) The muscular dystrophies. Lancet 359:687-695
- Jin P, Warren ST (2000) Understanding the molecular basis of fragile X syndrome. Hum Mol Genet 9:901-908
- Mannucci PM, Tuddenham EG (2001) The hemophilias: from royal genes to gene therapy. N Engl J Med 344:1773-17739
- O'Brien KF, Kunkel LM (2001) Dystrophin and muscular dystrophy: past, present, and future. Mol Genet Metab 74:75-88
- Oostra BA, Chiurazzi P (2001) The fragile X gene and its function. Clin Genet 60:399-408
- Shahbazian MD, Zoghbi HY (2002) Rett syndrome and MeCP2: linking epigenetics and neuronal function. Am J Hum Genet 71:1259-1272
- Thorburn DR, Dahl HH (2001) Mitochondrial disorders: genetics, counseling, prenatal diagnosis and reproductive options. Am J Med Genet 106:102-114
- Wallace DC (1999) Mitochondrial diseases in man and mouse. Science 283:1482-1488
- Wissinger B, Sharpe LT (1998) New aspects of an old theme: The genetic basis of human color vision. Am J Hum Genet 63:1257-1262

INTERNET RESOURCES

- MITOMAP (extensive information about the mitochondrial genome and its role in disease) http://www.mitomap.org/
- Muscular Dystrophy Association (information about various types of muscular dystrophy with links to other Web sites) http://www.mdausa.org/
- National Hemophilia Foundation (information about hemophilia and links to other Web sites)

http://www.hemophilia.org/home.htm

STUDY QUESTIONS

- 1. Females have been observed with five X chromosomes in each somatic cell. How many Barr bodies would such females have?
- 2. Explain why 8% to 10% of female carriers of the *DMD* gene have muscle weakness.
- 3. For X-linked recessive disorders, the ratio of affected males to affected females in populations increases as the disease frequency decreases. Explain this in terms of gene and genotype frequencies.
- 4. Figure 5-20 shows the inheritance of hemophilia A in a family. What is the risk that the male in generation IV is affected with hemophilia A? What is the risk that the female in generation IV is a heterozygous carrier? What is the risk that she is affected by the disorder?
- 5. Pedigrees for autosomal dominant and X-linked dominant diseases are sometimes difficult to distinguish. Name as many features as you can that would help to tell them apart.
- 6 How would you distinguish mitochondrial inheritance from other modes of inheritance?
- 7. A man with Becker muscular dystrophy marries a phenotypically normal female. On average, what proportion of their male offspring will be affected, and what proportion of their female offspring will be affected by this disorder?

FIGURE 5.20 Pedigree for study question 4.

- 8. A female carrier of a Duchenne muscular dystrophy mutation marries a phenotypically normal man. On average, what proportion of their male offspring will be affected, and what proportion of their female offspring will be affected with the disorder?
- 9. A boy and his brother both have hemophilia A. If there is no family history of hemophilia A in previous generations, what is the probability that the boys' aunt (the mother's sister) is a heterozygous carrier of the disease gene?

CHAPTER U

Clinical Cytogenetics: The Chromosomal Basis of Human Disease

The previous two chapters have dealt with single-gene diseases. We turn now to diseases caused by alterations in the number or structure of chromosomes. The study of chromosomes and their abnormalities is called **cytogenetics**.

Chromosome abnormalities are responsible for a significant proportion of genetic diseases, occurring in approximately 1 of every 150 live births. They are the leading known cause of both mental retardation and pregnancy loss. Chromosome abnormalities are seen in 50% of first-trimester and 20% of second-trimester spontaneous abortions. Thus, they are an important cause of morbidity and mortality.

As in other areas of medical genetics, advances in molecular genetics have contributed many new insights in the field of cytogenetics. For example, molecular techniques have permitted the identification of chromosome abnormalities, such as deletions, that affect very small regions. In some cases, specific genes responsible for cytogenetic syndromes are being pinpointed. Thus, the distinction between "chromosome abnormalities" and "single-gene diseases" is becoming somewhat blurred. In addition, the ability to identify DNA polymorphisms in parents and offspring has enabled researchers to specify whether an abnormal chromosome is derived from the mother or from the father. This has increased our understanding of the biological basis of meiotic errors and chromosome abnormalities.

In this chapter we discuss abnormalities of chromosome number and structure. The genetic basis of sex determination is reviewed, the role of chromosome alterations in cancer is examined, and several diseases caused by chromosomal instability are discussed. Emphasis is given to the new contributions of molecular genetics to cytogenetics.

CYTOGENETIC TECHNOLOGY AND NOMENCLATURE

Although it was possible to visualize chromosomes under microscopes as early as the mid-1800s, it was quite difficult to observe individual chromosomes. It was thus hard to count the number of chromosomes in a cell or to examine structural abnormalities. Beginning in the 1950s, several techniques were developed that improved our ability to observe chromosomes. These included (1) the use of spindle poisons, such as colchicine and colcemid, that arrest dividing somatic cells in metaphase, when chromosomes are maximally condensed and easiest to see; (2) the use of a hypotonic (low salt) solution, which causes swelling of cells, rupture of the nucleus, and better separation of individual chromosomes; and (3) the use of staining materials that are absorbed differentially by different parts of chromosomes, thus producing the characteristic bands that help to identify individual chromosomes.

Our ability to study chromosomes has been improved by the visualization of chromosomes in metaphase, by hypotonic solutions that cause nuclear swelling, and by staining techniques that bring out chromosome bands.

Chromosomes are analyzed by collecting a living tissue (usually blood), culturing the tissue for the appropriate amount of time (usually 48 to 72 hours for peripheral lymphocytes), adding colcemid to produce metaphase arrest, harvesting the cells, placing the cell sediment on a slide, rupturing the cell nucleus with a hypotonic saline solution, staining with a designated nuclear stain, and photographing the metaphase "spreads" of chromosomes on the slide. The images of the 22 pairs of autosomes are arranged according to length, with the sex chromosomes in the right-hand corner. This ordered display of chromosomes is termed a **karyotype** (Fig. 6-1). Currently, computerized image analyzers are usually used to display chromosomes.

After sorting by size, chromosomes are further classified according to the position of the centromere. If the centromere occurs near the middle of the chromosome, the chromosome is said to be **metacentric** (Fig. 6-2). An **acrocentric** chromosome has its centromere near the tip, and **submetacentric** chromosomes have centromeres somewhere between the middle and the tip. The tip of each chromosome is termed the **telomere**. The short

FIGURE 6.1 A banded karyotype of a normal female. The banded metaphase chromosomes are arranged from largest to smallest in size.

arm of a chromosome is labeled p (for *petite*), and the long arm is labeled q. In metacentric chromosomes, where the arms are of roughly equal length, the p and q arms are designated by convention.

A karyotype is a display of chromosomes ordered according to length. Depending on the position of the centromere, a chromosome may be acrocentric, submetacentric, or metacentric.

FIGURE 6.2 Metacentric, submetacentric, and acrocentric chromosomes. Note the stalks and satellites present on the short arms of the acrocentric chromosomes.

A normal female karyotype is designated 46,XX; a normal male karyotype is designated 46,XY. The nomenclature for various chromosome abnormalities is summarized in Table 6-1 and will be indicated for each condition discussed in this chapter.

Chromosome Banding

Early karyotypes were useful in counting the number of chromosomes, but structural abnormalities, such as balanced rearrangements or small chromosomal deletions, were often undetectable. Staining techniques were developed in the 1970s to produce the chromosome bands characteristic of modern karyotypes. Chromosome banding helps greatly in the detection of deletions, duplications, and other structural abnormalities, and it facilitates the correct identification of individual chromosomes. The major bands on each chromosome are numbered (Fig. 6-3). Thus, 14q32 refers to the second band in the third region of the long arm of chromosome 14. Sub-bands are designated by decimal points following the band number (e.g., 14q32.3 is the third sub-band of band 2).

Karyotype	Description			
46,XY	Normal male chromosome constitution			
47,XX,+21	Female with trisomy 21, Down syndrome			
47,XY,+21[10]/46,XY[10]	Male who is a mosaic of trisomy 21 cells and normal cells (10 cells scored for each karyotype)			
46,XY,del(4)(p14)	Male with distal deletion of the short arm of chromosome 4 band designated 14			
46,XX,dup(5)(p14p15.3)	Female with a duplication of the short arm of chromosome 5 from bands p14 to p15.3			
45,XY,der(13;14)(q10;q10)	A male with a balanced Robertsonian translocation of chromosomes 13 and 14. Karyotype shows that one normal 13 and one normal 14 are missing and replaced with a derivative chromosome			
46,XY,t(11;22)(q23;q22)	A male with a balanced reciprocal translocation between chromosomes 11 and 22. The breakpoints are at 11q23 and 22q22			
46,XX,inv(3)(p21;q13)	An inversion on chromosome 3 that extends from p21 to q13; because it includes the centromere, this is a pericentric inversion			
46,X,r(X)	A female with one normal X chromosome and one ring X chromosome			
46,X,i(Xq)	A female with one normal X chromosome and an isochromosome of the long arm of the X chromosom			

TABLE 6.1 🔳 Standard Nomenclature for Chromosome Karyotypes

Several chromosome-banding techniques are used in cytogenetics laboratories. **Quinacrine** banding (Qbanding) was the first staining method used to produce specific banding patterns. This method requires a fluorescence microscope and is no longer as widely used as **Giemsa banding** (G-banding). To produce G bands, a Giemsa stain is applied after the chromosomal proteins are partially digested by trypsin. **Reverse banding** (Rbanding) requires heat treatment and reverses the usual white and black pattern that is seen in G-bands and Qbands. This method is particularly helpful for staining the distal ends of chromosomes. Other staining techniques

FIGURE 6.3 A schematic representation of the banding pattern of a G-banded karyotype; 300 bands are represented in this ideogram. The short and long arms of the chromosomes are designated, and the segments are numbered according to the standard nomenclature adopted at the Paris conference, 1971. In this illustration, both sister chromatids are shown for each chromosome.

include **C-banding** and nucleolar organizing region stains (**NOR stains**). These latter methods specifically stain certain portions of the chromosome. C-banding stains the **constitutive heterochromatin**, which usually lies near the centromere, and NOR staining highlights the satellites and stalks of acrocentric chromosomes (see Fig. 6-2).

High-resolution banding involves the staining of chromosomes during prophase or early metaphase (prometaphase), before they reach maximal condensation. Because prophase and prometaphase chromosomes are more extended than metaphase chromosomes, the number of bands observable for all chromosomes increases from about 300 to 450 (as in Fig. 6-3) to as many as 800. This allows the detection of less obvious abnormalities usually not seen with conventional banding.

Chromosome bands help to identify individual chromosomes and structural abnormalities in chromosomes. Banding techniques include quinacrine, Giemsa, reverse, C, and NOR banding. Highresolution banding, using prophase or prometaphase chromosomes, increases the number of observable bands.

Fluorescence In Situ Hybridization and Comparative Genomic Hybridization

In the widely used fluorescence in situ hybridization (FISH) technique, a labeled chromosome-specific DNA segment (probe) is exposed to denatured metaphase, prophase, or interphase chromosomes. It undergoes complementary base pairing (hybridization) with the DNA sequence that corresponds to its location on a specific chromosome. Because the probe is labeled with a fluorescent dye, the location at which it hybridizes with the patient's chromosomes can be visualized under a fluorescence microscope. A common use of FISH is to determine whether a portion of a chromosome is deleted in a patient. In a normal individual, a probe hybridizes in two places, reflecting the presence of two homologous chromosomes in a somatic cell nucleus. If a probe from the chromosome segment in question hybridizes to only one of the patient's chromosomes, then the patient probably has the deletion on the copy of the chromosome to which the probe fails to hybridize. FISH provides considerably better resolution than high-resolution banding approaches; it can typically detect deletions as small as 1 million base pairs (1 Mb) in size.

Excess chromosome material can also be detected using FISH. In this case, the probe hybridizes in three places instead of two. Combinations of FISH probes can also be used to detect chromosome rearrangements such as translocations (see later discussion).

Figure 6-4 illustrates a FISH result for a child who is missing a small piece of the short arm of chromosome 17. Although a centromere probe (used as a control) hybridizes to both copies of chromosome 17, a probe corresponding to a specific region of 17p hybridizes to only one chromosome. This demonstrates the deletion that causes the Smith-Magenis syndrome (see Table 6-3 later in the chapter).

Because FISH detection of an euploidy can be carried out with interphase chromosomes, it is not necessary to stimulate cells to divide in order to obtain metaphase chromosomes (a week-long procedure required for traditional microscopic approaches). This allows analyses and diagnoses to be completed more rapidly. FISH analysis of interphase chromosomes is commonly used in the prenatal detection of fetal aneuploidy and in the analysis of chromosome rearrangements in tumor cells.

Fluorescence in situ hybridization (FISH) is a technique in which a labeled probe is hybridized to metaphase, prophase, or interphase chromosomes. FISH can be used to test for missing or additional chromosomal material as well as chromosome rearrangements.

The FISH technique has been extended by using multiple probes, each labeled with a different color, so that several of the most common numerical abnormalities (e.g., those of chromosomes 13, 18, 21, X, and Y) can be tested simultaneously in the same cell (see Color Plate 4). In addition, newer techniques such as **spectral karyotyping** utilize varying combinations of five

FIGURE 6.4 A fluorescence in situ hybridization (FISH) result. The longer arrows point to a centromere-hybridizing probe for chromosome 17, and the shorter, thicker arrow points to a probe that hybridizes to 17p. The latter probe reveals only one spot in this individual, who has a deletion of 17p, producing the Smith-Magenis syndrome. (Courtesy Dr. Arthur Brothman, University of Utah Health Sciences Center.)

different fluorescent probes in conjunction with special cameras and image-processing software so that each chromosome is uniquely colored ("painted") for ready identification (see Color Plate 5). Such images are especially useful for identifying chromosome rearrangements (see Color Plate 6).

Losses or duplications of specific chromosome regions can be detected by a technique known as comparative genomic hybridization, or CGH (Fig. 6-5). DNA taken from a test source (e.g., tumor cells) is labeled with a substance that exhibits one color (e.g., green) under a fluorescence microscope; DNA taken from normal control cells is labeled with a second color (e.g., red). Both sets of DNA are then hybridized to normal metaphase chromosomes. If any chromosome region is duplicated in the tumor cell, then this region of the metaphase chromosome will hybridize with excess quantities of the green-labeled DNA. This region will exhibit a green color under the microscope. Conversely, if a region is deleted in the tumor cell, then the corresponding region of the metaphase chromosome will hybridize with excess red-labeled DNA, and the region will exhibit a red color under the microscope. CGH is especially useful in scanning for deletions and duplications of chromosome material in cancer cells, where detection of such alterations may help to predict the severity of the cancer.

In a variant of CGH, labeled DNA from the test and control sources is hybridized with a microarray (see Chapter 3) containing probes corresponding to specific regions of the genome. The ratio of test versus control DNA that hybridizes to a given probe indicates whether this region may be duplicated or deleted in the test source.

The FISH technique can be extended with multiple colors to detect several possible alterations of chromosome number simultaneously. Multiple probes can be used to paint each chromosome with a unique color, facilitating the detection of structural rearrangements. The comparative genomic hybridization (CGH) technique, in which differentially labeled DNA from test and control sources is hybridized to normal metaphase chromosomes, allows the detection of chromosome duplications and deletions.

ABNORMALITIES OF CHROMOSOME NUMBER

Polyploidy

A cell that contains a multiple of 23 chromosomes in its nucleus is said to be **euploid** (Greek, eu = "good," ploid = "set"). Thus, haploid gametes and diploid somatic cells are euploid. **Polyploidy**, the presence of a complete set of extra chromosomes in a cell, is seen commonly in plants and often improves their agricultural value.

FIGURE 6.5 The comparative genomic hybridization (CGH) technique. Green-labeled test DNA (from a tumor sample in this case) and red-labeled reference DNA (from normal cells) are both hybridized to normal metaphase chromosomes. The ratio of green to red signal on the hybridized metaphase chromosomes indicates the location of duplications (excess green) or deletions (excess red) in the tumor chromosomes. More recently, a version of CGH has been developed in which test and normal DNA are hybridized to probes embedded in a microarray.

Polyploidy also occurs in humans, although much less frequently. The polyploid conditions that have been observed in humans are **triploidy** (69 chromosomes in the nucleus of each cell) and **tetraploidy** (92 chromosomes in each cell nucleus). The karyotypes for these two conditions would be designated 69,XXX and 92,XXXX, respectively (assuming that all of the sex chromosomes were X; other combinations of the X and Y chromosomes may be seen). Because the number of chromosomes present in each of these conditions is a multiple of 23, the cells are euploid in each case. However, the additional chromosomes encode a large amount of surplus gene product, causing multiple anomalies such as defects of the heart and central nervous system. www

Triploidy is seen in only about 1 in 10,000 live births, but it accounts for an estimated 15% of the chromosome abnormalities occurring at conception. Thus, the vast majority of triploid conceptions are spontaneously aborted, and those that survive to term typically die shortly after birth. The most common cause of triploidy is the fertilization of an egg by two sperm (dispermy). The resulting zygote receives 23 chromosomes from the egg and 23 chromosomes from each of the two sperm cells. Triploidy can also be caused by the fusion of an ovum and a polar body, each containing 23 chromosomes, and subsequent fertilization by a sperm cell. **Meiotic failure**, in which a diploid sperm or egg cell is produced, can also produce a triploid zygote.

Tetraploidy is much rarer than triploidy, both at conception and among live births. It has been recorded in only a few live births, and those infants survived for only a short period. Tetraploidy can be caused by a mitotic failure in the early embryo in which all of the duplicated chromosomes migrate to one of the two daughter cells. It can also result from the fusion of two diploid zygotes.

Cells that have a multiple of 23 chromosomes are said to be euploid. Triploidy (69 chromosomes) and tetraploidy (92 chromosomes) are polyploid conditions found in humans. Most polyploid conceptions are spontaneously aborted, and all are incompatible with long-term survival.

Autosomal Aneuploidy

Cells that do not contain a multiple of 23 chromosomes are termed **aneuploid**. These cells contain missing or additional chromosomes. Usually only one chromosome is affected, but it is possible for more than one chromosome to be missing or duplicated. Aneuploidies of the autosomes are among the most clinically important of the chromosome abnormalities. They consist primarily of **monosomy** (the presence of only one copy of a chromosome in an otherwise diploid cell) and **trisomy** (three copies of a chromosome). Autosomal monosomies are nearly always incompatible with survival to term, so only a small number of them have been observed among liveborn individuals. In contrast, some trisomies are seen with appreciable frequencies among live births. The fact that trisomies produce less severe consequences than monosomies illustrates an important principle: *the body can tolerate excess genetic material more readily than it can tolerate a deficit of genetic material.*

The most common cause of aneuploidy is **nondisjunction**, the failure of chromosomes to disjoin normally during meiosis (Fig. 6-6). Nondisjunction can occur during meiosis I or meiosis II. The resulting gamete either lacks a chromosome or has two copies of it, producing a monosomic or trisomic zygote, respectively.

Aneuploid conditions consist primarily of monosomies and trisomies. They are usually caused by nondisjunction. Autosomal monosomies are almost always lethal, but some autosomal trisomies are compatible with survival.

FIGURE 6.6 In meiotic nondisjunction, two chromosome homologs migrate to the same daughter cell instead of disjoining normally and migrating to different daughter cells. This produces monosomic and trisomic offspring.

TRISOMY 21

Α

Trisomy 21 (karyotype 47,XY,+21 or 47,XX,+21)* is seen in approximately 1 of every 800 to 1,000 live births, making it the most common aneuploid condition compatible with survival to term. This trisomy produces Down syndrome, a phenotype originally described by John Langdon Down in 1866. Almost 100 years elapsed between Down's description of this syndrome and the discovery (in 1959) that it is caused by the presence of an extra copy of chromosome 21.

Although there is considerable variation in the appearance of individuals with Down syndrome, they present a constellation of features that help the clinician to make a diagnosis. The facial features include a low nasal root, upslanting palpebral fissures, measurably small and sometimes overfolded ears, and a flattened maxillary and malar region, giving the face a characteristic appearance (Fig. 6-7). Some of these features led to the use of the term "mongolism" in earlier literature, but this term is inappropriate. The cheeks are round, and the corners of the mouth are sometimes downturned. The neck is short, and the skin is redundant at the nape of the neck, especially in newborns. The occiput is flat, and the hands and feet tend to be rather broad and short. Approximately

50% of individuals with Down syndrome have a deep flexion crease across their palms (termed a simian crease). Decreased muscle tone (hypotonia) is a highly consistent feature that is helpful in making a diagnosis. www

Several medically significant problems occur with increased frequency among infants and children with Down syndrome. About 3% of these infants develop an obstruction of the duodenum or atresia (closure or absence) of the esophagus, duodenum, or anus. Respiratory infections are quite common, and the risk of developing leukemia is 15 to 20 times higher in patients with Down syndrome than in the general population. The most significant medical problem is that approximately 40% of these individuals are born with structural heart defects. The most common of these is an atrioventricular (AV) canal, a defect in which the interatrial and interventricular septa fail to fuse normally during fetal development. The result is blood flow from the left side of the heart to the right side and then to the pulmonary vasculature, producing pulmonary hypertension. Ventricular septal defects (VSDs) are also common among babies with Down syndrome. Moderate to severe mental retardation (IQ ranging from 25 to 60) is seen in most individuals with Down syndrome. This syndrome alone accounts for 10% of all cases of mental retardation in the United States.

Several other medical problems occur in infants and young children with Down syndrome. Conductive and

typical features are present but less obviously expressed. Continued

В

^{*}For brevity, the remainder of the karyotype designations for abnormalities not involving the sex chromosomes will indicate an affected male.

FIGURE 6.7, cont'd C, A karyotype of a male with trisomy 21.

sometimes neural hearing loss, hypothyroidism, and various eye abnormalities are the most important and frequent. Clinical Commentary 6-1 outlines a plan for routine medical care of infants and children with Down syndrome.

Because of the medical problems seen in children with Down syndrome, their survival rates are significantly decreased. Congenital heart defects are the most important single cause of decreased survival. In the early 1960s, only about half of children with this disorder survived as long as 5 years. As a result of improvements in corrective surgery, antibiotic treatment, and management of leukemia, the survival rate has increased considerably in the past 40 years. Currently, it is estimated that approximately 80% of children with Down syndrome will survive to age 10 years, and about half survive to 50 years of age. There is strong evidence that enriched environments can produce significant improvements in intellectual function.

Males with Down syndrome are nearly always sterile; only two cases have been reported in which a male with Down syndrome has reproduced. Many females with this condition can reproduce, although approximately 40% fail to ovulate. Because reproduction is so uncommon, nearly all cases of trisomy 21 can be regarded as new mutations. A female with Down syndrome has a 50% risk of producing a gamete with two copies of chromosome 21 (which would then produce a trisomic zygote). However, because approximately 75% of trisomy 21 conceptions are spontaneously aborted, the Down syndrome female's risk of producing affected live-born offspring is considerably lower than 50%.

Approximately 95% of Down syndrome cases are caused by nondisjunction, with most of the remainder being caused by chromosome translocations (see later discussion). Based on comparisons of chromosome morphology in affected offspring and their parents, it was long thought that about 80% of chromosome 21 nondisjunctions occur in the mother. A more accurate assessment is now made possible by comparing microsatellite polymorphisms on chromosome 21 in parents and offspring. This approach shows that the extra chromosome is contributed by the mother in 90% to 95% of trisomy 21 cases. About 75% of these maternal nondisjunctions

CLINICAL COMMENTARY 6.1

Anticipatory Guidance in Children with Down Syndrome

In recent years, an approach termed "anticipatory guidance" has evolved for the care and treatment of individuals with genetic syndromes and chronic diseases. After a thorough study of the disease in question (including an extensive literature review), basic guidelines are established for the screening, evaluation, and care of patients. If followed by the primary care practitioner or the specialist, these guidelines should help to prevent further disability or illness. We will illustrate the anticipatory guidance approach with the current guidelines for care of children with Down syndrome.

- Evaluation of heart defects. As mentioned in the text, AV canals are the most common congenital heart defect seen in newborns with Down syndrome. Surgical correction of this condition is appropriate if it is detected before 1 year of age (after this time, pulmonary hypertension has been present too long for surgery to be successful). Accordingly, it is now recommended that an *echocardiogram* be performed during the newborn period.
- Because Down syndrome patients often have strabismus (deviation of the eye from its normal visual axis) and other eye problems, they should be examined regularly by their physician. In

asymptomatic children, an *ophthalmological examination* before the age of 4 years is recommended to evaluate visual acuity.

- Hypothyroidism is common, especially during adolescence. Therefore, *thyroid hormone* levels should be measured annually.
- Sensorineural and conductive hearing loss are both seen in children with Down syndrome. The routine follow-up should include a *hearing test* at 6 to 8 months of age and as needed afterward.
- Instability of the first and second vertebrae has led to spinal cord injuries in some older Down syndrome patients. It is thus suggested that *imaging studies* be carried out in children with neurological symptoms and in those planning to participate in athletic activities.
- It is appropriate to refer children with Down syndrome to preschool programs to provide intervention for developmental disabilities.

Similar series of guidelines have been developed for children with trisomy 18 and Turner syndrome. In principle, the anticipatory guidance approach can be applied to any genetic disease for which there is sufficient knowledge.

occur during meiosis I, with the remainder occurring during meiosis II. As discussed in greater detail later, there is a strong correlation between maternal age and the risk of producing a child with Down syndrome.

Mosaicism is seen in approximately 2% to 4% of trisomy 21 live births. These individuals have some normal somatic cells and some cells with trisomy 21. This type of mosaicism in a male would be designated 47,XY,+21[10]/ 46,XY[10], with the numbers inside the brackets indicating the number of cells scored with each karyotype. The most common cause of mosaicism in trisomy is a trisomic conception followed by loss of the extra chromosome in some cells during mitosis in the embryo. Mosaicism often results in milder clinical expression of a chromosome abnormality.

Depending on the timing and manner in which the mosaicism originated, some individuals may be **tissuespecific mosaics**. As the term suggests, this type of mosaicism is confined only to certain tissues. This can complicate diagnosis, since karyotypes are usually made from a limited number of tissue types (usually circulating lymphocytes derived from a blood sample, or, less commonly, fibroblasts derived from a skin biopsy). Mosaicism affecting primarily the germ line of a parent can lead to multiple recurrences of Down syndrome in the offspring. This factor helps to account for the fact that the recurrence risk for Down syndrome among mothers younger than 30 years of age is about 1% (i.e., ten times higher than the population risk for this age group).

Because of the prevalence and clinical importance of Down syndrome, considerable effort has been devoted to defining the specific genes responsible for this disorder. Molecular approaches, such as cloning and sequencing, are being used to identify specific genes in this region that are responsible for the Down syndrome phenotype, and the process will be made easier with the availability of a complete DNA sequence for chromosome 21. A candidate for mental retardation in Down syndrome is DYRK, a kinase gene located on 21q. Overexpression of this gene in the mouse causes learning and memory defects. Another gene located in the critical region, APP, encodes the amyloid β precursor protein. A triple copy of APP is likely to account for the occurrence of Alzheimer-like features in nearly all Down syndrome patients by 40 years of age. Mutations of APP cause a small percentage of Alzheimer disease cases (see Chapter 12), and Down syndrome individuals with

partial trisomies that do not include the *APP* gene do not develop Alzheimer-like features.

Trisomy 21, which causes Down syndrome, is the most common autosomal aneuploidy seen among live births. The most significant problems include mental retardation, gastrointestinal tract obstruction, congenital heart defects, respiratory infections, and leukemia. The extra 21st chromosome is contributed by the mother in approximately 90% of cases. Mosaicism is seen in 2% to 4% of Down syndrome cases, and it often accompanies a milder phenotype. Specific genes contributing to the Down syndrome phenotype are now being identified.

TRISOMY 18

Trisomy 18 (47,XY,+18), also known as Edwards syndrome, is the second most common autosomal trisomy, with a prevalence of about 1 per 6,000 live births. It is, however, much more common at conception and is the most common chromosome abnormality among stillborns with congenital malformations. It is estimated that fewer than 5% of trisomy 18 conceptions survive to term.

The Edwards syndrome phenotype is as discernable as Down syndrome, but because it is less common, it is less likely to be recognized clinically. Trisomy 18 patients have prenatal growth deficiency (weight that is low for gestational age), characteristic facial features, and a distinctive hand abnormality that often allows the clinician to make the initial diagnosis (Fig. 6-8). Minor anomalies of diagnostic importance include small ears with unraveled helices, a small mouth that is often hard to open, a short sternum, and short big toes. Most babies with trisomy 18 have major malformations. Congenital heart defects, particularly VSDs, are the most common. Other medically significant congenital malformations include omphalocele (protrusion of the bowel into the umbilical cord), diaphragmatic hernia, and, occasionally, spina bifida. www

About 50% of infants with trisomy 18 die within the first several weeks of life, and only about 5% are still alive at 12 months of age. A combination of factors, including

aspiration pneumonia, predisposition to infections and apnea, and congenital heart defects, accounts for the high mortality rate.

Marked developmental disabilities are seen among those trisomy 18 patients who survive infancy. The degree of delay is much more significant than in Down syndrome, and most children are not able to walk. However, children with trisomy 18 do progress somewhat in their milestones, and older infants learn some communication skills.

More than 95% of infants with Edwards syndrome have complete trisomy 18. A small percentage have mosaicism. As in trisomy 21, there is a significant maternal age effect. Molecular analyses indicate that, as in trisomy 21, approximately 90% of trisomy 18 cases are the result of a maternally contributed extra chromosome.

TRISOMY 13

Trisomy 13 (47,XY,+13), also termed Patau syndrome, is seen in about 1 of every 10,000 births. The malformation pattern is quite distinctive and usually permits clinical recognition. It consists primarily of oral-facial clefts, microphthalmia (small, abnormally formed eyes), and postaxial polydactyly (Fig. 6-9). Malformations of the central nervous system are seen frequently, as are heart defects and renal abnormalities. Cutis aplasia (a scalp defect on the posterior occiput) may also be seen.

The survival rate is very similar to that of trisomy 18, with 95% of live-born infants dying during the first year of life. Children who survive infancy have significant developmental retardation, with skills seldom progressing beyond those of a child of 2 years. However, as in trisomy 18, children with trisomy 13 do progress somewhat in their development and are often able to communicate with their families.

About 80% of patients with Patau syndrome have full trisomy 13. Most of the remaining patients have trisomy of the long arm of chromosome 13 due to a translocation (see later discussion). As in trisomies 18 and 21, the risk of bearing a child with this condition increases with

FIGURE 6.8 ■ An infant with trisomy 18 (Edwards syndrome), exhibiting characteristic facial features, short sternum, overlapping fingers with clenched fists, and a left-sided clubfoot.

COLOR PLATE 1 Automated DNA sequencing. **A**, Gel image produced by an automated DNA sequencer. Each lane (labeled 1 to 19) represents a separate DNA sequence. Fluorescent labels that emit different colors on the gel image distinguish between bases. This permits the identity and order of bases in a strand of DNA to be determined. **B**, Analyzed data from a single DNA template sequenced on an automated DNA sequencer. Peaks of different colors represent the identity and relative location of different nucleotides in the DNA sequence. For example, the peak on the upper left is blue and identifies the position of a cytosine. The next peak is red, indicating the presence of a thymine. This "base-calling" continues until the end of the DNA template is reached (typically a few hundred base pairs).

COLOR PLATE 2 An African woman with oculocutaneous albinism. Note her light-colored hair and skin. She is looking away from the camera because her eyes are more sensitive to bright light than are those of individuals with normally pigmented retinas. (Courtesy of Dr. Phil Fischer, Mayo Clinic.)

COLOR PLATE 3 Fundus photos of ocular albinism. **A**, Fundus photograph of a female heterozygous carrier for X-linked ocular albinism. The pigmented and nonpigmented patches demonstrate mosaicism of the X chromosome as a result of random X inactivation. **B**, Fundus photograph of the heterozygous carrier's affected son, showing a distinct lack of melanin pigment. (**A** and **B**, Courtesy of Dr. Don Creel, University of Utah Health Sciences Center.)

В

COLOR PLATE 4 Fluorescence in situ hybridization (FISH) technique using different-colored probes (multicolor FISH) that identify the X (green) and Y (red) chromosomes in a male. Multicolor FISH can also be used to label each chromosome with a different color. (Courtesy of Dr. Art Brothman, University of Utah Health Sciences Center.)

COLOR PLATE 5 Spectral karyotype. Each pair of metaphase chromosomes is colored differently. In the nucleus of a cell in interphase (*top*), chromosome-specific coloring illuminates a tangled web of chromatin fibers. (Courtesy of Dr. Art Brothman, University of Utah Health Sciences Center.)

COLOR PLATE 6 Spectral karyotype. The power of spectral karyotyping is demonstrated by the identification of a rearrangement between chromosomes 2 and 22. Note that a portion of chromosome 2 (brown) has exchanged places with a portion of chromosome 22 (yellow). (Courtesy of Dr. Art Brothman, University of Utah Health Sciences Center.)

COLOR PLATE 7 Fluorescence in situ hybridization (FISH) analysis of the elastin locus. This region is commonly deleted in patients with Williams syndrome. A control signal (green) is used to identify the pericentromeric region of chromosome 7. (Note that there are two signals.) The elastin locus is identified by a red signal. Only a single red signal is observed, indicating that the elastin locus is absent from the chromosome 7 with only a green signal. (Courtesy of Dr. Art Brothman, University of Utah Health Sciences Center.)

COLOR PLATE 8 A microarray containing 36,000 oligonucleotides. This microarray was exposed to DNA from normal fibroblasts (labeled red, see *arrows*) and fibroblasts from a patient with Niemann-Pick disease, type C (labeled green). Arrows point to regions in which there was a strong hybridization signal with either normal or disease DNA. This microarray was used to search for genes that are highly expressed in the fibroblasts of patients.

FIGURE 6.9 A, A newborn male with full trisomy 13 (Patau syndrome). This baby has a cleft palate, atrial septal defect, inguinal hernia, and postaxial polydactyly of the left hand. **B**, An individual with full trisomy 13 at age 7 years (survival beyond the first year is uncommon). He has significant visual and auditory impairments. (B, Courtesy Susan Barg.)

advanced maternal age. It is estimated that 95% or more of trisomy 13 conceptions are spontaneously lost during pregnancy. www

Trisomies of the 13th and 18th chromosomes are sometimes compatible with survival to term, although 95% or more of affected fetuses are spontaneously aborted. These trisomies are much less common at birth than trisomy 21, and they produce a more seriously affected phenotype, with 95% mortality during the first year of life. As in trisomy 21, there is a maternal age effect, and the mother contributes the extra chromosome in approximately 90% of cases.

TRISOMIES, NONDISJUNCTION, AND MATERNAL AGE

The prevalence of Down syndrome among offspring of mothers of different ages is shown in Fig. 6-10. Among mothers younger than 30 years of age, the risk is less than 1/1,000. It increases to approximately 1/400 at age 35 years, 1/100 at age 40, and approximately 1/25 after age 45. Most other trisomies, including those in which the fetus does not survive to term, also increase in prevalence as maternal age increases. This risk is one of the primary indications for prenatal diagnosis among women older than 35 years of age (see Chapter 13).

Several hypotheses have been advanced to account for

this increase, including the idea that older women are less likely to spontaneously abort a trisomic pregnancy. Direct studies of the frequency of chromosome abnormalities in sperm and egg cells indicate that the pattern is instead due to an increase in nondisjunction among older

FIGURE 6.10 ■ The prevalence of Down syndrome among live births in relation to age of the mother. The prevalence increases with maternal age and becomes especially notable after the age of 35 years. (Data from Hook EB, Chambers GM [1977]. Birth Defects 23[3A]:123-141.)

117

mothers. Recall that all of a female's oocytes are formed during her embryonic development. They remain suspended in prophase I until they are shed during ovulation. Thus, an ovum produced by a 45-year-old woman is itself about 45 years old. This long period of suspension in prophase I may impair normal disjunction, although the precise nature of this mechanism is not understood.

Many factors have been examined to determine whether they may affect the frequency of nondisjunction in women. These include hormone levels, cigarette smoking, autoimmune thyroid disease, alcohol consumption, and radiation (the latter does increase nondisjunction when administered in very large doses to experimental animals). None of these factors has shown consistent correlations with nondisjunction in humans, however, and maternal age remains the only known correlated factor.

Although maternal age is strongly correlated with the risk of Down syndrome, it should be pointed out that approximately three fourths of Down syndrome children are born to mothers younger than 35 years of age. This is because the great majority of children (more than 90%) are borne by women in this age group.

Numerous studies, including direct analysis of sperm cells, have tested the hypothesis of a paternal age effect for trisomies. The consensus is that such an effect, if it exists at all, is minor. This may reflect the fact that spermatocytes, unlike oocytes, are generated throughout the life of the male.

Nearly all autosomal trisomies increase with maternal age as a result of nondisjunction in older mothers. There is little evidence for a paternal age effect on nondisjunction in males.

Sex Chromosome Aneuploidy

Among live-born infants, about 1 in 400 males and 1 in 650 females have some form of sex chromosome aneuploidy. Primarily because of X inactivation, the consequences of this class of aneuploidy are less severe than those of autosomal aneuploidy. With the exception of a complete absence of X chromosome material, all of the sex chromosome aneuploidies are compatible with survival in at least some cases.

MONOSOMY OF THE X CHROMOSOME (TURNER SYNDROME)

The phenotype associated with a single X chromosome (45,X) was described by Henry Turner in 1938 (an earlier description, in 1930, was given by Otto Ullrich). Individuals with Turner syndrome are female and usually have a characteristic phenotype. The findings include the variable presence of (1) proportionate short stature, (2) sexual infantilism and ovarian dysgenesis, and (3) a pattern of major and minor malformations. The physical features may include a triangle-shaped face; posteriorly rotated

external ears; and a broad, "webbed" neck (Fig. 6-11). In addition, the chest is broad and shield-like in shape. Lymphedema of the hands and feet is observable at birth. Many patients with Turner syndrome have congenital heart defects, most commonly obstructive lesions of the left side of the heart (bicuspid aortic valve in 50% of patients and coarctation [narrowing] of the aorta in 15% to 30%). Severe obstructions should be surgically repaired. About 50% of individuals with Turner syndrome have

FIGURE 6.11 A female with Turner syndrome (45,X). Note the characteristically broad, "webbed" neck. Stature is reduced, and swelling (i.e., lymphedema) is seen in the ankles and wrists.

structural kidney defects, but they usually do not cause medical problems. There is typically some diminution in spatial perceptual ability, but females with Turner syndrome usually have normal intelligence. www

Girls with Turner syndrome exhibit proportionate short stature and do not undergo an adolescent growth spurt. Mature height is reduced by approximately 20 cm, on average. Growth hormone administration produces increased height in these girls. Gonadal dysgenesis (lack of ovaries) is commonly seen in Turner syndrome. Instead of ovaries, most females with Turner syndrome have streaks of connective tissue. Lacking normal ovaries, they do not usually develop secondary sexual characteristics, and most women with this condition are infertile (about 5% to 10% have sufficient ovarian development to undergo menarche, and a small number have borne children). Teenagers with Turner syndrome are typically treated with estrogen to promote the development of secondary sexual characteristics. The dose is then continued at a reduced level to maintain these characteristics and to help avoid osteoporosis.

Frequently the diagnosis is made in the newborn infant, especially if there is a striking webbing of the neck coupled with a heart defect. The facial features are more subtle than in the autosomal abnormalities described previously, but the experienced clinician can often diagnose Turner syndrome on the basis of one or more of the listed clues. If Turner syndrome is not recognized in infancy or childhood, it is often diagnosed later because of short stature and/or amenorrhea.

The chromosome abnormalities in females with Turner syndrome are quite variable. About 50% of these patients have a 45,X karyotype in their peripheral lymphocytes. At least 30% to 40% are mosaics, most commonly 45,X/46,XX and less commonly 45,X/46,XY. Mosaics who have Y chromosomes in some cells are predisposed to malignancies (gonadoblastomas) in their gonadal streaks. About 10% to 20% of patients with Turner syndrome have structural X chromosome abnormalities involving a deletion of some or all of the short arm. This variation in chromosome abnormality helps to explain the considerable phenotypic variation seen in this syndrome.

Molecular studies have shown that approximately 60% to 80% of monosomy X cases are caused by the absence of a paternally derived sex chromosome, occurring either during early mitosis in the embryo or during meiosis in the father (i.e., the offspring receives an X chromosome only from the mother). The 45,X karyotype is estimated to occur in 1% to 2% of conceptions, but Turner syndrome is seen in only about 1/2,000 to 1/3,000 live-born females. Thus, the great majority (more than 99%) of 45,X conceptions are lost prenatally. Among those that do survive to term, many are chromosomal mosaics, with mosaicism of the placenta alone **(confined placental mosaicism)** being especially common. It is likely that the presence of some normal cells in mosaic fetuses enhances fetal survival.

Molecular analysis has begun to pinpoint specific genes involved in the Turner syndrome phenotype. For example, mutations in the *SHOX* gene, which encodes a transcription factor expressed in embryonic limbs, produce short stature. This gene is located on the distal tip of the X and Y short arms (in the pseudoautosomal region, which escapes X inactivation; see Clinical Commentary 6-2). Thus, it is normally transcribed in two copies in both males and females. In females with Turner syndrome, this gene would be present in only one active copy, and the resulting haploinsufficiency is likely to contribute to short stature.

It has been reported that females with Turner syndrome who receive the X chromosome from their father have higher verbal IQ scores and better social cognition than those who receive the X chromosome from their mother. This difference implies the presence of a genomic imprinting effect on a specific region of the X chromosome. Interestingly, a study of partial deletions of the X chromosome showed that the imprinted region escapes X inactivation. Because normal females inherit active copies of this region from both parents, while males inherit a copy only from their mothers (the existence of a Y homolog is not yet known), this finding could have important implications for general male-female differences in social cognition and verbal intelligence.

Turner syndrome is most commonly caused by a 45,X karyotype. Although this disorder is common at conception, it is relatively rare among live births, reflecting a very high rate of spontaneous abortion. Mosaicism, including confined placental mosaicism, appears to increase the probability of survival to term.

KLINEFELTER SYNDROME

Like the Down and Turner syndromes, the syndrome associated with a 47,XXY karyotype was identified before the underlying chromosomal abnormality was understood. Described in 1942 by Harry Klinefelter, the syndrome that bears his name is seen in approximately 1/500 to 1/1,000 male births. Although Klinefelter syndrome is a common cause of primary hypogonadism in the male, the phenotype is less striking than those of the syndromes described thus far. Males with Klinefelter syndrome tend to be taller than average, with disproportionately long arms and legs (Fig. 6-12). Clinical examination of postpubertal patients reveals small testes (less than 10 ml), and most males with Klinefelter syndrome are sterile as a result of atrophy of the seminiferous tubules. Testosterone levels in adolescents and adults are low. Gynecomastia (breast development) is seen in approximately one third of affected males and leads to an increased risk of breast cancer. The risk can be reduced by mastectomy (breast removal). Body hair is typically sparse in postpubertal males, and muscle mass tends to be reduced. In addition, there is a predisposition for learning disabilities and a reduction in verbal IQ. Although males with Klinfelter syndrome usually are not mentally retarded,

FIGURE 6.12 A male with Klinefelter syndrome (47,XXY). Stature is increased, gynecomastia may be present, and body shape may be somewhat feminine. (From McKusick VA [1960]. J Chronic Dis 12:1-202.)

the IQ is on average 10 to 15 points lower than that of the affected individual's siblings. Because of the subtlety of this disorder, many patients with Klinefelter syndrome are not diagnosed until after puberty, and the condition is sometimes first ascertained in fertility clinics. www

The extra X chromosome is derived maternally in about 50% of Klinefelter cases, and the syndrome increases in incidence with advanced maternal age. Despite the relatively mild phenotypic features of this disorder, it is estimated that at least half of 47,XXY conceptions are spontaneously aborted. Mosaicism, which is seen in about 15% of patients, increases the likelihood of viable sperm production.

Individuals with the 48,XXXY and 49,XXXY karyotypes have also been reported. Because they have a Y chromosome, they have a male phenotype, but the degree of mental deficiency and physical abnormality increases with each additional X chromosome.

Testosterone therapy, beginning in midadolescence, may enhance secondary sex characteristics, and it helps to decrease the risk of osteoporosis. There is some evidence that this treatment also improves general well-being, but this has not been clearly substantiated.

TRISOMY X

The 47,XXX karyotype occurs in approximately 1/1,000 females and usually has benign consequences. Overt physical abnormalities are rarely seen, but these females sometimes suffer from sterility, menstrual irregularity, or mild mental retardation. As in Klinefelter syndrome, females with the 47,XXX karyotype are often first ascertained in fertility clinics. Approximately 90% of cases are the result of nondisjunction in the mother, and, as with other trisomies, the incidence increases among the offspring of older mothers.

Females have also been seen with four, five, or even more X chromosomes. Each additional X chromosome is accompanied by increased mental retardation and physical abnormality.

47,XYY SYNDROME

The final sex chromosome aneuploidy to be discussed is the 47,XYY karyotype. Males with this karyotype tend to be taller than average, and they have a 10- to 15-point reduction in average IQ. This condition, which causes few physical problems, achieved great notoriety when its incidence in the male prison population was discovered to be as high as 1/30, compared with 1/1,000 in the general male population. This led to the suggestion that this karyotype might confer a predisposition to violent, criminal behavior. A number of studies have addressed this issue and have shown that XYY males are not inclined to commit violent crimes. There is, however, evidence of minor behavioral disorders, such as hyperactivity, attention deficit disorder, and learning disabilities.

The 47,XXX and 47,XYY karyotypes are seen in about 1/1,000 females and males, respectively. Each involves a slight degree of reduction in IQ but few physical problems.

CHROMOSOME ABNORMALITIES AND PREGNANCY LOSS

For a long time it was difficult to detect the early stages of pregnancy with certainty. It was thus possible for a woman to become pregnant but to lose the embryo before knowing of the pregnancy. Sensitive urinary assays of chorionic gonadotropin levels, which increase when the embryo implants in the uterine wall, have allowed researchers to pinpoint accurately the occurrence of pregnancy at this early stage. Follow-up of women in whom implantation was verified in this way has shown that about one third of pregnancies are lost after implantation (the number lost before implantation is unknown). Therefore, spontaneous pregnancy loss is common in the human.

As mentioned earlier, chromosome abnormalities are the leading known cause of pregnancy loss. It is estimated that a *minimum* of 10% to 15% of conceptions have a

Males with Klinefelter syndrome (47,XXY) are taller than average, may have a reduction in IQ, and are usually sterile. Testosterone therapy and mastectomy for gynecomastia are sometimes recommended.

CLINICAL COMMENTARY 6.2

XX Males, XY Females, and the Genetic Basis of Sex Determination

During normal meiosis in the male, crossover occurs between the tip of the short arm of the Y chromosome and the tip of the short arm of the X chromosome. These regions of the X and Y chromosomes contain highly similar DNA sequences. Because this resembles the behavior of autosomes during meiosis, the distal portion of the Y chromosome is known as the pseudoautosomal region (Fig. 6-13). It spans approximately 2.5 Mb. Just centromeric of the pseudoautosomal region lies a gene known as SRY (sex-determining region on the Y). This gene, which is expressed in embryonic development, encodes a product that interacts with other genes to initiate the development of the undifferentiated embryo into a male (including Sertoli cell differentiation, secretion of müllerian inhibiting substance, and so on). As mentioned in Chapter 2, the SRY gene product is a member of the high-mobility group (HMG) family of DNA-bending transcription factors. By bending DNA, the protein is thought to promote DNA-DNA interactions that trigger events in the developmental cascade leading to male differentiation. In particular, SRY interacts antagonistically with DAX1, a gene that represses other genes that promote differentiation of the embryo into a male. In the absence of SRY, DAX1 continues to repress these genes, and a female embryo is created. When the mouse sry gene is inserted experimentally into a female mouse embryo, a male mouse is produced. Loss-of-function mutations of SRY can produce individuals with an XY karyotype but a female phenotype. Thus, there is very good evidence that the SRY gene is the initiator of male sexual differentiation in the embryo. Mutations in another member of this gene family, SOX9, can produce sex reversal (XY females) and campomelic dysplasia (malformations of bone and cartilage). www

Approximately 1 of every 20,000 males presents with a condition similar to Klinefelter syndrome (without increased height), but chromosome evaluation shows that they have a normal *female* karyotype (46, XX). It has been demonstrated that these XX males have an X chromosome that includes the *SRY* gene. This is explained as a result of a faulty crossover between the X and Y chromosomes during male meiosis, such that the *SRY* gene, instead of remaining on the Y chromosome, is transferred to the X chromosome

chromosome abnormality. At least 95% of these chromosomally abnormal conceptions are lost before term. Karyotype studies of miscarriages indicate that about 50% of the chromosome abnormalities are trisomies, 20% are monosomies, 15% are triploids, and the remain-

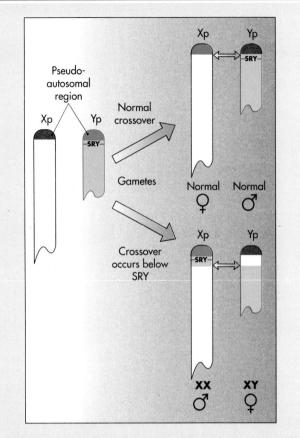

FIGURE 6.13 The distal short arms of the X and Y chromosomes exchange material during meiosis in the male. The region of the Y chromosome in which this crossover occurs is called the pseudoautosomal region. The *SRY* gene, which triggers the process leading to male gonadal differentiation, is located just outside the pseudoautosomal region. Occasionally, the crossover occurs on the centromeric side of the *SRY* gene, causing it to lie on an X chromosome instead of on the Y chromosome. An offspring receiving this X chromosome will be an XX male, and an offspring receiving the Y chromosome will be an XY female.

(see Fig. 6-13). The offspring who inherits this X chromosome from his father consequently has a male phenotype. Conversely, it should be apparent that an offspring who inherits a Y chromosome that lacks the SRY gene would be an XY female. These females have gonadal streaks rather than ovaries and have poorly developed secondary sexual characteristics.

der consists of tetraploids and structural abnormalities. Some chromosome abnormalities that are common at conception seldom or never survive to term. For example, trisomy 16 is thought to be the most common trisomy at conception, but it is never seen in live births.

It is possible to study chromosome abnormalities directly in sperm and egg cells. Oocytes are typically obtained from unused material in in vitro fertilization studies. Karyotypes obtained from these cells indicate that 20% to 25% of oocytes have missing or extra chromosomes (this may be an underestimate, because the oocyte's chromosomes are difficult to visualize and count). Human sperm cells can be studied after fusing them with hamster oocytes so that their DNA begins mitosis and condenses, allowing easier visualization. The frequency of aneuploidy in these sperm cells is about 3% to 4%. Structural abnormalities (see later discussion) are seen in about 5% of sperm cells and about 1% of oocytes (it is noteworthy that structural abnormalities increase with advanced paternal age). Undoubtedly, this high rate of chromosome abnormality contributes importantly to later pregnancy loss.

These approaches, while informative, may involve some biases. For example, mothers in whom in vitro fertilization is performed are not a representative sample of the population. In addition, their oocytes have been stimulated artificially, and only those oocytes that could not be fertilized by sperm cells are studied. Thus, the oocytes themselves may not be a representative sample. The sperm cells studied in human-hamster hybrids represent only those that are capable of penetrating the hamster oocyte and again may not be a representative sample.

Missing or extra chromosomes in human sperm cells have also been detected using FISH. This approach can evaluate thousands of cells fairly rapidly, giving it an important advantage over the human-hamster technique. In general, the FISH studies have yielded results similar to those of the human-hamster studies, showing that, on average, the frequency of disomy is approximately 0.15% for each autosome and 0.26% for the sex chromosomes. These studies have also confirmed a tendency for elevated frequencies of nondisjunction of the sex chromosomes and some of the acrocentric chromosomes, including chromosome 21, in sperm cells.

Pregnancy loss is common in humans, with approximately one third of pregnancies lost spontaneously after implantation. Chromosome abnormalities, which have been studied in sperm and egg cells and in miscarriages and stillbirths, are an important cause of pregnancy loss.

ABNORMALITIES OF CHROMOSOME STRUCTURE

In addition to the loss or gain of whole chromosomes, parts of chromosomes can be lost or duplicated as gametes are formed, and the arrangement of portions of chromosomes can be altered. Structural chromosome abnormalities may be **unbalanced** (the rearrangement causes a gain or loss of chromosomal material) or **balanced** (the rearrangement does not produce a loss or gain of chromosome material). Unlike aneuploidy and polyploidy, balanced structural abnormalities often do not produce serious health consequences. Nevertheless, abnormalities of chromosome structure, especially those that are unbalanced, can produce serious disease in individuals or their offspring.

Alterations of chromosome structure can occur when homologous chromosomes line up improperly during meiosis (e.g., unequal crossover, as described in Chapter 5). In addition, **chromosome breakage** can occur during meiosis or mitosis. Mechanisms exist to repair these breaks, and usually the break is repaired perfectly with no damage to the daughter cell. Sometimes, however, the breaks remain, or they heal in a fashion that alters the structure of the chromosome. The likelihood of chromosome breakage may be increased in the presence of certain harmful agents, called **clastogens**. Clastogens identified in experimental systems include ionizing radiation, some viral infections, and some chemicals.

Translocations

A translocation is the interchange of genetic material between nonhomologous chromosomes. Balanced translocations represent one of the most common chromosomal aberrations in humans, occurring in 1 of every 500 to 1,000 individuals (Table 6-2). There are two basic types of translocations, termed **reciprocal** and **Robertsonian**.

TABLE 6.2 Prevalence of Chromosomal Abnormalities Among Newborns

Abnormality	Prevalence at birth
Autosomal syndromes	
Trisomy 21	1/800
Trisomy 18	1/6,000
Trisomy 13	1/10,000
Unbalanced rearrangements	1/17,000
Balanced rearrangements	
Robertsonian translocations	1/1,000
Reciprocal translocations	1/11,000
Sex chromosome abnormalities	
47,XXY	1/1,000 male births
47,XYY	1/1,000 male births
45,X*	1/5,000 female births
47,XXX	1/1,000 female births
All chromosome abnormalities	
Autosomal disorders and unbalanced	
rearrangements	1/230
Balanced rearrangements	1/500*

*The 45,X karyotype accounts for about half of the cases of Turner syndrome.

RECIPROCAL TRANSLOCATIONS

Reciprocal translocations happen when breaks occur in two different chromosomes and the material is mutually exchanged. The resulting chromosomes are called **derivative chromosomes**. The carrier of a reciprocal translocation is usually unaffected because he or she has a normal complement of genetic material. However, the carrier's offspring can be normal, can carry the translocation, or can have duplications or deletions of genetic material.

An example of a reciprocal translocation between chromosomes 3 and 6 is shown in Fig. 6-14. The distal half of the short arm of chromosome 6 is translocated to the short arm of chromosome 3, and a small piece of chromosome 3 is translocated to the short arm of chromosome 6. This karyotype is 46,XX,t(3p;6p). The offspring of this woman received the derivative chromosome 3, termed der(3), and the normal 6; thus, the child had a **partial trisomy** of the distal portion of chromosome 6 (i.e., 6p trisomy). This is a well-established but rather uncommon chromosomal syndrome.

Reciprocal translocations are caused by two breaks on different chromosomes, with a subsequent exchange of material. While carriers of balanced reciprocal translocations usually have normal phenotypes, their offspring may have a partial trisomy or a partial monosomy and an abnormal phenotype.

ROBERTSONIAN TRANSLOCATIONS

In the Robertsonian type of translocation, the short arms of two nonhomologous chromosomes are lost and the long arms fuse at the centromere to form a single chromosome (Fig. 6-15). This type of translocation is confined to chromosomes 13, 14, 15, 21, and 22, because the short arms of these acrocentric chromosomes are very small and contain no essential genetic material. When a Robertsonian translocation takes place, the short arms are usually lost during subsequent cell divisions. Because the carriers of Robertsonian translocations lose no essential genetic material, they are phenotypically normal but have only 45 chromosomes in each cell. Their offspring, however, may inherit a missing or extra long arm of an acrocentric chromosome.

A common Robertsonian translocation involves fusion of the long arms of chromosomes 14 and 21. The karyotype of a male carrier of this translocation would be 45,XY,der(14;21)(q10;q10). This individual lacks one normal 14 and one normal 21 and instead has a chromosome derived from a translocation of the entire long arms of chromosomes 14 and 21. During meiosis in this individual, the translocation chromosome must still pair with its homologs. Figure 6-16 illustrates the ways in which these chromosomes may segregate in the gametes formed by the translocation carrier. If **alternate segregation** occurs, then the offspring are either chromosomally nor-

FIGURE 6.14 A, The parent has a reciprocal balanced translocation involving the short arms of chromosomes 6 and 3. The distal short arm of the 6 has been translocated to the very distal tip of the 3. A small piece of chromosome 3 is attached to the derivative 6. This individual had a child whose chromosomes are depicted in **B**. The child received the derivative chromosome 3 (with part of the 6 short arm attached) and the normal 6; from the other parent, the child received a normal 3 and a normal 6. Therefore, the child had a partial trisomy of the 6 short arm and, presumably, a small deletion of the 3 short arm.

mal or have a balanced translocation with a normal phenotype. If one of the **adjacent segregation** patterns occurs, then the gametes are unbalanced and the offspring may have trisomy 14, monosomy 14, monosomy 21, or trisomy 21 (note that these trisomies and monosomies are genetically the same as trisomies and monosomies produced by nondisjunction, because only the

FIGURE 6.15 In a Robertsonian translocation, shown here, the long arms of two acrocentric chromosomes (13 and 14) fuse, forming a single chromosome.

long arms of these chromosomes contain genetically significant material). Fetuses with the first three possibilities do not survive to term, while the last translocation results in an infant with three copies of the long arm of chromosome 21 and a Down syndrome phenotype. Robertsonian translocations are responsible for approximately 5% of Down syndrome cases.

It is expected that the three types of conceptions compatible with survival would occur in equal frequencies: one third would be completely normal, one third would carry the translocation but be phenotypically normal, and one third would have Down syndrome. In part because of prenatal loss, the actual proportion of live-born offspring with Down syndrome is less than one third (about 10% to 15% for mothers who carry the translocation, and only 1% to 2% for fathers who carry it). This recurrence risk, however, is greater than the risk for parents of a child who has the nondisjunction type of Down syndrome, which is 1% for mothers younger than 30 years of age. This difference in recurrence risks demonstrates why it is critical to order a chromosome study whenever a condition such as Down syndrome is suspected.

Robertsonian translocations occur when the long arms of two acrocentric chromosomes fuse at the centromere. The carrier of a Robertsonian translocation can produce conceptions with monosomy or trisomy.

Deletions

A **deletion** is caused by a chromosome break and subsequent loss of genetic material. A single break leading to a loss that includes the chromosome's tip is called a **terminal deletion**. When two breaks occur and the material between the breaks is lost, an **interstitial deletion** occurs. For example, a chromosome segment with normal DNA might be symbolized ABCDEFG. An interstitial deletion could produce the sequence ABEFG, while a terminal deletion could produce ABCDE.

Usually, a gamete containing a chromosome with a deletion unites with a normal gamete to form a zygote. The zygote then has one normal chromosome and a homolog with the deletion. Microscopically visible deletions generally involve multiple genes, and the consequences of losing this much genetic material from even one member of the chromosome pair can be severe.

After the three autosomal aneuploidies described earlier, the autosomal deletion syndromes are the most common group of clinically significant chromosome abnormalities. A well-known example of a chromosome deletion syndrome is the *cri-du-chat* syndrome. This term (French, "cry of the cat") describes the distinctive cry of the child. This cry usually becomes less obvious as the child ages, making a clinical diagnosis more difficult after 2 years of age. *Cri-du-chat* syndrome is caused by a deletion of the distal short arm of chromosome 5: the karyotype is 46,XY,del(5p). Seen in approximately 1 in 50,000 live births, it is also characterized by mental retardation (average IQ about 35), microcephaly (small head), and a characteristic but not distinctive facial appearance. Survival to adulthood has been observed but is not common.

Wolf-Hirschhorn syndrome (Fig. 6-17), caused by a deletion of the distal short arm of chromosome 4, is another well-characterized deletion syndrome. Other well-known deletions include those of 18p, 18q, and 13q. With the exception of the 18p deletion syndrome, each of these disorders is relatively distinctive, and the diagnosis can often be made before the karyotype is obtained. The features of the 18p deletion syndrome are more subtle, and usually children with this condition are recognized when chromosome analysis is performed for evaluation of developmental disability. www

Microscopically observable chromosome deletions, which may be either terminal or interstitial, usually affect a fairly large number of genes and produce recognizable syndromes.

FIGURE 6.16 The possible segregation patterns for the gametes formed by a carrier of a Robertsonian translocation. Alternate segregation (quadrant a alone, or quadrant b with quadrant c) produces either a normal chromosome constitution or a translocation carrier with a normal phenotype. Adjacent segregation (quadrant a with c, quadrant c alone, quadrant a with b, or quadrant b alone) produces unbalanced gametes and results in conceptions with translocation Down syndrome, monosomy 21, trisomy 14, or monosomy 14, respectively. For example, monosomy 14 is produced when the parent who carries the translocation transmits a copy of chromosome 21 but does not transmit a copy of chromosome 14 (as in the lower right corner).

Microdeletion Syndromes

The deletions described thus far all involve relatively large segments of chromosomes. Each of these was described before chromosome banding techniques were developed. With the advent of high-resolution banding, it has become possible to identify microscopically a large number of deletions that were previously too small for detection. In addition, advances in molecular genetics, particularly the FISH technique (see Fig. 6-4) and the development of large numbers of easily identified polymorphisms, have permitted the detection of deletions that are often too small to be observed microscopically (i.e., less than 5 Mb). Prader-Willi syndrome, a disorder discussed in Chapter 4, is a good example of a **microdeletion syndrome**. Although this condition was described in the 1950s,* it was not until 1981 that advanced banding techniques detected a small deletion of chromosome bands 15q11-q13 in about 50% of these patients. With the use of molecular techniques, deletions that were too small to be detected cytogenetically were also discovered. In total, about 70% of Prader-Willi cases are caused by microdeletions of 15q.

^{*}Although Prader is commonly credited with the first complete description of Prader-Willi syndrome in 1956, John Langdon Down (of Down syndrome fame) published a fairly complete description of the disorder in 1887.

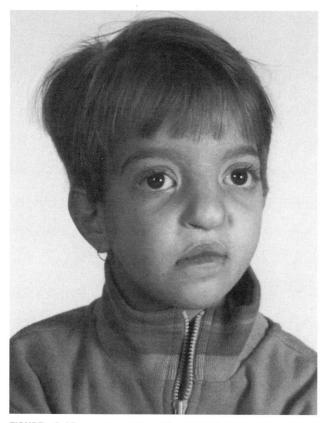

FIGURE 6.17 A child with Wolf-Hirschhorn syndrome (46,XX,del[4p]). Note the wide-spaced eyes and repaired cleft lip.

Because of imprinting, the inheritance of a microdeletion of the paternal chromosome 15 material produces Prader-Willi syndrome, while a microdeletion of the maternally derived chromosome 15 produces the phenotypically and genetically distinct Angelman syndrome (see Chapter 4).

High-resolution banding and molecular genetic techniques have often led to a more precise specification of the critical chromosome region that must be deleted to cause a given syndrome. Wolf-Hirschhorn syndrome, for instance, can be produced by the deletion of only a very small telomeric segment of 4p. In some instances, specific genes responsible for chromosome abnormality syndromes can be pinpointed. For example, individuals with a deletion of 11p may present with a series of features including Wilms tumor (a kidney tumor), aniridia (absence of the iris), genitourinary abnormalities,* and mental retardation (sometimes termed the WAGR syndrome). The genes responsible for the kidney tumor and for aniridia have now each been identified and cloned. Because the WAGR syndrome involves the deletion of a series of adjacent genes, it is sometimes referred to as an example of a **contiguous gene syndrome**. In addition to microdeletions, microduplications can also produce contiguous gene syndromes. www

Williams syndrome, which is characterized by mental retardation, supravalvular aortic stenosis (SVAS), multiple peripheral pulmonary arterial stenoses, characteristic facial features, dental malformations, and hypercalcemia, is another example of a microdeletion syndrome (Fig. 6-18;

^{*}Because individuals with the WAGR syndrome also have gonadoblastomas (gonadal tumors), some authorities believe that the "G" should stand for gonadoblastoma rather than genitourinary abnormality.

В

FIGURE 6.18 A, A girl with Williams syndrome, illustrating typical facial features: broad forehead, short palpebral fissures, low nasal bridge, anteverted nostrils, long filtrum, full cheeks, and relatively large mouth with full lips. **B**, An angiogram illustrating supravalvular aortic stenosis (narrowing of the ascending aorta). (Courtesy Dr. Mark Keating, Harvard University.)

see Color Plate 7). A series of molecular analyses have identified some of the individual genes responsible for the Williams syndrome phenotype. The elastin gene, for example, is located in the Williams syndrome critical region and is expressed in blood vessels. Elastin is an important component of the aortic wall (microfibrils, which were discussed in Chapter 4 in the context of Marfan syndrome, are another component). Mutations or deletions of elastin alone result in isolated SVAS without the other features of Williams syndrome. Larger deletions, encompassing additional genes, produce the complete Williams syndrome phenotype. A second gene in the critical region, LIMK1, encodes a brain-expressed kinase that is likely to be involved in the visual-spatial cognition defects observed in patients with Williams syndrome. This is supported by the observation of patients with partial deletions of the critical region affecting only the elastin and LIMK1 genes. These individuals have SVAS and visual-spatial cognitive deficiency but none of the other features of Williams syndrome. www

Some of the microdeletion syndromes, such as the Prader-Willi and Williams syndromes, often manifest deletions of a fairly consistent portion of a chromosome. Recent studies show that this is caused by the presence of multiple repeated sequences, termed **low-copy repeats** (see Chapter 2), at the deletion boundaries. It appears that these repeated sequences promote unequal crossing over (see Chapter 5), which then produces duplications and deletions of the region bounded by the repeat elements.

Several additional examples of microdeletions are given in Table 6-3. Many of these conditions, including the Prader-Willi, Miller-Dieker, Williams, and velocardiofacial syndromes (Clinical Commentary 6-3), are now diagnosed using the FISH technique. Microdeletions are a subtype of chromosome deletion that can be observed only in banded chromosomes or, in some cases, using molecular genetic approaches. Syndromes caused by the deletion of a series of adjacent genes are sometimes called contiguous gene syndromes.

Subtelomeric Rearrangements

The regions near telomeres of chromosomes tend to have a high density of genes. Consequently, rearrangements of genetic material (e.g., deletions, duplications) in these regions often result in genetic disease. One study estimated that approximately 7% of unexplained cases of mental retardation are caused by subtelomeric rearrangements. Collections of probes have been designed so that FISH analysis of metaphase chromosomes can be undertaken to determine whether a subtelomeric deletion or duplication has occurred in a patient. In addition, comparative genomic hybridization (CGH, discussed earlier) can be carried out, hybridizing differentially labeled patient and control DNA samples to microarrays that contain probes corresponding to all human subtelomeric regions. If a subtelomeric region is duplicated or deleted, the patient DNA will show either excessive or deficient hybridization to the probe corresponding to that region (visible as a difference in color in the portion of the microarray containing that probe).

Subtelomeric rearrangements involve deletions or duplications of DNA in the gene-rich regions near telomeres. They can be detected by hybridizing specifically designed FISH probes to metaphase chromosomes, or by comparative genomic hybridiza-

TABLE 6.3 Microdeletion Syndromes*		
Syndrome	Clinical features	Chromosomal deletion
Prader-Willi	Mental retardation, short stature, obesity, hypotonia, characteristic facies, small feet	15q11-13
Angelman	Mental retardation, ataxia, uncontrolled laughter, seizures	15q11-13
Langer-Giedion	Characteristic facies, sparse hair, exostosis, variable mental retardation	8q24
Miller-Dieker	Lissencephaly, characteristic facies	17p13.3
Velocardiofacial	DiGeorge anomaly/characteristic facies, cleft palate, heart defects	22q11
Smith-Magenis	Mental retardation, hyperactivity, dysmorphic features, self-destructive behavior	17p11.2
Williams	Developmental disability, characteristic facies, supravalvular aortic stenosis	7q1
Aniridia/Wilms tumor	Mental retardation, aniridia, predisposition to Wilms tumor, genital defects	11p13
Deletion 1p36	Mental retardation, seizures, hearing loss, heart defects, growth failure, distinctive facial features	1p36
Rubinstein-Taybi	Mental retardation, broad thumbs and great toes, characteristic facial features, vertebral and sternal abnormalities, pulmonary stenosis	16p13.3
Alagille	Neonatal jaundice, "butterfly" vertebrae, pulmonic valvular stenosis, characteristic facial features	20p12

*For most of these conditions, only some cases are caused by the listed microdeletion; other cases may be caused by single-gene mutations within the same region.

CLINICAL COMMENTARY 6.3

The DiGeorge Anomaly, the Velocardiofacial Syndrome, and Microdeletions of Chromosome 22

The DiGeorge anomaly consists of a pattern of structural or functional defects of the thymus, hypoparathyroidism (reduced parathyroid function), secondary hypocalcemia (decreased serum calcium), and conotruncal heart defects. This pattern is a malformation complex that is probably caused by an alteration of the embryonic migration of neural crest cells to the developing structures of the neck. In the 1980s it was learned that some children with the DiGeorge anomaly had a deletion of part of the long arm of chromosome 22, often related to an unbalanced translocation between this and another chromosome. This led to the hypothesis that genes on chromosome 22 were responsible for the DiGeorge anomaly. www

Independent of this work, a condition called the velocardiofacial (VCF) or Shprintzen syndrome was described in the late 1970s. This autosomal dominant syndrome involves palate (velum) abnormalities (including clefts), a characteristic facial appearance, and, in some cases, heart disease. In addition, these patients have learning disabilities and developmental delay. Later it was discovered that some individuals with VCF have dysfunctional T-cells (these cells mature in the thymus), and some have all features of the DiGeorge anomaly. This suggested that the DiGeorge anomaly was somehow related to VCF.

The resemblance between the DiGeorge anomaly and VCF led to the hypothesis that both conditions were caused by abnormalities on chromosome 22. High-resolution chromosome studies, including FISH,

tion of patient and control DNA to microarrays containing subtelomeric probes.

Uniparental Disomy

As just mentioned, about 70% of Prader-Willi cases are caused by microdeletions. Most of the remaining cases involve **uniparental disomy** (di = two), a condition in which one parent has contributed two copies of a chromosome and the other parent has contributed no copies (Fig. 6-19). If the parent has contributed two copies of one homolog, the condition is termed **isodisomy**. If the parent has contributed one copy of each homolog, it is termed **heterodisomy**. Isodisomy or heterodisomy of an imprinted chromosome can cause diseases such as Prader-Willi syndrome (i.e., the inheritance of two copies from the mother and none from the father means

of patients with the DiGeorge anomaly and patients with VCF revealed small deletions of chromosome 22 in both groups. This analysis also helped to narrow the critical region that causes both conditions. Approximately 90% of infants with the DiGeorge anomaly have a microdeletion of the 22q11.2 region, and about 70% of VCF patients have the same microdeletion. In addition, 15% of individuals with isolated conotruncal defects exhibit this deletion. Alterations of a gene or genes in this region produce a variable phenotype ranging from the DiGeorge anomaly to the full VCF syndrome. The VCF syndrome is a contiguous gene syndrome, and it is possible that the gene or genes causing the DiGeorge anomaly are a subset of those that cause VCF. This group of disorders is now termed the 22q11.2 deletion syndrome, the prevalence of which is approximately 1 in 4,000 live births.

About 90% of individuals with 22q11.2 deletion syndrome exhibit the same deletion of a region that contains about 30 genes. Another 8% have a smaller, 1.5-Mb deletion located within the same 3-Mb region. Both the 1.5- and 3-Mb regions are flanked by lowcopy repeats that are thought to promote unequal crossing over, and thus deletion, in this region.

This example illustrates how cytogenetic studies can demonstrate potential biological relationships between genetic syndromes. Further studies are under way to identify the individual genes that cause the DiGeorge anomaly and VCF.

that the individual receives no active paternal genes in the imprinted region; see Chapter 4). Isodisomy can result in autosomal recessive disease in the offspring of a heterozygous parent if the parent contributes two copies of the chromosome homolog that contains the diseasecausing mutation (see Fig. 6-19).

Uniparental disomy can arise in a number of ways. For example, a trisomic conception can lose one of the extra chromosomes, resulting in an embryo that has two copies of the chromosome contributed by one parent. Disomy can also result from the union of a gamete that contains two copies of a specific chromosome with a gamete that contains no copies of that chromosome (see Fig. 6-19). In the early embryo, cells with uniparental disomy can be produced by mitotic errors, such as chromosome loss with subsequent duplication of the homologous chromosome. Uniparental disomy has been observed in several conditions besides Prader-Willi and

FIGURE 6.19 Two mechanisms that can produce uniparental disomy. **A**, Parental nondisjunction produces a sperm cell with two copies of a specific chromosome, and maternal nondisjunction produces an ovum with no copies of the same chromosome. The resulting zygote has two copies of the father's chromosome and no copies of the mother's chromosome (in this example the father contributes both chromosomes, but it is also possible that the mother could contribute both chromosomes). **B**, Nondisjunction (in the mother, in this example) results in a trisomic zygote. Loss of the paternal chromosome during mitosis produces embryonic cells that have two copies of the mother's chromosome.

Angelman syndromes. These include cystic fibrosis (see Chapter 4), Russell-Silver syndrome, hemophilia A (see Chapter 5), and Beckwith-Wiedemann syndrome (see Chapters 4 and 14).

Duplications

A partial trisomy, or **duplication**, of genetic material may be seen in the offspring of individuals who carry a reciprocal translocation. Duplications can also be caused by unequal crossover during meiosis, as described for the X-linked color vision loci (see Chapter 5) and for Charcot-Marie-Tooth disease (see Chapter 3). Duplications tend to produce less serious consequences than deletions, again illustrating the principle that a loss of genetic material is more serious than an excess of genetic material.

Ring Chromosomes

Deletions sometimes occur at both tips of a chromosome. The remaining chromosome ends can then fuse, forming a **ring chromosome** (Fig. 6-20). The karyotype of a female with a ring X chromosome would be 46,X,r(X). If the ring chromosome includes a centromere, it can often proceed through cell division, but its structure can create difficulties. Ring chromosomes are often lost, resulting in monosomy for the chromosome in at least some cells (i.e., mosaicism for the ring chromosome may be seen). Ring chromosomes have been described in at least one case for each of the human autosomes.

Inversions

An **inversion** is the result of two breaks on a chromosome followed by the reinsertion of the missing fragment at its original site but in inverted order. Thus, a chromosome symbolized as ABCDEFG might become ABED-CFG after an inversion. If the inversion includes the centromere, it is called a **pericentric inversion**.

Duplications can arise from unequal crossover, or they can occur among the offspring of reciprocal translocation carriers. Duplications generally produce less serious consequences than deletions do.

FIGURE 6.20 Both tips of a chromosome can be lost, leaving sticky ends that attach to one another, forming a ring chromosome. A chromosome 12 ring is shown here.

Inversions that do not involve the centromere are termed **paracentric inversions**.

Like reciprocal translocations, inversions are a balanced structural rearrangement. Consequently, they seldom produce disease in the inversion carrier (recall from Chapter 5, though, that an inversion that interrupts the factor VIII gene produces severe hemophilia A). Inversions can interfere with meiosis, however, producing chromosome abnormalities in the offspring of inversion carriers. Because chromosomes must line up in perfect order during prophase I, a chromosome with an inversion must form a loop to line up with its normal homolog (Fig. 6-21). Crossing over within this loop can result in duplications or deletions in the chromosomes of daughter cells. Thus, the offspring of individuals who carry inversions often have chromosome deletions or duplications. It is estimated that about 1 in 1,000 people carries an inversion and is therefore at risk for producing gametes with duplications or deletions.

Figure 6-21 gives an example of a pericentric inversion on chromosome 8 (46,XX,inv[8]). About 5% of the offspring of persons who carry this inversion will receive a deletion or duplication of the distal portion of 8q. This combination results in the recombinant 8 syndrome, which is characterized by mental retardation, heart defects, seizures, and a characteristic facial appearance. www Chromosome inversions are relatively common structural abnormalities and may be either pericentric (including the centromere) or paracentric (not including the centromere). Parents with inversions are usually normal in phenotype but can produce offspring with deletions or duplications.

Isochromosomes

Sometimes a chromosome divides along the axis perpendicular to its usual axis of division (Fig. 6-22). The result is an isochromosome, a chromosome that has two copies of one arm and no copies of the other. Because the genetic material is substantially altered, isochromosomes of most autosomes are lethal. Most isochromosomes observed in live births involve the X chromosome, and babies with isochromosome Xq (46,X,i[Xq]) usually have features of Turner syndrome. Isochromosome 18q, which produces an extra copy of the long arm of chromosome 18, has been observed in infants with Edwards syndrome. Although most isochromosomes appear to be formed by faulty division, they can also be created by Robertsonian translocations of homologous acrocentric chromosomes (e.g., a Robertsonian translocation of the two long arms of chromosome 21).

CHROMOSOME ABNORMALITIES AND CLINICAL PHENOTYPES

As we have seen, most autosomal aberrations induce consistent patterns of multiple malformations, minor anomalies, and phenotypic variations with variable degrees of developmental retardation. Although the individual features are usually nonspecific (e.g., simian creases can be seen in both Down syndrome and trisomy 18), the general pattern of features is usually distinctive enough to permit a clinical diagnosis. This is especially true of the well-known chromosome syndromes: Down syndrome, Edwards syndrome, Patau syndrome, and Turner syndrome. However, there is considerable phenotypic variability even within these syndromes. No one patient has every feature; most congenital malformations (e.g., heart defects) are seen in only some of affected individuals. This phenotypic variability, and the attendant potential for misdiagnosis, underscores the need to order a karyotype whenever clinical features suggest a chromosome abnormality.

Usually the biological basis for this phenotypic variability is unknown, although mechanisms such as mosaicism, which often leads to milder expression, are being uncovered. The basis of variable expression of chromosome syndromes will be better understood as the individual genes involved in these abnormalities are identified and characterized.

In spite of the variability of chromosome syndromes, it is possible to make several generalizations:

FIGURE 6.21 A pericentric inversion in chromosome 8 causes the formation of a loop during the alignment of homologous chromosomes in meiosis. Crossing over in this loop can produce duplications or deletions of chromosome material in the resulting gamete. The offspring in the lower panel received one of the recombinant 8 chromosomes from this parent.

- 1. Most chromosome abnormalities (especially those involving autosomes) are associated with developmental delay in children and mental retardation in older individuals. This reflects the fact that a large number of human genes, perhaps one third or more of the total, participate in the development of the central nervous system. Therefore, a chromosome abnormality, which typically may affect hundreds or thousands of genes, is very likely to involve genes that affect nervous system development.
- 2. Most chromosome syndromes involve alterations of facial morphogenesis that produce characteristic facial features. For this reason, the patient often resembles other individuals with the same disorder more than members of his or her own family. Usually the facial features and minor anomalies of the head and limbs are the best aids to diagnosis (see Chapter 14).
- 3. Growth delay (short stature and/or poor weight

gain in infancy) is commonly seen in autosomal syndromes.

4. Congenital malformations, especially congenital heart defects, occur with increased frequency in most autosomal chromosome disorders. These defects occur in specific patterns. For example, while AV canals and VSDs are common in children with Down syndrome, other congenital heart defects, such as aortic coarctation or hypoplastic (underdeveloped) left ventricle, are seldom seen in these children but may be seen in those with Turner syndrome.

The most common clinical indications for a chromosome analysis are a newborn with multiple congenital malformations or a child with developmental retardation. A summary of clinical situations in which a chromosome evaluation should be considered is given in Box 6-1.

FIGURE 6.22 An isochromosome is formed when a chromosome divides along an axis perpendicular to its usual axis of division. This produces one chromosome with only the short arms and another with only the long arms. A normal X chromosome is compared with an isochromosome of Xq.

Chromosome abnormalities typically result in developmental delay, mental retardation, characteristic facial features, and various types of congenital malformations. Despite some overlap of phenotypic features, many chromosome abnormalities can be recognized by clinical examination.

Indications for Performing Chromosome Analysis

- Persons with a suspected recognizable chromosome syndrome (e.g., Down syndrome)
- Persons with an unrecognizable pattern of two or more malformations

Persons with ambiguous genitalia

- Mental retardation or developmental delay in children who are dysmorphic or have multiple physical abnormalities
- Parents and children of persons with chromosomal translocations, deletions, or duplications
- Stillborn infants with malformation or with no recognizable reason for fetal death
- Females with proportionate short stature and primary amenorrhea

Males with small testes or significant gynecomastia

CANCER CYTOGENETICS

Most chromosome abnormality syndromes are caused by errors that occur in the meiotic process leading to gamete formation. Chromosome rearrangements in somatic cells are responsible for a number of important cancers in humans. The first of these to be recognized was a chromosome alteration seen consistently in patients with chronic myelogenous leukemia (CML). Initially, it was suggested that the chromosome alteration was a deletion of the long arm of either chromosome 21 or chromosome 22. With the subsequent development of chromosome banding techniques, the abnormality was identified as a reciprocal translocation between chromosomes 9 and 22. The Philadelphia chromosome, as this translocation is commonly known, consists of a translocation of most of chromosome 22 onto the long arm of chromosome 9. A small distal portion of 9q in turn is translocated to chromosome 22. The net effect is a smaller chromosome 22, which explains why the Philadelphia chromosome was initially thought to be a deletion. This translocation (Fig. 6-23) is seen in most cases of CML. www

Much has been learned about the effects of this translocation by isolating the genes that are located near the translocation **breakpoints** (i.e., the locations on the chromosomes at which the breaks occur preceding translocation). A proto-oncogene called *ABL* is moved from its normal position on 9q to 22q. This alters the *ABL* gene product, causing increased tyrosine kinase activity, which leads to malignancy in hematopoietic cells (i.e., cells that form blood cells such as lymphocytes). In fact, the introduction of this altered gene into the bone marrow of normal mice causes them to develop malignancies, including CML.

A second example of a translocation that produces cancer is given by Burkitt lymphoma, a childhood jaw tumor. In this case a reciprocal translocation involving chromosomes 8 and 14 moves the *MYC* proto-oncogene from

FIGURE 6.23 A reciprocal translocation between chromosome 22 and the long arm of chromosome 9 (the so-called Philadelphia chromosome). The occurrence of this translocation in hematopoietic cells can produce chronic myelogenous leukemia.

8q24 to 14q32, near the immunoglobulin heavy chain loci (see Chapter 9). There is good evidence that transcription regulation sequences near the immunoglobulin genes then activate *MYC*, causing malignancies to form.

More than 100 different rearrangements, involving nearly every chromosome, have been observed in more than 40 different types of cancer. Some of these are summarized in Table 6-4. Increasingly, these translocations are identified using spectral karyotypes. In some cases, identification of the chromosome rearrangement leads to a more accurate prognosis and better therapy. Hence, the cytogenetic evaluation of bone marrow cells from leukemia patients is a routine part of diagnosis. Furthermore, identification and characterization of the genes that are altered in translocation syndromes are leading to a better understanding of carcinogenesis in general.

Balanced translocations in somatic cells can sometimes cause malignancies by interrupting or altering genes or their regulatory sequences.

CHROMOSOME INSTABILITY SYNDROMES

Several autosomal recessive disease conditions exhibit an increased incidence of chromosome breaks under specific

Туре	Most common chromosome aberration
Leukemias	
Chronic myelogenous leukemia	t(9;22)(q34;q11)
Acute myeloblastic leukemia	t(8;21)(q22;q22)
Acute promyelocytic leukemia	t(15;17)(q22;q11-12)
Acute myeloid leukemia	+8,-7,-5,del(5q),del(20q)
Acute lymphocytic leukemia	t(12;21)(p13;q22)
Solid Tumors	
Burkitt lymphoma	t(8;14)(9q24;q32)
Ewing sarcoma	t(11;22)(q24;q12)
Meningioma	Monosomy 22
Retinoblastoma	del(13)(q14)
Wilms tumor	del(11)(p13)
Neuroblastoma	N-myc amplification
Breast cancer	Her2/Neu amplification

TABLE 6.4 Specific Cytogenetic Changes Observed in

laboratory conditions. These conditions, which are termed **chromosome instability syndromes**, include ataxia-telangiectasia, Bloom syndrome, Fanconi anemia, and xeroderma pigmentosum (see Chapter 2). Among patients with Fanconi anemia, the frequency of breaks can be increased further if the chromosomes are exposed to certain alkylating agents. Patients with Bloom syndrome also have a high incidence of somatic cell sister chromatid exchange (exchange of chromosome material between sister chromatids; see Chapter 2). Each of these syndromes is associated with a significant increase in cancer risk. All are thought to be the result of faulty DNA replication or repair, as discussed in Chapter 2.

The chromosome instability syndromes all involve increased frequencies of chromosome breakage and an increased risk of malignancy. All are associated with defects in DNA replication or repair.

SUGGESTED READINGS

- Allanson JE, Graham GE (2002) Sex chromosome abnormalities. In: Rimoin DL, Connor JM, Pyeritz RE, Korf BR (eds) Emery and Rimoin's Principles and Practice of Medical Genetics, 4th ed. Vol 1. Churchill Livingstone, London, pp 1184-1201
- Baty BJ, Blackburn BL, Carey JC (1994a) Natural history of trisomy 18 and trisomy 13: I. Growth, physical assessment, medical histories, survival, and recurrence risk. Am J Med Genet 49:175-188
- Baty BJ, Jorde LB, Blackburn BL, Carey JC (1994b) Natural history of trisomy 18 and trisomy 13: II. Psychomotor development. Am J Med Genet 49:189-194

- Bayani J, Squire JA (2001) Advances in the detection of chromosomal aberrations using spectral karyotyping. Clin Genet 59:65-73
- Carpenter NJ (2001) Molecular cytogenetics. Semin Pediatr Neurol 8:135-146
- Gotz MJ, Johnstone EC, Ratcliffe SG (1999) Criminality and antisocial behaviour in unselected men with sex chromosome abnormalities. Psychol Med 29:953-962
- Hassold T, Hunt P (2001) To err (meiotically) is human: the genesis of human aneuploidy. Nat Rev Genet 2:280-291
- Hassold T, Sherman S (2000) Down syndrome: genetic recombination and the origin of the extra chromosome 21. Clin Genet 57:95-100
- Hunt PA, Hassold TJ (2002) Sex matters in meiosis. Science 296:2181-2183
- Jackson L (2002) Cytogenetics and molecular cytogenetics. Clin Obstet Gynecol 45:622-639; discussion 730-732
- Knight SJ, Flint J (2000) Perfect endings: a review of subtelomeric probes and their use in clinical diagnosis. J Med Genet 37:401-409
- Lee C, Lemyre E, Miron PM, Morton CC (2001) Multicolor fluorescence in situ hybridization in clinical cytogenetic diagnostics. Curr Opin Pediatr 13:550-555
- Lindsay EA (2001) Chromosomal microdeletions: dissecting del22q11 syndrome. Nat Rev Genet 2:858-868
- McDermid HE, Morrow BE (2002) Genomic disorders on 22q11. Am J Hum Genet 70:1077-1088
- Morris CA, Mervis CB (2000) Williams syndrome and related disorders. Annu Rev Genomics Hum Genet 1:461-484
- Ostrer H (2001) Sex determination: lessons from families and embryos. Clin Genet 59:207-215
- Ranke MB, Saenger P (2001) Turner's syndrome. Lancet 358:309-314
- Reeves RH, Baxter LL, Richtsmeier JT (2001) Too much of a good thing: mechanisms of gene action in Down syndrome. Trends Genet 17:83-88
- Robinson WP (2000) Mechanisms leading to uniparental disomy and their clinical consequences. Bioessays 22:452-459
- Ross JL (2001) The adult consequences of pediatric endocrine

disease: II. Turner syndrome. Growth Genet Hormones 17:1-8

- Rowley JD (2000) Cytogenetic analysis in leukemia and lymphoma: an introduction. Semin Hematol 37:315-319
- Roylance R (2002) Methods of molecular analysis: assessing losses and gains in tumours. Mol Pathol 55:25-28
- Shi Q, Martin RH (2000) Aneuploidy in human sperm: a review of the frequency and distribution of aneuploidy, effects of donor age and lifestyle factors. Cytogenet Cell Genet 90:219-226
- Smyth CM (1999) Diagnosis and treatment of Klinefelter syndrome. Hosp Pract Sept. 15:111-120
- Spinner NB, Emanuel BS (2002) Deletions and other structural abnormalities of the autosomes. In: Rimoin DL, Connor JM, Pyeritz RE, Korf BR (eds) Emery and Rimoin's Principles and Practice of Medical Genetics, 4th ed. Vol 1. Churchill Livingstone, London, pp 1202-1236
- Stankiewicz P, Lupski JR (2002) Genome architecture, rearrangements and genomic disorders. Trends Genet 18:74-82
- Therman E (1993) Human Chromosomes: Structure, Behavior, Effects. Springer-Verlag, New York
- Yang Q, Rasmussen SA, Friedman JM (2002) Mortality associated with Down's syndrome in the USA from 1983 to 1997: a population-based study. Lancet 359:1019-1025

INTERNET RESOURCES

- European Cytogenetics Association (a series of URLs for various cytogenetics Web sites) http://www.biologia.uniba.it/eca/
- Mitelman Database of Chromosome Aberrations in Cancer http://cgap.nci.nib.gov/Chromosomes/Mitelman
- National Association for Down Syndrome (contains many URLs for Down syndrome Web sites) http://www.nads.org/
- Support Organization for Trisomy 18, 13, and Related Disorders (S.O.F.T.) http://www.trisomy.org/

STUDY QUESTIONS

- 1. Distinguish among haploidy, diploidy, polyploidy, euploidy, and aneuploidy.
- 2. Explain the uses and relative advantages of FISH, spectral karyotyping, and comparative genomic hybridization (CGH).
- Describe three ways in which triploidy could arise.
- 4. Studies of karyotypes obtained by prenatal diagnosis at 10 weeks' gestation (chorionic villus sampling; see Chapter 13) reveal prevalence rates of chromosome abnormalities that differ from those obtained in karyotypes at 16 weeks' gestation (amniocentesis; see Chapter 13). Explain this.
- 5. Even though conditions such as Down syndrome and Edwards syndrome can usually be diagnosed accurately by clinical examination alone, a karyotype is always recommended. Why?
- **6.** Rank the following, from lowest to highest, in terms of the risk of producing a child with Down syndrome:

45-year-old female with no previous family history of Down syndrome

- 25-year-old female who has had one previous child with Down syndrome
- 25-year-old male carrier of a 21/14 Robertsonian translocation

25-year-old female carrier of a 21/14 Robertsonian translocation

- 7. Females with the 49,XXXXX karyotype have been reported. Explain how this karyotype could occur.
- 8. A male with hemophilia A and a normal female produce a child with Turner syndrome (45,X). The child has normal factor VIII activity. In which parent did the meiotic error occur?
- **9.** A cytogenetics laboratory reports a karyotype of 46,XY,del(8)(p11) for one patient and a karyotype of 46,XY,dup(8)(p11) for another patient. Based on this information alone, which patient is expected to be more severely affected?
- 10. Why do translocations in somatic cells sometimes lead to cancer?

CHAPTER

Biochemical Genetics: Disorders of Metabolism

Each of us is composed of a large number of complex molecules that are hierarchically arranged in space to form cells, tissues, organs, and ultimately a complete human being. These molecules are constructed from individual elements that may be synthesized endogenously or obtained from the environment. Once created, these molecules are not static. In fact, they are perpetually being synthesized, degraded, excreted, and sometimes recycled in a tightly choreographed metabolic dance.

Each metabolic process consists of a sequence of catalytic steps mediated by enzymes encoded by genes. Usually, these genes are replicated with high fidelity, and enzymatic systems continue to work effectively from generation to generation. Occasionally, mutations reduce the efficiency of encoded enzymes to a level at which normal metabolism cannot occur. Such variants of metabolism were recognized by Sir Archibald Garrod at the beginning of the 20th century, based partly on his studies of alkaptonuria (AKU). Garrod recognized that these variants illustrated "chemical individualities" and called these disorders "inborn errors of metabolism," thus setting the cornerstone for contemporary biochemical genetics.

AKU is a rare disorder in which homogentisic acid (HGA), an intermediate metabolite in phenylalanine and tyrosine metabolism (Fig. 7-1), is excreted in large quantities in urine, causing it to darken on standing. Hence, AKU was classically referred to as "black urine disease." Additionally, an oxidation product of HGA is directly deposited in connective tissues, resulting in abnormal pigmentation and debilitating arthritis.

Garrod proposed in 1902 that AKU was caused by a deficiency of the enzyme that normally splits the aromatic ring of HGA. Fifty years later, it was established that AKU is produced by a failure to synthesize homogentisate 1,2-dioxygenase (HGO). However, it was not until 1996 that the gene for AKU was cloned, based on homology to a gene encoding an HGO enzyme that was isolated from a fungus species. The coding region of *HGO* comprises 14 exons distributed over 60 kb of DNA. Many of the mutations identified in *HGO* encode proteins that show no HGO activity when expressed in vitro. This indicates that AKU is caused

by a loss-of-function mutation, confirming the hypothesis put forth by Garrod more than a century ago.

Almost all biochemical processes of human metabolism are catalyzed by enzymes. Variations of enzymatic activity among humans are common, and a minority of these variants cause disease. These concepts were introduced by Archibald Garrod and exemplified by his studies of alkaptonuria.

VARIANTS OF METABOLISM

Prevalence of Metabolic Disease

More than 350 different inborn errors of metabolism have been described to date, and most of these are rare. Taken together, however, metabolic disorders account for a substantial percentage of the morbidity and mortal-

FIGURE 7.1 Major pathway of phenylalanine metabolism. Different enzymatic defects in this pathway cause (1) classical PKU, (2) tyrosinase-negative oculocutaneous albinism, (3) AKU, and (4) tyrosinemias.

Name	Prevalence	Mutant gene product	Chromosomal location
Carbohydrate Disorders			
Classical galactosemia	1/35,000 to 1/60,000	Galactose-1-phosphate uridyl transferase	9p13
Hereditary fructose intolerance	1/20,000	Fructose 1,6-bisphosphate aldolase	9q13-q32
Fructosuria	~1/100,000	Fructokinase	2p23
Hypolactasia (adult)	Common	Lactase	2q21
Diabetes mellitus type 1	1/400 (Caucasians)	Unknown	Polygenic
Diabetes mellitus type 2	1/20	Unknown	Polygenic
Maturity-onset diabetes of youth (MODY)	~1/400	Glucokinase (60%)	7p13
Amino Acid Disorders			
Phenylketonuria	1/10,000	Phenylalanine hydroxylase	12q24
Tyrosinemia (type 1)	1/100,000	Fumarylacetoacetate hydrolase	15q23-25
Maple syrup urine disease	1/180,000	Branched-chain α-ketoacid dehydrogenase (multiple subunits)	Multiple loci
Alkaptonuria	1/250,000	Homogentisic acid oxidase	3q2
Homocystinuria	1/340,000	Cystathionine β-synthase	21q2
Oculocutaneous albinism	1/35,000	Tyrosinase	11q
Cystinosis	1/100,000	CTNS	17p13
Cystinuria	1/7,000	SLC3A1 (type 1) SLC7A9 (types II & III)	2p 19q13
Lipid Disorders			
MCAD	1/20,000	Medium-chain acyl-CoA dehydrogenase	1p31
LCAD	Rare	Long-chain acyl-CoA dehydrogenase	2q34-q35
SLO	1/10,000	Δ 7-sterol reductase	11q12-q13
Organic Acid Disorders Methylmalonic acidemia	1/20,000	Methylmalonyl-CoA mutase	6р
Propionic acidemia	Rare	Propionyl-CoA carboxylase	13q32; 3q
Urea Cycle Defects			
Ornithine transcarbamylase deficiency	1/70,000 to 1/100,000	Ornithine carbamyl transferase	Xp21
Carbamyl phosphate synthetase deficiency	1/70,000 to 1/100,000	Carbamyl phosphate synthetase I	2р
Argininosuccinic acid synthetase deficiency	1/70,000 to 1/100,000	Argininosuccinic acid synthetase	9q34
Energy Production Defects Cytochrome C oxidase deficiency	Rare	Cytochrome oxidase peptides	Multiple loci
Pyruvate carboxylase deficiency	Rare	Pyruvate carboxylase	11q
Pyruvate dehydrogenase complex (E_1) deficiency	Rare	Pyruvate decarboxylase, $E_1 \alpha$	Xp22
NADH-CoQ reductase deficiency	Rare	Multiple nuclear genes	Multiple loci
Heavy Metal Transport Defects Wilson disease	1/50,000	ATP7B	13q14
Menkes disease	1/250,000	ATP7A	Xq13
Hemochromatosis	1/200 to 1/500 (Europeans)	HFE	6p21
Acrodermatitis enteropathica	Rare	SLC39A4	8q24

ity directly attributable to genetic disease (Table 7-1). A recent survey conservatively estimated that the incidence of metabolic disorders is approximately 1 in every 2,500 births, or 10% of all monogenic conditions in children. Moreover, we are beginning to understand that different alleles can alter one's risk for many common diseases. For

example, polymorphisms in the gene encoding angiotensinogen have been associated with heightened risks for hypertension and preeclampsia.*

^{*}Preeclampsia is a disorder of pregnancy that is characterized by hypertension, excess excretion of protein in the urine, and excess fluid accumulation.

The diagnosis of a metabolic disorder can be challenging (Clinical Commentary 7-1); thus, the morbidity associated with metabolic defects is probably underestimated. In the 1970s many children were diagnosed with an often fatal acute metabolic encephalopathy called Reye syndrome. In the following decades, we learned that some children diagnosed with an encephalopathy indistinguishable from Reye syndrome had a urea cycle defect that produced hyperammonemia (increased levels of circulating ammonia) and death. Recognition of Reye syndrome as a **phenocopy** of a urea cycle defect is important because, in addition to sup-

The Diagnosis of a Metabolic Disorder

CLINICAL COMMENTARY 7.1

The presentations of individuals with inborn errors of metabolism are highly variable. During gestation, the maternal-placental unit usually provides essential nutrients and prevents the accumulation of toxic substrates. Thus, a fetus is infrequently symptomatic. However, after birth, individuals with metabolic disorders may present at ages ranging from the first 24 hours of life to adulthood. The presentation may be precipitous and characterized by dramatic alterations in homeostasis and even death. In contrast, the disorder may be insidious, with only subtle changes in function over long periods. For most metabolic disorders, the presymptomatic period and onset of symptoms lie somewhere between these two extremes. The following case illustrates this point.

Anthony is a 9-month-old Hispanic male who comes to the emergency department accompanied by his parents. His parents complain that he has been irritable and vomiting for the last 36 hours, and over the past 12 hours he has become increasingly sleepy. They sought medical attention because it was difficult to awaken Anthony to breast-feed him. Anthony's medical history is unremarkable. He has a healthy 8year-old sister and had a brother who died in his crib at 7 months of age. An investigation of the brother's death and an autopsy were performed. The findings were consistent with sudden infant death syndrome (SIDS).

Anthony is hospitalized and is noted to be hypoglycemic (low serum glucose level), slightly acidemic (serum pH less than 7.4), and hyperammonemic (elevated plasma ammonia). Intravenous infusion of glucose transiently improves his level of alertness, but he becomes comatose and dies 5 days later. An autopsy reveals marked cerebral edema (swelling of the brain) and fatty infiltration of the liver consistent with a diagnosis of Reye syndrome. Anthony's mother is concerned that the boys' deaths are related to each other, especially since she is pregnant again. She is counseled that the causes of death are unrelated and neither disorder is likely to recur in her family.

One year later her 6-month-old daughter, Maria, is

hospitalized for the third time because of lethargy and weakness. Laboratory studies reveal moderate hypoglycemia, hyperammonemia, and ketonuria (ketones in the urine). Additional studies, including measurement of urine organic acids,* serum amino acids, and free and esterified plasma carnitines, suggest that Maria has a defect of fatty acid oxidation. Therapy is initiated with intravenous glucose, oral carnitine, and the restriction of fats to no more than 20% of her caloric requirements. More specific biochemical and molecular studies confirm that Maria has mediumchain acyl-CoA dehydrogenase (MCAD) deficiency. Molecular studies from preserved tissues that had been collected at autopsy from Maria's deceased brothers indicate that they also had MCAD deficiency. Maria's asymptomatic older sister is similarly affected. Both girls are healthy 2 years later, eating a low-fat diet and using a carnitine supplement. They have a new baby brother who underwent prenatal testing for MCAD and was found to be unaffected.

The disparate presentations of MCAD deficiency in this family (sudden death, acute illness, chronic illness, and asymptomatic) illustrate the phenotypic variability often observed in individuals with inborn errors of metabolism, even those sharing an identical mutation. Thus, there may not be a disease-specific pattern of symptoms and findings. Often it is the heightened index of suspicion of care providers that leads to the testing necessary to identify a metabolic disorder. Supportive therapy can be lifesaving and should be initiated before making a diagnosis. Nevertheless, it is imperative that prudent attempts be made to make a specific diagnosis, because it may have important implications for the family (e.g., prenatal testing, presymptomatic therapy). The treatment of MCAD deficiency is completely effective at preventing early death from the toxic effects of accumulated fatty acid intermediates.

^{*}Organic acids are carbon-based acids that are products of intermediate metabolism and normally do not accumulate in plasma or urine beyond the buffering capacities of these fluids.

portive care,* the urea cycle defects are directly treatable. Similarly, on postmortem examination, some children who have died from sudden infant death syndrome (SIDS) have been found to have a defect of fatty acid metabolism. These are also treatable disorders, and lifethreatening episodes can be avoided with appropriate care.

Although individual metabolic disorders are rare, their overall direct and indirect contribution to morbidity and mortality is substantial.

Inheritance of Metabolic Defects

Most metabolic disorders are inherited in an autosomal recessive pattern; only individuals having two mutant alleles are affected. Although a mutant allele produces reduced or no enzyme activity, it usually does not alter the health of a heterozygous carrier. Since many of the genes encoding disease-related enzymes have been cloned and their mutations characterized, carrier testing and prenatal diagnosis for many metabolic disorders is available. However, testing samples of dried blood for elevated levels of metabolites in the newborn period (e.g., for phenylketonuria and galactosemia; see Chapter 13) remains the most commonly used population-based screening test for metabolic disorders. Unfortunately, many deaths caused by inborn errors of metabolism are due to enzyme variants that are not included in most newborn screening programs. As the technology for rapid and efficient DNA testing of mutant alleles progresses, population-based screening for additional disorders is likely to be incorporated.

Most inborn errors of metabolism are inherited in an autosomal recessive pattern. The carrier state usually is not associated with morbidity. Carrier and diagnostic testing are becoming widely available for many disorders.

Types of Metabolic Processes

Metabolic disorders have been classified in many different ways, based on (1) the pathological effects of the pathway blocked (e.g., absence of end product, accumulation of substrate); (2) different functional classes of proteins (e.g., receptors, hormones); (3) associated cofactors (e.g., metals, vitamins); and (4) pathways affected (e.g., glycolysis, citric acid cycle). Each of these has advantages and disadvantages, and none of them encompasses all metabolic disorders. However, the classification that most completely integrates our knowledge of cell biology, physiology, and pathology with metabolic disorders categorizes defects of metabolism by the types of processes that are disturbed.

DEFECTS OF METABOLIC PROCESSES

Almost all biochemical reactions in the human body are controlled by enzymes, which act as **catalysts**. The catalytic properties of enzymes typically increase reaction rates by more than a millionfold. These reactions mediate the synthesis, transfer, utilization, and degradation of biomolecules to build and maintain the internal structures of cells, tissues, and organs. Biomolecules can be categorized into four primary groups: nucleic acids, proteins, carbohydrates, and lipids. The major metabolic pathways that metabolize these molecules include glycolysis, citric acid cycle, pentose phosphate shunt, gluconeogenesis, glycogen and fatty acid synthesis/storage, degradative pathways, energy production, and transport systems. We will discuss how defects in each of these metabolic pathways can cause human disease.

Carbohydrate Metabolism

Because of the many different applications that they serve in all organisms, carbohydrates are the most abundant organic substance on Earth. Carbohydrates function as substrates for energy production and storage, as intermediates of metabolic pathways, and as the structural framework of DNA and RNA. Consequently, carbohydrates account for a major portion of the human diet and are metabolized into three principal monosaccharides: glucose, galactose, and fructose. Galactose and fructose are converted to glucose before glycolysis. The failure to effectively utilize these sugars accounts for the majority of the inborn errors of human carbohydrate metabolism.

Galactose

The most common monogenic disorder of carbohydrate metabolism, transferase deficiency galactosemia (classical galactosemia) affects 1 in every 55,000 newborns. It is caused by mutations in the gene encoding galactose-1-phosphate uridyl transferase (*GAL-1-P uridyl transferase*) (Fig. 7-2). This gene is composed of 11 exons distributed across 4 kb of DNA, and approximately 70% of galactosemia-causing alleles have a single missense mutation in exon 6. As a result of diminished GAL-1-P uridyl transferase activity, affected individuals cannot effectively convert galactose to glucose; consequently, galactose is alternatively metabolized to galactitol and galactonate (see Fig. 7-2). Although galactose and its metabolites accumulate in many tissues, the pathophysiology of classical galactosemia is not well understood.

The most common clinical signs of classical galac-

^{*}Supportive care is care that supports the elementary functions of the body, such as maintenance of fluid balance, oxygenation, and blood pressure, but is not aimed at treating the disease process directly.

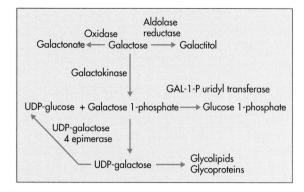

FIGURE 7.2 Major pathways of galactose metabolism. The most common enzymatic abnormality producing galactosemia is a defect of GAL-1-P uridyl transferase. Defects of galactokinase or of UDP-galactose 4-epimerase are much less common causes of galactosemia.

tosemia are failure to thrive, hepatic insufficiency, cataracts (opacification of the lens of the eye) and developmental delay.* Long-term disabilities include poor growth, mental retardation, and ovarian failure in females. Newborn screening for galactosemia is widespread and is commonly performed by measuring plasma GAL-1-P uridyl transferase activity from a dried drop of blood. Early identification affords prompt treatment, which consists largely of eliminating dietary galactose. This substantially reduces the morbidity associated with the acute effects of elevated levels of galactose metabolites. The effects of prospective dietary therapy on the prevalence of central nervous system disease or ovarian dysfunction in patients with classical galactosemia are less clear. Early studies suggested that there was no effect, but as more longitudinal data become available, it appears that patients treated early in life with dietary therapy may have a better cognitive outcome.

Galactosemia can also be caused by mutations in the genes encoding galactokinase or uridine diphosphate galactose-4-epimerase (UDP-galactose-4-epimerase)(see Fig. 7-2). Deficiency of galactokinase is associated with the formation of cataracts but does not cause growth failure, mental retardation, or hepatic disease. Dietary restriction of galactose is also the treatment for galactokinase deficiency. Deficiency of UDP-galactose-4epimerase can be limited to red blood cells and leukocytes, causing no ill effects, or it can be systemic and result in symptoms similar to those of classical galactosemia. Treatment is aimed at reducing the dietary intake of galactose, but not as severely as in patients with classical galactosemia, because some galactose must be provided to produce UDP-galactose for the synthesis of some complex carbohydrates.

Galactosemia is one of the most common inherited disorders of carbohvdrate metabolism. Newborn screening for galactosemia is widespread. Early identification affords prompt treatment, which consists largely of eliminating dietary galactose. If left untreated, children with galactosemia develop liver disease, poor growth, and mental retardation. Mutations in GAL-1-P uridyl transferase are the most common cause of galactosemia.

Fructose

Three autosomal recessive defects of fructose metabolism have been described. The most common is caused by mutations in the gene encoding hepatic fructokinase. This enzyme catalyzes the first step in the metabolism of dietary fructose, the conversion to fructose-1-phosphate (Fig. 7-3). Inactivation of hepatic fructokinase results in asymptomatic fructosuria (presence of fructose in the urine).

In contrast, hereditary fructose intolerance (HFI) results in poor feeding, failure to thrive, hepatic and renal insufficiency, and death. HFI is caused by a deficiency of fructose 1,6-bisphosphate aldolase in the liver, kidney cortex, and small intestine. Infants and adults with HFI are asymptomatic unless they ingest fructose or sucrose (a sugar composed of fructose and glucose). Infants who are breast-fed become symptomatic after weaning, when fruits and vegetables are added to their diet. Affected infants may survive into childhood because they avoid foods they consider noxious, thereby self-limiting their intake of fructose. The prevalence of HFI may be as high as 1 in 20,000 births, and, since the cloning of the gene encoding fructose-1-phosphate aldolase, differences in the geographic distribution of mutant alleles have been found.

Deficiency of hepatic fructose 1,6-bisphosphatase (FBPase) causes impaired gluconeogenesis, hypoglycemia (reduced level of circulating glucose), and severe metabolic acidemia (serum pH less than 7.4). Affected individuals commonly present shortly after birth, although children diagnosed later in life have been reported. If patients are adequately supported beyond childhood, growth and development appear to be normal. A handful of mutations have been found in the gene encoding FBPase, some of which encode mutant proteins that are inactive in vitro.

Asymptomatic deficiency of fructokinase is the most common defect of fructose metabolism. Hereditary fructose intolerance is less prevalent but associated with much more severe problems.

Glucose

Abnormalities of glucose metabolism are the most common errors of carbohydrate metabolism. However, the causes of these disorders are heterogeneous and include

^{*}Developmental delay is the delayed attainment of age-appropriate motor, speech, and/or cognitive milestones; the outcomes of developmental delay range from normal to profound mental retardation.

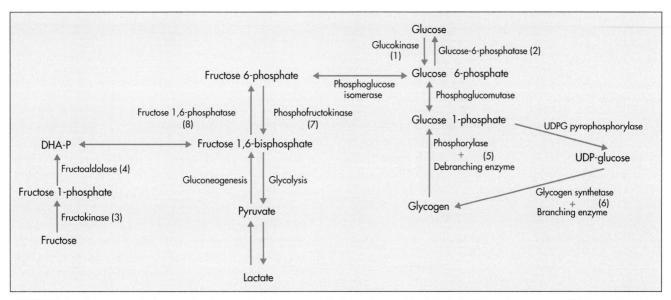

FIGURE 7.3 Summary of glucose, fructose, and glycogen metabolism. Enzymatic defects in this pathway cause (1) hyperglycemia, (2) Von Gierke disease, (3) fructosuria, (4) hereditary fructose intolerance, (5) Cori disease, (6) Anderson disease, (7) Tarui disease, and (8) FBPase deficiency.

both environmental and genetic factors. Historically, disorders associated with elevated levels of plasma glucose (hyperglycemia) have been classified into three categories: diabetes mellitus (DM) type 1, DM type 2, and maturity-onset diabetes of youth (MODY), a subtype of DM type 2. DM type 1 is associated with reduced or absent levels of plasma insulin and usually presents in childhood. DM type 2 is characterized by insulin resistance and, typically, adult onset. A more detailed discussion of DM types 1 and 2 can be found in Chapter 12.

Substantial advances in understanding of the pathophysiology of common diabetes have been achieved by identifying mutations that cause rare forms of hyperglycemia. Mutations in the insulin receptor gene have been associated with a disorder characterized by insulin resistance and acanthosis nigricans (hypertrophic skin with a corrugated appearance). These mutations may decrease the number of insulin receptors on a cell's surface, or they may decrease the insulin-binding activity level or the insulin-stimulated tyrosine kinase activity level. Mutations in mitochondrial DNA and in the genes encoding insulin and glucokinase have also been associated with hyperglycemic disorders.

Studies of rare, monogenic forms of diabetes (abnormal glucose metabolism) define the pathways that may be disturbed in the more common forms of diabetes mellitus.

Lactose

The ability to metabolize lactose (a sugar composed of glucose and galactose) is dependent, in part, on the

activity of an intestinal brush-border enzyme called lactase-phlorizin hydrolase (LPH). In most mammals, LPH activity diminishes after infants are weaned from maternal milk. However, the persistence of intestinal LPH activity is a common autosomal recessive trait in human populations, with a frequency ranging from 5% to 90%. The geographic distribution of lactase persistence is concordant with areas of high milk intake, such as northwestern Europe and certain parts of Africa. The persistent ability for adults to use dairy products as a source of vitamin D may have had a selective advantage in these populations.

Lactase nonpersistence (i.e., adult-type hypolactasia or lactose intolerance) is common in most tropical and subtropical countries. Individuals with lactase nonpersistence may experience nausea, bloating, and diarrhea after ingesting lactose. Thus, in many regions where reduced lactase activity is prevalent, the lactose in dairy products is often partially metabolized (e.g., by lactobacilli in the preparation of yogurt) before consumption. The role of lactase nonpersistence as a cause of abdominal pain and symptoms of irritable bowel syndrome is controversial.

LPH is encoded by the lactase gene (LCT) on chromosome 2. Despite intense scrutiny, no differences have been found in the coding and promoter regions of LCTbetween individuals with lactase persistence and those with lactase nonpersistence. Analysis of short tandem repeat polymorphisms (STRPs) surrounding LCT identified a haplotype that was associated with reduced transcript levels of LCT and lactase nonpersistence. This suggests that one or more regulatory elements on this haplotype contribute to the lactase nonpersistence phenotype. Mutations that abolish lactase activity altogether cause congenital lactase deficiency and produce severe diarrhea and malnutrition in infancy. Such mutations are very rare.

Glycogen

Carbohydrates are most commonly stored as glycogen in humans. Consequently, enzyme deficiencies that lead to impaired synthesis or degradation of glycogen are also considered disorders of carbohydrate metabolism. Defects of each of the proteins involved in glycogen metabolism have been identified (Table 7-2). These cause different forms of glycogen storage disorders and are classified numerically according to the chronological order in which their enzymatic basis was described. The two organs most severely affected by glycogen storage disorders are the liver and skeletal muscle. Glycogen storage disorders that affect the liver typically cause hepatomegaly (enlarged liver) and hypoglycemia (low plasma glucose level). Glycogen storage disorders that affect skeletal muscle cause exercise intolerance, progressive weakness, and cramping. Some glycogen storage disorders, such as Pompe disease, can also affect cardiac muscle, causing cardiomyopathy and early death.

Each disorder of carbohydrate metabolism is uncommon, yet taken together these defects account for substantial morbidity. Early intervention can prevent severe disabilities and/or early death.

Amino Acid Metabolism

Proteins play the most diverse roles of the major biomolecules (e.g., providing mechanical support, coordinating immune responses, generating motion). Indeed, nearly all known enzymes are proteins. The fundamental structural units of proteins are amino acids. Some amino acids can be synthesized endogenously (nonessential), while others must be obtained from the environment (essential). Many defects of the metabolism of amino acids have been described.

Hyperphenylalaninemias

Defects in the metabolism of phenylalanine (an essential amino acid) cause the hyperphenylalaninemias, some of the most widely studied of all metabolic defects. These disorders are caused by mutations of the loci encoding components of the phenylalanine hydroxylation pathway (see Fig. 7-1). Elevated levels of plasma phenylalanine disrupt essential cellular processes in the brain such as myelination and protein synthesis, eventually producing severe mental retardation. Most cases of hyperphenylalaninemia are caused by mutations of phenylalanine hydroxylase (PAH) and produce classical phenylketonuria (PKU). Hundreds of different mutations have been identified in PAH, including substitutions, insertions, and deletions. The prevalence of hyperphenylalaninemia varies widely among ethnic groups, with PKU ranging from 1 in every 10,000 Caucasians to 1 in every 90,000 in Africans. Less commonly, hyperphenylalaninemia is caused by defects in the synthesis of tetrahydrobiopterin, a cofactor necessary for the hydroxylation of phenylalanine, or by a deficiency of dihydropteridine reductase.

Treatment of most hyperphenylalaninemias is aimed at restoring normal blood phenylalanine levels by restricting dietary intake of phenylalanine-containing foods (Box 7-1). However, phenylalanine is an essential amino acid, and adequate supplies are necessary for normal growth and development. A complete lack of phenylalanine is fatal. Thus, a fine balance must be maintained between providing enough protein and phenylalanine for normal growth and preventing the serum phenylalanine level from rising too high. Children with PKU clearly benefit from lifelong treatment. Thus, once diagnosed

Туре	Defect	Major affected tissues
Ia (Von Gierke)	Glucosc-6-phosphatase	Liver, kidney, intestine
Ib	Microsomal glucose-6-phosphate transport	Liver, kidney, intestine, neutrophils
II (Pompe)	Lysosomal acid α-glucosidase	Muscle, heart
IIIa (Cori)	Glycogen debranching enzyme	Liver, muscle
IIIb	Glycogen debranching enzyme	Liver
IV (Anderson)	Branching enzyme	Liver, muscle
V (McArdle)	Muscle phosphorylase	Muscle
VI (Hers)	Liver phosphorylase	Liver
VII (Tarui)	Muscle phosphofructokinase	Muscle

Dietary Management of Inborn Errors of Metabolism

The most important component of therapy for many inborn errors of metabolism is manipulation of the diet. This commonly includes restriction of substrates that are toxic, such as carbohydrates (e.g., in galactosemia, diabetes mellitus), fats (e.g., in MCAD deficiency), and amino acids (e.g., in PKU, MSUD, urea cycle defects); avoidance of fasting; replacement of deficient cofactors (e.g., B vitamins, carnitine); and/or utilizing alternative pathways of catabolism to eliminate toxic substances. Since many metabolic disorders are diagnosed in infants whose nutritional requirements change quickly (sometimes weekly), it is imperative to provide them with diets that provide adequate calories and nutrients for normal growth and development. Thus, the responsibility for maintaining a special diet begins with the parents of an affected child and shifts to the child when he or she is capable of managing independently. For most individuals with metabolic diseases, the use of a special diet is lifelong. This results in many unique challenges that are often unforeseen by families and care providers alike. Consequently, it is important that support and guidance be provided by clinical dietitians, gastroenterologists, psychologists, genetic counselors, and biochemical geneticists.

For example, newborns with PKU are fed a low-phenylalanine diet to prevent the effects of hyperphenylalaninemia on the brain. Breast milk contains too much phenylalanine (Table 7-3) to be used as the only source of nutrients. Therefore, many infants are fed an expensive lowphenylalanine formula that is available only by prescription, a so-called medical food.* Small quantities of breast milk can be mixed with the formula, although the breast milk must be pumped and carefully titrated to avoid giving the infant too much phenylalanine. Serum phenylalanine levels are measured frequently, and adjustments must be made to the diet to compensate for an infant's growth and varying individual tolerances for phenylalanine. These interventions may

*U. S. Public Law 100-290 defines a medical food as a food which is formulated to be consumed or administered enterally under the supervision of a physician and which is intended for the specific dietary management of a disease or condition for which distinctive nutritional requirements, based on recognized scientific principles, are established by medical evaluation.

TABLE 7.3	Phenylalanine Content of	Some Common Foods
-----------	--------------------------	-------------------

Food	Measure	Phenylalanine (mg)
Turkey, light meat	1 cup	1662
Tuna, water-packed	1 cup	1534
Baked beans	1 cup	726
Lowfat milk, 2%	1 cup	393
Soy milk	1 ounce	46
Breast milk	1 ounce	14
Broccoli (raw)	3 tablespoons	28
Potato (baked)	2 tablespoons	14
Watermelon	$\frac{1}{2}$ cup	12
Grapefruit (fresh)	¹ / ₄ fruit	13
Beer	6 ounces	11
Gelatin dessert	$\frac{1}{2}$ cup	36

disrupt maternal-infant bonding and distort a family's social dynamics.

As a child with PKU grows older, low-protein food substitutes are introduced to supplement the formula (e.g., lowprotein breads and pasta). To put this in perspective, consider that a 10-year-old child with PKU may eat 300 to 500 mg of phenylalanine per day. Thus, 3 or 4 slices of regular bread would meet a child's nutritional needs and dietary phenylalanine limit, because of the relatively high protein content of grains. Low-protein foods make the diet more substantive and varied. Indeed, 7 slices of low-protein bread contain the phenylalanine equivalent of 1 piece of regular bread. Yet, many of these foods have an odor, taste, texture, and/or appearance that differs distinctively from foods containing normal amounts of protein.

The intake of many fruits, fats, and carbohydrates is less restricted (see Table 7-3). However, phenylalanine is found unexpectedly in many food items (e.g., gelatin, beer). In fact, the U.S. Food and Drug Administration (FDA) requires manufacturers to label products containing aspartame (a common artificial sweetener that contains phenylalanine) with a warning for individuals with PKU.

Teenagers with PKU sometimes have difficulty socializing with their peers because their dietary restrictions limit food choices at restaurants, sporting events, and parties. Adults with PKU must consume more medical food than they did during childhood due to their size and protein requirements (Fig. 7-4). Women with PKU must be on a severely restricted low-phenylalanine diet during pregnancy, because hyperphenylalaninemia is a known teratogen (see text).

Inborn errors of metabolism are chronic diseases that are often treated by substantially modifying the diet. This may require considerable changes in lifestyle, precipitating financial and emotional hardships of which health care providers need to be aware.

with PKU, an individual should be maintained on a phenylalanine-restricted diet for life.

Hyperphenylalaninemia in a pregnant woman results in elevated phenylalanine levels in the fetus. This can cause poor growth, birth defects, microcephaly, and mental retardation in the fetus (regardless of the fetus' genotype). Thus, it is important that women with PKU receive appropriate pregnancy counseling. Optimally, they should be following a low-phenylalanine diet at conception and throughout gestation. www

Tyrosinemia

The amino acid tyrosine is the starting point of the synthetic pathways leading to catecholamines, thyroid hormones, and melanin pigments, and it is incorporated into many proteins. Elevated levels of serum tyrosine can be acquired (e.g., severe hepatocellular dysfunction), or they can result from an inborn error of catabolism, of which there are several. Hereditary tyrosinemia type 1 (HT1) is the most common metabolic defect and is caused by a deficiency of fumarylacetoacetate hydrolase (FAH), which catalyzes the last step in tyrosine catabolism (see Fig. 7-1). Accumulation of FAH's substrate, fumarylacetoacetate, and its precursor, maleylacetoacetate, is thought to be mutagenic and toxic to the liver. Consequently, HT1 is characterized by renal tubular dysfunction, acute episodes of peripheral neuropathy, progressive liver disease leading to cirrhosis, and a high risk of developing liver cancer (hepatocellular carcinoma). Management of HT1 includes supportive care, dietary restriction of phenylalanine and tyrosine, and liver transplantation. Liver transplantation can be curative.

More recently, administration of 2-(nitro-4-trifluoromethylbenzoyl)-1,3-cyclohexanedione (NTBC), an inhibitor of an enzyme upstream of FAH (4-hydroxyphenylpyruvate dioxygenase), has produced marked improvement in children with HT1. The long-term effects of NTBC are still unclear, but children who have been treated for more than 10 years appear to be doing well. In a mouse model of HT1, gene therapy (see Chapter 14) has been used to repopulate the liver with cells that exhibit stable long-term expression of *FAH* (i.e., FAH+ hepatocytes). Because some FAH– hepatocytes remain in these livers, it is unclear whether the risk of hepatocellular carcinoma is reduced. Gene therapy for HT1 in humans may someday replace life-long dietary and pharmacological treatment.

FAH has been cloned, and mutations have been identified in many families. A splice-site mutation is quite common in French-Canadians, and its high frequency is probably the result of founder effect (see Chapter 3). This mutation results in an in-frame deletion of an exon, which removes a series of critically important amino acids from FAH. Missense and nonsense mutations of *FAH* have also been found in families with HT1.

Tyrosinemia type 2 (oculocutaneous tyrosinemia) is caused by a deficiency of tyrosine aminotransferase. It is characterized by corneal erosions, thickening of the skin on the palms and the soles, and variable mental retardation. Tyrosinemia type 3 is associated with reduced activity of 4-hydroxyphenylpyruvate dioxygenase and neurological dysfunction, although only a few affected individuals have been reported.

Deficiency of fumarylacetoacetate hydrolase (FAH) causes hereditary tyrosinemia type 1 (HT1). Accumulation of the substrates of FAH leads to neurological, kidney, and liver dysfunction. Although liver transplantation has been the cornerstone of treatment for HT1, the use of drugs that block the production of FAH substrates appears promising.

Branched-Chain Amino Acid Disorders

Approximately 40% of the preformed amino acids required by mammals are branched-chain amino acids (BCAAs) such as valine, leucine, and isoleucine. BCAAs can be used as a source of energy through an oxidative pathway that uses an α -ketoacid as an intermediate. Decarboxylation of α -ketoacids is mediated by a multimeric enzyme complex called branched-chain α -ketoacid dehydrogenase (BCKAD). The BCKAD complex is composed of at least four catalytic components and two regulatory enzymes, which are encoded by six loci. A deficiency of any one of these six components produces a disorder known as maple syrup urine disease (MSUD), so named because the urine of affected individuals has an odor reminiscent of maple syrup.

The prevalence of MSUD in the general population is low, but MSUD is relatively common in the Mennonite community of Lancaster County, Pennsylvania, where approximately 1 in every 7 individuals is a carrier. All of these carriers have the same disease-causing mutation of $E1\alpha$, one of the loci encoding a catalytic component of BCKAD, and all are descendants of a couple who emigrated from Europe in the 18th century. This is another example of founder effect in a small, relatively isolated population (see Chapter 3).

Untreated patients with MSUD accumulate BCAAs and their associated ketoacids, leading to progressive neurodegeneration and death in the first few months of life. Treatment of MSUD consists of dietary restriction of BCAAs to the minimum required for normal growth. Despite treatment, episodic deterioration is common, and supportive care is required during these crises. Because increasing BCKAD activity by only a few per-

Hyperphenylalaninemias are the most common defects of amino acid metabolism. Classical PKU is caused by mutations in phenylalanine hydroxylase. Hyperphenylalaninemias are treated by restricting dietary intake of phenylalanine-containing foods.

centage points can alter the course of disease substantially, therapy with thiamine, a cofactor of BCKAD, is used to treat these patients. Gene therapy for MSUD is also being investigated.

Maple syrup urine disease (MSUD) is caused by defects in branched-chain α-ketoacid dehydrogenase. Accumulation of branched-chain amino acids (BCAAs) causes progressive neurodegeneration and death. Treatment of MSUD consists of restricting dietary intake of BCAAs to a minimal level.

Early detection of amino acid defects, coupled with prompt intervention, can prevent severe physical impairment and/or death. Moderate increases of enzyme activity can dramatically alter the course of some aminoacidopathies, making them good candidates for the use of somatic cell gene therapy.

Lipid Metabolism

Lipids (Greek, *lipos* or fat) are a heterogeneous group of biomolecules that are insoluble in water and highly soluble in organic solvents (e.g., chloroform). They provide the backbone for phospholipids and sphingolipids, which are components of all biological membranes. Lipids are also constituents of hormones; they act as intracellular messengers and serve as an energy substrate. Elevated serum lipid levels (hyperlipidemia) are common and result from defective lipid transport mechanisms. Errors in the metabolism of fatty acids (hydrocarbon chains with a terminal carboxylate group) are much less frequent. However, characterizing errors of fatty acid metabolism has been a powerful approach for understanding the biochemical basis of lipid catabolism. During fasting and prolonged aerobic exercise, fatty acids are mobilized from adipose tissue and become a major substrate for energy production in the liver, skeletal muscle, and cardiac muscle. Major steps in this pathway include the uptake and activation of fatty acids by cells, transport across the outer and inner mitochondrial membranes, and entry into the β -oxidation spiral in the mitochondrial matrix (Fig. 7-5). Defects in each of these steps have been described in humans, although defects of fatty acid oxidation (FAO) are the most common.

MCAD Deficiency

The most common inborn error of fatty acid metabolism results from a deficiency of medium-chain acyl-coenzyme A dehydrogenase (MCAD). MCAD deficiency is characterized by episodic hypoglycemia, which is often provoked by fasting (see Clinical Commentary 7-1). Commonly, a child with MCAD deficiency presents with vomiting and lethargy after a period of diminished oral intake due to a minor illness (e.g., upper respiratory illness, gastroenteritis). Fasting results in the accumulation of fatty acid intermediates, a failure to produce ketones in sufficient quantities to meet tissue demands, and the exhaustion of glucose supplies. Cerebral edema and encephalopathy result from the indirect and direct effects of fatty acid intermediates in the central nervous system. Death often follows unless a usable energy source such as glucose is provided promptly. Between these episodes, children with MCAD deficiency often have normal examinations. Treatment consists of providing supportive care during periods of nutritional stress, ensuring an adequate source of calories, and the avoidance of fasting.

To date, most of the reported MCAD patients are of

northwestern European origin, and 90% of their alleles have an A-to-G missense mutation that results in the substitution of glutamate for lysine. Additional substitution, insertion, and deletion mutations have been identified but are much less common. The molecular characterization of MCAD has made it possible to offer direct DNA testing as a reliable and inexpensive diagnostic tool. Furthermore, since MCAD deficiency appears to meet the criteria established for newborn screening (see Chapter 13), this test may be added to those already performed on all newborns in the United States (e.g., PKU testing).

LCHAD Deficiency

Long-chain acyl-CoA fatty acids are metabolized in a sequence of steps catalyzed by a handful of different enzymes. The first step is controlled by long-chain acyl-CoA dehydrogenase (LCAD), and to date, no human case of LCAD deficiency has been reported (children previously reported to have LCAD deficiency were found to have a deficiency of very-long-chain acyl-CoA dehydrogenase). The second step is catalyzed by enzymes that are part of an enzyme complex called the mitochondrial trifunctional protein (TFP). One of the enzymes of the TFP is long-chain L-3-hydroxyacyl-CoA dehydrogenase (LCHAD).

LCHAD deficiency is one of the most severe of the FAO disorders. The first cases reported presented with severe liver disease ranging from fulminant neonatal liver failure to a chronic, progressive destruction of the liver. Over the last 10 years, the phenotype has expanded to include cardiomyopathy, skeletal myopathy, retinal disease, peripheral neuropathy, and sudden death. Its clinical and biochemical characteristics clearly differentiate it from other FAO disorders.

In the last decade, a number of women pregnant with a fetus affected with LCHAD deficiency have developed a severe liver disease called acute fatty liver of pregnancy (AFLP) and HELLP syndrome (hemolysis, elevated liver function tests, low platelets). It is hypothesized that the failure of the fetus to metabolize free fatty acids results in the accumulation of abnormal fatty acid metabolites in the maternal liver and placenta. The former may cause the abnormalities observed in women with AFLP and HELLP. The latter may cause intrauterine growth retardation and increase the probability of preterm delivery, both of which are common in children with LCHAD deficiency.

Defects of Cholesterol Biosynthesis

Elevated levels of plasma cholesterol have been associated with various conditions, most notably atherosclerotic heart disease. It has been demonstrated that substantially reduced levels of cholesterol can also adversely affect the growth and development of an individual. The final step of cholesterol biosynthesis is catalyzed by the enzyme Δ 7-sterol reductase (DHCR7). For years it has been noted that individuals with an autosomal recessive disorder called Smith-Lemli-Opitz (SLO) syndrome have reduced levels of cholesterol and increased levels of 7-dehydrocholesterol (a precursor of DHCR7). SLO is characterized by various congenital anomalies of the brain, heart, genitalia, and hands (Fig. 7-6). It is unusual in this respect, because most inborn errors of metabolism do not cause birth defects.

In 1998, SLO was discovered to be caused by mutations in the *DHCR7* gene, and to date more than 70 different mutations in *DHCR7* have been found. Most of these are missense mutations that result in substitutions of a highly conserved residue of the protein. Two mutations are much more frequent in European populations, suggesting that there may have been a selective advantage to being a heterozygous carrier for either of them. Supplementing the diet of SLO children with cholesterol may ameliorate their growth and feeding problems, although its effect on cognitive development is less clear. Other primary defects of cholesterol biosynthesis have been discovered, including several that cause skeletal dysplasias.

The clinical presentation of children with defects of lipid metabolism varies from slow deterioration to sudden death. MCAD

FIGURE 7.6 A child with Smith-Lemli-Opitz syndrome. (Nowaczyk MJ, Whelan DT, Hill RE [1998] Smith-Lemli-Opitz syndrome: phenotypic extreme with minimal findings. Am J Med Genet 78:419-423.)

deficiency is the most common of these disorders. Most affected patients can be diagnosed by biochemical analysis of a drop of dried blood at birth. Deficiency of long-chain acyl-CoA dehydrogenase has also been reported.

Degradative Pathways

Most biomolecules are dynamic, perpetually being recycled as part of the normal metabolic state of a cell. Existing molecules are degraded into their constituents to produce substrates for the building of new molecules. Furthermore, the byproducts of energy production, substrate conversions, and anabolism need to be processed and eliminated. Errors in these degradative pathways result in the accumulation of metabolites that would otherwise have been recycled or eliminated.

Lysosomal Storage Disorders

The lysosomal storage disorders are the prototypical inborn errors of metabolism: disease results from the accumulation of substrate. Enzymes within lysosomes catalyze the stepwise degradation of sphingolipids, glycosaminoglycans (mucopolysaccharides), glycoproteins, and glycolipids. Accumulation ("storage") of undegraded molecules results in cell, tissue, and organ dysfunction. Most of the lysosomal disorders are caused by enzyme deficiencies, although some are caused by the inability to activate an enzyme or to transport an enzyme to a subcellular compartment where it can function properly. Many of the lysosomal storage disorders are found with uncommonly high prevalence in various ethnic populations as a result of founder effect, genetic drift, and possibly natural selection (see Chapter 3).

The mucopolysaccharidoses (MPS disorders) are a heterogeneous group of disorders caused by a reduced ability to degrade one or more glycosaminoglycans (e.g., dermatan sulfate, heparan sulfate, keratan sulfate, chondroitin sulfate). These glycosaminoglycans are degradation products of proteoglycans found in the extracellular matrix. Ten different enzyme deficiencies cause six different MPS disorders, which share many clinical features (Table 7-4), but these disorders can be distinguished from each other by clinical, biochemical, and molecular analyses. Assays that measure enzyme activity in fibroblasts, leukocytes, or serum are available for each MPS disorder, and prenatal testing after amniocentesis or chorionic villus sampling (see Chapter 13) is possible. Except for the X-linked recessive Hunter syndrome, all of the MPS disorders are inherited in an autosomal recessive fashion.

All MPS disorders are characterized by chronic and progressive multisystem deterioration, which causes hearing, vision, joint, and cardiovascular dysfunction (Fig. 7-7). Hurler, severe Hunter, and Sanfilippo syndromes are characterized by mental retardation, while normal cognition is observed in other MPS disorders.

Deficiency of iduronidase (MPS I) is the prototypic MPS disorder. It produces a spectrum of phenotypes that have been traditionally delimited into three groups— Hurler, Hurler-Scheie, and Scheie syndromes—which manifest severe, moderate, and mild disease, respectively. MPS I disorders cannot be distinguished from each other

TABLE 7.4	Mucopolysaccharidoses*								
Name	Mutant enzyme	Clinical features							
Hurler/Scheie	α-1-Iduronidase	Coarse face, hepatosplenomegaly, corneal clouding, dysostosis multiplex, † mental retardation							
Hunter	Iduronate sulfatase	Coarse face, hepatosplenomegaly, dysostosis multiplex, mental retardation, behavioral problems							
Sanfilippo A	Heparan-N-sulfamidase	Behavioral problems, dysostosis multiplex, mental retardation							
Sanfilippo B	α -N-Acetylglucosaminidase	Behavioral problems, dysostosis multiplex, mental retardation							
Sanfilippo C	Acetyl-CoA: α -glucosaminide N-acetyltransferase	Behavioral problems, dysostosis multiplex, mental retardation							
Sanfilippo D	N-Acetylglucosamine-6-sulfatase	Behavioral problems, dysostosis multiplex, mental retardation							
Morquio A	N-Acetylglucosamine-6-sulfatase	Short stature, bony dysplasia, hearing loss							
Morquio B	β-Galactosidase	Short stature, bony dysplasia, hearing loss							
Maroteaux- Lamy	Aryl sulfatase B	Short stature, corneal clouding, cardiac valvular disease, dysostosis multiplex							
Sly	β-Glucuronidase	Coarse face, hepatosplenomegaly, corneal clouding, dysostosis multiplex							

*Hunter syndrome is an X-linked recessive disorder; the remaining MPS disorders are autosomal recessive.

[†]Dysostosis multiplex is a distinctive pattern of bony changes including a thickened skull, anterior thickening of the ribs, vertebral abnormalities, and shortened and thickened long bones.

FIGURE 7.7 A, A boy with a mutation in α -l-iduronidase, which causes Hurler syndrome. Note his coarse facial features, crouched stance, thickened digits, and protuberant abdomen. **B**, Transgenic mice with a targeted disruption of α -l-iduronidase. Progressive coarsening of the face is apparent as 8-week-old mice (*left*) grow to become 52-week-old mice (*right*). (Courtesy Dr. Lorne Clarke, University of British Columbia.)

by measurement of enzyme activity; therefore, assignment of the MPS I phenotype is usually made on the basis of clinical criteria. The *iduronidase* gene has been cloned, and eventually genotype-phenotype correlations may lead to earlier and more accurate classification. Hunter syndrome (MPS II) is caused by a deficiency of iduronate sulfatase. It is separated into mild and severe phenotypes based on clinical assessment. The onset of disease usually occurs between 2 and 4 years of age. Affected children develop coarse facial features, short stature, skeletal deformities, joint stiffness, and mental retardation. The gene for iduronate sulfatase is composed of 9 exons spanning 24 kb. Twenty percent of all identified mutations are large deletions, and most of the remainder are missense and nonsense mutations. www

Defects of glycosaminoglycan degradation cause a heterogeneous group of disorders called mucopolysaccharidoses (MPS disorder). All MPS disorders are characterized by progressive multisystem deterioration causing hearing, vision, joint, and cardiovascular dysfunction. These disorders can be distinguished from each other by clinical, biochemical, and molecular studies.

Defects in the degradation of sphingolipids (sphingolipidoses) result in their gradual accumulation, which leads to multiorgan dysfunction (Table 7-5). Deficiency of the lysosomal enzyme, acid β-glucosidase, causes accumulation of glucosylceramide and Gaucher disease. It is characterized by visceromegaly (enlarged visceral organs), multiorgan failure, and debilitating skeletal disease. There are three subtypes of Gaucher disease, which can be distinguished by their clinical features. Type 1 is most common and does not involve the central nervous system. Type 2 is the most severe, often leading to death within the first 2 years of life. Type 3 Gaucher disease is intermediate between the other two forms.

Gaucher disease is rare, although the frequency of disease-causing alleles is greater than 0.03 in Ashkenazi Jews. The most common allele is produced by an A-to-G mutation that results in a single amino acid substitution. DNA screening for the five most common Gaucher alleles detects 97% of all mutations found in this population.

Enzymes that function in lysosomes are targeted and transported into the lysosomal space by specific pathways. Targeting is mediated by receptors that bind mannose-6-phosphate recognition markers attached to the enzyme (i.e., a posttranslational modification). The synthesis of these recognition markers is deficient in I-cell disease (mucolipidosis II), so named because the cytoplasm of fibroblasts from affected individuals was found by light microscopy to contain inclusions. These inclusions represent partially degraded oligosaccharides, lipids, and glycosaminoglycans. As a consequence of recognition marker deficiency, newly synthesized lysosomal enzymes are secreted into the extracellular space instead of being correctly targeted to lysosomes. Individuals with I-cell disease have coarse facial features, skeletal abnormalities, hepatomegaly, corneal opacities, mental retardation, and early death. There is no specific treatment for I-cell disease.

Some of the lysosomal storage disorders may be amenable to treatment by exogenously supplied enzyme or by restoration of endogenous enzyme activity through bone marrow transplantation or gene therapy. Children with Hurler syndrome who underwent bone marrow transplantation demonstrated less mental deterioration than was expected. It remains to be seen whether these positive results will persist over an extended period. www

Many different lysosomal enzymes catalyze the degradation of sphingolipids, glycosaminoglycans, glycoproteins, and glycolipids. Deficiency of a lysosomal enzyme causes accumulation of substrate, visceromegaly, organ dysfunction, and early death if

Name	Mutant enzyme	Clinical features							
Tay-Sachs	β-Hexosaminidase (A isoenzyme)	Hypotonia, spasticity, seizures, blindness							
Gaucher (type 1; non- neuropathic)	β-Glucosidase	Splenomegaly, hepatomegaly, bone marrow infiltration, brain usually spared							
Niemann-Pick, type 1A	Sphingomyelinase	Hepatomegaly, corneal opacities, brain deterioration							
Fabry	α -Galactosidase	Paresthesia of the hands and feet, corneal dystrophy, hypertension renal failure, cardiomyopathy							
GM1 gangliosidosis (infantile)	β-Galactosidase	Organomegaly, dysostosis multiplex, [†] cardiac failure							
Krabbe	β-Galactosidase	Hypertonicity, blindness, deafness, seizures, (galactosylceramide-specific) atrophy of the brain							
Metachromatic leukodystrophy	Aryl sulfatase A	Ataxia, weakness, blindness, brain atrophy (late-infantile)							
Sandhoff	β -Hexosaminidase (total)	Optic atrophy, spasticity, seizures							
Schindler	α-N-Acetylgalactosaminidase	Seizures, optic atrophy, retardation							
Multiple sulfatase deficiency	Aryl sulfatase A, B, C	Retardation, coarse facial features, weakness, hepatosplenomegaly, dysostosis multiplex							

*Of the lysosomal storage disorders included in this table, Fabry syndrome is X-linked recessive and the remainder are autosomal recessive. [†]Dysostosis multiplex is a distinctive pattern of bony changes including a thickened skull, anterior thickening of the ribs, vertebral abnormalities, and shortened and thickened long bones.

TABLE 7.5	Lysosomal Storage	Disorders*

untreated. Genes encoding many of the lysosomal enzymes have been cloned, and treatment with gene therapy is being tested.

Urea Cycle Disorders

The primary role of the urea cycle is to prevent the accumulation of nitrogenous wastes by incorporating nitrogen into urea, which is subsequently excreted by the kidney. Additionally, the urea cycle is responsible for the de novo synthesis of arginine. The urea cycle consists of five major biochemical reactions (Fig. 7-8); defects in each of these steps have been described in humans.

Deficiencies of carbamyl phosphate synthetase (CPS), ornithine transcarbamylase (OTC), argininosuccinic acid synthetase (ASA), and argininosuccinase (AS) result in the accumulation of urea precursors such as ammonium and glutamine. Consequently, the clinical presentations of individuals with CPS, OTC, ASA, and AS deficiencies are similar, producing progressive lethargy and coma and closely resembling the clinical presentation of Reye syndrome. Affected individuals may present in the neonatal period or at any time thereafter, and there is wide interfamilial variability in severity. In contrast, arginase deficiency causes a progressive spastic quadriplegia and mental retardation. Differentiation among these disorders is based on biochemical testing.

Each of these disorders except OTC deficiency is inherited in an autosomal recessive pattern. Although OTC deficiency is an X-linked recessive disorder, women can be symptomatic carriers depending, in part, on the proportion of hepatocytes in which the normal allele is inactivated. The goal of therapy for each disorder is to provide sufficient calories and protein for normal growth and development while preventing hyperammonemia.

OTC deficiency is the most prevalent of the urea cycle disorders and thus has been intensively studied. The *OTC* gene contains 10 exons spanning approximately 85 kb and is located just proximal to dystrophin on Xp. A variety of exon deletions and missense mutations have been described. In addition, mutations that affect RNA processing have been observed.

The urea cycle consists of five major biochemical reactions that convert nitrogenous waste products to urea, which is subsequently excreted by the kidney. Enzymatic defects in this pathway lead to the accumulation of urea precursors, progressive neurological impairment, and death if untreated. The genes for most of these disorders have been cloned, including the most common observed defect, X-linked ornithine transcarbamylase (OTC) deficiency.

Energy Production

Energy for cellular activities can be produced from many different substrates, including glucose, ketones, amino acids, and fatty acids. Catabolism of these substrates requires their stepwise cleavage into smaller molecules (via processes such as the citric acid cycle or β -oxidation), followed by passage of hydrogen ions through the oxidative phosphorylation (OXPHOS) system. Alternatively, some substrates may be processed anaerobically.

The OXPHOS system consists of five multiprotein complexes that transfer electrons to oxygen. These complexes are composed of more than 100 polypeptides and are located in the inner mitochondrial membrane.

FIGURE 7.8 Schematic diagram of the urea cycle. AS, Argininosuccinase; ASA, argininosuccinic acid synthetase; CPS, carbamyl phosphate synthetase; NAGS, *N*-acetylglutamate synthetase; OTC, ornithine transcarbamylase.

Thirteen of these polypeptides are encoded by the mitochondrial genome (see Fig. 5-18 in Chapter 5), and the remainder are encoded by nuclear genes. Thus, assembly and function of the OXPHOS system require ongoing signaling and transport between the nucleus and the mitochondrion. OXPHOS regulation is mediated by a wide variety of factors, including oxygen supply, hormone levels, and metabolite-induced transcription control.

More than 20 disorders characterized by OXPHOS defects are caused by substitutions, insertions, or deletions in the mitochondrial genome and are maternally inherited (see Chapter 5). However, nuclear genes that can cause mitochondrial DNA (mtDNA) deletions or depletion of mtDNA have been isolated, and these disorders are inherited in an autosomal recessive pattern. Mutations in genes affecting the OXPHOS system produce very complex phenotypes as a consequence of the varying metabolic requirements of different tissues and systems at different developmental stages.

Electron transfer flavoprotein (ETF) and ETFubiquinone oxidoreductase (ETF-QO) are nuclearencoded proteins through which electrons can enter the OXPHOS system. Inherited defects in either of these proteins cause glutaric acidemia type II, which is characterized by hypotonia, hepatomegaly, hypoketotic or nonketotic hypoglycemia, and metabolic acidemia. Most affected individuals present in the neonatal period or shortly thereafter, and despite aggressive therapy, affected children often die within months.

In most tissues, the metabolism of pyruvate proceeds though pyruvate dehydrogenase, the citric acid cycle, and the OXPHOS system. However, in tissues with high glycolytic activity and a reduced or absent OXPHOS capacity, the end products of metabolism are pyruvate and lactic acid (see Fig. 7-3). Lactate is produced by the reduction of pyruvate, and the bulk of circulating lactate is usually absorbed by the liver and converted to glucose. Defects in the pathways of pyruvate metabolism produce lactic acidemia. The most common of such disorders is a deficiency of the pyruvate dehydrogenase (PDH) complex. It may be caused by mutations in the genes encoding one of five components of the PDH complex: E_1 , E_2 , E₃, X-lipoate, or PDH phosphatase. These disorders are characterized by varying degrees of lactic acidemia, developmental delay, and abnormalities of the central nervous system. It has been suggested that the facial features of some children with PDH deficiency resemble those of children with fetal alcohol syndrome (see Clinical Commentary 14-6 in Chapter 14). It has also been proposed that acetaldehyde from the circulation of mothers with alcoholism inhibits PDH in the fetus, creating a phenocopy of PDH deficiency. www

tissues and organs. Once the condition is diagnosed, the goal of treatment is to utilize alternative pathways of energy production.

Transport Systems

The efficient movement of molecules between compartments (e.g., organelles, cells, the environment), and hence across a barrier, often requires a macromolecule that connects the compartments and mediates transport through the barrier. Abnormalities of these transport systems have myriad effects, depending on whether altered barrier integrity or the accumulation of substrate has a greater impact on normal physiology.

Cystine is the disulfide derivative of the amino acid cysteine. Abnormal cystine transport can produce two diseases, cystinuria and cystinosis. Both disorders are inherited in an autosomal recessive fashion.

Abnormal cystine transport between cells and the extracellular environment causes cystinuria, one of the most common inherited disorders of metabolism. Although cystinuria produces substantial morbidity, early death is uncommon. Cystinuria is a genetically heterogeneous disorder caused by a defect of dibasic amino acid transport affecting the epithelial cells of the gastrointestinal tract and renal tubules. As a result, cystine, lysine, arginine, and ornithine are excreted in urine in quantities higher than normal. Cystine is the most insoluble of the amino acids; therefore, elevated urinary cystine predisposes to the formation of renal calculi (kidney stones). Complications of chronic nephrolithiasis (presence of kidney stones) include infection, hypertension, and renal failure. Treatment of cystinuria consists largely of rendering cystine more soluble. This is accomplished by the administration of pharmacological amounts of water (4 to 6 L/day), alkalinizing the urine, and using chelating agents such as penicillamine.

Based on amino acid excretion studies, cystinuria has been divided into three phenotypes. Type I cystinuria has been associated with missense, nonsense, and deletion mutations in a gene termed *soluble carrier family 3, member 1 amino acid transporter* (*SLC3A1*). Types II and III cystinuria are caused by mutations in a gene called *SLC7A9. SLC3A1* and *SLC7A9* encode the heavy and light subunits of the amino acid transporter b^{0,+} located on the brush-border plasma membrane of epithelial cells in the proximal tubules of the kidney. In vitro studies of mutant *SLC3A1* and *SLC7A9* protein have demonstrated a marked reduction in transport activity, providing direct evidence for the role of these proteins in cystinuria.

Cystinosis is a rare disorder caused by a diminished ability to transport cystine across the lysosomal membrane. This produces an accumulation of cystine crystals in the lysosomes of most tissues. Affected individuals are normal at birth but develop electrolyte disturbances, corneal crystals, rickets, and poor growth by the age of 1 year. Renal glomerular damage is severe enough to

The phenotype produced by defects of energy metabolism is complex because of the varying oxidative demands of different

necessitate dialysis or transplantation within the first decade of life. Transplanted kidneys function normally, but chronic complications such as diabetes mellitus, pancreatic insufficiency, hypogonadism, myopathy, and blindness occur. Until recently, treatment was largely supportive, including renal transplantation. However, cysteine-depleting agents such as cysteamine have proved successful in slowing renal deterioration and improving growth. A novel gene encoding an integral lysosomal membrane protein was recently found to be mutated in individuals with cystinosis.

The phenotype of transport defects is partly contingent on the degree of barrier disruption as well as the compartments through which normal traffic is compromised. Abnormal cystine transport between cells and the extracellular environment causes cystinuria, renal disease, and hypertension. Cystinosis is produced by a defect of cystine efflux from the lysosome; it leads to severe chronic disabilities and, if untreated, death.

Many of the enzymes controlling metabolic processes require additional factors (cofactors) to function properly and efficiently. These cofactors are commonly trace elements such as ions of heavy metals (metals that are more dense than those in the first two groups of the periodic table). There are at least 12 trace elements that are essential to humans. For example, a zinc ion acts as a cofactor in carbonic anhydrase, placing a hydroxide ion next to carbon dioxide to facilitate the formation of bicarbonate. Although an adequate supply of trace elements is critical for normal metabolism, excessive amounts of circulating and/or stored heavy metals are highly toxic. Accordingly, a complex series of transport and storage proteins precisely control heavy metal homeostasis. Abnormalities of these proteins cause progressive dysfunction of various organs, often leading to premature death if untreated. Human disorders that disrupt the normal homeostasis of copper (Wilson disease, Menkes disease, occipital horn syndrome), iron (hereditary hemochromatosis; Clinical Commentary 7-2), and zinc (hereditary acrodermatitis enteropathica) have been described.

Copper is absorbed by epithelial cells of the small intestine via a transporter called hCTR1 and is subsequently distributed by various chaperone proteins that shuttle it to different places in the cell (e.g., cytoplasmic enzymes that use copper as a cofactor, enzymes in the mitochondria). Some copper is transported to the liver to be incorporated into proteins that distribute it to other parts of the body (e.g., brain). Excess copper in hepatocytes is secreted into bile and excreted from the body.

Menkes disease (MND) is an X-linked recessive disorder described in 1962 by John Menkes, who studied five male siblings, all of whom died before 3 years of age. MND is characterized by mental retardation, seizures, hypothermia, twisted and hypopigmented hair (pili torti), loose skin, arterial rupture, and death in early childhood. In MND patients, copper can be absorbed by the gastrointestinal epithelium but cannot be exported effectively from these cells into the bloodstream. Consequently, when the intestinal cells slough, the trapped copper is excreted from the body. The lack of available copper leads to an overall deficiency of copper.

Copper is a required cofactor in tyrosinase, lysyl oxidase, superoxide dismutase, cytochrome c oxidase, and dopamine β -hydroxylase. Reduced availability of copper leads to impaired enzyme function, explaining the major clinical features of MND. For example, lysyl oxidase is required for cross-linking collagen and elastin; therefore, ineffectual cross-linking leads to weakened vascular walls and laxity of the skin. Treatment of MND consists of restoring copper levels in the body to normal. Since copper cannot be absorbed via the gastrointestinal tract in MND patients, it must be administered by an alternative route such as subcutaneous injections. Patients treated this way have demonstrated some clinical improvement. However, none of the abnormalities is completely corrected or prevented. Based on studies in an animal model of MND, the brindled mouse, it has been proposed that treatment for MND would be most effective if it were started in midgestation. Consequently, prenatal therapy is being investigated.

In contrast to MND, in which a deficiency of copper causes disease, Wilson disease (WND) results from an excess of copper caused by defective excretion of copper into the biliary tract. This causes progressive liver disease and neurological abnormalities. WND, an autosomal recessive disorder, was first described by Kinnear Wilson in 1912 and was called hepatolenticular degeneration because of end-stage destruction of the liver and brain. It remained unknown until the 1940s that these findings were due to the accumulation of copper. Further progress in understanding the defect underlying WND did not occur until the 1990s.

Patients with WND usually present with acute or chronic liver disease in childhood. If left untreated, the liver disease is progressive, resulting in liver insufficiency, cirrhosis, and failure. Adults commonly develop neurological symptoms such as dysarthria (the inability to correctly articulate words) and diminished coordination. Accumulation of copper can also cause arthropathy (inflammation of the joints), cardiomyopathy (abnormal function of the heart muscle), kidney damage, and hypoparathyroidism (diminished secretion of or response to parathormone). Deposition of copper in Descemet's membrane (at the limbus of the cornea) produces a characteristic finding in the eye (the Kayser-Fleischer ring), which is observed in 95% of WND patients and 100% of WND patients with neurological symptoms.

Biochemical testing can be used to confirm the diagnosis of WND. Findings include decreased serum ceruloplasmin, increased serum nonceruloplasmin copper, increased urinary copper excretion, and increased depo-

CLINICAL COMMENTARY 7.2

Hereditary Hemochromatosis

Hereditary hemochromatosis (HH) is an autosomal recessive disorder of iron metabolism in which excessive iron is absorbed in the small intestine and then accumulates in a variety of organs such as the liver, kidney, heart, joints, and pancreas. It was described by von Recklinghausen, the same physician who described neurofibromatosis 1, in 1889. Approximately 1 of every 8 northern Europeans is a carrier for HH, and 1 of every 200 to 400 individuals is a homozygote. Although the penetrance of the disease-causing genotype is incomplete (as discussed later), HH is one of the most common genetic disorders observed in Caucasians. Its prevalence is substantially lower in Asian and African populations.

HH exhibits delayed age of onset, with a presymptomatic period of 40 years or longer in men. Women commonly develop symptoms 20 years or so later than men do, because accumulation of iron in women is tempered by iron losses during menstruation, gestation, and lactation. The most common symptom of HH is fatigue, although the clinical presentation of patients with HH can vary considerably. Additional findings include joint pain, diminished libido, diabetes, increased skin pigmentation, cardiomyopathy, liver enlargement, and cirrhosis. Abnormal serum iron parameters can identify most men at risk for iron overload, but many premenopausal women may not be detected. The most sensitive diagnostic test for HH is a liver biopsy accompanied by histochemical staining for hemosiderin (a form of stored iron) (Fig. 7-9).

As early as the 1970s, an increased frequency of the human leukocyte antigen HLA-A3 allele in HH patients indicated that an HH gene might be located near the major histocompatibility region (MHC) on chromosome 6p. Subsequent linkage studies confirmed this hypothesis in the late 1970s, but it was not until 1996 that the HH gene was cloned. The HH gene is a widely expressed HLA Class I–like gene, designated *HFE*. The gene product is a cell-surface protein that binds to the transferrin receptor (transferrin carries iron molecules), overlapping the binding site for transferrin and inhibiting transferrin-mediated

FIGURE 7.9 Comparison of hemosiderin stain of normal liver (*upper left*) with hemosiderin stain of livers from individuals affected with hemochromatosis (*upper right, lower right, and lower left*). Note the varying degree of increased deposition of hemosiderin livers of HH homozygotes. This damages the liver, impairs its function, and can lead to cirrhosis and liver cancer.

CLINICAL COMMENTARY 7.2

Hereditary Hemochromatosis—cont'd

iron uptake. However, this does not directly affect iron transport from the small intestine. Instead, this interaction is thought to be involved in a cell's ability to sense iron levels. This function is disrupted in individuals with mutations in *HFE*, resulting in excessive iron absorption from the small intestine and iron overload. Thus, hemochromatosis is not caused by a defect of an iron transport protein, but rather by a defect in the regulation of transport.

A single missense mutation that results in the substitution of a tyrosine for cysteine in a β_2 -microglobulin-binding domain is found on the majority of HH chromosomes. A single ancestral haplotype predominates in Caucasians, suggesting that there was a selective advantage conferred by having at least one copy of the HH gene. Since iron deficiency affects one third of the world's population and is significantly less common in HH heterozygotes, it is likely that this explains the higher frequency of HH in many populations.

Treatment of HH consists of reducing the accumulated iron. This is accomplished by serial phlebotomy or by the use of an iron-chelating agent such as deferoxamine. Depending on the quantity of iron stored, return to a normal level of iron may take a few years. However, iron reduction prevents further liver dam-

sition of copper in the liver. The most sensitive indicator of WND is the reduced incorporation of isotopes of copper into cells cultured in vitro. Treatment of WND consists of reducing the load of accumulated copper using chelating agents such as penicillamine and ammonium tetrathiomolybdate.

In 1993 the gene causing MND, ATP7A, was cloned. It encodes an adenosine triphosphatase with six tandem copies of a heavy-metal-binding sequence homologous to previously identified bacterial proteins that confer resistance to toxic heavy metals. The high sequence conservation between human and bacterial binding sequences indicated that ATP7A has had an important role in regulating heavy-metal ion transport. ATP7A was expressed in a variety of tissues but not the liver, suggesting that a similar gene that is expressed in the liver might cause WND. Portions of the ATP7A gene were used as a probe to test for the presence of a similar gene on chromosome 13 (the known location of a WND gene, revealed by linkage analysis). This strategy led to the cloning of the gene for WND (ATP7B) in 1993. The protein product is highly homologous (76% amino acid homology) to ATP7A. In contrast to ATP7A, ATP7B is expressed predominantly in the liver and kidney, which are major sites age, cures the cardiomyopathy, returns skin pigmentation to normal, and may improve the diabetes. Individuals who have not developed irreversible liver damage have a nearly normal life expectancy. Of individuals who are homozygous for a mutation causing HH, approximately 50% of men older than 40 years of age and 15% of women older than 50 years of age will exhibit an HH-related condition. Thus, among at-risk individuals there is a clear benefit to presymptomatic testing and early reduction of stored iron.

Once the protein has folded into a triple helix, it moves from the endoplasmic reticulum to the Golgi apparatus (see Fig. 2–1) and is secreted from the cell. Yet another modification then takes place: the procollagen is cleaved by proteases near both the NH₂ and the COOH termini of the triple helix, removing some amino acids at each end. These amino acids performed essential functions earlier in the life of the protein (e.g., helping to form the triple helix structure, helping to thread the protein through the endoplasmic reticulum) but are no longer needed. This cleavage results in the mature protein, type I collagen. The collagen then assembles itself into fibrils, which react with adjacent molecules outside the cell to form the covalent crosslinks that impart tensile strength to the fibrils.

of involvement in WND based on clinical and biochemical data.

The ATP7A protein is usually localized to the Golgi network within a cell, where it supplies copper to various enzymes. When copper levels in an epithelial cell of the small intestine exceed a certain concentration, ATP7A redistributes to the plasma membrane and pumps copper into the bloodstream. When copper levels drop, ATP7A returns to the Golgi network. Thus, it mediates the efflux of copper into the bloodstream. ATP7A is also an important transporter of copper across the blood-brain barrier.

A variety of missense, nonsense, and splice site mutations in *ATP7A* have been found in MND patients. Approximately 15% to 20% of the mutations in *ATP7A* are large deletions. Several mutations of splice sites in *ATP7A* have been associated with another disorder called the occipital horn syndrome (OHS), which is characterized by mild mental retardation, bladder and ureteric diverticula (cul-de-sac-like herniations through the wall), skin and joint laxity, and ossified occipital (the most posterior bone of the calvarium) horns. These mutations permit the production of a small amount of normal protein. www

ATP7B plays a similar role as an effector of copper

transport. However, it moves between the Golgi network and either endosomes or the cell membrane of hepatocytes, and it controls the excretion of copper into the biliary tree. ATP7B also aids in the incorporation of copper into ceruloplasmin. More than 200 different mutations have been described in patients with WND. A single missense mutation accounts for about 40% of alleles in individuals of northern European ancestry.

Wilson disease (WND) is an autosomal recessive disorder characterized by progressive liver disease and neurological abnormalities. Menkes disease (MND) is an X-linked recessive disorder characterized by mental retardation, seizures, and death in early childhood. Accumulation of excess copper causes disease in WND, while MND results from a lack of copper and impaired enzyme function. WND and MND are caused by mutations in the highly homologous genes, *ATP7B* and *ATP7A*, respectively.

In contrast to WND and MND, acrodermatitis enteropathica (AE) is caused by a defect in the absorption of zinc from the intestinal tract. Individuals with AE experience growth retardation, diarrhea, dysfunction of the immune system, and a severe dermatitis (inflammation of the skin) that typically affects the skin of the genitals and buttocks, around the mouth, and the limbs (Fig. 7-10). Children usually present after weaning, and AE can be fatal if it is not treated with high doses of supplemental zinc, which is curative. AE is caused by mutations in SLC39A4, which encodes a putative zinctransporter protein expressed on the apical membrane of the epithelial cell of the small intestine. It is unknown whether individuals with AE can still absorb small amounts of zinc through a mutant form of this transporter or whether another transporter exists that can also transport zinc when it is given in high doses.

PHARMACOGENETICS

We often consider errors of metabolism only as deficiencies of enzymes required for metabolism of nutrients and endogenously synthesized molecules. However, many of the drinks and foods that we ingest each day (e.g., coffee, tea) contain thousands of complex compounds that must be processed. Some of these compounds never leave the gastrointestinal tract, but most are absorbed, distributed, metabolized, and eliminated (i.e., biotransformed) to a variety of products that are utilized immediately, stored, or excreted. Exogenously synthesized compounds that are administered to achieve a specific effect on the human body (i.e., pharmaceuticals or drugs) also undergo biotransformation, and humans vary in the efficiency and speed at which they do this. Moreover, the response of a drug's target (e.g., enzymes, receptors) can also vary among individuals. The study of the genetic modification of variable human responses to pharmacological agents is called pharmacogenetics.

FIGURE 7.10 A child with acrodermatitis enteropathica caused by mutations in *SLC39A4*, encoding a protein necessary for intestinal absorption of zinc. The resulting deficiency of zinc produces a characteristic scaly, red rash around the mouth, genitals, buttocks, and limbs. (Courtesy Dr. Virginia Sybert, University of Washington.)

Over the last decade, ambitious efforts have been undertaken to advance the knowledge of pharmacogenetics. This has been driven, in part, by the expectation that through the use of pharmacogenetics, we will be able to profile DNA differences among individuals and thereby predict responses to different medicines. For example, a genetic profile may predict who is more or less likely to respond to a drug or to suffer an adverse event. Such a profile would greatly personalize an individual's health care and could substantially change the way that medicine is practiced.

Many drugs have a response rate between 25% and 75%. This means that, for some drugs, only 1 in 4 people benefit from their use. The use of drugs in individuals who are unlikely to respond increases the incidence of adverse effects and adds to the burden of health care costs. Many drugs have adverse effects that are of clinical importance, and of the approximately 1,200 drugs approved for use in the United States, about 15% are associated with severe adverse effects. A widely cited analysis conducted in the mid 1990s suggested that nearly 2 million people are hospitalized each year as a result of adverse drug effects and approximately 100,000 people die from them, even when the drugs are appropriately prescribed and administered. Thus, identifica-

tion of genetic profiles that predict an individual's response to drugs and risk of experiencing an adverse effect is likely to increase the overall efficacy and safety of pharmaceuticals.

One of the major challenges of pharmacogenetics is the selection of targets that might be amenable to manipulation by a drug to treat a symptom or disease or that might influence the biotransformation of or response to a drug. Human genetic data can be used to identify polymorphisms associated with varying susceptibility to disease (i.e., a potential target for a drug) or polymorphisms that modify the human response to a drug. For example, genetic studies in families with long QT syndrome, characterized by abnormal cardiac rhythms (i.e., arrhythmias) and sudden death, found that long QT syndrome could be caused by mutations in one of at least five different genes (HERG, KVLQT1, SCN5A, KCNE1, or KCNE2). Each of these genes encodes a different type of ion channel (e.g., Na⁺ or K⁺ channels) found on the surface of a cardiac cell. These channels became the targets for drugs to treat arrhythmias. Moreover, because different drugs are used to block Na⁺ channels compared with K⁺ channels, the choice of drug used to treat an individual with long QT syndrome is dependent on his or her genetic profile. In this case, the relationship between disease and target is well characterized.

An alternative approach is to use genomic data (e.g., databanks of human DNA sequence or differential gene expression) and technologies (e.g., transgenic mice) to identify plausible targets without knowing whether these targets are related to a specific disease. The analysis of the genome and its products as they relate to drug responses is called **pharmacogenomics**.

Although pharmacogenetics and pharmacogenomics share tools and methods, the experimental approaches are different. For example, many types of lymphoma (a malignancy of lymphoid tissue) respond favorably to different kinds of chemotherapy, but it is sometimes difficult to determine whether a specific tumor is likely to respond to a particular drug. That is, two lymphomas can look identical but respond differently to the same chemotherapeutic agent, potentially leading to different patient outcomes. Using differential gene expression data (see Chapters 3 and 8), it became clear that two tumors that look the same sometimes express different genes. This information was used to classify these lymphomas and provide more accurate prognostic information. Furthermore, the genes differentially expressed by each type of tumor are potential targets of drug development. Similar comparisons have been made between metastatic and nonmetastatic skin cancers.

Many of the physiological effects of variation in drug response have been known for decades. A deficiency of glucose-6-phosphate dehydrogenase causes increased sensitivity to the antimalarial drug, primaquine, producing an acute hemolytic anemia. The slow metabolism of isoniazid (a drug commonly used to treat tuberculosis) is caused by a hepatic acetylation polymorphism. Reduced activity of plasma cholinesterases can produce an abnormal prolongation of the effects of succinylcholine (a neuromuscular relaxant). In each of these examples, the exposure of an individual having a common enzyme polymorphism to a specific chemical produces an unanticipated pharmacological effect.

More recently, polymorphisms in enzymes that produce a much broader effect on the body's response to many different pharmaceuticals have been described. Many of these polymorphisms are in genes that encode proteins involved in a drug's biotransformation, while others are in genes that encode a drug's target (Table 7-6). An example of such an enzyme is debrisoquine hydroxylase, an isozyme of the microsomal cytochrome P450 monooxygenase system encoded by the gene, CYP2D6. The cytochrome P450 superfamily includes genes that encode many different membranebound hemoproteins. These enzymes are responsible for the biotransformation of compounds with widely divergent structures. Polymorphisms of CYP2D6 affect the metabolism of more than 25% of all pharmaceuticals, including β-adrenergic receptor antagonists, neuroleptics, and tricyclic antidepressants. All of these are examples of relatively simply genetic profiles (i.e., single polymorphisms) that affect drug response. Many drug responses are likely to be determined by much more complex profiles that are composed of multiple polymorphisms at multiple loci.

Various strategies are being used to create complex genetic profiles that are predictive of drug response. No single strategy always works best, but one approach is popular, particularly when the exact DNA sequence causing a varied drug response has not been identified. This approach begins by identifying polymorphisms in or near a gene that may be influencing the response to a drug (Fig. 7-11). For several reasons, the favored polymorphisms to use are single-base differences in the DNA sequence, so-called single nucleotide polymorphisms (SNPs). SNPs are found throughout the human genome with a frequency of about 1 per 1,000 bp, so there are almost always SNPs near target genes. SNPs are easy, fast, and inexpensive to assay; many sites can be assaved simultaneously; and the assays are amenable to automation. Combinations of SNPs can be used to construct haplotypes (i.e., SNPs that occur together on the same chromosome). Haplotypes that are associated with varied drug responses are the genetic profiles that can used in clinical trials to test whether a particular response is associated with a specific genetic profile.

Pharmacogenetics and pharmacogenomics are slowly beginning to change the way that medicine is practiced, although the pace of change is likely to accelerate over the next few decades. A primary issue for all profiles that are associated with drug response is validating whether these variants will affect the clinical management of patients and, if so, to what extent. General guidelines for

Gene	Enzyme/Target	Drug	Clinical response						
CYP2D6	Cytochrome P450 2D6	Codeine	Individuals homozygous for an inactivating mutation do not metabolize codeine to morphine and thus experience no analgesic effect						
CYP2C9	Cytochrome P450 2C9	Warfarin	Individuals heterozygous for a polymorphism need a lower dose of warfarin to maintain anticoagulation						
NAT2	N-Acetyl transferase 2	Isoniazid	Individuals homozygous for "slow-acetylation" polymorphisms are more susceptible to isoniazid toxicity						
TPMT	Thiopurine S-methyltransferase	Azathioprine	Individuals homozygous for an inactivating mutation develop severe toxicity if treated with standard doses of azathioprine						
ADRB2	β-Adrenergic receptor	Albuterol	Individuals homozygous for a polymorphism get worse with regular use of albuterol						
KCNE2	Potassium channel, voltage-gated	Clarithromycin	Individuals heterozygous for a polymorphism are more susceptible to life-threatening arrhythmias						
SUR1	Sulfonylurea receptor 1	Sulfonylureas	Individuals heterozygous for polymorphisms exhibit diminished sensitivity to sulfonylurea-stimulated insulin secretion						
F5	Coagulation factor V (Leiden)	Oral contraceptives	Individuals heterozygous for a polymorphism are at increased risk for venous thrombosis						

FIGURE 7.11 ■ Different combinations of single nucleotide polymorphisms (SNPs) are found in different individuals. The locations of these SNPs can be pinpointed on maps of human genes. Subsequently, they can be used to create profiles that are associated with differences in response to a drug, such as efficacy and nonefficacy. (Adapted from Roses A [2000] Pharmacogenetics and the practice of medicine. Nature 405:857-865.)

determining the clinical relevance of a profile associated with a drug are available. The profile of a drug response may be important if (1) the drug is widely used in clinical practice and the response to the drug is medically important, (2) the drug's therapeutic and toxic effects are difficult to assess and titrate clinically, (3) adverse effects are difficult to predict with existing information, and (4) a profile provides easily interpretable results with few false-negative or false-positive results. To date, there is no estimate of how many drug/genetic profile combinations are likely to meet these criteria. However, it is likely that these pharmacogenetic profiles will be useful in at least some clinical circumstances.

Each individual's response to natural and synthetic chemicals is partly determined by polymorphisms in genes controlling pathways of biotransformation and the chemical's target. Many responses produce only minor variations from normal, while others precipitate dramatic deviations.

SUGGESTED READINGS

- Andrews NC (2002) Metal transporters and disease. Curr Opin Chem Biol 6:181-186
- Chakrapani A, Cleary MA, Wraith JE (2001) Detection of inborn errors of metabolism in the newborn. Arch Dis Child Fetal Neonatal Ed 84:205-210
- Enattah NS, Sahi T, Savilahti E, Terwilliger JD, Peltonen L, Jarvela I (2002) Identification of a variant associated with adult-type hypolactasia. Nat Genet 30:233-237
- Fletcher LM, Halliday JW (2002) Haemochromatosis: understanding the mechanism of disease and implications for diagnosis and patient management following the recent cloning of novel genes involved in iron metabolism. J Intern Med 251:181-192

- Levy HL, Albers S (2000) Genetic screening of newborns. Annu Rev Genomics Hum Genet 1:139-177
- Mercer JFB (2001) The molecular basis of copper-transport diseases. Trends Mol Med 7:64-69
- Phillips KA, Veenstra DL, Oren E, Lee JK, Sadee W (2001) Potential role of pharmacogenomics in reducing adverse drug reactions: a systematic review. 1. JAMA 286:2270-2279
- Russo PA, Mitchell GA, Tanguay RM (2001) Tyrosinemia: a review. Pediatr Dev Pathol 4:212-221
- Petry KG, Reichardt JKV (1998) The fundamental importance of human galactose metabolism: lessons from genetics and biochemistry. Trends Genet 14:98-102
- Rinaldo P, Matern D (2002) Fatty acid oxidation disorders. Annu Rev Physiol 64:477-502
- Roses AD (2001) Pharmacogenetics and the practice of medicine. Nature 405:857-865
- Saudubray JM, Martin D, de Lonlay P, Touati G, Poggi-Travert F, Bonnet D, Jouvet P, Boutron M, Slama A, Vianey-Saban C, Bonnefont JP, Rabier D, Kamoun P, Brivet M. (1999) Recognition and management of fatty acid oxidation defects: a series of 107 patients. J Inherit Metab Dis 22:488-502
- Scriver CR, Sly WS, Childs B, Beaudet AL, Valle D, Kinzler KW, Vogelstein B (eds) (2000) The Metabolic and Molecular Bases of Inherited Disease. McGraw-Hill, New York
- Scriver CR (2001) Garrod's foresight: our hindsight. J Inherit Metab Dis 24:93-116
- Wappner R, Cho S, Kronmal RA, Schuett V, Seashore MR (1999) Management of phenylketonuria for optimal outcome: a review of guidelines for phenylketonuria management and a report of surveys of parents, patients, and clinic directors. Pediatrics 104:e68
- Zhao H, Grabowski GA (2002) Gaucher disease: perspectives on a prototype lysosomal disease. Cell Mol Life Sci 59:694-707

STUDY QUESTIONS

- 1. Garrod found alkaptonuria to be more common in the offspring of consanguineous matings. Explain this finding. In general, what is the association between the coefficient of relationship and the prevalence of an inborn error of metabolism?
- 2. If many metabolic reactions can proceed in the absence of an enzyme, explain how diminished or absent enzyme activity can produce disease.
- **3.** Despite the low prevalence of most metabolic disorders, why is it important to understand the pathogenesis of inborn errors of metabolism?
- 4. Describe three types of metabolic processes and

give examples of disorders disturbing each of them.

- **5.** A 1-week-old neonate is diagnosed with galactosemia, yet enzymatic activity of GAL-1-P uridyl transferase is normal. Interpret these results and explain how mutations of different genes can produce a similar phenotype.
- 6. The prevalence of PKU varies from 1 in 10,000 to less than 1 in 100,000. Explain how prevalence rates of inborn errors of metabolism can vary so widely among different ethnic groups.
- 7. An 18-year-old woman comes to your office for prenatal counseling. She had a younger brother

STUDY QUESTIONS—cont'd

who died from a defect of mitochondrial fatty acid oxidation when he was a few months old. What is her risk of having an affected child? Explain your answer.

- 8. An 8-year-old girl develops hyperammonemia and is critically ill. Biochemical testing performed on a liver biopsy confirms that she has OTC deficiency. Which genetic test would you order next? Why?
- **9.** Disorders of the OXPHOS system are commonly associated with elevated blood lactic acid levels. Explain this finding.
- 10. Polymorphisms that affect drug metabolism presumably have been maintained by selection because they offer heterozygotes a slight advantage. Provide an example of how these polymorphisms may have been advantageous to a group of hunter-gatherers 10,000 years ago.

Gene Mapping and Cloning

The identification of genes that cause disease is a central focus of medical genetics. This often begins by mapping genes to specific locations on chromosomes. Dramatic advances in molecular genetic technology, coupled with important developments in the statistical analysis of genetic data, have greatly increased the rate at which genes are being mapped (Fig. 8-1). Currently, more than 14,000 genes have been assigned to chromosome locations. While this is an admirable rate of progress, this number represents only a portion of the estimated 30,000

to 40,000 genes that exist within the human genome. Moreover, only about 1,500 of the diseases listed in McKusick's online catalog (http://www3.ncbi.nlm.nih. gov/Omim/) have been associated with mutations in specific genes. Clearly, a great deal of work remains to be done in order to find the alterations in specific genes responsible for each inherited disease. An important consequence of the Human Genome Project (see Box 8-3 later in this chapter) will be the expedited mapping of disease-causing mutations to specific chromosome loca-

FIGURE 8.1 The number of coding genes mapped to specific chromosome locations. As of March 2003, the number of genes identified is just over 14,000. (From Guyer MS, Collins FS [1995] How is the Human Genome Project doing, and what have we learned so far? Proc Natl Acad Sci U S A 92:10841-10848; and the Online Genome Data Base [March 2003].)

tions. As this work is completed, our understanding of the biological basis of genetic disease will surely progress.

Gene mapping is an important step in the understanding, diagnosis, and eventual treatment of a genetic disease. When a disease gene's location has been pinpointed, it is often possible to provide a more accurate prognosis for individuals at risk for a genetic disease. Locating a disease gene is usually the first step in cloning the gene (as discussed in Chapter 3, cloning refers to the insertion of a gene into a vector so that copies, or clones, can be made). Once a gene has been cloned, its DNA sequence and protein product can be studied. This can contribute to our understanding of the actual cause of the disease. Furthermore, it may open the way to the manufacture of a normal gene product through recombinant DNA techniques, permitting more effective treatment of a genetic disease. Gene therapy-the modification of genes of individuals affected with a genetic disease-also becomes a possibility. Thus, gene mapping contributes directly to many of the primary goals of medical genetics.

This chapter discusses the approaches commonly used in gene mapping and cloning. Two major types of gene mapping can be distinguished. In **genetic mapping**, the frequency of meiotic crossovers between loci is used to estimate interlocus distances. **Physical mapping** involves the use of cytogenetic and molecular techniques to determine the actual, physical locations of genes on chromosomes. Later sections in this chapter describe how these mapping techniques lead to more accurate prediction of disease risk in families and how they lead to the isolation and cloning of disease genes.

GENETIC MAPPING

Linkage Analysis

One of Gregor Mendel's laws, the principle of independent assortment, states that an individual's genes will be transmitted to the next generation independently of one another (see Chapter 4). Mendel was not aware that genes are located on chromosomes and that genes located near one another on the same chromosome are transmitted together, rather than independently. Thus, the principle of independent assortment holds true for most pairs of loci, but not for those that occupy the same region of a chromosome. Such loci are said to be **linked**.

Figure 8-2 depicts two loci, A and B, that are located close together on the same chromosome. A third locus, C, is located on another chromosome. In the individual in our example, each of these loci has two alleles, designated 1 and 2. A and B are linked, so A_1 and B_1 are inherited together. Because A and C are on different chromosomes and thus unlinked, their alleles do follow the principle of independent assortment. Hence, if the process of meiosis places A_1 in a gamete, the probability that C_1 will be found in the same gamete is 50%.

Recall from Chapter 2 that homologous chromosomes

sometimes exchange portions of their DNA during prophase I (this is known as crossing over or crossover). The average chromosome experiences one to three crossover events during meiosis. As a result of crossover, new combinations of alleles can be formed on a chromosome. Consider again the linked loci, A and B, in Fig. 8-2. Alleles A_1 and B_1 are located together on one chromosome, and alleles A_2 and B_2 are located on the homologous chromosome. The combination of alleles on each chromosome is termed a haplotype (from "haploid genotype"). The two haplotypes of this individual are denoted A_1B_1/A_2B_2 . As Fig. 8-3A shows, in the absence of crossover A_1B_1 will be found in one gamete and A_2B_2 in the other. But when there is a crossover, new allele combinations, A_1B_2 and A_2B_1 , will be found in the two gametes (see Fig. 8-3B). The process of forming such new arrangements of alleles is called recombination. Crossover does not necessarily lead to recombination, however, because a double crossover can occur between two loci, resulting in no recombination (see Fig. 8-3C).

As Fig. 8-4 shows, crossovers are more likely to occur between loci that are situated far apart on a chromosome than between loci that are situated close together. Thus, the distance between two loci can be inferred by estimating how frequently recombinations occur in families (this is called the **recombination frequency**). If, in a large series of meioses studied in families, the alleles of A and B undergo recombination 5% of the time, then the recombination frequency for A and B would be 5%.

The genetic distance between two loci is measured in **centiMorgans (cM)**, in honor of T. H. Morgan, who discovered the process of crossing over in 1910. One cM is approximately equal to a recombination frequency of 1%. The relationship between recombination frequency and genetic distance is approximate, because double crossovers produce no recombination. The recombination frequency thus underestimates map distance, especially as the recombination frequency increases above about 10%. Mathematical formulae have been devised to correct for this underestimate.

FIGURE 8.2 Loci *A* and *B* are linked on the same chromosome, so alleles A_1 and B_1 are usually inherited together. Locus *C* is on a different chromosome, so it is not linked to *A* and *B*, and its alleles are transmitted independently of the alleles of A and B.

FIGURE 8.3 The genetic results of crossover. **A**, No crossover: A_1 and B_1 remain together after meiosis. **B**, A crossover between A and B results in a recombination: A_1 and B_2 are inherited together on one chromosome, and A^2 and B_1 are inherited together on another chromosome. **C**, A double crossover between A and B results in no recombination of alleles. (Modified from McCance KL, Huether SE [1998] Pathophysiology, 3rd ed. Mosby, St Louis.)

Loci that are on the same chromosome are said to be **syntenic** (meaning "same thread"). If two syntenic loci are 50 cM apart, they are considered to be unlinked. This is because their recombination frequency, 50%, is equivalent to independent transmission, as in the case of alleles of loci that are on different chromosomes. (To understand this, think of the chromosomes shown in Fig. 8-2: if an individual transmits allele A_1 , the probability that he or she also transmits allele C_1 , which is on another chromosome, is 50%, and the probability that he or she transmits allele C_2 is also 50%.)

Crossovers between loci on the same chromosome can produce recombination. Loci on the same chromosome that experience recombination less than 50% of the time are said to be linked. The distance between loci can be expressed in centiMorgans (cM); 1 cM represents a recombination frequency of approximately 1%.

Recombination frequencies can be estimated by observing the transmission of genes in pedigrees. Figure 8-5A is an example of a pedigree in which neuro-fibromatosis type 1 (NF1) is being transmitted. The members of this pedigree have also been typed for a two-allele polymorphism, termed *1F10*, which, like the *NF1* gene, is located on chromosome 17. The *1F10* genotypes are shown below each individual's number in the pedigree. Examination of generations I and II allows us to deter-

mine that, under the hypothesis of linkage between NF1 and 1F10, the disease-causing mutation in the NF1 gene must be on the same copy of chromosome 17 as allele 1 of the 1F10 locus in this family, because individual I-2, who is homozygous for allele 2, is unaffected with the disease. Only the affected father (I-1), who is a heterozygote for the 1F10 locus, could have transmitted a copy of chromosome 17 that contains both the NF1 disease allele and 1F10 allele 1 to the daughter (II-2). The arrangement of these alleles on each chromosome is referred to as linkage phase. Knowing the linkage phase, individual II-2's haplotypes would then be N1/n2, where N indicates the mutated allele causing NF1, *n* indicates the normal allele, and 1 and 2 are the two 1F10 alleles (in other words, individual II-2 has one copy of chromosome 17 that contains both the disease-causing mutation N and allele 1 of 1F10, while her other copy of chromosome 17 contains the normal allele n and allele 2 of 1F10). This woman's husband (individual II-1) is unaffected with the disease and is a homozygote for allele 2 at 1F10. He must have the haplotypes n2/n2. If the NF1 and 1F10 loci are linked, the children of this union who are affected with NF1 should usually have 1F10 allele 1, while those who are unaffected should have allele 2. In seven of eight children in generation III, we find this to be true. In one case a recombination occurred (individual III-6). This gives a recombination frequency of 1/8, or 12.5%, supporting the hypothesis of linkage between the NF1 and 1F10 loci.

FIGURE 8.4 Crossover is more likely between loci that are far apart on chromosomes (*left*) than between those that are close together (*right*).

A recombination frequency of 50% would support the hypothesis that the two loci are not linked. Note that the pedigree allows us only to determine linkage phase in individual II-2, but we cannot determine whether a recombination took place in the gamete transmitted to II-2 by her father. Thus, the recombination frequency is estimated only in the descendants of II-2.

In actual practice, a much larger sample of families would be used to ensure statistical accuracy of this result. If this were done, it would show that *1F10* and *NF1* are in fact much more closely linked than indicated by this example, with a recombination frequency of less than 1%.

Estimates of recombination frequencies are obtained by observing the transmission of alleles in families. Determination of the linkage phase (i.e., the chromosome on which each allele is located) is an important part of this procedure.

Polymorphisms such as *1F10*, which can be used to follow a disease gene through a family, are termed **markers** (i.e., they can "mark" the chromosome on which a disease allele is located). Since linked markers can be typed in an individual of any age (even in a fetus), they are useful for the early diagnosis of genetic disease (see Chapter 13). It is important to emphasize that a marker locus simply designates which chromosome is being transmitted by a parent; it usually has nothing to do with the actual *causation* of the genetic disease.

In general, 1 cM corresponds to approximately 1 million base pairs (1 Mb) of DNA. However, this is only a very approximate relationship, since several factors are known to influence crossover rates. First, crossovers are roughly 1.5 times more common during female meiosis (oogenesis) than during male meiosis (spermatogenesis). Crossovers tend to be more common near the telomeres of chromosomes than near the centromeres. Finally, some chromosome regions exhibit substantially elevated crossover rates. These regions are termed **recombination hot spots**. It is not yet known what causes recombination hot spots in humans, although specific DNA sequences, possibly including *Alu* sequences (see Chapter 2), are thought to be especially prone to crossover.

Although there is a correlation between centiMorgans and actual physical distances between loci, this relationship is complicated by gender differences in recombination, higher recombination frequencies near telomeres, and the existence of recombination hot spots.

LOD Scores: Determining the Significance of Linkage Results

As in any statistical study, we must be careful to ensure that the results obtained in a linkage study are not due simply to chance. For example, consider a two-allele

FIGURE 8.5 A, An NF1 pedigree in which each member has been typed for the *1F10* polymorphism. Genotypes for this twoallele marker locus are shown below each individual in the pedigree. Affected pedigree members are indicated by a shaded symbol. **B**, An autoradiogram for the *1F10* polymorphism in this family.

marker locus that has been typed in a pedigree. It is possible *by chance* for all affected offspring to inherit one allele and for all unaffected offspring to inherit the other allele even if the marker is not linked to the disease gene. This misleading result becomes less likely as we increase the number of subjects in our linkage study (just as the chance of a strong deviation from a 50/50 heads-tails ratio becomes smaller as we toss a coin many times).

How do we determine whether a linkage result is likely to be due to chance alone? In linkage analysis, a standard method is used. We begin by comparing the **likelihood** (a likelihood is similar in concept to a probability) that two loci are linked at a given recombination frequency (denoted θ) versus the likelihood that the two loci are not linked (recombination frequency = 50%, or θ = 0.5). Suppose we wish to test the hypothesis that two loci are linked at a recombination frequency of θ = 0.1 versus the hypothesis that they are not linked. We use our pedigree data to form a **likelihood ratio**:

likelihood of observing pedigree data if $\theta = 0.1$

likelihood of observing pedigree data if $\theta = 0.5$

If our pedigree data indicate that θ is more likely to be 0.1 than 0.5, then the likelihood ratio (or "odds") will be

greater than 1. If, however, the pedigree data argue against linkage of the two loci, then the denominator will be greater than the numerator, and the ratio will be less than 1.0. For convenience, the common logarithm* of the ratio is usually taken; this "logarithm of the odds" is termed a **LOD score**. Conventionally, a LOD score of 3.0 is accepted as evidence of linkage; a score of 3.0 indicates that the likelihood in favor of linkage is 1,000 times greater than the likelihood against linkage. Conversely, a LOD score lower than -2.0 (odds of 100 to 1 against linkage) is considered to be evidence that two loci are not linked. Box 8-1 provides details on the calculation of LOD scores.

The statistical odds that two loci are a given number of cM apart can be calculated by measuring the ratio of two likelihoods: the likelihood of linkage at a given recombination frequency divided by the likelihood of no linkage. The logarithm of this odds ratio is a LOD score. LOD scores of 3.0 or higher are taken as evidence of linkage, and LOD scores lower than -2.0 are taken as evidence that the two loci are not linked.

^{*}Recall that the common logarithm (\log_{10}) of a number is the power to which 10 is raised to obtain the number. The common logarithm of 100 is 2, the common logarithm of 1,000 is 3, and so on.

The Estimation of LOD Scores in Linkage Analysis

A simple example will help to illustrate the concepts of likelihood ratios and LOD scores. Consider the pedigree in Fig. 8-6, which illustrates another family in which NF1 is being transmitted. The family has been typed for the 1F10 marker, as in Fig. 8-5. The male in generation II has to receive the 1F10-1 allele from his mother, since she can transmit only this marker allele. Thus, his 1F10-2 allele had to come from his father, on the same chromosome as the NF1 disease gene (under the hypothesis of linkage). This allows us to establish linkage phase in this pedigree: the affected male in generation II must have the haplotypes N2/n1. He marries an unaffected woman who is a homozygote for the 1F10-2 allele. Thus, the hypothesis of close linkage ($\theta = 0.0$) predicts that each child in generation III who receives allele 2 from his or her father must also receive the NF1 disease allele. Under the hypothesis of linkage, the father can transmit only two possible combinations: either the chromosome that carries both the disease gene and the 1F10-2 allele (N2 haplotype) or the other chromosome, which has the normal gene and the 1F10-1 allele (haplotype n1). The probability of each of these events is 1/2. Therefore, if $\theta = 0.0$, the probability of observing five children with the genotypes shown in Fig. 8-6 is $(1/2)^5$, or 1/32 (i.e., the multiplication rule is applied to obtain the probability that all five of these events will occur together). This is the numerator of the likelihood ratio.

Now consider the likelihood of observing these genotypes if *1F10* and *NF1* are not linked ($\theta = 0.5$). Under this hypothesis, there is *independent assortment* of alleles at *1F10* and *NF1*. The father could transmit any of four combinations (*N1*, *N2*, *n1*, and *n2*) with equal probability (1/4). The probability of observing five children with the observed genotypes would then be (1/4)⁵ = 1/1,024. This likelihood is the denominator of the likelihood ratio. The likelihood ratio is then 1/32 divided by 1/1,024, or 32. Thus, the data in this pedigree tell us that linkage, at $\theta = 0.0$, is 32 times more likely than nonlinkage.

If we take the common logarithm of 32, we find that the

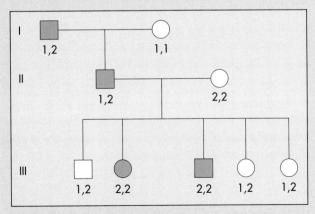

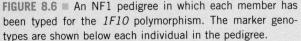

LOD score is 1.5, which is still far short of the value of 3.0 usually accepted as evidence of linkage. To prove linkage, we would need to examine data from additional families. LOD scores obtained from individual families can be added together to obtain an overall score. (Note that, mathematically, adding LOD scores is the same as multiplying the odds of linkage in each family together and then taking the logarithm of the result. This is another example of the use of the multiplication rule to assess the probability of cooccurrence.)

Suppose that a recombination had occurred in the meiosis producing III-5, the fifth child in generation III (i.e., she would retain the same marker genotype but would be affected with the disease rather than unaffected). This event is impossible under the hypothesis that $\theta = 0.0$, so the numerator of the likelihood ratio becomes zero, and the LOD score for $\theta = 0.0$ is $-\infty$. It is possible, however, that the marker and disease loci are still linked, but at a recombination frequency greater than zero. Let us test the hypothesis that $\theta = 0.1$. This hypothesis predicts that the disease allele, N, will be transmitted along with marker allele 2 90% of the time and with marker allele 1 10% of the time (i.e., when a recombination has occurred). By the same reasoning, the normal allele, n, will be transmitted with marker allele 1 90% of the time and with marker allele 2 10% of the time. As in the previous example, the father can transmit either the normal allele or the disease allele with equal probability (0.5) to each child. Thus, the probability of inheriting the disease allele with marker allele 2 (haplotype N2) is $0.5 \times 0.90 = 0.45$, and the probability of inheriting the disease allele with marker allele 1 (haplotype N1) is $0.5 \times 0.1 = 0.05$. The probability inheriting the normal allele with marker 1 (n1) is 0.45, and the probability of inheriting the normal allele with marker 2(n2)is 0.05. In either case, then, the probability of receiving a nonrecombination (N2 or n1) is 0.45, and the probability of receiving a recombination (N1 or n2) is 0.05. We know that four of the children in generation III are nonrecombinants, and each of these events has a probability of 0.45. We know that one individual is a recombinant, and the probability of this event is 0.05. The probability of four nonrecombinations and one recombination occurring together in generation III is obtained by applying the multiplication rule: $0.45^4 \times 0.05$. This becomes the numerator for our LOD score calculation. As before, the denominator (the likelihood that $\theta = 0.5$) is $(1/4)^5$. The LOD score for $\theta = 0.1$, then, is given by $\log_{10}[(0.45^4 \times 0.05)/(1/4)^5] = 0.32.$

To test the hypothesis that $\theta = 0.2$, the approach just outlined is used again, with $\theta = 0.2$ instead of $\theta = 0.1$. This yields a LOD score of 0.42. It makes sense that the LOD score for $\theta = 0.2$ is higher than that for $\theta = 0.1$, because we know that one of five children (0.2) in generation III is a recombinant. Applying this formula to a series of possible θ values (0, 0.1, 0.2, 0.3, 0.4, and 0.5) shows that 0.2 yields the highest LOD score, as we would expect:

θ	0	0.1	0.2	0.3	0.4	0.5
		0.32				

BOX The Estimation of LOD Scores in Linkage Analysis—cont'd
8.1

Sometimes the linkage phase in a pedigree is not known. For example, if the grandparents in Fig. 8-6 had not been typed, we would not know the linkage phase of the father in generation II. It is equally likely that his haplotypes are N2/n1 or N1/n2 (i.e., each combination has a probability of 1/2). Thus, we need to take both possibilities into account. If he has the N2/n1 haplotypes, then the first four children are nonrecombinants, each with a probability of $(1-\theta)/2$, while the fifth child is a recombinant, with a probability of $\theta/2$ (using the reasoning outlined previously). Under the hypothesis that $\theta = 0.1$, the overall probability that the father has haplotypes N2/n1 and that the five children have the observed genotypes is $1/2(0.45^4 \times 0.05) = 0.001$. We now need to take the alternative phase into account (i.e., that the father has haplotypes N1/n2). Here, the first four children would each be recombinants, with probability $\theta/2$, and only the fifth child would be a nonrecombinant, with probability $(1-\theta)/2$. The probability that the father has the N1/n2 haplotypes and that the children have the observed genotypes is $1/2(0.45 \times 0.05^4) = 0.000001$. This probability is considerably smaller than the probability of the previous phase, which makes sense when we consider that, under the hypothesis of linkage at $\theta = 0.1$, four of five recombinants is unlikely. We can now consider the probability of either linkage phase in the father by adding the two probabilities together: $1/2(0.45^4 \times 0.05) + 1/2(0.45 \times 0.05^4)$. This becomes the numerator for the LOD score calculation. As before, the denominator (i.e., the probability that $\theta = 0.5$) is simply $(1/4)^5 = 1/1,024$. Then, the total LOD score for unknown linkage phase at $\theta = 0.1$ is $\log_{10}[(1/2[0.45^4 \times 0.05]$ + $1/2[0.45 \times 0.05^4])/(1/1,024)] = 0.02$. As before, we can estimate LOD scores for each recombination frequency:

Notice that each LOD score is lower than the corresponding score when linkage phase is known. This follows from the fact that a known linkage phase contributes useful information to allow more accurate estimation of the actual genotypes of the offspring.

LOD scores are often graphed against the θ values, as shown in Fig. 8-7. The highest LOD score on the graph is

Linkage Analysis and the Human Gene Map

Suppose that we are studying a disease gene in a series of pedigrees, and we wish to map it to a specific chromosome location. Typically, we would type the members of our pedigree for marker loci distributed along each chromosome, testing for linkage between the disease gene and each marker. Most of these tests would yield negative LOD scores, indicating no linkage between the marker and the disease gene. Eventually this exercise will reveal linkage between a marker and the disease gene. Because of the large size of the human genome, one may have to the maximum likelihood estimate of θ . That is, it is the most likely distance between the two loci being analyzed.

In practice, the analysis of human linkage data is not as simple as in these examples. Penetrance of the disease gene may be incomplete, recombination frequencies differ between the sexes, and the mode of inheritance of the disease may be unclear. Consequently, linkage data are analyzed using one of several available computer software packages such as LIPED or MLINK (hyperlinks to these sites are provided on our Web page). Many of these packages also allow one to carry out **multipoint mapping**, an approach in which the map locations of several markers are estimated simultaneously. www

FIGURE 8.7 The LOD score (y axis) is plotted against the recombination frequency (x axis) to determine the most likely recombination frequency for a pair of loci.

type dozens, or even hundreds, of markers before finding linkage. Many important diseases have been localized using this approach, including cystic fibrosis, Huntington disease, Marfan syndrome, and NF1.

Until fairly recently, linkage analyses had little chance of success because there were only a few dozen useful polymorphic markers in the entire human genome. Thus, it was unlikely that a disease gene would be located near enough to a marker to yield a significant linkage result. This situation has changed dramatically over the past two decades, as thousands of new polymorphic markers (restriction fragment length polymorphisms [RFLPs], variable number of tandem repeats [VNTRs], and short tandem repeat polymorphisms [STRPs]; see Chapter 3) have been generated. With efficient genotyping techniques and large numbers of markers, it is now commonplace to map a disease gene with only a few weeks or months of laboratory and statistical analysis.

To be useful for gene mapping, marker loci should have several properties. First, they should be codominant (i.e., homozygotes should be distinguishable from heterozygotes). This makes it easier to determine linkage phase. RFLPs, short tandem repeat polymorphisms (STRPs) (see Chapter 3), and single nucleotide polymorphisms (SNPs) (see Box 8-3) fulfill this criterion, while some of the older types of markers, such as the ABO and Rh blood groups, do not. Second, marker loci should be numerous, so that close linkage to the disease gene is likely. Many thousands of markers have now been identified throughout the genome, so this requirement has been fulfilled. Each chromosome is now saturated with markers (Fig. 8-8). Finally, marker loci are most useful when they are highly polymorphic (i.e., when the locus has many different alleles in

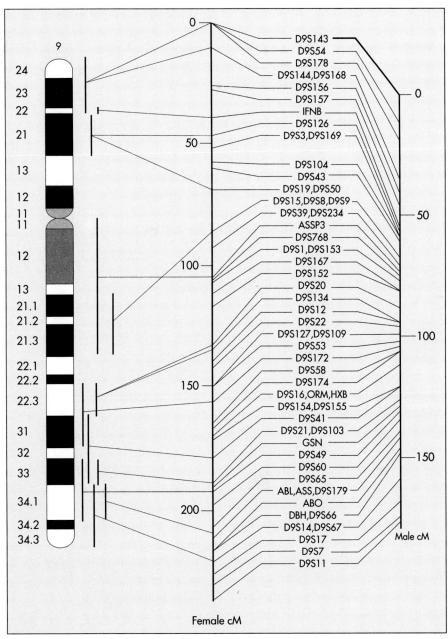

FIGURE 8.8 A genetic map of chromosome 9, showing the locations of a large number of polymorphic markers. Because recombination rates are usually higher in female meiosis, the distances between markers (in centiMorgans) are larger for females than for males. (From Attwood J, Chiano M, Collins A, et al. [1994] CEPH consortium Map of chromosome 9. Genomics 19:203-214.)

the population). A high degree of polymorphism ensures that most parents will be heterozygous for the marker locus, making it easier to establish linkage phase in families. Microsatellite repeat polymorphisms typically have many alleles and are easy to assay; they are thus especially well suited to gene mapping.

An example will illustrate this last point. Consider the pedigree in Fig. 8-9A. The affected man is a homozygote for a two-allele RFLP that is closely linked to the disease locus (recall that most RFLPs are caused by the presence or absence of a restriction site and thus have only two alleles in a population). The man's wife is a heterozygote. Their affected daughter is homozygous for the marker allele. Based on these genotypes, it is impossible to determine linkage phase in this generation, so we cannot predict which children will be affected with the disorder and which will not. The mating in generation I is called an uninformative mating. In contrast, an STRP with six alleles has been typed in the same family (see Fig. 8-9B). Because the mother in generation I has two alleles that differ from those of the affected father, it is now possible to determine that the affected daughter in generation II has inherited the disease gene on the single chromosome that contains marker allele 1. Since she married a man who has alleles 4 and 5, we can predict that each offspring who receives allele 1 from her will be affected, while each one who receives allele 2 will be normal. Exceptions will be due to recombination. This example demonstrates the value of highly polymorphic markers for both linkage analysis and diagnosis of genetic disease (see Chapter 13).

To be useful in gene mapping, linked markers should be codominant, numerous, and highly polymorphic. A high degree of polymorphism increases the probability that matings will be informative.

The availability of many highly polymorphic markers throughout the genome helps researchers to narrow the location of a disease gene by direct observation of recombinants within families. Suppose that a series of marker polymorphisms, labeled A, B, C, D, and E, are all known to be closely linked to a disease-causing gene. The family shown in Fig. 8-10 has been typed for each marker, and we observe that individual II-2 carries marker alleles A2, B2, C2, D2, and E2 on the same copy of the chromosome that contains the disease-causing mutation (linkage phase). The other (normal) copy of this chromosome in individual II-2 carries marker alleles A1, B1, C1, D1, and E1. Among the affected offspring in generation III, we see evidence of two recombinations. Individual III-2 clearly inherited marker allele A1 from her affected mother (II-2), but she also inherited the disease-causing mutation from her mother. This tells us that there has been a recombination (crossover) between marker A and the disease-causing gene. Thus, we now know that the region of the chromosome between marker A and the telomere cannot contain the disease-causing gene. We observe another recombination in the gamete transmitted to individual III-5. In this case, the individual inherited markers D1 and E1 but also inherited the disease-causing mutation from II-2. This indicates that a crossover occurred between marker locus D and the disease-causing locus. We now know that the region between marker D and the centromere (including marker E) cannot contain the disease-causing locus. These two key recombinations have thus allowed us to narrow substantially the region that contains the disease-causing locus. Further analyses in other families could narrow the location even further, provided that additional recombinations can be observed. In this way, it is often possible to narrow the location of a disease-causing locus to a region that is several cM or so in size.

FIGURE 8.9 An autosomal dominant disease gene is segregating in this family. **A**, A closely linked two-allele RFLP has been typed for each member of the family, but linkage phase cannot be determined (uninformative mating). **B**, A closely linked six-allele STRP has been typed for each family member, and linkage phase can now be determined (informative mating).

FIGURE 8.10 A family in which markers *A*, *B*, *C*, *D*, and *E* have been typed and assessed for linkage with an autosomal dominant disease-causing mutation. As explained in the text, recombination is seen between the disease locus and marker *A* in individual III-2 and between the disease locus and marker *D* in individual III-5.

Sometimes, a linkage analysis produces a total LOD score close to zero. This could mean simply that the pedigrees are uninformative (a LOD score of zero indicates that the likelihoods of linkage and nonlinkage are approximately equal). However, a total LOD score of zero can also result when one subset of families has positive LOD scores (indicating linkage) while another subset has negative LOD scores (arguing against linkage). This result would provide evidence of locus heterogeneity for the disease in question (see Chapter 4). For example, osteogen-

169

esis imperfecta type I may be caused by mutations on either chromosome 7 or chromosome 17 (see Chapter 4). A study of families with this disease could show linkage to markers on chromosome 17 in some families and linkage to chromosome 7 in others. Linkage analysis has helped to define locus heterogeneity in a large number of diseases, including retinitis pigmentosa, a major cause of blindness (Clinical Commentary 8-1).

The direct observation of recombinants between marker loci and the disease-causing locus can help to narrow the size of the region that contains the disease-causing locus. In addition, linkage analysis sometimes shows that some affected families demonstrate linkage to markers in a given chromosome region while others do not. This is an indication of locus heterogeneity.

Linkage Disequilibrium: Nonrandom Association of Alleles at Linked Loci

Within families, one allele of a marker locus will be transmitted along with the disease allele if the marker and disease loci are linked. For example, allele 1 of a linked two-allele marker could co-occur with the Huntington disease (HD) allele in a family. This association is part of the definition of linkage. However, if one examines a series of families for linkage between HD and the marker locus, allele 1 will co-occur with the disease in some families, while allele 2 of the marker will cooccur with the disease in others. This reflects two things. First, disease-causing mutations may have occurred multiple times in the past, sometimes on a chromosome carrying marker allele 1 and other times on a chromosome carrying marker allele 2. Second, even if the disease is the result of only one original mutation, crossovers occurring through time will eventually result in recombination of the marker and disease alleles. A disease allele and a linked marker allele will thus be associated within families, but not necessarily between families. If we study a large collection of families and find that there is no preferential association between the disease gene and a specific allele at a linked marker locus, the two loci are said to be in linkage equilibrium.

Sometimes, however, we do observe the preferential association of a specific marker allele and the disease allele in a population. By this we mean that the chromosome haplotype consisting of one marker allele and the disease allele is found more often than we would expect based on the frequencies of the two alleles in the population. Suppose, for example, that the disease allele has a frequency of 0.01 in the population and the frequencies of the two alleles (labeled 1 and 2) of the marker are 0.4 and 0.6, respectively. Assuming independence between the two loci (i.e., linkage equilibrium), the multiplication rule would predict that the population frequency of the haplotype containing both the disease allele and marker

allele *1* would be $0.01 \times 0.4 = 0.004$. By collecting family information, we can directly count the haplotypes in the population. If we find that the actual frequency of this haplotype is 0.009 instead of the predicted 0.004, then the assumption of independence has been violated, indicating preferential association of marker allele *1* with the disease allele. This association of alleles at linked loci is termed **linkage disequilibrium**.

Figure 8-12 illustrates how linkage disequilibrium can come about. Imagine two markers linked to the myotonic dystrophy locus on chromosome 19. Marker B is closely linked, at less than 1 cM away. Marker A is less closely linked, at about 5 cM away. Since each of these marker loci has two alleles (denoted 1 and 2), there are four possible combinations of marker alleles at the two loci, as shown in Figure 8-12. When a new myotonic dystrophy mutation first occurs in a population, it can be found on only one chromosome, in this case the one with the A_1B_2 marker combination. As the disease mutation is passed through multiple generations, crossovers will occur between it and the two markers. Because the disease locus is more closely linked to marker B than marker A, fewer crossovers will occur between the disease mutation and marker B. As a result, the disease mutation is found on a B_2 chromosome 90% of the time, while it is found on an A_1 chromosome 72% of the time. The degree of linkage disequilibrium is stronger between marker B and the disease allele than between marker A and the disease allele. Notice also that both the A_1 and the B_2 alleles are still positively associated with the disease allele, since each allele has a much lower frequency (50%) in the population of individuals lacking the disease allele (see Fig. 8-12). If enough generations elapse, recombination would eventually eliminate the allelic associations completely, and the loci would be in linkage equilibrium.

Because linkage disequilibrium is a function of the distance between loci, it can be used to help infer the order of genes on chromosomes. Linkage disequilibrium provides an advantage over linkage analysis in that it reflects the action of recombinations that have occurred during dozens or hundreds of past generations. Linkage analysis, in contrast, is limited to the recombinations that can be directly observed in only the past several generations. Consequently, there are seldom enough recombinants in a series of families to map a gene to a region smaller than several cM using linkage analysis, whereas linkage disequilibrium analysis can sometimes map a gene to an interval of 0.1 cM or less. However, linkage disequilibrium can be influenced by evolutionary forces, such as natural selection or genetic drift, that have acted during the history of a population. For example, some loci in the major histocompatibility complex on chromosome 6 (see Chapter 9) are in disequilibrium, presumably because certain allelic combinations confer a selective advantage for immunity to some diseases.

CLINICAL COMMENTARY 8.1

Retinitis Pigmentosa: A Genetic Disorder Characterized by Locus Heterogeneity

Retinitis pigmentosa (RP) describes a collection of inherited retinal defects that together are the most common inherited cause of human blindness, affecting 1 in 3,000 to 1 in 4,000 individuals. The first clinical signs of RP are seen as the rod photoreceptor cells begin to die, causing night blindness. Rod electroretinogram (ERG) amplitudes are reduced or absent. With the death of rod cells, other tissue begins to degenerate as well. Cone cells die, and the vessels that supply blood to the retinal membranes begin to attenuate. This leads to a reduction in daytime vision. Patients develop tunnel vision, and most are legally blind by 60 years of age. The name "retinitis pigmentosa" comes from the pigments that are deposited on the retinal surface as pathological changes accumulate (Fig. 8-11). RP is neither preventable nor curable, but its progress can be slowed somewhat by dietary supplementation with vitamin A.

RP is known to be inherited in different families in an autosomal dominant, autosomal recessive, or Xlinked recessive fashion. In addition, a small number of cases are caused by mitochondrial mutations, and one form of RP is caused by the mutual occurrence of mutations at two different loci (*peripherin/RDS* and *ROM1*, both of which encode structural components of photoreceptor outer segment disc membranes). This mode of inheritance is termed **digenic**. Cloning studies have identified mutations in 21 different genes that cause RP, and linkage analyses have identified 24 additional chromosome regions that contain genes that cause symptoms of RP (these genes remain to be cloned). RP is thus an example of extensive locus heterogeneity. www

An early linkage analysis mapped an autosomal dominant form of RP to the long arm of chromosome 3. This was a significant finding, because the gene encoding rhodopsin (a retinal visual pigment) had also been mapped to this region. Because of its role in the phototransduction cascade, rhodopsin was a reasonable candidate gene (see text) for RP. Linkage analysis was performed using a polymorphism located within the rhodopsin gene, and a LOD score of 20 was obtained for a recombination frequency of zero in a large Irish pedigree. Subsequently, approximately 150 different mutations in the rhodopsin gene have been shown to cause RP, confirming the role of this locus in causing the disease. Rhodopsin mutations are estimated to account for about 10% of RP cases.

Additional studies have identified mutations in

FIGURE 8.11 A fundus photograph illustrating clumps of pigment deposits and retinal blood vessel attenuation in retinitis pigmentosa. (Courtesy Dr. Don Creel, University of Utah Health Sciences Center.)

genes involved in many different aspects of retinal degeneration. Some of these genes encode proteins involved, for example, in visual transduction (e.g., rhodopsin, the α subunit of the rod cyclic guanosine monophosphate [cGMP] cation-gated channel protein, and the α and β subunits of rod cGMP photodiesterase); photoreceptor structure (e.g., peripherin/ RDS and ROM1); and retinal protein transport (e.g., ABCR). Additional genes have been implicated in syndromes that include RP as one feature. For example, RP is seen in Leber congenital amaurosis (LCA), the most common hereditary visual disorder of children. Seven genes have thus far been identified in the causation of LCA. RP is also one of the features of Usher syndrome, which involves vestibular dysfunction and sensorineural deafness (four causative genes identified). And RP is seen in Bardet-Biedl syndrome, in which mental retardation and obesity are also observed (three genes thus far identified).

Although considerable progress has been made in pinpointing genes involved in RP, linkage results indicate that many additional genes remain unidentified. It is sobering to consider that more than 70 loci have been identified for photoreceptor defects in the fruit fly, *Drosophila*. Undoubtedly, continued linkage and cloning analyses will lead to a more complete identification and understanding of genes underlying the pathogenesis of RP.

FIGURE 8.12 Linkage disequilibrium between the myotonic dystrophy (*DM*) locus and two linked loci, *A* and *B*. The *DM* mutation first arises on the chromosome with the A_1B_2 haplotype. After a number of generations have passed, most chromosomes carrying the *DM* mutation still have the A_1B_2 haplotype, but, as a result of recombination, the *DM* mutation is also found on other haplotypes. Because the A_1B_2 haplotype is seen in 70% of *DM* chromosomes but only 25% of normal chromosomes, there is linkage disequilibrium between *DM* and loci *A* and *B*. Because locus *B* is closer to *DM*, it has greater linkage disequilibrium with *DM* than does locus *A*.

Linkage disequilibrium is the nonrandom association of alleles at linked loci. Linkage disequilibrium between loci diminishes through time as a result of recombination. It can be used to infer the order of genes on chromosomes.

Linkage Versus Association in Populations

The phenomena of linkage and association are sometimes confused. *Linkage* refers to the positions of loci on chromosomes. When two loci are linked, specific combinations of alleles at these loci will be transmitted together (on the same chromosome) *within families*. But, as the HD example cited previously showed, the specific combinations of alleles transmitted together can vary from one family to another. **Association**, on the other hand, refers to a statistical relationship between two traits *in the general population*. The two traits occur together in the same individual more often than would be expected by chance alone.

As just discussed, two linked loci may exhibit allelic association in the population if there is linkage disequilibrium. In this case, a population association can lead to mapping of a disease gene. An example is given by idiopathic hemochromatosis, an autosomal recessive disorder discussed in Chapter 7. One association study showed that 78% of patients with hemochromatosis had the A3 allele of the human leukocyte antigen (HLA) A locus (see Chapter 9 for further discussion of the HLA system), whereas only 27% of unaffected subjects (controls) had this allele. This strong statistical association prompted linkage analyses using HLA polymorphisms and led to the mapping of the hemochromatosis gene to a region of several cM on chromosome 6. The large size of this region made it very difficult to pinpoint a specific gene. Linkage disequilibrium analysis was subsequently used to narrow the region to approximately 250 kb, prompting the ready identification of an HLA-like gene (HFE) in which a single mutation is responsible for approximately 85% of hemochromatosis-causing chromosomes. www

The association between the hemochromatosis gene and the linked HLA-A locus is probably the result of a recent hemochromatosis-causing mutation occurring on a chromosome containing the HLA-A3 allele. Population associations can also result from a causal relationship between an allele and a disease condition. An example of such an association involves ankylosing spondylitis, a disease that primarily affects the sacroiliac joint (Fig. 8-13). Inflammation of the ligaments leads to their ossification and eventually to fusion of the joints (ankylosis). The HLA-B27 allele is found in about 90% of U.S. Caucasians who have ankylosing spondylitis but in only 5% to 10% of the general U.S. Caucasian population. Since the population incidence of ankylosing spondylitis is quite low (less than 1%), most people who have the HLA-B27 allele do not develop ankylosing spondylitis. However, those who have the HLA-B27 allele are about 90 times more likely to develop the disease than are those who do not have it (i.e., 9% of individuals with HLA-B27 shown in Table 8-1 have ankylosing spondylitis, while only about 0.1% of those without HLA-B27 have the disease). Because of this strong association, a test for HLA-B27 is sometimes included as part of the diagnosis of ankylosing spondylitis. It is important to emphasize that the genetic and environmental factors causing ankylosing spondylitis remain unclear and that the observed population association between HLA-B27 and this disorder does not necessarily imply genetic linkage. Because ankylosing spondylitis is thought to be an autoimmune disorder, the association may reflect the fact that the HLA system is a key element in the body's immune response (see Chapter 9).

A population association is also seen between a nucleotide variant in the HLA- $DQ\beta$ locus and type 1 diabetes (see Chapter 12). Since autoimmunity is a factor in the etiology of type 1 diabetes, there may well be a causative relationship between the HLA- $DQ\beta$ and increased susceptibility to this form of diabetes.

FIGURE 8.13 ■ Ankylosing spondylitis, caused by ossification of discs, joints, and ligaments in the spinal column. Note the characteristic posture. (Modified from Mourad LA [1991] Orthopedic Disorders. Mosby, St Louis.)

Association studies should be interpreted cautiously, because many things can produce spurious associations between a disease and a potential risk factor. An example is ethnic stratification in a population: certain diseases are more frequent in certain ethnic groups, and allele frequencies may also differ among these groups because of their evolutionary histories. Thus, if one compares disease cases and controls without proper matching for ethnicity, a false association, due simply to ethnic differences between the two groups, could be found. For example, type 2 diabetes (see Chapter 12) has been studied exten-

	Association of Ankylosing Spondylitis and the HLA-B27 Allele in a Hypothetical Population*								
	Ankylosing	spondylitis							
HLA-B27	Present	Absent							
Present	90	1,000							

*This table shows that individuals with ankylosing spondylitis are much more likely to have the HLA-B27 allele than are normal controls.

10

9,000

Absent

sively among the Pima Native American population, where the disease is much more common than among Caucasians. It was observed that the absence of haplotype Gm3;5,13,14 of human immunoglobulin G (abbreviated here as Gm3) was strongly associated with type 2 diabetes among the Pima. This suggested initially that the absence of Gm3 might be involved in the causation of type 2 diabetes. However, further analysis revealed that the proportion of Caucasian ancestry varied substantially among members of the Pima population and that the Gm3 frequency also varied with the degree of Caucasian ancestry: Gm3 is absent in Pima individuals with no Caucasian ancestry but has a frequency of 65% among Caucasians. Since type 2 diabetes is much less common among Caucasians, the apparent association between type 2 diabetes and the absence of Gm3 was most likely a consequence of the level of Caucasian mixture. Once the degree of Caucasian ancestry in the study subjects was taken into account, there was no evidence of an association.

Other factors that may produce false associations include imprecise definition of the disease state, inadequate sample sizes, and improper matching of cases and controls for variables such as age and gender. The inability to replicate an association in multiple study populations is an indication that the association may be invalid. An example is given by an association that was reported, but not replicated, between alcoholism and a polymorphism near the dopamine D2 receptor locus (discussed further in Chapter 12).

Population association refers to the nonrandom co-occurrence of factors at the population level. Associations are distinguished from linkage, which refers to the positions of loci on chromosomes. Linkage disequilibrium is a special case of association in which there is nonrandom association of specific alleles at linked loci.

PHYSICAL MAPPING AND CLONING

Linkage analysis allows us to determine the relative distances between loci, but it does not assign specific locations to markers or disease genes. Physical mapping, which involves a variety of methods, accomplishes this goal, and considerable progress has been made in developing high-resolution physical mapping approaches.

Chromosome Morphology

A simple and direct way of mapping disease genes is to show that the disease is consistently associated with a cytogenetic abnormality, such as a duplication, deletion, or other variation in the appearance of a chromosome. Such abnormalities may have no clinical consequences themselves (thus serving as a marker), or they may cause the disease. Because these approaches are historically the oldest of the physical mapping approaches, they are discussed first.

Heteromorphisms

A heteromorphism is a variation in the appearance of a chromosome. Conceptually, heteromorphisms are similar to polymorphisms: they are natural variations that occur among individuals in populations. The difference is that polymorphisms are not detectable microscopically, while heteromorphisms are.

A well-known example of a heteromorphism is an "uncoiled" (and therefore elongated) region of chromosome 1, a rare feature that is transmitted regularly in families. In the 1960s a researcher named R. P. Donahue was practicing cytogenetic analysis on his own chromosomes and found that he had this heteromorphism. He studied other members of his family and found that the heteromorphism was transmitted through his family as a mendelian trait. He then typed his family members for several blood groups. He found that the heteromorphism was perfectly associated in his family with allele *A* of the Duffy blood group. Linkage analysis of the "uncoiler" locus and the Duffy locus showed that they were closely linked, leading to the first assignment of a gene to a specific autosome.

It should be emphasized that heteromorphisms, like marker loci, do not *cause* a genetic variant or disease, but they may be associated with it within a family, thus indicating the gene's location. Although such heteromorphisms can be useful in mapping genes, they are not very common and therefore have been useful in only a few instances.

Deletions

Karyotypes of patients with a genetic disease occasionally reveal deletions of a specific region of a chromosome. This provides a strong hint that the locus causing the disease may lie within the deleted region. The extent of a deletion may vary in several patients with the same disease. Deletions are compared in many patients to define the region that is deleted in all patients, thereby narrowing the location of the disease gene (Fig. 8-14). Deletion mapping has been used, for example, in locating the genes responsible for retinoblastoma (see Chapters 4 and 11), Prader-Willi and Angelman syndromes (scc Chapter 4), and Wilms tumor, a childhood kidney tumor that can be caused by mutations on chromosome 11. In contrast to the heteromorphisms just discussed, deletions of genetic material are the direct cause of the genetic disease.

Note that these deletions affect only one member of the homologous pair of chromosomes, making the patient heterozygous for the deletion. If a region large enough to be microscopically observable were missing from both chromosomes, it would usually produce a lethal condition.

FIGURE 8.14 ■ Localization of a disease gene through deletion mapping. A series of overlapping deletions is studied in which each deletion produces the disease phenotype. The region of overlap of all deletions defines the approximate location of the disease gene.

Translocations

As discussed in Chapter 6, balanced chromosome translocations often have no effect on a translocation carrier because the individual still has a complete copy of his or her genetic material. However, when a translocation happens to interrupt a gene, it can produce genetic disease. For example, after linkage analysis had mapped the *NF1* gene approximately to the long arm of chromosome 17, a more refined location was obtained when two patients were identified—one with a balanced translocation between chromosomes 17 and 22, and the other with a balanced translocation between chromosomes 17 and 1.

The breakpoints of these translocations on chromosome 17 were located very close to one another, in the same region implicated by linkage analysis. They provided a physical starting point for experiments that subsequently led to cloning of the *NF1* gene.

A similar example is provided by translocations observed between the X chromosome and autosomes in females affected with Duchenne muscular dystrophy (DMD). Because this is a lethal X-linked recessive disorder, affected homozygous females are rare. The translocation breakpoint on the X chromosome was found to be in the same location (Xp21) in several affected females, suggesting that the translocation interrupted the DMD gene. This proved to be the case, and these translocations aided considerably in mapping and cloning of the DMD gene. (Although these females also carried a normal X chromosome, the normal X was preferentially inactivated, leaving only the interrupted X as the active chromosome.)

Dosage Mapping Using Deletions and Duplications

When a deletion occurs on a chromosome, it stands to reason that the protein products encoded by genes in the deleted region will be present in only half the normal quantity. This is the basis of a simple approach known as **dosage mapping**. For example, it was observed that a 50% reduction in the level of the enzyme adenylate kinase was consistently associated with a deletion on chromosome 9, mapping the adenylate kinase gene to this chromosome region. Dosage mapping was also used to map the gene for red cell acid phosphatase to chromosome 2.

Similarly, a duplication of chromosome material should be associated with an increase in gene product levels. Because three genes are present instead of two, the increase should be approximately 50% above normal. This form of dosage mapping was used to assign the gene encoding superoxide dismutase-1 (SOD-1) to the long arm of chromosome 21.

In Situ Hybridization

In situ hybridization, illustrated in Figure 8-15, is a direct and intuitively simple approach to mapping DNA segments. Suppose that we have a segment of DNA, located near a polymorphic marker or within a disease gene whose location we wish to know. This DNA can be cloned into a probe using the recombinant DNA methods outlined in Chapter 2. The probe is labeled with a

A gene can be physically mapped to a chromosome region by associating cytogenetically observable variations (heteromorphisms, translocations, deletions, duplications) with gene expression (including the presence of a genetic disease).

FIGURE 8.15 Mapping a DNA segment to a chromosome location through in situ hybridization.

radioactive substance, such as tritium, or with a fluorescent tag. The labeled probe is then exposed to a slide containing metaphase chromosomes whose DNA has been denatured in place (in situ). The probe undergoes complementary base pairing with the denatured DNA of a specific chromosome segment. The label indicates the position on the chromosome at which the probe hybridized. Radioactive labels are visualized by placing xray film over the slide (autoradiography; see Chapter 3); fluorescent labels are visualized under a fluorescence microscope.

In situ hybridization using radioactive probes is usu-

ally a slow process, and the degree of resolution (2 to 5 Mb) is rather low. The use of fluorescent probes (FISII technique; see Chapter 6) offers better resolution of a probe's location, often within 1 Mb for metaphase chromosomes, and is more rapid. By using interphase chromosomes, which are less condensed than metaphase chromosomes, FISH resolution can be increased to 25 to 250 kb. Another variation of FISH, termed **fiber FISH**, involves the chemical and physical manipulation of interphase chromosomes to loosen and stretch the chromatin fibers such that individual DNA loops (see Chapter 2) can be visualized. With fiber FISH, probes within a few

kilobases of one another may be resolved. Because of its high resolution and ease of use, FISH has largely supplanted radioactive in situ hybridization as a physical mapping technique.

In situ hybridization is a physical mapping technique in which a labeled probe is hybridized to fixed metaphase chromosomes to determine the chromosomal location of the DNA in the probe. Fluorescence in situ hybridization (FISH) can be applied to interphase chromosomes and can achieve better resolution than radioactive in situ hybridization. Fiber FISH can distinguish probes that are only a few kilobases apart.

Somatic Cell Hybridization

Somatic cell hybridization, a method that was important in helping to locate many disease-causing genes, exploits the fact that somatic cells from different species, when cultured in the presence of agents such as polyethylene glycol or Sendai virus, will sometimes fuse together to form hybrid cells (Fig. 8-16). When mouse and human cells are grown together in this way, the resulting hybrid cells contain 86 chromosomes: the 46 human chromosomes together with the 40 mouse chromosomes. The cells are exposed to selective media such as hypoxanthine, aminopterin, and thymidine (HAT) to eliminate those that did not fuse. The hybrid cells are then allowed to replicate. These cells will begin to lose some of their human chromosomes as they undergo mitosis. Eventually cells remain that have a full set of mouse chromosomes but only one or a few human chromosomes. The cells are karyotyped to determine which human chromosomes remain (human and mouse chromosomes are distinguishable from one another on the basis of size and banding patterns). These sets of cells can then be studied to determine which ones consistently contain the gene in question (Table 8-2). For example, if the gene is always found in cells that contain human chromosome 1 but never found in those that do not, we would conclude that the gene must be located on chromosome 1.

Presence of the gene in the hybrid cell can be detected in several ways. If the gene encodes an enzyme that is produced by the cell, then an enzyme assay can be used. Protein electrophoresis (see Chapter 3) may be used to detect a human protein product and to distinguish it from the equivalent mouse protein product. These approaches, however, require that a known protein product can be detected. More often, investigators now test for hybridization of the fused cell lines with a labeled probe containing the DNA of interest using Southern blotting or polymerase chain reaction (PCR) techniques (Fig. 8-17).

Occasionally a gene can be assigned to a specific *segment* of a chromosome using somatic cell hybridization. Translocations infrequently occur such that only part of a single human chromosome is attached to one of the mouse

FIGURE 8.16 Gene mapping by somatic cell hybridization. The human and rodent cells that fused are selected with the use of a medium such as HAT. The hybrid cells preferentially lose human chromosomes, resulting in clones that each have only a few human chromosomes. Each clone is examined to determine whether the gene is present, thus assigning the gene to a specific chromosome.

TABLE	8.2	Son	natic	Cell I	lybric	lizatio	on Pa	nel*																	
Clone	DNA seg- ment	1	2	3	4	5	6	7	8	9	10	11	12	13	14	15	16	17	18	19	20	21	22	Х	Y
1	+	-	-	_	+	_	+	+	+	+	-	+	+	_	_	+	_	+	_	+	_	_	_	+	_
2	-	+	+	+	-	+	_	+	-	-	+	-	-	-	+	+	+	-	-	+	+	+	+	_	_
3	+	-	-	-	-	+	+	+	+	+	-	-	-	+	-	+	_	+	-	+	+	_	+	_	_
4	+	+	-	+	-	-	-	+	-	+	-	+	+	_	_	-	+	_	+	_	-	+	-	_	-
5	-	-	+	+	+	+	+	-	-	-	+	-	-	+	-	+	_	+	-	-	+	+	-	+	+
6	-	+	-	+	-	-	+	-	-	-	+	+	-	+	+	-	+	-	+	-	-	-	+	+	_
7	+	-	+	-	+	-	+	+	+	+	-	+	-	-	-	+	+	-	+	-	+	+	_	+	_
8	-	-	+	+	+	-	-	+	-	-	+	+	+	-	+	_	+	+	-	+	+	-	-	-	-

*Note that the DNA segment being tested shows a positive hybridization signal to clones 1, 3, 4, and 7. Each of these clones contains chromosome 9, whereas clones 2, 5, 6, and 8 do not contain this chromosome. This pattern localizes the DNA segment to chromosome 9.

chromosomes. If the gene or DNA segment of interest is detectable in a cell containing such a translocation, then the gene must be located on the translocated segment of the human chromosome. Similarly, if a gene is consistently absent in cell lines containing a known deletion, then the gene can be localized to the region that is deleted.

Somatic cell hybridization is a physical mapping technique in which human and rodent cells are hybridized, resulting in cells that have a reduced number of human chromosomes. Panels of such cells are used to correlate the presence of a gene with the consistent presence of one chromosome (or, when translocations are available, with a specific segment of a chromosome).

Radiation Hybrid Mapping

Radiation hybrid mapping, a powerful technique illustrated in Fig. 8-18, typically begins with a somatic cell hybrid that contains a single human chromosome. The cells are irradiated with x-rays or γ -rays to induce multiple double-strand breaks in the chromosomes. This radiation kills the cells, so they must be fused with rodent cells to survive. This is accomplished using approaches similar to those described for somatic cell hybridization. Some of the resulting cells, termed **radiation hybrids**, contain small fragments of human chromosomes fused with rodent chromosomes. The presence of human chromosomes can be detected by screening for *Alu* sequences, which occur every few kb in human chromosomes but are

FIGURE 8.17 A Southern blot used in a somatic cell hybridization gene mapping experiment (compare with panel shown in Table 8-2). Human and mouse bands differ in size because the two species have different recognition sequences. The human gene probe hybridizes only to the hybrid cells 1, 3, 4, and 7, showing that the probe hybridizes only when chromosome 9 is present (see Table 8-2).

FIGURE 8.18 Radiation hybrid mapping. A cell line containing a human chromosome is irradiated to produce chromosome breaks. The resulting human chromosome fragments are fused with rodent chromosomes so that they will survive. The presence of human chromosome material in rodent cells can be detected by the presence of *Alu* sequences. Closely linked loci, such as *A* and *B*, are frequently found on the same chromosome fragment, whereas loosely linked loci, such as *A* and *C*, are infrequently found on the same chromosome fragment.

not found in rodent chromosomes (see Chapter 2). Because radiation breaks the human chromosomes at random intervals, loci that are located closer to one another will be found more often on the same chromosome fragment. Techniques such as PCR can then be used to determine which radiation hybrids contain specific combinations of human loci (i.e., PCR primers specific for each locus are used to determine whether DNA segments from each locus can be amplified, indicating their presence in the hybrid). Then statistical techniques are applied to assess how often each pair of loci is found on the same chromosome fragment, providing an estimate of the relative distances between the loci. Increased levels of radiation can be used to generate smaller fragments, increasing the resolution of the technique.

Closing in on the Gene: Positional Cloning

Sometimes the gene product responsible for a genetic disease is known before the gene itself is identified. This was the case, for example, with the β -globin polypeptide

and sickle cell disease. In such cases, one can deduce the DNA sequence from the amino acid sequence of the polypeptide; this DNA sequence can be used to make a probe in order to locate the disease gene using the techniques just described. This type of approach, in which the gene product and its function are used to pinpoint the gene, is an example of **functional cloning**.

More often, however, we have only a linkage result that has localized the disease gene to a region that may be several Mb or larger. Such a region can easily contain dozens of genes, interspersed with noncoding DNA. A common approach is to begin with a linked marker and then canvas the region around the marker to locate and clone the disease gene itself. This process, previously known as "reverse genetics," is now usually referred to as **positional cloning**.

Suppose that we know the approximate location of a disease gene, determined through linkage analysis. The region that contains the disease-causing gene may be defined by the recombination fraction between the disease gene and a marker polymorphism (typically one to several cM). Its boundaries are more commonly defined by markers that have not undergone observable recombination with the disease gene (see Fig. 8-10). The disease gene could be located anywhere in this region, so the region's DNA sequence must be assembled and evaluated to pinpoint the sequence corresponding to the disease gene. Traditionally, this has been accomplished by assembling a series of DNA fragments that overlap partially, forming a contiguous DNA sequence (referred to as a contig map). A DNA sequence at or near a linked marker (e.g., the PCR primers that were used to amplify an STRP marker) can be used as a probe to pick out partially overlapping segments of DNA from a genomic library (Box 8-2). The overlap can be determined by using PCR to show that a portion of the probe and the DNA segment taken from the library can both be amplified by the same primers (Fig. 8-20). Once identified, the overlapping DNA segment itself is used as a probe to pick out another DNA segment from the genomic library with which it partially overlaps. In this way, one uses partially overlapping DNA segments to "walk" along the region until the disease gene itself is reached.

The determination of overlap among DNA segments has been greatly facilitated by the creation and mapping of thousands of **sequence tagged sites (STSs)**. STSs are sequences of a few hundred bp whose chromosome location is known. They are flanked by known PCR primers, so that any laboratory can use PCR to amplify them for analysis. They thus create physical "signposts" of known sequence throughout the genome whose mutual occurrence on different DNA segments indicates overlap between the segments (Fig. 8-21). STSs have been localized to specific chromosome locations using techniques such as radiation hybrid mapping. www

The DNA segments used in this process can be cloned into vectors such as plasmids, cosmids, or yeast artificial

Probes and Libraries: Their Construction and Use in Gene Mapping

Probes and libraries play central roles in gene mapping and cloning. A DNA library is much like an ordinary library, except that the library is composed of pieces of DNA rather than books. There are several types of DNA libraries. The most general type, termed a genomic library, consists of fragments of DNA that are the result of a restriction digest of whole genomic DNA. The DNA is partially digested, so that some recognition sites are cleaved while others are not. This produces fragments that will overlap with one another. These fragments are then cloned into vectors such as phage, cosmids, or YACs, using the recombinant DNA techniques discussed in Chapter 3. A genomic library contains all of the human genome: introns, exons, enhancers, promoters, and the vast stretches of noncoding DNA that separate genes.

180

Probes and Libraries: Their Construction and Usc in Gene Mapping—cont'd

A **cDNA library** is much more limited (and thus often easier to search); it contains only the DNA corresponding to exons. It is obtained by purifying mRNA from a specific tissue, such as liver or skeletal muscle, and then exposing the mRNA to an enzyme called **reverse transcriptase**. This enzyme copies the mRNA into the appropriate complementary cDNA sequence. DNA polymerase can then be used to convert this single-stranded DNA to double-stranded DNA, after which it is cloned into phage or other vectors, as in the genomic library. The steps involved in making genomic and cDNA libraries are summarized in Figure 8-19.

BOX

8.2

Yet another type of DNA library is the **chromosomespecific library**. Chromosomes are sorted by a method called **flow cytometry**, which separates chromosomes according to the proportion of AT base pairs in each one. The result is a library that consists mostly of DNA from only one chromosome. For example, after the gene for Huntington disease was mapped to a region on the short arm of chromosome 4, a library specific for that chromosome was used to refine the location of the gene.

DNA libraries are often used in making new polymorphic markers. For example, microsatellite polymorphisms can be obtained from DNA libraries by constructing a probe that contains multiple repeated DNA sequences (e.g., multiple CA repeats). Then the DNA library is "screened" with this probe to find fragments in the library that hybridize with the probe. These fragments can be tested in a series of individuals to see whether they are polymorphic. The polymorphism can then be mapped to a specific location by using physical mapping techniques such as in situ hybridization (see text).

Probes are also highly useful in isolating specific disease

2

1

3

1

genes. In this context, they can be made in several different ways. If the defective protein (or part of it) has been identified, the protein's amino acid sequence can be used to deduce part of the DNA sequence of the gene. Generally, a short DNA sequence, only 20 to 30 bp in length, is sufficiently unique so that it will hybridize only to the cDNA in the disease gene. These sequences can be synthesized in a laboratory instrument to make oligonucleotide probes (see Chapter 3). Because of the degeneracy of the DNA code, more than one triplet codon may specify an amino acid. For this reason, different possible combinations of base pairs must be tried. These combinations of oligonucleotide probes are mixed together, and the mixture is then used to probe a DNA library (e.g., a cDNA library). When one of the oligonucleotide probes in the mixture hybridizes with a fragment in the library, a portion of the desired gene has been identified. This fragment can be mapped using the physical techniques mentioned in the text.

Often an investigator has no knowledge of the sequence of the gene product. In this case it is sometimes possible to isolate the gene by purifying mRNA produced by specialized cell types. For example, reticulocytes (immature red blood cells) produce mostly globin polypeptides. mRNA taken from these cells can be converted to cDNA using reverse transcriptase, as discussed previously, and then used as a probe to find additional fragments of the gene in a DNA library. It is sometimes easier to obtain mRNA from an experimental animal, such as a pig or rodent. Because of sequence similarity between these animals and humans, the animal-derived probe will usually hybridize appropriately with segments of a human DNA library.

8

7

5

6

FIGURE 8.20 A probe was tested against eight clones taken from a human YAC library. The probe hybridized with two of the clones (lanes 6 and 7), indicating overlap between the DNA in the probe and the DNA in each of the two YAC clones.

FIGURE 8.21 The use of STSs to indicate overlap between DNA segments in establishing a contig map. Overlap is indicated when PCR primers for a specific STS amplify DNA from different DNA segments taken from a genomic library.

chromosomes (YACs), as discussed in Chapter 3. Plasmids accommodate the smallest DNA inserts, while YACs accommodate the largest ones (200 to 2000 kb). Nearly all of the human genome has now been cloned into YACs. Although they are very useful, YACs sometimes combine DNA from completely different genomic regions in the same clone (known as chimerism). Obviously, this can complicate the assembly of DNA sequences into a contig map. Other cloning vectors are more stable but accept smaller inserts: **bacterial artifi**- cial chromosomes (BACs) and bacteriophage P1 artificial chromosomes (PACs) both accept inserts of 50 to 200 kb. They are often used in combination with YACs in positional cloning experiments. Figure 8-22 depicts a contig map of overlapping YACs and cosmids in the vicinity of the gene that causes adenomatous polyposis coli (a form of colon cancer; see Chapter 11).

These approaches have been a central part of the largescale effort to compile the entire DNA sequence of the human genome (Box 8-3). Most of the human genome sequence is now available in computerized databases, so investigators may often scan a region of interest simply by accessing the appropriate DNA sequence on a computer. However, when a gap in the published sequence is encountered, the positional cloning steps described here can be undertaken to assemble the needed sequence.

Positional cloning typically involves the isolation of partially overlapping DNA segments from genomic libraries in an attempt to progress along the chromosome toward a disease gene.

As we scan the DNA region containing a disease gene, how do we know when we have actually reached the gene? Several approaches may be used.

Analysis of Cross-Species Conservation

As we search along a segment of genomic DNA for the gene in question, most of the sequence is likely to be noncoding DNA, which we wish to avoid. Coding DNA, which we wish to locate, generally cannot change very much through the course of evolution because it is likely to perform an important function. This means that it will be **conserved**, or similar in DNA sequence, in a large number of different species. In contrast, noncoding DNA is likely to change rapidly and to differ substantially among species. Thus, if the sequence we are cur-

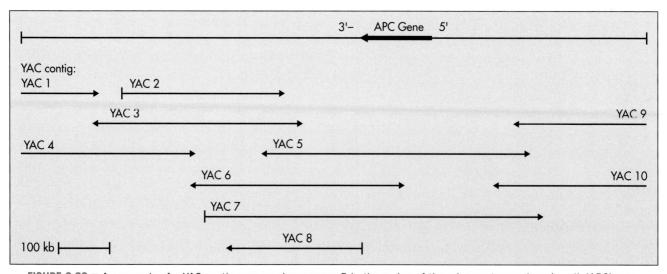

FIGURE 8.22 An example of a YAC contig map on chromosome 5 in the region of the adenomatous polyposis coli (APC) gene.

The Human Genome Project

BOX

8.3

The Human Genome Project is one of the most widely publicized and ambitious undertakings in the history of biomedical research. Initiated in October 1990, this 15-year project had three major goals: (1) a genetic marker map, (2) a physical map, and (3) the complete 3 billion bp sequence of the human genome.

Considerable progress has been made in achieving these goals. The marker map was completed several years ago and currently includes many thousands of polymorphisms distributed throughout the genome. These include RFLPs, VNTRs, and STRPs. On average, a useful polymorphism can be found at intervals of less than 1 cM. Thus, a closely linked marker can be found for virtually any disease gene. In addition to these polymorphisms, more than 4 million single nucleotide polymorphisms (SNPs) have been identified throughout the genome. SNPs are single-base variants that individually are less polymorphic than an STRP or VNTR polymorphism. However, they have a lower mutation rate than these polymorphisms, and they are especially amenable to computerized automated processing (e.g., DNA chips; see Chapter 3). They will thus add even further to the usefulness of the human genetic map.

The second goal, a physical map of known STSs distributed at 100-kb intervals throughout the genome, is also complete. These physical signposts are invaluable in positional cloning experiments, where they can be used to place a series of DNA sequences (e.g., those inserted in YACs, BACs, PACs, or cosmids) in relative order.

The final goal, the complete genome sequence, has been the most challenging of all and has been pursued in both the public and private sectors. The publicly funded effort began by establishing a "framework" of overlapping cloned segments of human DNA. These DNA segments, which were cloned into vectors such as BACs and PACs, were typically on the order of 100 to 200 kb in size. Establishing accurate overlaps and chromosome locations for these segments presented formidable technical challenges, and the effort was aided considerably by the physical STS map. Each DNA segment was then broken into small restriction fragments and sequenced, and the resulting data were placed into a publicly accessible database. In contrast, the privately funded effort began with much smaller DNA segments (several kb in size), cloned into plasmid vectors. Each of these small segments was sequenced and then searched for overlap in order to assemble the larger DNA sequence, making use of the publicly available data.

In February 2001, both groups announced that they had completed approximately 90% of the sequence of human euchromatic DNA (i.e., the portion of DNA that contains genes). A high degree of sequencing accuracy has been established, with an error rate lower than 1 in every 10,000 bp. Although incomplete, this "rough draft" of the genome is already useful because it contains most of our genes. A completed, highly accurate sequence was unveiled in the spring of 2003, exactly 50 years after Watson and Crick first described the structure of DNA.

Completion of this project is providing many benefits. Already, gene mapping projects can often be completed in a matter of weeks because of dense and freely available marker maps. Positional cloning, once the bane of genetics laboratories, is now much more feasible because of the existing physical map. The amount of time required to identify genes via positional cloning and other approaches continues to decrease, and the number of disease genes that have been pinpointed in this way is growing each year. The cloning of disease genes yields many important benefits: improved genetic diagnosis, the potential for manufacture of gene products by recombinant DNA techniques, and improved treatment through more specific drugs or gene therapy (see Chapter 13).

The complete genome sequence is likely to yield predictable—and unpredictable—results and benefits. Having a complete sequence in hand will greatly speed the identification of all human genes. It will provide the ultimate genetic "blueprint" of the human. It is also quite possible that the vast expanses of noncoding DNA will surprise us with previously unknown insights about our biology and our origins.

The same technology used to sequence the human genome has been applied to dozens of other organisms: medically significant viruses and bacteria, agriculturally important crops such as rice and maize, and important experimental organisms such as yeast, fruit flies, mice, and rats. Homology between the genes of these organisms and the human has helped us to understand the nature of a number of human disease genes.

It is a mistake to think of the completion of the human genome sequence as the end of an era of research. The genome sequence, while of immense value, is still nothing more than a long string of nucleotides. The challenge will be to use this vast pool of information to identify genes, understand their regulation and expression, and characterize the many complex interactions among genes and environment that ultimately give rise to phenotypes. In addition, the comparison of DNA sequences of different individuals, which has just begun in earnest, will inform us about differential susceptibility to genetic disease. The human genome sequence thus represents the beginning, rather than the end, of an era of fruitful and exciting biological research.

rently evaluating consists of coding DNA, it is more likely to hybridize (i.e., undergo complementary base pairing) with the DNA of many other species. A nonconserved sequence is less likely to show cross-species hybridization. To test whether a DNA segment is conserved across species, a probe containing the DNA segment is constructed and then exposed to denatured DNA from several species to determine whether it hybridizes (this is whimsically termed a "zoo blot"). Although this approach does not necessarily identify the disease gene itself, it alerts us to the possibility that a DNA segment may be part of a coding gene.

183

Identification of CG Islands

As discussed in Chapter 3, most CG dinucleotides are methylated. However, approximately 60% of human genes, including nearly all of the housekeeping genes and most of the widely expressed genes, have *unmethylated* CG dinucleotides **(CG islands)** in their 5' region. (A lack of methylation in the 5' region of the gene probably makes it more accessible to transcription factors required for active expression.) The identification of a series of CpG islands can often pinpoint a coding gene.

Exon Identification Techniques

Several approaches are now used to identify exons in a genomic DNA sequence. In one approach, termed exon trapping, the presence of an exon or exons in a DNA sequence is detected by inserting the sequence into a plasmid vector that is allowed to undergo transcriptional processing in yeast or mammalian cells (Fig. 8-23). Normal messenger RNA (mRNA) processing takes place, and all sequences except the exons are spliced out. If the DNA sequence in question contains exons, a larger fragment will be produced after mRNA processing; if the DNA sequence does not contain exons, a smaller fragment will be produced. In addition to identifying exons in DNA sequences, exon trapping is used to determine whether specific alterations in disease-causing genes, such as splice-site mutations, result in skipped exons in the mature mRNA transcript.

Another commonly used exon detection technique is termed direct cDNA selection. Here, the genomic DNA sequence under scrutiny is inserted into a YAC. The YACs are then hybridized to complementary DNA (cDNA) clones taken from a complete human cDNA library. If the DNA sequence in the YAC contains exons, they should undergo complementary base pairing with sequences in the cDNA library (since cDNA is made only from coding DNA; see Box 8-2). If the DNA sequence does not contain exons, it should not hybridize effectively. After several repeated cycles of hybridization, the cDNA clones corresponding to exons in the DNA sequence will be greatly enriched, permitting their identification. A weakness of this approach is that it may miss genes that are poorly represented in the cDNA library because they are expressed only rarely.

Computer Analysis of DNA Sequence

Computer analysis, sometimes termed *in silico* research, has become an effective and popular approach for identifying genes. Sophisticated computer algorithms, such as GRAIL, can test a DNA sequence for patterns that signal a coding gene (e.g., transcription initiation sites, stop codons, intron-exon boundaries). This approach was used, for example, to help identify and characterize one of the adult polycystic kidney disease genes (*PKD1*; see Chapter 4). In

FIGURE 8.23 ■ The exon trapping technique. The human DNA segment is placed in a plasmid vector using recombinant DNA techniques. The plasmid vector is cloned into a yeast or mammalian cell that contains appropriate transcriptional machinery. Mature mRNA is isolated and converted to cDNA. The cDNA sequence can then be amplified with PCR to determine its length. If the human DNA segment contains an exon or exons, the resulting fragment will be longer than if it does not.

addition, these algorithms can often recognize patterns typical of genes that encode specific classes of proteins (e.g., transcription factors, transmembrane proteins).

Computerized databases of known DNA sequences also play an important role in gene identification. When studying a specific region of DNA to find a genc, it is common to search for similarity between DNA sequences from the region and DNA sequences in the database. The sequences in the database may derive from genes with known function or tissue-specific expression patterns. Suppose, for example, that we have used linkage analysis to identify a region containing a gene that causes a developmental disorder such as a limb malformation. As we evaluate DNA sequences in the region, we would look for similarity between a DNA sequence from this region and a plausible sequence from the database (e.g., a sequence from a gene that encodes a protein involved in bone development, such as a fibroblast growth factor). Because genes that encode similar protein products usually have similar DNA sequences, a match between the sequence from our region and a sequence in the database could be a vital clue that this particular DNA sequence is actually part of the gene that causes the limb malformation.

A computerized database commonly used in these searches consists of small DNA sequences known as expressed sequence tags (ESTs). ESTs are obtained by sequencing several hundred base pairs from both ends of cDNA clones taken from a cDNA library (see Box 8-2). Because these clones consist of DNA that is complementary to mRNA, the ESTs represent expressed portions of genes. Often, they are expressed only in certain tissues at certain points in time. ESTs can be mapped to specific chromosome locations using previously discussed physical mapping techniques, such as radiation hybrid mapping or FISH. Then the investigator can search for sequence similarity between DNA sequences in a region of interest and ESTs known to be located in the same region (and possibly known to be expressed in a tissue that would be consistent with the disease in question). This strategy was used, for example, to identify one of the genes known to cause Alzheimer disease (see Chapter 12). The identification of ESTs has proceeded rapidly, with approximately 4.5 million ESTs now available in computerized databases. www

The similarity search need not be confined to human genes. Often, sequence similarity is observed with genes of known function in other organisms, such as mouse or even yeast or bacteria. Because genes with important protein products tend to be highly conserved throughout evolution, the identification of a human homologue in another organism can provide important information about the gene's function in the human. For example, many of the genes involved in cell cycle regulation are quite similar in yeast and human (e.g., portions of the NF1 gene and the yeast IRA2 gene). Indeed, approximately one third of human disease-causing genes identified to date have homologues in yeast. These genes and their products can easily be manipulated in experimental organisms, so their well-understood functions in these organisms can provide useful inferences about their functions in humans. A number of important human disease genes have been discovered because homologous candidate genes had previously been identified in other organisms (e.g., the mouse "small eye" gene and aniridia, the mouse "splotch" gene and Waardenburg syndrome, the Drosophila and mouse "patched" genes and basal cell nevus syndrome, the mouse "pink eye" gene and oculocutaneous albinism type 2).

Screen for Mutations in the Sequence

Once a portion of coding DNA has been isolated, it can be examined for mutations using techniques such as single-strand conformation polymorphism (SSCP) analysis, denaturing gradient gel electrophoresis (DGGE), and direct DNA sequencing (see Chapter 3). If a DNA sequence represents the disease gene, then mutations should be found in individuals with the disease, but they should not be found in unaffected individuals. To help distinguish disease-causing mutations from polymorphisms that vary naturally among individuals, it is particularly useful to compare the DNA of patients whose disease is caused by a new mutation with the DNA of their unaffected parents. While a harmless polymorphism will be seen in both the affected offspring and the unaffected parents, a mutation that is responsible for the disease in the offspring will not be seen in the parents. This approach is especially useful for identifying mutations in highly penetrant autosomal dominant diseases such as NF1.

Another type of mutation that can be tested is a submicroscopic deletion (i.e., a deletion too small to be observable under a microscope). Small deletions can be detected using Southern blotting techniques (see Chapter 3). A deletion will produce a smaller-than-normal restriction fragment, which migrates more quickly through a gel. Somewhat larger deletions can be detected through pulsed-field gel electrophoresis, a variation on the Southern blotting technique in which restriction digests are done with enzymes that, because their recognition sequences are rare, cleave the DNA infrequently. This produces restriction fragments that can be tens or hundreds of kb in length. These fragments are too large to be distinguished from one another using standard gel electrophoresis, but they will migrate differentially according to size when the electrical current is pulsed in alternating directions across the gel.

Test for Gene Expression

To help verify that a gene is responsible for a given disease, one can test various tissues to determine the ones in which the gene is expressed (i.e., transcribed into mRNA). This can be done by purifying mRNA from the tissue, placing it on a blot, and testing for hybridization with a probe made from the gene. This technique, known as Northern blotting (Fig. 8-24), is conceptually similar to Southern blotting except that mRNA, rather than DNA, is being probed. If the gene in question causes the disease, the mRNA may be expressed in tissues known to be affected by the disease (the same reasoning is applied to the analysis of ESTs obtained from tissue-specific cDNA libraries). For example, one would expect the phenylalanine hydroxylase gene (mutations in which can cause PKU) to be expressed in the liver, where this enzyme is known to be synthesized.

Increasingly, microarrays (see Chapter 3) are being used to test for gene expression. Microarrays containing thousands of oligonucleotide sequences representing genes of interest have been manufactured, and these can -ibroblast

FIGURE 8.24 An example of a Northern blot, showing the hybridization of a cDNA probe from the *EVI2A* gene (a gene embedded within an intron of the *NF1* gene) with mRNA from adrenal gland, brain, and fibroblasts. This result indicates that *EVI2A* is expressed in the brain at a much higher level than in the other two tissues. (Courtesy Dr. Richard Cawthon, University of Utah Health Sciences Center.)

be exposed to mRNA from tissues of interest to determine the tissues in which specific genes are expressed.

Another gene expression test involves inserting the normal version of the DNA sequence into a defective cell from an affected individual (or animal model), using recombinant DNA techniques. If the normal sequence corrects the defect, then it is very likely to represent the disease gene of interest. This approach has been used, for example, to show that mutations in the *CFTR* gene can cause cystic fibrosis.

Many things can complicate the positional cloning procedure. For example, the isolation of overlapping DNA sequences can become very difficult when long sequences of repetitive DNA are encountered. As a result, this process can be very laborious and timeconsuming. The Huntington disease gene, for example, was localized to chromosome 4p by linkage analysis in 1983, but 10 years of hard work by a large group of dedicated researchers elapsed before the disease gene itself was cloned. Four years of positional cloning were required to isolate the cystic fibrosis gene. The positional cloning process has been accelerated as better cloning techniques and vectors have been devised (such as BACs, PACs, and YACs, which can carry much larger inserts than cosmids). The availability of a completed human DNA sequence, made possible by the Human Genome Project, has greatly increased the speed and efficiency of positional cloning. During the course of positional cloning, one needs to determine whether the DNA segment currently under consideration is part of a disease gene. Tests used for this purpose include cross-species hybridization, identification of unmethylated CpG islands, exon trapping, direct cDNA selection, computer analysis of DNA sequence, mutation screening in affected individuals, and tests of gene expression.

Candidate Genes

The gene hunting process can be expedited considerably if a candidate gene is available. As the name implies, this is a gene whose known protein product makes it a likely candidate for the disease in question. For example, the various collagen genes were considered to be reasonable candidates for Marfan syndrome because collagen is an important component of connective tissue. However, linkage analysis using collagen gene markers in Marfan syndrome families consistently yielded negative results. Another candidate gene emerged when the *fibrillin-1* gene was identified on chromosome 15. Fibrillin, as discussed in Chapter 4, is also a connective tissue component. Linkage analysis had localized the Marfan syndrome gene to chromosome 15, so *fibrillin-1* became an even stronger candidate. Analysis of *fibrillin-1* mutations showed that they were consistently associated with Marfan syndrome, confirming these mutations as a cause of the disease. This combination of linkage analysis to identify the region containing a gene followed by a search of the region for plausible candidate genes is sometimes called the **positional candidate** approach.

Another example of candidate gene analysis is provided by hyperkalemic periodic paralysis, an autosomal dominant muscle disorder characterized by transient episodes of weakness or paralysis. The electrophysiological abnormalities observed in this disorder suggested that a defect in a voltage-gated sodium channel could be involved. A sodium channel gene on chromosome 17 presented itself as a likely candidate, and a polymorphism in this gene showed perfect linkage with the disease phenotype in large families. Subsequent analyses verified the pathogenic role of the sodium channel gene by detecting mutations in affected individuals.

Candidate genes are those whose characteristics (e.g., protein product) suggest that they may be responsible for a genetic disease. The analysis of candidate genes in a region known to contain the disease-causing gene is termed the positional candidate approach.

Using the techniques described in this chapter, a large number of important disease genes have now been mapped, and many of them have also been cloned. Some examples are given in Table 8-3.

Disease	Chromosome location	Gene product
α-1-Antitrypsin deficiency	14q	Serine protease inhibitor
α-Thalassemia	16p	α-Globin component of hemoglobin
3-Thalassemia	11p	β-Globin component of hemoglobin
Achondroplasia	4p	Fibroblast growth factor receptor 3
Adult polycystic kidney disease	16р 4р 6р	Polycystin-1 membrane protein Polycystin-2 membrane protein Fibrocystin—possible receptor protein
Albinism, oculocutaneous		
(type 1) (type 2)	11q 15q	Tyrosinase Tyrosine transporter
Alzheimer disease*	14q 1q 19q 21q	Presenilin 1 Presenilin 2 Apolipoprotein Ε β-Amyloid precursor protein
Amyotrophic lateral sclerosis	21q	Superoxide dismutase 1
Angelman syndrome	15q	Ubiquitin-protein ligase E3A
Ataxia telangiectasia	11q	Cell cycle control protein
Beckwith-Wiedemann syndrome	11p	Insulin-like growth factor II
Bloom syndrome	15q	RecQ helicase
Breast cancer (familial)	17q 13q 22q	BRCA1 tumor suppressor/DNA repair protein BRCA2 tumor suppressor/DNA repair protein CHEK2 DNA repair protein
Li-Fraumeni syndrome	17p	P53 tumor suppressor

(type AB)11qMyorubularin-related protein-2(type XI)XqConnexin-32 gap junction proteinCystic fibrosis7qCystic fibrosis transmembrane regulator (CFTFDeafness, nonsyndromic (more than 7513qConnexin-26 gap junction proteingenes identified to date; representative5qActin polymerization regulatorexamples shown here)7qPendrin (anion transporter; mutations also foun syndrome)DiabetesI1qc-TiectorinDiabetes(MODY1)20qHepatocyte nuclear factor-1α (MODY2)7pChuckinaseInsulin promoter factor-1 (MODY3)MOD13)12qHepatocyte nuclear factor-1α (MODY4)MOD14)13qInsulin promoter factor-1(MODY5)17qHepatic transcription factor-2Duchenne/Becker muscular dystrophyXpDystrophinEhlers-Danlos syndrome*2qCollagen (COL3A1); there are numerous types most of which are produced by mutations in colElis van Creveld syndrome4pProtein with possible leucine zipper domain fradreich ataxia9qGalactose-1-phosphate-uridyltransferaseHemochromatosis6pTransferrin receptor binding protein6pMSI42 DNA mismatch repair protein 2pHemophilia AXqClotting factor NIIHemophilia AXqClotting factor VIIIHemophilia AXqClotting factor VIIIHemophilia AXqClotting factor VIIIHereduary nonpolyposis colorectal 2pMLH1 DNA mismatch repair protein <th>Disease</th> <th>Chromosome location</th> <th>Gene product</th>	Disease	Chromosome location	Gene product
(type 1B)1qMyelin protein zero(type 2A)1pKIF1B motor protein(type 4A)8qGanglioside-induced differentiation-associated j(type 4A)8qGanglioside-induced differentiation-associated j(type 4A)1qMyotubularin-related protein-associated j(type 4A)8qConnexin-32 gap junction protein(type 4A)7qCystic fibrosis transmembrane regulator (CFTIDeafness, nonsyndromic (more than 7513qConnexin-26 gap junction proteingenes identified to date; representative5qActin polymerization regulatorsamples shown here)7qPendrin (moino transporter; mutations also foun syndrome)Diabetes(MODY1)20qHepatocyte nuclear factor-1ac (MODY3)(MODY3)12qHepatocyte nuclear factor-1ac (MODY4)13qInsulin promoter factor-1(MODY5)17qHepatocyte nuclear factor-2(MODY6)2qNeuroD transcription factorDucheme/Becker muscular dystrophyXpDystrophinEhlers-Danlos syndrome*2qCollagen (COL3A1); there are numerous types 			
(type 2A)1pKIF1B motor protein (type 4A)8q(type 4B)11qLamin A/C nuclear envelope protein (type 4B)NqCystic fibrosis7qConnexin-32 gap junction protein (Type XI)XqCostic fibrosis7qConnexin-32 gap junction protein (Type XI)YqDeafness, nonsyndromic (more than 75 ears identified to date; representative sqSqActin polymerization regulatorCarger Sidentified to date; representative sqSqActin polymerization regulatorDiabetes			
type 2B1) iq Lamin A/C nuclear envelope protein (type 4A) 8q Gangliosic-induced differentiation-associated (type 4B) 11q Myotubalarin-related protein-32 (type XI) Xq Cystic fibrosis 7q Cystic fibrosis transmembrane regulator (CFTT Deafness, nonsyndromic (more than 75 13q Connexin-32 gap junction protein genes identified to date; representative 5q Actin polymerization regulator pens identified to date; representative 5q Actin polymerization regulator pens identified to date; representative 5q Actin polymerization regulator Diabetes			
type 4A)8qGanglioside-induced differentiation-associated jtype 4B)11qMyotubalarin-related protein-2type X1)XqConnexin-32 gap junction proteinCystic fibrosis7qCystic fibrosis transmembrane regulator (CFTTDeafness, nonsyndromic (more than 7513qConnexin-32 gap junction proteingenes identified to date; representative5qActin polymerization regulatorgenes identified to date; representative5qActin polymerization regulatorDiabetes			Lamin A/C nuclear envelope protein
Type HB)1/qMyorubularin-related protein-2(type XI)XqConnexin-32 gap junction protein(type XI)XqConnexin-32 gap junction proteinDeafness, nonsyndromic (more than 7513qConnexin-76 gap junction proteingenes identified to date; representative5qActin polymerization regulatorgenes identified to date; representative5qActin polymerization regulatormamples shown here)7qPendrin (anion transporter; mutations also foun syndrome)DiabetesIIqa.TectorinMODY1)20qHepatocyte nuclear factor-1aMODY3)12qHepatocyte nuclear factor-1MODY4)13qInsulin promoter factor-1MODY5)17qHepatocyte nuclear factor-1Duchene/Becker muscular dystrophyXpDystrophinCalcenser-Danlos syndrome*2qCollagen (COL3A1); there are numerous typesFriedrich ataxia9qFrataxin mitochondrial proteinFriedrich ataxia9qFrataxin mitochondrial proteinGalactosemia9pGalactoseriHemochromatosis6pTransferrin receptor binding proteinHemochromatosis6pMLH1 DNA mismatch repair protein <td></td> <td>1</td> <td>Ganglioside-induced differentiation-associated protein-1</td>		1	Ganglioside-induced differentiation-associated protein-1
Cystic fibrosis 7q Cystic fibrosis transmembrane regulator (CFTT Deafness, nonsyndromic (more than 75 13q Connexin-26 gap junction protein genes identified to date; representative squamples shown here) 7q Diabetes 7q Pendrin (ninon transporter; mutations also foun syndrome) 11q Diabetes (MODY1) 20q Hepatocyte nuclear factor-4α (MODY3) 12q Hepatocyte nuclear factor-1α (MODY3) 12q Hepatic transcription factor (MODY3) 12q NeuroD transcription factor Dachenne/Becker muscular dystrophy Xp Dystrophin Ellers-Danlos syndrome* 2q Collagen (CoL3A1); there are numerous types most of which are produced by mutations in col Fragile X syndrome 4p Protein with possible leucine zipper domain Fradial polyposis coli 5q APC tumor suppressor Fradie ch ataxia 9q Galactose-1-phosphate-uridyltransferase Hemochromatosis 6p Transferrin receptor binding protein			
Deafness, nonsyndromic (more than 75 13q Connexin-26 gap junction protein genes identified to date; representative 5q Actin polymerization regulator examples shown here) 7q Pendrin (anion transporter; mutations also foun syndrome) 11q α -Tectorin Diabetes (MODY1) 20q Hepatocyte nuclear factor-1 α (MODY3) 12q Hepatocyte nuclear factor-1 α (MODY5) 27p Glucokinase (MODY5) 17q Hepatocyte nuclear factor-1 α (MODY5) 24p Dystrophin Eblers-Danlos syndrome* 24 Collagen (COL3A1); there are numerous types most of which are produced by mutations in col Fragile X syndrome 4p Protein with possible leucine zipper domain Friedreich ataxia 9q Frataxin mitochondrial protein Friedreich ataxia 9q Frataxin mitochondrial protein Friedreich ataxia 9q Clotting factor VII Hemophilia A Xq Clotting factor VII Hemophilia B Xq Clotting factor IVII Hemophilia B Xq Clotting factor IVII Hereditary nonpolyposis colorectal 3p MLH11 DNA mismatch repair protein Fright S2 DNA mismatch repair protein Fright S2 DNA mismatch repair protein Hirschsprung disease (type 1)* 10q Effort IX Hirschsprung disease (type 1)* 10q KET tyrosine kinase proto-oncogene Equation (familial) 19p LDL receptor Long QT syndrome 15q Figure 4p MLH3 DNA mismatch repair protein Huntington disease 4p Huntingtin Hypercholesterolemia (familial) 19p LDL receptor Long QT syndrome (LQT1) 7q HERG cardiac potassium channel α subunit (LQT2) 7q HERG cardiac potassium channel β subunit (LQT5) 21q KCNE2 cardiac potassium channel β subunit (LQT6) 21q KCNE2 cardiac potassium channel β subunit (LQT6) 21q KCNE2 cardiac potassium channel β subunit (LQT6) 21q KCNE2 cardiac potassium channel β pubmit (LQT6) 21q KCNE2 cardiac potassium channel β subunit (LQT6) 21q KCNE2 cardiac potassium channel β subunit (LQT6) 21q KCNE2 cardiac potassium channel β pubmit (LQT6) 21q KCNE2 cardiac potassium channel β	(type X1)	Xq	Connexin-32 gap junction protein
genes identified to date; representative 5q Actin polymerization regulator examples shown here) 7q Pendrin (anion transporter; mutations also foun syndrome) 11q α-Tectorin Diabetes (MODY1) 20q Hepatocyte nuclear factor-4α (MODY2) 7p Glacokinase (MODY3) 12q Hepatocyte nuclear factor-1α (MODY4) 13q Insulin promoter factor-1 (MODY5) 17q Hepatic transcription factor-2 (MODY5) 17q Hepatic transcription factor-2 (MODY5) 17q Hepatic transcription factor-2 (MODY6) 2q NeuroD transcription factor-2 (MODY6) 2q NeuroD transcription factor-1 Ehlers-Danlos syndrome* 2q Collagen (COL3A1); there are numerous types most of which are produced by mutations in col Friderick ataxia 9q Frataxin mitochondrial protein Friderick ataxia 9q Frataxin mitochondrial protein Friderick ataxia 9q Frataxin mitochondrial protein Friderick ataxia 9q Clotting factor VIII Hemophilia A Xq Clotting factor VIII Hemophilia B Xq Clotting factor VIII Hemophilia A Xq Clotting factor VIII Hemophilia B Yq Clotting factor XC Pacina Pactoring factor Yp PMSE2 DNA mismatch repair	Cystic fibrosis	7q	Cystic fibrosis transmembrane regulator (CFTR)
examples shown here) 7q Pendrin (anion transporter; mutations also foun syndrome) Diabetes (MODY1) 20q Hepatocyte nuclear factor-4α (MODY3) 7p Glucokinase (MODY3) MODY4) 13q Hepatocyte nuclear factor-1α (MODY3) MODY4) 13q Insulin promoter factor-1α (MODY6) MODY5) 17q Hepatic transcription factor Duchenne/Becker muscular dystrophy Xp Dystrophin Ehlers-Danlos syndrome* 2q Collagen (COL3A1); there are numerous types most of which are produced by mutations in col Ellis van Creveld syndrome 4p Protein with possible leucine zipper domain Fragile X syndrome Xq FMR1 RNA-binding protein Friedreich ataxia 9q Galactose-1-phosphate-uridyltransferase Hemochromatosis 6p Transferrin receptor binding protein Hemosphilia A Xq Clotting factor IX Hereditary nonpolyposis colorectal 3p MLH1 DNA mismatch repair protein 2p MS1 DNA mismatch repair protein 2p MLH2 DNA mismatch repair protein 14q MLH3 DNA mismatch repair protein 2p MLH3 DNA misma	Deafness, nonsyndromic (more than 75	13q	Connexin-26 gap junction protein
$\begin{tabular}{ c c c c } & syndrome) & 11q & α^{-Tectorin}$ \\ \hline \begin{tabular}{ c c c c c c } & α^{-Tectorin}$ \\ \hline \begin{tabular}{ c c c c c c c c c c c c c c c c c c c$			
I1qα-TectorinDiabetes	examples shown here)	7q	Pendrin (anion transporter; mutations also found in Pendred
Diabetes (MODY1)20qHepatocyte nuclear factor- 4α (MODY2)7pGlucokinase (MODY3)12qHepatocyte nuclear factor- 1α (MODY3)12q(MODY3)12qHepatocyte nuclear factor- 1α (MODY5)17q(MODY5)17qHepatic transcription factorDuchenne/Becker muscular dystrophyXpDystrophinEhlers-Danlos syndrome*2qCollagen (COL3AD); there are numerous types most of which are produced by mutations in col fragile X syndromeFamilia polyposis coli5qAPC tumor suppressorFradila polyposis coli5qFrataxin mitochondrial proteinGalactosemia9qFrataxin mitochondrial proteinGalactosemia9pGalactose-1-phosphate-uridyltransferaseHemophilia AXqClotting factor IXHereditary nonpolyposis colorectal3pMLH1 DNA mismatch repair protein aproteincancer2qPMS1 DNA mismatch repair protein app2qPMS1 DNA mismatch repair protein app2qHereditary nonpolyposis colorectal app3pMLH1 DNA mismatch repair protein appHirschsprung disease (type 2)13qEndothelin receptor type BHuntington disease4pHuntingtin LDL receptorLog T syndrome (LQT1)*1pKVLQT1 cardiac potassium channel Acmize solum channel (LQT1)Log T syndrome (LQT1)*1qKCNE2 cardiac potassium channel fa subunit (LQT5)Log T syndrome (LQT5)2qCyclin-dependent kinase inhibitor tumor supprMarfan syndrome<		110	
$\begin{array}{llllllllllllllllllllllllllllllllllll$	Diabetes	**4	
$ \begin{array}{cccccc} (\mathrm{MODY2}) & 7p & \mathrm{Glucokinase} \\ \mathrm{(MODY3)} & 12q & \mathrm{Hepatocyte nuclear factor-1}\alpha \\ \mathrm{(MODY4)} & 13q & \mathrm{Insulin promoter factor-1} \\ \mathrm{(MODY5)} & 17q & \mathrm{Hepatic transcription factor-2} \\ \mathrm{(MODY6)} & 2q & \mathrm{NeuroD transcription factor} \\ \mathrm{Duchenne/Becker muscular dystrophy } & \mathrm{Yp} & \mathrm{Dystrophin} \\ \mathrm{Ehlers-Danlos syndrome}^* & 2q & Collagen (COL3A1); there are numerous types most of which are produced by mutations in col entry of which are produced by mutations in col entry of which are produced by mutations in col entry of which are produced by mutations in col entry of which are produced by mutations in col entry of which are produced by mutations in col entry of which are produced by mutations in col entry of which are produced by mutations in col entry of the syndrome & 4p & Protein with possible leucine zipper domain Friedreich ataxia & 9q & Frataxin mitochondrial protein & Galactosenia & 9p & Galactose-1-phosphate-uridyltransferase & Hemochromatosis & 6p & Transferrin receptor binding protein & Hemophilia A & Xq & Clotting factor VIII & Hemophilia B & Xq & Clotting factor IX & Hereditary nonpolyposis colorectal & 3p & MLH1 DNA mismatch repair protein & 2p & MSH2 DNA mismatch repair protein & 2p & MSH2 DNA mismatch repair protein & 2p & MSH2 DNA mismatch repair protein & 2p & MLH6 DNA mismatch repair protein & 2p &$		20g	Hepatocyte nuclear factor- 4α
(MODY4)13qInsulin promoter factor-1(MODY5)17qHepatic transcription factor-2(MODY6)2qNeuroD transcription factorDuchenne/Becker muscular dystrophyXpDystrophinEhlers-Danlos syndrome*2qCollagen (COL3A1); there are numerous types most of which are produced by mutations in col most of which are produced by mutations in colEllis van Creveld syndrome4pProtein with possible leucine zipper domain familial polyposis coliFagile X syndromeXqFMR1 RNA-binding proteinFriedreich ataxia9qFrataxin mitochondrial proteinGalactosemia9pGalactose-1-phosphate-uridyltransferaseHemochromatosis6pTransferrin receptor binding proteinHemophilia AXqClotting factor VIIIHereditary nonpolyposis colorectal3pMLH1 DNA mismatch repair protein 2p2qPMSI DNA mismatch repair protein 2pMILH3 DNA mismatch repair protein 2pHirschsprung disease4pHuntingtin Hungtin Hypercholesterolemia (familial)Hypercholesterolemia (familial)19pLDL receptorLong QT syndrome11pKVLQT1 cardiac potasium channel α subunit (LQT1)(LQT1)7qHERG cardiac potasium channel β subunit (LQT5)(LQT5)21qKCNE1 cardiac potasium channel β subunit (LQT6)Marfan syndrome15qFibrillin-1Melanoma (familial)*9pCyclin-dependent kinase 4	(MODY2)		
(MODY5)17qHepatic transcription factor-2(MODY6)2qNeuroD transcription factorDuchenne/Becker muscular dystrophyXpDystrophinEhlers-Danlos syndrome*2qCollagen (COL3A1); there are numerous types most of which are produced by mutations in colEllis van Creveld syndrome4pProtein with possible leucine zipper domain Familial polyposis coliFagile X syndromeXqFMR1 RNA-binding proteinFriedreich ataxia9qFrataxin mitochondrial proteinGalactosemia9pGalactose-1-phosphate-uridyltransferaseHemophilia AXqClotting factor VIIIHemophilia BXqClotting factor VIIIHereditary nonpolyposis colorectal3pMLH1 DNA mismatch repair proteinacacer2pMSH2 DNA mismatch repair protein 7pPMS1 DNA mismatch repair protein 4qHith ONA mismatch repair protein 7pHirschsprung disease (type 1)*10qRET tyrosine kinase proto-oncogene Endothelin receptor type BHuntington disease4pHuntingtinHypercholesterolemia (familial)19pLDL receptorLong QT syndrome7qHERG cardiae potassium channel α subunit (LQT1)*(LQT5)21qKCNE1 cardiae potassium channel KCNE2 cardiae potassium channel MarinalMelanoma (familial)*9pCyclin-dependent kinase 4			
(MODY6)2qNeuroD transcription factorDuchenne/Becker muscular dystrophyXpDystrophinEhlers-Danlos syndrome*2qCollagen (COL3A1); there are numerous types most of which are produced by mutations in colEllis van Creveld syndrome4pProtein with possible leucine zipper domainFamilial polyposis coli5qAPC tumor suppressorFragile X syndromeXqFMR1 RNA-binding proteinFriedreich ataxia9qGalactose-1-phosphate-uridyltransferaseGalactosemia9pGalactose-1-phosphate-uridyltransferaseHemochromatosis6pTransferrin receptor binding proteinHemophilia AXqClotting factor IXHereditary nonpolyposis colorectal cancer3pMLH1 DNA mismatch repair protein 2qPMS1 DNA mismatch repair protein 2pMLH6 DNA mismatch repair protein 2pHirschsprung disease (type 2)10qRET tyrosine kinase proto-oncogene (type 2)Huntington disease4pHuntingtin HuntingtinHypercholesterolemia (familial)10pLDL receptorLong QT syndrome (LQT1)7qHERG cardiac potassium channel α subunit (LQT5)(LQT5)21qKCNE1 cardiac potassium channel β subunit (LQT6)Marfan syndrome15qFibrillin-1Melanoma (familial)*9pCyclin-dependent kinase 4			
Duchenne/Becker muscular dystrophyXpDystrophinEhlers-Danlos syndrome*2qCollagen (COL3A1); there are numerous types most of which are produced by mutations in colEllis van Creveld syndrome4pProtein with possible leucine zipper domainFamilial polyposis coli5qAPC tumor suppressorFragile X syndromeXqFMR1 RNA-binding proteinFriedreich ataxia9qGalactose-1-phosphate-uridyltransferaseGalactosemia9pGalactose-1-phosphate-uridyltransferaseHemochromatosis6pTransferrin receptor binding proteinHemophilia AXqClotting factor VIIIHemophilia BXqClotting factor IXHereditary nonpolyposis colorectal cancer3pMLH1 DNA mismatch repair protein 2pPPMS1 DNA mismatch repair protein 14qMLH3 DNA mismatch repair protein 14qHirschsprung disease (type 2)13qEndothelin receptor type BHuntington disease4pHuntingtinHypercholesterolemia (familial)19pLDL receptorLong QT syndrome (LQT1)*11pKVLQT1 cardiac potassium channel α subunit (LQT5)L(QT5)21qKCNE1 cardiac potassium channel KCNE2 cardiac potassium channel KCNE2 cardiac potassium channel KCNE2 cardiac potassium channel KCNE2 cardiac potassium channelMarfan syndrome15qFibrillin-1Melanoma (familial)*9pCyclin-dependent kinase 4			
Ehlers-Danlos syndrome*2qCollagen (COL3A1); there are numerous types most of which are produced by mutations in col most of which are produced by mutations in col most of which are produced by mutations in col pratilial polyposis coli5qAPC tumor suppressorFragile X syndromeXqFMR1 RNA-binding proteinFriedreich ataxia9qGalactose-1-phosphate-uridyltransferaseGalactosemia9pGalactose-1-phosphate-uridyltransferaseHemochromatosis6pTransferrin receptor binding proteinHemophilia AXqClotting factor VIIIHereditary nonpolyposis colorectal3pMLLH1 DNA mismatch repair protein2qPMS1 DNA mismatch repair protein2pMLH6 DNA mismatch repair protein2pMLH6 DNA mismatch repair protein14qMLH3 DNA mismatch repair protein14qHirschsprung disease4pHuntingtinHypercholesterolemia (familial)19pLDL receptorLong QT syndrome(LQT1)*11pKVLQT12qRCN5A cardiac potassium channel α subunit(LQT3)3pSCN5A cardiac potassium channel β subunit(LQT5)21qKCNE1 cardiac potassium channel(LQT6)21qKCNE1 cardiac potassium channelMarfan syndrome15qFibrillin-1Melanoma (familial)*9pCyclin-dependent kinase inhibitor tumor suppre Cyclin-dependent kinase 4			
most of which are produced by mutations in colEllis van Creveld syndrome4pFamilial polyposis coli5qAPC tumor suppressorFragile X syndromeXqFriedreich ataxia9qGalactosemia9pGalactosemia9pGalactosenia6pHemochromatosis6pTransferrin receptor binding proteinHemochromatosis6pTransferrin receptor binding proteinHemophilia AXqClotting factor VIIHereditary nonpolyposis colorectal2pMLH1 DNA mismatch repair protein2pMSH2 DNA mismatch repair protein2pMSH2 DNA mismatch repair protein2pMLH6 DNA mismatch repair protein2p14qHuntington disease(type 1)*10qHypercholesterolemia (familial)19pLDL receptorLong QT syndrome(LQT1)*11p(LQT3)3p21qKCNE1 cardiac potassium channel α subunit(LQT6)21qKardiac potassium channel βMarlan syndrome15q12qCyclin-dependent kinase inhibitor tumor suppr12qCyclin-dependent kinase 4			
Familial polyposis coli5qAPC tumor suppressorFragile X syndromeXqFMR1 RNA-binding proteinFriedreich ataxia9qFrataxin mitochondrial proteinGalactosemia9pGalactose-1-phosphate-uridyltransferaseHemochromatosis6pTransferrin receptor binding proteinHemophilia AXqClotting factor VIIIHemophilia BXqClotting factor IXHereditary nonpolyposis colorectal3pMLH1 DNA mismatch repair proteincancer2pMSH2 DNA mismatch repair protein2qPMS1 DNA mismatch repair protein2pMLH6 DNA mismatch repair protein2pMLH6 DNA mismatch repair protein7pPMS2 DNA mismatch repair protein14qML16 DNA mismatch repair protein14qBNAHuntington disease4pHuntingtin19pLDL receptorLong QT syndrome(LQT1)*1p(LQT3)3p21qKCNE1 cardiac potassium channel β subunit(LQT5)21qKCNE2 cardiac potassium channel β subunit(LQT6)21qKCNE2 cardiac potassium channelMarfan syndrome15qKolaFibrillin-1Melanoma (familial)*9pCyclin-dependent kinase 4	·	2q	Collagen (COL3AI); there are numerous types of this disorder most of which are produced by mutations in collagen genes
Fragile X syndromeXqFMR1 RNA-binding proteinFriedreich ataxia9qFrataxin mitochondrial proteinGalactosemia9pGalactose-1-phosphate-uridyltransferaseHemochromatosis6pTransferrin receptor binding proteinHemophilia AXqClotting factor VIIIHemophilia BXqClotting factor IXHereditary nonpolyposis colorectal3pMLH1 DNA mismatch repair proteincancer2pMSH2 DNA mismatch repair protein2qPMS1 DNA mismatch repair protein2pMLH6 DNA mismatch repair protein2pMLH3 DNA mismatch repair protein4dqMLH3 DNA mismatch repair protein14qMLH3 DNA mismatch repair proteinHuntington disease4pHuntingtinHypercholesterolemia (familial)1pLDL receptorLong QT syndrome(LQT1)7q4p(LQT3)3p5cN5A cardiac potassium channel β subunit(LQT5)21qKCNE2 cardiac potassium channel(LQT6)<	Ellis van Creveld syndrome	4p	Protein with possible leucine zipper domain
Friedreich ataxia9qFrataxin mitochondrial proteinGalactosemia9pGalactose-1-phosphate-uridyltransferaseHemochromatosis6pTransferrin receptor binding proteinHemophilia AXqClotting factor VIIIHemophilia BXqClotting factor IXHereditary nonpolyposis colorectal3pMLH1 DNA mismatch repair protein2pMSH2 DNA mismatch repair protein2qPMS1 DNA mismatch repair protein2qPMS1 DNA mismatch repair protein2pMLH6 DNA mismatch repair protein2pMLH6 DNA mismatch repair protein2pMLH6 DNA mismatch repair protein2pMLH6 DNA mismatch repair protein4qMLH3 DNA mismatch repair protein14qMLH3 DNA mismatch repair proteinHirschsprung disease10q(type 2)13qHuntington disease4pHuntington disease4pLog CT syndrome11p(LQT1)*11p(LQT1)*11p(LQT3)3p21qKCNE1 cardiac potassium channel α subunit(LQT5)21qKCNE2 cardiac potassium channel β subunit(LQT6)21qKCNE2 cardiac potassium channel β subunit<	Familial polyposis coli	5q	APC tumor suppressor
Galactosemia9pGalactose-1-phosphate-uridyltransferaseHemochromatosis6pTransferrin receptor binding proteinHemophilia AXqClotting factor VIIIHemophilia BXqClotting factor IXHereditary nonpolyposis colorectal3pMLH1 DNA mismatch repair protein2pMSH2 DNA mismatch repair protein2qPMS1 DNA mismatch repair protein2pMLH6 DNA mismatch repair protein14qHH73 DNA mismatch repair proteinHirschsprung diseaseI(type 1)*10qRET tyrosine kinase proto-oncogene(type 2)13qHuntingtinHypercholesterolemia (familial)19pLDL receptorLong QT syndrome(LQT1)*11pKVLQT1 cardiac potassium channel α subunit(LQT5)21qKCNE1 cardiac potassium channel β subunit(LQT6)21qMarfan syndrome15qHibrilin-1Melanoma (familial)*9pCyclin-dependent kinase inhibitor tumor suppr12qCyclin-dependent kinase 4	Fragile X syndrome	Xq	FMR1 RNA-binding protein
Hemochromatosis6pTransferrin receptor binding proteinHemophilia AXqClotting factor VIIIHemophilia BXqClotting factor IXHereditary nonpolyposis colorectal3pMLH1 DNA mismatch repair protein2pMSH2 DNA mismatch repair protein2qPMS1 DNA mismatch repair protein2qPMS2 DNA mismatch repair protein2pMLH6 DNA mismatch repair protein2pMLH6 DNA mismatch repair protein14qMLH3 DNA mismatch repair proteinHirschsprung disease10q(type 1)*10q(type 2)13qHuntingtinHypercholesterolemia (familial)19pLDL receptorLong QT syndrome(LQT1)*11p(LQT5)21qKCNE1 cardiac potassium channel α subunit(LQT6)21qKCNE1 cardiac potassium channelMarfan syndrome15qMarfan syndrome15qKelanoma (familial)*9pCyclin-dependent kinase 4	Friedreich ataxia	9q	Frataxin mitochondrial protein
Hemophilia AXqClotting factor VIIIHemophilia BXqClotting factor IXHereditary nonpolyposis colorectal3pMLH1 DNA mismatch repair proteincancer2pMSH2 DNA mismatch repair protein2qPMS1 DNA mismatch repair protein2pMLH6 DNA mismatch repair protein2pMLH6 DNA mismatch repair protein2pMLH6 DNA mismatch repair protein2pMLH6 DNA mismatch repair protein14qMLH3 DNA mismatch repair proteinHirschsprung disease10q(type 1)*10q(type 2)13qHuntingtinHypercholesterolemia (familial)19pLDL receptorLong QT syndrome11p(LQT1)*11pKVLQT1 cardiac potassium channel α subunit(LQT5)21qKCNE1 cardiac potassium channel(LQT6)21qMarfan syndrome15qMelanoma (familial)*9pQpCyclin-dependent kinase inhibitor tumor suppr 12q12qCyclin-dependent kinase 4	Galactosemia	9p	Galactose-1-phosphate-uridyltransferase
Hemophilia BXqClotting factor IXHereditary nonpolyposis colorectal3pMLH1 DNA mismatch repair proteincancer2pMSH2 DNA mismatch repair protein2qPMS1 DNA mismatch repair protein2qPMS1 DNA mismatch repair protein2pMLH6 DNA mismatch repair protein2pMLH6 DNA mismatch repair protein4qMLH3 DNA mismatch repair protein4qMLH1 DNA mismatch repair protein4qMLH1 DNA mismatch repair protein4qMLH1 DNA mismatch repair protein4qMLH1 DNA mismatch repair protein4qMLH3 DNA mismatch repair protein4qMLH3 DNA mismatch repair proteinHirschsprung disease4pHuntingtinHypercholesterolemia (familial)19p19pLDL receptorLong QT syndrome1p(LQT1)*1pKCNE1 cardiac potassium channel(LQT5)21qKCNE2 cardiac potassium channelMarfan syndrome15qMarfan syndrome15qMarfan syndrome15qMarfan syndrome12q <td>Hemochromatosis</td> <td>6р</td> <td>Transferrin receptor binding protein</td>	Hemochromatosis	6р	Transferrin receptor binding protein
Hereditary nonpolyposis colorectal3pMLH1 DNA mismatch repair proteincancer2pMSH2 DNA mismatch repair protein2qPMS1 DNA mismatch repair protein2pMLH6 DNA mismatch repair protein2pMLH6 DNA mismatch repair protein2pMLH6 DNA mismatch repair protein14qMLH3 DNA mismatch repair proteinHirschsprung disease10q(type 1)*10qRET tyrosine kinase proto-oncogene(type 2)13qHuntington disease4pHuntingtinHypercholesterolemia (familial)19pLDL receptorLong QT syndrome(LQT1)*11pKVLQT1 cardiac potassium channel α subunit(LQT5)21qKCNE1 cardiac potassium channel(LQT6)21qKCNE2 cardiac potassium channelMarfan syndrome15qFibrillin-1Melanoma (familial)*9pCyclin-dependent kinase inhibitor tumor suppr 12qCyclin-dependent kinase 4	Hemophilia A	Xq	Clotting factor VIII
Hereditary nonpolyposis colorectal3pMLH1 DNA mismatch repair proteincancer2pMSH2 DNA mismatch repair protein2qPMS1 DNA mismatch repair protein2pMLH6 DNA mismatch repair protein2pMLH6 DNA mismatch repair protein2pMLH6 DNA mismatch repair protein14qMLH3 DNA mismatch repair proteinHirschsprung disease10q(type 1)*10qRET tyrosine kinase proto-oncogene(type 2)13qHuntington disease4pHuntingtinHypercholesterolemia (familial)19pLDL receptorLong QT syndrome(LQT1)*11pKVLQT1 cardiac potassium channel α subunit(LQT5)21qKCNE1 cardiac potassium channel(LQT6)21qKCNE2 cardiac potassium channelMarfan syndrome15qFibrillin-1Melanoma (familial)*9pCyclin-dependent kinase inhibitor tumor suppr 12qCyclin-dependent kinase 4	Hemophilia B	Xq	Clotting factor IX
cancer 2p MSH2 DNA mismatch repair protein 2q PMS1 DNA mismatch repair protein 7p PMS2 DNA mismatch repair protein 2p MLH6 DNA mismatch repair protein 2p MLH6 DNA mismatch repair protein 14q MLH3 DNA mismatch repair protein Hirschsprung disease (type 1)* 10q RET tyrosine kinase proto-oncogene (type 2) 13q Endothelin receptor type B Huntington disease 4p Huntingtin Hypercholesterolemia (familial) 19p LDL receptor Long QT syndrome (LQT1)* 11p KVLQT1 cardiac potassium channel α subunit (LQT2) 7q HERG cardiac potassium channel (LQT3) 3p SCN5A cardiac sodium channel (LQT5) 21q KCNE1 cardiac potassium channel β subunit (LQT6) 21q KCNE1 cardiac potassium channel β subunit (LQT6) 21q KCNE1 cardiac potassium channel Marfan syndrome 15q Fibrillin-1 Melanoma (familial)* 9p Cyclin-dependent kinase inhibitor tumor supprint 12q Cyclin-dependent kinase 4			
$\begin{array}{cccccccccccccccccccccccccccccccccccc$			
2p 14qMLH6 DNA mismatch repair protein MLH3 DNA mismatch repair proteinHirschsprung disease10qRET tyrosine kinase proto-oncogene (type 2)(type 1)*10qRET tyrosine kinase proto-oncogene Endothelin receptor type BHuntington disease4pHuntingtinHypercholesterolemia (familial)19pLDL receptorLong QT syndrome11pKVLQT1 cardiac potassium channel α subunit (LQT1)*(LQT1)*11pKVLQT1 cardiac potassium channel (LQT3)(LQT5)21qKCNE1 cardiac potassium channel (LQT6)Marfan syndrome15qFibrillin-1Melanoma (familial)*9pCyclin-dependent kinase inhibitor tumor suppra (2q)			
I4qMLH3 DNA mismatch repair proteinHirschsprung disease10qRET tyrosine kinase proto-oncogene(type 1)*10qRET tyrosine kinase proto-oncogene(type 2)13qEndothelin receptor type BHuntington disease4pHuntingtinHypercholesterolemia (familial)19pLDL receptorLong QT syndromeI1pKVLQT1 cardiac potassium channel α subunit(LQT1)*11pKVLQT1 cardiac potassium channel(LQT3)3pSCN5A cardiac sodium channel(LQT5)21qKCNE1 cardiac potassium channel β subunit(LQT6)21qKCNE2 cardiac potassium channelMarfan syndrome15qFibrillin-1Melanoma (familial)*9pCyclin-dependent kinase inhibitor tumor suppration12q21qCyclin-dependent kinase 4			
Hirschsprung diseaseI0qRET tyrosine kinase proto-oncogene(type 1)*13qEndothelin receptor type BHuntington disease4pHuntingtinHypercholesterolemia (familial)19pLDL receptorLong QT syndromeI1pKVLQT1 cardiac potassium channel α subunit(LQT1)*11pKVLQT1 cardiac potassium channel α subunit(LQT3)3pSCN5A cardiac sodium channel(LQT5)21qKCNE1 cardiac potassium channel β subunit(LQT6)21qKCNE2 cardiac potassium channelMarfan syndrome15qFibrillin-1Melanoma (familial)*9pCyclin-dependent kinase inhibitor tumor supprint			
(type 1)*10qRET tyrosine kinase proto-oncogene(type 2)13qEndothelin receptor type BHuntington disease4pHuntingtinHypercholesterolemia (familial)19pLDL receptorLong QT syndromeI1pKVLQT1 cardiac potassium channel α subunit(LQT1)*11pKVLQT1 cardiac potassium channel(LQT3)7qHERG cardiac potassium channel(LQT5)21qKCNE1 cardiac potassium channel(LQT6)21qKCNE2 cardiac potassium channelMarfan syndrome15qFibrillin-1Melanoma (familial)*9pCyclin-dependent kinase inhibitor tumor suppre 12q	Hirsebannung disease	тq	WEITS DIVIT Inisiliaten repair protein
(type 2)13qEndothelin receptor type BHuntington disease4pHuntingtinHypercholesterolemia (familial)19pLDL receptorLong QT syndromeI1pKVLQT1 cardiac potassium channel α subunit(LQT1)*11pKVLQT1 cardiac potassium channel α subunit(LQT3)3pSCN5A cardiac sodium channel(LQT5)21qKCNE1 cardiac potassium channel β subunit(LQT6)21qKCNE2 cardiac potassium channelMarfan syndrome15qFibrillin-1Melanoma (familial)*9pCyclin-dependent kinase inhibitor tumor suppre 12q	1 0	10a	RET tyrosine kinase proto-oncogene
Hypercholesterolemia (familial)19pLDL receptorLong QT syndrome		1	
Hypercholesterolemia (familial)19pLDL receptorLong QT syndrome	Huntington disease	4p	Huntingtin
Long QT syndrome(LQT1)*11pKVLQT1 cardiac potassium channel α subunit(LQT2)7qHERG cardiac potassium channel(LQT3)3pSCN5A cardiac sodium channel(LQT5)21qKCNE1 cardiac potassium channel β subunit(LQT6)21qMarfan syndrome15qFibrillin-1Melanoma (familial)*9pCyclin-dependent kinase inhibitor tumor supprint12qCyclin-dependent kinase 4			
(LQT1)*11pKVLQT1 cardiac potassium channel α subunit(LQT2)7qHERG cardiac potassium channel(LQT3)3pSCN5A cardiac sodium channel(LQT5)21qKCNE1 cardiac potassium channel β subunit(LQT6)21qKCNE2 cardiac potassium channelMarfan syndrome15qFibrillin-1Melanoma (familial)*9pCyclin-dependent kinase inhibitor tumor suppre 12q	••	1	1
(LQT2)7qHERG cardiac potassium channel(LQT3)3pSCN5A cardiac sodium channel(LQT5)21qKCNE1 cardiac potassium channel β subunit(LQT6)21qKCNE2 cardiac potassium channelMarfan syndrome15qFibrillin-1Melanoma (familial)*9pCyclin-dependent kinase inhibitor tumor suppre 12q		11p	KVLQT1 cardiac potassium channel α subunit
(LQT5)21qKCNE1 cardiac potassium channel β subunit(LQT6)21qKCNE2 cardiac potassium channelMarfan syndrome15qFibrillin-1Melanoma (familial)*9pCyclin-dependent kinase inhibitor tumor suppre 12q12qCyclin-dependent kinase 4		7q	
(LQT6)21qKCNE2 cardiac potassium channelMarfan syndrome15qFibrillin-1Melanoma (familial)*9pCyclin-dependent kinase inhibitor tumor suppre 12qCyclin-dependent kinase 4			
Marfan syndrome15qFibrillin-1Melanoma (familial)*9pCyclin-dependent kinase inhibitor tumor suppr 12qCyclin-dependent kinase 4			
Melanoma (familial)* 9p Cyclin-dependent kinase inhibitor tumor suppr 12q Cyclin-dependent kinase 4			
12q Cyclin-dependent kinase 4			
			Cyclin-dependent kinase 4
Myotonic dystrophy 19q Protein kinase 3q Zinc finger protein	Myotonic dystrophy	1	

Disease	Chromosome location	Gene product
Myoclonus epilepsy (Unverricht- Lundborg)	21q	Cystatin B cysteine protease inhibitor
Neurofibromatosis type 1	17q	Neurofibromin tumor suppressor
Neurofibromatosis type 2	22q	Merlin (schwannomin) tumor suppressor
Parkinson disease (familial) (autosomal recessive early-onset)	4q 6q	α-Synuclein Parkin
Phenylketonuria	12q	Phenylalanine hydroxylase
Retinitis pigmentosa* (more than 20 genes cloned to date; representative examples shown here)	3q 6p 11q 6p 4p Xp 4p	Rhodopsin TULP1 tubby-like protein Rod outer segment membrane protein-1 Peripherin/RDS Retinal rod photoreceptor cGMP phosphodiesterase, β subuni Retinitis pigmentosa GTPase regulator Retinal rod cGMP-gated channel, α subunit
Retinoblastoma	13q	pRB tumor suppressor
Rett syndrome	Xq	Methyl CpG binding protein
Sickle cell disease	11p	β-Globin component of hemoglobin
Smith-Lemli-Opitz syndrome	11q	7-Dehydrocholesterol reductase
Stargardt disease	1p	ATP-binding cassette transporter
Tay-Sachs disease	15q	Hexosaminidase A
Tuberous sclerosis (type 1)* (type 2)	9q 16p	Hamartin tumor suppressor Tuberin tumor suppressor
Usher syndrome* (type 1B) (type 1C) (type 1D) (type 1F) (type 2A) (type 3A)	11q 11p 10q 10q 1q 3q	Myosin VIIA Harmonin (PDZ domain-containing protein) Cadherin-23 Protocadherin-15 Usherin (extracellular matrix protein) Predicted transmembrane protein
Waardenburg syndrome (type 1 and 3)* (type 2) (type 4) (type 4) (type 4)	2q 3p 13q 20q 22q	PAX3 transcription factor MITF transcription factor Endothelin B receptor Endothelin 3 SOX10 transcription factor
Wilms tumor*	11p	WT1 zinc finger protein tumor suppressor
Wilson disease	13q	Copper transporting ATPase
von Willebrand disease	12q	von Willebrand clotting factor

TABLE 8.3 Examples of Disease Genes That Have Been Mapped and Cloned*—cont'd

*Additional disease-causing loci have been mapped and/or cloned.

SUGGESTED READINGS

- Collins FS, McKusick VA (2001) Implications of the Human Genome Project for medical science. JAMA 285:540-544
- Farrar GJ, Kenna PF, Humphries P (2002) On the genetics of retinitis pigmentosa and on mutation-independent approaches to therapeutic intervention. Embo J 21:857-864
- Gray IC, Campbell DA, Spurr NK (2000) Single nucleotide polymorphisms as tools in human genetics. Hum Mol Genet 9:2403-2408
- Hirschhorn JN, Lohnueller K, Byrne E, Hirschhorn K (2002)

A comprehensive review of genetic association studies. Genet Med 4:45-61

- Jorde LB (2000) Linkage disequilibrium and the search for complex disease genes. Genome Res 10:1435-1444
- Lander ES, Linton LM, Birren B, Nusbaum C, Zody MC, Baldwin J, Devon K, et al. (2001) Initial sequencing and analysis of the human genome. Nature 409:860-921
- Le Hellard S, Semple CA, Morris SW, Porteous DJ, Evans KL (2001) Physical mapping: integrating computational and molecular genetic data. Ann Hum Genet 65:221-228

Morton NE (1995) LODs past and present. Genetics 140:7-12

- Olivier M, Aggarwal A, Allen J, Almendras AA, Bajorek ES, Beasley EM, Brady SD, et al. (2001) A high-resolution radiation hybrid map of the human genome draft sequence. Science 291:1298-1302
- Ott J (1999) Analysis of Human Genetic Linkage, 3rd ed. Johns Hopkins University Press, Baltimore
- Peltonen L, McKusick VA (2001) Genomics and medicine: dissecting human disease in the postgenomic era. Science 291:1224-1229
- Reich DE, Cargill M, Bolk S, Ireland J, Sabeti PC, Richter DJ, Lavery T, Kouyoumjian R, Farhadian SF, Ward R, Lander ES (2001) Linkage disequilibrium in the human genome. Nature 411:199-204
- Sachidanandam R, Weissman D, Schmidt SC, Kakol JM, Stein LD, Marth G, Sherry S, et al. (2001) A map of human genome sequence variation containing 1.42 million single nucleotide polymorphisms. Nature 409:928-933
- Venter JC, Adams MD, Myers EW, Li PW, Mural RJ, Sutton GG, Smith HO, et al. (2001) The sequence of the human genome. Science 291:1304-1351
- Weier HU (2001) DNA fiber mapping techniques for the assembly of high-resolution physical maps. J Histochem Cytochem 49:939-948

STUDY QUESTIONS

1. In Fig. 8-25, a pedigree for an autosomal dominant disease, each family member has been typed for a four-allele microsatellite marker, as shown in the autoradiogram below the pedigree. Determine linkage phase for the disease and marker

locus in the affected male in generation II. Based on the meioses that produced the offspring in generation III, what is the recombination frequency for the marker and the disease locus?

2. In the Huntington disease pedigree in Fig. 8-26,

INTERNET RESOURCES

- Computational Biology at the Oak Ridge National Laboratory (contains a number of useful links, including the URL for the GRAIL gene-finding program) *http://compbio.ornl.gov/*
- Ensembl (provides DNA and protein sequences for humans and other organisms, along with descriptive information; includes the BLAST sequence analysis algorithm) http://www.ensembl.org/
- Genamics (contains hundreds of links for genetic analysis software, including programs for the analysis of linkage, linkage disequilibrium, and DNA sequence variation) http://genamics.com/
- GeneCards (database of human genes and their products, with information about the function of each gene product) http://bioinfo.weizmann.ac.il/cards/
- National Center for Biotechnology Information (maps of chromosomes and disease loci, with links to other useful genomics sites such as the SNP and STS databases) http://www.ncbi.nlm.nih.gov/genome/guide/human/

0.1.01

STUDY QUESTIONS—cont'd

FIGURE 8.26 Pedigree for study question 2.

the family has been typed for two two-allele markers, A and B. The genotypes for each marker are shown below the symbol for each family member, with the genotype for marker A above the genotype for marker B. Under the hypothesis that $\theta = 0.0$, what is the LOD score for linkage between each marker locus and the Huntington disease locus?

3. Interpret the following table of LOD scores and recombination frequencies (θ):

θ	0.0	0.05	0.1	0.2	0.3	0.4	0.5
LOD		1.7	3.5	2.8	2.2	1.1	0.0

4. Two pedigrees for an autosomal dominant disease are shown in Fig. 8-27. The families have been typed for a six-allele microsatellite polymorphism. Based on the data in these families, what is the recombination frequency between the marker locus and the disease locus? What is the LOD score for linkage between the marker and disease loci under the hypothesis that $\theta = 0.0$?

- 5. Consider the pedigree in Fig. 8-28, in which an autosomal recessive gene is being transmitted and each family member has been typed for a five-allele microsatellite polymorphism. Carrier status in each individual has been established by an independent enzymatic assay. What is the recombination frequency between the microsatellite polymorphism and the disease locus?
- 6. An autosomal dominant disease is being transmitted in the pedigree in Fig. 8-29. A two-allele marker has been typed for each family member. What is the recombination frequency for the marker and the disease locus? What is the LOD score for a recombination frequency of 0.0? What

FIGURE 8.28 Pedigree for study question 5.

FIGURE 8.27 Pedigrees for study question 4.

FIGURE 8.29 Pedigree for study question 6.

is the LOD score for a recombination frequency of 0.1?

- 7. The family shown in the pedigree in Fig. 8-30 has been presented for genetic diagnosis. The disease in question is autosomal dominant. The family members have been typed for a closely linked two-allele marker locus. What can you tell the family about the risks for their offspring?
- 8. Distinguish the differences among the concepts of synteny, linkage, linkage disequilibrium, and association.
- 9. A recent study showed no linkage disequilibrium between NF1 and a very closely linked marker

FIGURE 8.30 Pedigree for study question 7.

locus. Explain this, keeping in mind that the NF1 gene has a high rate of new mutations.

10. The somatic cell hybridization panel in Fig. 8-31 indicates the clones that yielded a positive hybridization signal for a cDNA segment. Based on this information, on which chromosome is the cDNA segment likely to reside?

Clone	DNA segment	1	2	3	4	5	6	7	8	9	10	11	12	13	14	15	16	17	18	19	20	21	22	Х	٢
1		-	-	+	-	-	-	+	-	+	-	+	+	-	+	+	+	-	-	+	-	-	-	+	•
2	ni - 10	-	+	+	-	-	-	+	-	-	+	-	-	-	+	-	+	-	-	+	-	+	-	+	-
3	+	-	+	+	-	+	-	+	-	+	-	+	+	+	-	+	-	+	-	+	-	-	+	-	-
4	-	+	-	+	-	-	-	+	-	-	-	+	+	-	+	-	+	-	+	+	+	+	-	-	i i
5	-	-	+	+	+	-	+	-	-	-	+	-	-	+	-	-	+	-	+	+	+	-	+	+	-
6	+	-	+	+	-	+	-	+	+	+	+	+	+	-	-	-	+	-	+	+	-	-	+	+	-

Immunogenetics

Each day, our bodies are confronted with a formidable series of invaders: viruses, bacteria, and many other disease-causing organisms whose goal is to overcome our natural defenses. These defenses, known collectively as the immune system, consist of a diverse collection of trillions of cells. The immune system must be able to cope with a multitude of invading microorganisms, and it must be able to distinguish "self" from "non-self" with a high degree of accuracy.

CHAPTER

As one might expect, the genetic basis of the immune system is complex. The study of the genetics of the immune system, known as **immunogenetics**, has benefited enormously from new developments in gene mapping and cloning. Most of the techniques discussed in earlier chapters (e.g., linkage analysis, positional cloning, DNA sequencing) have been used to study genes responsible for the immune response. Many new genes have been discovered, and their functions and interactions have been studied intensely. This chapter provides a brief review of basic immunology and discusses the genes underlying the body's capacity to defend against a highly diverse array of pathogens. Aspects of autoimmune disease are examined, and some of the major immunodeficiency disorders are discussed.

THE IMMUNE RESPONSE: BASIC CONCEPTS

The Innate Immune System

When a pathogenic microorganism is encountered, the body's first line of defense includes **phagocytes** (a type of cell that engulfs and destroys the microorganism) and the **complement system**. The complement proteins can destroy microbes directly by perforating their cell membranes, and they can also attract phagocytes and other immune system agents to microbes by coating the microbial surface (it is because of this assisting role that the term "complement" originated). **Natural killer cells**, a specific type of lymphocyte, can respond to certain viral infections and some tumor cells. Phagocytes, complement, and natural killer cells are all part the **innate immune system**. This component of the immune system is capable of responding very rapidly to pathogens; some form of innate immunity is thought to exist in all multicellular organisms.

The innate immune system is activated by general features that are detected in pathogens but are not found in the host. For example, gram-negative bacteria produce lipopolysaccharides, and gram-positive bacteria produce peptidoglycans. Some bacteria have a high proportion of unmethylated CG sequences, and some viruses produce double-stranded RNA. These distinctive features of pathogenic organisms can be detected by receptor molecules located on the surfaces of innate immune system cells. An important example is the Toll-like receptor, named after a cell-surface receptor, Toll, that was first described in fruit flies. The genes encoding the human and fruit-fly versions of Toll-like receptors have a remarkable similarity to one another, attesting to their importance in maintaining an innate immune response in a wide variety of organisms.

The innate immune system, which includes some phagocytes, natural killer cells, and the complement system, is an early part of the immune response and recognizes general features of invading microorganisms.

The Adaptive Immune System

While the innate immune system typically helps to hold an infection in check in its early phases, it is sometimes incapable of overcoming the infection. This becomes the task of a more specialized component of the immune system, the **adaptive immune system**. As its name suggests, this part of the immune system is capable of "adapting" to features of the invading microorganism in order to mount a more specific and more effective immune response. The adaptive immune system is a more recent evolutionary development than the innate immune system and is found only in vertebrates.

Key components of the adaptive immune response include T lymphocytes (or T cells) and B lymphocytes (or **B** cells). These cells develop in the body's primary lymphoid organs (bone marrow for B cells and the thymus for T cells). In the thymus, T cells that can tolerate the body's own peptides are selected, and those that would attack the body's peptides are eliminated. The B and T cells then progress to secondary lymphoid tissues, such as the lymph nodes, spleen, and tonsils, where they encounter disease-causing microorganisms. Mature B lymphocytes secrete circulating antibodies, which combat infections. The B lymphocyte component of the immune system is sometimes called the humoral immune system because it produces antibodies that circulate in the bloodstream. Helper T lymphocytes stimulate B lymphocytes and other T lymphocytes to respond to infections more effectively, and cytotoxic T lymphocytes can directly kill infected cells. Because T cells interact directly with other cells (B cells or infected cells), the T-cell component of the immune system is sometimes called the cellular immunc system. It is estimated that the body contains several trillion B and T cells.

B lymphocytes are a component of the adaptive immune system; they produce circulating antibodies in response to infection. T lymphocytes, another component of the adaptive immune system, interact directly with infected cells to kill these cells, and they aid in the B cell response.

The B Cell Response: Humoral Immune System

A major element of the adaptive immune response begins when specialized types of phagocytes, which are part of the innate immune system, engulf invading microbes and then present peptides derived from these microbes on their cell surfaces. These cells, which include macrophages and dendritic cells, are termed antigenpresenting cells (APCs). B cells are also capable of engulfing microbes and presenting foreign peptides on their cell surfaces. The APCs alert the adaptive immune system to the presence of pathogens in two ways. First, the foreign peptide is transported to the surface of the APC by a class II major histocompatibility complex (MHC) molecule, which carries the foreign peptide in a specialized groove (Fig. 9-1). This complex, which projects into the extracellular environment, is recognized by T lymphocytes, which have receptors on their surfaces that are capable of binding to the MHC-peptide complex. In addition, the APCs, upon encountering a pathogen, display costimulatory molecules on their cell surfaces as a signal that foreign pathogens have been encountered (see Fig. 9-1). Binding to the MHC-peptide complex stimulates the helper T lymphocyte to secrete **cytokines,** which are signaling proteins that mediate communication between cells. In particular, these cytokines help to stimulate the subset of B lymphocytes whose cell surface receptors, termed **immunoglobulins**, can bind to the invading microorganism's peptides (Fig. 9-2). The immunoglobulin's capacity to bind a specific foreign peptide (i.e., its affinity for the peptide) is determined by its shape and other characteristics.

In the humoral immune response, foreign particles are displayed in conjunction with class II MHC molecules by antigen-presenting cells. These displayed molecules are recognized by helper T cells, which then stimulate proliferation of B cells whose receptors (immunoglobulins) can bind to the foreign pathogen.

It is estimated that, upon initial exposure to a foreign microbe, as few as 1 in every 1 million B lymphocytes happens to produce receptors capable of binding to the microbe. This number is too small to fight an infection effectively. Furthermore, the receptor's binding affinity is likely to be relatively poor. However, once this relatively small population of B lymphocytes is stimulated, they begin an adaptive process in which minor DNA sequence variations are introduced with each mitotic division (somatic hypermutation; see later discussion). These DNA sequence variations in turn produce alterations in the binding characteristics of receptors (e.g., the shape of the protein). Some of these variant receptors will possess a higher level of binding affinity for the microorganism. The B cells producing these receptors are favorably selected because they bind the pathogen for a longer period of time. They thus proliferate rapidly. These B cells then become plasma cells, which secrete their receptors, or immunoglobulins, into the bloodstream. The secreted immunoglobulins, which are structurally identical to the receptors on the B cell's surface, are antibodies. It can now be seen how the adaptive immune system gets its name: it involves the initial selection of B cells and T cells whose receptors can bind with the pathogen and subsequent fine-tuning of these cells to achieve higher binding affinity.

During the B-cell response to a foreign peptide, the binding affinity of immunoglobulins for the invading pathogen increases. When mature, the B cell becomes an antibody-secreting plasma cell.

After initial stimulation by the disease pathogen, the process of B-cell differentiation and maturation into antibody-producing plasma cells requires about 5 to 7 days for completion. Each plasma cell is capable of secreting approximately 10 million antibody molecules per hour. Antibodies bind to the pathogen's surface **antigens** (a term derived from "*anti*body *generating*") and may destroy the microorganism directly. More often, the antibody "tags" the pathogen for destruction by other com-

FIGURE 9.1 The humoral immune response. Class II MHC molecules in antigen-presenting cells carry foreign peptides to the surface of the cell, where the foreign peptide is recognized by a helper T cell. The T cell secretes cytokines, which stimulate B cells whose immunoglobulins will bind to the foreign peptide. These B cells become plasma cells, which secrete antibodies into the circulation to bind with the microbe, helping to combat the infection. (Modified from Nossal GJ [1993] Life, death and the immune system. Sci Am 269:53-62.)

FIGURE 9.2 ■ A detailed view of the binding between a helper T cell and a B cell. In addition to the binding of the T-cell receptor to the MHC-peptide complex, a number of other molecules interact with one another, such as the costimulatory B7-CD28 complex. (Modified from Roitt et al. [2001] Immunology, 6th ed. Mosby, St. Louis.)

ponents of the immune system, such as complement proteins and phagocytes.

Another important activity of the humoral immune response is the creation of **memory cells**, a subset of high-affinity-binding B cells that persist in the body after the infection has subsided. These cells, which have already been highly selected for response to the pathogen, provide a more rapid response should the pathogen be encountered again later in the individual's life. Vaccinations are effective because they induce the formation of memory cells that can respond to a specific pathogen.

The Cellular Immune System

Some microorganisms, such as viruses, are very adept at quickly inserting themselves into the body's cells. Here, they are inaccessible to antibodies, which are water-soluble proteins that cannot pass through the cell's lipid membrane. A second component of the adaptive immune system, the cellular immune system, has evolved to combat such infections. A key member of the cellular immune system is the **class I MHC molecule**, which is found on the surfaces of nearly all of the body's cells. In a normal cell, the class I MHC molecule binds with small peptides (8 to 10 amino acids in length) derived from the interior of the cell. It migrates to the cell's surface, carrying the peptide with it and displaying it outside the cell. Because this is one of the body's *own* peptides, no immune response is elicited. In an infected cell, however, the class I MHC molecule can bind to small peptides that are derived from the infecting organism. Cell-surface presentation of the *foreign peptide* by the class I MHC molecule alerts the immune system, T cells in particular. Recall that T lymphocytes learn to tolerate "self" peptides while developing in the thymus, but they are highly intolerant of foreign peptides. The MHC-peptide complex binds to receptors on the appropriate T cell's surface, which prompts the T cell to emit a chemical that destroys the infected cell (Fig. 9-3). Because of their ability to destroy cells in this way, these T lymphocytes are termed **cytotoxic T lymphocytes**, or **killer T lymphocytes**.* Each cytotoxic T lymphocyte can destroy one infected cell every 1 to 5 minutes.

The immune system is capable of destroying the body's cells once they are infected. Peptides from the pathogen are displayed on cell surfaces by class I MHC molecules. These are recognized by cytotoxic (killer) T lymphocytes, which destroy the infected cell.

Circulating dendritic cells present the foreign peptides on their cell surfaces and migrate to secondary

^{*}They are also known as CD8 T cells because of the presence of CD8 (cluster of differentiation antigen 8) coreceptors on their surfaces (see Fig. 9-3). Helper T cells have CD4 coreceptors on their cell surfaces (see Fig. 9-2) and are thus a type of CD4 T lymphocyte.

FIGURE 9.3 In a cell infected by a virus, the viral peptides (1, 2) are carried to the cell surface by class I MHC molecules (3). The T-cell receptor of a CD8 cytotoxic T cell binds to the peptide-MHC complex (4). Recognizing the peptide as foreign, the cytotoxic T cell secretes chemicals that either kill the infected cell directly or induce it to undergo programmed cell death (apoptosis; see Chapter 11) (5). (Modified from Janeway CA Jr. [1993] How the immune system recognizes invaders. Sci Am 269:73-79.)

lymphoid tissues, where most of the T cells reside, helping to alert the appropriate subset of T cells to the infection. As with B lymphocytes, only a small proportion of the body's T cells will have binding affinity for the infecting pathogen. By secreting cytokines, helper T cells stimulate the proliferation of the cytotoxic T lymphocytes whose receptors can bind to the infected cells.

The Innate, Humoral, and Cellular Immune Systems: A Comparison

Although the innate and adaptive immune systems are described separately, a great deal of interaction takes place between them, and the two systems fulfill complementary functions. The innate system, because it recognizes general features of pathogens, can react very quickly to foreign elements. While doing so, it signals the adaptive immune system to initiate a fine-tuned response to the pathogen. Indeed, the adaptive immune system is incapable of responding to an infection without this signal. After several days during which the adaptive system "learns" the characteristics of the pathogen, it can launch a massive, specialized response. Through the creation of memory B and T cells, the adaptive immune system allows the organism to respond quickly and effectively to a pathogen should it be encountered again. No such memory cells exist for the innate immune system.

The humoral immune system is specialized to combat extracellular infections, such as circulating bacteria and viruses. The cellular immune system combats intracellular infections, such as parasites and viruses within cells. However, this division of labor is not strict, and there is

197

again a great deal of interaction between the humoral and cellular components of the immune system.

IMMUNE RESPONSE PROTEINS: GENETIC BASIS OF STRUCTURE AND DIVERSITY

Immunoglobulin Molecules and Genes

As illustrated in Fig. 9-4, each antibody (or immunoglobulin) molecule is composed of four chains: an identical pair of longer **heavy chains** and an identical pair of shorter **light chains**. The chains are linked together by disulfide bonds. There are five different types of heavy chains (termed γ , μ , α , δ , and ε) and two types of light chains (κ and λ). The five types of heavy chains determine the major **class** (or **isotype**) to which an immunoglobulin (Ig) molecule belongs: γ , μ , α , δ , and ε correspond to the immunoglobulin isotypes IgG, IgM, IgA, IgD, and IgE, respectively. Immature B lymphocytes produce only IgM, but as they mature, a rearrangement of heavy chain genes called **class switching** occurs. This produces the

other four major classes of immunoglobulins, each of which differs in amino acid composition, charge, size, and carbohydrate content. Each class tends to be localized in certain parts of the body, and each tends to respond to a different type of infection. The two types of light chains can be found in association with any of the five types of heavy chains.

The heavy and light chains both contain a **constant** and a **variable** region, which are located at the carboxyl (C)-terminal and amino (N)-terminal ends of the chains, respectively. The arrangement of genes encoding the constant region determines the major class of the Ig molecule (e.g., IgA, IgE). The variable region is responsible for antigen recognition and binding and thus varies within immunoglobulin classes. Three distinct gene segments encode the light chains: C for the constant region, V for the variable region, and J for the region joining the constant and variable regions. Four gene segments encode the heavy chains, with C, V, and J coding again for the constant, variable, and joining regions, respectively, and a "diversity" (D) region located between the joining and variable regions. The genes

FIGURE 9.4 ■ An antibody molecule consists of two identical light chains and two identical heavy chains. The light chain includes variable, joining, and constant regions; the heavy chain includes these regions as well as a diversity region located between its variable and joining regions. The upper portion of the figure depicts a molecular model of antibody structure.

encoding the κ light chain are located on chromosome 2, and those encoding the λ light chain are on chromosome 22. The genes that encode the heavy chains are on chromosome 14.

Immunoglobulin molecules consist of two identical heavy chains and two identical light chains. The heavy chain constant region determines the major class to which an immunoglobulin belongs. The variable regions of the light and heavy chains recognize and bind antigens.

The Genetic Basis of Antibody Diversity

Because the immune system cannot "know" in advance what types of microbes it will encounter, the system must contain a huge reservoir of structurally diverse immune cells so that at least a few cells can respond (i.e., bind) to any invading microbe. Indeed, the humoral immune system is capable of generating at least 10 billion structurally distinct antibodies. At one time, it was thought that, since each antibody has a unique amino acid sequence, each must be encoded by a different gene. However, this "one gene–one antibody" hypothesis could not possibly be correct, because the human genome has only 30,000 to 40,000 genes. Further study has shown that several mechanisms are responsible for generating antibody diversity:

- 1. *Multiple germline immunoglobulin genes:* Molecular genetic studies (cloning and DNA sequencing) have shown that, for each heavy and light chain, an individual has more than 80 different V segments located contiguously in his or her germ line and six different J segments. There are at least 30 D segments in the heavy chain region.
- 2. Somatic recombination (VD7 recombination): As immunoglobulin molecules are formed during B lymphocyte maturation, a specific combination of single V and J segments is selected for the light chain, and another combination of V, J, and D segments is selected for the heavy chain. This is accomplished by deletion of the DNA sequences separating the single V, J, and D segments before they are transcribed into mRNA (Fig. 9-5). The deletion process is carried out in part by **recombinases** (encoded by the RAG1 and RAG2 genes), which initiate double-strand DNA breaks at specific DNA sequences that flank the V and D gene segments. After the deletion of all but one V, D, and J segment, the nondeleted segments are joined by ligases. This "cutting and pasting" process is known as somatic recombination, as opposed to the germline recombination that takes place during meiosis. Somatic recombination produces a rather unique result: unlike most other cells of the body, whose DNA composition is identical, mature B lymphocytes vary in terms of their

rearranged immunoglobulin DNA sequences. Because there are many possible combinations of single V, J, and D segments, somatic recombination can generate a large number of different types of antibody molecules.

- 3. *Junctional diversity:* As the V, D, and J regions are assembled, slight variations occur in the position at which they are joined, and small numbers of nucleotides may be deleted or inserted at the junctions joining the regions. This creates even more variation in antibody amino acid sequence.
- 4. Somatic hypermutation: After stimulation by a foreign antigen, the B lymphocytes undergo a "secondary differentiation" process characterized by somatic hypermutation, as mentioned previously. The mutation rate of the genes encoding the immunoglobulins increases to approximately 10⁻³ per base pair per cell division. This causes minor variation in the DNA sequences encoding immunoglobulins and thus in their peptide-binding characteristics. Somatic hypermutation of the V, D, and J genes, which may be caused by an errorprone DNA polymerase or a lack of accurate DNA repair, produces considerable antibody diversity.
- 5. *Multiple combinations of heavy and light chains:* Further diversity is created by the random combination of different heavy and light chains in assembling the immunoglobulin molecule.

Each of these mechanisms contributes to antibody diversity. Considering all of them together, it has been estimated that as many as 10^{10} to 10^{14} distinct antibodies can potentially be produced.

Mechanisms that produce antibody diversity include multiple germline immunoglobulin gene segments, somatic recombination of the immunoglobulin gene segments, junctional diversity, somatic hypermutation, and the potential for multiple combinations of heavy and light chains.

FIGURE 9.5 Somatic recombination in the formation of a heavy chain of an antibody molecule. The functional heavy chain is encoded by only one segment each from the multiple V, D, and J segments. (Modified from Roitt I, Brostoff J, Male D [2001] Immunology, 6th ed. Mosby, St. Louis.)

T-Cell Receptors

The T-cell receptors are similar in many ways to the immunoglobulins produced by B cells. Like the immunoglobulins, T-cell receptors must be able to bind to a large variety of peptides from invading organisms. Unlike immunoglobulins, however, T-cell receptors are never secreted from the cell, and T-cell activation requires the presentation of foreign peptide along with an MHC molecule. Approximately 90% of T-cell receptors are heterodimers composed of an α and a β chain, and approximately 10% are heterodimers composed of a γ and a δ chain (Fig. 9-6). The genes encoding the α and δ chains are located on chromosome 14, and those encoding the β and γ chains are located on chromosome 7. A given T cell will have a population of either α - β receptors or γ - δ receptors.

Most of the mechanisms involved in generating immunoglobulin diversity—multiple germline gene segments, VDJ somatic recombination, and junctional diversity—are also important in generating T-cell receptor diversity. However, somatic hypermutation does not occur in the genes that encode the T-cell receptors. This is probably a consequence of the requirement that T-cell receptors must be able to tolerate normal "self" peptides and also recognize MHC molecules.

T-cell receptors are similar in function to B-cell receptors (immunoglobulins). Unlike immunoglobulins, however, they can bind to foreign peptide only when it is presented by an MHC molecule. Their diversity is created by the same mechanisms that produce immunoglobulin diversity, with the exception of somatic hypermutation.

THE MAJOR HISTOCOMPATIBILITY COMPLEX

Class I, II, and III Genes

The MHC includes a series of more than 200 genes that lie in a 4-Mb region on the short arm of chromosome 6 (Fig. 9-7). The MHC is commonly classified into three groups: class I, class II, and class III. As previously

FIGURE 9.6 The T-cell receptor, a heterodimer that consists of either an α and a β chain, or a γ and a δ chain. (Modified from Raven PH, Johnson GB [1992] Biology, 3rd ed. Mosby, St. Louis.)

mentioned, the class I MHC molecule forms a complex with foreign peptides that is recognized by receptors on the surfaces of cytotoxic T lymphocytes. Class I presentation is thus essential for the cytotoxic T cell response; some viruses evade cytotoxic T cell detection by downregulating the expression of MHC class I genes in the cells they infect.

Class I MHC molecules are composed of a single heavy glycoprotein chain and a single light chain called β_2 -microglobulin; the latter protein is encoded by a gene on chromosome 15 (Fig. 9-8A). The most important of the class I loci are labeled *HLA*-A*, *-B*, and *-C*. Each of these loci has dozens of alleles, resulting in a high degree of class I MHC variability among individuals. The class I region spans 1.8 Mb and includes a number of additional genes and **pseudogenes** (genes that are similar in DNA sequence to coding genes but that have been altered so that they cannot be transcribed or translated).

^{*}HLA stands for "human leukocyte antigen," reflecting the fact that these molecules were seen in early studies on leukocyte (white cell) surfaces. However, as mentioned previously, they are found on the surfaces of nearly all cells.

FIGURE 9.7 A map of the human MHC. The 4-Mb complex is divided into three regions: classes I, II, and III.

The class I molecules were first discovered in the 1940s by scientists who were experimenting with tissue grafts in mice. When the class I alleles in donor and recipient mice differed, the grafts were rejected. This is the historical basis for the term "major histocompatibility complex." In humans, matching of the donor's and recipient's class I alleles increases the probability of graft or transplant tolerance. Since grafts and transplants are a relatively new phenomenon in human history, the MHC obviously did not evolve to effect transplant rejection. Instead, T cells, when confronted with foreign MHC molecules on donor cells, interpret these as foreign peptides and attack the cells.

The class I MHC molecules are encoded by the highly polymorphic *HLA-A, -B,* and *-C* loci on chromosome 6. In addition to presenting foreign peptides on the surfaces of infected cells, they can also bring about transplant rejection when foreign MHC molecules stimulate cytotoxic T cells.

Whereas the class I MHC molecules are found on the surfaces of nearly all cells and can bind with cytotoxic Tcell receptors, the class II MHC molecules ordinarily are found only on the surfaces of the immune system's APCs (phagocytes and B lymphocytes). When associated with foreign peptides, they stimulate helper T cell activity after binding to the T cells' receptors, as described previously. The class II molecules are heterodimers consisting of an α and a β chain, each of which is encoded by a different gene located on chromosome 6 (see Fig. 9-8*B*). In addition to the genes in the major class II groups $(HL_{4} DP, DQ, \text{ and } -DR)$, this region includes genes that encode peptide transporter proteins (TAP1 and TAP2) that help to transport peptides into the endoplasmic reticulum, where they initially form complexes with class I molecules before migration to the cell surface.

Class II MHC molecules are heterodimers encoded by genes on chromosome 6. They present peptides on the surfaces of antigenpresenting cells. These peptides, in conjunction with class II MHC molecules, are bound by receptors on helper T cells.

Like the major class I MHC loci, the major class II loci are highly polymorphic, expressing hundreds of different alleles. Indeed, the MHC loci are, as a class, the most polymorphic loci known in the human. This high degree of polymorphism is thought to be the result of natural selection for allelic variability. Each MHC allele encodes a molecule with slightly different binding properties: some variants will bind peptide from a given pathogen more effectively than will others.* Consequently, an individual who expresses a greater variety of MHC molecules has a better chance of dealing effectively with a variety of infectious organisms. For example, someone who is homozygous for each of the major class I loci (A, B, and C) will express only three different class I MHC molecules in each cell, while someone who is heterozygous for each of these loci will express six different class I MHC molecules in each cell and will be able to cope more successfully with pathogenic diversity

FIGURE 9.8 • **A**, A class I MHC molecule, showing the structure of the heavy chain, which consists of three extracellular domains (α_1 , α_2 , and α_3), a membrane-spanning domain, and a cytoplasmic domain. A groove formed by the α_1 and α_2 domains carries peptide for presentation to T-cell receptors. The α_3 domain associates closely with the β_2 -microglobulin chain. **B**, A class II MHC molecule, showing the structure of the α and β chains. Each has two globular extracellular domains, a membrane-spanning domain, and a cytoplasmic domain. The α_1 and β_1 domains form a groove into which peptide nestles for presentation to T-cell receptors. (Modified from Raven PH, Johnson GB [1992] Biology, 3rd ed. Mosby, St. Louis.)

(many thousands of MHC molecules are expressed on a typical cell's surface). A higher degree of polymorphism in the general population increases the chance that any individual in the population will be heterozygous. In addition, greater MHC polymorphism in a population decreases the chance that an infectious pathogen can spread easily through the population.

In some cases, specific MHC alleles are known to produce proteins that are effective against specific pathogens. For example, the *HLA-B53* allele was shown to have a strong protective effect against severe malaria in the population of Gambia, Africa, and the *HLA-DRB1*1302* allele protects against hepatitis B infection in the same population. These alleles produce MHC molecules that have higher-affinity binding of the infectious agents.

Like the class I MHC genes, class II genes are highly polymorphic. This increases the ability of individuals and populations to respond to a wide variety of pathogens.

It can be seen that both class I and class II MHC molecules guide T-cell receptors (cytotoxic and helper, respectively) to specific cells. The T-cell requirement for MHC presentation of peptides is called **MHC restriction**. Not all components of the immune system are MHC restricted. The complement system, for example, does not require direct interaction with MHC molecules. Natural killer cells, a previously discussed component of the innate immune system, detect foreign cells because of their absence of MHC molecules. Indeed, natural killer cells can destroy some virus-infected cells and tumor cells that lose their MHC molecules and might otherwise be ignored by the cellular immune system (Clinical Commentary 9-1).

The class III MHC region spans 680 kb and contains at least 36 genes, only some of which are involved in the immune response. Among the most important of these are the genes encoding the complement proteins.

The genes encoding the immunoglobulins, the T-cell receptors, and the class I and class II MHC proteins all share similar DNA sequences and structural features. Thus, they are members of a gene family, like the globin genes, the color vision genes, and the collagen genes described in earlier chapters. Table 9-1 provides a summary of the major genes of the immune system and their chromosome locations.

It is important to emphasize that the class I and class II MHC molecules differ greatly *among* individuals, but each cell within an individual has the same class I and class II molecules (this uniformity is necessary for recognition by T cells). In contrast, after VDJ recombination

the T-cell receptors and immunoglobulins differ from cell to cell *within* individuals, allowing the body to respond to a large variety of different infectious agents.

The immunoglobulin, T-cell receptor, and MHC genes are members of a gene family. Whereas immunoglobulins and T-cell receptors vary between cells within an individual, MHC molecules vary between individuals.

MHC-Disease Associations

A number of diseases show significant associations with specific MHC alleles: those individuals who have the allele are much more likely to develop the disease than are those who lack it. Some examples, mentioned in earlier chapters, include the association of HLA-B27 (i.e., allele 27 of the HLA-B locus) with ankylosing spondylitis and of HLA-DQB1 with type 1 diabetes. An especially strong association is seen between several HLA-DR and -DQ alleles and narcolepsy, a disorder characterized by sudden and uncontrollable episodes of sleep. As Table 9-2 shows, most of the HLA-disease associations involve the class II MHC genes.

In some cases the association between MHC alleles and a disease is caused by linkage disequilibrium. For example, the hemochromatosis locus is closely linked to HLA-A, and significant associations occur between HLA-A3 and the hemochromatosis disease gene (see Chapter 8). There is no known causal link between HLA-A3 and this disorder, however. More likely, the association represents a past event in which the primary hemochromatosis mutation arose on a copy of chromosome 6 that had the HLA-A3 allele. Similarly, the association between HLA-DQB1 and HLA-DQA1 and narcolepsy is due to linkage disequilibrium between the HLA-DQ region and the nearby locus that causes narcolepsy (the hypocretin type 2 receptor gene).

In other cases a causal association may exist. Some MHC-disease associations may involve autoimmunity, a puzzling situation in which the body's immune system attacks its own normal cells. For example, type 1 diabetes is characterized by T-cell infiltration of the pancreas and subsequent T-cell destruction of the insulin-producing beta cells. The biological basis of autoimmunity remains incompletely understood, but it is thought that it often involves "molecular mimicry." Here, a peptide that stimulates an immune response is so similar to the body's own peptides that the immune system begins to attack the body's own cells. This phenomenon helps to explain the onset of ankylosing spondylitis, another autoimmune disease. Infections of HLA-B27-positive individuals with specific microbes, such as Klebsiella, may lead to a crossreaction in which the immune system mistakes peptides from some of the body's normal cells for microbial peptides. Another such example is given by rheumatic fever, in which a streptococcal infection initiates cross-

^{*}Because of the relatively limited repertoire of different MHC molecules, the peptide binding affinity of MHC molecules is usually much lower than the binding affinity of finely-tuned T-cell receptors.

CLINICAL COMMENTARY 9.1 The Immune Response as a Molecular Arms Race

The vast majority of the pathogens that assault the human body are destroyed by our immune system. Consequently, there is strong natural selection for pathogens that can evade immune surveillance and destruction. These microorganisms often have high mutation rates, and their numbers are huge. Thus, despite their biological simplicity, viruses and other pathogens have evolved some very clever ways of overcoming the immune response. Our immune systems, in turn, are constantly creating new ways to deal with pathogenic ingenuity. Three examples of this molecular "arms race" are discussed here.

Cytomegalovirus (CMV) is a common infectious agent that can produce mononucleosis, hemolytic anemia, pneumonitis, congenital infections, and thrombocytopenia (a decrease in the number of platelets). Cells infected with CMV are the targets of destruction by cytotoxic T cells. However, some CMV strains (as well as other viruses and tumor cells) can evade T-cell detection by down-regulating the expression of class I molecules. Without viral peptide presentation by class I molecules, the cytotoxic T cells are blind to the presence of CMV, and they do not destroy the infected cell. At this point, the cell would normally become the target of natural killer cells, which attack cells that lack MHC class I molecules on their surfaces. But the CMV has devised a way to outwit natural killer cells, too. The virus encodes a cell-surface protein that resembles class I molecules closely enough so that the natural killer cells mistake the viral protein for a true class I molecule. The viral protein is also sufficiently different from a true class I MHC molecule that it does not trigger destruction by the more finely tuned cytotoxic T cell. In this way, the CMV can avoid destruction by both T cells and natural killer cells.

Although a fetus is by no means a pathogen, pregnancy does present an interesting immunological challenge in that placental cells express foreign class I MHC molecules derived from the father. Ordinarily, such cells would be quickly destroyed by the mother's cytotoxic T cells. To avoid this, class I MHC expression is down-regulated in these cells. As with viral down-regulation of class I molecules, this lack of MHC class I expression leaves the placental cells liable to destruction by the mother's natural killer cells. In this case, the cells are saved from destruction by presenting HLA-G molecules on their surface. This relatively nonvariant MHC molecule does not stimulate a T cell response, which is limited to presentation of HLA-A, -B, and -C molecules. It does inhibit the natural killer cell, which has HLA-G receptors on its surface. The fetus, like CMV, has thus devised ways of avoiding destruction by both T cells and natural killer cells.

A third example of the molecular arms race is given by one of the most feared infectious agents of modern times, the human immunodeficiency virus (HIV). Some strains of this virus gain entry to macrophages and helper T cells via a cell-surface receptor that normally binds to a cytokine. Once inside the cell, HIV inserts its genetic material into the nucleus and takes advantage of the cell's machinery to replicate itself (HIV is a retrovirus, a type of virus that is discussed further in Chapter 13). Helper T cells, as already discussed, are a critical component of the body's immune system, and their destruction by HIV leads to severe secondary immunodeficiency. Recently, it has been demonstrated that individuals who are homozygous for a 32-bp deletion of the gene that encodes the cytokine receptor (CCR5) are remarkably resistant to HIV infection. Among those who are heterozygous for this deletion, progression to AIDS symptoms after seroconversion is slowed by 2 to 4 years. This deletion is especially common in northeastern European populations, where the gene frequency reaches 0.20. It is absent in Asian and African populations. Analysis of linkage disequilibrium in the chromosomal region that contains CCR5 indicates that the deletion arose in European populations only 700 to 2,000 years ago. Since HIV appeared in humans only a few decades ago, the high gene frequency in northeastern Europe must be due to some other selective force or perhaps to genetic drift. Considering the age of the deletion, it is possible that it underwent positive selection because it provided resistance to the bacterium that causes bubonic plague. Clearly, there would be strong selection in favor of this mutation in populations now heavily exposed to HIV, and the deletion would eventually rise in frequency in these populations. Even now, knowledge of the consequences of this deletion may well help accelerate the medical arms race against HIV.

Gene system	Chromosome location	Gene product function
Immunoglobulin heavy chain (C, V, D, and J genes)	14q32	Heavy chain, the first part of antibody molecule, which binds foreign antigens
Immunoglobulin κ light chain (C, V, and J genes)	2p13	Light chain, the second part of antibody molecule
Immunoglobulin λ light chain (C, V, and J genes)	22q11	Light chain, the second part of antibody molecule (either κ or λ may be used)
T-cell receptor α	14q11	One chain of the $\alpha\text{-}\beta$ T-cell receptor, which recognizes antigen with MHC molecule
T-cell receptor β	7q35	The other chain of the α - β T-cell receptor
T-cell receptor γ	7p15	One chain of the γ - δ T-cell receptor
T-cell receptor δ	14q11	The second chain of the γ - δ T-cell receptor
MHC (Classes I, II, and III); includes <i>TAP1</i> and <i>TAP2</i>	6p21	Cell-surface molecules that present peptides to T-cell receptors. <i>TAP1</i> and <i>TAP2</i> are transporter molecules that process foreign peptides and carry them to the endoplasmic reticulum.
β_2 -microglobulin	15q21-22	Forms second chain of the class I MHC molecule
RAG1, RAG2	11p13	Recombinases that participate in VDJ somatic recombination

TABLE 9.1	Chromosome	Location and	Function	of Maior	Immune	Response Gen	es

Disease	MHC (HLA) associated allele	Approximate relative risk'
Type 1 diabetes	DQB1*0302	10
Ankylosing spondylitis	B27	90
Narcolepsy	DR2 and DQA1, DQB1	>100
Celiac disease	DR3, DR7	10
Rheumatoid arthritis	DR1, DR4	5
Myasthenia gravis	DR3, DR7	2.5
Multiple sclerosis	DR2	4
Pemphigus vulgaris	DR4	14
Systemic lupus erythematosus	DR3	6
Hemochromatosis	A3	20
Malaria	B53	0.59
Graves disease	DR3	5
Psoriasis vulgaris	Cw6	13
Squamous cell cervical carcinoma	DQw3	7

*Relative risk can be interpreted loosely as the odds that an individual who has a risk factor (in this case, an MHC antigen) will develop the disease, compared with an individual who lacks the risk factor. Thus, a relative risk of 4 for DR2 and multiple sclerosis means that persons with DR2 are four times more likely to develop multiple sclerosis than are those without DR2. A relative risk less than one (as seen for malaria and B53) indicates that the factor is *pratective* against the disease.

Data taken from Bell JI et al. (1989) The molecular basis of HLA-disease association. Adv Hum Genet 18:1-41; Wank R, Thomssen C (1991) High risk of squamous cell carcinoma of the cervix for women with HLA-DQW3. Nature 352:723-725; Hill AV et al. (1991) Common West African HLA antigens are associated with protection from severe malaria. Nature 352:595-600; Doherty DG, Nepom GT (1997) The human major histocompatibility complex and disease susceptibility. In: Rimoin DL, Connor JM, Pyeritz RE (eds) Emery and Rimoin's Principles and Practice of Medical Genetics. Vol 1. Churchill Livingstone, New York; and Klein J, Sato A (2000) The HLA system. Second of two parts. N Engl J Med 343:782-786.

reactivity between streptococcus and cardiac myosin. In each of these scenarios, the body already has a small population of self-reactive T cells, but they remain inactive and quite harmless until they are stimulated to proliferate by a foreign peptide that closely resembles a self peptide.

Other common diseases that involve autoimmunity include rheumatoid arthritis, systemic lupus erythematosus, psoriasis, and multiple sclerosis. It is estimated that approximately 5% of the population suffer from some type of autoimmune disease.

THE ABO AND RH BLOOD GROUPS

Another component of the immune system involves red blood cell surface molecules that can cause an immune reaction during blood transfusions. The ABO and Rh red-cell antigen systems were discussed in Chapter 3 as early examples of polymorphic marker loci. They are also the most important systems determining transfusion compatibility.

The ABO System

There are four major ABO blood types: A, B, AB, and O. The first three groups respectively represent individuals who carry the A, B, and A and B antigens on their erythrocyte surfaces. Those with type O have neither the A nor the B antigen. Individuals who have a given antigen on their erythrocyte surfaces possess antibodies against all other ABO antigens in their bloodstream (these are formed as a result of exposure to antigens that are identical to the A and B antigens but present in various microorganisms). Thus, if a type B individual received type A or AB blood, his or her anti-A antibodies would produce a severe and possibly fatal reaction. Type O individuals, who have neither antigen and both anti-A and anti-B antibodies, would react strongly to blood of the other three types (A, B, and AB). It was once thought that type O persons, because they lack both types of antigens, could be "universal donors" (anyone could accept their blood). Similarly, type AB persons were termed "universal recipients" because they lacked both anti-A and anti-B antibodies. However, when transfusions of whole blood containing large volumes of serum are conducted, the donor's antibodies can react with the recipient's erythrocyte antigens, and a reaction can result. Hence, complete matching is nearly always done for blood transfusions.

The Rh System

The Rh blood group is encoded by two tightly linked loci, one of which is labeled D. The other locus produces Rh systems labeled C and E through alternative splicing of the messenger RNA. The D locus is of primary interest because it is responsible for Rh maternal-fetal incompatibility and the resulting disease, hemolytic disease of the newborn (HDN). Persons with the DD or Dd genotype have the Rh antigen on their erythrocytes and are termed "Rh-positive." The recessive homozygotes, with genotype dd, are "Rh-negative" and do not have the Rh antigen. About 85% of North Americans are Rh-positive, and about 15% are Rh-negative.

Unlike the ABO system, in which antibodies normally are formed in response to antigens presented by other organisms, anti-Rh antibody production requires a stimulus by the human Rh antigen itself. An Rh-negative person does not begin to produce anti-Rh antibodies unless he or she is exposed to the Rh antigen, usually through a blood transfusion or during pregnancy. Maternal-fetal incompatibility results when an Rh-positive man and an Rh-negative woman produce children. If the man's genotype is *DD*, all of their offspring will be Rh-positive and will have Rh antigens on their erythrocytes. If the man is a heterozygote, with genotype *Dd*, half of their children will be Rh-positive, on average.

There are usually no difficulties with the first Rhincompatible child, because very few of the fetus's red blood cells cross the placental barrier during gestation. When the placenta detaches at birth, a large number of fetal red blood cells typically enter the mother's bloodstream. These cells, carrying the Rh antigens, stimulate production of anti-Rh antibodies by the mother. These antibodies persist in the bloodstream for a long time, and if the next offspring is again Rh-positive, the mother's anti-Rh antibodies enter the fetus's bloodstream and destroy its red blood cells. As this destruction proceeds, the fetus becomes anemic and begins to release many erythroblasts (immature nucleated red cells) into its bloodstream. This phenomenon is responsible for the descriptive term erythroblastosis fetalis. The anemia can lead to a spontaneous abortion or stillbirth. Because the maternal antibodies remain in the newborn's circulatory system, destruction of red cells can continue in the neonate. This causes a buildup of bilirubin and a jaundiced appearance shortly after birth. Without replacement transfusions, in which the child receives Rh-negative red cells, the bilirubin is deposited in the brain, producing cerebral damage and usually death. Those infants who do not die may suffer from mental retardation, cerebral palsy, and/or high-frequency deafness.

Among North American Caucasians, approximately 13% of all matings are Rh-incompatible. Fortunately, a simple therapy now exists to avoid Rh sensitization of the mother. During and after pregnancy, an Rh-negative

A significant number of diseases are associated with specific MHC alleles. Some of these associations are the result of linkage disequilibrium, but most are likely to result from causal associations involving autoimmunity.

The ABO locus encodes red cell antigens that can cause a transfusion reaction if donors and recipients are not properly matched.

mother is given injections of Rh immune globulin, which consists of anti-Rh antibodies. These antibodies destroy the fetal erythrocytes in the mother's bloodstream before they stimulate production of maternal anti-Rh antibodies. Since the injected antibodies do not remain in the mother's bloodstream for long, they do not affect subsequent offspring. To avoid sensitization, these injections must be administered with each pregnancy. The Rh-negative mother must also be careful not to receive a transfusion containing Rh-positive blood, because this would also stimulate production of anti-Rh antibodies.

Maternal-fetal Rh incompatibility (Rh-negative mother and Rhpositive fetus) can produce hemolytic disease of the newborn if the mother's Rh antibodies attack the fetus. Administration of Rh immune globulin prevents this reaction.

A rarer form of maternal-fetal incompatibility can result when a mother with type O blood carries a fetus with type A or B blood. The HDN produced by this combination is usually so mild that it does not require treatment. Interestingly, if the mother is also Rh-negative and the child is Rh-positive, the ABO incompatibility *protects* against the more severe Rh incompatibility. This is because any fetal red blood cells entering the mother's circulatory system are quickly destroyed by her anti-A or anti-B antibodies before she can form anti-Rh antibodies.

IMMUNODEFICIENCY DISEASES

Immunodeficiency disease results when one or more components of the immune system (e.g., T cells, B cells, MHC, complement proteins) are missing or fail to function normally. Primary immunodeficiency diseases are caused by abnormalities in cells of the immune system and are usually produced by genetic alterations. To date, more than 100 different primary immunodeficiency syndromes have been described, and it is estimated that these diseases affect at least 1 in 10,000 individuals. Secondary immunodeficiency occurs when components of the immune system are altered or destroyed by other factors, such as radiation, infection, or drugs. For example, the human immunodeficiency virus (HIV), which causes acquired immunodeficiency syndrome (AIDS), attacks macrophages and helper T lymphocytes, central components of the immune system. The result is increased susceptibility to a multitude of opportunistic infections rarely seen in healthy individuals.

B-cell immunodeficiency diseases render the patient especially susceptible to recurrent bacterial infections, such as *Streptococcus pneumoniae*. An important example of a B-cell immunodeficiency is X-linked agammaglobulinemia (XLA). Patients with this disorder, the overwhelming majority of whom are males, lack B cells completely and have no IgA, IgE, IgM, or IgD in their serum. Because IgG crosses the placenta during pregnancy, infants with XLA have some B cell immune response for the first several months of life. However, the IgG supply is soon depleted, and the infants develop recurrent bacterial infections. They are treated with large amounts of gamma globulin. XLA is caused by mutations in a gene (*BTK*) that encodes a B-cell tyrosine kinase necessary for normal B cell maturation. Autosomal recessive B-cell immunodeficiency can be caused by mutations in the genes that encode the immunoglobulin heavy and light chains.

T-cell immunodeficiency diseases directly affect T cells, but they also affect the humoral immune response, because B cell proliferation is largely dependent on helper T cells. Thus, affected patients develop severe combined immune deficiency (SCID) and are susceptible to many opportunistic infections, including Pneumocystis carinii (a protozoan that commonly infects AIDS patients). Without bone marrow transplants, these patients usually die within the first several years. About half of SCID cases are caused by X-linked recessive mutations in a gene encoding the γ chain that is found in six different cytokine receptors (those of interleukins 2, 4, 7, 9, 15, and 21). Lacking these receptors, T cells and natural killer cells cannot receive the signals they need for normal maturation. These receptors all interact with an intracellular signaling molecule called Jak3. As might be expected, individuals who lack Jak3 as a result of autosomal recessive mutations in the 7AK3 gene experience a form of SCID that is very similar to the X-linked form just described.

About 15% of SCID cases are caused by adenosine deaminase (ADA) deficiency, an autosomal recessive disorder of purine metabolism that results in a buildup of metabolites that are toxic to B and T cells. This type of SCID, as well as the X-linked form, can be treated by bone marrow transplantation, and a few cases are being treated experimentally with gene therapy (see Chapter 13).

SCID can also arise from mutations in *RAG1* or *RAG2*, two of the genes involved in VDJ recombination and the proper formation of T-cell and B-cell receptors. These mutations produce a combined B-cell and T-cell immunodeficiency, although normal natural killer cells are produced. Other examples of SCID are given in Table 9-3.

Several immune system defects result in lymphocytes that lack MHC molecules on their surfaces. These are collectively termed "bare lymphocyte syndrome." One form of this syndrome is caused by mutations in the *TAP2* gene. The TAP2 protein, as mentioned previously, helps to transport peptides to the endoplasmic reticulum, where they are bound by class I MHC molecules. A defect in the TAP2 protein destabilizes the class I MHC molecules so that they are not expressed on the cell surface. The result is a severe reduction in the number of functional T and B cells. Bare lymphocyte syndrome can

TABLE 9.3 Examples of Primary Immunodeficiency Diseases

Condition	Mode of inheritance	Brief description
X-linked agammaglobulinemia	XR	Absence of B cells leads to recurrent bacterial infections
Severe combined immune deficiency (SCID) (γ chain cytokine receptor defect or ADA deficiency)	XR, AR	T-cell deficiency leading also to impairment of humoral immune response; fatal unless treated by bone marrow transplantation or gene therapy
SCID due to Jak3 deficiency	AR	Protein kinase deficiency leading to T-cell and B-cell deficiency
SCID due to <i>RAG1</i> or <i>RAG2</i> deficiency; Omenn syndrome	AR	Lack of recombinase activity impairs VDJ recombination, leading to B-cell and T-cell deficiency
SCID due to interleukin-7 α chain deficiency	AR	T-cell deficiency leading to impaired B cell response
Zap70 kinase deficiency	AR	Lack of cytotoxic T cells; defective helper T cells; impaired antibody response
Purine nucleoside phosphorylase deficiency	AR	Purine metabolism disorder leading to T-cell deficiency
Bare lymphocyte syndrome (BLS)	AR	Deficient MHC class I expression (<i>TAP2</i> mutation) leads to T-cell and B-cell deficiency in type 1 BLS; mutations in transcription factors for MHC class II genes lead to a relative lack of helper T cells in type 2 BLS
Complement system defects	Mostly AR	Increased susceptibility to bacterial and other infections
DiGeorge anomaly	AD, sporadic	Congenital malformations include abnormal facial features, congenital heart disease, and thymus abnormality leading to T-cell deficiency
Ataxia telangiectasia	AR	DNA repair defect characterized by unsteady gait (ataxia), telangiectasia (dilated capillaries), and thymus abnormality producing T-cell deficiency
Wiskott-Aldrich syndrome	XR	Abnormal, small platelets, eczema, and abnormal T cells causing susceptibility to opportunistic infections
Chediak-Higashi syndrome	AR	Partial albinism, defective lysosomal assembly, giant cytoplasmic granules, abnormal natural killer cells and neutrophils leading to recurrent bacterial infections
Leukocyte adhesion deficiency	AR	Mutations in integrin receptor gene produce phagocytes that cannot recognize and ingest microorganisms, resulting in severe bacterial infections
Chronic granulomatous disease	XR, AR	Phagocytes ingest microbes but cannot kill them; leads to formation of granulomas and recurrent infections

AD, autosomal dominant; AR, autosomal recessive; XR, X-linked recessive.

also be caused by defects in several different transcription factors that bind to promoters in the class II MHC region. The result is a lack of class II MHC molecules on APCs, a deficiency of helper T cells, and a consequent lack of antibody production.

Chronic granulomatous disease (CGD) is a primary immunodeficiency disorder in which phagocytes can ingest bacteria and fungi but are then unable to kill them. This brings about a persistent cellular immune response to the ingested microbes, and granulomas (nodular inflammatory lesions containing macrophages) form, giving the disease its name. These patients develop pneumonia, lymph node infections, and abscesses of the skin, liver, and other sites. The most common cause of CGD is an X-linked gene, but there are also at least three autosomal recessive genes that can cause CGD. The gene that causes X-linked CGD was the first disease gene to be isolated through positional cloning. It encodes a subunit of cytochrome b, a protein that the phagocyte requires for a burst of microbe-killing oxygen metabolism.

Multiple defects in the various proteins that make up the complement system have been identified. Most of these are inherited as autosomal recessive disorders, and most result in increased susceptibility to bacterial infections.

Finally, a number of syndromes include immunodeficiency as one of their features. One example is the DiGeorge anomaly (see Chapter 6), in which a lack of thymic development leads to T-cell deficiency. Wiskott-Aldrich syndrome is an X-linked recessive disorder that involves deficiencies of platelets and B and T cells. It is caused by mutations in a gene (*WAS*) whose protein product is needed for normal formation of the cellular cytoskeleton. Several syndromes that involve DNA instability are characterized by immunodeficiency (e.g., ataxia telangiectasia, Bloom syndrome, Fanconi anemia; see Chapter 3).

Primary immunodeficiency diseases involve intrinsic defects of immune response cells (B cells, T cells, MHC, complement system, or phagocytes) and are usually caused by genetic alterations. Secondary immunodeficiency disorders, of which AIDS is an example, are caused by external factors. Immunodeficiency is also seen in a number of genetic syndromes, including several DNA instability disorders.

SUGGESTED READINGS

- Abbas AK, Janeway CA (2000) Immunology: improving on nature in the twenty-first century. Cell 100:129-138
- Buckley RH (2002) Primary cellular immunodeficiencies. J Allergy Clin Immunol 109:747-757
- Carrington M, Dean M, Martin MP, O'Brien SJ (1999) Genetics of HIV-1 infection: chemokine receptor CCR5 polymorphism and its consequences. Hum Molec Genet 8:1939-1945

- Davidson A, Diamond B (2001) Autoimmune diseases. N Engl J Med 345:340-350
- Delves PJ, Roitt IM (2000a) The immune system: first of two parts. N Engl J Med 343:37-49
- Delves PJ, Roitt IM (2000b) The immune system: second of two parts. N Engl J Med 343:108-117
- Fischer A (2001) Primary immunodeficiency diseases: an experimental model for molecular medicine. Lancet 357:1863-1869
- Janeway CA Jr, Medzhitov R (2002) Innate immune recognition. Annu Rev Immunol 20:197-216
- Klein J, Sato A (2000a) The HLA system: first of two parts. N Engl J Med 343:702-709
- Klein J, Sato A (2000b) The HLA system: second of two parts. N Engl J Med 343:782-786
- Medzhitov R, Janeway CA Jr (2002) Decoding the patterns of self and nonself by the innate immune system. Science 296:298-300
- Roitt I, Brostoff J, Male D (2001) Immunology. Mosby, St. Louis
- The MHC Sequencing Consortium (1999) Complete sequence and gene map of a human major histocompatibility complex. Nature 401:921-923

INTERNET RESOURCES

- Immunogenetics Database
- http://www.ebi.ac.uk/imgt/
- Nature Reviews Immunology Web sites http://www.nature.com/nri/info/links.html#inna

STUDY QUESTIONS

- Compare the functions of class I and class II MHC molecules.
- 2. MHC molecules and immunoglobulins both display a great deal of diversity, but in different ways. How and why do these types of diversity differ?
- 3. In what ways are T-cell receptors and immunoglobulins similar? In what ways are they different?
- 4. If there are 80 V segments, 6 J segments, and 30 D segments that can encode an immunoglobulin heavy chain of one particular class, how many dif-

ferent immunoglobulins can be formed on the basis of somatic recombination alone?

- 5. When matching donors and recipients for organ transplants, siblings are often desirable donors because they are more likely to be HLA-compatible with the recipient. If we assume no crossing over within the HLA loci, and assume four distinct HLA haplotypes among the parents, what is the probability that a transplant recipient will be HLA-identical with a sibling donor?
- 6. What types of matings will produce Rh maternalfetal incompatibility?

CHAPTER 10

Developmental Genetics

Birth defects are the most common cause of infant* death in the United States. Approximately 100,000 children are born each year with a birth defect, and the prevalence is even higher among miscarriages. Birth defects can be isolated abnormalities, or they can be features of one of more than 2,000 known genetic syndromes. The etiology of most birth defects is unknown; however, it is estimated that a substantial proportion are caused by mutations in genes that control normal development. The characterization of genes coordinating animal development is revolutionizing our understanding of the molecular basis of human birth defects. This chapter provides a brief review of the genes and proteins that control development and then discusses some of the cardinal developmental processes that, when disturbed, cause birth defects.

DEVELOPMENT: BASIC CONCEPTS

Animal development can be defined as the process by which a fertilized ovum becomes a mature organism capable of reproduction. A single fertilized egg divides and grows to form different cell types, tissues, and organs, all of which are arranged in a species-specific body plan (i.e., the arrangement and pattern of body parts). Many of the instructions necessary for normal development are encoded by an animal's genes. Because the genes in each cell of an organism are identical, several questions arise: How do cells with identical genetic constitutions form a complex adult organism composed of many different cells and tissues? What controls the fate of each cell, instructing a cell to become, for example, a brain cell or a liver cell? How do cells organize into discrete tissues? How is the body plan of an organism determined? Answering such fundamental questions has been a major focus of developmental biology for more than a century. The pace of discovery has accelerated dramatically in the last 10 years, and these discoveries are helping us to understand the causes of human malformations and genetic syndromes.

For ethical and technical reasons, it is difficult to study early developmental events in human embryos. Consequently, a variety of nonhuman model organisms are used to facilitate the study of development (Table 10-1). This approach is feasible because the major elements (genes and pathways) that control animal development are conserved across a wide range of species and body plans. In addition, many regulatory switches and signaling pathways are used repeatedly during development to control various patterning and differentiation events. This underscores the point that the evolution of species proceeds, in part, by continual tinkering with similar developmental programs to effect changes in an organism's phenotype.

For example, ectopic expression (i.e., expression of the gene product in an abnormal location) of the *Drosophila* gene, *eyeless*, results in the formation of a wellformed but misplaced eye. Mice have a homologous gene, Pax6,* in which mutations can produce abnormally small eyes. When inserted ectopically into *Drosophila*, Pax6 again produces a misplaced fly eye. Mutations in the human homolog, PAX6, cause defects of the eye such as cataracts and aniridia (absence of the iris). PAX6, Pax6, and *eyeless* are homologous genes that encode DNA transcription factors (see Chapter 3). Although the ancestors of *Drosophila* and mouse diverged from the lineage leading to humans 500 and 60 million years ago, respectively, the genes and pathways involved in development of the eye have been conserved. www

Approximately 2% to 3% of babies are born with a recognizable birth defect. Some birth defects are caused by mutations in genes encoding elements in pathways that control development. These pathways are highly conserved among animal species. Thus, stud-

^{*}It is conventional to capitalize all letters of the names of human genes but only the first letter of the names of mouse genes, except for recessive mutations, which begin with a lower-case letter.

^{*} An infant is an individual who is less than 1 year of age.

Organism Generation time*		Advantages	Disadvantages
<i>Caenorhabditis</i> <i>elegans</i> (roundworm)	9 days	Fate of every cell known Genome well characterized Easy to breed and maintain	Alternative body plan compared to vertebrates Targeted mutagenesis not yet possible Tissues cannot be cultured
Drosophila melanogaster (fruit fly)	10 days	Easy to breed Large populations Vast database of mutants	Alternative body plan compared to vertebrates Must be stored live; cannot be frozen
Danio rerio (zebrafish)	3 months	Transparent embryo Easy to maintain large populations	Small size of embryo makes manipulation difficult
Xenopus laevis (frog)	12 months	Transparent embryo is large and easy to manipulate	Tetraploid genome makes genetic experiments difficult
Gallus gallus (chicken)	5 months	Easy to observe and manipulate embryo	Genetic experiments difficult
<i>Mus musculus</i> (mouse)	2 months	Easy to breed Large populations Many different strains available Dense genetic maps available Large regions of genome syntenic with human chromosomes	Relatively expensive to maintain Manipulation of embryo is challenging
Papio bamadryas (baboon)	60 months	Physiology similar to that of humans Genetic linkage map complete	Very expensive to maintain Small populations Long generation lines

TADLE TO.T Annual mouchs of numan Development	TA	BLE	10.1	Animal	Models of	f Human	Development
---	----	-----	------	---------------	-----------	---------	-------------

*Generation time is defined as the age at which the organism is first capable of reproduction.

ies of nonhuman animal models are invaluable for understanding human development and the causes of birth defects. processes is controlled by a series of proteins that provide signals and form structures necessary for normal development of the embryo.

A Brief Overview of Major Processes in Embryonic Development

Several major processes are involved in the development of the embryo. These include axis specification, pattern formation, and organogenesis. As the name suggests, pattern formation describes a series of steps in which differentiated cells are arranged spatially to form tissues and organs. The interactions of these cells are mediated by processes such as induction, which occurs when the cells of one embryonic region influence the organization and differentiation of cells in a second region. Axis specification involves the definition of the major axes of the body: ventral/dorsal, anterior/posterior, medial/lateral, and left/right. Specification of polarity (direction) is an important part of this process. As the axes are specified, the formation of organs and limbs (organogenesis) begins. Each of these major processes involves many different proteins that form structures and provide signals to coordinate the development of the embryo. The major types of these proteins, and the genes that encode them, are described next.

GENETIC MEDIATORS OF DEVELOPMENT: THE MOLECULAR TOOLBOX

The genes required for normal development encode many different products, including signaling molecules and their receptors, DNA transcription factors, components of the extracellular matrix, enzymes, transport systems, and other proteins. Each of these genetic mediators is expressed in combinations of spatially and temporally overlapping patterns that control different developmental processes. As detailed in this chapter, mutations in the genes mediating development are a common cause of human birth defects (Table 10-2).

Paracrine Signaling Molecules

Interactions between neighboring cells are usually mediated by proteins that can diffuse across small distances to induce a response. These molecules are often called paracrine factors because they are secreted into the space surrounding a cell (unlike hormones, which are secreted into the bloodstream). Closely related paracrine factors have been isolated from a variety of organisms, making it clear that homologous molecules are utilized throughout the animal kingdom. To date, four major families of

Embryonic development involves the processes of pattern formation, axis specification, and organogenesis. Each of these

TABLE 10.2 🔳 Genes That Cause Human Birth Defects

Gene	Type of protein	Syndrome	Birth defects
BOR1	Transcription factor	Branchio-oto-renal	External ear anomalies, hearing loss, kidney defect
COL2A1	Extracellular matrix protein	Stickler	Skeletal dysplasia, cleft palate, nearsightedness
EMX2	Transcription factor	Schizencephaly	Clefting of the cerebral cortex
EVC	Transcription factor	Ellis-van Creveld	Skeletal dysplasia, extra digits, heart defects
GLI3	Transcription factor	Greig	Premature fusion of the cranial sutures, extra digits
GLI3	Transcription factor	Pallister-Hall	Hypothalamic hamartomas, extra digits
GLI3	Transcription factor	Polydactyly type A	Extra posterior digits
HOXA13	Transcription factor	Hand-foot-genital	Hypoplasia of the first digits, kidney and genital defects
HOXD13	Transcription factor	Synpolydactyly	Extra digits that are often fused with other digits
IHH	Signaling molecule	Brachydactyly A1	Short fingers and toes
IRF6	Transcription factor	van der Woude	Cleft lip/palate with lip pits
IRF6	Transcription factor	Popliteal pterygium	Cleft lip/palate, webbing across joints
KIT	Receptor molecule	Piebaldism	Hypopigmented patches of skin
LMX1	Transcription factor	Nail-patella	Anomalies of bones, kidneys, fingernails
MITF	Transcription factor	Waardenburg	Hypopigmentation, hearing impairment
MSX1	Transcription factor	_	Cleft lip/palate, missing teeth
NOG	Extracellular protein	Multiple synostosis	Abnormal fusion of bones, hearing loss
TP63	Transcription factor	Ectrodactyly/ectodermal dysplasia	Limb, teeth, hair defects
PAX2	Transcription factor	_	Kidney and optic nerve defects
PAX3	Transcription factor	Waardenburg	Hypopigmentation, hearing impairment
PAX6	Transcription factor	Aniridia	Hypoplasia or aplasia of the irides
PAX9	Transcription factor	Oligodontia	Missing teeth
ROR2	Receptor molecule	Robinow	Short forearms and digits
RIEG1	Transcription factor	Rieger	Defects of teeth, eyes, and umbilicus
SALL1	Transcription factor	Townes-Brocks	Anal, kidney, limb, and ear defects
SALL4	Transcription factor	Okihiro	Limb, heart, and ocular defects
SHH	Signaling molecule	Holoprosencephaly	Lack of midline cleavage of the brain
SOX9	Transcription factor	Campomelic dysplasia	Skeletal defects, sex reversal
SOX10	Transcription factor	Hirschsprung	Bowel hypomotility
TBX3	Transcription factor	Ulnar-mammary	Posterior upper limb anomalies, breast and genital anomalies
TBX5	Transcription factor	Holt-Oram	Anterior upper limb anomalies, heart defects
TBX22	Transcription factor		Ankyloglossia, cleft palate
TCOF1	Transcription factor	Treacher Collins	Mid-face hypoplasia, small jaw, external ear defects
WT1	Transcription factor	Denys-Drash	Kidney defects, sex reversal
DHCR7	Catalytic enzyme	Smith-Lemli-Optiz	Mental retardation, syndactyly, multiple organ defects

paracrine signaling molecules have been described: (1) the Fibroblast Growth Factor (FGF) family; (2) the Hedgehog family; (3) the Wingless (Wnt) family; and (4) the Transforming Growth Factor β (TGF- β) family. Each of these signaling molecules binds to one or more receptors to effect a response, and mutations in genes encoding these molecules may lead to abnormal communication between cells. Clinical Commentary 10-1 dis-

cusses the FGF family and associated receptors; the other three families are described in this section.

The first member of the Hedgehog family was originally isolated in a *Drosophila* mutant that has bristles in an area that is naked in the normal fly (hence, it was named *hedgehog*). Vertebrates have several homologs of *hedgehog*, the most widely used of which is termed *Sonic hedgehog* (*Shb*). Among its many roles, Shh participates in axis

CLINICAL COMMENTARY 10.1

Disorders of Fibroblast Growth Factor Receptors

Fibroblast growth factor receptors (FGFRs) are highly homologous glycoproteins with a common structure consisting of a signal peptide (an amino acid sequence that helps to direct the protein to its proper cellular location), three immunoglobulin-like (Ig-like) domains, a membrane-spanning segment, and an intracellular tyrosine kinase domain (Fig. 10-1). FGFRs are receptors for at least 22 fibroblast growth factors (FGFs) that participate in a wide variety of biological processes, including cell migration, growth, and differentiation. With varying affinities, FGFs bind FGFRs, leading to phosphorylation, and hence activation, of the tyrosine kinase domain.

FGFRs are widely expressed in developing bone, and many common human autosomal dominant disorders of bone growth (i.e., skeletal dysplasias) are caused by mutations in FGFR genes. The most prevalent of these disorders is achondroplasia (ACH), which is characterized by disproportionate short stature (i.e., the limbs are disproportionately shorter than the trunk) and macrocephaly (see Chapter 4). Nearly all individuals with ACH have a glycine \rightarrow arginine substitution in the transmembrane domain of FGFR3 (see Fig. 10-1), resulting in constitutive FGFR3 activation. www

FGFR3 is normally expressed in resting chondrocytes, where it restrains chondrocyte proliferation and differentiation. In mice, FGFR3-inactivating mutations cause expansion of the zones of proliferating cartilage and increased long bone growth. Overactivation causes inhibition of chondrocyte growth, producing skeletal defects. The degree of FGFR3 activation, which may vary depending on the domain that is altered, corresponds to the severity of long bone

FIGURE 10.1 Schematic drawing of fibroblast growth factor 3 receptor (FGFR3) protein. Important functional domains of FGFR3 include a signal peptide (SP), three immunoglobulin-like (Ig) domains, an acid box (AB), a transmembrane (TM) domain, and a split tyrosine kinase (Kinase) domain. The locations of point mutations causing achondroplasia (A; gray), hypochondroplasia (H; dark blue), and thanatophoric dysplasia (T; light blue) are indicated. Photographs of children with mutations in FGFR3: A, A boy with hypochondroplasia. He has mildly short limbs relative to his trunk. B, An infant with thanatophoric dysplasia, the most common of the so-called "lethal skeletal dysplasias." He has markedly shortened limbs and a very narrow thoracic cage. C, A young girl with achondroplasia. She has short limbs relative to the length of her trunk, resulting in redundant skin folds in the arms and legs, a prominent forehead, and a depressed nasal root.

(Modified from Webster MK, Donoghue DJ [1997] FGFR activation in skeletal disorders: too much of a good thing. Trends Genet 13:178-182.)

Je -

CLINICAL COMMENTARY 10.1 Disorders of Fibroblast Growth Factor Receptors—cont'd

shortening. Lesser degrees of activation result in the milder skeletal abnormalities observed in hypochondroplasia, while markedly increased activation causes a virtually lethal disorder called thanatophoric dysplasia.

Abnormal bone growth is also a feature of a group of disorders characterized by premature fusion (synostosis) of the cranial sutures, misshapen skulls, and various types of limb defects. Collectively, these disorders are called craniosynostosis syndromes. Mutations in FGFR1, FGFR2, and FGFR3 cause at least five distinct craniosynostosis disorders (Table 10-3). The same mutation can sometimes cause two or more different craniosynostosis syndromes. For example, a cysteine \rightarrow tyrosine substitution in FGFR2 can cause either Pfeiffer or Crouzon syndrome. This suggests that additional factors, such as modifying genes, are partly responsible for creating different phenotypes. www

TABLE 10.3 Craniosynostosis Syndromes Caused by Mutations in Fibroblast Growth Factor Receptors

Gene	Syndrome	Characteristics
FGFR1	Pfeiffer	Broad first digits, hypertelorism
FGFR2	Apert Pfeiffer Crouzon Beare-Stevenson Jackson-Weiss	Fusion of digits, mid-face hypoplasia Broad first digits, hypertelorism Mid-face hypoplasia, ocular proptosis Mid-face hypoplasia, corrugated skin Mid-face hypoplasia, foot anomalies
FGFR3	Crouzon Nonsyndromic craniosynostosis	Mid-face hypoplasia, ocular proptosis, acanthosis nigricans* Digital defects, hearing loss

*Acanthosis nigricans is characterized by hyperplastic and hypertrophic skin of varying pigmentation, most often covering the axillae, neck, genitalia, and flexural surfaces.

specification, induction of motor neurons within the neural plate, and patterning of the limbs. One of the receptors of Shh is a transmembrane protein encoded by a gene called patched. Binding of Shh to the patched receptor suppresses transcription of genes encoding members of the TGF-B and Wnt families and inhibits growth. Mutations in the human homolog, cell PATCHED (PTC), cause Gorlin syndrome, a disorder characterized by rib anomalies, cysts of the jaw, and basal cell carcinomas (a form of skin cancer). Mutations in PTC have also been found in sporadic basal cell carcinomas. Thus, germline mutations in PTC alter the regulation of developing cells to cause birth defects, while somatic mutations in PTC can alter the regulation of terminally differentiated cells to cause cancer. www

The Wnt family of genes is named after the *Drosophila* gene *wingless* and one of its vertebrate homologs, *integrated*. The *wingless* gene establishes polarity during *Drosophila* limb formation, and members of the Wnt family play similar roles in vertebrates. Wnt genes encode secreted glycoproteins that bind to members of the *frizzled* and low-density lipoprotein (LDL) receptor-

related protein families. In humans, 19 different Wnt genes have been identified, and they participate in a wide variety of developmental processes, including specification of the dorsal/ventral axis and formation of the brain, muscle, gonads, and kidneys. Although no human developmental defects are known to be caused by mutations in Wnt genes, abnormal Wnt signaling has been associated with the formation of tumors.

The TGF- β supergene family^{*} is composed of a large group of structurally related genes that encode proteins that form homodimers or heterodimers. Members of the TGF- β supergene family include the TGF- β family itself, the bone morphogenetic protein (BMP) family, the activin family, and the Vg1 family. Although the role of BMPs is not limited to bone development, members of the BMP family were originally isolated because of their ability to induce bone formation.

Mutations in a member of the BMP family, cartilagederived morphogenetic protein 1 (CDMP1), cause various

^{*}A supergene family is a group of related gene families.

skeletal abnormalities. Different mutations can produce distinct phenotypes (allelic heterogeneity; see Chapter 4). For example, a nonsense mutation in CDMP1 causes dominantly inherited brachydactyly (short digits). Individuals homozygous for a 22-bp duplication in CDMP1 have brachydactyly as well as shortening of the long bones of the limbs in an autosomal recessive disorder called acromesomelic dysplasia. A homozygous missense mutation produces autosomal recessive Grebe chondrodysplasia, also characterized by severe shortening of the long bones and digits. The mutant protein is not secreted, and it is thought to inactivate other BMPs by forming heterodimers with them and preventing their secretion. Thus, mutations causing Grebe chondrodysplasia produce a novel type of "dominant negative" effect by inactivating the products of other genes. www

Other secreted proteins inhibit the function of BMPs. In humans, mutations in the gene encoding one of these inhibitors, *Noggin*, cause fusion of the bones in various joints. In some affected individuals, the joints initially appear to be normal. However, they are progressively obliterated by formation of excess cartilage that ultimately fuses the bones of the joint together (i.e., a synostosis) as the individual ages. The primary joints affected are those of the spine, the middle ear bones, and the limbs, particularly the hands and feet. Affected individuals develop progressively limited movement of these joints and develop hearing loss.

Paracrine signaling molecules are secreted, diffuse a short distance, and bind to a receptor that effects a response. There are four major families of paracrine signaling molecules: (1) the fibroblast growth factor (FGF) family; (2) the Hedgehog family; (3) the Wingless (Wnt) family; and (4) the Transforming Growth Factor β (TGF- β) family.

DNA Transcription Factors

There are many different ways to regulate the expression of a gene. For example, a gene may not be transcribed, the rate of transcription may be altered, or the transcribed mRNA may not be translated into protein. As discussed in Chapter 2, genes encoding proteins that turn on (activate) or turn off (repress) other genes are called transcription factors. Transcription factors commonly do not activate or repress only a single target. Often they regulate the transcription of many genes that, in turn, regulate other genes in a cascading effect. Consequently, mutations in transcription factor genes typically have pleiotropic effects.

There are many different families of transcription factors, members of which commonly share specific properties such as a common DNA-binding domain. Members of these different families have pivotal roles in controlling development, and alterations can cause birth defects. Examples include homeobox-containing genes such as the HOX, PAX, EMX, and MSX families; high-mobility group (HMG)-box–containing genes such as the SOX family; and the T-box family.

As described in Chapter 2, the HMG domain of SOX proteins appears to activate transcription indirectly by bending DNA so that other factors can make contact with promoter regions of genes. Several SOX genes act in different developmental pathways. The prototypic SOX gene is the SRY (sex-determining region of the Y chromosome) gene, which encodes the mammalian testis-determining factor (see Clinical Commentary 6-2 in Chapter 6). Sox9 is expressed in the genital ridges of both sexes, but it is up-regulated in males and downregulated in females prior to differentiation of the gonads. Furthermore, Sox9 regulates chondrogenesis and the expression of Col2A1, a collagen gene (see Chapter 2). As might be predicted from these expression and interaction patterns, mutations in SOX9 cause a disorder characterized by skeletal defects (campomelic dysplasia) and sex reversal that produces XY females. Mutations in a related gene, SOX10, result in a syndrome characterized by Hirschsprung disease (hypomotility of the bowel caused by a reduced number of enteric nerve cells), pigmentary disturbances, and deafness (Clinical Commentary 10-2). www

There are many different families of transcription factors, each of which regulates the transcription of specific genes. The same transcription factor is often used in different developmental pathways. Thus, disorders caused by mutations in genes encoding transcription factors are often pleiotropic.

Extracellular Matrix Proteins

Extracellular matrix proteins (EMPs) are secreted macromolecules that serve as scaffolding for all tissues and organs. These molecules include collagens, fibrillins, proteoglycans, and large glycoproteins such as fibronectin, laminin, and tenascin. EMPs are not simply passive structural elements. By separating adjacent groups of cells and forming matrices on which cells may migrate, they are active mediators of development. For example, the proteins encoded by *fibrillin-1* and *elastin* coordinate microfibril assembly in the extracellular matrix. Mutations in these two genes result in Marfan syndrome (see Chapter 4) and supravalvular aortic stenosis (see Chapter 6), respectively. Both of these conditions are characterized by abnormalities of the heart and/or large blood vessels. www

To facilitate cell migration, EMPs must transiently adhere to a cell's surface. This is commonly accomplished by two families of cell surface receptors: integrins and glycosyltransferases. Integrins are so named because they integrate the extracellular matrix and the cytoskeleton, allowing them to function in tandem. Attachment between cells and the extracellular matrix can be more

CLINICAL COMMENTARY 10.2

Defects of Neural Crest Development

During neurulation, neural crest cells migrate from the neuroepithelium along defined routes to tissues, where they differentiate into various cell types (Fig. 10-2). One fate of neural crest cells is to populate the small and large bowel (i.e., the enteric tract) with nerve cells to create the enteric nervous system. These cells partly control and coordinate the normal movements of the enteric tract that facilitate digestion and transport of bowel contents. Reduced or absent nerve cells in the enteric tract causes a disorder called Hirschsprung disease (HSCR).

HSCR occurs in approximately 1/5,000 live births, although its incidence varies among ethnic groups. Additionally, there is a sex bias, with males affected four times as often as females. The major characteristic of HSCR is hypomotility of the bowel, which leads to severe constipation. The disease often presents in the newborn period, although it is also found in children and sometimes adults. If untreated, bowel hypomotility can lead to obstruction and gross distention of the bowel. Consequently, HSCR was formerly termed "congenital megacolon." www

In approximately 70% of cases, HSCR occurs as an isolated trait and affected individuals have no additional problems. However, HSCR is also a well-recognized feature of many multiple birth defect syndromes, such as trisomy 21 and Waardenburg syndrome. For the last few decades, HSCR has been considered an example of a disorder that fits a multifactorial model of inheritance (i.e., caused by a combination of genes plus environmental factors; see Chapter 12). However, it has become clear that half of all cases of familial HSCR and 15% to 20% of sporadic cases are caused by mutations in one of at least eight different genes. Study of these genes provides us with a window through which we can observe the development of neural crest cells.

Most commonly, HSCR is caused by mutations that inactivate the *RET* (REarranged during Transfection) gene, which encodes a receptor tyrosine kinase (other mutations in *RET* have been associated with cancer; see Chapter 11). More than 80 different mutations have been found, including missense and nonsense mutations as well as deletions encompassing the *RET* gene. Thus, haploinsufficiency is the most likely mechanism by which mutations in *RET* cause HSCR. Only 50% of familial cases and 15% to 20% of isolated cases of HSCR have been found to have mutations in *RET*. The penetrance of *RET* mutations is higher in males than in females, suggesting that sexspecific modifiers of the phenotype might exist.

FIGURE 10.2 Fates of selected populations of neural crest cells migrating from different levels along the anterior/posterior axis of the developing embryo. Appropriate fate of neural crest derivatives is dependent on normal cell migration and terminal differentiation. Defects of neural crest cells can cause Hirschsprung disease or Waardenburg-Shah syndrome (see text).

Normal signaling through RET appears to be required for neural crest migration into the distal portions of the bowel and for differentiation into nerve cells. One ligand for RET is glial cell line derived neurotrophic factor (GDNF).

Mutations of another cell membrane receptor, endothelin-B (EDNRB), or its ligand, endothelin-3 (EDN3), also cause HSCR. Penetrance appears to vary by sex and genotype. In a large Mennonite com-

CLINICAL COMMENTARY 10.2 Defects of Neural Crest Development—cont'd

munity, individuals homozygous for an EDNRB mutation were four times more likely to develop HSCR than were heterozygous individuals. In addition to HSCR, some individuals with mutations in either EDNRB or EDN3 have melanocyte abnormalities that produce hypopigmented patches of skin and sensorineural hearing loss (normal melanocytes are required for auditory development). This disorder is called the Waardenburg-Shah syndrome. Thus, normal EDNRB and EDN3 signaling is required for the

development of neural crest cells into enteric nerve cells and melanocytes.

More recently, mutations in the SOX10 transcription factor gene have been found in individuals with Waardenburg-Shah syndrome. Disruption of the homologous mouse gene, Sox10, causes coat spotting and aganglionic megacolon. Although SOX genes are involved in many different biological processes, the role of SOX10 in neural crest cell development remains to be determined.

permanent as well. Because of an inability of epithelial cells to properly anchor themselves to the basement membrane, the skin of individuals with autosomal recessive junctional epidermolysis bullosa (JEB) spontaneously forms large blisters. JEB is caused by mutations in LAMC2, a gene that encodes a subunit of laminin. www

EMPs are secreted macromolecules that serve as a dynamic scaffolding for tissues and organs. They are also active mediators of development.

PATTERN FORMATION

The process by which ordered spatial arrangements of differentiated cells create tissues and organs is called pattern formation. The general pattern of the animal body plan is laid down during embryogenesis. This leads to the formation of semiautonomous regions of the embryo, in which the process of pattern formation is repeated to form organs and appendages. Such regional specification takes place in several steps: (1) definition of the cells of a region, (2) establishment of signaling centers that provide positional information, and (3) differentiation of cells within a region in response to additional cues. For example, cells in the developing vertebrate upper limb differentiate into many cell types, including muscle (myocytes), cartilage (chondrocytes), and bone cells (osteocytes). However, these cells must also be arranged in a temporal-spatial pattern that creates functional muscle and bone. Additional information is required to determine whether a bone becomes an ulna or a humerus. How do particular structures develop in specific places? How do cells acquire information about their relative positions? Answering such questions is an area of intense investigation.

For pattern formation to occur, cells and tissues com-

municate with each other through many different signaling pathways. It has become clear that these pathways are used repeatedly and are integrated with one another to control specific cell fates (i.e., the eventual location and function of the cell). For example, the Shh protein is involved in patterning of the vertebrate neural tube, somites, and limbs, as well as the way the left side is distinguished from the right. Point mutations in the human Shh gene, SHH, can cause abnormal midline brain development (holoprosencephaly; Fig. 10-3), severe mental retardation, and early death. (Not all affected individuals have holoprosencephaly, however; some have only minor birth defects, such as a single upper central incisor.) Attachment of the SHH protein to cholesterol appears to be necessary for proper patterning of hedgehog signaling. This may partly explain how midline brain defects could be caused by some environmental substances that inhibit embryonic cholesterol biosynthesis and by genetic disorders of cholesterol metabolism (e.g., Smith-Lemli-Opitz syndrome). www

The process by which ordered spatial arrangements of differentiated cells create tissues and organs is called pattern formation. Regional specification takes place in several steps: (1) definition of the cells of a region, (2) establishment of signaling centers that provide positional information, and (3) differentiation of cells within a region in response to additional cues.

Gastrulation

Gastrulation is the process of cell and tissue movements whereby the cells of the blastula are rearranged so that they have new positions and neighbors. In the human embryo, gastrulation occurs between days 14 and 28 of gestation. In this process, the embryo is transformed into a three-layer (trilaminar) structure composed of three germ layers: ectoderm (outer layer), endoderm (inner

FIGURE 10.3 Postmortem photograph of a neonate with holoprosencephaly (failure of the forebrain to completely separate). Note the sloping forehead, reduced midline scalp hair, small and closely spaced palpebral fissures, single nostril (proboscis), and small mouth. Holoprosencephaly can be caused by mutations in *Sonic hedgehog* that produce abnormal formation of the dorsal/ventral axis.

(Courtesy of Dr. Edward Klatt, Florida State University.)

layer), and mesoderm (middle layer) (Fig. 10-4). The formation of these layers is a prerequisite for the next phase of development, organogenesis. The major structural feature of mammalian gastrulation is the **primitive streak**, which appears as a thickening of epiblast tissue extending along the anterior-to-posterior axis (Fig. 10-5). In placental animals such as humans, gastrulation includes formation of the extraembryonic tissues. As might be predicted, the process of gastrulation is dominated by cell migration. Thus, many of the genes expressed during gastrulation encode proteins that facilitate cell movement.

Neurulation and Ectoderm

Once a trilaminar embryo is formed, the dorsal mesoderm and the overlying ectoderm interact to form the hollow neural tube. This event, called **neurulation**, is mediated by induction. In amphibians, induction of the neural tube and transformation of the flanking mesoderm to create an embryo with clear anterior/posterior and dorsal/ventral axes is controlled by a group of cells known as the Spemann-Mangold organizer. A number of proteins are expressed almost exclusively in the organizer. Chordin is a secreted protein that prevents dorsalized mesoderm from being ventralized. Another secreted protein, Noggin, induces neural tissue from dorsal ectoderm and dorsalizes the mesoderm. Understanding the major functions of the organizer and the molecules that mediate these functions is an area of active investigation.

Neurulation is a critical event in development because it initiates organogenesis and divides the ectoderm into three different cell populations: (1) the neural tube, which will eventually form the brain and spinal cord, (2) the epidermis of the skin, and (3) the neural crest cells. In humans, neural tube closure begins at five separate sites, which correspond to the locations of common neural tube defects such as anencephaly (absence of the brain), occipital encephalocele, and lumbar spina bifida (see Chapter 12). Neural crest cells migrate from the neuroepithelium along defined routes to tissues, where they differentiate into cell types such as sensory neurons, melanocytes, neurons of the small bowel, and smooth muscle cells (see Clinical Commentary 10-2). www

Induction is the process by which cells of one embryonic region influence the organization and differentiation of cells in a second embryonic region. Neurulation initiates organogenesis and induces the ectoderm to divide into the neural tube and neural crest cells. Defects of neural tube closure and neural crest migration or differentiation cause birth defects.

Mesoderm and Endoderm

The formation of a layer of mesoderm between the endoderm and ectoderm is one of the major events in gastrulation. Mesoderm can be divided into five components: the notochord; the dorsal, intermediate, and lateral mesoderms; and head **mesenchyme**.* The notochord is a transient midline structure that induces the formation of the neural tube and body axis. The adjacent dorsal mesoderm on either side of the notochord differentiates into elements that form the axial skeleton, skeletal muscles, and connective tissue of the skin. Intermediate mesoderm forms the kidneys and genitourinary system. Lateral plate mesoderm differentiates into the heart, the appendicular skeleton, the connective tissue of viscera

Human gastrulation is characterized by cell and tissue movements that result in the formation of three germ layers: ectoderm, endoderm, and mesoderm. The major structural feature of mammalian gastrulation is the primitive streak.

^{*}Mesenchyme is tissue that forms the connective tissues, blood vessels, and lymphatic vessels.

FIGURE 10.4 Human gastrulation. **A**, Sagittal section through the midline of an embryo embedded in the uterine lining. **B**, Dorsal surface of an embryo exposed by removing part of the embryonic mesoderm surrounding the amniotic cavity and yolk sac. Arrows denote ingressing epiblast cells. On days 14 to 15, epiblast cells replace hypoblast cells to form endoderm. A day later, migrating epiblast cells are creating a layer of mesoderm.

and the body wall, and the connective tissue elements of the amnion and chorion. Finally, the muscles of the eyes and head arise from head mesenchyme.

The primary function of embryonic endoderm is to form the linings of the digestive tract and the respiratory tree. Outgrowths of the intestinal tract form the pancreas, gallbladder, and liver. A bifurcation of the respiratory tree produces the left and right lungs. The endoderm also produces the pharyngeal pouches, which, in conjunction with cells derived from the neural crest, give rise to endodermal-lined structures such as the middle ear, thymus, parathyroids, and thyroid.

A process common to endoderm-derived structures is budding and branching. This process appears to be controlled, in part, by FGFs, BMPs, and their respective receptors. Mutations in *fibroblast growth factor receptor 3* (FGFR3), one of four FGFRs, cause three different skeletal dysplasias (see Clinical Commentary 10-1). The most severe of these, thanatophoric dysplasia, is caused by mutations that activate FGFR3, resulting in shortened long bones, a poorly developed vertebral column, a small thoracic cage, and a relatively large skull. Children with thanatophoric dysplasia may also have pulmonary hypoplasia and brain anomalies, suggesting that FGFR3plays a role in formation of the lung and brain. www

Formation of a layer of mesoderm between endoderm and ectoderm is one of the major events of gastrulation. Mesoderm contributes to the formation of the skeleton, urogenital system, and limbs. Endoderm lines the digestive and respiratory tracts and forms visceral organs and the lungs.

Axis Specification

Animal body plans have evolved into a wide variety of symmetries. Some animals, such as the volvox, are completely symmetrical. Other animals (e.g., starfish) exhibit only a dorsal/ventral symmetry. Many animals, such as worms, add an anterior/posterior axis. All chordates (animals that develop a notochord) have a third axis that is perpendicular to the first two, the left/right axis. Specification and formation of these axes are critical events in development because they determine the orientation of the body plan. The proteins mediating these processes are rapidly being discovered. Many of these mediators have additional roles in patterning of the body plan and tissues.

Formation of the Anterior/Posterior Axis

The anterior/posterior axis of a developing mammalian embryo is defined by the primitive streak. At the anterior end of the primitive streak is a structure called the node. Expression of a gene called *nodal* is required for initiation and maintenance of the primitive streak; later in gastrulation, its expression is important in forming the left/right axis (Clinical Commentary 10-3).

CLINICAL COMMENTARY 10.3

Laterality Defects: Disorders of the Left/Right Axis

Left/right (L/R) asymmetry is common in nature. For example, all animals utilize only L-amino acids and Dsugars. Likewise, all vertebrates have asymmetrical structures that are consistently oriented L/R of the midline. For example, looping of the heart tube toward the right, the first observable sign of L/R asymmetry in the embryo, is seen in all chordates. How did L/R asymmetry evolve? How and when is L/R asymmetry established? Substantial progress is being made toward understanding the molecular basis of L/R asymmetry so that answers may be obtained for these questions. This is important because disorders of L/R asymmetry (i.e., laterality defects) are found in approximately 1/10,000 live births. The final position of asymmetrically placed vertebrate structures is determined by at least three different mechanisms. Unpaired organs in the chest and abdomen (e.g., heart, liver) begin their development in the midline and then lateralize to their adult positions. The mirror image of a paired structure may regress, leaving a lateralized, unpaired structure (e.g., some blood vessels). Some organs (e.g., lungs) begin as asymmetrical outgrowths from a midline structure. It is unknown whether the molecular basis of laterality determination differs among these mechanisms. Disorders of L/R asymmetry can cause randomization (*situs ambiguus*) or L/R reversal of organ position (*situs inversus*) (Fig. 10-5). These defects may be limited to a

FIGURE 10.5 Abnormalities of left/right (L/R) asymmetry in humans. **A**, The normal L/R positions of organs arranged along midline (*situs solitus*). The apex of the heart points toward the left. The right lung is trilobed and the left lung is bilobed. In the abdominal cavity, the spleen and stomach are positioned on the left side and the liver is on the right. The small bowel is looped in a counterclockwise direction. **B**, A complete mirror image of organ arrangement along the midline is called *situs inversus*. Individuals with situs inversus may not be symptomatic. **C**, Randomization of the arrangement of the heart, lungs, liver, spleen, and stomach along the midline (*situs ambiguus*, or heterotaxy). Situs ambiguus is often associated with congenital heart defects. Situs inversus and situs ambiguus can be caused by mutations in *ZIC3*.

CLINICAL COMMENTARY 10.3 Laterality Defects: Disorders of the Left/Right Axis—cont'd

single organ (as with a right-sided heart, or dextrocardia), or they may include many organs with L/R asymmetry (e.g., stomach and spleen). www

Initially, establishment of L/R asymmetry requires a mechanism that generates asymmetry. Studies of chick and frog embryos suggest that this is accomplished by a cascade of signaling molecules beginning with asymmetrical expression of Sonic hedgehog (Shh) from the notochord. This results in left-sided expression of a member of the TGF- β family called *nodal*, which is responsible for rightward looping of the heart tube. L/R expression of nodal is randomized in a naturally occurring mouse mutant that exhibits a form of randomized organ asymmetry called inversus viscerum. This phenotype is caused by mutations in a gene that encodes dynein, a component of the motor that drives ciliary movement. Defects of dynein have also been described in humans with immotile cilia and a reversal of L/R asymmetry (Kartagener syndrome).

Mutations in *zinc-finger protein of the cerebellum* (ZIC3), a member of the Gli transcription factor family located on the X chromosome, have been identified in humans with laterality defects. Affected males exhibit randomization defects, while some carrier females have L/R reversal. In *Drosophila*, some members of the Gli family are known to be regulated by forming a

Patterning along the anterior/posterior axis is controlled by a cluster of genes that encode transcription factors containing a DNA-binding domain of approximately 60 amino acids called the homeodomain. These genes compose the homeotic gene complex (HOM-C) in Drosophila, the organism in which they were first isolated through mutation identification (a classic example of such a mutation, termed antennapedia, disturbs axis patterning so that antennae are replaced by legs). Four copies of HOM-C (HoxA through HoxD) are found in the human and the mouse (Fig. 10-6). There are 39 Hox genes, and each 100-kb gene cluster is located on a different chromosome. Mammalian Hox genes are numbered from 1 to 13, although not every cluster contains 13 genes. Equivalent genes in each complex (e.g., Hoxa13, Hoxc13, Hoxd13) are called paralogs.

Hox genes are expressed along the dorsal axis from the anterior boundary of the hindbrain to the tail. Within each cluster, 3' Hox genes are expressed earlier than 5' Hox genes (temporal colinearity). Also, the 3' Hox genes are expressed anterior to the 5' Hox genes (spatial colinearity). Thus, *Hoxa1* expression occurs earlier and in a more anterior location than does the expression of *Hoxa2* (see Fig. 10-6). These overlapping domains of

complex with costal2, a motor molecule similar to dynein. Because of these similarities, it has been suggested that ZIC3 and dynein may interact in humans. This could explain how mutations in genes encoding dissimilar proteins could both cause human laterality disorders.

Once L/R asymmetry has been established in the early embryo, the left and right sides of individual organs must also be patterned. For example, two related transcription factors, dHAND and eHAND, play roles in patterning the right and left ventricles of the heart. In mice, homozygous mutation of *dHAND* produces animals that fail to form a right ventricle, indicating that *dHAND* participates in cardiac differentiation.

Abnormalities of L/R asymmetry are found more frequently in human conjoined twins than in singletons or dizygotic twins. Most commonly, it is the twin arising on the right side that exhibits randomization of the L/R information. It has been suggested that randomization of the right-sided twin is caused by inadequate signaling from the left-sided embryo. A candidate for this signaling molecule discovered in frogs is Vg1. This suggests a possible molecular pathway for the formation of birth defects in human conjoined twins. www

Hox gene expression produce combinations of codes that specify the positions of cells and tissues. Collectively these codes identify various regions along the anterior/posterior axis of the trunk and limbs. To study the role of different Hox genes in mammalian development, it has been common to produce a "knockout" mouse—a mouse that lacks a functional copy of the gene of interest (Box 10-1).

The anterior/posterior axis of a developing mammalian embryo is defined by the primitive streak and patterned by combinations of Hox genes. Collectively these combinations identify various regions along the anterior/posterior axis of the body and limbs. Disruption of Hox genes produces defects in body, limb, and organ patterning.

Formation of the Dorsal/Ventral Axis

Dorsal/ventral patterning of the vertebrate depends on the interaction between dorsalizing and ventralizing signals (Fig. 10-9). As previously mentioned, *noggin* and *chordin* are expressed in the amphibian organizer and encode secreted proteins that are capable of dorsalizing

Anterior 1 1 1 1 1+22 1+2 2 В 2 3 Hox b2 Hox b3 1+2Hox b2 1+2+3**b**3 **b**4 Hox Hox Posterior Hox Hox Axial Hox Axial structure expression code structure expression

FIGURE 10.6 A, Distribution of 39 Hox genes among clusters on four chromosomes in human (HOX) and mouse (Hox). Individual Hox genes are labeled from 1 (3') to 13 (5') within each cluster (A/a through D/d). Hox genes that share the same number but are located in different clusters are called paralogs (e.g., HOXA13 and HOXD13 are paralogs). Paralogs often exhibit more sequence homology than do different Hox genes in the same cluster. Hox genes are expressed from 3' to 5' along the anterior/posterior axis of the embryo, and Hox genes located 3' are expressed earlier than Hox genes located 5'. B, Schematic diagram of combinatorial codes of overlapping Hox gene expression domains along the anterior/posterior body axis. Hox codes determine the identity of each segment. Thus, if expression of Hoxb4 is eliminated (e.g., in a knockout), the combinatorial code in the third segment is altered from 1+2+3 to 1+2. This results in transformation of the third segment into another second segment. The transformation of one structure into another is called a homeotic transformation.

ventral mesoderm and restoring dorsal structures that have been ventralized. In contrast, *Bmp-4* is expressed ventrally and induces ventral fates, patterning the dorsal/ventral axis. Noggin and chordin bind directly to Bmp-4 to prevent it from activating its receptor. Thus, the organizer promotes dorsalization by repressing a ventralizing signal encoded by *Bmp-4*. This mechanism, in which a signal promotes one process by repressing another competing process, is a common feature of embryonic development.

Dorsal/ventral patterning of the embryo is an active process that is coordinated by signaling molecules and their antagonists.

Formation of Organs and Appendages

The formation of organs and limbs (organogenesis) occurs after gastrulation. Many of the proteins used dur-

ing this process are the same ones used earlier in embryonic development. As might be expected, however, a number of genes that were transcriptionally silent now become active. To date, most of the developmental genes known to cause human birth defects have prominent roles in this phase of development. This could represent an ascertainment bias, because mutations in genes that disrupt earlier developmental events may be lethal.

Craniofacial Development

Development of the craniofacial region is directly related to the formation of the underlying central nervous system. In mammalian embryos, neural crest cells from the forebrain and midbrain contribute to the nasal processes, palate, and mesenchyme of the first pharyngeal pouch. This mesenchyme forms the maxilla, mandible, incus, and malleus. The neural crest cells of the anterior hindbrain migrate and differentiate to become the mes-

BOX Animal Models in the Study of Human Development

There are significant obstacles to the study of genes that affect human development. Many of these genes are expressed embryonically, and it is difficult (or in some cases ethically undesirable) to analyze human embryos directly. Humans have relatively small family sizes and a long generation length. And human mating patterns are often not conducive to genetic study. For these and other reasons, animal models of human diseases are a useful alternative to the direct study of the disease in humans.

The mouse is commonly used as an animal model of human disease because it is a well-understood and easily manipulated experimental system and because many developmental genes are conserved in most mammalian species. In some cases a naturally occurring mouse model of a human genetic disease may exist (e.g., dog and mouse models for muscular dystrophy), but natural mouse models are relatively uncommon. To overcome this difficulty, human genes can be inserted directly into mouse embryonic stem cells, which are then placed into mouse embryos to create a **transgenic** mouse (Fig. 10-7). The expression of the human gene can then be studied directly in mouse embryos. It is also possible to use **targeted disruption** to alter a specific mouse gene so that it is not expressed. This is termed a **knockout** model. Mice that are heterozygous for the disrupted gene can be bred to produce homozygotes. Many human genetic diseases have been studied using mouse knockouts, including neurofibromatosis type 1, Gaucher disease, Huntington disease, myotonic dystro-

FIGURE 10.7 Construction of an animal model. Blastocysts are collected from a pregnant mouse that has a marker that identifies its strain (e.g., light coat color). The inner cell mass is isolated. and embryonic stem (ES) cells are cultured. ES cells can be modified to introduce foreign genes (creating a transgenic animal) or to disrupt the normal function of an endogenous gene (creating a knockout animal). Genetically modified ES cells are implanted into blastocysts from a different mouse strain that has a marker recessive to the marker in the modified strain (e.g., dark coat color is recessive to light coat color). Modified blastocysts are injected into a pseudopregnant surrogate mouse. Development of introduced blastocysts results in chimeric animals with two populations of cells (i.e., some cells have the genetic modification and other cells do not). Chimeras can be detected by the presence of two markers in the same mouse (e.g., two different coat colors in the same mouse). Backcrossing of chimeras and mating of heterozygotes can produce mice that are homozygous for a genetic modification (e.g., a knockout), heterozygous for a genetic modification, or normal. (Modified from Strachan T, Read AP [1996] Human Molecular Genetics. Oxford. **Bios Scientific.)**

Animal Models in the Study of Human Development—cont'd

phy, fragile X syndrome, cystic fibrosis, and subtypes of Alzheimer disease.

In addition to their roles in morphogenesis and organogenesis, some genes are critical for early embryogenesis. Consequently, knocking out their function results in embryonic lethality. This makes it difficult to study the role of these genes using targeted disruption. One way to overcome this problem is to condition the disruption of a gene so that it takes place only in a certain type of cell (e.g., neural crest), in a specific tissue (e.g., the limb), or at a specific time during development. This is called a conditional knockout. For example, constitutional disruption of Fgf8 is lethal in early embryogenesis. To study the effect of inactivating Fgf8 in the limb, a mouse can be engineered such that the function of Fgf8 is disrupted only in the apical ectodermal ridge (AER) of the forelimb bud (Fig. 10-8). The result is a live-born mouse in which the forelimbs are severely truncated but all of the other organs and body areas are normal.

Animal models do not always mimic their human counterparts accurately. Sometimes this reflects differences in the interactions of gene products in the model system and the human. Such differences may account for the fact that a heterozygous mouse knockout of the retinoblastoma homolog (RB) develops pituitary tumors instead of retinoblastomas. In some cases the knockout has little detectable effect, possibly reflecting genetic redundancy: even though the expression of one gene product is blocked, a "backup" system may compensate for its loss. Thus, the mouse knockout of either Hoxall or Hoxdll alone has little phenotypic effect, but the simultaneous knockout of both genes produces a severe reduction in length of the radius and ulna. Despite these potential shortcomings, the introduction or disruption of genes in mice and other model systems can be a powerful approach for analyzing human genetic disease.

FIGURE 10.8 Conditional mutants that lack *Fgf8* expression in the apical ectodermal ridge (AER) of the forelimb. **A**, In situ hybridization demonstrating *Fgf8* expression (*dark band at tip of arrow*) in the AER of the developing limbs of a wild-type mouse. **B**, In the conditional mutant, no *Fgf8* is expressed in the forelimb (no dark band at tip of arrows), although it is expressed in the hindlimb bud. **C**, Normal forelimb in the wild-type mouse (*tip of arrow*). **D**, Severely hypoplastic limb in the conditional mutant (*tip of arrow*). (Courtesy of Dr. Anne Moon, University of Utah.)

enchyme of the second pharyngeal pouch and the stapes and facial cartilage. Cervical neural crest cells produce the mesenchyme of the third, fourth, and sixth pharyngeal arches (in humans the fifth pharyngeal arch degenerates). This mesenchyme becomes the muscles and bones of the neck. The fate of each group of neural crest cells is specified by Hox genes. For example, functional inactivation of *Hoxa3* results in mice with small or absent thymuses and thyroid and parathyroid glands, as well as malformations of the heart and major blood vessels. Although the number of neural crest cells in these mice is normal, they lack fate information and thus fail to proliferate and differentiate. These defects are similar to those found in children with deletions of chromosome 22q11 (see Chapter 6).

The bones of the skull develop directly from mes-

enchyme produced by neural crest cells. Complete fusion of these bones usually does not occur until adulthood. Premature fusion (synostosis) of the skull bones (craniosynostosis) causes the head to be misshapen and can impair brain growth. Often, craniosynostosis is associated with additional birth defects (e.g., hearing loss). Many of the craniosynostosis syndromes are caused by mutations in FGFR genes (see Clinical Commentary 10-1). Craniosynostosis also can be caused by mutations in *MSX2*, a transcription factor that may play a role in controlling the programmed death of neural crest cells in the skull. www

Craniosynostosis is also a feature of Greig cephalopolysyndactyly, a disorder caused by mutations of the gene encoding GLI3, a zinc-finger transcription factor. *GLI3* encodes at least seven conserved domains, including

FIGURE 10.9 ■ Schematic illustration of signals that dorsalize or ventralize mesoderm in the developing embryo. Noggin and chordin are secreted from cells in the node and bind to Bmp-4 to prevent it from activating its receptor. Because the ventralizing signal is blocked, mesoderm expressing chordin and noggin is dorsalized.

DNA-binding, zinc-finger, and microtubular anchor domains. Studies of the Drosophila homolog of GLI3 suggest that this gene may be regulated so that it can have either activator or repressor functions. Mutations causing Greig cephalopolysyndactyly occur in the carboxy-terminal portion of GLI3, eliminating both its activator and repressor functions. Mutations in the region between the zinc-finger and the microtubular anchor domains produce a protein in which the amino terminal is cleaved so that it can migrate to the nucleus and repress transcription. Such mutations in GLI3 cause a disorder called Pallister-Hall syndrome, characterized by hypothalamic hamartomas, visceral anomalies, and posterior polydactyly. Mutations 3' of the microtubular anchor domain produce a protein retaining both repressor and activator functions and have been described in individuals with isolated posterior polydactyly, a relatively minor birth defect. Thus, mutations in GLI3 alter the balance between its activator and repressor functions and cause three distinct disorders of varying severity. www

The majority of craniofacial structures are derived from neural crest cells. The fate of each group of neural crest cells is specified by homeobox-containing genes. Some of the genes controlling craniofacial development have been isolated by analysis of craniosynostosis syndromes.

Development of the Limb

The limb is our best understood classical model of development. Surgical manipulation, ectopic gene expression, and targeted disruption of genes in animal models (see Box 10-1) have led to the isolation and characterization of many of the genes controlling growth and patterning of the limb. Many of the signaling pathways and transcriptional control elements that coordinate limb development in model organisms such as *Drosophila* and chick appear to be conserved in mammals. Because the newborn prevalence of limb defects is second only to that of congenital heart defects, the limb defect phenotypes are well documented. As a result, our knowledge of the molecular basis of human limb defects has expanded rapidly.

The vertebrate limb is composed of elements derived from lateral plate mesoderm (bone, cartilage, and tendons) and somitic mesoderm (muscle, nerve, and vasculature). The first step in the formation of a limb is its induction. The exact mediators and mechanism of limb induction remain controversial. The signal that initiates induction of forelimbs and hindlimbs appears to arise in the intermediate mesoderm, although that is not the only tissue involved in limb induction. One candidate for this signal, Fgf8, is expressed in forelimbs and hindlimbs of the mouse. Fgf8 is sufficient to induce the entire limb bud program. This signal appears to be mediated, in part, by the expression of Fgf10 in the prospective limb areas of the lateral plate mesoderm. However, members of the Wnt family, Wnt2b and Wnt8c, maintain Fgf10 expression in these prospective limb areas and thus are upstream of Fgf10.

Once initiated, proximal/distal growth of the limb bud is dependent on a region of ectoderm called the apical ectodermal ridge (AER), which extends from anterior to posterior along the dorsal/ventral boundary of the limb bud (Fig. 10-10). Prior to AER differentiation, two genes, *Radical fringe (r-Fng)* and *Wnt7a*, are expressed in the dorsal ectoderm. In the ventral ectoderm, expression of *r-Fng* and *Wnt7a* is blocked by *Engrailed-1 (En-1)*, a homeobox-containing transcription factor. The AER

FIGURE 10.10 Schematic illustration of a limb bud. The apical ectodermal ridge (AER) extends from anterior to posterior along the dorsal/ventral boundary of the limb bud. Proximal to the AER is a region of rapidly proliferating mesodermal cells called the progress zone (PZ). Located in the posterior mesoderm is an important signaling center called the zone of polarizing activity (ZPA). The signaling pathways of the AER, PZ, and ZPA are interconnected so that pattern formation and growth are partly dependent on their coordinated function.

forms at the interface of r-Fng-expressing and non-r- Fng-expressing cells, while expression of Wnt7a instructs the mesoderm to adopt dorsal characteristics. Mesoderm in which Wnt7a expression is blocked becomes ventralized. Thus, the processes of AER formation and dorsal/ventral patterning are interconnected and coordinated by En-1. In the mouse, functional inactivation of Wnt7a results in ventralization of the dorsal surface

of *Wnt7a* results in ventralization of the dorsal surface (i.e., pads on both sides of the foot). Ventralization of the dorsal surface of the limb has been described in humans, but the etiology remains unknown. Mediation of proximal/distal growth by the AER is controlled in part by FGFs (e.g., *FGF2*, *FGF4*, *FGF8*) that stimulate proliferation of an underlying population

that stimulate proliferation of an underlying population of mesodermal cells in the progress zone (PZ). Maintenance of the AER is dependent on a signal from a posterior portion of the limb bud known as the zone of polarizing activity (ZPA). The signaling molecule of the ZPA is Shh, which is also responsible for dorsal/ventral patterning of the central nervous system and establishment of the embryonic left/right axis. The ZPA also specifies positional information along the anterior/posterior axis of the limb bud.

Defects of the anterior and posterior elements of the upper limb occur in the Holt-Oram syndrome and ulnarmammary syndrome, respectively (Fig. 10-11). Holt-Oram syndrome is caused by mutations in a gene called TBX5, while ulnar-mammary syndrome is caused by mutations in the tightly linked gene, TBX3. TBX3 and TBX5 are members of a highly conserved family of DNA transcription factors containing a DNA-binding domain called a T-box (see Chapter 2). It appears that TBX3 and TBX5 have evolved from a common ancestral gene, and each has acquired specific yet complementary roles in patterning the anterior/posterior axis of the mammalian upper limb. TBX3 and TBX5 also play roles in the development of many other organs. For example, individuals with Holt-Oram syndrome also have congenital heart defects, most commonly an atrial septal defect that allows blood in the left and right atria to mix. Interestingly, TBX5 interacts with another transcription factor, Nkx2-5, during heart development. Mutations in the gene encoding Nkx2-5 also cause atrial septal defects. Thus, perturbation of two different mediators in the same developmental program can produce the same type of birth defect. www

If the early events of limb bud signaling provide positional information to developing cells, what controls the growth and differentiation of these cells? One important component is the transcription factors encoded by Hox genes. The expression patterns of *Hoxa9* through *Hoxa13* define overlapping domains along the proximal/distal axis of the developing limb bud. Combinations of Hox paralogs preferentially promote growth within different segments of the limb according to their 5' position within a Hox cluster. For example, mice with *Hoxa11* or *Hoxd11* mutations have only minor abnormalities, while *Hoxa11*/ 225

FIGURE 10.11 A, Absence of the left third, fourth, and fifth digits (i.e., posterior digits) accompanied by aplasia of the ulna and hypoplasia of the radius in an individual with ulnarmammary syndrome. The fifth digit of the right hand is also missing. **B**, Bilateral absence of the thumb (i.e., an anterior digit) and radius with marked hypoplasia of the humerus in a child with Holt-Oram syndrome.

Hoxd11 double mutants exhibit a marked reduction in the size of the radius and ulna. Similarly, deletion of increasing numbers of Hox-13 paralogs has a cumulative effect on phenotypic abnormalities of the hands or feet, presumably because the functions of Hox paralogs are partially redundant.

For this reason, it was suspected that mutations in Hox genes would be unlikely causes of human birth defects. However, Hox mutations have been described in individuals with synpolydactyly and with hand-foot-genital syndrome. Synpolydactyly is characterized by duplication and fusion of the middle digits of the hands and feet. It is caused by mutations in *HOXD13* that produce an expansion of a polyalanine tract in the amino-terminal end of the HOXD13 protein. A similar defect can be reproduced by simultaneous disruption of *Hoxd13*, *Hoxd12*, and *Hoxd11*, suggesting that expansion of the polyalanine tract in *HOXD13* results in the functional inactivation of its 3' neighbors. www The vertebrate limb is composed of elements derived from lateral plate mesoderm and somitic mesoderm. Growth and patterning are controlled by proteins secreted from specialized collections of cells called the apical ectodermal ridge, the progress zone, and the zone of polarizing activity.

Organ Formation

Many developmental processes must be coordinated simultaneously to construct the specific arrangement of cells and tissues that compose an organ. As in limb development, the formation of organs involves numerous interactions. These interactions are mediated by secreted signaling molecules that bind to receptors, conduct signals through various interconnected pathways, and stimulate or repress DNA transcription. Use of the same elaborate networks to form different organs allows for genomic economy while maintaining developmental flexibility.

Once a specialized cell within an organ is terminally differentiated, various proteins turn on its molecular machinery so that it may perform its intended function. Often, development of the organ and function of the differentiated cell are interrelated. For example, the endocrine pancreas is largely composed of three different cell types: alpha, beta, and gamma. Transcription of insulin in beta cells is stimulated by the binding of insulin promoter factor 1 (IPF1) to the insulin promoter region. Mutations in the gene encoding IPF1 prevent pancreatic development, indicating that IPF1 is necessary for the maturation and differentiation of pancreatic precursor cells.

Interactions between mesenchymal and epithelial cells are prominent in the development of cutaneous structures (e.g., hair, sweat glands, breasts), parenchymal organs (e.g., liver, pancreas), lungs, thyroid, kidneys, and teeth. These interactions are dynamic in that expression patterns in the epithelia and mesenchyme change over time and continue to influence one another. For example, during tooth development, the epithelium secretes Bmp-4, which signals the underlying mesenchyme to express a set of transcription factors, including Msx1. The mutual exchange of signals between epithelium and mesenchyme leads to formation of a dental papilla and cusp and finally to terminal differentiation of mesenchyme into toothforming odontoblasts. In humans, mutations in MSX1 disrupt tooth formation and cause loss of the second premolars. Similarly, mutations in the human homolog of the mouse gene, hairless, cause loss of all body hair, including that of the scalp, eyebrows, axillae, and pubis.

The integrity of signals exchanged between the epithelium and the mesenchyme is dependent on the integrity of these tissues. Several proteins produced within the epithelium are known to promote the growth and differentiation of the epithelium. One of these proteins is p63, a homolog of the prototypic tumor suppressor gene product, p53. Mutations that perturb the function of p63 decrease the availability of epithelial progenitor cells. This results in abnormalities of the limb, skin, teeth, hair, and nails in a several different malformation syndromes.

One of the largest organs in the body is the skeleton. Skeletal formation is dependent on bone-forming cells called osteoblasts. The differentiation of osteoblasts is regulated by an osteoblast-specific transcription factor, Cfba1. Targeted disruption of *Cfba1* produces mice with a complete lack of ossification of the skeleton. Heterozygous mice have widened cranial sutures, shortened digits, and abnormalities of the shoulder girdle. Similar defects are found in individuals with cleidocranial dysplasia, which is caused by mutations in *CFBA1*, the human homolog of mouse *Cfba1*. www

Formation of organs involves reciprocal interactions between epithelium and mesenchyme. This interaction is mediated by secreted signaling molecules that bind to receptors, conduct signals through various interconnected pathways, and stimulate or repress DNA transcription.

SUGGESTED READINGS

- Anderson E, Beddington R (1997) Pattern formation and developmental mechanisms. Curr Opin Genet Dev 7:3455-3458
- Capdevila J, Vogan KJ, Tabin CJ, Izpisúa Belmonte JC (2000) Mechanisms of left-right determination in vertebrates. Cell 101:9-21
- Capecchi MR (2001) Generating mice with targeted mutations. Nat Med 7:1086-1090
- Ducy P, Karsenty G (2000) The family of bone morphogenetic proteins. Kidney Int 57:2207-2214
- Epstein CJ (1995) The new dysmorphology: application of insights from basic developmental biology to the understanding of human birth defects. Proc Natl Acad Sci U S A 92:8566-8573
- Gilbert SF (2000) Developmental Biology. Sinauer Associates, Sunderland, MA
- Hamada H, Meno C, Watanabe D, Saijoh Y (2002) Establishment of vertebrate left-right asymmetry. Nat Rev Genet 3:103-113
- Harvey RP (2002) Patterning the vertebrate heart. Nat Rev Genet 3.544-556
- Jorgensen EM, Mango SE (2002) The art and design of genetic screens: *Caenorhabditis elegans*. Nat Rev Genet 3:356-369
- Kamachi Y, Uchikawa M, Kondoh H (2000) Pairing SOX off with partners in the regulation of embryonic development. Trends Genet 16:182-187
- Kelley RI, Herman GE. (2001) Inborn errors of sterol biosynthesis. Annu Rev Genomics Hum Genet 2:299-341
- LaBonne C, Bronner-Fraser M (1999) Molecular mechanisms of neural crest formation. Annu Rev Cell Dev Biol 15:81-112

- Mark M, Rijli FM, Chambon P (1997) Homeobox genes in embryogenesis-pathogenesis. Pediatr Res 42:421-429
- McMahon AP (2000) More surprises in the Hedgehog signaling pathway. Cell 100:185-188
- McIntosh I, Bellus GA, Jabs EW (2000) The pleiotropic effects of fibroblast growth factor receptors in mammalian development. Cell Struct Funct 25:85-96

Miller JR (2001) The Wnts. Genome Biol 3:1-15

- Peifer M, Polakis P (2000) Wnt signaling in oncogenesis and embryogenesis: a look outside the nucleus. Science 287:1606-1609
 - STUDY QUESTIONS
 - 1. Explain how nonhuman animal models are useful for studying human development and birth defects. Give at least one example.
 - 2. Mutations in fibroblast growth factor receptors (FGFRs) cause at least five different craniosynostosis syndromes. Moreover, the same mutation in *FGFR2* causes Pfeiffer syndrome in some families but Crouzon syndrome in other families. How can the same mutation produce two distinct disorders?
 - **3.** Disorders caused by mutations in genes encoding transcription factors are often pleiotropic. Explain this finding.
 - 4. Define pattern formation, and give an example of a birth defect caused by disruption of this process.

- Pichaud F, Desplan C (2002) Pax genes and eye organogenesis. Curr Opin Genet Dev 12:430-434
- Sanz-Ezquerro JJ, Tickle C (2001) "Fingering" the vertebrate limb. Differentiation 69:91-99
- Shubin N, Tabin C, Carroll S (1997) Fossils, genes, and the evolution of animal limbs. Nature 388:639-648
- Tada M, Smith JC (2001) T-targets: clues to understanding the functions of T-box proteins. Dev Growth Differ 43:1-11
- Veraksa A, Del Campo M, McGinnis W (2000) Developmental patterning genes and their conserved functions: from model organisms to humans. Mol Genet Metab 69:85-100

- **5.** If the control of developmental processes is tightly regulated, how can you explain that mutations in some developmental genes (e.g., Hox genes) produce subtle phenotypes?
- 6. Loss-of-function mutants in mammals are commonly studied by creating a knockout mouse model. Explain why it is impractical to use some organisms (e.g., baboons) to generate knockouts. Can you think of a way to circumvent some of these obstacles?
- 7. Give an example of a birth defect that can be caused by a defect in a ligand or its receptor.
- 8. Explain what may be some of the obstacles to using gene therapy to treat birth defects.

Cancer Genetics

Present evidence indicates that approximately one in four deaths is now due to cancer and that more than half of the population will be diagnosed with invasive cancer at some point in their lives. Many cancers are increasing in frequency, largely due to the increasing proportion of our population in older age groups. As shown in this chapter, the causes of cancer are a mixture of environmental components and genetic alterations occurring in our tissues. Inherited predisposition plays a role in some families. Dramatic advances in molecular biology and genetics have now clarified the basic molecular elements of cancer and provide a schematic outline of the cellular events leading to cancer. This understanding will be crucially important in the control of cancer, providing the beginnings of a base of knowledge that should lead to significantly improved therapies and possibly prevention.

CHAPI

FR

"Cancer" is a collection of disorders that share the common feature of uncontrolled cell growth. This leads to a mass of cells termed a neoplasm (Greek, "new formation"), or tumor. The formation of tumors is called tumorigenesis. Several key events must occur if cells are to escape the usual constraints that prevent uncontrolled proliferation. Additional growth signals must be produced and processed, and cells must become resistant to signals that normally inhibit growth. Because these abnormal characteristics would typically trigger the process of programmed cell death (apoptosis), cells must somehow disable this process. The growing cell mass (tumor) requires nourishment, so a new blood supply must be obtained through angiogenesis (the formation of new blood vessels). Additional inhibitory signals must be overcome for the tumor to achieve a malignant state, in which neoplasms invade nearby tissues and metastasize (spread) to more distant sites in the body. The capacity to invade and metastasize distinguishes malignant from **benign** neoplasms.

Tumors are classified according to the tissue type in which they arise. Major types of tumors include those of epithelial tissue (**carcinomas**, the most common tumors), connective tissue (**sarcomas**), lymphatic tissue (lymphomas), glial cells of the central nervous system (gliomas), and hematopoietic organs (leukemias). The cells composing a tumor are usually derived from a single ancestral cell, making them a single clone (monoclonal).

Many of the basic biological features of **carcinogene**sis (cancer development) are now understood. Throughout our lives, many of our cells continue to grow and differentiate. These form, for example, the epithelial layers of our lungs and colons and the precursors of the cells of our immune systems. Relatively undifferentiated stem cells produce large numbers of progeny cells to repopulate and renew our worn defensive layers. Through integration of information provided by a complex array of biochemical signals, the new cells are designed to commit themselves to stop dividing and terminally differentiate into a cell type appropriate for their heritage and circumstances (Fig. 11-1).

Occasionally one of these cells will fail to differentiate and will begin to divide without restraint. The descendants of such cells can become the founders of neoplasms, capable of further transformation into invasive, metastatic cancer. Our goals are to understand in detail what has gone wrong in such rogue cells, to detect them very early in their careers, and ultimately to intervene in their development to eliminate them.

Cells in the body are "programmed" to develop, grow, differentiate, and die in response to a complex system of biochemical signals. Cancer results from the emergence of a clone of cells freed

FIGURE 11.1 In response to environmental signals, a cell may continue to divide or it may differentiate or die (apoptosis).

of these developmental programming constraints and capable of inappropriate proliferation.

CAUSES OF CANCER

Genetic Considerations

Genetic alterations of cell regulatory systems are the primary basis of carcinogenesis. We can create cancer in animal models by damaging specific genes. In cell culture systems, we can reverse a cancer phenotype by introducing normal copies of the damaged genes into the cell. Most of the genetic events that cause cancer occur during the lifetime of the individual, in his or her somatic tissues. The frequency of these events can be altered by exposure to mutagens, thus establishing a link to environmental **carcinogens** (cancer-causing agents). However, because these genetic events occur in somatic cells, they are not transmitted to future generations. Even though they are *genetic* events, they are not *inherited*.

It is also possible for cancer-predisposing mutations to occur in germline cells. This results in the transmission of cancer-causing genes from one generation to the next, producing families that have a high frequency of specific cancers (Fig. 11-2). Such "cancer families," although rare, demonstrate that inheritance of a damaged gene can cause cancer. In these families, inheritance of one mutant allele seems sufficient to cause a specific form of cancer: almost all individuals who inherit the mutant allele will develop a tumor. This is because each of their cells now carries the altered gene and thus has already taken the first step down the cancer pathway. The childhood cancer of the eye, retinoblastoma, is a good example. As discussed in Chapter 4, those who inherit a mutant version of the retinoblastoma gene have approximately a 90% chance of developing one or more retinoblastoma tumors.

While the transmission of cancer as a single-gene

disorder is relatively uncommon, there is good evidence for more frequent clustering of some cancer types in families. For many kinds of cancer, such as breast and colon, the diagnosis of the cancer in a first-degree relative implies at least a two-fold increase in one's risk of developing the cancer. A genetic basis for this familial clustering of cancer is suggested but remains unspecified. However, it is possible that genetic transmission of altered forms of specific genes is responsible.

The extent to which each of these mechanisms inherited germline mutations versus mutations occurring in somatic cells—contributes to human cancer is an important question. If inherited predispositions are significant determinants of an individual's risk of acquiring a specific form of cancer, it should ultimately be possible to identify individuals whose risk is elevated. More intensive screening of defined high-risk populations could result in early detection and intervention, leading to better prognoses for individuals and lowered morbidity and mortality in the population.

The basic cause of cancer is damage to specific genes. Usually, mutations in these genes accumulate in somatic cells over the years, until a cell loses a critical number of growth-control mechanisms and initiates a tumor. If damage occurs in cells of the germ line, however, an altered form of one of these genes can be transmitted to progeny and predispose them to cancer. The greatly increased risk of cancer in such individuals is due to the fact that each of their cells now carries the first step in a multistep cancer pathway.

Environmental Considerations

What is the role of the environment in carcinogenesis? At the level of the cell, cancer seems intrinsically genetic. Tumor cells arise when certain changes, or mutations, occur in genes that are responsible for regulating the cell's growth. However, the frequency and consequences

FIGURE 11.2 A familial colon cancer pedigree. Darkened symbols represent individuals diagnosed with colon cancer.

of these mutations can be altered by a large number of environmental factors. It is well documented, for example, that many chemicals that cause mutation in experimental animals also cause cancer and are thus carcinogens. Furthermore, other environmental agents may enhance the growth of genetically altered cells without directly causing new mutations. Thus, it is often the interaction of genes with the environment that determines carcinogenesis; both play key roles in this process.

Two additional lines of argument support the idea that exposure to environmental agents can significantly alter an individual's risk of cancer. The first is that a number of environmental agents with carcinogenic properties have been identified. For example, cigarette smoke has been shown to cause lung and other types of cancer, both through epidemiological studies and in laboratory experiments. Roles for other environmental agents in specific cancers are also well documented (e.g., uranium dust in lung cancer among miners, asbestos exposure in lung cancer and mesothelioma).

The second line of argument is based on epidemiological comparisons among populations with differing lifestyles. Many kinds of cancer have quite different frequencies in different populations. Breast cancer, for example, is prevalent among northern Europeans and Americans but relatively rare among women in developing countries. It is usually difficult to determine whether such dissimilarities reflect differences in lifestyle or in gene frequencies.

Examination of genetically similar populations under differing lifestyles, however, provides an opportunity to evaluate the genetic and environmental components of cancer. Epidemiological studies among migrant Japanese populations, for example, have yielded important findings with respect to colon cancer. This type of cancer is relatively rare in the Japanese population living in Japan but is the second most common form of cancer in the United States. Stomach cancer, on the other hand, is frequent in Japan but relatively rare in the United States. These statistics in themselves cannot distinguish environmental from genetic influences in the two populations. However, because large numbers of Japanese have immigrated, first to Hawaii and then to the U.S. mainland, we can observe what happens to the rates of stomach and colon cancer among the immigrants. It is important to note that many of the Japanese immigrants have maintained a genetic identity, marrying largely among themselves.

In the U. S. population as a whole, the lifetime risk of colon cancer is approximately 5%; in Japan that risk is tenfold lower, only 0.5%. Among the first-generation Japanese in Hawaii, the frequency of colon cancer rises severalfold—not yet as high as in the U. S. mainland, but higher than in Japan. Among second-generation Japanese on the U. S. mainland, the colon cancer rate is 5%, equal to the U. S. average. At the same time, stom-ach cancer is relatively rare among Japanese-Americans.

These observations strongly suggest an important role for environment or lifestyle in the etiology of colon cancer.

Are we then to assume that genetic factors play no role in colon cancer? The fact remains that in the North American environment some individuals will get colon cancer and others will not. This distinction can result from differences within this environment (e.g., dietary variation) as well as differences in genetic predisposition: inherited genes that increase the individual's probability of developing cancer. To account for the difference in colon cancer frequency between Japanese living in the U. S. and those living in Japan, however, we argue that environmental features in Japan render the predisposing genes less penetrant. Furthermore, a genetic component is strongly suggested by the severalfold increase in risk to an individual when a first-degree relative has colon cancer. It is likely, then, that cancer risk is a composite of both genetics and environment, with interaction between the two components.

Environmental factors are known to play important roles in carcinogenesis. However, an individual's overall cancer risk depends on a combination of inherited factors and environmental components.

CANCER GENES

Genetic Control of Cell Growth and Differentiation

Cancers form when a clone of cells emerges that has lost the normal controls over growth and differentiation. More than 100 cancer-causing genes that encode proteins participating in this regulation have now been identified. Characterization of the biochemical activities and interactions of these gene products has revealed an increasingly detailed picture of the normal regulation of cell growth and differentiation and the ways in which these processes become deregulated by the events of carcinogenesis.

Many features of this fundamental process are now well understood (Fig. 11-3). One component of cell regulation is mediated by external signals coming to the cell through polypeptide **growth factors** (e.g., plateletderived growth factor, epidermal growth factor, steroid hormones) produced in other cells. Each growth factor interacts with specific **growth factor receptors** located on the cell surface. Binding of a growth factor activates the receptor, triggering molecules that send messages to the cell's nucleus in a process termed **signal transduction**. These signal transduction molecules include **protein kinases**, such as src tyrosine kinase, mitogenactivated protein kinase (MAPK), and jun kinase (JunK), which can alter the activity of target proteins by tagging them at a specific site with a phosphate molecule

FIGURE 11.3 The major features of cellular regulation. External *growth factors* (proteins and steroid hormones such as epidermal growth factor) bind to membrane-spanning *growth factor receptors* on the cell surface, activating *signal-transduction* pathways in which genes such as *RAS* participate. Components of the signal-transduction pathway in turn interact with *nuclear transcription factors*, such as *MYC* and *FOS*, which can bind to regulatory regions in DNA.

(phosphorylation). The ultimate stage of the signal transduction pathway is regulation of DNA transcription in the nucleus. Components of the signal transduction cascade interact with nuclear transcription factors that regulate the activity of specific genes whose protein products influence cellular growth and proliferation. Genes that encode these transcription factors include *MYC*, *FOS*, and *7UN*.

After several rounds of cell division, cells normally receive signals that tell them to stop growing and to differentiate into specialized cells. The signals may come from polypeptides, from steroid hormones, from direct contact with adjacent cells, or from internal programs that define the number of cell divisions that are allowed. The signals are transduced to the nucleus of the recipient cell. Here, by altering the transcription patterns of genes that govern the steps of the cell cycle, they repress genes that promote cell division and induce genes that inhibit entry into the cell division cycle. transduction molecules that activate a cascade of phosphorylating reactions within the cell; and (4) nuclear transcription factors. The cell integrates and interprets the host of signals it receives from its environment. Decisions to grow and divide, or to stop growing and differentiate, result from processing of the signals.

A cancer cell may emerge from within a population of growing cells through the accumulation of mutations in these regulatory genes. Although such mutations occur only rarely, these cells may fail to respond to differentiation signals and continue to divide instead of undergoing their normal differentiation program. Furthermore, cancers seem usually to result from a progressive series of events that incrementally increase the extent of deregulation within a cell lineage. Eventually, a cell emerges whose descendants multiply without appropriate restraints. Further changes give these cells the capacity to invade adjacent tissues and form metastases. Each of these changes involves mutations, and the requirement for more than one mutation has been characterized as the multi-hit concept of carcinogenesis. An example of this concept is given by colorectal cancer, in which several genetic events are required to complete the progression from a benign growth to a malignant neoplasm (see later discussion).

Mutations may occur in any of the steps involved in regulation of cell growth and differentiation. Accumulation of such mutations within a cell lineage may result in a progressive deregulation of growth, eventually producing a tumor cell.

The Inherited Cancer Gene Versus the Somatically Altered Gene

Although "cancer families" have long been recognized, it was not until the early 1970s that we began to understand the relationship between the inherited genetic aberrations and the carcinogenic events that occur in somatic tissue. In 1971, A. G. Knudson's analysis of retinoblastoma, a disease already mentioned as a model of inherited cancer, led him to a hypothesis that opened a new window into the mechanism of carcinogenesis. In the genetic form of retinoblastoma (see Chapter 4), an affected individual usually has an affected parent, and there is a 50% chance of genetic transmission to each of the offspring. In the sporadic (noninherited) form, neither parent is affected, nor is there additional risk to other progeny. A key feature distinguishing the two forms is that inherited retinoblastoma is usually bilateral (affecting both eyes), whereas sporadic retinoblastoma usually involves only a single tumor and therefore affects only one eye (unilateral).

Knudson reasoned that at least two mutations may be required to create a retinoblastoma. One of the mutations would alter the retinoblastoma gene; if this happened in the germ line, it would be present in all cells of

The regulation of cell growth is accomplished by substances that include (1) growth factors that transmit signals from one cell to another; (2) specific receptors for the growth factors; (3) signal

a child receiving the mutant allele. The second mutation would be an additional, unspecified genetic event occurring in an already-altered cell. The hypothesis of a second event was required to explain why only a tiny fraction of the retinoblasts of an individual who has inherited a mutant retinoblastoma gene actually give rise to tumors. Knudson's hypothesis is known as the **two-hit model of carcinogenesis**.

Familial retinoblastoma would thus be caused by the inheritance of one of the genetic "hits" as a constitutional mutation (i.e., a mutation present in all cells of the body). Individuals who inherited one hit would require only one additional mutational event in a single retinoblast for that cell to seed a tumor clone. In sporadic cases, on the other hand, both mutations would have to occur independently within the same retinoblast, a highly improbable combination of rare events even considering the several million cells of the target tissue. The child who developed a retinoblastoma by this two-hit somatic route would be unlikely to develop more than one tumor. The individual *inheriting* a mutant retinoblastoma gene, however, would need only a single, additional genetic hit in a retinoblast for a tumor clone to develop. Knudson argued that such an event was likely to occur in several of the retinoblasts of each carrier of the inherited mutant gene, thus explaining the bilaterality of inherited retinoblastoma.

An important corollary of this two-hit hypothesis is that the genes in which inherited mutations cause familial cancer syndromes may be the same as those that generate common cancers by somatic mutation. By understanding the nature of the mutant alleles inherited in rare cancer families, therefore, we will come to understand more about the somatic pathway to common cancer as well. The converse is likewise true: understanding the nature of somatically mutated genes can help in understanding the inherited versions.

Alfred Knudson's two-hit theory of carcinogenesis in retinoblastoma became the paradigm for a model to describe how inheritance of an altered gene predisposes the gene carrier to cancer. The theory states that a cell can initiate a tumor only when it contains two damaged alleles; therefore, a person who inherits one copy of a mutant retinoblastoma gene must experience a second, somatic mutation in one or more retinoblasts in order to develop one or more retinoblastomas. Two somatic mutations can also occur in a single retinoblast of a nonpredisposed fetus, producing sporadic retinoblastoma.

MAJOR CLASSES OF CANCER GENES

Cancer genes can be classified into three major categories: those that normally inhibit cellular proliferation (tumor suppressors), those that activate proliferation (oncogenes), and those that participate in DNA repair. Each of these categories will be discussed.

Tumor Suppressor Genes

If the first event in the two-hit model is an inherited mutation, what is the nature of the second hit? Again with retinoblastoma as the paradigm, two possibilities seemed plausible at first: (1) the second mutation could affect the function of a gene distinct from the retinoblastoma gene, and the presence of two mutant genes in the same cell would result in the tumor; or (2) the second event could inactivate or alter the remaining (normal) copy of the retinoblastoma gene. If the second possibility were correct, the second hit might sometimes involve the loss of a chromosome or an extensive deletion of a specific chromosome region that contains the retinoblastoma gene. Such large-scale chromosomal losses should be detectable with DNA markers located on the chromosome carrying the retinoblastoma gene.

In fact, losses of marker DNA near the retinoblastoma gene (RB1) on chromosome 13 do occur in more than 50% of retinoblastomas. Several mechanisms, including point mutation, deletion, and somatic recombination, can produce such a loss (Fig. 11-4). The observation of DNA loss shows that the second hit, which occurs in the fetus during the period in which retinoblasts are rapidly dividing and proliferating, has removed the remaining normal allele of this gene. This implies that a cell with one mutant RB1 allele and one normal RB1 allele cannot form a tumor. Thus, the product of the normal gene, even when present only in a single copy, prevents tumor formation. The term tumor suppressor has been coined to describe the RB1 gene and a growing list of other cancer-associated genes that operate through this mechanism (Table 11-1). To date, more than 20 tumor suppressor genes have been identified.

Characteristic of tumor suppressors is the somewhat perplexing feature that inherited mutations are dominant alleles at the level of the individual (i.e., heterozygotes usually develop the disease), but they are recessive alleles at the level of the cell (heterozygous cells do not form tumors). This apparent contradiction is resolved by realizing that, in individuals who have inherited the first hit, a second hit that occurs in any one cell will cause a tumor. Because there are several million target retinoblasts in the developing fetus, heterozygous individuals form, on the average, several retinoblasts homozygous for an RB1 mutation. Each of these leads to a retinoblastoma. Thus, it is the strong predisposition to tumor formation (i.e., the first hit) that is inherited as an autosomal dominant trait. The reduced penetrance of the retinoblastoma mutation (90%) is explained by the fact that some individuals who inherit the disease-causing mutation do not experience a second hit in any of their retinoblasts.

A general property of tumor suppressors is that they normally block the uncontrolled cellular proliferation that can lead to cancer. Often, this is done by participating in pathways that regulate the cell cycle. For example, the protein encoded by RB1 (pRb) is active when it is rel**FIGURE 11.4** Persons inheriting an *RB1* mutation are heterozygous for the mutation in all cells of their body. The second "hit" occurs during embryonic development and may consist of a point mutation, a deletion, loss of the normal chromosome and duplication of the abnormal one, or somatic recombination. Each process leads to homozygosity for the mutant *RB1* allele and thus to tumor development. (Modified from Cavenee WK, Dryja TP, Phillips RA, et al. [1983] Expression of recessive alleles by chromosomal mechanisms in retinoblastoma. Nature 305:779-784.)

atively unphosphorylated but is down-regulated when it is phosphorylated by cyclin-dependent kinases (CDKs) just before the S phase of the cell cycle (see Chapter 2). In its active, hypophosphorylated state, pRb binds to members of the E2F transcription complex, inactivating them (Fig. 11-5). E2F activity is required for progression into S phase, so its inactivation by pRb halts the cell cycle. pRb thus serves as a cell cycle "brake" that is normally released only when pRb is inactivated through phosphorylation by CDKs. It becomes reactivated later in the cell cycle when its phosphate groups are removed. However, loss-of-function mutations in RB1, and in some cases hypermethylation of its 5' region, can lead to permanent inactivation. Without this brake on the cell cycle, the cell can proceed through numerous uncontrolled divisions.

Loss-of-function mutations of other inhibitory factors can also lead to an unregulated cell cycle. A number of tumor suppressor genes encode **CDK inhibitors** (see Fig. 11-5), which inactivate CDKs and thus prevent them from phosphorylating target proteins such as pRb. Tumor suppressors may also control cell proliferation through their effects on transcription or on cell-cell interactions (some examples will be discussed later). Again, mutations in these genes can lead to unrestricted cell division and ultimately to cancer.

The discovery that retinoblastoma results when both alleles of the same locus on chromosome 13 are inactivated in the same retinoblast led to the concept of tumor suppressor genes. The products of such genes suppress tumor formation by controlling cell growth and can do so even if a cell contains only one normal version of the gene. Loss-of-function mutations that inactivate both copies of a cell's tumor suppressor gene can lead to uncontrolled cellular proliferation.

Because of the pivotal role of tumor suppressors in the prevention of tumor formation, their study is of considerable medical significance. By understanding how can-

Gene (related genes in parentheses)	Chromosome location	Function of gene product	Disease caused by germline mutations	
<i>RB1(p107, p130)</i> 13q14		Cell cycle brake; binds to E2F transcription factor complex	Retinoblastoma; osteosarcoma	
APC	5q21	Interacts with β-catenin in Wnt signaling pathway	Familial adenomatous polyposis	
NF1	17q11	Down-regulates ras protein	Neurofibromatosis type 1	
NF2	22q12	Cytoskeletal regulation	Neurofibromatosis type 2	
TP53	17p13	Transcription factor; induces cell cycle arrest or apoptosis	Li-Fraumeni syndrome	
VHL	3p25	Regulates transcriptional elongation	Von-Hippel Lindau disease (renal cancer)	
WT1	11p13	Zinc finger transcription factor; binds to epidermal growth factor gene	Wilms tumor	
CDKN2A (p15)	9p21	CDK4 inhibitor	Familial melanoma	
BRCA1	17q21	Interacts with BRCA2/RAD51 DNA repair protein complex	Familial breast/ovarian cancer	
BRCA2	13q12	Interacts with RAD51 DNA repair protein	Familial breast cancer	
PTEN	10q23	Phosphatase	Cowden syndrome (breast and thyroid cancer	
ATM	11q22	Protein kinase; phosphorylates BRCA1 in response to DNA damage	Ataxia telangiectasia; conflicting evidence for direct involvement in breast cancer	
CHK2	22q12	Phosphorylates p53 and BRCA1	Li-Fraumeni syndrome	
PTC	9q22	Sonic hedgehog receptor	Gorlin syndrome (basal cell carcinoma, medulloblastoma)	
DPC4	18q21	Transduces transforming growth factor-β signals	Juvenile polyposis	
MLH1	3p21	DNA mismatch repair	HNPCC	
MSH2	2p22	DNA mismatch repair	HNPCC	

TABLE 11.1 Examples of Tumor Suppressor Genes and Their Roles in Inherited Cancer

cer is naturally suppressed by the body, we can ultimately develop more effective medical therapies for tumor prevention and treatment.

Oncogenes

A second category of genes that can cause cancer is termed **oncogenes** (i.e., "cancer genes"). Most oncogenes originate from **proto-oncogenes**, which are genes involved in the four basic regulators of normal cell growth mentioned previously (growth factors, growth factor receptors, signal transduction molecules, and nuclear transcription factors). When a mutation occurs in a proto-oncogene, it can become an oncogene, a gene whose constantly active product can lead to unregulated cell growth and differentiation. When a cell proceeds from regulated to unregulated growth, the cell is said to have been **transformed**.

Unlike tumor suppressor genes, oncogenes are usually dominant at the cellular level: only a single copy of a mutated oncogene is required to contribute to the multistep process of tumor progression. Whereas tumor suppressors are typically disabled by loss-of-function mutations, oncogenes are typically activated by gain-offunction mutations (these and other differences are summarized in Table 11-2). Most tumor suppressor genes are known to exhibit germline mutations that cause inherited cancer syndromes (e.g., retinoblastoma, Li-Fraumeni syndrome). In contrast, although oncogenes are commonly found in sporadic tumors, germline oncogene mutations that cause inherited cancer syndromes are uncommon (a few exceptions will be noted later in the discussion). In this section, we review three approaches that have been used to identify specific oncogenes: retroviral definition, transfection experiments, and mapping in tumors.

Proto-oncogenes encode products that control cell growth and differentiation. When mutated, they may become oncogenes, which can cause cancer. Most oncogenes act as dominant gain-of-function mutations that lead to the deregulation of cell cycle control. In contrast to tumor suppressor genes, most oncogenes do not exhibit germline mutations that cause inherited cancer syndromes. Instead, somatic mutations are seen that lead to sporadic cancers.

FIGURE 11.5 Regulation of the cell cycle is accomplished by a complex series of interactions among activators and repressors of the cycle. pRb acts as a master brake on the cell cycle by binding the E2F transcription complex, halting the cycle before S phase begins. The cyclin D-CDK4 complex inactivates pRb by phosphorylating it, thereby releasing the E2F complex and allowing the cell to progress through S phase. CDK inhibitors such as p16 and p21 inactivate CDKs, thus acting as another brake on the cycle. p53, acting through p21, can either halt the cell cycle or induce apoptosis in response to DNA damage.

Retroviruses

Retroviruses are a type of RNA virus that is capable of using reverse transcriptase to transcribe RNA into DNA. In this way, the RNA genome of the retrovirus is converted to DNA, which can be inserted into a chromosome of a host cell. Oncogenes were first identified through the study of retroviruses that cause cancer in animal systems. These retroviruses carry altered versions of certain growth-promoting genes into cells. In an earlier cycle of infection, a retrovirus may have incorporated a mutant oncogene from the genome of its host. When the retrovirus invades a new cell, it can transfer the oncogene into the genome of the new host, thus transforming the cell.

A number of gene products that receive and interpret extracellular signals for growth or differentiation have been identified through oncogenes carried by transforming retroviruses. For example, the *v*-sis oncogene,

TABLE 11.2 🔳 Comparison of Key Features of Tumor Suppressor Genes and Oncogenes					
	Tumor suppressor genes	Oncogenes			
Function of normal version	Regulates cell growth and proliferation; may induce apoptosis	Promotes cell growth and proliferation			
Mutation (at cell level)	Recessive (both copies of gene inactivated)	Dominant (only one copy of gene mutated)			
Effect of mutation	Loss of function	Gain of function			
Germline mutations resulting in inherited cancer syndromes	Seen in most tumor suppressor genes	Seen in only a few oncogenes			

carried by the simian sarcoma virus, has been identified as an altered version of the human gene that encodes platelet-derived growth factor (PDGF). Retrovirus studies have likewise identified the gene encoding the receptor molecule for another of the growth factors, epidermal growth factor (EGF), through the *ERBB* oncogene. The *RAS* (*rat* sarcoma) oncogenes, Harvey and Kirsten, were first identified through transforming retroviruses and are altered in at least 25% of cancers. Transforming retroviruses have also identified the nuclear transcription factor genes, *MYC*, *JUN*, and *FOS*, as other molecular components capable of initiating cell transformation. Table 11-3 provides some examples of proto-oncogenes.

Retroviruses are capable of inserting oncogenes into the DNA of a host cell, thus transforming the host into a tumor-producing cell. The study of such retroviral transmission has identified a number of specific oncogenes.

Transfection Experiments

The identification of cellular genes involved in carcinogenesis was complemented by experiments in which mutated forms of cellular proto-oncogenes were transferred from tumor cells to nontumor cells (transfection), causing transformation of the recipients. The prototype experiment was the transfer of DNA from a human bladder-cancer cell line into mouse cells. A few recipient cells became fully transformed; cloning and examination of the human-specific DNA sequences present in the transformed mouse cells revealed that the transforming gene was a mutant allele of the same Harvey *RAS* oncogene previously identified by retroviral studies.

Characterization of the protein product of mutant forms of *RAS* has revealed an important mechanism for the regulation of signal transduction. The RAS protein normally cycles between an *active* form bound to **guanosine triphosphate (GTP)** and an *inactive* form bound to **guanosine diphosphate (GDP)**. The biochemical con-

Oncogene	Chromosome location	Proposed function	Associated tumor
	1068(1011		Associated tumor
Growth factor genes			
HST	11q13	Fibroblast growth factor	Stomach carcinoma
SIS	22q12	β subunit of platelet-derived growth factor	Glioma (brain tumor)
Growth factor receptor genes			
RET^*	10q	Receptor tyrosine kinase	Multiple endocrine neoplasia; thyroid carcinoma
ERBB	7p12	Epidermal growth factor receptor	Glioblastoma (brain tumor); breast cancer
ERBA	17q11	Thyroid hormone receptor	Acute promyelocytic leukemia
NEU (ERBB2)	17q21	Receptor protein kinase	Neuroblastoma; breast carcinoma
MET*	7q31	Receptor tyrosine kinase	Hereditary papillary renal carcinoma; hepatocellula carcinoma
KIT*	4q12	Receptor tyrosine kinase	Gastrointestinal stromal tumor syndrome
Signal transduction gene	S		
HRAS	11p15	GTPase	Carcinoma of colon, lung, pancreas
KRAS	12p12	GTPase	Melanoma, thyroid carcinoma, acute monocytic leukemia, colon carcinoma
BRAF	7q34	Serine/threonine kinase	Malignant melanoma; colon cancer
4BL	9q34	Protein kinase	Chronic myelogenous leukemia; acute lymphocytic leukemia
CDK4*	12q14	Cyclin-dependent kinase	Malignant melanoma
ranscription factor genes	S		
NMYC	2p24	DNA-binding protein	Neuroblastoma; lung carcinoma
MYB	6q22	DNA-binding protein	Malignant melanoma; lymphoma; leukemia
FOS	14q24	Interacts with JUN oncogene to	Osteosarcoma

*MET, RET, KIT, and CDK4 are the four proto-oncogenes in which germline mutations can give rise to inherited cancer syndromes.

regulate transcription

sequence of *RAS* mutations is a RAS protein that is unable to shift from the active GTP form, which stimulates growth, to the inactive GDP form. The mutant RAS protein cannot quench its growth signal.

The transfection of oncogenes from tumor cells to normal cells can cause transformation of the normal cells. This helps to confirm the role of oncogenes in carcinogenesis.

Mapping in Tumors

The association of chromosomal translocations with human tumors provides a third method for observing the functions of oncogenes. As discussed in Chapter 6, specific chromosomal rearrangements are characteristic of some tumor types. A well-known example is the Philadelphia chromosome, in which a translocation between chromosomes 9 and 22 activates the ABL protooncogene and produces chronic myelogenous leukemia. Close examination of the t(15;17)(q22;q11.2-12) translocation characteristic of acute promyelocytic leukemia (APL) has shown that the translocation fuses two genes together: the retinoic acid receptor alpha ($RAR\alpha$) gene on chromosome 17 and the promyelocytic leukemia (PML) gene on chromosome 15. The fusion product (PML-RAR α) interferes with the ability of the normal RARa protein to induce terminal differentiation of myeloid cells. (Interestingly, retinoic acid was already in use as a therapeutic agent for APL.) The fusion product also impairs the function of the PML protein, which acts as a tumor suppressor by helping to initiate apoptosis in damaged cells.

Some oncogenes were identified when specific rearrangements of chromosomal material were found to be associated with certain cancers. Because these translocations of genetic material are likely to have disrupted genes vital to cellular growth control, the sites of such rearrangements can be investigated to identify new oncogenes.

DNA Repair Genes, Chromosome Integrity, and Tumorigenesis

Tumor cells typically are characterized by widespread mutations, chromosome breaks, and aneuploidy. This condition, termed **genomic instability**, contributes to tumorigenesis because mutations and chromosome defects can activate oncogenes or deactivate tumor suppressor genes. Genomic instability can occur because of defects in the proteins required for accurate cell division or in proteins responsible for DNA repair. These defects are in turn the result of mutations. Sometimes, these mutations are inherited, resulting in relatively rare inherited cancer syndromes. More frequently, they arise in somatic cells and contribute to common, noninherited cancers.

There are a number of ways in which various types of genomic instability can give rise to cancer. Some breast cancers are caused by defective repair of double-stranded breaks that occur in DNA (e.g., from radiation exposure). An inherited form of colon cancer, discussed later, can result from faulty DNA mismatch repair (so named because single-base mutations can lead to a DNA molecule in which base pairs are not complementary to one another: a "mismatch"). Xeroderma pigmentosum, an inherited condition that is characterized in part by multiple skin tumors (see Chapter 3), is the result of impaired nucleotide excision repair. Defects in proteins responsible for chromosome separation during mitosis (e.g., spindle fibers) can give rise to the multiple aneuploidies typically seen in tumor cells. Aneuploidy can contribute to tumorigenesis by creating extra copies of oncogenes or by deleting tumor suppressor genes.

Genomic instability, which can result from defects in DNA repair, is frequently observed in tumor cells and is characterized by widespread mutations, chromosome breaks, and aneuploidy. These alterations can cause cancer when they affect pathways that regulate cellular proliferation.

Genetic Alterations and Cancer Cell Immortality

Even after a tumor cell has escaped regulation by tumor suppressors or DNA repair proteins, it must overcome one more hurdle to unlimited proliferation: the intrinsic limitation on the number of cell divisions allowed to each cell. Ordinarily, a cell is restricted to about 50 to 70 mitotic divisions. After reaching this number, the cell typically becomes **senescent** and cannot continue to divide. Recent research has provided new insights on the mechanisms that count the number of cell divisions and has illustrated new ways in which tumor cells can circumvent the counting system.

Each time a cell divides, the telomeres of chromosomes shorten slightly because DNA polymerase cannot replicate the tips of chromosomes. Once the telomere is reduced to a critical length, a signal is transmitted that causes the cell to become senescent. This process would place severe limitations on the proliferating cells in a tumor, preventing further clonal expansion. Tumor cells overcome the process by activating a gene that encodes telomerase, a reverse transcriptase that replaces the telomeric segments that are normally lost during cell division. Activation of this enzyme, which is rarely present in normal cells but is found in 85% to 90% of tumor cells, is part of a process that allows a tumor cell to continue to divide without the restraint ordinarily imposed by telomere shortening. This uninhibited division allows the tumor to become large, and, by allowing continued DNA replication, it permits the accumulation of additional mutations that may further contribute to the aggressiveness of the tumor cell.

Normally, progressive shortening of telomeres limits the number of divisions of a cell to about 50 to 70. Tumor cells overcome this limitation by activating telomerase, which replaces the telomere segments that are lost during each cell division. This appears to help tumor cells escape the restraint of cellular senescence.

IDENTIFICATION OF INHERITED CANCER GENES

Although the methods described in the previous section were successful in identifying many oncogenes, they did not identify the tumor suppressor genes that cause most inherited forms of cancer. This may have been because these methods require dominant expression of the mutant phenotype, whereas the mutant tumor suppressor alleles seem to have a primarily recessive phenotype at the level of the cell. An alternative approach to the identification of these genes was necessary.

When genes responsible for genetically transmitted diseases cannot be identified through known biochemical behavior, they become candidates for investigations based on gene mapping and detection of mutations in patients, as described in Chapter 8. There are two avenues for initial mapping of tumor genes. The primary and most general route is through linkage mapping in families, where the pattern of inheritance of the cancer phenotype defines the genetic transmission of an altered allele. The chromosomal segment bearing this mutation can be identified by linkage with polymorphic markers.

The second basis for mapping takes advantage of the frequent chromosomal losses associated with revealed tumor suppressor genes. As already described, the genetically transmitted mutation is a recessive allele at the cellular level; it does not reveal its tumor phenotype unless both normal copies of the gene are lost. Often an inherited mutant allele is unmasked in the tumor by a deletion of part or all of the homologous chromosome carrying the normal allele. Therefore, the observation that a specific chromosome segment is deleted in a tumor suggests

a map location for the inherited mutation. Small deletions can be helpful in pinpointing the subchromosomal location of the gene being sought. As mentioned in Chapter 8, the detection of inherited deletions on chromosome 13q in retinoblastoma patients was an important step in finding the retinoblastoma gene.

The deleted chromosome regions in tumors are pinpointed by examining a series of closely linked marker polymorphisms in the region and determining which of the markers that are heterozygous in the patient's constitutional DNA have become homozygous in tumor DNA (i.e., which markers have lost an allele in the process of tumorigenesis). This **loss of heterozygosity** in tumor DNA indicates that the normal tumor suppressor gene, as well as polymorphic markers surrounding it, has been lost, leaving only the abnormal copy of the tumor suppressor gene (Fig. 11-6; see Fig. 11-4). This approach was used, for example, to help narrow the locations of the retinoblastoma gene on the long arm of chromosome 13 and of a gene for Wilms tumor (nephroblastoma) on 11p.

Although gene mapping studies can often define a region in which an inherited cancer gene is located, they cannot alone identify the disease gene. As discussed in Chapter 8, detection of mutations carried in DNA from patients with the disease is crucial for identifying the specific disease-causing gene.

Map locations of tumor-associated genes can be detected through linkage analysis or by showing that one homolog of a chromosome (or a part of it) is missing in DNA from a tumor. Confirmation of the etiological role of a possible cancer-causing gene is obtained by showing the consistent presence of mutations in the gene in DNA from patients.

Neurofibromatosis Type 1

The initial evidence for mapping of the neurofibromatosis type 1 gene (*NF1*) to chromosome 17 came from linkage studies in families. Subsequently, chromosomal

> FIGURE 11.6 ■ A and B represent two microsatellite polymorphisms that have been assayed using DNA from a cancer patient's normal cells (N) and tumor cells (T). In normal cells, the patient is heterozygous for both marker loci. Deletion of the long arm from one of the paired chromosomes in tumor cells results in loss of heterozygosity (LOH) for locus B (i.e., the band corresponding to allele B1 is missing, with only a faint signal due to residual traces of normal cells in the tumor specimen). LOH is a signpost for a tumor suppressor gene near the deleted locus. (Courtesy of Dr. Dan Fults, University of Utah Health Sciences Center.)

translocations were discovered in the karyotypes of two unrelated patients with neurofibromatosis, each of whom had a breakpoint on chromosome 17q at a location indistinguishable from the map location of the *NF1* gene. These translocations were assumed to have caused neurofibromatosis in these individuals by disrupting the *NF1* gene. Located only 50 kb apart, the breakpoints provided the physical clues necessary to define several candidate genes that were screened for mutations in patients with NF1 (Fig. 11-7).

The nucleotide sequence of the *NF1* gene provided an early clue to function when its predicted amino acid sequence was compared with amino acid sequences of known gene products found in computerized databases. Extended similarities were observed with the mammalian GTPase-activating protein (GAP). This was an important finding, because at least one function of GAP is to decrease the amount of active, GTP-bound RAS. As mentioned previously, the RAS protein is a key component of the signal transduction pathway, transmitting positive growth signals in its active form. The closely associated *NF1* gene product, neurofibromin, also plays a role in signal transduction by down-regulating RAS.

With the identification of the NF1 gene product as a component in signal transduction, a picture began to form of how the inheritance of a mutation in one NF1 allele might contribute to the development of neurofibromas and *café-au-lait* spots. Reduced expression of the NF1 gene permits increased RAS activity and allows the cell to escape from differentiation and continue its growth. Loss of the remaining allele further encourages unchecked growth. Discovery of the NF1 gene has led to the identification of a key tumor suppressor that helps to regulate the fundamental process of signal transduction. www

The gene responsible for NF1 was mapped to chromosome 17q by linkage in families and was identified through translocations and point mutations in patients. DNA sequencing of the gene predicted a protein product with a domain related to GAP, and a similar role in down-regulating the RAS signal transduction protein was confirmed by biochemical experiments.

The TP53 Gene

Somatic mutations in the *TP53* gene are found in more than half of all human tumors, making this the most commonly altered cancer gene. Mutations in the *TP53* gene occur in more than 50 different types of tumors, including those of the bladder, brain, breast, cervix, colon, esophagus, larynx, liver, lung, ovary, pancreas, prostate, skin, stomach, and thyroid.

Initially, chromosomal losses and deletions of the short arm of chromosome 17 were shown to be characteristic of colon carcinoma. Overlapping deletions defined a segment of 17p that was commonly altered in tumor DNAs. Examination of the genes that had been mapped to this region revealed that *TP53* was among them. The numerous mutations found in *TP53* in colonic tumors indicate a significant role for this gene in colon tumorigenesis. Indeed, somatic *TP53* mutations are seen in approximately 70% of colorectal tumors, as well as 40% of breast tumors and 60% of lung tumors. Approximately 80% to 90% of *TP53* mutations are of the missense type, and these are concentrated in the portion of the gene that encodes a DNA-binding domain.

Like *RB1* and *NF1*, *TP53* is a tumor suppressor gene. Its protein product, p53, increases in quantity in response to cell damage (e.g., double-stranded DNA breaks caused by ionizing radiation). Acting as a transcription factor,

FIGURE 11.7 \blacksquare Localization of the *NF1* gene on chromosome 17q involved linkage analysis and identification of two translocation breakpoints that interrupted the disease gene. Candidate genes were isolated from this region and tested for mutations in patients with NF1 and in normal controls.

p53 can interact with many other genes that help to control the cell cycle. For example, p53 binds to the promoter of *CDKN1A*, whose protein product, p21, is a CDK inhibitor that blocks CDK4's inactivation of pRb (see Fig. 11-5). As discussed previously, this halts the cell cycle in the G1 phase, before DNA replication occurs in S phase. Arrest of the cell cycle before S phase provides time for the repair of damaged DNA. If the cell's DNA is severely damaged, p53 may instead induce programmed cell death (**apoptosis**). This response is more likely if the pRb pathway for cell cycle arrest is not intact. Lacking the possibility of cell cycle arrest to repair damage, the p53 protein "chooses" cell death by interacting with genes involved in apoptotic pathways (e.g., *PTEN*, *BAX*).

When *TP53* is mutated, cells with damaged DNA may evade both repair and destruction, and continued replication of the damaged DNA may lead to tumor formation. For this to happen, other components of cell cycle control must also be compromised. For example, several DNA tumor viruses, such as the human papilloma virus that often is responsible for cervical cancer, inactivate both pRb and p53. This produces cells that can neither repair their DNA nor undergo apoptosis in response to damage, leading in some cases to cancer.

Carcinogenic substances can induce specific *TP53* mutations. For example, dietary ingestion of aflatoxin B1, which can produce liver cancer, is associated with a mutation that produces an arginine-to-serine substitution at position 249 of the p53 protein. Exposure to benzopyrene, a powerful mutagen and carcinogen found in cigarette smoke, leads to alterations of specific *TP53* base pairs in lung tumors. This demonstrates a direct molecular link between cigarette smoking and lung cancer. Thus, examination of the type of *TP53* mutation seen in a tumor may provide clues to the identity of the causative carcinogenic agent.

Although tumor-causing TP53 mutations have been observed mostly in somatic cells, germline mutations of TP53 are responsible for an inherited cancer condition known as the Li-Fraumeni syndrome (LFS). This rare syndrome is transmitted in autosomal dominant fashion and involves breast and colon carcinomas, soft-tissue sarcomas, osteosarcomas, brain tumors, leukemia, and adrenocortical carcinomas. These tumors usually develop at early ages in members of LFS families, and multiple primary tumors are commonly seen in an affected individual. The demonstration of consistent TP53 mutations in the constitutional DNA of patients with LFS confirmed the causative role of this gene. As in retinoblastoma, the inheritance of a mutated TP53 gene greatly increases the individual's susceptibility to subsequent cell transformation and tumor development when a cell loses the other, normal copy of TP53 (two-hit model). Among LFS family members who inherit an abnormal TP53 gene, approximately 50% will develop invasive cancer by 30 years of age, and more than 90% will develop invasive cancer by age 70 years.

TP53 mutations account for only about 75% of LFS cases. Some of the remaining cases are the result of mutations in another tumor suppressor gene, *CHK2*. This gene encodes a kinase that normally phosphorylates p53 in response to ionizing radiation, resulting in the accumulation and activation of p53. Loss-of-function mutations in *CHK2* result in a lack of p53 activation, causing LFS via the p53 pathway.

TP53 is medically important in at least two ways. First, the presence of TP53 mutations in tumors, particularly those of the breast and colon, often signals a more aggressive cancer with relatively poor survival prospects. It is thus a useful prognostic indicator. Second, TP53 may ultimately prove important in tumor prevention. Laboratory experiments show that the insertion of a normal TP53 gene into tumor cells can induce tumor regression by inducing abnormal cancer cells to undergo apoptosis. This has led to gene therapy protocols (see Chapter 13) in which normal TP53 copies are inserted into tumors in an effort to eliminate cancerous cells.

Somatic mutations of the *TP53* gene are found in more than 50% of tumors. This gene encodes a transcription factor that can induce either cell cycle arrest or apoptosis in response to damaged DNA. Inherited *TP53* mutations can cause Li-Fraumeni syndrome.

The Familial Adenomatous Polyposis Gene, *APC*

Colon cancer affects approximately one in 20 Americans, and it clusters in families. A small proportion of colon cancer cases are inherited as autosomal dominant syndromes. The two most important of these syndromes are discussed next.

Familial adenomatous polyposis (FAP), also called adenomatous polyposis coli (APC), is characterized by the early appearance of multiple adenomas, or polyps, of the colon. Colonic adenomas are now understood to be the immediate precursors to colon cancer. The multiple adenomas of the patient with FAP therefore present a grave risk of early malignancy. Because early detection and removal of adenomatous polyps can significantly reduce the occurrence of colon cancer, it is important to understand the causative gene and its role in the development of polyps (Clinical Commentary 11-1).

The gene responsible for FAP was initially placed on the map of the long arm of chromosome 5 by linkage analysis in families after a microscopically visible chromosomal deletion in a patient with this syndrome provided an important clue to its location. Discovery of small, overlapping deletions in two unrelated patients provided the key to isolation of the gene. Among the genes that lay within the 100-kb region that was deleted in both patients, one showed apparent mutations in other patients. This mutation was seen in one patient but not

CLINICAL COMMENTARY 11.1

The APC Gene and Colorectal Cancer

About 1 in 20 Americans will be diagnosed with colorectal cancer. Currently, the mortality rate for this cancer is approximately one third. Genetic and environmental factors, such as dietary fat and fiber, are known to influence the probability of occurrence of colorectal cancer.

As indicated in the text, familial adenomatous polyposis (FAP), also called adenomatous polyposis coli (APC), is an autosomal dominant subtype of colon cancer that is characterized by a large number of adenomatous polyps (Fig. 11-8). These polyps typically develop during the second decade of life and number in the hundreds or more (polyposis itself is defined as the presence of more than 100 polyps). Germline mutations in the APC gene are consistently identified in family members affected with FAP. Approximately one third of these cases are the result of new mutations in this gene. Because of the large size of the gene and the large number of disease-causing mutations, it is difficult and expensive to test family members for germline mutations in order to determine whether they have inherited the disease gene. However, one test takes advantage of the fact that most APC mutations are nonsense or frameshift mutations that yield a truncated protein product. This protein truncation test (see Chapter 3) involves the in vitro manufacture of a protein product from APC DNA to determine whether the at-risk individual has inherited an APC mutation. This test is important for family members because it alerts them to the necessity of frequent surveillance and possible colectomy.

FAP, however, is relatively rare, affecting only about 1 in 8,000 individuals. The broader significance of the *APC* gene derives from the fact that somatic mutations in this gene are seen in approximately 85% of all colon cancers. Furthermore, *APC* mutations occur very early in the development of colorectal malignancies. A better understanding of the *APC* gene product, how it interacts with other proteins, and how it interacts with environmental factors such as diet, may provide important clues for the prevention and treatment of common colon cancer. In this way, the mapping and cloning of a gene responsible for a relatively rare cancer syndrome may have widespread clinical implications. www

Mutations in the APC gene can also produce a related syndrome, termed attenuated familial adeno-

FIGURE 11.8 A portion of a colon removed from a patient with FAP, illustrating a large number of adenomatous polyps covering the colon. Each of these benign neoplasms has the potential to become a malignant tumor.

matous polyposis. This syndrome differs from FAP in that patients have fewer than 100 polyps (typically 10 to 20). There is some evidence that mutations in the 5' region of *APC* are more likely to produce attenuated FAP.

Treatment for colorectal cancer usually involves surgical resection of the colon. However, because colorectal carcinoma is preceded by the appearance of benign polyps, it is one of the most preventable of cancers. The National Polyp Study Workgroup estimates that colonoscopic removal of polyps could reduce the nationwide incidence of colon cancer by as much as 90%. The importance of early intervention and treatment further underscores the need to understand early events in colorectal cancer, such as somatic mutations in the *APC* gene.

Because polyps usually begin to appear in the second decade of life in those who inherit an *APC* mutation, an annual colonoscopy is recommended in these individuals starting at 12 years of age. Colectomy is often necessary by age 20 years. There is evidence that the use of nonsteroidal anti-inflammatory drugs causes some degree of polyp regression.

in his unaffected parents, confirming the identification of the *APC* gene.

Like *RB1* and *TP53*, *APC* is a tumor suppressor gene, and both copies of *APC* must be inactivated for tumor progression to begin. Individuals who inherit an *APC* mutation typically experience somatic loss-of-function mutations in hundreds of their colonic epithelial cells, giving rise to multiple adenomas. In some cases, loss of function of *APC* occurs because of hypermethylation of *APC's* promoter region, which results in reduced transcription (Chapter 3).

While the identification of the APC gene has been important in diagnosing and managing colon cancer in families with FAP (see Clinical Commentary 11-1), the importance of this finding is magnified by the fact that APC mutations are found in 85% of all sporadic (noninherited) colon tumors. Somatic APC mutations (i.e., those that disable both copies of the gene in a colonic cell) are among the earliest alterations in cells that give rise to colon cancer. But APC mutations are not sufficient by themselves to complete the progression to metastatic disease. As shown in Fig. 11-9, other genes may also be altered. For example, gain-of-function mutations are seen in the KRAS gene in approximately 50% of colon tumors. As mentioned previously, this gene encodes a signal transduction molecule, and a gain-of-function mutation increases signaling and thus cellular proliferation. Loss-of-function mutations in the TP53 gene are seen in more than 50% of colon tumors and usually occur relatively late in the pathway to cancer. Ordinarily, p53 would be activated in response to mutations like those of *APC* and *KRAS*, leading to DNA repair or apoptosis. Cells that lack p53 activity are free to continue along the path to malignancy in spite of their damaged DNA. Still another tumor suppressor gene, termed *SMAD4*, appears also to be mutated in the colon cancer pathway. Thus, at least seven mutations are required to produce a colon tumor (two in each of the three tumor suppressor genes, as well as one dominant gain-of-function mutation in *KRAS* or another signal transduction gene).

Extensive studies have revealed at least three ways in which the APC protein acts as a tumor suppressor. Perhaps most importantly, it down-regulates β -catenin, a key molecule in the Wnt signal transduction pathway. Among other things, this pathway is involved in activation of the MYC transcription factor. By reducing βcatenin levels, APC dampens signals that lead to cellular proliferation. Examination of colon carcinomas that do not carry mutations in the APC gene revealed that some of them have gain-of-function mutations in the β -catenin gene, thus confirming the potential etiological role of this gene in colon cancer. APC mutations are also thought to affect cell-cell and cell-matrix adhesion properties (this is important because alteration of cell adhesion control permits cells to invade other tissues and to metastasize to other sites). Again, this activity is mediated

FIGURE 11.9 ■ The pathway to colon cancer. Loss of the *APC* gene transforms normal epithelial tissue lining the gut to hyperproliferating tissue. Hypomethlyation of DNA, activation of the *KRAS* proto-oncogene, and loss of the *SMAD4* gene are involved in the progression to a benign adenoma. Loss of the *TP53* gene and other alterations are involved in the progression to malignant carcinoma and metastasis. Note that these alterations are present in varying frequencies in colon tumor cells. (Modified from Vogelstein B, Kinzler KW [1993] The multistep nature of cancer. Trends Genet 9:138-141.)

through β -catenin, which interacts with a cell-surface molecule (E-cadherin) whose loss of function leads to abnormal cell adhesion properties. Finally, it was shown recently that APC is expressed in the microtubules that pull chromosomes apart during meiosis (Chapter 2). Alterations in APC result in altered microtubule activity, such that aneuploidies and chromosome breaks arise during mitosis. Thus, *APC* mutations also give rise to genomic instability.

The adenomatous polyposis coli gene (*APC*), which strikingly predisposes to colon cancer, was ultimately identified from mutations in patients. *APC* is also involved in the great majority of sporadic cases of colon cancer and is in fact one of the earliest alterations leading to colon tumorigenesis. This tumor suppressor gene has been shown to function as a major regulator of the Wnt signal transduction pathway via its interaction with β-catenin. It is also involved in cell adhesion control and in maintaining chromosome stability during mitosis.

The Hereditary Nonpolyposis Colon Cancer Genes

Hereditary nonpolyposis colon cancer (HNPCC), a second form of inherited colon cancer, accounts for approximately 1% to 5% of all colorectal cancer cases. Like FAP, HNPCC is an autosomal dominant, highpenetrance cancer syndrome, with a lifetime colorectal cancer risk of 70% to 90% in heterozygotes. In addition, endometrial cancer occurs in approximately 20% to 40% of female mutation carriers. Cancers of the small bowel, renal pelvis, ovary, and ureter are seen in a smaller proportion of gene carriers. Mutations in the MSH2 gene account for approximately 40% to 60% of HNPCC cases, and mutations in the MLH1 gene account for about 25% to 30% of cases. Mutations in four other genes, PMS1, PMS2, MLH3, and MSH6, help to account for the small proportion of additional cases. Each of these genes is known to play an important role in DNA mismatch repair (an important clue in their identification was the existence of highly similar DNA repair genes in yeast and bacteria). Inactivation of both alleles of any one of these genes increases the genome-wide mutation rate in an affected cell by as much as 1,000-fold.

This increased rate of mutation results in the alteration of a number of cellular regulatory genes, thus leading to an increased frequency of cancer. A characteristic feature of tumors from HNPCC patients is a high degree of instability of microsatellite loci (see Chapter 3), which generates many new microsatellite alleles. Such microsatellite instability is also seen in about 15% of sporadic colorectal carcinomas, but somatic loss-of-function mutations in the HNPCC genes seem to occur only infrequently in these tumors. Instead, the most common alteration seen in these sporadic tumors is hypermethylation of the *MLH1* gene, resulting in its inactivation.

A comparison of FAP and HNPCC reveals interesting differences in the way in which each syndrome leads to colon cancer. In FAP, an inherited APC mutation results in a large number of polyps, each of which has a relatively low probability of incurring all of the other genetic alterations required for progression to metastatic cancer. But, because the number of polyps is large, there is a high probability (almost 100%) that at least one of them will produce a cancerous tumor by approximately the age of 45 years. In HNPCC, the number of polyps is much smaller (hence the term "nonpolyposis"), but, because of a lack of DNA repair, each polyp has a relatively high probability of experiencing the multiple alterations necessary for tumor development. Consequently, the average age of onset of colon cancer in HNPCC is similar to that of FAP.

HNPCC is an inherited form of colorectal cancer that is caused by mutations in any of six genes involved in DNA mismatch repair. It represents an example of a cancer syndrome caused by genomic instability.

Inherited Breast Cancer

The lifetime prevalence of breast cancer in women is 1 in 8, and a woman's risk of developing breast cancer doubles if a first-degree relative is affected. Two genes, *BRCA1* and *BRCA2*, have been identified as major contributors to inherited breast cancer. This section addresses three critical questions regarding these genes: (1) What proportion of breast cancer cases are the result of *BRCA1* and *BRCA2* mutations? (2) Among those who inherit a mutation, what is the risk of developing cancer? (3) How do mutations in these genes contribute to cancer susceptibility?

Most population-based studies show that only a small percentage of all breast cancers—approximately 1% to 3%—can be attributed to inherited mutations in *BRCA1* or *BRCA2*. Among women with breast cancer who also have a positive family history of the disease, the percentage with inherited mutations in either of these genes increases to approximately 20%. Among affected women who have a positive family history of breast *and* ovarian cancer, 60% to 80% have inherited a *BRCA1* or *BRCA2* mutation. Inherited mutations in these genes are also more common among women with early-onset breast cancer.

Women who inherit a mutation in *BRCA1* or *BRCA2* experience a 50% to 80% lifetime risk of developing breast cancer. The upper range of these risk estimates reflects studies that focused on high-risk families with multiple affected members and may thus be somewhat inflated. *BRCA1* mutations also increase the risk of ovarian cancer among women (20% to 50% lifetime risk), and they confer a modestly increased risk of prostate and colon cancers. *BRCA2* mutations also confer

an increased risk of ovarian cancer (10% to 20% lifetime prevalence). Approximately 6% of males who inherit a *BRCA2* mutation will develop breast cancer; this represents a 100-fold increase over the risk in the general male population (see Chapter 12 for further discussion of breast cancer risk factors).

BRCA1 and BRCA2 were both identified by linkage analysis in families, followed by positional cloning. Both genes are large: BRCA1 spans approximately 100 kb, and BRCA2 spans 70 kb. More than 350 BRCA1 mutations and more than 200 BRCA2 mutations have been identified. Most of these mutations result in truncated protein products and a consequent loss of function. As for the RB1 and APC genes, affected individuals inherit one copy of a BRCA1 or BRCA2 mutation and then experience a somatic loss of the remaining normal allele in one or more cells (following the two-hit model for tumor suppressor genes). In contrast to RB1 and APC, somatic mutations affecting these genes are seldom seen in sporadic (noninherited) breast tumors. The large size of these genes, together with extensive allelic heterogeneity, poses challenges for genetic diagnosis (see Chapter 13). www

Although BRCA1 and BRCA2 share no significant DNA sequence similarity, they both participate in the DNA repair process. The protein product of BRCA1 is phosphorylated (and thus activated) by the ATM and CHK2 kinases in response to DNA damage (Fig. 11-10). The BRCA1 protein product binds to the BRCA2 product, which in turn binds to RAD51, a protein involved in the repair of double-stranded DNA breaks (as with the HNPCC genes, RAD51 has homologs in yeast and bacteria). Both genes thus participate in an important DNA repair pathway, and their inactivation results in incorrect DNA repair and genomic instability. In addition to their roles in the RAD51 pathway, BRCA1 and BRCA2 help to suppress tumor formation through their interactions with previously discussed proteins such as p53, pRb, and Myc.

Since all of the genes illustrated in Fig. 11-10 are involved in a DNA repair pathway, it might be anticipated that mutations in genes other than *BRCA1* or *BRCA2* could lead to DNA repair defects and possibly cancer. This is indeed the case. As already discussed, mutations in *CHK2* can cause LFS. Mutations in the *ATM* gene can cause ataxia telangiectasia (Chapter 3), an autosomal recessive disease that involves extensive genomic instability, cerebellar ataxia, dilated vessels in the eyes and skin (telangiectasia), and cancers of mainly lymphoid origin. Another autosomal recessive chromosome instability syndrome, Fanconi anemia, can be caused by the inheritance of two copies of a *BRCA2* mutation.

Although *BRCA1* and *BRCA2* mutations are the most common known causes of inherited breast cancer, this disease can also be caused by inherited mutations in several other tumor suppressor genes (e.g., the previously discussed *CHK2* and *TP53* genes). Germline mutations in a tumor suppressor gene called *PTEN* are responsible for Cowden disease, which is characterized by multiple benign tumors and an increased susceptibility to breast cancer. Some studies have suggested that heterozygous carriers of mutations in the *ATM* gene have an increased susceptibility to breast cancer, but these findings remain controversial

Mutations in *BRCA1* and *BRCA2* are responsible for a significant proportion of inherited breast cancer cases, especially those of early onset. These mutations usually result in a truncated protein product and loss of function. The protein products of these genes play important roles in DNA repair.

Familial Melanoma

Largely as a result of increased exposure to ultraviolet radiation, the incidence of melanoma has increased about 20-fold in the United States during the past 70 years. It is now one of the most common cancers, with 37,000 new cases per year. The risk of developing melanoma increases by a factor of 2 when a first-degree relative is affected. The risk increases further, to approximately 6.5, when the first-degree relative is affected before 50 years

of age. It is estimated that approximately 5% to 10% of melanoma cases occur in inherited, familial forms.

Linkage analysis in families and studies of loss of heterozygosity in melanoma tumor cells mapped a gene for familial melanoma to the short arm of chromosome 9. Subsequent positional cloning and mutation analysis led to the identification of the *CDKN2A* gene as a cause of familial melanoma. This gene encodes a cyclin-dependent kinase inhibitor (termed p16) which, like p21, interacts negatively with a cyclin-dependent kinase (CDK4) that phosphorylates and down-regulates the pRb protein (see Fig. 11-5). Because active pRb acts as a brake on the cell cycle, loss-of-function mutations in the *CDKN2A* tumor suppressor gene result in a lack of cell cycle control, thereby producing melanomas.

Inherited mutations in the gene that encodes CDK4 can also result in familial melanoma. These gain-of-function mutations convert the cyclin-dependent kinase from a proto-oncogene to an activated oncogene. The activated CDK4 constantly down-regulates pRb, resulting again in a lack of cell cycle control and tumor formation. Melanoma provides an example in which the same tumor type can result from either the activation of a proto-oncogene (*CDK4*) or the loss of a tumor suppressor gene (*CDKN2A*).

CDKN2A plays a role not only in familial melanoma but also in approximately 25% of sporadic melanomas, in which somatic loss-of-function mutations of this gene lead to inactivation of the p16 tumor suppressor protein. As might be expected, somatic mutations in other genes are also seen in sporadic melanomas. Approximately two thirds of these tumors contain gain-of-function mutations in *BRAF*, a gene that encodes a kinase involved in the RAS signal transduction pathway. In addition, lossof-function mutations in the *APAF1* gene enable the altered cell to avoid the p53 apoptosis pathway.

■ Familial melanoma can be caused by loss-of-function mutations in the *CDKN2A* tumor suppressor gene or by gain-of-function mutations in the *CDK4* proto-oncogene. Both mutations result in a loss of cell cycle control via the pRb pathway. Somatic mutations of *CDKN2A* and of *BRAF* are seen in 25% and in 65% to 70% of sporadic melanomas, respectively.

The *RET* Proto-Oncogene and Multiple Endocrine Neoplasia

The *RET* gene, initially identified by a transfection assay (see previous discussion), encodes a receptor tyrosine kinase that includes an extracellular receptor domain, a transmembrane domain, and an intracellular tyrosine kinase domain. RET is involved in embryonic neural crest cell migration (see Chapter 10), and it is normally activated by a complex consisting of glial-derived neurotrophic factor (GDNF) and a coreceptor termed GFR α . The RET protein interacts with several signal

transduction pathways, including the well-known RAS pathway.

Inherited loss-of-function mutations in RET can produce Hirschsprung disease (a lack of enteric nerve cells, resulting in severe, chronic constipation and bowel distention). Gain-of-function mutations in the same gene result in excess tyrosine kinase activity and increased signal transduction, leading ultimately to cellular proliferation and, depending on the type and location of the mutation, any of three forms of inherited multiple endocrine neoplasia type 2 (MEN2). (1) MEN2A is characterized by medullary thyroid carcinomas, parathyroid hyperplasia, and pheochromocytoma (an adrenal tumor). More than 98% of MEN2A cases are caused by missense mutations that affect cysteine residues in RET's extracellular domain. (2) MEN2B is similar to MEN2A but lacks parathyroid hyperplasia and includes multiple mucosal neuromas and a marfanoid appearance. Nearly all MEN2B alterations are missense mutations that affect RET's tyrosine kinase domain. (3) A syndrome consisting only of familial medullary thyroid carcinomas can be caused by mutations in both the extracellular and tyrosine kinase domains of RET. RET is one of only four proto-oncogenes in which mutations can cause inherited cancer syndromes (see Table 11-3 for other examples).

Identification of the mutations responsible for each of these inherited cancer syndromes has provided an accurate means of early diagnosis in more than 98% of MEN2A cases. Prophylactic thyroidectomy before 6 years of age is recommended for children who inherit a disease-causing mutation (thyroidectomy before age 3 years may be indicated for the more aggressive MEN2B tumors).

Somatic alterations of RET can produce papillary thyroid carcinomas, the most common type of thyroid tumor. The prevalence of this tumor has increased substantially among individuals who were exposed to radioactive fallout from the Chernobyl nuclear reactor accident (see Chapter 3). Sixty percent of the papillary thyroid carcinomas in these individuals have contained somatic *RET* alterations.

The *RET* gene provides an example of extraordinary allelic heterogeneity. Loss-of-function mutations in this gene produce defects in the embryonic development of the bowel, while gain-of-function mutations result in increased signal transduction and various forms of endocrine neoplasia. This example illustrates the critical connection between development and cancer: both involve a finely tuned genetic regulation of cell growth and differentiation.

Loss-of-function mutations in the *RET* proto-oncogene can produce Hirschsprung disease, a disorder of embryonic development. Germline gain-of-function mutations in the same gene can lead to any of three different types of inherited cancers. Somatic alterations in *RET* can produce noninherited papillary thyroid carcinoma.

Other Inherited Cancer Genes

More than 30 mutant genes responsible for various inherited cancer syndromes have been identified. These include the genes that cause neurofibromatosis type 2, von Hippel-Lindau syndrome, and Beckwith-Wiedemann syndrome (see Table 11-1). With the current generation of genomic resources, including the complete human DNA sequence, it is reasonable to expect the identification of more such genes.

MOLECULAR BASIS OF CANCER

Each of the identified genes associated with inherited cancer syndromes provides a unique insight into the genetic mechanisms of carcinogenesis. Those that represent important elements in transcriptional regulation of the cell cycle (*RB1*, *TP53*), signal transduction (*NF1*), and DNA repair (*BRCA1*, *BRCA2*, and the HNPCC genes) promise to make significant contributions to our understanding of these processes.

It is striking that nearly all of the inherited tumorcausing genes described to date seem to have cellrecessive properties, at least at the level of the carcinoma. This observation suggests that an inherited allele that produces a tumor in the heterozygous state would not be tolerated during development. That view is supported by the nearly ubiquitous tissue distribution of the products of these genes. Because they are expressed in many if not all cell types, they may each play a fundamental role during embryonic development (see Chapter 10).

From a medical perspective, the characterization of inherited tumor genes can be very fruitful. Presymptomatic diagnosis of at-risk individuals in cancer families may specify those who must undergo close surveillance or even intervention, and it can lift a major medical and psychological burden from those who have not inherited the family's mutant allele. If more subtle, predisposing alleles prove to be important in the incidence of cancer in general, the ability to define an at-risk population might reduce the overall cost of cancer surveillance in the population as a whole. In the future, greater understanding of these genes and their functions will offer hope for the ultimate prevention of cancer, because these genes are clearly rate-limiting for tumor formation. If their mutant alleles serve as indicators for the appearance of nascent tumors, or if their normal functions can be restored by medical intervention, they will have served an important role in cancer prevention.

Studies of inherited cancer genes have provided many insights, but many important questions remain. Although inherited cancer genes are widely expressed in many tissues, why are most inherited cancer syndromes characterized by very specific tumor types (e.g., retinoblastomas and osteosarcomas for *RB1*, colon tumors for *APC*)? Why do the tumor types associated with the inherited alterations of cancer genes often differ from the tumor types associated with somatic alterations of the same genes (e.g., inherited *TP53* mutations lead to breast cancer, leukemia, brain tumors, soft tissue sarcoma, and osteosarcoma, but somatic *TP53* mutations can produce lung and colon tumors, among others)? To what degree, and in what ways, are inherited cancer genes involved in common, noninherited cancers?

The continued mapping and cloning of genes for cancer syndromes will provide valuable insights into mechanisms of carcinogenesis and into fundamental biological processes. Presymptomatic diagnosis of family members at risk for cancer, and ultimately the possibility of genetic interventions, are other important goals and potential rewards of such studies.

IS GENETIC INHERITANCE IMPORTANT IN COMMON CANCERS?

The role, or even the significance, of inherited predisposition in the common cancers, such as carcinomas of breast, colon, or prostate, is not yet certain. An apparently increased frequency of common cancers in some families has led some to suggest that common cancercausing alleles may exist. Familial clustering translates into an increased relative risk of breast cancer, for example, among women with first-degree relatives who have had breast cancer. The genetic basis of this increased risk has not yet been demonstrated. However, evidence indicates that a significant fraction of premenopausal breast cancer cases are associated with the *BRCA1* and *BRCA2* genes. In addition, statistical analysis of large pedigrees has provided support for a genetic component in common colon cancer and prostate cancer.

How will we ultimately determine whether common "cancer alleles" exist in the population? One way, perhaps, could exploit new approaches of gene mapping that identify genes involved in cellular pathways to cancer. Each of these becomes a candidate gene that, we hypothesize, may confer a predisposition to cancer. The most critical test of the candidate-gene hypothesis will be to determine whether there are mutations in the gene among cancer patients. Finding these mutations will validate the genetic hypothesis. If no mutations are found, however, we will remain uncertain, because a genetic predisposition could still be conferred by an allele of a gene not yet identified and tested.

The question of whether common cancer alleles exist in the population may be approached by seeking mutations among the growing number of identified genes known to be involved in cellular mechanisms leading to cancer.

A detailed description of the genes and genetic events underlying cancer is rapidly emerging. The identified genes fall into three relatively distinct categories: mutant oncogenes that act as promoters of cell growth, mutant tumor suppressors that often fail to inhibit cell growth, and DNA repair gene mutations that create a high frequency of mutant oncogenes and tumor suppressors. These categories share a commonality in that each ultimately affects the genetic regulation of cell growth and development. Although acting at different points, they regulate the same fundamental cell activities and information pathways. New and powerful techniques in molecular biology and genetics are now identifying the specific genes associated with specific tumor types. Significant new information is becoming available to researchers and clinicians and can be expected to create highly specific diagnostic and therapeutic tools to reduce the cancer burden.

SUGGESTED READINGS

- Balmain A, Gray J, Ponder B (2003) The genetics and genomics of cancer. Nat Genet 33:238-244.
- Blasco MA (2003) Telomeres and cancer: a tale with many endings. Curr Opin Genet Dev 13:70-76.
- Deng CX, Brodie SG (2000) Roles of BRCA1 and its interacting proteins. Bioessays 22:728-737
- Fodde R, Smits R, Clevers H (2001) APC, signal transduction and genetic instability in colorectal cancer. Nat Rev Cancer 1:55-67
- Grady WM, Markowitz SD (2002) Genetic and epigenetic alterations in colon cancer. Annu Rev Genomics Hum Genet 3:101-128
- Hahn WC, Weinberg RA (2002) Modelling the molecular circuitry of cancer. Nat Rev Cancer 2:331-341
- Hanahan D, Weinberg RA (2000) The hallmarks of cancer. Cell 100:57-70
- Hansford JR, Mulligan LM (2000) Multiple endocrine neoplasia type 2 and RET: from neoplasia to neurogenesis. J Med Genet 37:817-827

- Hickman ES, Moroni MC, Helin K (2002) The role of p53 and pRb in apoptosis and cancer. Curr Opin Genet Dev 12:60-66
- Ho A, Dowdy SF (2002) Regulation of G(1) cell-cycle progression by oncogenes and tumor suppressor genes. Curr Opin Genet Dev 12:47-52
- Knudson AG (2001) Two genetic hits (more or less) to cancer. Nat Rev Cancer 1:157-162
- Knudson AG (2002) Cancer genetics. Am J Med Genet 111:96-102
- Lynch HT, de la Chapelle A (2003) Hereditary colorectal cancer. N Engl J Med 348:919-932.
- Maser RS, DePinho RA (2002) Connecting chromosomes, crisis, and cancer. Science 297:565-569
- Nathanson KL, Wooster R, Weber BL, Nathanson KN (2001) Breast cancer genetics: what we know and what we need. Nat Med 7:552-556
- Nevins JR (2001) The Rb/E2F pathway and cancer. Hum Mol Genet 10:699-703
- Pandolfi PP (2001) Oncogenes and tumor suppressors in the molecular pathogenesis of acute promyelocytic leukemia. Hum Mol Genet 10:769-775
- Peltomaki P (2001) Deficient DNA mismatch repair: a common etiologic factor for colon cancer. Hum Mol Genet 10:735-740
- Ponder BA (2001) Cancer genetics. Nature 411:336-341
- Venkitaraman AR (2002) Cancer susceptibility and the functions of BRCA1 and BRCA2. Cell 108:171-182
- Vogelstein B, Kinzler KW (eds) (1998) The Genetic Basis of Human Cancer. McGraw-Hill, New York

INTERNET RESOURCES

Massachusetts General Hospital Cancer Center (links to many useful breast cancer Web sites)

http://www.cancer.mgh.harvard.edu/Links.htm

National Cancer Institute Information site (general information on cancer and cancer genetics, as well as links to other useful Web sites)

http://cancer.gov/cancerinformation

STUDY QUESTIONS

- 1. The *G6PD* locus is located on the X chromosome. Studies of *G6PD* alleles in tumor cells from women show that all tumor cells usually express the same single *G6PD* allele, even though the women are heterozygous at the *G6PD* locus. What does this finding imply about the origin of the tumor cells?
- 2. If we assume that the somatic mutation rate at the *RB1* locus is three mutations per million cells, and that there is a population of 2 million retinoblasts per individual, what is the expected frequency of *sporadic* retinoblastoma in the population? What is

the expected *number of tumors* per individual among those who *inherit* a mutated copy of the *RB1* gene?

- **3.** Compare and contrast oncogenes and tumor suppressor genes. How have the characteristics of these classes of cancer-causing genes affected our ability to detect them?
- **4.** Members of Li-Fraumeni syndrome families nearly always develop tumors by 65 to 70 years of age, but the probability of developing a *specific* type of cancer, such as a breast or colon carcinoma, is relatively small. Explain this.

CHAPTER 4

Multifactorial Inheritance and Common Diseases

The focus of previous chapters has been on diseases that are caused by mutations in single genes or by abnormalities of single chromosomes. Much progress has been made in identifying specific mutations that cause these diseases, leading to better risk estimates and in some cases more effective treatment. However, these conditions form only a small portion of the total burden of human genetic disease. Most congenital malformations are not caused by single genes or chromosome defects. Many common adult diseases, such as cancer, heart disease, and diabetes, have genetic components, but again they usually are not caused by single genes or by chromosome abnormalities. These diseases, whose treatment collectively occupies the attention of most health care practitioners, are the result of a complex interplay of genetic and environmental factors.

PRINCIPLES OF MULTIFACTORIAL INHERITANCE

The Basic Model

Traits in which variation is thought to be caused by the combined effects of multiple genes are called **polygenic** ("many genes"). When environmental factors are also believed to cause variation in the trait, which is usually the case, the term **multifactorial** is used. Many **quantitative traits** (those, such as blood pressure, that are measured on a continuous numerical scale) are multifactorial. Because they are caused by the additive effects of many genetic and environmental factors, these traits tend to follow a normal, or "bell-shaped," distribution in populations.

Let us use an example to illustrate this concept. To begin with the simplest case, suppose (unrealistically) that height is determined by a single gene with two alleles, A and a. Allele A tends to make people tall, whereas allele a tends to make them short. If there is no dominance at this locus, then the three possible genotypes, AA, Aa, and aa, will produce three phenotypes: tall, intermediate, and short. Assume that the gene frequencies of A and a are each 0.50. If we look at a population of individuals, we will observe the height distribution depicted in Fig. 12-1A.

Now suppose, a bit more realistically, that height is determined by two loci instead of one. The second locus also has two alleles, B (tall) and b (short), and they affect height in exactly the same way as alleles A and a do. There are now nine possible genotypes in our population: *aabb, aaBb, aaBb, Aabb, AaBb, AaBb, AaBb, AAbb, AABb, and AABB.* Because an individual may have zero, one, two, three, or four "tall" alleles, there are now five distinct phenotypes (see Fig. 12-1B). Although the height distribution in our population is not yet normal, it approaches a normal distribution more closely than in the single-gene case.

We now extend our example so that many genes and environmental factors influence height, each having a small effect. Then there are many possible phenotypes, each differing slightly, and the height distribution approaches the bell-shaped curve shown in Fig. 12-1C.

It should be emphasized that the individual genes underlying a multifactorial trait such as height follow the Mendelian principles of segregation and independent assortment, just like any other genes. The only difference is that many of them *act together* to influence the trait.

Blood pressure is another example of a multifactorial trait. There is a correlation between parents' blood pressures (systolic and diastolic) and those of their children. There is good evidence that this correlation is due in part to genes. But blood pressure is also influenced by environmental factors, such as diet and stress. One of the goals of genetic research is identification of the genes responsible for multifactorial traits such as blood pressure and of the interactions of those genes with environmental factors.

Many traits are thought to be influenced by multiple genes as well as environmental factors. These traits are said to be multifactorial. When they can be measured on a continuous scale, they often follow a normal distribution.

FIGURE 12.1 A, The distribution of height in a population, assuming that height is controlled by a single locus with genotypes *AA*, *Aa*, and *aa*. **B**, The distribution of height, assuming that height is controlled by two loci. There are now five distinct phenotypes instead of three, and the distribution begins to look more like the normal distribution. **C**, Distribution of height, assuming that multiple factors, each with a small effect, contribute to the trait (the multifactorial model).

The Threshold Model

A number of diseases do not follow the bell-shaped distribution. Instead, they appear to be either present or absent in individuals. Yet they do not follow the patterns expected of single-gene diseases. A commonly used expla-

FIGURE 12.2 A liability distribution for a multifactorial disease in a population. To be affected with the disease, an individual must exceed the threshold on the liability distribution. This figure shows two thresholds, a lower one for males and a higher one for females (as in pyloric stenosis).

nation is that there is an underlying **liability distribution** for these diseases in a population (Fig. 12-2). Those individuals who are on the low end of the distribution have little chance of developing the disease in question (i.e., they have few of the alleles or environmental factors that would cause the disease). Those who are closer to the high end of the distribution have more of the disease-causing genes and environmental factors and are more likely to develop the disease. For multifactorial diseases that are either present or absent, it is thought that a **threshold of liability** must be crossed before the disease is expressed. Below the threshold, the individual appears normal; above it, he or she is affected by the disease.

A disease that is thought to correspond to this threshold model is pyloric stenosis, a disorder that manifests shortly after birth and is caused by a narrowing or obstruction of the pylorus, the area between the stomach and intestine. Chronic vomiting, constipation, weight loss, and electrolyte imbalance result from the condition, but it sometimes resolves spontaneously or can be corrected by surgery. The prevalence of pyloric stenosis among Caucasians is about 3/1,000 live births. It is much more common in males than in females, affecting 1/200 males and 1/1,000 females. It is thought that this difference in prevalence reflects *two* thresholds in the liability distribution, a lower one in males and a higher one in females (see Fig. 12-2). A lower male threshold implies that fewer disease-causing factors are required to generate the disorder in males.

The liability threshold concept may explain the pattern of sibling recurrence risks for pyloric stenosis, shown in Table 12-1. Notice that males, having a lower threshold, always have a higher risk than females. However, the recurrence risk also depends on the sex of the proband. It is higher when the proband is female than when the proband is male. This reflects the concept that females, having a higher liability threshold, must be exposed to more disease-causing factors than males in order to develop the disease. Thus, a family with an affected female must have more genetic and environmental risk factors, producing a higher recurrence risk for pyloric stenosis in future offspring. In such a situation, we would expect that the highest risk category would be *male* relatives of *female* probands; Table 12-1 shows that this is indeed the case.

A similar pattern has been observed in a study of infantile autism, a behavioral disorder in which the malefemale sex ratio is approximately 4:1. As expected for a multifactorial disorder, the recurrence risks for siblings of male probands (3.5%) is substantially lower than that of siblings of female probands (7%). For diseases in which the sex ratio is reversed (i.e., more affected females than males), we would expect a higher recurrence risk when the proband is male.

A number of other congenital malformations are thought to correspond to this model. They include isolated* cleft lip and/or cleft palate, neural tube defects (anencephaly and spina bifida), club foot (talipes), and some forms of congenital heart disease. In addition, many of the common adult diseases, such as hypertension, heart disease, stroke, diabetes mellitus (types 1 and 2), and some cancers, are caused by complex genetic and environmental factors and can thus be considered multifactorial diseases.

The threshold model applies to many multifactorial diseases. It assumes that there is an underlying liability distribution in a population and that a threshold on this distribution must be passed before a disease is expressed.

Recurrence Risks and Transmission Patterns

Whereas recurrence risks can be given with confidence for single-gene diseases (50% for typical autosomal dominant diseases, 25% for autosomal recessive diseases, and

	Subdivided by Gender of Affected Probands and Relatives*					
Relatives	Male Pro	obands	Female Probands			
	London	Belfast	London	Belfast		
Brothers	3.8	9.6	9.2	12.5		
Sisters	2.7	3.0	3.8	3.8		

TABLE 12.1 Recurrence Risks (%) for Pyloric Stenosis,

*Note that the risks differ somewhat between the two populations. Adapted from Carter CO (1976) Genetics of common single malformations. Br Med Bull 32:21–26.

so on), the situation is more complicated for multifactorial diseases. This is because the number of genes contributing to the disease is usually not known, the precise allelic constitution of the parents is not known, and the extent of environmental effects can vary substantially. For most multifactorial diseases, empirical risks (i.e., risks based on direct observation of data) have been derived. To estimate empirical risks, a large series of families is examined in which one child (the proband) has developed the disease. The relatives of each proband are surveyed in order to calculate the percentage who have also developed the disease. For example, in North America neural tube defects are seen in about 2% to 3% of the siblings of neural tube defect probands (Clinical Commentary 12-1). Thus, the recurrence risk for parents who have had one child with a neural tube defect is 2% to 3%. For conditions that are not lethal or severely debilitating, such as cleft lip/palate, recurrence risks can also be estimated for the offspring of affected parents. Because risk factors vary among diseases, empirical recurrence risks are specific for each multifactorial disease.

In contrast to most single-gene diseases, recurrence risks for multifactorial diseases can change substantially from one population to another (notice the differences between the London and Belfast populations in Table 12-1). This is because gene frequencies as well as environmental factors can differ among populations.

Empirical recurrence risks for multifactorial diseases are based on studies of large collections of families. These risks are specific to a given population.

It is sometimes difficult to differentiate polygenic or multifactorial diseases from single-gene diseases that have reduced penetrance or variable expression. Large data sets and good epidemiological data are necessary to make the distinction. Several criteria are usually used to define multifactorial inheritance:

1. The recurrence risk is higher if more than one family member is affected. For example, the sibling recur-

^{*}In this context, the term "isolated" means that this is the *only* observed disease feature (i.e., the feature is not part of a larger constellation of findings, as in cleft lip/palate secondary to trisomy 13).

CLINICAL COMMENTARY 12.

Neural Tube Defects

Neural tube defects (NTDs) include anencephaly, spina bifida, and encephalocele, as well as several other less common forms. They are one of the most important classes of birth defects, with a newborn prevalence of 1 to 3 per 1,000. There is considerable variation in the prevalence of NTDs among various populations, with an especially high rate among some northern Chinese populations (as high as 6 per 1,000 births). For reasons that are not fully known, the prevalence of NTDs has been decreasing in many parts of the United States and Europe during the past two decades.

Normally the neural tube closes at about the fourth week of gestation. A defect in closure or a subsequent reopening of the neural tube results in an NTD. Spina bifida (Fig. 12-3A) is the most commonly observed NTD and consists of a protrusion of spinal tissue through the vertebral column (the tissue usually includes meninges, spinal cord, and nerve roots). About 75% of spina bifida patients have secondary hydrocephalus, which sometimes in turn produces mental retardation. Paralysis or muscle weakness, lack of sphincter control, and club feet are often observed. A study conducted in British Columbia showed that survival rates for spina bifida patients have improved dramatically over the past several decades. Fewer than 30% of such children born between 1952 and 1969 survived to 10 years of age, while 65% of those born between 1970 and 1986 survived to this age. www

Anencephaly (Fig. 12-3B) is characterized by partial or complete absence of the cranial vault and calvarium and partial or complete absence of the cerebral hemispheres. At least two thirds of anencephalics are stillborn; term deliveries do not survive more than a few hours or days. Encephalocele (Fig. 12-3C) consists of a protrusion of the brain into an enclosed sac. It is seldom compatible with survival. www

NTDs are thought to arise from a combination of genetic and environmental factors. In most populations surveyed thus far, empirical recurrence risks for siblings of affected individuals range from 2% to 5%. Consistent with a multifactorial model, the recurrence

FIGURE 12.3 The major neural tube defects (NTDs). A, An infant with an open spina bifida (meningomyelocele).

FIGURE 12.3, cont'd **B**, A fetus with anencephaly. Note the abnormalities of the orbits of the eye and the cranial defect.

risk increases with additional affected siblings. A Hungarian study showed that the overall prevalence of NTDs in that country was 1/300 births and that the sibling recurrence risks were 3%, 12%, and 25% after one, two, and three affected offspring, respectively. Recurrence risks tend to be slightly lower in populations with lower NTD prevalence rates, as predicted by the multifactorial model. Recurrence risk data support the idea that the major forms of NTDs are caused by similar factors. An anencephalic conception increases the recurrence risk for subsequent spina bifida conceptions, and vice versa.

NTDs can usually be diagnosed prenatally, sometimes by ultrasound and usually by an elevation in α fetoprotein (AFP) in the maternal serum or amniotic fluid (see Chapter 13). A spina bifida lesion can be either open or closed (i.e., covered with a layer of skin). Fetuses with open spina bifida are more likely to be detected by AFP assays. A major epidemiological finding is that mothers who supplement their diet with folic acid at the time of conception are less likely to produce children with NTDs. This result has been replicated in several different populations and is thus well confirmed. It has been estimated that approximately 50% to 70% of NTDs can be avoided simply by dietary folic acid supplementation. (Traditional prenatal vitamin supplements would not have an effect because administration does not usually begin until well after the time that the neural tube closes.) Since mothers would be likely to ingest similar amounts of folic acid from one pregnancy to the next, folic acid deficiency could well account for at least part of the elevated sibling recurrence risk for NTDs.

Dietary folic acid is an important example of a nongenetic factor that contributes to familial clustering of a disease. However, it is likely that there is genetic variation in response to folic acid, which helps

CLINICAL COMMENTARY 12.1

Neural Tube Defects—cont'd

to explain why most mothers with folic acid deficiency do not bear children with NTDs and why some who ingest adequate amounts of folic acid nonetheless bear children with NTDs. To address this issue, researchers are testing for associations between NTDs and variants in several genes whose products (e.g., methylene tetrahydrofolate reductase) are involved in folic acid metabolism (see Clinical Commentary 14-6 in Chapter 14 for further information on dietary folic acid supplementation and NTD prevention).

FIGURE 12.3, cont'd = C, An occipital encephalocele. (A-C, Courtesy of Dr. Edward Klatt, Florida State University College of Medicine.)

rence risk for a ventricular septal defect (VSD, a type of congenital heart defect) is 3% if one sibling has had a VSD but increases to approximately 10% if two siblings have had VSDs. In contrast, the recurrence risk for single-gene diseases remains the same regardless of the number of affected siblings. It should be emphasized that this increase does not mean that the family's risk has actually changed. Rather, it means that we now have more information about the family's true risk: because they have had two affected children, they are probably located higher on the liability distribution than a family with only one affected child. In other words, they have more risk factors (genetic and/or environmental) and are more likely to produce an affected child. www

2. If the expression of the disease in the proband is more severe, the recurrence risk is higher. This is again consistent with the liability model, because a more severe expression indicates that the affected indi-

vidual is at the extreme tail of the liability distribution (see Fig. 12-2). His or her relatives are thus at a higher risk to inherit disease genes. For example, the occurrence of a bilateral (both sides) cleft lip/palate confers a higher recurrence risk on family members than does the occurrence of a unilateral (one side) cleft. www

- 3. The recurrence risk is higher if the proband is of the less commonly affected sex (see, for example, the previous discussion of pyloric stenosis). This is because an affected individual of the less susceptible sex is usually at a more extreme position on the liability distribution.
- 4. The recurrence risk for the disease usually decreases rapidly in more remotely related relatives (Table 12-2). While the recurrence risk for single-gene diseases decreases by 50% with each degree of relationship (e.g., an autosomal dominant disease has a 50% recurrence risk for siblings, 25% for uncle-nephew relationships, 12.5% for first cousins, and so on),

	Prevalence	Degr	Degree of Relation		
Disease	in general population	First degree	Second degree	Third degree	
Cleft lip/palate	0.1	4.0	0.7	0.3	
Club foot	0.1	2.5	0.5	0.2	
Congenital hip dislocation	0.2	5.0	0.6	0.4	
Infantile autism	0.04	4.5	0.1	0.05	

TABLE 12.2	Recurrence Risks (%) for First-, Second-, and Third-Degree Relatives of Probands

it decreases much more quickly for multifactorial diseases. This reflects the fact that many genes and environmental factors must combine to produce a trait. All of the necessary risk factors are unlikely to be present in less closely related family members.

5. If the prevalence of the disease in a population is f, the risk for offspring and siblings of probands is approximately \sqrt{f} . This does not hold true for single-gene traits, because their recurrence risks are independent of population prevalence. It is not an absolute rule for multifactorial traits either, but many such diseases do tend to conform to this prediction. Examination of the risks given in Table 12-2 shows that the first three diseases follow the prediction fairly well. However, the observed sibling risk for the fourth disease, infantile autism, is substantially higher than predicted by \sqrt{f} .

Risks for multifactorial diseases usually increase (1) if more family members are affected, (2) if the disease has more severe expression, and (3) if the affected proband is a member of the less commonly affected sex. Recurrence risks decrease rapidly with more remote degrees of relationship. In general, the sibling recurrence risk is approximately equal to the square root of the prevalence of the disease in the population.

Multifactorial Versus Single-Gene Inheritance

It is important to clarify the difference between a multifactorial disease and a single-gene disease in which there is locus heterogeneity. In the former case, a disease is caused by the simultaneous operation of multiple genetic and environmental factors, each of which has a relatively small effect. In contrast, a disease with locus heterogeneity, such as osteogenesis imperfecta, requires only a single mutation for its causation. Because of locus heterogeneity, a chromosome 7 mutation may cause the disease in one family, while a chromosome 17 mutation may cause the disease in another family. More than one gene can cause the disease, but *in a given individual* a single gene causes the disease.

In some cases a trait may be influenced by the combination of both a single gene with large effects and a multifactorial "background" in which additional genes and environmental factors have small individual effects (Fig. 12-4). Imagine that variation in height, for example, is caused by a single locus (termed a major gene) and a multifactorial component. Individuals with the AA genotype tend to be taller, those with the *aa* genotype tend to be shorter, and those with Aa tend to be intermediate. But additional variation is caused by other factors (the multifactorial component). Thus, those with the aa genotype vary in height from 130 cm to about 170 cm, those with the Aa genotype vary from 150 cm to 190 cm, and those with the AA genotype vary from 170 to 210 cm. There is substantial overlap among the three major genotypes because of the influence of the multifactorial background. The total distribution of height, which is bell-shaped, is caused by the superposition of the three distributions about each genotype.

Many of the diseases to be discussed later can be the result of either a major gene or multifactorial inheritance. That is, there are subsets of the population in which diseases such as colon cancer, breast cancer, or heart disease are inherited as single-gene disorders (with additional variation in disease susceptibility contributed by other genetic and environmental factors). These subsets usually account for only a small percentage of the

FIGURE 12.4 The distribution of height, assuming the presence of a major gene (genotypes *AA*, *Aa*, and *aa*) combined with a multifactorial background. The multifactorial background causes variation in height among individuals of each genotype. If the distributions of each of the three genotypes were superimposed, then the overall distribution of height would be approximately normal, as shown by the dotted line.

total number of disease cases. It is nevertheless important to identify the responsible major genes, since their function can provide important clues to the pathophysiology and treatment of the disease.

Multifactorial diseases can be distinguished from single-gene disorders caused by mutations at different loci (locus heterogeneity). Sometimes a disease has both single-gene and multifactorial components.

NATURE AND NURTURE: DISENTANGLING THE EFFECTS OF GENES AND ENVIRONMENT

Family members share genes and a common environment. Family resemblance in traits such as blood pressure therefore reflects both genetic and environmental commonality ("nature" and "nurture," respectively). For centuries, people have debated the relative importance of these two types of factors. It is a mistake, of course, to view them as mutually exclusive. Few traits are influenced *only* by genes or *only* by environment. Most are influenced by both.

Determining the relative influence of genetic and environmental factors can lead to a better understanding of disease etiology. It can also help in the planning of public health strategies. A disease in which hereditary influence is relatively small, such as lung cancer, may be prevented most effectively through emphasis on lifestyle changes (avoidance of tobacco). When a disease has a relatively larger hereditary component, as in breast cancer, examination of family history should be emphasized in addition to lifestyle modification.

In the following sections, we review two research strategies that are often used to estimate the relative influence of genes and environment: twin studies and adoption studies. We then discuss methods that aim to delineate the individual genes responsible for multifactorial diseases.

Twin Studies

Twins occur with a frequency of about 1/100 births in Caucasian populations. They are slightly more common among Africans and a bit less common among Asians. **Monozygotic** (MZ, or "identical") twins originate when, for unknown reasons, the developing embryo divides to form two separate but identical embryos. Because they are genetically identical, MZ twins are an example of natural clones. Their physical appearances can be strikingly similar (Fig. 12-5). **Dizygotic** (DZ, or "fraternal") twins

FIGURE 12.5 ■ Monozygotic twins, showing a striking similarity in physical appearance. Both twins developed myopia as teenagers.

are the result of a double ovulation followed by the fertilization of each egg by a different sperm.* Thus, DZ twins are genetically no more similar than other siblings. Because two different sperm cells are required to fertilize the two eggs, it is possible for each DZ twin to have a different father.

Because MZ twins are genetically identical, any differences between them should be due only to environmental effects. MZ twins should thus resemble one another very closely for traits that are strongly influenced by genes. DZ twins provide a convenient comparison: their environmental differences should be similar to those of MZ twins, but their genetic differences are as great as those between siblings. Twin studies thus usually consist of comparisons between MZ and DZ twins. If both members of a twin pair share a trait (e.g., cleft lip), they are said to be concordant. If they do not share the trait, they are discordant. For a trait determined totally by genes, MZ twins should always be concordant, while DZ twins should be concordant less often, since they, like siblings, share only 50% of their genes. Concordance rates can differ between opposite-sex DZ twin pairs and same-sex DZ pairs for some traits, such as those that have different frequencies in males and females. For such traits, only same-sex DZ twin pairs should be used when comparing MZ and DZ concordance rates, since MZ twins are necessarily of the same sex.

A concordance estimate would not be appropriate for quantitative traits, such as blood pressure or height. Here the intraclass correlation coefficient is used. This statistic varies between -1.0 and 1.0 and measures the degree of homogeneity of a trait in a sample of individuals. For example, we may wish to assess the degree of similarity between twins for a trait such as height. The measurements are made in a collection of twins, and correlation coefficients are estimated separately for the MZ sample and the DZ sample. If a trait were determined entirely by genes, we would expect the correlation coefficient for MZ pairs to be 1.0 (i.e., each pair of twins would have exactly the same height). A correlation coefficient of 0.0 would mean that the similarity between MZ twins for the trait in question is no greater than chance. Because DZ twins share half of their genes, we would expect a DZ correlation coefficient of 0.50 for a trait determined entirely by genes.

Monozygotic (identical) twins are the result of an early cleavage of the embryo, whereas dizygotic (fraternal) twins are caused by the fertilization of two eggs by two sperm cells. Comparisons of concordance rates and correlations in MZ and DZ twins help to determine the extent to which a trait is influenced by genes. Concordance rates and correlation coefficients for a number of traits are given in Table 12-3. The concordance rates for contagious diseases like measles are quite similar in MZ and DZ twins. This is expected, since a contagious disease is unlikely to be influenced markedly by genes. On the other hand, the concordance rates for schizophrenia and bipolar disorder are quite dissimilar

TABLE 12.3	Concordance Rates in Monozygotic (MZ) and Dizygotic (DZ) Twins for Selected Traits and
	Diseases*

	Concorda	nce rate	
Trait or disease	MZ twins	DZ twins	Heritability
Affective disorder (bipolar)	0.79	0.24	>1.0 [±]
Affective disorder (unipolar)	0.54	0.19	0.70
Alcoholism	>0.60	< 0.30	0.60
Autism	0.92	0.0	>1.0
Blood pressure (diastolic) [†]	0.58	0.27	0.62
Blood pressure (systolic) [†]	0.55	0.25	0.60
Body fat percentage [†]	0.73	0.22	>1.0
Body mass index [†]	0.95	0.53	0.84
Cleft lip/palate	0.38	0.08	0.60
Club foot	0.32	0.03	0.58
Dermatoglyphics (finger ridge count)†	0.95	0.49	0.92
Diabetes mellitus	0.45-0.96	0.03-0.37	>1.0
Diabetes mellitus (type 1)	0.35-0.50	0.05-0.10	0.60-0.80
Diabetes mellitus (type 2)	0.70-0.90	0.25-0.40	0.90-1.0
Epilepsy (idiopathic)	0.69	0.14	>1.0
Height [†]	0.94	0.44	1.0
IQ^\dagger	0.76	0.51	0.50
Measles	0.95	0.87	0.16
Multiple sclerosis	0.28	0.03	0.50
Myocardial infarction (males)	0.39	0.26	0.26
Myocardial infarction (females)	0.44	0.14	0.60
Schizophrenia	0.47	0.12	0.70
Spina bifida	0.72	0.33	0.78

^{*}These figures were compiled from a large variety of sources and represent primarily European and U.S. populations.

^{*}While MZ twinning rates are quite constant across populations, DZ twinning rates vary somewhat. DZ twinning increases with maternal age until about age 40 years, after which the rate declines. The frequency of DZ twinning has increased dramatically in developed countries during the past two decades because of the use of ovulation-inducing drugs.

[†]Since these are quantitative traits, correlation coefficients are given rather than concordance rates.

[‡]Several heritability estimates exceed 1.0. Since it is impossible for >100% of the variance of a trait to be genetically determined, these values indicate that other factors, such as shared environmental factors, must be operating.

between MZ and DZ twins, indicating a sizable genetic component for these diseases. The MZ correlation for dermatoglyphics (fingerprints), which is determined almost entirely by genes, is close to 1.0.

Correlations and concordance rates in MZ and DZ twins can be used to measure the heritability of multifactorial traits. Essentially, heritability is the percentage of population variation in a trait that is due to genes (statistically, it is the proportion of the total variance of a trait that is caused by genes). A simple formula for estimating heritability (b) from twin correlations or concordance rates is as follows: $b = 2(c_{MZ} - c_{DZ})$, where c_{MZ} is the concordance rate (or intraclass correlation) for MZ twins and c_{DZ} is the concordance rate (or intraclass correlation) for DZ twins.* As this formula illustrates, traits that are largely determined by genes will result in a heritability estimate that approaches 1.0 (i.e., c_{MZ} will approach 1.0, and c_{DZ} will approach 0.5). As the difference between concordance rates becomes smaller, heritability approaches zero. Correlations and concordance rates in other pairs of relatives (e.g., parents and offspring) can also be used to measure heritability.

Like recurrence risks, heritability values are specific for the population in which they are estimated. However, there is usually agreement from one population to another regarding the general range of heritability estimates of most traits (e.g., the heritability of height is almost always high, while the heritability of contagious diseases is almost always low). The same is true of empirical recurrence risks.

Comparisons of correlations and concordance rates in MZ and DZ twins allow the estimation of heritability, a measure of the proportion of population variation in a disease that can be attributed to genes.

At one time, twins were thought to provide a perfect "natural laboratory" in which to determine the relative influences of genetics and environment. But several difficulties arise. One of the most important is the assumption that the environments of MZ and DZ twins are equally similar. MZ twins are often treated more similarly than DZ twins. The eminent geneticist L. S. Penrose once joked that, if one were to study the clothes of twins, it might be concluded that clothes are inherited biologically. A greater similarity in environment can make MZ twins more concordant for a trait, inflating the apparent influence of genes. In addition, MZ twins may be more likely to seek the same type of environment, further reinforcing environmental similarity. On the other hand, it has been suggested that some MZ twins tend to develop personality differences in an attempt to assert their individuality.

Another difficulty is that somatic mutations can occur during mitotic divisions of the cells of MZ twin embryos. Thus, the MZ twins may not be quite "identical," especially if a mutation occurred early in the development of one of the twins. Finally, the uterine environments of different pairs of MZ twins can be more or less similar, depending on whether there are two amnions and two chorions, two amnions and one shared chorion, or one shared amnion and one shared chorion.

Of the various problems with the twin method, the greater degree of environmental sharing among MZ twins is perhaps the most serious. One way to circumvent this problem, at least in part, is to study MZ twins who were raised in separate environments. Concordance among these twin pairs should be caused by genetic, rather than environmental, similarities. As one might expect, it is not easy to find such twin pairs. A major effort to do so has been undertaken by researchers at the University of Minnesota, whose studies have shown a rather remarkable congruence among MZ twins reared apart, even for many behavioral traits. However, these studies must be viewed with caution, because the sample sizes are relatively small and because many of the twin pairs had at least some contact with one another before they were studied.

Although twin studies provide valuable information, they are also affected by certain biases. The most serious is greater environmental similarity between MZ twins than between DZ twins. Other biases include somatic mutations that may affect only one MZ twin and differences in the uterine environments of twins.

Adoption Studies

Studies of adopted children are also used to estimate the genetic contribution to a multifactorial trait. Children born to parents who have a disease but adopted by parents lacking the disease can be studied to find out whether they develop the disease. In some cases, such children develop the disease more often than do children in a comparative control population (i.e., adopted children who were born to parents who do *not* have the disease). This provides some evidence that genes may be involved in the causation of the disease, since the adopted children do not share an environment with their affected natural parents. For example, schizophrenia is seen in 8% to 10% of adopted children whose natural parent had schizophrenia, whereas it is seen in only 1% of adopted children of unaffected parents.

As with twin studies, several precautions must be exercised in interpreting the results of adoption studies. First, prenatal environmental influences could have long-lasting effects on an adopted child. Second, children are sometimes adopted after they are several years old,

^{*}This formula represents one of the simplest ways of estimating heritability. A description of more complex and accurate approaches can be found in the books by Cavalli-Sforza and Bodmer (1971) and Neale and Cardon (1992) cited at the end of this chapter.

ensuring that some environmental influences have been imparted by the natural parents. Finally, adoption agencies sometimes try to match the adoptive parents with the natural parents in terms of factors such as socioeconomic status. All of these factors could exaggerate the apparent influence of biological inheritance.

Adoption studies provide a second means of estimating the influence of genes on multifactorial diseases. They consist of comparing disease rates among the adopted offspring of affected parents with the rates among adopted offspring of unaffected parents. As with the twin method, certain biases can influence these studies.

These reservations, as well as those summarized for twin studies, underscore the need for caution in basing conclusions on twin and adoption studies. These approaches do not provide definitive measures of the role of genes in multifactorial disease, nor can they identify specific genes responsible for disease. Instead, they serve a useful purpose in providing a preliminary indication of the extent to which a multifactorial disease may be influenced by genetic factors. Methods for the direct detection of genes underlying multifactorial traits are summarized in Box 12-1.

THE GENETICS OF COMMON DISEASES

Having discussed the principles of multifactorial inheritance, we turn next to a discussion of the common multifactorial disorders themselves. Some of these disorders, the congenital malformations, are by definition present at birth. Others, including heart disease, cancer, diabetes, and most psychiatric disorders, are seen primarily in adolescents and adults. Because of their complexity, unraveling the genetics of these disorders is a daunting task. Nonetheless, significant progress is now being made.

Congenital Malformations

Approximately 2% of newborns present with a **congenital** malformation (i.e., one that is present at birth); most of these conditions would be considered multifactorial in etiology. Some of the more common congenital malformations are listed in Table 12-4. In general, sibling recurrence risks for most of these disorders range from 1% to 5%.

Some congenital malformations, such as cleft lip/ palate and pyloric stenosis, are relatively easy to repair and thus are not considered to be serious problems. Others, such as the neural tube defects, usually have more severe consequences. While some cases of congenital malformations may occur in the absence of any other problems, it is quite common for them to be associated with other disorders. For example, hydrocephaly and club foot are often seen secondary to spina bifida, cleft lip/palate is often seen in babies with trisomy 13, and congenital heart defects are seen in many syndromes, including trisomy of chromosomes 13, 18, and 21.

Considerable progress is now being made in isolating single genes that can cause congenital malformations. Many of these, including the HOX, PAX, and TBX families of genes, were discussed in Chapter 10. Another example is the *RET* proto-oncogene, which is responsible for some cases of Hirschsprung disease. However, the causes of most cases of this disorder remain undiscovered. Indeed, the genetic factors contributing to many important congenital malformations (e.g., neural tube defects, common congenital heart defects, cleft lip/palate) are as yet unidentified.

Environmental factors have also been shown to cause some congenital malformations. An example is thalidomide, a sedative used during pregnancy in the early 1960s (and recently reintroduced for the treatment of dermatological conditions such as leprosy). When ingested during early pregnancy, this drug often caused phocomelia (severely shortened limbs) in babies. Maternal exposure to retinoic acid, which is used to treat acne, can cause congenital defects of the heart, ear, and central nervous system. Maternal rubella infection can cause congenital heart defects. Other environmental factors that can cause congenital malformations are discussed in Chapter 14.

Congenital malformations are seen in roughly 1 of every 50 live births. Most of them are considered to be multifactorial disorders. Specific genes and environmental causes have been detected for some congenital malformations, but the causes of most congenital malformations remain largely unknown.

Multifactorial Disorders in the Adult Population

Until recently, very little was known about specific genes responsible for common adult diseases. With more powerful laboratory and analytical techniques, this situation is changing. We next review recent progress in understanding the genetics of the major common adult diseases. Table 12-5 gives approximate prevalence figures for these disorders in the United States.

Heart Disease

Heart disease is the leading killer of Americans, accounting for approximately 25% of all deaths in this country. The most common underlying cause of heart disease is coronary artery disease (CAD), which is caused by atherosclerosis (a narrowing of the coronary arteries resulting from the formation of lipid-laden lesions). This narrowing impedes blood flow to the heart and can eventually result in a myocardial infarction (death of heart tissue caused by an inadequate supply of oxygen). When atherosclerosis occurs in arteries that supply blood to the brain, a stroke can result. A number of risk factors for Finding the Underlying Genes: Quantitative Trait Loci

BOX

12.1

As mentioned in the text, twin and adoption studies are not designed to reveal specific genes that cause multifactorial diseases. The identification of specific causative genes is an important goal, since only then can we begin to understand the underlying biology of the disease and undertake to correct the defect. For complex multifactorial traits, this is a formidable task because of locus heterogeneity, the interactions of multiple genes, decreased penetrance, age-dependent onset, and phenocopies (individuals who have a phenotype, such as breast cancer, but who do not carry a known disease-causing mutation, such as a BRCA1 alteration). Fortunately, recent advances in gene mapping and molecular biology promise to make this goal more attainable. Here, we discuss several approaches that are used to identify the genes underlying multifactorial traits, often known as quantitative trait loci (QTLs).

One way to search for QTLs is to use conventional linkage analysis, as described in Chapter 8. Disease families are collected, a single-gene mode of inheritance is assumed, and linkage analysis is undertaken with a large series of marker polymorphisms that span the genome (this is termed a **genome scan**). If a sufficiently large LOD score (see Chapter 8) is obtained with a polymorphism, it is assumed that the region around this polymorphism may contain a QTL. This approach is sometimes successful, especially when there are subsets of families in which a single-gene mode of inheritance is seen (e.g., autosomal dominant, autosomal recessive). This was the case, for example, with familial breast cancer, where some families presented a clear autosomal dominant mode of inheritance.

With many multifactorial disorders, however, such subsets are not readily apparent. Because of obstacles such as heterogeneity and phenocopies, traditional linkage analysis may be impractical. One alternative to traditional linkage analysis is the affected sib-pair method. The logic of this approach is simple: if two siblings are both affected by a genetic disease, we would expect to see increased sharing of marker alleles in the genomic region that contains a susceptibility gene. To conduct an analysis using this approach, we begin by collecting DNA samples from a large number of sib pairs in which both members of the pair are affected by the disease. Then a genome scan is undertaken, and the proportion of affected sib pairs who share the same allele is estimated for each polymorphism. Because siblings share half their genes (see Chapter 4), we would expect this proportion to be 50% for marker polymorphisms that are not linked to a disease susceptibility locus. However, if we find that siblings share the same allele for a marker polymorphism more frequently than half the time (say, 75% of the time), this would be evidence that the marker is linked to a susceptibility locus. This approach was used, for example, to show that the HLA region contributes to susceptibility for type 1 diabetes.

The affected sib-pair method has the advantage that one does not have to assume a specific mode of inheritance. In addition, the method is unaffected by reduced penetrance, since both members of the sib pair must be affected to be included in the analysis. It is especially useful for disorders with late age of onset (e.g., prostate cancer), for which it would be difficult to assemble multigenerational families from whom DNA samples could be taken. A weakness of this method is that it tends to require large sample sizes to yield significant results, and it tends to have low resolution (i.e., the genomic region implicated by the analysis tends to be quite large, often 10 cM or more).

Affected sib-pair analyses are sometimes made more powerful by selecting subjects with extreme values of a trait (e.g., sib pairs with very high blood pressure) to enrich the sample for genes likely to contribute to the trait. A variation on this approach is to sample sib pairs that are highly discordant for a trait (e.g., one with very high blood pressure and one with very low blood pressure) and then to look for markers in which there is less allele sharing than the expected 50%.

Association tests such as linkage disequilibrium (see Chapter 8) can also be used in the course of a genome scan. These methods are becoming more practical as the Human Genome Project is developing dense sets of polymorphic markers (both microsatellites, and, more recently, single nucleotide polymorphisms, or SNPs). The likelihood of finding QTLs using these approaches, as well as sib-pair and traditional linkage methods, may be enhanced by analyzing isolated populations (e.g., island populations, populations such as those mentioned in Box 3-3 in Chapter 3). Because these populations are typically derived from a small number of founders and have experienced little admixture with other populations, it is thought that the number of mutations contributing to a multifactorial disease may be reduced and thus easier to pinpoint.

Another method combines genome scanning and the use of animal models. It consists basically of the following steps (Fig. 12-6):

- 1. Breeding experiments are carried out with experimental animals, such as rats or mice, to select progeny that have extreme values of a trait (e.g., rats that have high blood pressure). These are then crossed with normal animals to produce offspring that, for each chromosome pair, have one normal chromosome and one "affected" chromosome that presumably contains genes that cause high blood pressure. These offspring are in turn mated with the normal animal (a backcross). This produces a third generation of animals in whom one chromosome has only the normal genes, while the homologous chromosome has experienced recombinations between the normal and the affected chromosomes (as a result of crossovers during meiosis in the parents). This series of matings produces progeny that are useful for linkage analysis.
- 2. High-resolution genetic maps of the experimental

FIGURE 12.6 The basic steps involved in performing a genome scan for quantitative trait loci (QTLs) using an animal model (see text for details).

organism must be available. This means that polymorphic markers must be identified at regular intervals (ideally, at least every 10 cM) throughout the organism's genome.

- 3. Linkage analysis (see Chapter 8) is performed, comparing each polymorphic marker against the trait. Because animals with extreme values were selected, this procedure should uncover markers that are linked to loci that produce the extreme phenotype.
- 4. Once a linked marker (or markers) has been found, it may be possible to isolate the actual functional gene responsible for the trait using the gene-cloning techniques outlined in Chapter 8.
- 5. When a functional gene has been isolated and cloned in the experimental organism, it is used as a probe to search the human genome for a gene with high DNA sequence homology that may have the same function (a candidate gene). This approach is feasible because the DNA

sequences of functionally important genes are often similar in humans and experimental animals such as rodents.

This last approach has been applied in studies of type 1 diabetes and hypertension. It has the advantage that animals can easily be selected with extreme values of a trait, and any desired breeding scheme can be used to generate useful recombinants. Animals, of course, do not necessarily model humans accurately. Furthermore, this technique detects only individual genes that cause disease in the animal model; it cannot assess the pattern of interactions of these genes. There is evidence that the nature of these interactions may be critically important, and they may well differ in humans and experimental animals. Despite these reservations, this approach demonstrates effectively the way in which new developments in molecular genetics and gene mapping can increase our knowledge of the genes responsible for multifactorial disease.

TABLE 12.4 Prevalence Rates of Common Congenital Malformations in Caucasians			
Disorder Approximate prevalence/1,000 bir			
Cleft lip/palate	1.0		
Club foot	1.0		
Congenital heart defects	4.0-8.0		
Hydrocephaly	0.5–2.5		
Isolated cleft palate	0.4		
Neural tube defects	1.0-3.0		
Pyloric stenosis	3.0		

CAD have been identified, including obesity, cigarette smoking, hypertension, elevated cholesterol level, and positive family history (usually defined as having one or more affected first-degree relatives). Many studies have examined the role of family history in CAD, and they show that an individual with a positive family history is 2 to 7 times more likely to suffer from CAD than is an individual with no family history. Generally, these studies also show that the risk is higher (1) if there are more affected relatives, (2) if the affected relative is female (the less commonly affected sex) rather than male, and (3) if the age of onset in the affected relative is early (before 55 years of age). For example, one study showed that men between the ages of 20 and 39 years had a three-fold increase in CAD risk if they had one affected first-degree relative. This risk increased to 13-fold if there were two first-degree relatives affected with CAD before 55 years of age.

What part do genes play in the familial clustering of CAD? Because of the key role of lipids in atherosclerosis, many studies are focusing on the genetic determination of variation in circulating lipoprotein levels. An important advance in this area was the isolation and cloning of the gene that encodes the low-density lipoprotein (LDL) receptor. Heterozygosity for a mutation in this gene is seen in approximately 1 in 500 individuals; in these individuals, LDL cholesterol levels are approximately doubled. (This condition, known as familial hypercholesterolemia, is described further in Clinical Commentary 12-2.)

Disease	Number of affected Americans (approximate)	Annual cost (dollars)*
Alcoholism	14 million	185 billion
Alzheimer disease	4 million	90 billion
Arthritis	43 million	65 billion
Asthma	17 million	13 billion
Cancer	8 million	157 billion
Cardiovascular disease (all forms) Coronary artery disease Congestive heart failure Congenital defects Hypertension Stroke	13 million 5 million 1 million 50 million 5 million	300 billion
Depression and bipolar disorder	17 million	44 billion
Diabetes (type 1)	1 million	
Diabetes (type 2)	15 million	100 billion (type 1 + type 2)
Epilepsy	2.5 million	3 billion
Multiple sclerosis	350,000	5 billion
Obesity [†]	60 million	117 billion
Parkinson disease	500,000	5.5 billion
Psoriasis	3–5 million	3 billion
Schizophrenia	2 million	30 billion

*Cost estimates include direct medical costs as well as associated costs such as lost economic productivity.

[†]Body mass index >30. Data from National Center for Chronic Disease Prevention and Health Promotion; American Heart Association (2002 Heart and Stroke Statistical Update); National Institute on Alcohol Abuse and Alcoholism; Office of the U.S. Surgeon General; American Academy of Allergy, Asthma and Immunology; Cown WM, Kandel ER (2001) Prospects for neurology and psychiatry. JAMA 285:594–600; Flegal et al. (2002) Prevalence and trends in obesity among US adults, 1999–2000. JAMA 288:1723–1727.

CLINICAL COMMENTARY 12.2

Familial Hypercholesterolemia

Autosomal dominant familial hypercholesterolemia (FH) is an important cause of heart disease, accounting for approximately 5% of myocardial infarctions (MIs) in persons younger than 60 years of age. FH is one of the most common autosomal dominant disorders: in most populations surveyed to date, about 1 in 500 persons is a heterozygote. Plasma cholesterol levels are approximately twice as high as normal (i.e., about 300-400 mg/dl), resulting in substantially accelerated atherosclerosis and the occurrence of distinctive cholesterol deposits in skin and tendons, called xanthomas (Fig. 12-7). Data compiled from five studies showed that approximately 75% of men with FH developed coronary disease, and 50% had a fatal MI, by age 60 years. The corresponding percentages for women were lower (45% and 15%, respectively), because women generally develop heart disease at a later age than men.

Consistent with Hardy-Weinberg predictions (see Chapter 4), about 1/1,000,000 births is homozygous for the FH gene. Homozygotes are much more severely affected, with cholesterol levels ranging from 600 to 1,200 mg/dl. Most homozygotes experience MIs before 20 years of age, and a MI at 18 months of age has been reported. Without treatment, most FH homozygotes will die before the age of 30 years.

All cells require cholesterol as a component of their plasma membrane. They can either synthesize their own cholesterol, or preferentially they obtain it from the extracellular environment, where it is carried primarily by low-density lipoprotein (LDL). In a process known as *endocytosis*, LDL-bound cholesterol is taken into the cell via LDL receptors on the cell's surface (Fig. 12-8). FH is caused by a reduction in the number of functional LDL receptors on cell surfaces. Because the individual lacks the normal number of LDL receptors, cellular cholesterol uptake is reduced, and circulating cholesterol levels increase.

Much of what we know about endocytosis has been learned through the study of LDL receptors. The process of endocytosis and the processing of LDL in the cell is described in detail in Fig. 12-8. These processes result in a fine-tuned regulation of cholesterol levels within cells, and they influence the level of circulating cholesterol as well.

The cloning of the LDL receptor gene (*LDLR*) in 1984 was a critical step in understanding exactly how LDL receptor defects cause FH. This gene, located on chromosome 19, is 45 kb in length and consists of 18 exons and 17 introns. More than 900 different mutations, two thirds of which are missense and non-

FIGURE 12.7 Xanthomas (fatty deposits), seen here on the knuckles, are often seen in patients with familial hypercholesterolemia.

sense substitutions, have been identified. Most of the remaining mutations are insertions and deletions, many of which arise from unequal crossovers (see Chapters 5 and 6) that occur between *Alu* repeat sequences (see Chapter 2) scattered throughout the gene. The *LDLR* mutations can be grouped into five broad classes, according to their effects on the activity of the receptor:

Class I mutations in *LDLR* result in no detectable protein product. Thus, heterozygotes would produce only half the normal number of LDL receptors.

Class II mutations result in production of the LDL receptor, but it is altered to the extent that it cannot leave the endoplasmic reticulum. It is eventually degraded.

Class III mutations produce an LDL receptor that is capable of migrating to the cell surface but incapable of normal binding to LDL.

Class IV mutations, which are comparatively rare, produce receptors that are normal except that they do not migrate specifically to coated pits and thus cannot carry LDL into the cell.

Class V mutations produce an LDL receptor that cannot disassociate from the LDL particle after entry into the cell. The receptor cannot return to the cell surface and is degraded.

Each class of mutations reduces the number of effective LDL receptors, resulting in decreased LDL uptake and hence elevated levels of circulating choles-

263

CLINICAL COMMENTARY 12.2

Familial Hypercholesterolemia—cont'd

FIGURE 12.8 The process of receptor-mediated endocytosis. *1*, The LDL receptors, which are glycoproteins, are synthesized in the endoplasmic reticulum of the cell. *2*, They pass through the Golgi apparatus to the cell surface, where part of the receptor protrudes outside the cell. *3*, The circulating LDL particle is bound by the LDL receptor and localized in cell-surface depressions called "coated pits" (so named because they are coated with a protein called clathrin). *4*, The coated pit invaginates, bringing the LDL particle inside the cell. *5*, Once inside the cell, the LDL particle is separated from the receptor, taken into a lysosome, and broken down into its constituents by lysosomal enzymes. *6*, The LDL receptor is recirculated to the cell surface to bind another LDL particle. Each LDL receptor goes through this cycle approximately once every 10 minutes even if it is not occupied by an LDL particle. *7*, Free cholesterol is released from the lysosome for incorporation into cell membranes or metabolism into bile acids or steroids. Excess cholesterol can be stored in the cell as a cholesterol ester or removed from the cell by association with high-density lipoprotein (HDL). *8*, As cholesterol levels in the cell rise, cellular cholesterol synthesis is reduced by inhibition of the rate-limiting enzyme, HMG-CoA reductase. *9*, Rising cholesterol levels also increase the activity of acyl-coenzyme A:cholesterol acyltransferase (ACAT), an enzyme that modifies cholesterol for storage as cholesterol esters. *10*, In addition, the number of LDL receptors is decreased by lowering the transcription rate of the LDL receptor gene itself. This decreases cholesterol uptake. (Modified from Goldstein JL, Brown MS [1989] In: Scriver CR, Beaudet AL, Sly WS, Valle D [eds] The Metabolic Basis of Inherited Disease, 6th ed. McGraw-Hill, New York.)

CLINICAL COMMENTARY 12.2

Familial Hypercholesterolemia—cont'd

terol. The number of effective receptors is reduced by about half in FH heterozygotes, and homozygotes have virtually no functional LDL receptors.

Understanding the defects that lead to FH has helped in the development of effective therapies for the disorder. Dietary reduction of cholesterol (primarily through the reduced intake of saturated fats) has only modest effects on cholesterol levels in FH heterozygotes. Because cholesterol is reabsorbed into the gut and then recycled through the liver (where most cholesterol synthesis takes place), serum cholesterol levels can be reduced by the administration of bile-acid absorbing resins, such as cholestyramine. The absorbed cholesterol is excreted. It is interesting to note that reduced recirculation from the gut causes the liver cells to form additional LDL receptors, lowering circulating cholesterol levels. However, the decrease in intracellular cholesterol also stimulates cholesterol synthesis by liver cells, so the overall reduction in plasma LDL is only about 15% to 20%. This treatment is much more effective when combined with one of the "statin" class of drugs (e.g., lovastatin, pravastatin), which reduce cholesterol synthesis by inhibiting 3-hydroxy-3-methylglutaryl coenzyme A (HMG-CoA) reductase (see Fig. 12-8). Decreased synthesis leads to further production of LDL receptors. When these therapies are used in combination, serum cholesterol levels in FH heterozygotes can often be reduced to approximately normal levels.

The picture is less encouraging for FH homozygotes. The therapies mentioned can enhance cholesterol elimination and reduce its synthesis, but they are largely ineffective in homozygotes because these individuals have few or no LDL receptors. Liver transplants, which provide hepatocytes that have normal LDL receptors, have been successful in some cases, but this option is often limited by a lack of donors. Plasma exchange, carried out every 1 to 2 weeks, in combination with drug therapy, can reduce cholesterol levels by about 50%. However, this therapy is difficult to continue for long periods. Somatic cell gene therapy, in which hepatocytes carrying normal LDL receptor genes are introduced into the portal circulation, is now being tested (see Chapter 13). It may eventually prove to be an effective treatment for FH homozygotes.

The FH story illustrates how medical research has made important contributions to both the understanding of basic cell biology and advancements in clinical therapy. The process of receptor-mediated endocytosis, elucidated largely by research on the LDL receptor defects, is of fundamental significance for cellular processes throughout the body. Equally, this research, by clarifying how cholesterol synthesis and uptake can be modified, has led to significant improvements in therapy for this important cause of heart disease.

Mutations in the gene encoding apolipoprotein B, which are seen in about 1 in 1,000 individuals, are another common genetic cause of elevated LDL cholesterol. These mutations occur in the portion of the gene that is responsible for binding of apolipoprotein B to the LDL receptor, and they increase circulating LDL cholesterol levels by 50% to 100%. More than a dozen other genes involved in lipid metabolism and transport have been identified, including those genes that encode various apolipoproteins (these are the protein components of lipoproteins) (Table 12-6). Functional analysis of these genes is leading to increased understanding, and eventually more effective treatment, of CAD. www

It should be emphasized that environmental factors, many of which are easily modified, are also important causes of CAD. There is abundant epidemiological evidence that cigarette smoking and obesity increase the risk of CAD, while exercise and a diet low in saturated fats decrease the risk. Indeed, the approximate 60% reduction in mortality due to CAD and stroke in the United States since 1950 is usually attributed to a decrease in the proportion of adults who smoke cigarettes, decreased consumption of saturated fats, improved medical care, and increased emphasis on healthy lifestyle factors such as exercise.

Another form of heart disease is cardiomyopathy, an abnormality of the heart muscle that leads to inadequate cardiac function. Cardiomyopathy is a common cause of heart failure, resulting in approximately 10,000 deaths annually in the United States. Hypertrophic cardiomyopathy, one major form of the disease, is characterized by thickening (hypertrophy) of portions of the left ventricle and is seen in as many as 1 in 500 adults. About half of hypertrophic cardiomyopathy cases are familial and are caused by autosomal dominant mutations in any of 10 genes that encode various components of the cardiac sarcomere. The most commonly mutated genes are those that encode the β -myosin heavy chain (35% of familial

Gene	Chromosome location	Function of protein product
Apolipoprotein A-I	11q	HDL component; LCAT cofactor
Apolipoprotein A-IV	11q	Component of chylomicrons and HDL; may influence HDL metabolism
Apolipoprotein C-III	11q	Allelic variation associated with hypertriglyceridemia
Apolipoprotein B	2p	Ligand for LDL receptor; involved in formation of VLDL, LDL, IDL, and chylomicrons
Apolipoprotein D	2p	HDL component
Apolipoprotein C-I	19q	LCAT activation
Apolipoprotein C-II	19q	Lipoprotein lipase activation
Apolipoprotein E	19q	Ligand for LDL receptor
Apolipoprotein A-II	1p	HDL component
LDL receptor	19p	Uptake of circulating LDL particles
Lipoprotein (a)	6q	Cholesterol transport
Lipoprotein lipase	8p	Hydrolysis of lipoprotein lipids
Hepatic triglyceride lipase	15q	Hydrolysis of lipoprotein lipids
LCAT	16q	Cholesterol esterification
Cholesterol ester transfer protein	16q	Facilitates transfer of cholesterol esters and phospholipids between lipoproteins

TABLE 12.6 ILipoprotein Genes Known to Contribute to Coronary Heart Disease Risk

IDL, intermediate-density lipoprotein; LCAT, lecithin cholesterol acyltransferase; VLDL, very-low-density lipoprotein.

Adapted in part from King RA, Rotter JI, eds. (2002) The Genetic Basis of Common Diseases, 2nd ed. Oxford University Press, New York.

cases), myosin-binding protein C (20% of cases), and troponin T (15% of cases).

In contrast to the hypertrophic form of cardiomyopathy, dilated cardiomyopathy, which is seen in about 1 in 2,500 individuals, consists of increased size and impaired contraction of the ventricles. The end result is impaired pumping of the heart. This disease is familial in about one third of individuals; although autosomal dominant mutations are most common, mutations can also be Xlinked or mitochondrial. The genes affected by these mutations encode various cytoskeletal proteins, including actin, cardiac troponin T, desmin, and components of the dystroglycan-sarcoglycan complex. (Recall from Chapter 5 that abnormalities of the latter proteins can also cause muscular dystrophies.) www

Mutations have also been identified in several genes that cause the long QT (LQT) syndrome. LQT describes the characteristically elongated QT interval in the electrocardiogram of affected individuals, indicative of prolonged cardiac repolarization. This disorder, which can be caused either by inherited mutations or by exposure to drugs that block potassium channels, predisposes affected individuals to potentially fatal cardiac arrhythmia. An autosomal dominant form, known as Romano-Ward syndrome, can be caused by mutations in any of five genes, four of which (*KVLQT1*, *HERG*, *KCNE1*, and *KCNE2*) encode potassium channel subunits and one of

which (SCN5A) encodes a sodium channel (Table 12-7). The sodium and potassium ion channels are involved in cardiac repolarization, consistent with the LQT disease phenotype. A sixth locus has been mapped by linkage analysis to 4q25-27 but has not yet been identified. An autosomal recessive form of LQT syndrome, known as Jervell-Lange-Nielsen syndrome, is less common than the Romano-Ward syndrome but is associated with a longer QT interval, a higher incidence of sudden cardiac death, and sensorineural deafness. This syndrome is caused by mutations in either KVLQT1 or KCNE1. Because LQT syndrome can be difficult to diagnose accurately, linked markers and mutation detection are used to enable more accurate diagnosis of affected family members. In addition, the identification of disease-causing genes and their protein products is now guiding the development of drug therapy to activate the encoded ion channels. Because cardiac arrhythmias account for most of the 250,000 sudden cardiac deaths that occur annually in the United States, a better understanding of the genetic defects underlying arrhythmia is of considerable public health significance. www

Heart disease aggregates in families. This aggregation is especially strong if there is early age of onset and if there are multiple affected relatives. Specific genes have been identified for some subsets of families with heart disease, and lifestyle changes

Complex disease	Mendelian subtype	Protein (gene)	Consequence of mutation
Heart disease	Familial hypercholesterolemia Tangier disease Familial defective apoB100 Familial dilated cardiomyopathy	LDL receptor (<i>LDLR</i>) ATP-binding cassette 1 (<i>ABC1</i>) Apolipoprotein B (<i>APOB</i>) Cardiac troponin T (<i>TNNT2</i>)	Elevated LDL level Reduced HDL level Elevated LDL level Reduced force generation by sarcomere
		Cardiac β -myosin heavy chain (<i>MYH7</i>)	Reduced force generation by sarcomere
		β-sarcoglycan (SGCB)	Destabilized sarcolemma and signal transduction
		δ-sarcoglycan (SGCD)	Destabilized sarcolemma and signal transduction
		Dystrophin	Destabilized sarcolemma in cardiac myocytes
	Familial hypertrophic cardiomyopathy	Cardiac β -myosin heavy chain (<i>MYH7</i>)	Reduced force generation by sarcomer
		Cardiac troponin T (TNNT2)	Reduced force generation by sarcomere
	Long QT syndrome	Myosin-binding protein C (MYBPC) Cardiac potassium channel α subunit (LQT1, KVLQT1) Cardiac potassium channel α subunit (LQT2, HERG) Cardiac sodium channel (LQT3, SCN5.A) Cardiac potassium channel β subunit (LQT5, KCNE1) Cardiac potassium channel subunit (LQT6, KCNE2)	Sarcomere damage Prolonged QT interval on electrocardiogram, arrhythmia Prolonged QT interval on electrocardiogram, arrhythmia Prolonged QT interval on electrocardiogram, arrhythmia Prolonged QT interval on electrocardiogram, arrhythmia Prolonged QT interval on electrocardiogram, arrhythmia
Hypertension	Liddle syndrome	Renal epithelial sodium channel subunits (SCNN1B, SCNN1G)	Severe hypertension, low renin and suppressed aldosterone
	Gordon syndrome	WNK1 or WNK4 kinase genes	High serum potassium level and increased renal salt reabsorption
	Glucocorticoid-remediable aldosteronism	Fusion of genes that encode aldosterone synthase and steroid 11β-hydroxylase	Early-onset hypertension with suppressed plasma renin and normal or elevated aldosterone levels
	Syndrome of apparent mineralocorticoid excess	11β-Hydroxysteroid dehydrogenase (11β- <i>HSD2</i>)	Early-onset hypertension, low potassium and renin levels, low aldosterone

TABLE 12.7 Examples of Mendelian Subtypes of Complex Disorders*

Continued

(exercise, diet, avoidance of tobacco) can modify heart disease risks appreciably.

Stroke

Stroke, which refers to brain damage caused by a sudden and sustained loss of blood flow to the brain, can result from arterial obstruction (ischemic stroke) or breakage (hemorrhagic stroke). This disease is the third leading cause of mortality in the United States, accounting for nearly 170,000 deaths per year. As with heart disease, strokes cluster in families: one's risk of having a stroke increases by two- to three-fold if a parent has had a stroke. The largest twin study conducted to date showed that concordance rates for stroke death in MZ and DZ twins were 10% and 5%, respectively. These figures imply that genes may influence one's susceptibility to this disease.

Stroke is a well-known consequence of several singlegene disorders, including sickle cell disease (see Chapter 4), MELAS (a mitochondrial disorder discussed in Chapter 5), and cerebral autosomal dominant arteriopathy with subcortical infarcts and leukoencephalopathy (CADASIL, a condition characterized by recurrent strokes and dementia and caused by mutations in the *NOTCH3* gene). Because blood clots are a frequent cause of stroke, it is expected that mutations in genes that

Complex disease	Mendelian subtype	Protein (gene)	Consequence of mutation
Diabetes	MODY1 MODY2	Hepatocyte nuclear factor-4α (<i>HNF4A</i>) Glucokinase (<i>GCK</i>)	Decreased insulin secretion Impaired glucose metabolism, leading to mild nonprogressive hyperglycemia
	MODY3 MODY4 MODY5	Hepatocyte nuclear factor-1α (<i>HNF1A</i>) Insulin promoter factor-1 (<i>IPF1</i>) Hepatic transcription factor-2 (<i>TCF2</i>)	Decreased insulin secretion Decreased transcription of insulin gene Beta-cell dysfunction leads to decreased insulin secretion
	MODY6	NeuroD transcription factor (NEUROD1)	Decreased insulin secretion
Alzheimer disease	Familial Alzheimer disease	Amyloid beta precursor protein (APP)	Alteration of cleavage sites in amyloid beta precursor protein, producing longer amyloid fragments
		Presenilin 1(PS1)	Altered cleavage of amyloid beta precursor protein, producing larger proportion of long amyloid fragments
		Presenilin 2(PS2)	Altered cleavage of amyloid beta precursor protein, producing larger proportion of long amyloid fragments
Parkinson disease	Familial Parkinson disease (autosomal dominant)	α-Synuclein (PARK1, SNCA)	Formation of α -synuclein aggregates
	Familial Parkinson disease (autosomal recessive) Familial Parkinson disease	Parkin: E3 ubiquityl ligase, thought to ubiquinate α-Synuclein (<i>PARK2</i>) Ubiquitin C-hydrolase-L1 (<i>PARK5</i>)	Compromised degradation of α-synuclein Accumulation of α-synuclein
Amyotrophic lateral sclerosis (Lou Gehrig's disease)	(autosomal dominant) Familial amyotrophic lateral sclerosis	Superoxide dismutase 1 (SOD1)	Neurotoxic gain of function
uisease)	Juvenile amyotrophic lateral sclerosis (autosomal recessive)	Alsin (ALS2)	Presumed loss of function
Epilepsy	Benign neonatal epilepsy, types 1 and 2 Generalized epilepsy with febrile seizures plus type 1 Autosomal dominant nocturnal frontal lobe epilepsy	Voltage-gated potassium channels (<i>KCNQ2</i> and <i>KCNQ3</i> , respectively) Sodium channel β1 subunit (<i>SCN1B</i>) Neuronal nicotinic acetylcholine receptor subunits (<i>CHRNA4</i> and <i>CHRNB2</i>)	Reduced M current increases neuronal excitability Sodium current persistence leading to neuronal hyperexcitability Increased neuronal excitability in response to cholinergic stimulation
	Generalized epilepsy with febrile seizures plus type 3	$GABA_A$ receptor (<i>GABRG2</i>)	Loss of synaptic inhibition leading to neuronal excitability

TABLE 12.7	Examples of Mendelian Subtypes of Complex Disorders*—cont'd
------------	---

*See Table 8-3 for genes involved in other diseases, including hearing loss and blindness. This table is not meant to provide an exhaustive list of genes; additional genes are discussed in the review papers cited at the end of Chapter 12.

encode coagulation factors may affect stroke susceptibility. For example, inherited deficiencies of protein C and protein S, both of which are coagulation inhibitors, are associated with an increased risk of stroke, especially in children. A specific mutation in clotting factor V, termed the factor V Leiden allele, causes resistance to activated protein C and thus produces an increased susceptibility to clotting. Heterozygosity for this allele, which is seen in approximately 5% of Europeans, produces a seven-fold increase in the risk of venous thrombosis (clots). In homozygotes, the risk increases to 100-fold. However, the evidence for an association between the factor V Leiden allele and stroke is inconsistent.

In addition to family history and specific genes, several

factors are known to increase the risk of stroke. These include hypertension, obesity, atherosclerosis, diabetes, and smoking.

Stroke, which clusters in families, is associated with several single-gene disorders and with some inherited coagulation disorders.

Hypertension

Systemic hypertension, which is seen in approximately 25% of the adult populations of most developed countries, is a key risk factor for heart disease, stroke, and

kidney disease. Studies of blood pressure correlations within families yield heritability estimates of approximately 20% to 40% for both systolic and diastolic blood pressure. Heritability estimates based on twin studies tend to be higher (about 60%) and may be inflated because of greater similarities in the environments of MZ compared with DZ twins. The fact that the heritability estimates are substantially less than 100% indicates that environmental factors must also be significant causes of blood pressure variation. The most important environmental risk factors for hypertension are increased sodium intake, decreased physical activity, psychosocial stress, and obesity (as discussed later, the latter factor is itself influenced both by genes and environment).

Blood pressure regulation is a highly complex process that is influenced by many physiological systems, including various aspects of kidney function, cellular ion transport, vascular tone, and heart function. Because of this complexity, much research is now focused on specific components that may influence blood pressure variation, such as the renin-angiotensin system (involved in sodium reabsorption and vasoconstriction), vasodilators such as nitric oxide or the kallikrein-kinin system, and iontransport systems such as adducin or sodium-lithium countertransport (Fig. 12-9). These individual factors are more likely to be under the control of smaller numbers of genes than is blood pressure itself, simplifying the task of identifying these genes and their role in blood pressure regulation. For example, linkage and association studies have implicated the gene that encodes angiotensinogen in the causation of both hypertension and preeclampsia (a form of pregnancy-induced hypertension).

A small proportion of hypertension cases are the result of rare, single-gene disorders, such as Liddle syndrome (low plasma aldosterone and hypertension caused by mutations that alter the ENaC epithelial sodium channel) and Gordon syndrome (hypertension, high serum potassium level, and increased renal salt reabsorption caused by mutations in the *WNK1* or *WNK4* kinase genes); see Table 12-7 for additional examples. At least eight genes have now been identified that can lead to rare forms of hypertension, and all of them affect the reabsorption of water and salt by the kidney, which in turn affects blood volume and blood pressure. It is hoped that isolation and study of these genes will lead to the identification of genetic factors underlying essential hypertension.*

Large-scale genome scans, undertaken in humans and in experimental animals such as mice and rats, have sought to identify quantitative trait loci (see Box 12-1) that may underlie essential hypertension. These studies have identified a number of regions in which LOD scores (see Chapter 8) offer statistical support for the presence of genes that influence hypertension susceptibility, and in

FIGURE 12.9 The renin-angiotensin-aldosterone system. (Modified from King RA, Rotter JI, Motulsky AG [eds.] [1992] The Genetic Basis of Common Diseases. Oxford University Press, New York.)

some cases multiple studies have implicated the same genomic region. Such results may help to pinpoint specific genes that underlie susceptibility to essential hypertension.

Heritability estimates for systolic and diastolic blood pressure range from 20% to 40%. A number of genes responsible for rare hypertension syndromes have been identified, and genome scans have implicated regions that may contain genes that underlie susceptibility to essential hypertension. Other risk factors for hypertension include increased sodium intake, lack of exercise, psychosocial stress, and obesity.

Cancer

Cancer is the second leading cause of death in the United States, although it is estimated that it may soon surpass heart disease as the leading cause of death. It is well

^{*}The term "essential" refers to the 95% of hypertension cases that are not caused by a known mutation or syndrome.

established that many major types of cancer (e.g., breast, colon, prostate, ovarian) cluster strongly in families. This is due both to shared genes and shared environmental factors. Although numerous cancer genes have been isolated, environmental factors also play an important role in causing cancer by inducing somatic mutations. In particular, tobacco use is estimated to account for one third of all cancer cases in developed countries, making it the most important known cause of cancer. Diet (i.e., carcinogenic substances and the lack of "anticancer" components such as fiber, fruits, and vegetables) is another leading cause of cancer and may also account for as much as one third of cancer cases. It is estimated that approximately 15% of worldwide cancer cases are caused primarily by infectious agents (e.g., human papilloma virus for cervical cancer, hepatitis B and C for liver cancer). Since cancer genetics was the subject of Chapter 11, we confine our attention here to genetic and environmental factors that influence susceptibility to some of the most common cancers.

Breast Cancer. Breast cancer is the second most commonly diagnosed cancer (after skin cancer) among women, affecting approximately 12% of American women who live to age 85 years or older. It kills approximately 40,000 women annually in the United States and was formerly the leading cause of cancer death among women, but has recently been surpassed by lung cancer. Breast cancer can also occur in men, with a lifetime prevalence that is roughly 100 times lower than that of women. The familial aggregation of breast cancer has been recognized for centuries, having been described by physicians in ancient Rome. If a woman has one affected first-degree relative, her risk of developing breast cancer doubles. The risk increases further with additional affected relatives, and it increases if those relatives developed cancer at a relatively early age (before 45 years of age).

Several genes are now known to predispose women to developing hereditary breast cancer. Most important among these are BRCA1 and BRCA2, two genes involved in DNA repair (see Chapter 11). Germline mutations in the TP53 and CHK2 genes can cause Li-Fraumeni syndrome, which also predisposes to breast cancer. Cowden disease, a rare autosomal dominant condition that includes multiple hamartomas and breast cancer, is caused by mutations in the PTEN tumor suppressor gene (see Chapter 11). Ataxia telangiectasia, an autosomal recessive disorder caused by defective DNA repair, includes breast cancer in its presentation. Mutations in the MSH2 and MLH1 DNA repair genes, which lead to hereditary nonpolyposis colorectal cancer (HNPCC), also confer an increased risk of breast cancer. Despite the significance of these genes, it should be emphasized that more than 90% of breast cancer cases are not inherited as Mendelian diseases, www

A number of environmental factors are known to increase the risk of developing breast cancer. These include nulliparity (never bearing children), bearing the first child after 30 years of age, a high-fat diet, alcohol use, and estrogen replacement therapy.

Colorectal Cancer. It is estimated that 1 in 20 Americans will develop colorectal cancer, and roughly one third of those diagnosed with this cancer will die from it. With approximately 57,000 deaths in the United States in 2002, colorectal cancer is second only to lung cancer in the total number of annual cancer deaths. Like breast cancer, it clusters in families; familial clustering of this form of cancer was reported in the medical literature as early as 1881. The risk of colorectal cancer in people with one affected first-degree relative is two to three times higher than that of the general population.

As discussed in Chapter 11, familial colon cancer can be the result of mutations in the APC tumor suppressor gene or in one of six DNA mismatch repair genes (HNPCC). Another, less common, inherited cause of colon cancer is the autosomal dominant Peutz-Jeghers syndrome. About half of Peutz-Jeghers cases are caused by mutations in the STK11 tumor suppressor gene, which encodes a protein kinase. Juvenile intestinal polyposis, an autosomal dominant disease defined by the presence of 10 or more polyps before adulthood, can be caused by mutations in SMAD4 (see Chapter 11), in BMPRA1 (a receptor serine-threonine kinase gene), or, in rare cases, in PTEN. As discussed previously, PTEN mutations can also cause Cowden disease, which, in addition to breast tumors, often includes polyps in the intestinal tract.

As with breast cancer, most colon cancer cases (more than 90%) are not clearly inherited and are likely to be caused by a complex interaction of somatic gene alterations and environmental factors. The latter risk factors include a lack of physical activity and a high-fat, lowfiber diet.

Prostate Cancer. This cancer is the second most commonly diagnosed cancer in men (after skin cancer), with approximately 200,000 new cases annually in the United States. Prostate cancer is second only to lung cancer as a cause of cancer death in men, causing more than 30,000 deaths in 2002. Having an affected first-degree relative increases the risk of developing prostate cancer by a factor of two to three. It is estimated that about 5% to 10% of prostate cancer cases are the result of inherited mutations.

The relatively late age of onset of most prostate cancer cases (median age, 72 years) makes genetic analysis especially difficult. However, loss of heterozygosity (see Chapter 11) has been observed in a number of genomic regions in prostate tumor cells, possibly indicating the presence of genetic alterations in these regions. In addition, genome scans have indicated that several chromosome regions may contain prostate cancer susceptibility genes. One of the most promising, having been replicated in several studies, is a region on chromosome 1q that contains the *RNASEL* gene. The product of this gene, ribonuclease L, regulates cell proliferation and apoptosis and is thought to be a tumor suppressor. Mutations in *RNASEL* account for a small percentage of familial prostate cancer cases. Mutations in the *ELAC2* gene on chromosome 17p have been weakly associated with familial prostate cancer in some studies but not in others.

Nongenetic risk factors for prostate cancer may include a high-fat diet. Because prostate cancer usually progresses slowly and because it can be detected by digital examination and by the prostate-specific antigen (PSA) test, fatal metastasis can usually be prevented. www

Diabetes Mellitus

Like the other disorders discussed in this chapter, the etiology of diabetes mellitus is complex and not fully understood. Nevertheless, progress is being made in understanding the genetic basis of this disorder, which is the leading cause of adult blindness, kidney failure, and lower-limb amputation and a major cause of heart disease and stroke. An important advance has been the recognition that diabetes is actually a heterogeneous group of disorders, all characterized by elevated blood sugar. We focus here on the three major types of diabetes, type 1 (formerly termed insulin-dependent diabetes mellitus, or IDDM), type 2 (formerly termed non–insulin-dependent diabetes mellitus, or NIDDM), and maturity-onset diabetes of the young (MODY).

Type 1 Diabetes. This form of diabetes, which is characterized by T-cell infiltration of the pancreas and destruction of the insulin-producing beta cells, usually (though not always) manifests before 40 years of age. Patients with type 1 diabetes must receive exogenous insulin to survive. In addition to T-cell infiltration of the pancreas, autoantibodies are formed against pancreatic cells; the latter can be observed long before clinical symptoms occur. These findings, along with a strong association between type 1 diabetes and the presence of several human leukocyte antigen (HLA) class II alleles, indicate that this is an autoimmune disease.

Siblings of individuals with type 1 diabetes face a substantial elevation in risk: approximately 6%, as opposed to a risk of about 0.3% to 0.5% in the general population. The recurrence risk is also elevated when there is a diabetic parent, although this risk varies with the sex of the affected parent. The risk for offspring of diabetic mothers is only 1% to 3%, while it is 4% to 6% for the offspring of diabetic fathers (because type 1 diabetes affects males and females in roughly equal proportions in the general population, this risk difference is inconsistent with the sex-specific threshold model for multifactorial traits). Twin studies show that the empirical risk for MZ twins of type 1 diabetes patients ranges from 30% to 50%. In contrast, the concordance rate for DZ twins is 5% to 10%. The fact that type 1 diabetes is not 100% concordant among identical twins indicates that genetic factors are not solely responsible for the disorder. There is good evidence that specific viral infections contribute to the causation of type 1 diabetes in at least some individuals, possibly by activating an autoimmune response. www

The association of specific HLA class II alleles and type 1 diabetes has been studied extensively, and it is estimated that the HLA system accounts for about 40% of the familial clustering of type 1 diabetes. Approximately 95% of Caucasians with type 1 diabetes have the HLA DR3 and/or DR4 alleles, whereas only about 50% of the general Caucasian population has either of these alleles. If an affected proband and a sibling are both heterozygous for the DR3 and DR4 alleles, the sibling's risk of developing type 1 diabetes is nearly 20% (i.e., about 40 times higher than the risk in the general population). This association may in part reflect linkage disequilibrium between alleles of the DR locus and those of the HLA-DQ locus. The absence of aspartic acid at position 57 of the DQ chain is strongly associated with susceptibility to type 1 diabetes; in fact, those who do not have this amino acid at position 57 (and instead are homozygous for a different amino acid) are 100 times more likely to develop the type 1 diabetes. The aspartic acid substitution alters the shape of the HLA class II molecule and thus its ability to bind and present peptides to T-cells (see Chapter 9). Altered T-cell recognition may help to protect individuals with the aspartic acid substitution from an autoimmune episode.

The insulin gene, which is located on the short arm of chromosome 11, is another logical candidate for type 1 diabetes susceptibility. Polymorphisms within and near this gene have been tested for association with type 1 diabetes. Intriguingly, a strong risk association is seen with allelic variation in a VNTR polymorphism (see Chapter 3) located just 5' of the insulin gene. Differences in the number of VNTR repeat units may affect transcription of the insulin gene (possibly by altering chromatin structure), resulting in variation in susceptibility. It is estimated that inherited genetic variation in the insulin region accounts for approximately 10% of the familial clustering of type 1 diabetes.

Affected sib-pair analysis has been used extensively to map additional genes that can cause type 1 diabetes. In addition, an animal model, the nonobese diabetic (NOD) mouse, has been used to identify diabetes susceptibility genes that could have homologs in the human (see Box 12-1). These studies have identified at least 20 additional candidate regions that may contain type 1 diabetes susceptibility genes. Precise identification of such genes is made difficult by the genetic complexity of the disorder (locus heterogeneity, polygenic background) and by the

Most common cancers have genetic components. Recurrence risks tend to be higher if there are multiple affected relatives and if those relatives developed cancer at an early age. Specific genes have been discovered that cause inherited colon, breast, and prostate cancer in some families.

fact that genes other than insulin and HLA are likely to account for only a small proportion of the genetic susceptibility to type 1 diabetes. Nonetheless, their further study may aid understanding of this disease.

Type 2 Diabetes. Type 2 diabetes accounts for more than 90% of all diabetes cases, and it affects 10% to 20% of the adult populations of many developed countries. A number of features distinguish it from type 1 diabetes. There is nearly always some endogenous insulin production in persons with type 2 diabetes, and the disease can often be treated successfully with dietary modification, oral drugs, or both. Type 2 diabetes patients suffer from insulin resistance (i.e., their cells have difficulty utilizing insulin). This disease typically occurs among people older than 40 years of age, and, in contrast to type 1 diabetes, it is seen more commonly among the obese. The incidence of type 2 diabetes is rising dramatically among adolescents and young adults in developed countries and is strongly correlated with an increased incidence of obesity. Neither HLA associations nor autoantibodies are seen commonly in this form of diabetes. MZ twin concordance rates are substantially higher than in type 1 diabetes, often exceeding 90% (because of age dependence, the concordance rate increases if older subjects are studied). The empirical recurrence risks for first-degree relatives of patients with type 2 diabetes are higher than those for type 1 patients, generally ranging from 10% to 15%. The differences between type 1 and type 2 diabetes are summarized in Table 12-8.

The two most important risk factors for type 2 diabetes are a positive family history and obesity; the latter increases insulin resistance. The disease tends to rise in prevalence when populations adopt a diet and exercise pattern typical of United States and European populations. Increases have been seen, for example, among Japanese immigrants to the United States and among some native populations of the South Pacific, Australia, and the Americas. Several studies, conducted on both male and female subjects, have shown that regular exercise can substantially lower one's risk of developing type 2 diabetes, even among individuals with a family

TABLE 12.8 Comparison of the Major Features of Type and Type 2 Diabetes Mellitus			
Feature	Type 1 diabetes	Type 2 diabetes	

Age of onset	Usually <40 yr	Usually >40 yr
Insulin production	None	Partial
Insulin resistance	No	Yes
Autoimmunity	Yes	No
Obesity	Not common	Common
MZ twin concordance	0.35-0.50	0.90
Sibling recurrence risk	1-6%	10-15%

history of the disease. This is partly because exercise reduces obesity. However, even in the absence of weight loss, exercise increases insulin sensitivity and improves glucose tolerance.

Extensive linkage analyses have been undertaken to identify genes that may contribute to type 2 diabetes susceptibility. A region on chromosome 2q was implicated in these studies, and subsequent linkage disequilibrium analyses led to evidence that mutations in a gene that encodes calpain-10 (a cysteine protease) are associated with type 2 diabetes susceptibility. This association has been replicated in some populations, but not in others. A significant association has also been observed between type 2 diabetes and a common allele of the gene that encodes peroxisome proliferator-activated receptor-y (PPAR- γ), a transcription factor that is involved in adipocyte differentiation and glucose metabolism. Although this allele confers only a 25% increase in the risk of developing type 2 diabetes, it is found in more than 75% of individuals of European descent. Thus, it may help to account for a significant proportion of type 2 diabetes cases.

Maturity-Onset Diabetes of the Young. This form of diabetes, which accounts for 1% to 5% of all diabetes cases, typically occurs before 25 years of age and follows an autosomal dominant mode of inheritance. In contrast to type 2 diabetes, it is not associated with obesity. Studies of MODY pedigrees have shown that about 50% of cases are caused by mutations in the gene that encodes glucokinase, a rate-limiting enzyme in the conversion of glucose to glucose-6-phosphate in the pancreas. MODY can also be caused by mutations in any of five genes that encode transcription factors involved in pancreatic development or insulin regulation: hepatocyte nuclear factor $1-\alpha$ (*HNF1* α), hepatic nuclear factor $1-\beta$ (*HNF1* β), hepatocyte nuclear factor 4- α (HNF4 α), insulin promoter factor 1 (IPF1), and neurogenic differentiation 1 (NEU-ROD1). Mutations in these genes, all of which are expressed in pancreatic beta cells, lead to beta-cell abnormalities and thus to diabetes.

Type 1 (insulin-dependent) and type 2 (non-insulin-dependent) diabetes both cluster in families, with stronger familial clustering observed for type 2 diabetes. Type 1 has an earlier average age of onset, is HLA-associated, and is an autoimmune disease. Type 2 is not an autoimmune disorder and is more likely to be seen in obese individuals. Most cases of autosomal dominant MODY are caused by mutations in any of six specific genes.

Obesity

Obesity is most commonly defined as a body mass index (BMI) greater than 30.* Using this criterion, a survey published in 2002 showed that approximately 30% of

American adults are obese, and an additional 35% are overweight (BMI greater than 25 but less than 30). The proportion of obese adults and children continues to increase rapidly. Although obesity itself is not a "disease," it is an important risk factor for several common diseases, including heart disease, stroke, hypertension, and type 2 diabetes.

As one might expect, there is a strong correlation between obesity in parents and obesity in their children. This could easily be ascribed to common environmental effects: parents and children usually share similar dietary and exercise habits. However, there is good evidence for genetic components as well. Four adoption studies each showed that the body weights of adopted individuals correlated significantly with their natural parents' body weights but not with those of their adoptive parents. Twin studies also provide evidence for a genetic effect on body weight, with most studies yielding heritability estimates between 0.60 and 0.80.

Recent research, aided substantially by mouse models, has shown that several genes each play a role in human obesity. Important among these are the genes that encode leptin (Greek, "thin") and its receptor. The leptin hormone is secreted by adipocytes (fat storage cells) and binds to receptors in the hypothalamus, the site of the body's appetite control center. Increased fat stores lead to an elevated leptin level, which produces satiety and a loss of appetite. Lower leptin levels lead to increased appetite. Mice with loss-of-function mutations in the leptin gene have uncontrolled appetites and become obese. When injected with leptin, these mice lose weight. Mice with mutations in the leptin receptor gene cannot respond to increased leptin levels and also develop obesity.

Cloning of the human homologs of the leptin gene and its receptor led to optimistic predictions that leptin could be a key to weight loss in humans (without the perceived unpleasantness of dieting and exercise). However, most obese humans have high levels of leptin, indicating that the leptin gene is functioning normally. Leptin receptor defects were then suspected, but these are also uncommon in humans. Although mutations in the human leptin gene and its receptor have now been identified in a few humans with severe obesity (BMI greater than 40), they both appear to be extremely rare. Unfortunately, these genes will not solve the problem of human obesity. However, clinical trials using recombinant leptin have demonstrated moderate weight loss in a subset of obese individuals. In addition, leptin participates in important interactions with other components of appetite control, such as neuropeptide Y and α melanocyte-stimulating hormone and its receptor, the melanocortin-4 receptor (MC4R). Mutations in the gene that encodes MCR4 have been found in 3% to 5% of severely obese individuals. Identification of these human genes is leading to a better understanding of natural weight control in the human and could eventually lead to effective treatments for some cases of obesity.

Adoption and twin studies indicate that at least half of the population variation in obesity may be caused by genes. Specific genes and gene products involved in appetite control and susceptibility to obesity, including leptin and its receptor, are now being studied.

Alzheimer Disease

Alzheimer disease (AD), which is responsible for 60% to 70% of cases of progressive cognitive impairment among the elderly, affects approximately 10% of the population older than 65 years of age and 40% of the population older than 85 years of age. Because of the aging of the population, the number of Americans with AD is predicted to increase from the current figure of 4 million to a total of 10 million by the year 2010. AD is characterized by progressive dementia and memory loss and by the formation of amyloid plaques and neurofibrillary tangles in the brain, particularly in the cerebral cortex and hippocampus. The plaques and tangles lead to progressive neuronal loss, and death usually occurs within 7 to 10 years after the first appearance of symptoms.

The risk of developing AD doubles in individuals who have an affected first-degree relative. Although most cases do not appear to be caused by single loci, approximately 10% follow an autosomal dominant mode of transmission. About 3% to 5% of AD cases occur before age 65 and are considered early onset; these are much more likely to be inherited in autosomal dominant fashion. www

AD is a genetically heterogeneous disorder. Approximately half of early-onset cases can be attributed to mutations in any of three genes, all of which affect amyloid- β deposition. Two of the genes, presenilin 1 (*PS1*) and presenilin 2 (*PS2*), are very similar to one another, and their protein products are involved in cleavage of the amyloid- β precursor protein (APP) by γ -secretase (posttranslational modification; see Chapter 2). When APP is not cleaved normally, a long form of it accumulates excessively and is deposited in the brain (Fig. 12-10). This is thought to be a primary cause of AD. Mutations in *PS1* typically result in especially early onset of AD, with the first occurrence of symptoms in the fifth decade of life.

A small number of cases of early-onset AD are caused by mutations of the gene that encodes APP itself, which is located on chromosome 21. These mutations disrupt normal secretase cleavage sites in APP (see Fig. 12-10), again leading to the accumulation of the longer protein product. It is interesting that this gene is present in three copies in trisomy 21 individuals, where the extra gene copy leads to amyloid deposition and the occurrence of AD in Down syndrome patients (see Chapter 6).

An important risk factor for the more common lateonset form of AD is allelic variation in the apolipoprotein E (*APOE*) locus, which has three major alleles: $\varepsilon 2$, $\varepsilon 3$, and

 ε 4. Studies conducted in diverse populations have shown that persons who have one copy of the ε 4 allele are at least 2 to 5 times more likely to develop AD, while those with two copies of this allele are at least 5 to 10 times more likely to develop AD. The risk varies somewhat by population, with higher ε 4-associated risks in Europeans and Japanese and relatively lower risks in Hispanics and African-Americans. Despite the strong association between ε 4 and AD, approximately half of individuals who develop late-onset AD do not have a copy of the ε 4 allele, and many who are homozygous for ε 4 remain free of AD even at advanced age. The apolipoprotein E protein product is not involved in cleavage of APP but instead appears to be associated with clearance of amyloid from the brain.

Genome scans indicate that there are additional AD genes, with especially strong evidence for susceptibility loci in regions of chromosomes 10 and 12. A gene located within the chromosome 12 region encodes α_2 -macroglobulin, a protease inhibitor that interacts with apolipoprotein E. Another gene in this region encodes the low-density lipoprotein receptor-related protein (LRP), which also interacts with apolipoprotein E. Some studies support an association between alleles of these genes and late-onset AD, while others fail to replicate the association. It remains to be seen whether these genes play significant roles in causing AD.

AD has several features that have made it refractory to genetic analysis. Its genetic heterogeneity has already been described. In addition, because a definitive diagnosis can be obtained only by a brain autopsy, it is difficult to diagnose living family members (although clinical features and brain imaging studies can provide strong evidence that an individual is affected with AD). Finally, because onset of the disease can occur very late in life, individuals carrying an AD-predisposing mutation could die from another cause before developing the disease. These individuals would then be misdiagnosed as noncarriers. These types of difficulties arise not only with AD but with many other common adult diseases as well. Despite these obstacles, several AD genes have now been identified, leading to a better understanding of the disorder and to the possibility of more effective AD treatment.

Approximately 10% of AD cases are caused by autosomal dominant genes. Early-onset cases cluster more strongly in families and are more likely to follow an autosomal dominant inheritance pattern. This disease is genetically heterogeneous: at least four AD susceptibility genes have been identified. Three of the genes (encoding presenilin 1, presenilin 2, and amyloid- β precursor protein) cause early-onset AD and affect the cleavage and processing of the amyloid precursor protein. A fourth encodes the apolipoprotein E protein and is strongly associated with late-age onset of AD.

Alcoholism

At some point in their lives, alcoholism is diagnosed in approximately 10% of adult males and 3% to 5% of adult females in America (see Table 12-7). More than 100 studies have shown that this disease clusters in families: the risk of developing alcoholism among individuals with one affected parent is three to five times higher than for those with unaffected parents. Most twin studies have vielded concordance rates for DZ twins of less than 30% and for MZ twins in excess of 60%. Adoption studies have shown that the offspring of an alcoholic parent, even when raised by nonalcoholic parents, have a four-fold increased risk of developing the disorder. To control for possible prenatal effects from an alcoholic mother, some studies have included the offspring of alcoholic fathers only. The results have remained the same. These data argue that there may be genes that predispose some people to alcoholism.

Some researchers distinguish two major subtypes of alcoholism. Type I is characterized by a later age of onset

(after 25 years of age), occurrence in both males and females, and greater psychological dependency on alcohol. Type I alcoholics are more likely to be introverted, solitary drinkers. This form of alcoholism is less likely to cluster in families (one study yielded a heritability estimate of 0.21), has a less severe course, and is more easily treated. Type II alcoholism is seen predominantly in males, typically occurs before 25 years of age, and tends to involve individuals who are extroverted and thrillseeking. This form is more difficult to treat successfully and tends to cluster much more strongly in families, with one study obtaining a heritability estimate of 0.88.

It has long been known that an individual's physiologic response to alcohol can be influenced by variation in the key enzymes responsible for alcohol metabolism: alcohol dehydrogenases (ADH), which convert ethanol to acetaldehyde, and aldehyde dehydrogenases (ALDH), which convert acetaldehyde to acetate. In particular, an allele of the *ALDH2* gene (*ALDH2*2*) results in excessive accumulation of acetaldehyde and thus in facial flushing, nausea, palpitations, and lightheadedness. Because of these unpleasant effects, individuals who have the *ALDH2*2* allele are much less likely to become alcoholics. This "protective" allele is common in some Asian populations but is rare in other populations.

There is currently less reliable evidence regarding genes that may predispose individuals to become addicted to alcohol. Evidence has been published for an association between alcoholism and a restriction fragment length polymorphism linked to the dopamine D_2 receptor gene. Since the dopamine receptors are part of the brain's reward pathway, this association has some intuitive appeal. However, most studies have failed to replicate the association, and it now appears unlikely that this polymorphism contributes importantly to alcoholism susceptibility. The inability to replicate this finding reflects some of the difficulties encountered in population association studies (see Chapter 8). Nevertheless, the twin and adoption studies mentioned previously are compelling, and it is quite possible that the genome scans and candidate gene studies now under way may reveal genes that influence susceptibility to this important disease.

It should be underscored that we refer to genes that may increase one's *susceptibility* to alcoholism. This is obviously a disease that requires an environmental component, regardless of one's genetic constitution.

Twin and adoption studies show that alcoholism clusters quite strongly in families, reflecting a possible genetic contribution to this disease. Familial clustering is particularly strong for type II alcoholism (early-onset form primarily affecting males).

Psychiatric Disorders

Two of the major psychiatric diseases, schizophrenia and bipolar disorder, have been the subjects of numerous

genetic studies. Twin, adoption, and family studies have shown that both disorders aggregate in families.

Schizophrenia. Schizophrenia is a severe emotional disorder characterized by delusions, hallucinations, retreat from reality, and bizarre, withdrawn, or inappropriate behavior (contrary to popular belief, schizophrenia is not a "split personality" disorder). The lifetime recurrence risk for schizophrenia among the offspring of one affected parent is approximately 8% to 10%, which is about 10 times higher than the risk in the general population. The empirical risks increase when more relatives are affected. For example, an individual with an affected sibling and an affected parent has a risk of about 17%, and an individual with two affected parents has a risk of 40% to 50%. The risks decrease when the affected family member is a second- or third-degree relative. Details are given in Table 12-9. On inspection of this table, it may seem puzzling that the proportion of schizophrenic probands who have a schizophrenic parent is only about 5%, which is substantially lower than the risk for other first-degree relatives (e.g., siblings, affected parents, and their offspring). This can be explained by the fact that schizophrenics are less likely to marry and produce children than are other individuals. There is thus substantial selection against schizophrenia in the population.

Twin and adoption studies indicate that genetic factors are likely to be involved in schizophrenia. Data pooled from five different twin studies show a 47% concordance rate for MZ twins, compared with only 12% for DZ twins. The concordance rate for MZ twins reared apart, 46%, is about the same as the rate for MZ twins reared together. The risk of developing the disease for offspring of a schizophrenic parent who are adopted by normal parents is about 10%, approximately the same as the risk when the offspring are raised by a schizophrenic biological parent.

More than 20 genome scans have been performed in an effort to locate schizophrenia genes. While a number

TABLE 12.9 Recurrence Risks for Relatives of Schizophrenic Probands, Based on Multiple Studies of Western European Populations			
Relationship to proband	Recurrence risk (%)		
Monozygotic twin	44.3		
Dizygotic twin	12.1		
Offspring	9.4		
Sibling	7.3		
Niece/nephew	2.7		
Grandchild	2.8		
First cousin	1.6		
Spouse	1.0		

Adapted from McGue et al. (1986) The analysis of schizophrenia family data. Behav Genet 16:75–87.

of chromosome regions have been implicated, no schizophrenia gene has been conclusively identified. However, linkage to several chromosome regions has been replicated in multiple populations, and specific genes in these regions are being analyzed. Some of the techniques discussed in Chapter 8 (linkage disequilibrium, candidate gene analysis) have identified promising associations between schizophrenia and several brain-expressed genes whose products interact with glutamate receptors. These include dysbindin (chromosome 6p), neuregulin 1 (chromosome 8p), and G72 (chromosome 13q). Each of these associations has been identified in a specific population, and further studies in other populations will be needed to replicate these findings.

Bipolar Disorder. Bipolar disorder, also known as manic-depressive disorder, is a form of psychosis in which extreme mood swings and emotional instability are seen. The prevalence of the disorder in the general population is approximately 0.5% to 1%, but it rises to 5% to 10% among those with an affected first-degree relative. A study based on the Danish twin registry yielded concordance rates of 79% and 24% for MZ and DZ twins, respectively. The corresponding concordance rates for unipolar disorder (major depression) were 54% and 19%. Thus, it appears that bipolar disorder is more strongly influenced by genetic factors than is unipolar disorder.

As with schizophrenia, many linkage studies have been carried out to identify genes contributing to bipolar disorder. Considerable excitement was generated some years ago by a report linking the disorder to a polymorphism on chromosome 11p. This study examined a series of Old Order Amish families in which the disorder is transmitted in autosomal dominant fashion. As discussed in Box 12-1, the use of an isolated population such as this one should increase the likelihood of identifying a single causative gene. Linkage analysis initially yielded a LOD score (see Chapter 8) of 4.0. However, the result was later reversed with the addition of another branch of the pedigree and when two initially unaffected family members, who did not carry the marker allele segregating with the disorder, subsequently developed the disorder. This demonstrates the sensitivity of linkage analysis to changes in disease status. Many additional families have been studied since, and the LOD score eventually dropped to -9.0 (i.e., the odds are 1 billion to one against linkage to the chromosome 11 marker).

Comments on Psychiatric Disorders. Large-scale linkage studies involving thousands of polymorphisms throughout the genome have now been carried out for both schizophrenia and bipolar disorder. In addition, a number of candidate genes have been tested for linkage or association with both diseases. Most of those candidates were chosen on the basis of the known involvement of certain neurotransmitters, receptors, or neurotransmitter-related enzymes in each disease. (For example, schizophrenia can be treated by drugs that block

dopamine receptors, and bipolar disorder is sometimes treated with lithium.) None of the candidate genes tested thus far, including those that encode sodium-lithium countertransport, various components of the dopaminergic and serotonergic systems, and several neurotransmitterrelated enzymes (such as monoamine oxidase, dopamine- β -hydroxylase, and tyrosine hydroxylase), has been shown unequivocally to be associated with either disease.

These results reveal some of the difficulties encountered in genetic studies of complex disorders in general, and psychiatric disorders in particular. These diseases are undoubtedly heterogeneous, reflecting the influence of numerous genetic and environmental factors. Also, definition of the phenotype is not always straightforward, and it may change through time. As the bipolar affective disorder linkage story shows, such changes can be critical. Several measures are being taken to improve the likelihood of finding genes underlying these conditions. Phenotypes are being defined in standardized and rigorous fashion. Larger sample sizes of affected individuals, with more rigorous phenotype definition, are being collected in efforts to increase the power to detect linkage and association. Heterogeneity can be decreased by studying clinically defined subtypes of these diseases and by carrying out studies in genetically homogeneous populations.

Marked familial aggregation has been observed for schizophrenia and for bipolar affective disorder. Genes that encode neurotransmitters, receptors, and neurotransmitter-related enzymes have been studied in families, and many genome scans have been carried out. Although no specific genes predisposing to these diseases have been conclusively identified, several promising candidates are being studied.

Other Complex Disorders

The disorders discussed in this chapter represent some of the most common multifactorial disorders and those for which significant progress has been made in identifying genes. Many other multifactorial disorders are being studied as well, and in some cases specific susceptibility genes have been identified. These include, for example, Parkinson disease, hearing loss, multiple sclerosis, amyotrophic lateral sclerosis, epilepsy, asthma, inflammatory bowel disease, and some forms of blindness (see Table 12-7 and Table 8-3 in Chapter 8).

Some General Principles and Conclusions

Some general principles can be deduced from the results obtained thus far regarding the genetics of complex disorders. First, the more strongly inherited forms of complex disorders generally have an earlier age of onset (examples include breast cancer, Alzheimer disease, and heart disease). Often, these represent subsets of cases in which there is single-gene inheritance. Second, when there is laterality, bilateral forms sometimes cluster more strongly in families (e.g., cleft lip/palate). Third, while the sex-specific threshold model fits some of the complex disorders (e.g., pyloric stenosis, cleft lip/palate, autism, heart disease), it fails to fit others (e.g., type 1 diabetes).

There is a tendency, particularly among the lay public, to assume that the presence of a genetic component means that the course of a disease cannot be altered ("If it's genetic, you can't change it"). This is incorrect. Most of the diseases discussed in this chapter have both genetic and environmental components. Thus, environmental modification (e.g., diet, exercise, stress reduction) can often reduce risk significantly. Such modifications may be especially important for individuals who have a family history of a disease, because they are likely to develop the disease earlier in life. Those with a family history of heart disease, for example, can often add many years of productive living with relatively minor lifestyle alterations. By targeting those who can benefit most from intervention, genetics helps to serve the goal of preventive medicine.

In addition, it should be stressed that the identification of a specific genetic alteration can lead to more effective prevention and treatment of the disease. Identification of mutations causing familial colon cancer may enable early screening and prevention of metastasis. Pinpointing a gene responsible for a neurotransmitter defect in a behavioral disorder such as schizophrenia could lead to the development of more effective drug treatments. In some cases, such as familial hypercholesterolemia, gene therapy may be useful. It is important for health care practitioners to make their patients aware of these facts.

While the genetics of common disorders is complex and often confusing, the public health impact of these diseases and the evidence for hereditary factors in their etiology demand that genetic studies be pursued. Substantial progress is already being made. The next decade will undoubtedly witness many advancements in our understanding and treatment of these disorders.

SUGGESTED READINGS

- Baron M (2001) Genetics of schizophrenia and the new millennium: progress and pitfalls. Am J Hum Genet 68:299-312
- Barsh GS, Farooqi IS, O'Rahilly S (2000) Genetics of bodyweight regulation. Nature 404:644-651
- Bell GI, Polonsky KS (2001) Diabetes mellitus and genetically programmed defects in beta-cell function. Nature 414:788-791
- Botstein D, Risch N (2003) Discovering genotypes underlying human phenotypes: past successes for mendelian disease, future approaches for complex disease. Nat Genet 33:228-237.
- Botto LD, Moore CA, Khoury MJ, Erickson JD (1999) Neuraltube defects. N Engl J Med 341:1509-1519

- Breslow JL (2000) Genetics of lipoprotein abnormalities associated with coronary artery disease susceptibility. Annu Rev Genet 34:233-254
- Busch CP, Hegele RA (2001) Genetic determinants of type 2 diabetes mellitus. Clin Genet 60:243-254
- Cavalli-Sforza LL, Bodmer WF (1971) The Genetics of Human Populations. W. H. Freeman, San Francisco, CA
- Chapman PF, Falinska AM, Knevett SG, Ramsay MF (2001) Genes, models and Alzheimer's disease. Trends Genet 17:254-261
- Cloninger CR (2002) The discovery of susceptibility genes for mental disorders. Proc Natl Acad Sci U S A 99:13365-13367
- Dumaine R, Antzelevitch C (2002) Molecular mechanisms underlying the long QT syndrome. Curr Opin Cardiol 17:36-42
- Fajans SS, Bell GI, Polonsky KS (2001) Molecular mechanisms and clinical pathophysiology of maturity-onset diabetes of the young. N Engl J Med 345:971-980
- Field LL (2002) Genetic linkage and association studies of type I diabetes: challenges and rewards. Diabetologia 45:21-35
- Folstein SE, Rosen-Sheidley B (2001) Genetics of autism: complex aetiology for a heterogeneous disorder. Nature Rev Genet 2:943-955
- Franz WM, Muller OJ, Katus HA (2001) Cardiomyopathies: from genetics to the prospect of treatment. Lancet 358:1627-1637
- Glazier AM, Nadeau JH, Aitman TJ (2002) Finding genes that underlie complex traits. Science 298:2345-2349
- Hademenos GJ, Alberts MJ, Awad I, Mayberg M, Shepard T, Jagoda A, Latchaw RE, Todd HW, Viste K, Starke R, Girgus MS, Marler J, Emr M, Hart N (2001) Advances in the genetics of cerebrovascular disease and stroke. Neurology 56:997-1008
- Hunt SC, Hopkins PN, Lalouel J-M (2002) Hypertension. In: King RA, Rotter JI, Motulsky AG (eds) The Genetic Basis of Common Diseases, 2nd ed. Oxford University Press, Oxford, pp 127-154
- King RA, Rotter JI, Motulsky AG (eds) (2002) The Genetic Basis of Common Diseases, 2nd ed. Oxford University Press, Oxford
- Lansbury PT Jr, Brice A (2002) Genetics of Parkinson's disease and biochemical studies of implicated gene products. Curr Opin Genet Dev 12:299-306
- Lifton RP, Gharavi AG, Geller DS (2001) Molecular mechanisms of human hypertension. Cell 104:545-556
- MacGregor AJ, Snieder H, Schork NJ, Spector TD (2000) Twins: novel uses to study complex traits and genetic diseases. Trends Genet 16:131-134
- Marban E (2002) Cardiac channelopathies. Nature 415:213-218
- Meisler MH, Keamey J, Ottman R, Escayg A (2001) Identification of epilepsy genes in human and mouse. Annu Rev Genet 35:567-588
- Melvin EC, George TM, Worley G, Franklin A, Mackey J, Viles K, Shah N, Drake CR, Enterline DS, McLone D, Nye J, Oakes WJ, McLaughlin C, Walker ML, Peterson P, Brei T, Buran C, Aben J, Ohm B, Bermans I, Qumsiyeh M, Vance J, Pericak-Vance MA, Speer MC (2000) Genetic studies in neural tube defects. NTD Collaborative Group. Pediatr Neurosurg 32:1-9
- Myers AJ, Goate AM (2001) The genetics of late-onset Alzheimer's disease. Curr Opin Neurol 14:433-440

- Neale MC, Cardon LR (1992) Methodology for Genetic Studies of Twins and Families. Kluwer Academic Publishers, Dordrecht, The Netherlands
- Rankinen T, Perusse L, Weisnagel SJ, Snyder EE, Chagnon YC, Bouchard C (2002) The human obesity gene map: the 2001 update. Obes Res 10:196-243
- Reich T, Hinrichs A, Culverhouse R, Bierut L (1999) Genetic studies of alcoholism and substance dependence. Am J Hum Genet 65:599-605
- Rice TK, Borecki IB (2001) Familial resemblance and heritability. Adv Genet 42:35-44
- Rowland LP, Shneider NA (2001) Amyotrophic lateral sclerosis. N Engl J Med 344:1688-1700
- Scheuner MT (2001) Genetic predisposition to coronary artery disease. Curr Opin Cardiol 16:251-260
- Selkoe DJ, Podlisny MB (2002) Deciphering the genetic basis of Alzheimer's disease. Annu Rev Genomics Hum Genet 3:67-99

- Simard J, Dumont M, Soucy P, Labrie F (2002) Perspective: prostate cancer susceptibility genes. Endocrinology 143:2029-2040
- Towbin JA, Bowles NE (2002) The failing heart. Nature 415:227-233

INTERNET RESOURCES

Human Genome Epidemiology Network Reviews (contains links to review articles on genetics of Mendelian and common diseases)

http://www.cdc.gov/genomics/hugenet/reviews.htm

International Center for Birth Defects Web Guide http://www.icbd.org/link.htm

STUDY QUESTIONS

- Consider a multifactorial trait that is twice as common in females as in males. Indicate which type of mating is at higher risk for producing affected children (affected father and normal mother versus normal father and affected mother). Is the recurrence risk higher for their sons or their daughters?
- 2. Consider a disease that is known to have a 5% sibling recurrence risk. This recurrence risk could be the result of either multifactorial inheritance or a single autosomal dominant gene with 10% penetrance. How would you test which of these possibilities is correct?
- **3.** One member of a pair of MZ twins is affected by an autosomal dominant disease, and the other is not. List two different ways in which this could happen.
- 4. Suppose that the heritability of body fat is 0.80 when correlations between siblings are studied but only 0.50 when correlations between parents and offspring are studied. Suppose also that a significant positive correlation is observed in the body fat measurements of spouses. How would you interpret these results?

CHAPTER 13

Genetic Testing and Gene Therapy

As we have seen in previous chapters, significant advances have occurred in DNA technology, gene mapping and cloning, cytogenetics, and many other areas of medical genetics. These developments have paved the way for more accurate and efficient testing of genetic disorders. **Genetic testing** can be defined as the analysis of chromosomes, DNA, RNA, or proteins to detect abnormalities that may cause a genetic disease. Examples of genetic testing include prenatal diagnosis, heterozygote carrier detection, and presymptomatic diagnosis of genetic disease. The principles and applications of genetic testing in these contexts are one focus of this chapter.

Another focus is the treatment of genetic disease. Many aspects of disease management involve areas of medicine, such as surgery and drug treatment, that are beyond the scope of this book. However, gene therapy, in which patients' cells are genetically altered to combat specific diseases, is discussed here in some detail.

POPULATION SCREENING FOR GENETIC DISEASE

Screening tests represent an important component of routine health care. These tests are usually designed to detect treatable human diseases in their presymptomatic stage. Pap tests for the recognition of cervical dysplasia and population screening for hypercholesterolemia are well-known examples of this public health strategy. Population screening has been defined as "the presumptive identification of an unrecognized disease or defect by the application of tests, examinations, or other procedures which can be applied rapidly to sort out apparently well persons who probably have a disease from those who probably do not" (Mausner and Bahn, 1974). Screening tests are not intended to provide definitive diagnoses; rather, they are aimed at identifying a subset of the population on whom further, more exact, diagnostic tests should be carried out.

Genetic screening is defined as the "search in a pop-

ulation for persons possessing certain genotypes that (1) are already associated with disease or predisposition to disease, or (2) may lead to disease in their descendants" (National Academy of Sciences, 1975). Newborn screening for inherited metabolic diseases is a good example of the first type of genetic screening, and heterozygote detection for Tay-Sachs disease (discussed later) exemplifies the second. While these two examples involve screening of populations, genetic screening can also be applied to members of families that have a positive history of a genetic condition. An example would be testing for a balanced reciprocal translocation in families in which one or more members have had a chromosome disorder (see Chapter 6). Box 13-1 lists the various types of genetic screening, including several forms of prenatal diagnosis, that are discussed in this chapter.

The goal of screening is early recognition of a disorder so that intervention will prevent or reverse the disease process (as in newborn screening for inborn errors of metabolism) or so that informed reproductive decisions can be made (as in screening for heterozygous carriers of an autosomal recessive mutation). A positive result from a genetic screening test is typically followed by a more precise diagnostic test.

Principles of Screening

The basic principles of screening were developed in the 1960s and are still widely applied. The following points should be considered when deciding whether population screening is appropriate:

1. *Disease characteristics.* The condition should be serious and relatively common. This ensures that the benefits to be derived from the screening program will justify its costs. The natural history of the disease should be clearly understood. There should be an acceptable and effective treatment, or, in the case of some genetic conditions, prenatal diagnosis should be available.

Types of Genetic Screening and Prcnatal Diagnosis

- I. Population screening of genetic disorders
 - A. Newborn screening
 - 1. Blood
 - a. PKU, all 50 states in the United States
 - b. Galactosemia, all 50 states in the United States
 - c. Hypothyroidism, all 50 states in the United States
 - d. Hemoglobinopathies, nearly all states
 - e. Other: maple syrup urine disease, homocystinuria, tyrosinemia, and several other diseases are screened in some states
 - 2. Urine: aminoacidopathies
 - B. Heterozygote screening
 - 1. Tay-Sachs disease, Ashkenazi Jewish population
 - 2. Sickle cell disease, African-American population
 - 3. Thalassemias, at-risk ethnic groups
 - 4. Cystic fibrosis in some populations
- II. Prenatal diagnosis of genetic disorders
- A. Diagnostic testing (invasive prenatal diagnosis)
 - 1. Amniocentesis
 - 2. Chorionic villus sampling

- 3. Percutaneous umbilical blood sampling (PUBS)
- 4. Preimplantation diagnosis
- B. Fetal visualization techniques
 - 1. Ultrasonography
 - 2. Radiography
 - 3. Magnetic resonance imaging
- C. Population screening
 - 1. Maternal age greater than 35 years
 - 2. Family history of condition diagnosable by prenatal techniques
 - 3. Triple screen: maternal serum α-fetoprotein, estriol, human chorionic gonadotropin
- III. Family screening of genetic disorders
 - A. Family history of chromosomal rearrangement (e.g., translocation)
 - B. Screening female relatives in an X-linked pedigree (e.g., Duchenne muscular dystrophy, fragile X syndrome)
 - C. Heterozygote screening within at-risk families (e.g., cystic fibrosis)
 - D. Presymptomatic screening (e.g., Huntington disease, breast cancer, colon cancer)
- 2. *Test characteristics.* The screening test should be acceptable to the population, easy to perform, and relatively inexpensive. The screening test should be valid and reliable.
- 3. *System characteristics.* The resources for diagnosis and treatment of the disorder must be accessible. A strategy for communicating results efficiently and effectively must be in place.

As summarized in Clinical Commentary 13-1, the phenylketonuria (PKU) screening program meets these criteria quite well.

Screening programs typically use tests that are widely applicable and inexpensive in order to identify an at-risk population. Members of this population are then targeted for subsequent tests that are more accurate but also more expensive and time-consuming. In this context, the validity of a screening test deserves emphasis. Validity refers to the ability of a test to separate individuals who have the disease from those who do not. It involves two components: sensitivity and specificity. Sensitivity is defined as the ability to correctly identify those with the disease. It is measured as the proportion of affected individuals in whom the test is positive (i.e., true positives). **Specificity** is the ability to correctly identify those *with*out the disease. It is measured as the proportion of unaffected individuals in whom the test is negative (i.e., true negatives). Sensitivity and specificity are determined by comparing the screening results with those of a definitive diagnostic test (Table 13-1).

Screening tests are seldom, if ever, 100% sensitive and 100% specific. This is because the range of test values in the disease population overlaps that of the unaffected population (Fig. 13-1). Thus, a screening test (as opposed to the definitive follow-up diagnostic test) will diagnose some members of the population incorrectly. Usually a cutoff value for separating the diseased and non-diseased portions of the population is designated. A balance exists between the impact of nondetection or low sensitivity (i.e., an increased **false-negative rate**) and that of low specificity (an increased **false-positive rate**). If the penalty for missing affected individuals is high (as in untreated PKU), then the cutoff level is lowered so that nearly all disease cases will be detected (higher sensitivity). This also lowers the specificity, increasing the

TABLE 13.1 Definitions of Sensitivity and Specificity*			
Result of screening test	Actual disease state		
	Affected	Unaffected	
Test positive (+)	a (true positives)	b (false positives)	
Test negative (-)	c (false negatives)	d (true negatives)	

*a, b, c, and d represent the number of individuals in a population who were found to have the disease and test result combinations shown. The test sensitivity = a/(a+c); specificity = d/(b+d); positive predictive value = a/(a+b); and negative predictive value = d/(c+d).

279

CLINICAL COMMENTARY 13.1

Neonatal Screening for Phenylketonuria

DISEASE CHARACTERISTICS

Population screening of newborns for PKU represents the best example of the application of the screening model to genetic disease. As discussed in Chapter 4, the prevalence of this autosomal recessive disorder of phenylalanine metabolism is about 1 in 10,000 to 15,000 Caucasian births. The natural history of PKU is well understood. More than 95% of untreated PKU patients become moderately to severely mentally retarded. The condition is not identified clinically in the first year of life, because the physical signs are subtle and PKU usually manifests only as developmental delay. Dietary restriction of phenylalanine, when begun before 4 weeks of age, is highly effective in altering the course of the disease. A low-phenylalanine diet, while not particularly palatable, largely eliminates the IQ loss that would otherwise occur (an important exception is those who have a defect in biopterin metabolism, in whom a different therapy is used).

TEST CHARACTERISTICS

PKU is detected by the measurement of blood phenylalanine using a bacterial inhibition assay, the Guthrie test. Blood is collected in the newborn period, usually by heel stick, and placed on filter paper. The dried blood is placed on an agar plate and incubated with a bacterial strain (*Bacillus subtilis*) that requires phenylalanine for growth. Measurement of bacterial growth permits quantification of the amount of phenylalanine in the blood sample. Positive test results are usually repeated and followed by a quantitative assay of plasma phenylalanine and tyrosine.

If the test is performed after 2 days of age and after regular feeding on a protein diet, the detection rate (sensitivity) is about 98%. If it is performed at less than 24 hours of age, the sensitivity is about 84%. Thus, early discharge from the nursery requires a repeat test a few weeks after birth. Specificity is close to 100%.

SYSTEM CHARACTERISTICS

Because of the requirement of normal protein in the diet, many states request rescreening at 2 to 4 weeks of age. At that point, sensitivity approaches 100%. Because of the impact of a misdiagnosis, a high sensitivity level is desirable.

Phenylalanine levels in children with classical PKU typically exceed 20 mg/dl. For every 20 positive PKU screening results, only one infant will have classical PKU. The others represent either false-positive findings (usually due to a transient reversible tyrosinemia) or infants with a form of hyperphenylalaninemia (elevated phenylalanine) not caused by classical PKU.

The cost of a Guthrie test is typically less than a few dollars. Several studies have shown that the cost of nationwide PKU screening is significantly less than the savings it achieves by avoiding institutionalization costs and lost productivity.

FIGURE 13.1 The distribution of creatine kinase (CK) in normal women and in women who are heterozygous carriers for a mutation in the Duchenne muscular dystrophy gene. Note the overlap in distribution between the two groups: about two thirds of carriers have CK levels that exceed the 95th percentile in normal women. If the 95th percentile is used as a cutoff to identify carriers, then the sensitivity of the test is 67% (i.e., two thirds of carriers will be detected), and the specificity is 95% (i.e., 95% of normal women will be correctly identified).

number of individuals with false-positive results who are targeted for subsequent diagnosis. If confirmation of a positive test is expensive and/or hazardous, then falsepositive rates are minimized (i.e., the cutoff level is increased, producing high specificity at the expense of sensitivity).

The basic elements of a test's validity include its sensitivity (proportion of true positives detected) and specificity (proportion of true negatives detected). When sensitivity is increased, specificity decreases, and vice versa.

A primary concern in the clinical setting is the accuracy of a positive screening test. One needs to know the proportion of persons with a positive test result who truly have the disease in question (i.e., a/(a+b) in Table 13-1). This quantity is defined as the **positive predictive value**. It is also useful to know the **negative predictive value**, which is the proportion of persons with a negative result who truly do not have the disease (d/(c+d)).

The concepts of sensitivity, specificity, and positive predictive value can be illustrated by an example. Congenital adrenal hyperplasia (CAH) due to a deficiency of 21 hydroxylase is an inborn error of steroid biosynthesis that may produce ambiguous genitalia in females and adrenal crises in males and females. The screening test, a 17-hydroxyprogesterone assay, has a sensitivity of about 95% and a specificity of 99% (Table 13-2). The prevalence of CAH is about 1/10,000 in most Caucasian populations but rises to about 1/400 in the Yupik Native Alaskan population. www

Let us assume that a screening program for CAH has been developed in both of these populations. In a population of 500,000 Caucasians, the false-positive rate (1 specificity) is 1%. Thus, about 5,000 unaffected individuals will have a positive test. With 95% sensitivity, 47 of the 50 Caucasian individuals who have CAH will be detected through a positive test. Note that the great majority of people who have a positive test result would

TABLE 13.2 Hypothetical Results of Screening for Congenital Adrenal Hyperplasia (CAH) in a Low-Prevalence Caucasian Population and in a High-Prevalence Yupik Population*				
Result of screening test	CAH present	CAH absent		
Positive Caucasian	47	5,000		
Yupik	24	100		

Negative Caucasian 3 494,950 Yupik 1 9,875

*Caucasian positive predictive value = $47/(47 + 5,000) \approx 1\%$; Yupik positive predictive value = $24/(24 + 100) \approx 19\%$.

not have CAH: the positive predictive value is 47/(47 + 5,000), or less than 1%. Now suppose that 10,000 members of the Yupik population are screened for CAH. As Table 13-2 shows, 24 of 25 individuals with CAH will test positive, and 100 individuals without CAH will also test positive. Here, the positive predictive value is much higher than in the Caucasian population: 24/(24 + 100) = 19%. This example illustrates an important principle: *For a given level of sensitivity and specificity, the positive predictive value of a test increases as the prevalence of the disease increases.*

The positive predictive value of a screening test is defined as the proportion of positive tests that are true positives. It increases as the prevalence of the target disorder increases.

Newborn Screening

Newborn screening programs represent an ideal opportunity for presymptomatic detection and prevention of genetic disease. At present, all states in the United States screen newborns for PKU, galactosemia (see Chapter 7), and hypothyroidism. All of these conditions fulfill the previously stated criteria for population screening. Each is a disorder in which the individual is at significant risk for mental retardation, which can be prevented by early detection and effective intervention.

In recent years, most states of the United States and many other nations have instituted screening programs to identify neonates with hemoglobin disorders (e.g., sickle cell disease). These programs are justified by the fact that up to 15% of children with sickle cell disease will die from infections before 5 years of age (see Chapter 3). Effective treatment, in the form of prophylactic antibiotics, is available.

Some communities have begun screening for Duchenne muscular dystrophy by measuring creatine kinase levels in newborns. The objective is not presymptomatic treatment; rather it is identification of families who should receive genetic counseling in order to make informed reproductive decisions. Conditions for which newborn screening is commonly performed are summarized in Table 13-3.

Newborn screening is an effective public health strategy for treatable disorders such as PKU, hypothyroidism, galactosemia, and sickle cell disease.

Heterozygote Screening

The aforementioned principles of population screening can be applied to the detection of unaffected carriers of disease-causing mutations. The target population is a group known to be at risk. The "intervention" consists of the presentation of risk figures and options such as

Disease	Inheritance	Prevalence	Screening test	Treatment
Phenylketonuria	Autosomal recessive	1/10,000-1/15,000	Guthrie test	Dietary restriction of phenylalanine
Galactosemia	Autosomal recessive	1/50,000-1/100,000	Transferase assay	Dietary restriction of galactose
Congenital hypothyroidism	Usually sporadic	1/5,000	Measurement of thyroxine (T_4) or thyroid stimulating hormone	Hormone replacement
Sickle cell disease	Autosomal recessive	1/400–1/600 African-Americans	Isoelectric focusing or DNA diagnosis	Prophylactic penicillin

TABLE 13.3	Characteristics of Selected Newborn Screening Program	S
-------------------	---	---

Adapted from American Academy of Pediatrics Committee on Genetics (1996) Newborn Screening Fact Sheets. Pediatrics 98:473-501.

prenatal diagnosis. Genetic diseases amenable to heterozygote screening are typically autosomal recessive disorders for which prenatal diagnosis and genetic counseling are available, feasible, and accurate.

An example of a highly successful heterozygote screening effort is the Tay-Sachs screening program in North America. Infantile Tay-Sachs disease is an autosomal recessive lysosomal storage disorder in which the lysosomal enzyme β -hexosaminidase A (HEX A) is deficient (see Chapter 7), causing a buildup of the substrate, GM₂ ganglioside, in neuronal lysosomes. The accumulation of this substrate damages the neurons and leads to blindness, seizures, hypotonia, and death by about 5 years of age. www

Tay-Sachs disease is especially common among Ashkenazi Jews, with a heterozygote frequency of about 1 in 30. Thus, this population is a reasonable candidate for heterozygote screening. Accurate carrier testing is available (assays for HEX A or, in some populations, direct testing for mutations). Because the disease is uniformly fatal, options such as pregnancy termination or artificial insemination by non-carrier donors are acceptable to most couples. A well-planned effort was made to educate members of the target population about risks, testing, and available options. As a result of screening, the number of Tay-Sachs disease births in the United States and Canada declined by 90%, from 40 to 50 per year before 1970 to 3 to 5 per year in the 1990s.

β-Thalassemia major, another serious autosomal recessive disorder, is especially common among many Mediterranean and South Asian populations (see Chapter 3). Effective carrier screening programs have produced a 75% decrease in the prevalence of newborns with this disorder in Greece, Cyprus, and Italy.

Cystic fibrosis is another autosomal recessive disorder for which carrier screening is possible. However, the relative costs and benefits of such a screening program are less clear-cut than those of Tay-Sachs disease (Clinical Commentary 13-2). Table 13-4 presents a list of selected conditions for which heterozygote screening programs have been developed in industrial countries.

In addition to the criteria for establishing a population

screening program for genetic disorders, guidelines have been developed regarding the ethical and legal aspects of heterozygote screening programs. These are summarized in Box 13-2.

Heterozygote screening consists of testing (at the phenotype or genotype level) a target population to identify unaffected carriers of a disease gene. The carriers can then be given information about risks and reproductive options.

Presymptomatic Diagnosis

With the development of genetic diagnosis through linkage analysis and direct mutation detection, presymptomatic diagnosis has become feasible for some genetic diseases. Individuals who are known to be at risk for a disorder can be tested to determine whether they have inherited a disease-causing mutation before they develop clinical symptoms of the disorder. Presymptomatic diagnosis is available, for example, for Huntington disease, adult polycystic kidney disease, hemochromatosis, and autosomal dominant breast cancer. By informing individuals that they do or do not carry a disease-causing mutation, presymptomatic diagnosis can aid in making reproductive decisions. It can provide reassurance to those who learn that they do not carry a disease-causing mutation. In some cases, early diagnosis may improve health supervision. For example, persons who inherit an autosomal dominant breast cancer mutation can undergo mammography at an earlier age to increase the chances of early tumor detection. Individuals at risk for the inheritance of RET mutations (see Chapter 11), who are highly likely to develop multiple endocrine neoplasia type 2 (MEN2), can undergo a prophylactic thyroidectomy to reduce their chances of developing a malignancy. Those who inherit mutations that cause some forms of familial colon cancer (adenomatous polyposis coli [APC] and hereditary nonpolyposis colorectal cancer [HNPCC]; see Chapter 11) can also benefit from early diagnosis and treatment.

Because most genetic diseases are relatively un-

CIINICAL COMMENTARY 13.2 Population Screening for Cystic Fibrosis

There are now more than 1,000 known mutations at the CFTR locus that cause cystic fibrosis (CF). Clearly, it would be technologically impractical to test for all of them in a population carrier screening program. However, among the mutations that can cause CF in Caucasians, about 70% are the three-base deletion termed AF508 (see Chapter 4). Carrier screening using PCR-based detection of this mutation alone would detect approximately 90% of Caucasian couples in which one or both members of the couple are heterozygous carriers of this mutation $(1 - 0.30^2)$, where 0.30^2 represents the frequency of carrier couples in which neither member of the couple carries the Δ F508 mutation). It is now recommended to test simultaneously for 25 of the most common CFTR mutations. This will detect approximately 85% of CFTR mutations in North American Caucasians (because mutation frequencies vary among populations, this figure may be lower in other populations). Among Caucasians, 98% of those couples in which one or both members carry a CF mutation would be recognized (i.e., $1 - 0.15^2$), yielding a high level of sensitivity.

These carriers would define a subset of the population

in which prenatal diagnosis for CF might be offered. Given the CF heterozygote frequency of about 1/25 (see Chapter 4), only about 1 in every 600 couples would consist of two heterozygotes (1/25²). Only some of these couples would produce a child affected with CF. Considering the cost of these tests and the large number of tests required to identify one affected fetus, it has been estimated that the cost of identifying a single affected fetus through carrier screening would be about \$1,000,000. Moreover, an enormous amount of counseling time would be required to explain the complexities of these results to the at-risk families identified by screening. In this context, it is noteworthy that one study of the parents of children with CF showed that only 64% could accurately state the recurrence risk for their future children.

For these reasons, the professional community does not recommend general population screening for CF. Carrier screening is appropriate for individuals with a positive family history of CF and for couples in which one member is a known carrier. Screening for couples who are planning a pregnancy has been recommended by some bodies (see, for example, National Institutes of Health, 1997).

Disease	Ethnic group	Carrier frequency	At-risk couple frequency	Disease incidence in newborns
Sickle cell disease	African-Americans	1/12	1/150	1/600
Tay-Sachs disease	Ashkenazi Jews	1/30	1/900	1/3,600
β-Thalassemia	Greeks, Italians	1/30	1/900	1/3,600
α-Thalassemia	Southeast Asians, Chinese	1/25	1/625	1/2,500
Cystic fibrosis	Northern Europeans	1/25	1/625	1/2,500
Phenylketonuria	Northern Europeans	1/50	1/2,500	1/10,000

Modified from McGinniss MJ, Kaback MM (2002) Carrier screening. In: Rimoin DL, Conner JM, Pyeritz RE, Korf BR (eds) Emery and Rimoin's Principles and Practice of Medical Genetics, 4th ed. Churchill Livingstone, New York, pp 752–762.

BOX 13.2

Public Policy Guidelines for Heterozygote Screening

Recommended guidelines:

- 1. Screening should be voluntary, and confidentiality must be ensured.
- 2. Screening requires informed consent.
- Providers of screening services have an obligation to ensure that adequate education and counseling are included in the program.
- 4. Quality control of all aspects of the laboratory testing, including systematic proficiency testing, is required and should be implemented as soon as possible.
- 5. There should be equal access to testing.

From Elias S, Annas GJ, Simpson JL (1991) Carrier screening for cystic fibrosis: implications for obstetric and gynecologic practice. Am J Obstet Gynecol 164:1077-1083.

common in the general population, universal presymptomatic screening is currently impractical. It is usually recommended only for individuals who are known to be at risk for the disease, generally because of a positive family history.

Genetic testing can sometimes be performed to identify individuals who have inherited a disease-causing gene before they develop symptoms. This is termed "presymptomatic diagnosis."

Psychosocial Implications of Genetic Screening and Diagnosis

Screening for genetic diseases has many social and psychological implications. The burden of anxiety, cost, and potential stigmatization surrounding a positive test result must be weighed against the need for detection. Often, screening tests are misperceived as diagnostically definitive. The concept that a positive screening test does not necessarily indicate disease presence must be emphasized to those who undergo screening (see Box 13-2).

The initial screening programs for sickle cell carrier status in the 1970s were plagued by misunderstandings about the implications of carrier status. Occasionally, carrier detection led to cancellation of health insurance or employer discrimination. Such experiences underscore the need for effective genetic counseling and public education. Other issues include the right to choose *not* to be tested and the potential for invasion of privacy.

The social, psychological, and ethical aspects of genetic screening will become more complicated as newer techniques of DNA diagnosis become more accessible. For example, even though presymptomatic diagnosis of Huntington disease is available, a 10-year British study showed that only 20% of at-risk individuals elected this option. Largely, this reflects the fact that no effective treatment is presently available for this disorder. Presymptomatic diagnosis of BRCA1 and BRCA2 carrier status in breast/ovarian cancer families has also met with mixed responses. In part, this is a reaction to the cost of the test: because of the large number of different mutations in BRCA1 or BRCA2 that may cause breast cancer, testing typically consists of sequencing all exons of both genes, as well as some intronic nucleotides near each exon. This is an expensive procedure. Another concern is that periodic mammography, which may be indicated for gene carriers, will detect a tumor but not prevent it. Furthermore, it has been suggested that the radiation from mammography could induce a somatic second hit, leading to tumor formation. Preventive measures such as prophylactic mastectomy and oophorectomy (removal of the breasts and ovaries, respectively) are known to reduce cancer risk substantially, but they do not completely eliminate it.

For some genetic diseases, such as autosomal dominant colon cancer syndromes or hemochromatosis, early diag-

nosis can lead to improved survival because effective preventive treatments are readily available (polypectomy or colectomy for precancerous colon polyps; phlebotomy to reduce iron levels in hemochromatosis). In addition, many at-risk individuals will find that they do not carry the disease-causing gene, allowing them to avoid unpleasant (and possibly hazardous) diagnostic procedures such as colonoscopy or mammography. However, as screening for such diseases becomes more common, the issues of privacy and confidentiality and the need for accurate communication of risk information must also be addressed.

MOLECULAR TOOLS FOR SCREENING AND DIAGNOSIS

Until recently, genetic screening usually relied on assays of the disease phenotype, such as a β -hexosaminidase assay for Tay-Sachs disease or a creatine kinase assay for Duchenne muscular dystrophy. Advances in DNA technology have led to diagnosis at the level of the genotype. In some cases linkage analysis can determine whether an individual has inherited a disease gene, and in other cases direct assays of disease-causing mutations have been developed. Genetic diagnosis at the DNA level is now supplementing, and in some cases supplanting, screening tests based on phenotypic assays.

Linkage analysis and/or direct mutation diagnosis have been used for diagnostic testing within families, for prenatal diagnosis of genetic disorders, and, more recently, in population screening. Improved technology and an increased demand for testing have led to the establishment of clinical molecular laboratories in many medical centers in North America and Europe.

Linkage Analysis

DNA polymorphisms (restriction fragment length polymorphisms [RFLPs], variable number of tandem repeats [VNTRs], and, most commonly, short tandem repeat polymorphisms) can be used as markers in linkage analysis, as described in Chapter 8. Once linkage phase is established in a family, the marker locus can be assayed to determine whether an at-risk individual has inherited a chromosome (or, more precisely, a chromosome segment) containing a disease gene or one containing a normal gene (Fig. 13-2). Because this approach uses linked markers but does not involve direct examination of the diseasecausing mutations, it is a form of **indirect diagnosis**.

Linkage analysis has been employed successfully in diagnosing many of the genetic diseases discussed in this text. In principle, it can be used to diagnose any mapped genetic disease. It has the advantages that the disease gene and its product need not be known. The marker simply tells us whether or not the at-risk individual has inherited the chromosome region that contains a diseasecausing mutation.

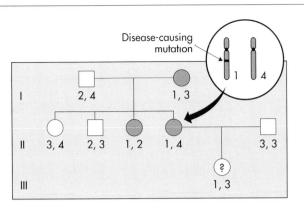

FIGURE 13.2 In this pedigree for autosomal dominant breast cancer, the analysis of a closely linked marker on chromosome 17 shows that the mutation is on the same chromosome as marker allele 1 in the affected mother in generation II. This indicates that the daughter in generation III has inherited the mutation-bearing chromosome from her mother and is highly likely to develop a breast tumor.

The disadvantages of this approach are that (1) multiple family members must be tested in order to establish linkage phase; (2) not all markers are informative (sufficiently heterozygous) in all families (see Chapter 8 for a discussion of uninformative families); and (3) recombination may occur between the marker and the disease-causing mutation, introducing a source of diagnostic error.

As discussed in Chapter 8, the highly polymorphic microsatellite loci greatly increase the likelihood that a marker will be informative in a family. Informativeness can also be increased by using multiple marker polymorphisms, all of which are closely linked to the disease locus. The use of markers flanking both sides of the disease locus can alert the investigator to a recombination.

Linkage analysis, a form of indirect genetic diagnosis, uses linked markers to determine whether an individual has inherited a chromosome containing a disease gene from his or her parent. The need for typing of multiple family members and the possibilities of recombination and uninformative matings are disadvantages of this approach.

Direct Mutation Analysis

Sometimes the mutation causing a disease happens to alter a recognition sequence for a restriction enzyme. In this case the mutation itself creates a restriction site polymorphism that can be detected after digestion with this enzyme. An example is given by the sickle cell disease mutation, which alters an MstII recognition site in the βglobin gene (see Fig. 3-16 in Chapter 3). Because the resulting RFLP reflects the disease-causing mutation directly, RFLP analysis in this context is an example of direct diagnosis of the disease. Direct diagnosis has the advantages that family information is not needed (the mutation is viewed directly in each individual), uninformative matings are not a problem, and there is no error resulting from recombination. (Table 13-5 summarizes the advantages and disadvantages of direct and indirect diagnosis.) The primary disadvantage of using RFLPs for direct diagnosis is that only about 5% of disease-causing mutations happen to affect known restriction sites.

Direct genetic diagnosis is accomplished by typing the diseasecausing mutation itself. It is potentially more accurate than indirect diagnosis and does not require family information. RFLP techniques can be used for direct diagnosis if the mutation affects a restriction site.

Allele-Specific Oligonucleotides

If the DNA sequence surrounding a mutation is known, an oligonucleotide probe can be synthesized that will hybridize (undergo complementary base pairing) only to the mutated sequence (such probes are often termed **allele-specific oligonucleotides**, or ASOs). A second probe that will hybridize to the normal DNA sequence is also synthesized. Stringent hybridization conditions are used so that a one-base mismatch will prevent hybridization. DNA from individuals who are homozygous for the mutated sequence, whereas DNA from individuals homozygous for the normal sequence hybridizes with the normal ASO. DNA from heterozygotes hybridizes with both probes (Fig. 13-3). The length of the ASO probes,

Attribute	Indirect diagnosis	Direct diagnosis	
Family information needed	Yes	No	
Errors possible because of recombination	Yes	No	
Markers may be uninformative	Yes	No	
Single test can uncover multiple mutations	Yes	No	
Disease-causing mutation must be known	No	Yes	

Normal

FIGURE 13.3 Hybridization of allele-specific oligonucleotide (ASO) probes corresponding to normal DNA sequence and a mutation (R117H) that can produce cystic fibrosis. In this "dot blot," the DNA from individuals A and B hybridizes only to the normal sequence; they are normal homozygotes. The DNA from individual C hybridizes to both ASO probes, so individual C is a heterozygous carrier.

(Courtesy of Lesa Nelson and Dr. Kenneth Ward, University of Utah Health Sciences Center.)

R117H

usually about 18 to 20 nucleotides, is critical. Probes of shorter length would not be unique in the genome and would therefore hybridize to multiple regions. Longer probes are more difficult to synthesize correctly and could hybridize to both the normal and the mutated sequence.

The ASO method of direct diagnosis has the same advantages that were listed for direct diagnosis using RFLPs. It has the additional advantage that it is not limited to mutations that cause alterations in restriction sites. However, it does require that at least part of the disease gene has been cloned and sequenced. In addition, each disease-causing mutation requires a different oligonucleotide probe. For this reason, this approach, while powerful, is impractical unless a disease is caused by a limited number of relatively common mutations.

Direct diagnosis can be performed by hybridization of an individual's DNA with allele-specific oligonucleotide probes. This approach is feasible if the DNA sequence causing a genetic disease is known and if the number of disease-causing mutations is limited.

Examples of diseases caused by a limited number of mutations include sickle cell disease and α_1 -antitrypsin deficiency (Clinical Commentary 13-3). Although more than 1,000 cystic fibrosis mutations have been identified, 25 of the most common ones account for the great majority of mutations in many populations (see Clinical Commentary 13-2). Thus, direct diagnosis can be used to

identify most cystic fibrosis homozygotes and heterozygous carriers. Prenatal diagnosis is also possible. Direct diagnosis, using polymerase chain reaction (PCR) or Southern blotting, can also be used to detect deletions or duplications (e.g., those of the dystrophin gene that cause most cases of Duchenne muscular dystrophy). Currently, genetic testing is clinically available for more than 450 genetic diseases, including almost all of the single-gene conditions discussed in this textbook. Despite this wide availability, it should be kept in mind that genetic testing, like all testing procedures, has a number of limitations (Box 13-3).

Other Methods of Direct Diagnosis

The ASO method, often implemented as a "dot blot" (see Fig. 13-3), is commonly used in direct mutation detection. Many other techniques can also be used for mutation detection, including several discussed in Chapter 3 (e.g., direct sequencing, single-strand conformation polymorphism [SSCP], denaturing gradient gel electrophoresis [DGGE], mismatch cleavage analysis). One of the most promising new methods for large-scale mutation detection is the use of microarrays ("DNA chips"), also discussed in Chapter 3. Microarrays have many convenient properties, including miniaturization and automated computerized processing. They can be designed to test large numbers of disease-causing mutations in a single, rapid analysis. In one application, the entire 16.6-kb sequence of the mitochondrial DNA genome was analyzed for polymor-

CLINICAL COMMENTARY 1.3.3 The Genetic Diagnosis of α_1 -Antitrypsin Deficiency

An inherited deficiency of α_1 -antitrypsin (α_1 -AT) is one of the most common autosomal recessive disorders among Caucasians, affecting approximately 1 in 2,500. α_1 -AT, synthesized primarily in the liver, is a serine protease inhibitor. It does bind trypsin, as its name suggests. However, α_1 -AT binds much more strongly to neutrophil elastase, a protease that is produced by neutrophils (a type of leukocyte) in response to infections and irritants. It carries out its binding and inhibitory role primarily in the lower respiratory tract, where it prevents elastase from digesting the alveolar septa of the lung. www

Individuals with less than 10% to 15% of the normal level of α_1 -AT activity experience significant lung damage and typically develop emphysema during their 30s, 40s, or 50s. In addition, at least 10% develop liver cirrhosis as a result of the accumulation of variant α_1 -AT molecules in the liver; α_1 -AT deficiency accounts for almost 20% of all nonalcoholic liver cirrhosis in the United States. An important feature of this disease is that cigarette smokers with α_1 -AT deficiency develop emphysema much earlier than do nonsmokers. This is because cigarette smoke irritates lung tissue, increasing secretion of neutrophil elastase. At the same time, it inactivates α_1 -AT, so there is also less inhibition of elastase. One study showed that the median age of death of nonsmokers with α_1 -AT deficiency was 62 years, whereas it was only 40 years for

smokers with this disease. The combination of cigarette smoking (an environmental factor) and an α_1 -AT mutation (a genetic factor) produces more severe disease than either factor alone; thus, this is an example of a **gene-environment interaction**.

The α_1 -AT gene has been localized to chromosome 14q32, and it has been cloned and sequenced. While there are more than 75 known α_1 -AT mutations, the only common one with clinically significant effects is a missense mutation in exon 5 that produces an allele known as "Z." The gene frequency of the Z allele is as high as 0.02 in Scandinavia and decreases to less than 0.01 in Southern European populations. It is virtually absent in Japanese and Chinese populations. Because it is the result of a single base-pair substitution, the Z mutation can be diagnosed directly by using ASO probes. Typically, PCR is used to amplify the individual's DNA from this region of the gene, and the amplified DNA is blotted onto a membrane. The amplified DNA is hybridized with an ASO probe that has a DNA sequence corresponding to the mutation and a second ASO probe that has the normal DNA sequence. This permits direct determination of the individual's genotype; those who are homozygous for the Z allele have a substantial risk of developing emphysema. Thus, rapid, direct genetic testing is possible for this important and common genetic disease.

phic variation by placing 135,000 different 16-bp oligonucleotide probes on a single chip. Mitochondrial DNA from study subjects was then hybridized with the probes on the chip to test simultaneously for 180 distinct polymorphisms.

Mass spectrometry, a method commonly used in chemistry, is also being explored as a means of rapid mutation detection. This technique detects minute differences in the mass of PCR-amplified DNA molecules. These differences represent variations in DNA sequence. Mass spectrometry, which offers the advantages of high speed and great accuracy, has been used, for example, to detect mutations in the CFTR and apolipoprotein E genes.

Another form of mass spectrometry, termed **tandem mass spectrometry**, is being used increasingly to screen newborns for protein variants that signal amino acid disorders (e.g., PKU, tyrosinemia, homocystinuria), organic acid disorders, and fatty acid oxidation disorders (e.g., MCAD and LCHAD deficiencies; see Chapter 7). This method begins with a sample of material from a dried blood spot, which is subjected to analysis by two mass spectrometers. The first spectrometer separates ionized molecules according to their mass, and the molecules are fragmented. The second spectrometer assesses the mass and charge of these fragments, allowing a computer to generate a molecular profile of the sample. Tandem mass spectrometry is highly accurate and very rapid: more than two dozen disorders can be screened in approximately 2 minutes.

New methods of direct mutation detection, including the use of microarrays and mass spectrometry, promise to increase the speed and accuracy of genetic diagnosis. Tandem mass spectrometry can be used to test for protein variants that are characteristic of a number of newborn disorders and is thus a useful screening tool.

Limitations of Genetic Testing

Although genetic testing offers many advantages, its limitations must also be borne in mind. These limitations can be summarized as follows:

- 1. No genetic test is 100% accurate. Although most genetic tests do achieve a high level of accuracy, factors such as mosaicism can complicate cytogenetic diagnosis, and genotyping errors can occur in the diagnosis of single-gene disorders.
- 2. Genetic tests reveal mutations, not the presence of disease. This reflects the fact that many disease-causing mutations have incomplete penetrance. For example, approximately 50% to 80% of women with *BRCA1* or *BRCA2* mutations develop breast cancer, and 70% to 90% of individuals with mutations in one of the HNPCC genes develop colorectal cancer. Even when penetrance approaches 100% (as in neurofibromatosis type 1 or Huntington disease), detection of the mutation typically reveals little about the severity or age of onset of the disease.
- 3. Genetic testing may not detect all of the mutations that can cause a disease. Even in the absence of genotyping or sequencing errors, many genetic tests lack sensitivity. For example, PCR-based tests detect only about 70% of Duchenne muscular dystrophy

cases, requiring creatine kinase assays or muscle biopsies (see Chapter 5) as follow-up or alternative procedures. When a large number of different mutations can produce a genetic disease (e.g., cystic fibrosis, autosomal dominant breast cancer, Marfan syndrome), it may not be practical to test for all possible mutations. In this case, the analysis of linked markers may provide additional diagnostic accuracy if multiple family members are affected. Additional factors that can reduce accuracy include locus heterogeneity and phenocopies.

4. Genetic testing can lead to complex ethical and social considerations. The results of a genetic test may lead to stigmatization or to discrimination on the part of employers or insurance companies. Effective treatment is not available for some genetic diseases (e.g., Huntington disease, familial Alzheimer disease), decreasing the value of early diagnosis through genetic testing. Because genes are shared in families, the results of a genetic test may affect not only the tested individual but also other members of the family (who may not wish to know about their risk for a genetic disease). These and other ethical and social issues are discussed further in Chapter 14.

PRENATAL DIAGNOSIS OF GENETIC DISORDERS AND CONGENITAL DEFECTS

Prenatal diagnosis is a major focus of genetic diagnosis, and several important areas of technology have evolved to provide this service. The principal aim of prenatal diagnosis is to supply at-risk families with information so that they can make informed choices during pregnancy. The potential benefits of prenatal testing include (1) providing reassurance to at-risk families when the result is normal; (2) providing risk information to couples who, in the absence of such information, would not choose to begin a pregnancy; (3) allowing a couple to prepare psychologically for the birth of an affected baby; (4) helping the health care professional to plan delivery, management, and care of the infant when a fetus is diagnosed with a disease; and (5) providing risk information to couples for whom pregnancy termination is an option.

Given the controversy surrounding the issue of pregnancy termination, it should be emphasized that the great majority of prenatal diagnoses yield a normal test result. Thus, most families receive reassurance, and only a small minority must face the issue of termination.

Prenatal diagnosis includes both screening and diagnostic tests. An example of a population screening test is an assay of maternal serum α -fetoprotein (AFP) at 15

weeks' gestation. An abnormal result identifies a subgroup for further testing. **Amniocentesis** (the withdrawal of amniotic fluid during pregnancy) and **chorionic villus sampling** (CVS, the biopsy of chorionic villus tissue) represent diagnostic tests. Another example of the distinction between screening and diagnosis is given by amniocentesis for pregnancies in advanced maternal age: the selection of women 35 years of age or older is the screening strategy, and amniocentesis is the diagnostic test. Primarily because of the increased risk of trisomies with advanced maternal age (see Chapter 6), more than half of North American women older than 35 years of age currently undergo amniocentesis or CVS during pregnancy.

Prenatal diagnostic methods can be divided into two major types: (1) analysis of fetal tissues (amniocentesis, CVS, cordocentesis, and in vitro fertilization diagnosis) and (2) visualization of the fetus (ultrasonography). In this section, each of these procedures is described, and their accuracy, safety, and feasibility are discussed.

Amniocentesis

Amniocentesis is traditionally performed at 15 to 17 weeks after a pregnant woman's last menstrual period (LMP). A needle is inserted through the abdominal wall into the

BOX

13.3

FIGURE 13.4 A schematic illustration of an amniocentesis, in which 20 to 30 ml of amniotic fluid is withdrawn transabdominally (with ultrasound guidance), usually at 15 to 17 weeks' gestation.

amniotic sac after real-time ultrasound imaging localizes the placenta and determines the position of the fetus (Fig. 13-4). Between 20 and 30 ml of amniotic fluid is withdrawn; this fluid contains living cells (**amniocytes**) shed by the fetus. Standard cytogenetic studies are carried out after culture of the amniocytes to increase their number. In addition, cells can be grown for biochemical assays, fluorescence in situ hybridization (FISH), or DNA diagnosis. AFP, which is used to test for the presence of a neural tube defect (NTD; see Chapter 12), is also measured in the amniotic fluid. The results of cytogenetic studies are typically available in 10 to 12 days. Indications for prenatal diagnosis by amniocentesis are listed in Box 13-4.

The safety and accuracy of amniocentesis have been established by several large collaborative studies. The risk of maternal complications is very low. Transient fluid leakage occurs in about 1% of mothers, and maternal infections are extremely rare. The risk of primary concern is fetal loss. Amniocentesis increases the risk of fetal loss by no more than 0.5% above the background risk at 15 to 17 weeks post-LMP (i.e., if the risk of pregnancy loss after 17 weeks were 3% in mothers who did not have an amniocentesis, the risk would increase to 3.5% in those who had the procedure). One must weigh the risk of fetal loss against the probability that the fetus is affected with a diagnosable condition. For women younger than 35 years of age, the former risk usually outweighs the latter. After age 35, the risk of bearing an aneuploid fetus increases considerably, and the latter risk outweighs the former. Thus, amniocentesis is not recommended for women younger than 35 years of age unless they have a previous indication of risk for a genetic disease, such as a positive family history (Clinical Commentary 13-4).

CLINICAL COMMENTARY 13.4

The Amniocentesis Decision

During the medical care of a pregnant woman who is older than 35 years of age, a common discussion with the primary care practitioner involves the decision to undergo amniocentesis. Several factors enter into this decision. First is the age-specific risk for Down syndrome and other chromosomal disorders. A second factor is the risk of fetal loss from the procedure (about 0.5% above the background risk). A third issue is the cost of an amniocentesis with ultrasound and cytogenetic analysis, which ordinarily ranges from \$1,000 to \$2,000. These factors must be weighed in terms of their relative costs and benefits for the woman and her family.

As this decision is explored in greater depth, other considerations often arise. If a woman has had previous

miscarriages, the 0.5% risk of fetal loss may be weighed more heavily. In addition, the seriousness of bearing a child with disabilities may be perceived differently from family to family. Some couples are uncomfortable with the amount of time that elapses before test results are available (usually 10 to 12 days). Here, the possibility of CVS, which can be performed earlier and which usually yields results more rapidly, may be explored. The possibility of an ambiguous result (e.g., mosaicism) also deserves discussion. Finally, it is important for the clinician to specify that a typical amniocentesis in a woman older than 35 years of age detects only a specific class of disorders (i.e., chromosome abnormalities and neural tube defects) and not the entire range of congenital malformations and genetic disorders.

Although amniocentesis provides highly accurate results, chromosomal mosaicism can lead to misdiagnosis. Most apparent mosaicism is caused by the generation of an extra chromosome during in vitro cell culture and is labeled as pseudomosaicism. This can be distinguished easily from true mosaicism if techniques are used in which all cells in a colony are the descendants of a single fetal cell. If only some cells in the colony have the extra chromosome, it is assumed that pseudomosaicism exists. If, however, consistent aneuploidy is visualized in all cells of multiple colonies, then true fetal mosaicism is diagnosed. Further confirmation of fetal mosaicism (which is generally a rare condition) can be obtained by fetal blood sampling, as described later.

Some centers have evaluated amniocentesis performed earlier in pregnancy, at about 12 to 14 weeks post-LMP. Since less amniotic fluid is present at this time, the risk of fetal loss or injury may be higher. A number of largescale evaluations have indicated significantly higher rates of fetal loss for early amniocentesis, and some studies have shown increased rates of specific congenital anomalies (club foot in particular).

Amniocentesis, the withdrawal of amniotic fluid during pregnancy, is performed at about 16 weeks post-LMP and is used to diagnose many genetic diseases. The rate of fetal loss attributable to this procedure is approximately 1/200 above the background risk level. Amniocentesis can also be performed earlier in the pregnancy; some studies indicate an elevated rate of fetal loss after early amniocentesis.

Chorionic Villus Sampling

CVS is performed by aspirating fetal trophoblastic tissue (chorionic villi) by either a transcervical or transabdominal approach (Fig. 13-5). Since it is usually performed at 10 to 11 weeks post-LMP, CVS has the advantage of providing a diagnosis much earlier in pregnancy than second-trimester amniocentesis. This may be important for couples who consider pregnancy termination an option.

Cell culture (as in amniocentesis) and direct analysis from rapidly dividing trophoblasts can provide material for cytogenetic analysis. When chorionic villi are successfully obtained, CVS provides diagnostic results in more than 99% of cases. Confined placental mosaicism (mosaicism in the placenta but not in the fetus itself) is seen in about 1% to 2% of cases in which direct analysis of villus material is performed. This confuses the diagnosis, because the mosaicism observed in placental (villus) material is not actually present in the fetus. This problem can usually be resolved by a follow-up amniocentesis. A disadvantage of CVS is that amniotic fluid AFP cannot be measured. Women who undergo CVS may have their serum AFP level measured at 15 to 16 weeks post-LMP as a screen for NTDs.

CVS, like amniocentesis, is generally a safe procedure. Several collaborative studies revealed a post-CVS fetal loss rate of approximately 1% to 1.5% above the background rate, compared with 0.5% above background for amniocentesis. The most important factors increasing the risk of fetal loss are a lack of experience with the procedure and an increase in the number of transcervical

FIGURE 13.5 A schematic illustration of a transcervical chorionic villus sampling (CVS) procedure. With ultrasound guidance, a catheter is inserted, and several milligrams of villus tissue is aspirated.

passages used to obtain the villus sample. In experienced hands, transcervical and transabdominal procedures appear to entail similar risk levels.

Some studies have indicated that CVS may increase the risk of limb deficiencies. Although other investigations have not corroborated this result, the apparent association has been of concern because the proposed mechanism (vascular insult leading to hypoperfusion of the limb) is biologically plausible. The risk is greatest when CVS is performed earlier than 10 weeks post-LMP and decreases to no more than one in several thousand when the procedure is performed at 10 to 11 weeks post-LMP. Accordingly, many professionals now recommend against performing CVS before 10 weeks post-LMP.

CVS is performed earlier than amniocentesis (at 10 to 11 weeks post-LMP), using either a transcervical or transabdominal approach. The risk of fetal loss attributable to CVS is approximately 1% to 1.5%. Confined placental mosaicism can confuse the diagnosis. There is some evidence that CVS may increase the risk of limb deficiencies; this risk is greatest when the procedure is performed before 10 weeks post-LMP.

Inborn errors of metabolism (see Chapter 7), which are usually autosomal or X-linked recessive diseases, can be diagnosed prenatally by amniocentesis or CVS if the specific metabolic defect is expressed in amniocytes or trophoblastic tissue. Table 13-6 lists selected inborn errors of metabolism and single-gene disorders for which amniocentesis or CVS is available. A comprehensive summary of conditions that may be prenatally diagnosed is provided by Weaver (1999).

Other Methods of Fetal Tissue Sampling

Cordocentesis, or **percutaneous umbilical blood sampling** (PUBS), has become the preferred method to access fetal blood. PUBS is usually carried out after the 16th week of gestation and is accomplished by ultrasound-guided puncture of the umbilical cord and withdrawal of fetal blood. The fetal loss rate attributable to PUBS is low, but it is slightly higher than that of amniocentesis or CVS. The primary applications of PUBS are as follows:

- 1. Cytogenetic analysis of fetuses with structural anomalies detected by ultrasound when rapid diagnosis is required. Cytogenetic analysis from fetal blood sampling is completed in 2 to 3 days, while diagnosis after amniocentesis requires 10 to 12 days because of the necessity of culturing amniocytes. This time difference can be critical in the later stages of a pregnancy.
- 2. Diagnosis of hematological diseases that are analyzed most effectively in blood samples or

Disease	Measurable enzyme	
Disorders of amino acid/organic acid metabolism		
Maple syrup urine disease	Branched-chain ketoacid decarboxylase	
Methylmalonic acidemia	Methylmalonic coenzyme A mutase	
Multiple carboxylase deficiency	Biotin responsive carboxylase	
Disorders of carbohydrate metabolism		
Glycogen storage disease, type 2	α-Glucosidase	
Galactosemia	Galactose-1-uridyl transferase	
Disorders of lysosomal enzymes	·	
Gangliosidosis (all types)	β-Galactosidase	
Mucopolysaccharidosis (all types)	Disease-specific enzyme (see Chapter 7)	
Tay-Sachs disease	Hexosaminidase A	
Disorders of purine and pyrimidine metabolism		
Lesch-Nyhan syndrome	Hypoxanthine-guanine phosphoribosyl transferase	
	asposantenne gaanne phosphorioosyr transterase	
Disorders of peroxisomal metabolism Zellweger syndrome		
Zenweger syndrome	Long-chain fatty acids	

TABLE 13.6 Selected Inborn Errors of Metabolism That are Diagnosable Through Amniocentesis and/or Chorionic Villus Sampling

diagnosis of immunologic disorders such as chronic granulomatous disease (see Chapter 9).

3. Rapid distinction between true fetal mosaicism and false mosaicism caused by maternal contamination of an amniotic fluid sample.

Percutaneous umbilical blood sampling (PUBS, or cordocentesis) is a method for the direct sampling of fetal blood and is used to obtain a sample for rapid cytogenetic or hematological analysis or for confirmation of mosaicism.

Ultrasonography

Technological advances in real-time **ultrasonography** have made this an important tool in prenatal diagnosis. A transducer placed on the mother's abdomen sends pulsed sound waves through the fetus. The fetal tissue reflects the waves in patterns corresponding to tissue density. The reflected waves are displayed on a monitor, allowing real-time visualization of the fetus. Ultrasonography has become the most widely used form of fetal visualization and is useful in the detection of many fetal malformations. It also assists in the effectiveness of amniocentesis, CVS, and PUBS. Box 13-5 lists some of the congenital malformations that are diagnosable by fetal ultrasound (a more comprehensive list is provided by Weaver, 1999).

Ultrasonography is sometimes used to test for a specific condition in an at-risk fetus (e.g., a short-limb skeletal dysplasia). More often, fetal anomalies are detected during the evaluation of obstetrical indicators such as uncertain gestational age, poor fetal growth, or amniotic fluid abnormalities. Several European nations perform routine second-trimester ultrasound screening in all pregnancies. Studies of ultrasound screening suggest that sensitivity for the detection of most major congenital malformations ranges from 30% to 50%. Specificity, however, approaches 99%.

The sensitivity of ultrasonography is higher for some congenital malformations. In particular, ultrasound can detect virtually all fetuses with an encephaly and 85% to 90% of those with spina bifida (Fig. 13-6). It may also sometimes identify a fetus with a chromosome abnormality by detecting a congenital malformation, intrauterine growth retardation, hydrops (abnormal accumulation of fluid in the fetus), or an alteration of the amniotic fluid volume.

FIGURE 13.6 A, Photograph of an ultrasound result, revealing the presence of a fetus with a normal spinal column. **B**, Ultrasound result for a fetus with a meningomyelocele, visible as fluid-filled sacs (*arrow*) located toward the base of the spinal column.

Ultrasonography is by far the most common technique now used for fetal visualization, but other techniques are also used. They include radiography and occasionally magnetic resonance imaging (MRI).

Prenatal diagnosis includes invasive techniques designed to analyze fetal tissue (CVS, amniocentesis, PUBS) and noninvasive procedures that visualize the fetus (ultrasonography).

$\alpha\text{-Fetoprotein}$ Measurement in Amniotic Fluid and Maternal Serum

AFP is a fetal protein similar to albumin; it is produced initially by the yolk sac and subsequently by the liver. The AFP level normally increases in amniotic fluid until about 10 to 14 weeks' gestation and then decreases steadily. Amniotic fluid AFP is significantly higher in pregnancies in which the fetus has an NTD. When an amniotic fluid AFP assay is used with ultrasonography in the second trimester, more than 98% of fetuses with an open spina bifida and virtually all of those with anencephaly can be recognized. Among women who undergo amniocentesis for cytogenetic analysis, it is routine to also measure their amniotic fluid AFP level.

In addition to a fetal NTD, there are several other causes of elevated (or apparently elevated) amniotic fluid AFP. These include underestimation of gestational age, fetal death, presence of twins, blood contamination, and several specific malformations (e.g., omphalocele or gastroschisis, which are abdominal wall defects). Usually, targeted ultrasonography can distinguish among these alternatives.

III The amniotic α -fetoprotein level is elevated when the fetus has

a neural tube defect and provides a reliable prenatal test for this condition.

Soon after the link between elevated amniotic fluid AFP and NTDs was recognized, an association between increased levels of **maternal serum AFP** (MSAFP) and NTDs was identified. AFP diffuses across the fetal membranes into the mother's serum, so MSAFP levels are correlated with amniotic fluid AFP levels. Thus, it is possible to measure amniotic fluid AFP noninvasively by obtaining a maternal blood sample at 15 to 17 weeks post-LMP.

Because 90% to 95% of NTD births occur in the absence of a family history of the condition, a safe, noninvasive population screening procedure for NTDs is highly desirable. However, there is considerable overlap of MSAFP levels in women carrying NTD and normal fetuses (Fig. 13-7). Thus, the issues of sensitivity and specificity must be considered. Typically, an MSAFP level is considered to be elevated if it is 2 to 2.5 times higher than the normal median level (adjustments for maternal weight, presence of diabetes mellitus, and race are included in these calculations). Approximately 1% to 2% of pregnant women exhibit MSAFP levels above this cutoff level. After adjustment for advanced gestational age, fetal demise, and presence of twins, about 1 in 15 of these women will have an elevated amniotic fluid AFP. The positive predictive value of the MSAFP screening test is thus rather low, approximately 6% (1/15). However, the sensitivity of the test is fairly high: MSAFP screening will identify approximately 90% of anencephaly cases and about 80% of open spina bifida cases. Although this sensitivity level is lower than that of amniotic fluid AFP testing, MSAFP measurement poses no risk of fetal loss and serves as an effective screening measure. Women who

FIGURE 13.7 Maternal serum α -fetoprotein (MSAFP) levels in mothers carrying normal fetuses and in mothers carrying fetuses with Down syndrome and open spina bifida. MSAFP is somewhat lowered when the fetus has Down syndrome, and it is substantially elevated when the fetus has an open spina bifida.

(From Milunsky A [1998] Genetic Disorders and the Fetus: Diagnosis, Prevention, and Treatment, 4th ed. Johns Hopkins University Press, Baltimore.)

have an elevated MSAFP may choose to undergo diagnostic amniocentesis to determine whether they are in fact carrying a fetus with an NTD.

An association has also been found between *low* MSAFP and the presence of a fetus with Down syndrome. Previously, population screening for Down syndrome consisted of amniocentesis for women older than 35 years of age. This screening strategy has a population-wide detection rate (sensitivity) of only 20%, because only about 20% of all babies with trisomy 21 are born to mothers older than age 35. MSAFP measurement has expanded the option of population screening for Down syndrome.

As indicated in Fig. 13-7, MSAFP levels overlap considerably in normal and Down syndrome pregnancies. The risk for Down syndrome in women younger than 35 years of age increases by a factor of 3 to 4 when the adjusted MSAFP value is lower than 0.5 multiples of the normal population median (see Fig. 13-7). In deriving a risk estimate, complex formulas take into account the mother's weight, age, and MSAFP level. A woman who is 25 years of age ordinarily has a risk of about 1/1,250 for producing a fetus with Down syndrome, but if she has a weight-adjusted MSAFP of 0.35 multiples of the median, her risk increases to 1/171. This risk is higher than that of a 35-year-old woman in the general population. Most screening programs use a risk factor of 1/380 (equivalent to the average risk for a 35-year-old woman to produce a newborn with Down syndrome) as an indication for subsequent diagnostic evaluation by amniocentesis.

The accuracy of Down syndrome screening can be increased by measuring the serum levels of unconjugated estriol and human chorionic gonadotropin in addition to MSAFP (**triple screen**). While MSAFP alone identifies only about 40% of Down syndrome pregnancies, the three indicators together can identify approximately 70% (with a false-positive rate of 5%). The triple screen can also detect most cases of trisomy 18. The use of additional tests, including ultrasonography and measurement of inhibin A levels, can further increase sensitivity.

First-trimester maternal serum screening (at approximately 10 to 13 weeks) for Down syndrome is also being evaluated. Three of the most useful measurements are free β -human chorionic gonadotropin (F β hCG), pregnancy-associated plasma protein A (PAPP-A), and an ultrasound assessment of nuchal translucency (the latter refers to the abnormal accumulation of fluid behind the neck of a fetus with Down syndrome). Measurement of these three quantities enables detection of 80% to 85% of Down syndrome cases (with a false-positive rate of 5%) in the first trimester. Measurement of F β hCG and PAPP-A is also useful for detection of trisomy 13 and trisomy 18 in the first trimester.

MSAFP provides a screening approach that increases the prenatal detection of fetuses with various abnormalities, including NTDs, trisomy 18, and Down syndrome. This noninvasive procedure entails virtually no risk, but its sensitivity and specificity for detecting NTDs are lower than those of amniotic AFP diagnosis. Use of additional markers (e.g., the "triple screen") in the second trimester increases sensitivity for detection of Down syndrome. Screening of maternal serum for Down syndrome, trisomy 13, and trisomy 18 is also possible in the first trimester.

New Diagnostic Techniques: Preimplantation Diagnosis and Circulating Fetal Cell Diagnosis

Several new approaches to prenatal diagnosis are now in the testing or early application stages. These include preimplantation diagnosis at three different stages: polar body, blastomere, and blastocyst. Research is also being done on genetic testing of fetal DNA obtained from the mother's circulation.

The most common type of preimplantation diagnosis is carried out on a blastomere obtained in the course of in vitro fertilization. Diagnosis is begun 3 days after fertilization, when the embryo contains six or eight cells. One or two cells are removed from the embryo for diagnosis (this does not harm it). DNA from the cell can be amplified using PCR, leading to the diagnosis of singlegene diseases. Also, FISH analysis (see Chapter 6) can be used to diagnose aneuploidy. If neither the disease-causing mutation nor aneuploidy is detected, the embryo is implanted into the mother's uterus. Testing protocols have been developed for more than 30 genetic diseases (e.g., cystic fibrosis, Tay-Sachs disease, β-thalassemia, myotonic dystrophy, Huntington disease, Duchenne muscular dystrophy), and more than 250 normal babies have been born after blastomere diagnosis.

An occasional problem with this procedure is that one of the two alleles of a locus may be undetectable, which could cause a heterozygote to appear as a homozygote. This phenomenon, termed "allelic dropout," occurs because of partial PCR amplification failure when using DNA from only a single cell. Because this has led to misdiagnosis in a small number of cases, various approaches are now employed to increase accuracy. For example, highly heterozygous STRPs closely linked to the diseasecausing locus can be tested as part of the PCR analysis. If only one of the parents' STRP alleles can be observed in the blastomere's DNA, it is likely that allelic dropout has also occurred for the disease-causing locus. The testing of two cells, rather than one, helps to avoid allelic dropout.

Diagnosis can also be carried out at the 100-cell blastocyst stage, using cells from the trophoectoderm of the blastocyst. This procedure has the advantage that a larger collection of cells is analyzed, helping to avoid allelic dropout. A disadvantage is that extraembryonic tissue (the trophoectoderm) is diagnosed, rather than the embryo itself.

Polar body diagnosis involves an examination of the first or second polar body produced along with the ovum (see Chapter 2). The polar body's DNA is tested to determine whether it contains a disease-causing mutation. If it does, it is assumed that the egg does not contain the mutation. This egg is then fertilized and implanted using the usual in vitro techniques. Because only the polar body is diagnosed, paternal mutations cannot be evaluated. Polar body diagnosis is thus most useful when only the mother is at risk to transmit a disease-causing mutation or when testing for aneuploidy (because most aneuploidies are contributed by the mother [see Chapter 6]).

Preimplantation diagnosis is most commonly used by couples who have resorted to in vitro fertilization diagnosis and wish to test for diagnosable genetic conditions. It can also be useful for couples who want prenatal diagnosis but would not consider a pregnancy termination. Preimplantation diagnostic approaches, however, are costly and technically challenging, and their availability is still limited.

Preimplantation diagnosis can be carried out on polar bodies, blastomeres, or blastocyst cells, on which PCR analysis and/or FISH is performed. Diagnosis of genetic conditions permits implantation of only unaffected embryos and avoids the issue of pregnancy termination.

Diagnosis Using Fetal Cells Isolated from Maternal Blood

During pregnancy, a small number of fetal cells find their way into the mother's circulation. One such cell type is the nucleated red blood cell, which is rare in the adult circulation. These cells can be isolated as early as 6 to 8 weeks post-LMP and are identified with the use of cellsorting techniques. Further specificity for fetal cells can be achieved by testing cells for surface proteins specific to the fetus. FISH analysis of these cells has been used to test for fetal conditions such as trisomies 13, 18, and 21. PCR has been used to test for a limited number of singlegene disorders, although this remains a challenge because of the difficulty of sorting pure populations of fetal cells. The major advantage of this approach is that it requires only a blood sample from the mother and thus poses no risk for the fetus. Its accuracy and feasibility are being evaluated.

Fetal cells that enter the maternal circulation can be isolated and evaluated for mutations using PCR or FISH. This experimental procedure entails no risk of fetal loss.

FETAL TREATMENT

A goal of prenatal diagnosis is treatment of the affected fetus. Although this is not currently possible for most conditions, some examples can be cited. Many of these procedures are experimental.

Two of the best-established forms of in utero intervention are treatment for rare inborn errors of metabolism and treatment for hormone deficiencies. An important example of a treatable biochemical disorder is biotin-responsive multiple carboxylase deficiency. This autosomal recessive enzyme deficiency can be diagnosed by amniocentesis. In one case report, oral administration of biotin to the mother was initiated at 23 weeks of pregnancy and resulted in the birth of a normal baby.

Congenital adrenal hyperplasia (CAH) is a second example of a condition for which in utero treatment has been successful after prenatal diagnosis. Because of excessive androgen secretion by the enlarged fetal adrenal glands, female fetuses with CAH become masculinized. Administration of dexamethasone to the mother beginning at 10 weeks post-LMP diminishes or prevents this masculinization.

Surgical treatment of fetuses, primarily for conditions involving urinary tract obstruction, has met with moderate success. Surgical correction of diaphragmatic hernia at 20 weeks' gestation has also been attempted. Preliminary results have been discouraging, but work is continuing. Surgical closure of myelomeningocele (spina bifida) has been performed in more than 200 cases, and there is evidence that the procedure helps to restore the normal flow of cerebrospinal fluid. Some success has been achieved in transplantation of hematopoietic stem cells into fetuses with X-linked severe combined immune deficiency (see Chapter 9).

GENE THERAPY

As we have seen, the isolation and cloning of disease genes provides opportunities for improved understanding and diagnosis of genetic diseases. In addition, the possibility of genetic alteration of the cells of individuals with genetic diseases (**gene therapy**) emerges. Although gene therapy is still in its infancy and has only begun to affect the lives of patients, the potential for curing genetic diseases through recombinant DNA techniques has excited a great deal of interest in both professional and lay circles. Currently, more than 500 gene therapy protocols involving more than 6,000 patients have been approved for experimental trials (see Table 13-7 for some examples). In this section we review gene therapy techniques and discuss their application to genetic disease.

Somatic Cell Therapy

Somatic cell gene therapy, which has been the focus of gene therapy research in humans, consists of the alteration of genes in human somatic cells to treat a specific disorder. The patient's cells may be extracted and manipulated outside the body (ex vivo therapy), or in some cases the cells may be treated while they are in the body (in vivo therapy). Some types of somatic cells are more amenable to gene therapy than others. Good candidates should be easily accessible and should have a long life span in the body. Proliferating cells are preferred for some gene delivery systems, because the vector carrying the gene can then integrate into the cell's replicating DNA. The bone marrow stem cell meets all of these qualifications and thus has been a prime candidate for somatic therapy. However, these cells are difficult to manipulate and to isolate from bone marrow (the great majority of bone marrow cells are not stem cells). Consequently, many other cell types have also been investigated as potential targets, including skin fibroblasts, muscle cells, vascular endothelial cells, hepatocytes, and lymphocytes. A disadvantage of using such cells is that their life span may be relatively short. Thus, therapy using them may require repeated treatment and administration of genetically altered cells.

Gene Replacement Therapy

Most current gene therapy techniques involve the replacement of a missing gene product by inserting a normal gene into a somatic cell. This approach is best suited to the correction of loss-of-function mutations

Disease	Target cell	Product of inserted gene
Adenosine deaminase deficiency	Circulating lymphocytes, bone marrow stem cells	Adenosine deaminase
X-linked severe combined immuno- deficiency (SCID)	Bone marrow stem cells	Gamma subunit of interleukin receptors
Hemophilia B	Hepatocytes, skin fibroblasts	Factor IX
Familial hypercholesterolemia	Hepatocytes	Low-density lipoprotein receptor
Cystic fibrosis	Airway epithelial cells	Cystic fibrosis transmembrane conductance regulator (CFTR)
Malignant melanoma	Melanoma tumor cells	B7 costimulatory molecule
Duchenne muscular dystrophy	Myoblasts	Dystrophin
Gaucher disease	Macrophages	Glucocerebrosidase
Lung cancer	Lung cancer cells	Normal p53
Brain tumors	Brain cells	Herpes thymidine kinase
Acquired immunodeficiency syndrome (AIDS)	Helper T lymphocytes	Dominant negative retrovirus mutations
Ischemic heart disease	Cardiomyocytes	Vascular endothelial growth factor, fibroblast growth factor

TABLE 13.7	A Partial List of Diseases for Which Somatic Cell Gene Therapy Protocols Are Being Tested	

that result in a nonfunctional or missing gene product; the insertion of a normal gene supplies the missing prod uct. Many recessive disorders can potentially be corrected with the production of only a small quantity of the gene product. Even a partially effective gene therapy strategy, producing perhaps 5% to 20% of the normal amount of the gene product, may provide significant health benefits.

There are many techniques for introducing genes into cells, including cell fusion, calcium phosphate coprecipitation (the chemical disturbs the cell membrane, allowing negatively charged DNA to overcome the natural chemical repulsion of the negatively charged cell membrane), electroporation (the cell is electrically shocked so that foreign DNA can pass through the membrane), liposome fusion, and the direct introduction of "naked" DNA (i.e., a human DNA segment cloned into a plasmid). Because viruses have evolved clever methods for inserting their genes into cells, they have thus far received the most attention as gene therapy vectors. In the following paragraphs viral methods are discussed first, followed by a discussion of some potentially effective nonviral delivery systems.

Retroviral Vectors. As mentioned in Chapter 11, retroviruses, a form of RNA virus, are able to insert copies of their genomes into the nuclei of host cells after reverse-transcribing their viral RNA into double-stranded DNA. They integrate into the host DNA with a high degree of efficiency, and they seldom provoke immune responses, making them a reasonable choice as a gene-delivery vector (Fig. 13-8). The retrovirus must be modified so that it cannot replicate and infect the host. This is done by using recombinant DNA techniques to delete most of the retroviral genome; it is replaced by a normal copy of a human gene, its regulatory elements, and a polyadenylation signal (the human genetic material is termed the "insert"). Retroviruses are capable of accepting inserts as large as 8 kb.

These replication-defective retroviruses are propagated in **packaging cells** that compensate for the missing replicative machinery of the retrovirus. This allows the production of multiple copies of retroviruses that contain the human gene but cannot replicate themselves. The modified retroviruses are then incubated with the patient's somatic cells (e.g., bone marrow stem cells, lymphocytes), and the modified retrovirus inserts the

FIGURE 13.8 Gene therapy using a retroviral vector. The retrovirus is prevented from replicating by removal of most of its genome, a normal human gene is inserted into the retrovirus, and the retrovirus is propagated in a packaging cell. Virions from the packaging cell are incubated with human somatic cells, allowing the retrovirus to insert copies of the normal human gene into the cell. Once integrated into the cell's DNA, the inserted gene produces normal gene product.

normal human gene into the DNA of the host cell. Ideally, the inserted gene will then encode a normal gene product in the patient's somatic cells. This type of protocol has been used to treat several diseases, including forms of severe combined immune deficiency (Clinical Commentary 13-5).

Although retroviruses offer the advantages of stable and efficient integration into the genome, they also present specific disadvantages. Because it integrates randomly into the host's DNA, the retrovirus could locate near a proto-oncogene, activating it and thus causing tumor formation. Because most retroviruses can enter the nucleus only when its membrane dissolves during cell division, they can typically infect only dividing cells and are ineffective in nondividing or slowly dividing cells (e.g., neurons). While this attribute typically is a disadvantage, it can be useful when the goal of therapy is to target only dividing cells and to avoid nondividing cells (e.g., in the treatment of a brain tumor, where tumor cells are dividing but nearby healthy neurons are not).

Adenovirus Vectors. Because of the inability of most retroviruses to infect nondividing cells, other delivery systems have been explored that are not limited in this way. An important example is the **adenovirus**, a doublestranded DNA virus that is often used in vaccine preparations. The adenovirus vectors used in most clinical trials can accept an insert of approximately 8 kb. They must be made replication-defective before use in gene therapy. Because of their ability to target nondividing cells, adenoviruses are being used, for example, in trials in which the normal *CFTR* gene (see Chapter 4) is delivered by an aerosol method to epithelial cells (in vivo gene therapy). It is hoped that this treatment may increase chloride ion channel activity in cystic fibrosis patients.

Adenoviruses do not integrate into the host cell's DNA, which provides the advantage that they will not activate a proto-oncogene or otherwise disturb the genome. However, lack of integration is also a disadvantage because adenoviruses are eventually inactivated. This results in transient gene expression and the necessity for reintroduction of the vector. Also, because typically only part of the adenovirus genome is removed, the vector often provokes an immune response (e.g., inflammatory responses in the airways of cystic fibrosis patients). This problem increases with repeated introduction of the adenovirus, which stimulates further immune response to the foreign protein. Current research is focusing on "gutless" adenoviruses, in which nearly all of the viral genome is removed. This is expected to decrease the immune response, and it allows the insertion of a larger segment of human DNA (up to 36 kb).

Adeno-associated Viruses. These DNA viruses are a type of parvovirus that requires the presence of adenoviruses for replication. Adeno-associated viruses offer the critical advantages that they elicit little, if any, immune response and that, like adenoviruses, they can enter nondividing cells. These vectors, however, can accept a DNA insert of only about 5 kb in size. Recently, an adeno-associated virus containing the human factor IX gene was administered via intramuscular injection to several hemophilia B patients. In one individual, the treatment resulted in sustained expression of factor IX at 1% of the normal level. While insufficient to cure the disease, even this level of expression significantly reduced the number of factor IX administrations needed to control bleeding.

Other Viral Vectors. Lentiviruses are complex retroviruses that, unlike simple retroviruses, can enter nondividing cells through pores in the nuclear membrane (human immunodeficiency virus [HIV] is an example of a lentivirus). Like other retroviruses, lentiviruses can integrate stably into the genome, and they can accept reasonably large (8 kb) inserts. Another viral vector under investigation is the disabled herpesvirus, which offers the advantage that it can insert DNA into ofteninaccessible neurons.

Although viral gene therapy holds considerable promise, there are several important challenges:

- 1. Transient and low-level expression. The gene product may be expressed at subtherapeutic levels, often less than 1% of the normal amount. In part, this reflects the fact that only some of the target cells successfully incorporate the normal gene. In addition, random insertion of the virus into the host's genome may affect gene regulation (e.g., enhancer sequences required for normal expression levels are not present). Cells sometimes respond to foreign inserted DNA by methylating-and thus inactivating-it. For these reasons, transcription of the gene often ceases after a few weeks or months. It should be noted, however, that transient expression is sufficient (and even desirable) for some types of therapy, such as the provocation of an immune response against a tumor or the generation of new blood vessels (discussed later).
- 2. Difficulties in reaching or specifying target tissue. While some systemic disorders may be relatively easy to target by modifying lymphocytes or bone marrow stem cells, others present formidable challenges. It may be difficult, for example, to target affected neurons responsible for central nervous system disorders. In addition, vectors must be modified so that they enter only the desired cell type.
- 3. Necessity for precise regulation of gene activity. Accurate regulation of gene activity is not a concern for some diseases (e.g., a 50-fold overexpression of adenosine deaminase has no clinically significant effects). However, it is critical for diseases such as thalassemia, in which the number of α -globin and β -globin chains must be closely balanced (see Chapter 3). It is difficult to achieve such precision using viral gene therapy.
- 4. Potential for insertional mutagenesis. The random

CLINICAL COMMENTARY 13.5 Gene Therapy and Severe Combined Immunodeficiency

Gene therapy has been attempted for several forms of severe combined immunodeficiency (SCID), including adenosine deaminase deficiency SCID (ADA-SCID) and X-linked SCID. ADA, which is produced primarily in lymphoid tissues, is an important component of the purine salvage pathway. It catalyzes the deamination of adenosine into inosine, as well as deoxyadenosine (dAdo) into deoxyinosine. ADA deficiency, an autosomal recessive disorder, results in the accumulation of dAdo and its metabolites. This inhibits DNA synthesis in cells and is especially toxic to T-lymphocytes. Subsequently, B-lymphocytes are also reduced in function and number. The resulting SCID is usually fatal by the age of 2 years if untreated. It is estimated that approximately 15% of SCID cases are caused by ADA deficiency.

The preferred treatment for ADA-SCID is bone marrow transplantation. However, complications of bone marrow transplantation increase patient morbidity and are sometimes fatal. In addition, major histocompatibility complex (MHC)-compatible sibling donors are available for fewer than 30% of ADA-SCID patients. Patients may be treated with polyethylene glycol (PEG)-conjugated ADA (administered once or twice weekly by intramuscular injection), but the response to this treatment is variable, and some patients develop antibodies against PEG-ADA.

Because it is a systemic autosomal recessive disorder caused by an enzyme deficiency, ADA-SCID represents a good candidate for gene replacement therapy. Ideally, proliferating bone marrow stem cells would be modified by retroviral vectors containing the normal ADA gene, resulting in a permanent cure for the disorder. Because of difficulties in dealing with bone marrow stem cells, gene therapy for ADA-SCID was initiated instead by retroviral insertion of ADA genes into lymphocytes that were extracted from patients and artificially stimulated to replicate. After retroviral insertion, the lymphocytes were injected back into the patient's peripheral circulation. This was the first application of gene therapy to an inherited human disorder.

Lymphocyte gene therapy has been applied in more than a dozen patients with ADA deficiency. In some patients, ADA levels increased, T-lymphocyte counts improved, and the number of infections decreased. Because of the limited life span of T-lymphocytes, these patients were reinjected with modified T-cells once every several months (however, the treated lymphocytes have displayed surprising longevity, surviving in the circulation for well over 1 year in some cases). These patients are typically treated with PEG-ADA, so it has been difficult to establish the efficacy of gene therapy.

More recently, ADA-SCID has been treated by retroviral insertion into bone marrow stem cells, rather than lymphocytes. This treatment has resulted in increased B- and T-cell counts in treated patients, and it offers the promise of a long-term cure of the disorder.

X-linked SCID results from mutations in the gene, *SCIDX1*, that encodes subunits of the γ chain that is found in six different cytokine receptors (those of interleukins 2, 4, 7, 9, 15, and 21; see Chapter 9). Lacking these receptors, T-cells and natural killer cells cannot receive the signals they need for normal maturation. The T-cell deficiency in turn produces a deficiency of B-cells, resulting in SCID. As with ADA deficiency, bone marrow transplantation can treat this disorder successfully, but human leukocyte antigen (HLA)-matched donors are often unavailable. Without a bone marrow transplant, the disease is fatal early in childhood.

In the year 2000, retroviral therapy was initiated to introduce *SCIDX1* into patients' bone marrow stem cells. In most treated individuals, the number of natural killer cells, T-cells, and B-cells increased to near-normal levels, with demonstrated resistance to infections. The therapy remains effective 30 months after treatment in several patients. This outcome has been widely heralded as one of the first successful uses of somatic cell gene therapy in the treatment of an inherited disease. However, 2 of 11 patients in a French protocol have developed a leukemia-like syndrome that is thought to be the result of insertional mutagenesis of a retroviral vector. This is the first known instance in which a retrovirus has had oncogenic effects in a human trial.

These examples illustrate some of the promise, as well as some of the perils, of somatic cell gene therapy. Clearly, gene therapy poses hazards that must be closely monitored. However, these protocols may lead to effective treatment of otherwise lethal diseases, and they provide invaluable information for the development of gene therapy protocols for other genetic diseases.

299

integration of a retroviral vector into the host's DNA can have undesired consequences, as discussed earlier. Although insertional mutagenesis appears to be a rare event, it apparently has occurred in at least two patients (see Clinical Commentary 13-5).

Considerable research is being devoted to overcoming these and other problems. In particular, methods for targeted insertion of genes are being explored, and ways to increase the levels and permanence of gene expression are being developed.

Viral vectors offer highly efficient transfer of therapeutic genes into somatic cells. However, they have several drawbacks, including low or transient expression of the gene product, limited insert size, generation of immune responses, difficulty in precise regulation, and, for some vectors, a lack of ability to invade nondividing cells and the potential for oncogenesis.

Nonviral Vectors. Although viral vectors provide the advantage of efficient gene transfer into cells, the disadvantages just listed have prompted researchers to investigate several types of nonviral vectors. One of the most extensively studied is the **liposome**, a fat body that can accept large DNA inserts. Liposomes will sometimes fuse with cells, allowing the DNA insert to enter the cell. Because the liposome has no peptides, it does not elicit an immune response. Its primary disadvantage is that it lacks the transfer efficiency of viruses: most of the liposomes are degraded in the cytoplasm, and those that are not degraded are typically unable to enter the nucleus.

Surprisingly, it is possible to insert plasmid DNA directly into cells without using any delivery vector at all. Although most "naked" DNA is repelled by the cell membrane, the DNA will, for unknown reasons, occasionally enter the cell, escape degradation, and temporarily encode proteins. Attempts are underway to use naked DNA as a "vaccine" that would encode a pathogenic protein to which the body mounts an immune response.

An intriguing development with potential for somatic cell therapy is the recent synthesis of **human artificial chromosomes**. Because these synthetically constructed chromosomes contain functional centromeres and telomeres, they should be able to integrate and replicate in human cell nuclei. They can reach 5 to 10 Mb in total size, which means they could accept huge inserts of therapeutic DNA.

Gene Blocking Therapies

Gene replacement techniques are not effective in correcting gain-of-function or dominant negative mutations (e.g., Huntington disease, Marfan syndrome); in these conditions, the defective gene product must be disabled in some way. Although not as well developed as gene replacement therapy methods, gene blocking methods are being developed, and some show promise.

Antisense Therapy. The principle behind **antisense therapy** is simple: an oligonucleotide is engineered whose DNA sequence is complementary to that of the messenger RNA (mRNA) sequence produced by a gainof-function mutation. This "antisense" oligonucleotide binds to the abnormal mRNA, preventing its translation into a harmful protein (Fig. 13-9). Antisense oligonucleotides can also be engineered to bind to doublestranded DNA containing the disease-causing mutation, creating a triple helix that cannot be transcribed into mRNA. A difficulty with this technique is that antisense oligonucleotides are often degraded before they can reach their target. Also, because of variation in the shape of the target DNA or RNA molecule, the antisense oligonucleotide may not be able to bind to its comple-

FIGURE 13.9 Gene therapy using an antisense technique. Binding of the abnormal mRNA by the antisense molecule prevents it from being translated into an abnormal protein.

Gene therapy using nonviral vectors, including liposomes, human artificial chromosomes, and naked DNA, offers some advantages over viral vectors, but they currently lack the transfer efficiency of viral vectors.

mentary sequence. Nevertheless, antisense therapy is being tested in a number of protocols. For example, it is being used to block expression of the *KRAS* oncogene (see Chapter 9) in pancreatic and colorectal tumors, and it is being tested as an inhibitor of hepatitis C virus expression.

Ribozyme Therapy. **Ribozymes** are enzymatic RNA molecules, some of which can cleave mRNA. They can be engineered to disrupt specific mRNA sequences that contain a mutation, destroying them before they can be translated into protein. Ribozyme therapy is being tested, for example, as a method of countering the overexpression of epidermal growth factor receptor type 2, a feature of many breast tumors.

Gene blocking techniques may be used to counter the effects of dominant-negative or gain-of-function mutations. They include the use of antisense molecules and RNA-cleaving ribozymes.

Gene Therapy for Noninherited Diseases

As indicated in Table 13-7, the application of gene therapy techniques is by no means limited to inherited diseases. Indeed, about two thirds of the gene therapy protocols now underway involve noninherited cancers, and approximately 10% involve acquired immunodeficiency syndrome (AIDS) therapy. For example, the TP53 tumor suppressor gene, which is lost in about half of all cancers (see Chapter 11), is inserted into lung tumors in an effort to halt tumor progression. As discussed in Chapter 9, some tumors evade immune system detection by discarding cell-surface molecules that are recognized by T-cells. Liposomes containing DNA that encodes the B7 costimulatory molecule (see Chapter 9) have been introduced into malignant melanoma cells, resulting in B7 expression on the cell surface and subsequent cell destruction by cytotoxic T-cells. In some cases, this has led to regression of the melanoma.

A variety of gene therapy approaches are being directed at HIV. Most of these efforts are aimed at halting replication of the virus or preventing its spread to healthy cells. For example, a dominant-negative mutation introduced into HIV-infected T-cells produces a protein that interferes with proteins produced by HIV, blocking their normal action.

Another example of gene therapy for a noninherited disease involves the treatment of coronary artery disease. Copies of the gene that encodes vascular endothelial growth factor (VEGF) have been injected into ischemic myocardium (either in adenovirus vectors or as naked DNA) with the hope of producing new coronary vessels. Preliminary studies indicate reduced angina and increased cardiac output in treated patients; further studies are needed to determine whether this treatment results in permanent, functional coronary vessels.

Germline Therapy

Somatic cell therapy consists of the alteration of only specific somatic cells and thus differs little in principle from many other types of medical intervention (e.g., bone marrow transplantation). In contrast, **germline gene therapy** involves the alteration of all cells of the body, including those giving rise to the gametes. Thus, this type of gene therapy would affect not only the patient but all of his or her descendants.

Germline therapy was first achieved in the mouse in 1983, when copies of a human growth hormone gene were successfully introduced into mouse embryos by microinjection (the gene was inserted directly into the embryo using a very small needle). Among the minority of embryos in which the gene integrated, the gametes were also modified, and the human growth hormone gene was transmitted to future generations (the mice, incidentally, were abnormally large).

While germline therapy is, in principle, possible in humans, it presents significant problems (Box 13-6). First, injected embryos usually die, and some develop tumors and malformations. Second, even in an autosomal dominant disorder, half of the embryos produced are genetically normal. If it were possible to distinguish the genetically normal embryos (e.g., through PCR diagnosis of in vitro fertilization products), it would be simpler to implant the normal embryos than to alter the abnormal ones. Finally, there are numerous ethical questions associated with the permanent alteration of a human's genetic legacy. For these reasons, it appears unlikely that human germline therapy would be useful or desirable.

Gene Therapy: A Perspective

The past several years have witnessed the first arguable successes of gene therapy, some of which have been discussed in this chapter (therapy for X-linked SCID, factor IX expression in hemophilia B patients, evidence of therapeutic effects in cancer and ischemic heart disease). However, these successes have been achieved in only a small number of individuals. And gene therapy is not without risk. In addition to the insertional mutagenesis potential already discussed, a young man with ornithine transcarbamylase deficiency (see Chapter 7) died as a result of an adverse immune reaction to an adenovirus vector. It thus remains unclear whether gene therapy will ever provide a safe treatment or cure for a reasonable cost.

Despite these reservations, gene therapy research is providing many new insights of fundamental biological significance. Somewhat unexpectedly, it is showing most promise in the treatment of diseases that are not inherited at all. As with many avenues of biomedical research, the potential of gene therapy research is considerable, and current progress suggests strongly that it may yet provide efficacious treatment of some important human diseases. Germline Therapy, Genetic Enhancement, and Human Cloning: Controversial Issues in Medical Genetics

For reasons outlined in the text, germline gene therapy is not being undertaken in humans. Nevertheless, it has been pointed out that germline gene therapy is in many ways technically easier to perform than is somatic cell therapy. Germline therapy also offers (in theory) the possibility of "genetic enhancement," the introduction of favorable genes into the embryo. However, a gene that is favorable in one environment may be quite unfavorable in another (e.g., the sickle cell mutation, which is advantageous only for heterozygotes in a malarial environment). And, because of pleiotropy, the introduction of "favorable" genes may have completely unintended consequences (e.g., a gene thought to enhance one characteristic could negatively affect another). For these reasons, and because germline therapy usually destroys the targeted embryo, neither germline therapy nor genetic enhancement is advocated by the scientific community.

Controversy also surrounds the prospect of cloning humans. Several species (e.g., sheep, pigs, cattle, goats, mice, cats) have been successfully cloned by introducing a diploid nucleus from an adult cell into an egg cell from which the original haploid nucleus was removed. The cell is manipulated so that all of its genes can be expressed (recall that most genes in a typical adult cell are transcriptionally silent). This procedure, termed "reproductive cloning," when allowed to proceed through a full-term pregnancy, could likely be used to produce a human being. Some argue that human cloning offers childless couples the opportunity to produce children to whom they are biologically related or even to "replace" a child who has died. Others respond with the challenge that this method of creating life is too artificial. In any case, it is important to keep in mind that a clone is only a genetic copy. The environment of the individual, which also plays a large role in development, cannot be replicated. Furthermore, the great majority of cloning attempts in mammals fail: in most cases, the embryo either dies or has gross malformations. Because the consequences of human cloning would almost certainly be similar, reproductive cloning to produce a human is condemned almost universally by scientists.

It is possible to derive embryonic stem cells from earlystage human embryos. These stem cells can potentially be treated to form many types of differentiated cells (e.g., neurons for individuals with Parkinson disease, myocytes for individuals with heart disease). The combination of embryonic stem cell technology and human cloning offers an interesting possibility: a pre-embryo could in theory be created from an individual's own cells, producing embryonic stem cells that would be immunologically a perfect match for the individual (creating a clone to provide embryonic stem cells has been termed "therapeutic cloning").

Although these technologies offer the hope of effective treatment for some recalcitrant diseases, they also present thorny ethical issues. Clearly, decisions regarding their use must be guided by constructive input from scientists, legal scholars, philosophers, and others.

SUGGESTED READINGS

- Aitken DA, Crossley JA, Spencer K (2002) Prenatal screening for neural tube defects and aneuploidy. In: Rimoin DL, Connor JM, Pyeritz RE, Korf BR (eds) Emery and Rimoin's Principles and Practice of Medical Genetics, 4th ed. Vol 1. Churchill Livingstone, New York, pp 763-801
- Braude P, Pickering S, Flinter F, Ogilvie CM (2002) Preimplantation genetic diagnosis. Nat Rev Genet 3:941-955
- Burke W (2002) Genetic testing. N Engl J Med 347:1867-1875
- Chace DH, Kalas TA, Naylor EW (2002) The application of tandem mass spectrometry to neonatal screening for inherited disorders of intermediary metabolism. Annu Rev Genomics Hum Genet 3:17-45
- Elias S, Simpson JL, Shulman LP (2002) Techniques for prenatal diagnosis. In: Rimoin DL, Connor JM, Pyeritz RE, Korf BR (eds) Emery and Rimoin's Principles and Practice of Medical Genetics, 4th ed. Vol 1. Churchill Livingstone, New York, pp 802-825
- Evans JP, Skrzynia C, Burke W (2001) The complexities of predictive genetic testing. BMJ 322:1052-1056
- Ferber D (2001) Gene therapy: safer and virus-free? Science 294:1638-1642
- Gewirtz AM (1999, September) The prospects for antisense therapy. Hosp Practice 15:97-107
- Harper PS, Lim C, Craufurd D (2000) Ten years of presymptomatic testing for Huntington's disease: the experience of the UK Huntington's Disease Prediction Consortium. J Med Genet 37:567-571

Isner JM (2002) Myocardial gene therapy. Nature 415:234-239 Kanavakis E, Traeger-Synodinos J (2002) Preimplantation

- genetic diagnosis in clinical practice. J Med Genet 39:6-11 Khoury MJ, McCabe LL, McCabe ER (2003) Population screen-
- ing in the age of genomic medicine. N Engl J Med 348:50-58 Lanza RP, Caplan AL, Silver LM, Cibelli JB, West MD, Green RM (2000) The ethical validity of using nuclear transfer in
- human transplantation. JAMA 284:3175-3179
- Levy HL, Albers S (2000) Genetic screening of newborns. Annu Rev Genomics Hum Genet 1:139-177
- Lovell-Badge R (2001) The future for stem cell research. Nature 414:88-91
- Mausner JS, Bahn AK (1974) Epidemiology: An Introductory Text. WB Saunders, Philadelphia
- McLaren A (2000) Cloning: pathways to a pluripotent future. Science 288:1775-1780
- Milunsky A (ed) (1998) Genetic Disorders and the Fetus: Diagnosis, Prevention, and Treatment, 4th ed. Johns Hopkins University Press, Baltimore
- National Academy of Sciences (1975) Genetic Screening Programs, Principles and Research. National Academy of Sciences, Washington, DC
- National Institutes of Health (1997) NIH Consensus Statement: Genetic Testing for Cystic Fibrosis. National Institutes of Health, Bethesda, MD
- Pagon RA, Tarczy-Hornoch P, Baskin PK, Edwards JE, Covington ML, Espeseth M, Beahler C, Bird TD, Popovich

BOX

13.6

B, Nesbitt C, Dolan C, Marymee K, Hanson NB, Neufeld-Kaiser W, Grolis GM, Kicklighter T, Abair C, Malmin A, Barclay M, Palepu RD (2002) GeneTests-GeneClinics: genetic testing information for a growing audience. Hum Mutat 19:501-509

- Pfeifer A, Verma IM (2001) Gene therapy: promises and problems. Annu Rev Genomics Hum Genet 2:177-211
- Vorburger SA, Hunt KK (2002) Adenoviral gene therapy. Oncologist 7:46-59
- Wachtel SS, Shulman LP, Sammons D (2001) Fetal cells in maternal blood. Clin Genet 59:74-79
- Walsh CE (2002) Gene therapy for the hemophilias. Curr Opin Pediatr 14:12-16
- Weaver D (1999) Catalog of Prenatally Diagnosed Conditions, 3rd ed. Johns Hopkins University Press, Baltimore

INTERNET RESOURCES

- Clinical Trials in Human Gene Transfer (updated list of all gene therapy protocols underway in the United States) http://www4.od.nib.gov/oba/rac/clinicaltrial.htm
- Gene Clinics/Gene Tests (reviews of genetic diseases and lists of laboratories that perform diagnostic tests) *http://www.geneclinics.org/*

Gene Therapy-Related Web sites

http://www.medschool.lsumc.edu/GeneTherapy/vector/Links.htm Human Genome Project Information (includes information on genetic testing and gene therapy, with relevant links)

http://www.ornl.gov/hgmis/medicine/assist.html

- National Newborn Screening and Genetics Resource Center http://genes-r-us.uthscsa.edu/
- National Organization for Rare Diseases (database of rare disorders that includes brief reviews and information on diagnostic tests and treatment for families and professionals) *http://www.rarediseases.org*

STUDY QUESTIONS

- 1. A newborn screening program for a metabolic disease has just been initiated. Of 100,000 newborns, 100 were shown by a definitive test to have been affected with the disease. The screening test identified 93 of these individuals as affected and 7 as unaffected. It also identified 1,000 individuals as affected who were later shown to be unaffected. Calculate the sensitivity, specificity, and positive predictive value of the screening test, and specify the rate of false positives and false negatives.
- 2. Study the family shown in the pedigree in Fig. 13-10. Individual 3 has PKU, an autosomal recessive disease. A two-allele RFLP closely linked to the PKU locus has been assayed for each family

member, and the figure shows the genotypes of each individual. The marker alleles are 5 kb and 3 kb in size. Based on the genotypes of the linked marker, is individual 6 affected, a heterozygous carrier, or a normal homozygote?

3. Study the family shown in the pedigree in Fig. 13-11. The affected individuals have neurofibromatosis type 1 (NF1), an autosomal dominant condition. A four-allele microsatellite system closely linked to the NF1 locus has been typed for each family member. Based on the genotypes shown in the accompanying figure, will individual 6 develop NF1?

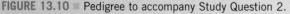

FIGURE 13.11 Pedigree to accompany Study Question 3.

STUDY QUESTIONS—cont'd

- 4. In the pedigree for an autosomal dominant disorder shown in Fig. 13-12, a tightly linked two-allele RFLP has been typed in each family member. Based on this information, what can you tell the family about the risk that the offspring in generation III will develop the disorder? How might diagnostic accuracy be improved in this case?
- 5. Compare the advantages and disadvantages of amniocentesis and chorionic villus sampling (CVS).
- 6. What type of gene therapy would be most appropriate for Huntington disease? Why?

CHAPTER 14

Clinical Genetics and Genetic Counseling

Medical genetics has recently emerged as a true specialty in medicine. In the 1960s the fields of biochemical genetics, clinical cytogenetics, and **dysmorphology** (the study of abnormal physical development) developed. The 1970s witnessed the establishment of the techniques necessary for the prenatal diagnosis of genetic disorders. By the end of the 1970s, discussions about the formation of an American Board of Medical Genetics had occurred, and in 1981 the first certification examination was administered. (Various types of geneticists, including genetic counselors, medical geneticists, and basic human geneticists, can now be certified.) Ten years later the American Board of Medical Specialties recognized this new field, and it has now become an integral part of mainstream medicine.

Whereas medical genetics is the study of the genetics of human disease, **clinical genetics** deals with the direct clinical care of persons with genetic diseases. The diagnostic, counseling, and management issues surrounding genetic disease are the principal foci of clinical genetics.

In this chapter, we summarize the principles of clinical genetics and the process of genetic counseling. In addition, we provide an overview of the field of dysmorphology, since the growth of this area has influenced and paralleled the emergence of clinical genetics. Finally, we discuss some of the ethical issues pertinent to medical genetics.

THE PRINCIPLES AND PRACTICE OF CLINICAL GENETICS

As mentioned in Chapter 1, genetic conditions as a group are common and are a significant cause of human mortality and morbidity. Typically, genetic disorders are complex, multiorgan, systemic conditions, and the care of persons with these disorders may also involve multiple medical specialties. Thus, genetic disorders are part of the differential diagnosis of most symptoms and clinical presentations. For example, when evaluating an infant with a blistering skin disease, the ability to distinguish between one of the many forms of epidermolysis bullosa (an inherited disorder of keratinocytes in which skin blisters develop after mild trauma) and staphylococcal skin disease must be part of the clinician's repertoire. www

Because of the complexity and number of human genetic diseases, their clinical diagnosis and treatment can seem overwhelming. To help manage this information, we provide an overview of the most important concepts, including the importance of accurate diagnosis, the application of the tenets of medical genetics to medical practice, and the role of genetic counseling in the care of persons with genetic disease.

Accurate Diagnosis

The significance of the basic medical principle of accurate diagnosis cannot be overemphasized. The process of genetic counseling, one of the central services of medical genetics, begins with correct diagnosis. All discussions of natural history, prognosis, management, risk determination, options for prenatal diagnosis, and referral to lay advocacy groups (also termed support groups) depend on an accurate diagnosis. For example, genetic counseling for a family who has a son with mental retardation usually involves questions of risk for this condition in future offspring. An accurate answer requires the clinician to identify a condition of known etiology. If a specific diagnosis (e.g., fragile X syndrome) is made, then the rest of the genetic counseling process starts: current information can be shared and management initiated (Clinical Commentary 14-1).

In clinical genetics, as in all of medicine, accurate diagnosis is the most important first step in patient care.

The process of diagnosing a genetic disorder is a complex sequence of events. It depends upon diagnostic decision making, biochemistry, dysmorphology, laboratory diagnosis, and the basic principles of medical genetics. For diseases in which the diagnostic criteria are well

CLINICAL COMMENTARY 14.1 Reasons for Making a Diagnosis of a Syndrome

The long list of syndromes associated with congenital malformations is overwhelming to the clinician. More than 400 conditions are listed in *Smith's Recognizable Patterns of Human Malformations*, and more than 1,000 are accessible through the POSSUM or London Dysmorphology computerized databases (see Internet Resources at the end of this chapter). This number imparts a sense that the diagnosis of a malformation syndrome lies in the arena of "academic trivia." However, this is not the case.

Consider, for example, the child who is large for gestational age and has a number of physical abnormalities: omphalocele (intestinal protrusion at the umbilicus), large tongue, facial hemangioma, flank mass, and asymmetrical limb length (Fig. 14-1). His

FIGURE 14.1 A child with Beckwith-Wiedemann syndrome. Note the prominent eyes and large, protruding tongue. (Courtesy Dr. David Viskochil, University of Utah Health Sciences Center)

family has questions such as, "What does he have?," "How will he do?," "Will he look different?," "Will he have mental retardation?," "What is the chance of his condition occurring again in another child?"

By putting these features together and making the pattern recognition diagnosis of the Beckwith-Wiedemann syndrome, the clinician is able to answer all of the parents' questions fairly precisely. Most cases of Beckwith-Wiedemann syndrome occur sporadically, but some are inherited. In addition, the genes that cause the disease exhibit imprinting effects (see Chapter 4). If there is no family history, however, the sibling recurrence risk is less than 5%. If there is a family history, the recurrence risk is higher, and linkage or mutation analysis may provide a more precise risk estimate. In future pregnancies, prenatal diagnosis using ultrasound can test for an omphalocele in the second trimester and for large size for gestational age, excessive amniotic fluid (polyhydramnios), and large tongue. If a fetus is thought to have Beckwith-Wiedemann syndrome, then the delivery plan would change and the baby should be born in a tertiary care center. www

Children with the Beckwith-Wiedemann syndrome do not usually have mental retardation. Although the large tongue can cause orthodontic problems, speech difficulties, and occasionally upper airway problems, these conditions usually improve as the child gets older. The facial appearance is not strikingly abnormal in later childhood.

Chromosomes should probably be studied, although most Beckwith-Wiedemann patients do not have the chromosome 11 abnormality that has been reported in a small number of cases. Otherwise, the main emphases of the medical care plan include regular abdominal ultrasound to look for intraabdominal malignancies, especially Wilms tumor and hepatoblastoma. Children with Beckwith-Wiedemann syndrome have a 5% to 10% risk of developing these tumors, and both types are treatable if detected early.

In this example, it was important to diagnose the Beckwith-Wiedemann syndrome. The correct label led to precise information for genetic counseling, prediction of natural history (including reassurance), organization of appropriate laboratory studies, a health supervision plan, and referral to a lay advocacy group. Diagnosis was helpful to the parents, the family physician, and the child. established, the practitioner has guidelines for making a diagnosis. An example of such criteria would be those recommended by the National Institutes of Health Consensus Development Conference for the diagnosis of neurofibromatosis type 1 (NF1; see Chapter 4). For conditions that are defined by a specific laboratory marker, such as an abnormal karyotype or biochemical assay, the diagnostic procedure is generally straightforward. For many genetic diseases, however, there are no wellestablished criteria, and the definition and delineation of the disorder are not as clear-cut.

Dysmorphic syndromes require knowledge and skills in the recognition of mild malformations, minor anomalies, and phenotypic variations. The diagnosis of other genetic diseases may require expertise from a variety of disciplines. For instance, the diagnosis of any of the forms of retinitis pigmentosa (see Chapter 8) requires input from an ophthalmologist who is familiar with this group of retinal degenerative conditions. The diagnostic process is further complicated by the variable expression, incomplete penetrance, and heterogeneity of many genetic diseases. These concepts are discussed in Chapter 4.

Application of the Principles of Medical Genetics

Developing a genetic approach to human disease in the clinical setting requires the application of all of the basic principles of medical genetics discussed in this book. For example, making or excluding the diagnosis of NF1 requires knowledge of the clinical variability and age of onset of certain features of the condition (Clinical Commentary 14-2). Recognition of the various forms of neurofibromatosis (i.e., heterogeneity) is also important.

Knowledge of the other formal principles of medical genetics is also necessary in the care of persons with genetic conditions. The accumulation of family history data and the interpretation of pedigree information are important in answering a family's questions regarding risk. An understanding of the various modes of inheritance is important in any explanation of recurrence risk. Discussion of the concepts of new mutation and pleiotropy are commonplace in reviewing the cause and pathogenesis of a genetic disease with a family. Even an understanding of meiosis is a requirement for discussions of etiology with the family of a newborn with Down syndrome (Clinical Commentary 14-3).

Genetic Counseling

DEFINITION AND PRINCIPLES

Genetic counseling represents one of the central foci of medical genetics. At first glance, use of the term "counseling" implies that this service lies in the domain of mental health, social work, or psychotherapy. In fact, genetic counseling is based on the conventional medical model because it depends significantly on accurate diagnosis and knowledge of medical genetics. As a tradition, genetic counseling grew out of the field of human genetics rather than from behavioral science, unlike other counseling disciplines.

In 1975 the American Society of Human Genetics adopted a definition of genetic counseling. While newer language has been proposed to widen this definition, it continues to stand the test of time:

Genetic counseling is a communication process which deals with the human problems associated with the occurrence or risk of occurrence of a genetic disorder in a family. This process involves an attempt by one or more appropriately trained persons to help the individual or family to: (1) comprehend the medical facts including the diagnosis, probable course of the disorder, and the available management; (2) appreciate the way heredity contributes to the disorder and the risk of recurrence in specified relatives; (3) understand the alternatives for dealing with the risk of recurrence; (4) choose a course of action which seems to them appropriate in their view of their risk, their family goals, and their ethical and religious standards and act in accordance with that decision; and (5) make the best possible adjustment to the disorder in an affected family member and/or to the risk of recurrence of that disorder.

This definition illustrates the complex tasks that face the practitioner. The first task involves establishing the diagnosis and discussing the natural history and management of the condition. In this regard, the medical care of a patient with a genetic disease does not differ from that of a patient with any other type of disease.

The second task requires an understanding of the basic tenets of medical genetics, especially risk determination. For chromosomal and multifactorial disorders, empirical risks are used to estimate recurrence. Inheritance patterns are used to predict the recurrence risk of mendelian disorders. However, the clinical issues are frequently complicated by incomplete penetrance, variable expression, delayed age of onset, and allelic and locus heterogeneity. In some cases, incorporation of additional information using the Bayesian probability approach can significantly alter risk estimates (Box 14-1).

The third and fourth objectives of the genetic counseling process underlie the primary differences between the genetic model and the traditional biomedical approach. These tasks involve the discussion of reproductive options and the facilitation of decision making. Implicit in the fourth part of the definition is the notion of respect for the family's autonomy and their perceptions of risk and of the disorder itself. This approach has been called **nondirectiveness**: the counselor leaves all decisions about future reproduction up to the family. This differs somewhat from the more traditional medical approach, in which *recommendations* for treatment or intervention are often made.

This is an important issue, because nondirectiveness sometimes conflicts with the broader view of preventive medicine, which might suggest that the principal goal of

CLINICAL COMMENTARY 14.2

The Negative Family History

One of the common discussions on ward rounds is the notation that a person's family history is "negative" or "noncontributory." This is often thought to rule out a genetic disorder. However, the majority of individuals who have a genetic disease do not have a "positive" family history. A quick review of the mechanisms of mendelian, chromosomal, and multifactorial disease inheritance shows that a lack of other affected persons in the family is common and does not by any means rule out the presence of a genetic disease. For example, the sibling recurrence risk is 25% for diseases with autosomal recessive inheritance. Thus, a significant number of families with multiple offspring will have only one affected child and no family history. Even some wellestablished autosomal dominant disorders may often present a negative family history because of high proportions of new mutations (examples include Marfan syndrome, neurofibromatosis type 1 [NF1], and achondroplasia, in which the proportions of cases caused by new mutations are 30%, 50%, and 80%, respectively). Chromosomal syndromes usually have a low recurrence risk. Even when a parent carries a balanced chromosome rearrangement, the recurrence risk among the offspring is usually less than 15%. The sibling recurrence risks for multifactorial conditions are usually 5% or less.

CASE

A family comes in with a 6-year-old boy who has 10 *caféau-lait* spots exceeding 0.5 cm in diameter and an optic glioma (Fig. 14-2). The family has questions about the diagnosis and the recurrence risk in future pregnancies. On initial telephone contact it is learned that there is no history of a family member with similar features.

There are several possible explanations for this finding. Exploring them underscores the implications of a negative family history:

- 1. *New mutation of the NF1 gene*. Because of the relatively high proportion of new mutations for this disorder, this is the most likely explanation.
- 2. *Variable expression*. It is also possible that one of the parents carries the gene but has mild expression of the phenotype. Occasionally a parent has multiple *café-au-lait* spots and a few neurofibromas, but a diagnosis of NF1 has never been made.
- 3. *Incomplete penetrance*. This is a possibility; however, it is unlikely for NF1, in which penetrance is close to 100%. If a family has two children with NF1 and neither parent has the gene, germline mosaicism would be the more likely explanation.
- 4. *Incorrect diagnosis*. One of the assumptions and basic principles of medical genetics is accurate diagnosis. This patient meets the National

Institutes of Health established criteria for NF1 (see Chapter 4). However, if this individual had only *café-au-lait* spots, then the diagnosis would have been an issue. One would need to know the differential diagnosis of multiple *café-au-lait* spots.

5. *False paternity*. Although it is relatively unlikely, this possibility must be kept in mind.

We began with an individual who had a classic autosomal dominant disorder with no family history. This can be explained in a number of ways. The statement that there is "a negative family history" should not be considered conclusive evidence against the presence of a heritable condition.

FIGURE 14.2 A 6-year-old boy with multiple *café-au-lait* spots and axillary freckling.

CLINICAL COMMENTARY 14.3

Talking to the Parents of a Newborn with Down Syndrome

The birth of a newborn with Down syndrome presents many challenges. Typically, the infant is not acutely ill and the parents are not aware of the diagnosis before the birth. Thus, the practitioner must approach the parents, often strangers, with potentially disappointing news. The family experiences a series of emotions that are somewhat similar to the reactions after a loss: anger, denial, sadness, and then usually reorganization and adaptation. Families face these situations with markedly different backgrounds: varying attitudes toward crisis, varied demographic and socioeconomic circumstances, and even a wide range of differences in the cultural meaning of a disability or defect. All of these variables, plus the fact that physicians are often not trained in being the bearers of difficult news, can make this a challenging situation. Parents remember in detail the way in which the news is presented. The practitioner has both the opportunity and the challenge to help the family through these events.

A number of practical suggestions have come from studies investigating the recommendations of parents who have experienced this event:

- 1. *Prepare yourself.* Set up the interview scenario, and think about how you will begin the discussion.
- 2. *Talk to both parents together whenever possible.* This is sometimes not practical, but when it can be accomplished it is critical.
- 3. *Communicate the diagnosis as soon as possible.* All studies of parental interviews show that they prefer early communication of the diagnosis.
- 4. Choose a place that is private and quiet where both the parents and the professionals can sit down. Avoid standing up with the parents seated. Always be sure to introduce yourself. Structure the interview from the beginning.
- 5. *Humanize the situation as much as possible*. Learn the baby's first name if it has been decided on, and always know the baby's gender. Refer to the

infant as a son or daughter, and be aware of the use of all language. Phrases such as "mental retardation" have great impact. Terms such as "mongolism" are not appropriate because they are stigmatizing, pejorative, and incorrect.

- 6. Develop a sense of realistic positivism. It is important to discuss the developmental limitations in a patient with Down syndrome, but it is also important to have an optimistic and positive attitude. This suggestion comes from the lay advocacy and parents' organizations that have developed in the last three decades.
- 7. Answer the parents' questions, but avoid technical overload. It is important to be accurate and current on the biological and medical aspects of the disease under discussion. When an answer is not known, mention that the question can be reviewed or referred to a consultant.
- 8. *Listen actively*. Assume that almost all feelings are natural and that parents will be wrestling with their own guilt and shame. Validate all feelings that arise. Most parents can meet this challenge quite effectively and do not require psychiatric consultation.
- 9. *Refer the family to the appropriate resources early.* This would include parents' lay advocacy groups or even individual parents who have a child with Down syndrome. Share available written material, but make certain that it is accurate and current.

Above all, be aware of the unique plight of families in such a situation, and make an effort to spend time with them. While it is difficult to present in written form how one can develop attributes such as kindness and empathy, it is important for physicians in training to learn from their mentors and utilize their own personality style as a strength. Clearly, the recommendations provided here apply not only to genetic counseling, but to any situation in which difficult information is presented to patients or families.

genetic counseling should be the reduction of the incidence of genetic diseases. If prevention or reduction of occurrence is the primary goal, then one's approach might be more directive. However, the main goal of genetic counseling is to help families understand and cope with genetic disease, not to reduce the incidence of genetic disease.

Although most geneticists subscribe to the principles

of autonomy and nondirectiveness, it may sometimes be impossible to be entirely nondirective, simply because of the limited options that the counselor has in a timerestricted session. In addition, information may be presented quite differently in different contexts. Information about Down syndrome, for example, may be communicated differently depending on whether the diagnosis was

Recurrence Risks and Bayes Theorem

The estimation of recurrence risks was treated at some length in Chapters 4 and 5. A typical example of recurrence risk estimation would be a case in which a man with hemophilia A, an X-linked recessive disorder, produces a daughter (individual II-1 in Fig. 14-3). Because the man can transmit only the X chromosome carrying the hemophilia A mutation to his daughter, she must be a carrier. The carrier's daughter, individual III-6, has a 50% chance of receiving the X chromosome carrying the mutation and being herself a carrier. Even though the daughter in generation III has five normal brothers, her risk remains 50% because we know that the mother in generation II is a carrier.

Suppose now that the woman in generation III produces three sons (generation IV), none of whom has hemophilia A. Intuitively, we might begin to suspect that she is not a carrier after all. How can we incorporate this new information into our recurrence risk estimate?

A statistical principle that allows us to make use of such information is called Bayes theorem (the application of Bayes theorem is often termed Bayesian analysis or Bayesian inference). The table below summarizes the basic steps involved in Bayesian analysis. We begin with the prior probability that the woman in generation III is a carrier. As its name suggests, the prior probability denotes the probability that she is a carrier before we account for the fact that she has produced three normal sons. Because we know her mother is a carrier, this woman's prior probability must be 1/2. Then the prior probability that she is not a carrier is 1 - 1/2, or 1/2.

	She is a carrier	She is not a carrier
Prior probability	1/2	1/2
Conditional probability	1/8	1
Joint probability	1/16	1/2
Posterior probability	1/9	8/9

Next we take into account the woman's three normal sons by estimating the probability that all three of them would be normal given that she is a carrier. Because this probability is conditioned on her carrier status, it is termed a conditional probability. If she is a carrier, the conditional probability that all three of her sons are normal would be $(1/2)^3$, or 1/8. We also estimate the probability that all of her sons would be normal given that she is not a carrier. This conditional probability is, of course, very close to 1.

Next we want to find the probability that the woman is a carrier and that she is a carrier with three normal sons. To obtain the probability of the co-occurrence of these two events, we multiply the prior probability times the conditional probability to derive a joint probability (i.e., the probability of both events occurring together, a concept discussed in Chapter 4). The joint probability that she is a carrier is then $1/2 \times 1/8 = 1/16$. Similarly, the joint probability that she is not a carrier is $1/2 \times 1 = 1/2$. These joint probabilities indicate the woman is 8 times more likely not to be a carrier than to be a carrier.

The final step is to standardize the joint probabilities so that the two probabilities under consideration (i.e., being a

FIGURE 14.3

carrier versus not being a carrier) sum to 1. To do this, we simply divide the joint probability that the woman is a carrier (1/16) by the sum of the two joint probabilities (1/16)+ 1/2). This yields a posterior probability of 1/9 that she is a carrier and 8/9 that she is not a carrier. Notice that this standardization process allows us to provide a risk estimate (1/9, or 11%), while preserving the odds of noncarrier versus carrier status indicated by the joint probabilities.

Having worked through the Bayesian analysis, we see that our intuition was confirmed: the fact that the woman in question produced three normal sons reduced her risk of being a carrier substantially, from an initial estimate of 50% to a final probability of only 11%.

Another common application of Bayesian analysis is illustrated in Fig. 14-4A. The male in generation II is affected with Duchenne muscular dystrophy (DMD), a lethal Xlinked recessive disease (see Chapter 5). Either his unaffected mother is a carrier of the mutation, or he received a new mutation on the X chromosome transmitted by his mother. It is important to determine whether the mother is a carrier or not, because this fact will influence recurrence risks for DMD in her subsequent offspring. If the mother has only one affected offspring, the probability that she is a carrier can be evaluated directly, because one third of all cases of X linked lethal recessive disorders arise as a result of new mutations. (To understand this, consider the fact that, because females have two X chromosomes and males have only one, 2/3 of all X-linked disease-causing mutations in a population must be found in females. For a lethal X-linked recessive, all of the male X chromosomes are eliminated from the population in each generation. Yet the frequency of the mutation remains the same, generation after generation. This is because new disease-causing mutations arise at the same rate as the loss of mutation-containing X chromosomes. Because

310

BOX

14.1

Recurrence Risks and Bayes Theorem—cont'd

one third of the mutation-containing X chromosomes are lost each generation, it follows that one third of the mutations in the population must occur as the result of new mutation.) If the probability that the affected son received a new mutation is 1/3, then the probability that the mother is a carrier—the alternative possibility—must be 1 - 1/3, or 2/3.

In the table below, we use Bayesian analysis to evaluate the probability that the mother is a carrier. As in the previous example, we derive a prior probability that she is a carrier, assuming no knowledge that she has produced an affected son. This probability is given by 4μ , where μ is the mutation rate for the DMD locus (i.e., the probability, per generation, that a disease-causing mutation arises at this locus in an individual). The derivation of the probability, 4µ, is beyond the scope of this text, but it can be found elsewhere (Hodge, 1998). Since the prior probability that the mother is a carrier is 4µ, the prior probability that she is not a carrier is $1 - 4\mu$, which is approximately equal to 1 because μ is very small. The conditional probability that the woman transmits the mutation given that she is a carrier is 1/2 (there is also a very small probability that she transmits her normal allele, which is then mutated, but this can be ignored). The conditional probability that she transmits a mutation given that she is not a carrier (i.e., the probability that a new mutation arises in the gamete she transmits) is u. We then multiply the prior probability that she is a carrier, 4µ, by the corresponding conditional probability, 1/2, to obtain a joint probability of 2µ. The same procedure produces a joint probability of µ that she is not a carrier. Finally, we standardize the joint probabilities to get the posterior probabilities. The posterior probability that she is a carrier is $2\mu \div (2\mu + \mu) = 2/3$, and the posterior probability that she is not a carrier is $\mu \div (2\mu + \mu) = 1/3$. As expected, these probabilities correspond to the ones we obtained by simple direct observation.

	She is a carrier	She is not a carrier
Prior probability	4μ	$1 - 4\mu \approx 1$
Conditional probability	1/2	μ
Joint probability	2μ	μ
Posterior probability	2/3	1/3

Suppose, however, that the woman has had an affected son and an unaffected son (see Fig. 14-4B). This gives us additional information, and intuitively it increases the possibility that she is not a carrier (i.e., that the one affected offspring is the result of a new mutation). In the table below, we incorporate this new information. The prior probabilities remain the same as before (i.e., we assume no knowledge of either of her offspring). But the conditional probability of transmission, given that she is a carrier, changes to account for the fact that she now has two offspring: $1/2 \times 1/2 = 1/4$ (i.e., the probability that she did not transmit the mutation to one offspring times the probability that she did transmit the mutation to the other offspring). The conditional probability that she transmitted a new mutation to the affected offspring is µ and the probability that she did not transmit a mutation to the unaffected offspring is $1 - \mu$. Thus, the

probability of both events, given that she is not a carrier, is $\mu \times (1 - \mu) \approx \mu$. The joint and posterior probabilities are obtained as before, and we see that the woman's chance of being a carrier is now reduced from 2/3 to 1/2. Again, this confirms (and quantifies) our expectation.

	She is a carrier	She is not a carrier
Prior probability	4μ	$1-4\mu \approx 1$
Conditional probability	1/4	$\mu \times (1-\mu) \approx \mu$
Joint probability	μ	μ
Posterior probability	1/2	1/2

Before the advent of disease diagnosis through linked markers or mutation detection, Bayesian analysis was often the only way to derive a risk estimate in situations such as these. Now, of course, an attempt would be made to identify the factor VIII or DMD mutation that causes hemophilia A or DMD in these families directly, or, failing that, linked markers would be used. This is a much more direct and accurate approach for determining carrier status. However, as discussed in Chapter 13, it is not always possible to identify the responsible mutation, particularly when a large number of mutations can cause the disorder (as is the case for hemophilia A, DMD, or cystic fibrosis). Bayesian inference can be used in such cases to incorporate the sensitivity of the genetic test (e.g., if a standard mutation analysis of the CFTR gene reveals 85% of the mutations [see Chapter 13], there is a 15% probability that the individual in question has the mutation even though the test did not reveal it). In addition, linkage analysis is not always informative. Thus, Bayesian analysis is still sometimes a useful tool for refining risk estimates.

The additional information incorporated in Bayesian analysis is not confined to the assessment of health status in relatives, as was shown in these examples. Another type of information is a biochemical assay, such as factor VIII activity level, that could help to indicate carrier status. Because there is usually overlap between carriers and normal homozygotes for such tests, the assay cannot determine carrier status with certainty, but it does provide a *probability* estimate for incorporation into Bayesian analysis. In diseases with delayed age of onset, such as adult polycystic kidney disease, the probability of being affected at a certain age can be used in a Bayesian analysis. Here, one considers the fact that the at-risk individual is less and less likely to possess the disease gene if he or she remains unaffected beyond a certain age.

made prenatally or after the birth of an affected newborn (see Clinical Commentary 14-3).

The majority of geneticists subscribe to the principle of nondirectiveness: information about risks, natural history, treatment, and outcome is presented in a balanced and neutral manner, but decisions about reproduction are left to the family.

The facilitation of discussion about reproductive decision making is central to the task of genetic counseling. Several factors are involved in a family's decision about future pregnancies when there is an increased risk. The obvious ones are the magnitude of the risk figure and the burden or impact of the disorder. However, these are not the only significant issues. The individual family's perception of the impact of the condition is probably more important in their decision making than the professional's perception of the burden. The meaning of children to the individual family, according to their own cultural, religious, or personal preferences, is weighed heavily in the reproductive decision-making process. In addition, families frequently play out the scenario of coping with a recurrence of the condition in another child. Identification of these issues for a family often helps to stimulate their own discussions. Some families perceive risk qualitatively rather than quantitatively: they consider themselves to be either "at risk" or not, with the actual risk estimate being a secondary consideration. The fact that there is so much variation in the importance people assign to each of these factors (perception of risk, perception of impact, meaning of children, and possibility of recurrence) underscores the point that the professional should be a facilitator and not the decision maker.

The final task of genetic counseling is to help the family cope with the presence of the disorder or its risk of recurrence, or both. This task is similar to the physician's support of a family dealing with any chronic disease or disability. What is unique, perhaps, is the family's perception of the *meaning* of a genetic disorder (Boxes 14-2 and 14-3). In many acquired conditions, such as infec-

Birth of a Child with Trisomy 18

Our daughter Juliett arrived on a beautiful summer afternoon in 1984. Late in my pregnancy, an ultrasound had showed an enlarged heart, dilated left kidney, and possible malformation of the cerebellum. During labor, our daughter's heart rate decelerated significantly, and we were given the option of an emergency C-section. Without hesitation, we opted for the Csection. A drape was hung so that I could not see, and I only knew that the baby was born when the pediatrician ran out of the room with something in his arms. My husband quickly followed, and then I waited for what seemed an eternity.

Juliett weighed 4 pounds, 6 ounces and was 18 inches long. I had graduated as an RN just before Juliett was conceived and had worked in a pediatric ICU. I had just enough experience to pick up a few of her obvious problems, but many escaped me. She was clearly much too thin, and her rib cage looked too short and prominent. But compared to the mental images I had formed after the ultrasound, I was relieved to see how beautiful she was. Her most striking feature was her incredible blue eyes, which were wide open and very alert. Her nose and mouth were beautifully formed and very petite. As my husband and I sat in awe over her, a neonatologist entered the room. He pointed out several characteristics, the only one of which I clearly remember was the clenched fist with the index finger lying over the middle finger. He concluded that she probably had trisomy 18. Of the grim things he rattled off, the only thing I remembered was that he said she would be a vegetable and that she would most likely die within the next couple of days. He then walked away, and we sat there, stunned. In this state of grief and turmoil I tried to understand how this clenched fist could lead to death, and how these bright, alert eyes could belong to a vegetable.

In the days that followed, I often opened up her fist and lay her fingers straight, hoping that the blood tests would not confirm the doctor's suspicions. Our bonding with Juliett had been instant, and our great desire was to be able to take her home before she died. As she began to tolerate feedings and was weaned away from oxygen, our pleas to take her home were granted.

We left with no follow-up or care plan. Each time she went to sleep, we prayed she would wake up again and that we could complete another feeding. At 3 months of age, she started to smile at us, and our hopes brightened. We have been fortunate to see her outlive the grim statistics, and we have learned that there is no clear explanation why some children with this condition live longer than others. Juliett's heart was enlarged because of a defect similar to a tetralogy of Fallot. Mild scoliosis at birth has now progressed to a 100-degree lumbar curve and a 90-degree thoracic curve. Despite her many physical challenges, Juliett has continued at her slower pace to learn and develop new skills. Her personality is delightful, and people are often surprised to see how responsive and interactive she is.

We have often been asked if we were afraid to have more children. Perhaps we were crazy, but we felt that another like Juliett would be great. We have had four more girls. To everyone's surprise, our fifth child, Camille, was born with Down syndrome. With Juliett, the grieving process had been covered up with the gratitude we felt that she was even alive. With Camille, we experienced the more typical grieving process.

On the day of Juliett's birth, a pediatrician came forward, put his arms around us, and told us he thought she was beautiful and to love her for as long as she could be with us. He turned her into a human being with a life to be highly valued. In the 13 years that have followed, Juliett has seen many doctors. Most of them, although they could not cure her problems, gave us the most important thing we needed: to know that our daughter's life was of great worth and that, if they could, they would do anything to help her.

Raising a Child with Bloom Syndrome

BOX

14.3

Tommy was born via an emergency cesarean section, because 1 week before his delivery date his fetal movements markedly decreased. At birth, he weighed only 4 pounds, and the first time that I saw him, he was in an incubator connected to all sorts of tubes. He spent his first month of life in the neonatal intensive care unit so that his weight gain could be closely monitored. Since he was so small, he was fed through a feeding tube for many months, and as a consequence, he refused to drink from a bottle. Eventually, he overcame his aversion to using his mouth to eat but only after substantial training. Nevertheless, despite our care, Tommy remained small for his age.

The following summer, Tommy developed dark red marks on his cheeks and under his eyes. Our pediatrician referred us to a dermatologist, who suspected that the marks on Tommy's face were related to his growth failure. We were very surprised. How could these two findings be related? That is when we were told that Tommy might have a genetic disorder called Bloom syndrome. We hoped that the doctor was wrong, but soon thereafter Tommy had a genetic test that measured the number of sister chromatid exchanges per cell (see Chapter 2). This test confirmed that Tommy had Bloom syndrome. Although I insisted that it was a false-positive result, I learned to accept that our son had a very rare cancer syndrome.

We were barraged by questions from family, friends, and doctors. As a result, we became very protective of our son and his privacy. Nevertheless, there was only so much we could do to protect him because he is such a social little boy,

tions or accidents, the ultimate meaning of the condition is externalized. In genetic disorders, the condition is more intrinsic to the individual and the family; it thus often presents a complex personal dilemma. Validation of the plight of families is vital and is probably more effective than simplistic attempts to wipe away guilt. Feelings of guilt and shame are natural to the situation and also need acknowledgment.

The primary care practitioner plays a vital role in the ongoing support of families in which a member has a genetic disease. Additional support strategies include referral of the family to a lay advocacy group, distribution of up-to-date written information on the disorder, referral to mental health professionals for ongoing counseling, and frequent follow-up visits that include time for discussions of feelings and thoughts.

Genetic counseling includes five themes: medical management, risk determination, risk options, reproductive decision making, and support services.

Numerous studies in the past two decades have attempted to evaluate the effectiveness of genetic counseling. The methodology of these studies is complicated, loving to play with family and friends. This also made choosing an appropriate elementary school a very difficult decision for us. We expected that children would pick on him because of his small size. However, to our surprise, he easily developed friendships and adjusted well to his classmates. In fact, the problems that he did develop were largely because of his misbehavior. Thus, we struggled to find a balance between protecting Tommy while not permitting him special privileges because of his small stature.

In our home, we try to treat Tommy like any of our other children. One challenge for us is that because of Tommy's small size, people wrongly perceive that he is much younger than his chronological age. This is very frustrating for Tommy, yet we occasionally reinforce this image because of our concern for his safety. For example, although Tommy is 6 years old, he weighs only 21 pounds. Thus, he must sit in an infant seat when he travels in a car and we explain to Tommy's friends that it helps him see through the windows. Another safety problem is that many of the sensors for the automatic doors at supermarkets cannot detect his presence and easily slam into him.

Overall, Tommy has adapted well. He climbs or jumps in order to reach things. To keep up with his peers, he often runs, hops, or jumps instead of walking. We constantly worry about his safety, but we cannot control all that happens to him. To date, he has been healthy, and although it seems like we have been riding an emotional roller-coaster, we wouldn't trade our experiences for anything.

and the evaluation of the results depends on one's interpretation of the goal of genetic counseling. A few general points, however, can be made. Families tend to recall recurrence risks relatively well. A letter sent to them after the visit improves this recall. Families who perceive their offspring's condition as being serious and one of "burden" recall risk figures better. Most studies suggest that genetic counseling is relatively effective in providing information about the medical aspects and genetic risks of the condition. Issues surrounding decision making and psychosocial support require additional investigation.

The Delivery of Genetic Counseling: Genetic Counselors and Lay Advocacy Groups

As genetic counseling evolved in the 1970s, it became clear that the delivery of this service is complex and timeconsuming. Not only did the geneticist need to have skills in most specialties of medicine, but facilitation of decision making and provision of psychological support were also necessary. As a need for genetics professionals other than physicians became apparent, a number of genetic counseling training programs were initiated. Currently, more than two dozen accredited programs in North America provide master's or doctoral degree training in genetic counseling. Genetic counselors have become an integral part of the delivery of medical genetic services. From this growth evolved a professional society, The National Society of Genetic Counselors, and, more recently, a certifying and accrediting board, the American Board of Genetic Counseling. Although the range of skills is wide and job descriptions vary in different med-

ical centers, genetic counselors have established themselves as experts in risk determination, reproductive decision making, and psychosocial support (Box 14-4).

Lay advocacy groups can provide critical support in assisting families who have a member with a genetic disorder (see, for example, Genetic Alliance under Internet Resources at the end of this chapter). These groups provide the family with the sense of a "fellow traveler" in a way that the professional is not able to do. The sense of

An Insider's View of Genetic Counseling

What Is a Genetic Counselor?

In its most general usage, the term "genetic counselor" refers to any medical professional who is professionally qualified to provide genetic counseling. Typically, a genetic counselor is a genetics professional with a master's or Ph.D. degree in genetic counseling. Degree programs in genetic counseling provide education and clinical training in medical genetics and counseling. A certified genetic counselor has also passed a certification examination administered by the American Board of Genetic Counseling or the American Board of Medical Genetics.

What Do Genetic Counselors Do?

Some of the primary responsibilities of a genetic counselor are to interview individuals and families with genetic disorders and to answer questions about the possibilities of a genetic disorder. A genetic counselor often works as part of a team that may include medical geneticists, other physicians (e.g., obstetricians, oncologists, neurologists), social workers, psychologists, nutritionists, or nurses. Genetic counselors help to collect and assess medical information leading to a diagnosis, provide patient education, provide psychosocial support and counseling, provide genetic counseling and risk assessment for genetic testing, and help physicians with the management of genetic conditions. They often triage inquiries and referrals to the genetics service in which they practice. They may manage or coordinate clinics and personnel. They are active in genetic education programs for medical professionals and the lay public.

In What Settings Do Genetic Counselors Work?

Genetic counselors often work in general genetics settings in pediatrics and adult medicine. They also work in obstetrical settings, providing counseling for prenatal diagnosis and screening, genetic testing for couples with multiple pregnancy loss, diagnosis and management of pregnancies affected with abnormalities detected by radiological imaging, and, most recently, alternative reproductive technologies. They work in multidisciplinary specialty clinics for groups of diseases (e.g., metabolic, craniofacial, bone dysplasia, neurogenetic) or for single diseases (e.g., Down syndrome, neurofibromatosis, hemophilia). More recently, genetic counselors are becoming increasingly integrated into cancer genetics clinics.

Many counselors participate in research related to clinical genetics and genetic counseling. For example, predictive testing for disorders such as Huntington disease and hereditary cancers has occurred mainly in research studies aimed at assessing the medical, ethical, legal, and social consequences. Within this research setting, genetic counselors provide counseling and help to design, implement, and evaluate research protocols.

Some genetic counselors work in laboratories to provide an interface between the laboratory and its clients and to help develop laboratory protocols. A small percentage of genetic counselors are in private practice, and some work in administrative positions for the state or federal government. Many genetic counselors are active at regional and national levels in professional organizations, and some counselors help to start, maintain, or advise lay advocacy groups for genetic disorders.

What Skills and Personal Qualities Make a Good Genetic Counselor?

A good genetic counselor needs both a strong background in the biological sciences and genetics and training in the theory and practice of psychosocial techniques (e.g., family systems, crisis counseling, interviewing skills). Since most genetic counselors provide direct patient service, it is essential to work well with people. Genetic counselors must work well both independently and on a team. There is a high level of responsibility involved in patient care aspects, and counselors must successfully learn to handle the stress of the difficult situations of the families with whom they work.

What Is the Future of Genetic Counseling?

It is difficult to predict the extent to which medical genetics will continue to move into mainstream medicine. Will geneticists and genetic counselors increase in number, or will genetics professionals remain small in number and limit their role to advising generalists and seeing only the most complicated cases? In either case, there is clearly a need for an increase in the genetic education of medical professionals and the public. Many observers think that medical genetics and genetic counseling have a high potential for expansion. What is undisputed is the striking emergence of medical genetics from an obscure medical subspecialty to an area of knowledge that is fast becoming integrated into every field of medicine.

(Courtesy of Bonnie J. Baty, M.S.)

isolation that frequently accompanies genetic disorders (and rare conditions in general) is often alleviated by meeting someone else in the same situation. Immediate bonds are formed that often assist in the coping process. In the last few decades, a clear partnership of professionals and persons with genetic disorders and disabilities has developed. Not only have these groups provided a needed service, but they also have promoted the establishment of databases and research studies. Referral to a lay advocacy group and distribution of their written information are now a routine part of the care and management of genetic disorders. www

Genetic counseling involves a partnership of physicians, genetic counselors, and lay advocacy groups.

Clinical Genetics Evaluation and Services

With the development of medical genetics as a medical specialty, clinical genetics services have become part of the health care delivery system. Most university medical centers in North America include a genetics clinic whose major objective is the provision of genetic diagnosis and counseling services.

As in all medical visits, evaluation of a person or family for a potential genetic condition requires a thorough history and physical examination. The history includes information about the family's concerns, the prenatal period, labor, delivery, and documentation of family relationships (the pedigree). The physical examination should focus on the physical variations or minor anomalies that provide clues to a diagnosis. Additional family members may need evaluation for the presence or absence of a genetic disorder. Photographs and recording of certain physical measurements are a standard component of the genetic evaluation. Ancillary tests may be required to document specific physical features (e.g., an echocardiogram for aortic dilatation in Marfan syndrome or radiographs to diagnose achondroplasia).

An important type of clinical data gathered in this process is the family history (Box 14-5). The data obtained in a family history are often useful in obtaining an accurate diagnosis of a condition. For example, a strong family history of early-onset coronary disease may indicate the presence of a low-density lipoprotein-receptor defect causing familial hypercholesterolemia. A family history of early-onset colon cancer could indicate that a gene for familial adenomatous polyposis or hereditary nonpolyposis colorectal cancer is present in the family. Family history information can also guide the estimation of recurrence risks by helping to determine whether a genetic disease has been transmitted by one's parents or has occurred as a new mutation (this is especially important for diseases with reduced penetrance). The knowledge and skills required to take an accurate and thorough family history are important for all clinicians, not only clinical geneticists.

Routinely, the clinician sends the family a letter summarizing the diagnosis, natural history, and risk information regarding the condition. This letter is a valuable resource for the family, because it helps to document the risk information for later review. Information regarding lay advocacy groups, including pamphlets, booklets, and brochures, is frequently provided. Follow-up visits are recommended depending on the individual situation. Box 14-6 provides a list of clinical genetics services.

Clinical genetic evaluations include physical examination, detailed family history, ancillary tests as needed, and communica-

The Family History

A thorough, accurate family history is an indispensable part of a medical evaluation, and a pedigree should be part of the patient's chart. At a minimum, the following items should be included:

- 1. The gender of each individual and his or her relationship to other family members. This information should be indicated using standard pedigree symbols (see Chapter 4).
- 2. A three-generation family history should be obtained. For example, male relatives on the mother's side of the family will be especially important when considering an X-linked recessive disorder.
- 3. The age of each individual. A record must be kept of whether each individual is affected with the disease in question, and inquiries should be made about diseases that may be related to the disease in question (e.g.,

ovarian cancer in a family being seen for familial breast cancer).

- 4. All known miscarriages and stillbirths.
- The ethnic origin of the family. This is important because many diseases vary considerably in prevalence among different ethnic groups.
- 6. Information about consanguinity. While relatively rare in most Western populations, consanguinity is common in many of the world's populations, and immigrant populations often maintain relatively high rates of consanguinity (see Chapter 4).
- Changes in family histories. Family members develop newly diagnosed diseases, and additional children are born. These changes can affect diagnosis and risk estimation, so the family history and pedigree should be updated periodically.

tion of information to the family through letters and the distribution of published literature.

In recent years, the care of persons with genetic disease has included the development of guidelines for follow-up and routine care. Knowledge of the natural history of a condition, coupled with a critical review of screening tests and interventions, can provide a framework for health supervision and anticipatory guidance. The management plan can subsequently be used by the primary care provider. It is primarily for this purpose that many of the specialized clinics, such as those for NF1 or hemophilia, have been established. An example of this approach is the management checklist for the health maintenance of infants and children with Down syndrome (see Chapter 6).

Traditionally, genetic counseling involves the family who comes in with questions about the diagnosis, management, and recurrence risk of the condition in question. Thus, in the majority of situations, genetic counseling is carried out retrospectively. With the increased availability of prenatal, carrier, and presymptomatic testing, "prospective" genetic counseling will become more common. Box 14-7 lists common reasons for referral for genetic evaluation.

BOX 14.7

Common Indications for Genetics Referral

- 1. Evaluation of a person with mental retardation or developmental delay
- 2. Evaluation of a person with single or multiple malformations; question of a dysmorphic syndrome
- 3. Evaluation of a person with a possible inherited metabolic disease
- 4. Presence of a possible single-gene disorder
- 5. Presence of a chromosomal disorder, including balanced rearrangements
- 6. Person at risk for a genetic condition, including questions of presymptomatic diagnosis or cancer risk
- 7. Person or family with questions about the genetic aspects of any medical condition
- 8. Couples with a history of recurrent miscarriages
- 9. Consanguinity in a couple, usually first cousin or closer relationship
- 10. Teratogen counseling
- 11. Preconceptional counseling and risk factor counseling, including advanced maternal age and other potential indications for prenatal diagnosis

DYSMORPHOLOGY AND CLINICAL TERATOLOGY

Dysmorphology was defined at the beginning of this chapter as the study of abnormal physical development (morphogenesis). Congenital defects are caused by altered morphogenesis. Although the term "dysmorphology" may seem synonymous with **teratology**, the latter term usually implies the study of the environmental causes of congenital anomalies, even though its literal meaning does not refer to etiology. (The term teratology is derived from *teras*, the Greek word for "monster." The newer term, dysmorphology, was partly a reaction to the pejorative connotation of teratology.)

As mentioned previously, congenital defects represent an important cause of infant mortality and morbidity. Current studies indicate that the frequency of medically significant malformations diagnosed in the newborn period is 2% to 3%. Investigations that have observed children for a longer period demonstrate that this frequency increases to 3% to 4% by the age of 1 year. In the United States, congenital malformations represent the most frequent cause of mortality during the first year of life. Table 14-1 lists some of the most common and important malformation syndromes.

There are several ways in which congenital defects can be classified. The most common classification approach is by organ system or body region (e.g., craniofacial, limb, heart). More clinically useful systems of classification

Syndromes	Etiology	
Down syndrome	Chromosomal	
Neurofibromatosis type 1	Single gene (AD)	
Oligohydramnios sequence	Heterogeneous	
Amnion disruption sequence	Unknown	
Osteogenesis imperfecta	Single gene; heterogeneous; type I collagen	
Trisomy 18	Chromosomal	
VATER association	Unknown	
Marfan syndrome	Single gene (AD)	
Prader-Willi syndrome	Microdeletion of chromosome 15q uniparental disomy	
Noonan syndrome	Single gene (AD)	
Williams syndrome	Microdeletion of chromosome 7	
Achondroplasia	Single gene (AD)	
Trisomy 13	Chromosomal	
Turner syndrome	Chromosomal (45,X)	
Rubinstein-Taybi syndrome	Single gene (AD)	
Klippel-Trenaunay-Weber syndrome	Unknown	
Fetal alcohol syndrome	Excessive alcohol	
Cornelia de Lange syndrome	Unknown	

TABLE 14.1 The Most Common Multiple Congenital Anomaly/Dysplasia Syndromes

AD, autosomal dominant.

Adapted from Hall BD (1981) Genetic Issues in Pediatrics and Obstetrics. Chicago: Practice Yearbook.

include (1) single defect versus multiple congenital anomaly syndrome, (2) major (medically or surgically significant defects) versus minor anomalies, (3) categorization by pathogenic process, and (4) an etiological classification.

Table 14-2 lists the causes of main defects in a major study conducted in Boston. Three key messages emerged from these data: (1) the etiology of two thirds of congenital defects is unknown or multifactorial; (2) wellestablished environmental causes of congenital malformations are infrequent; and (3) a known genetic component is identified in approximately 30% of cases.

Principles of Dysmorphology

In discussing the basic principles of dysmorphology, it is important to define certain key terms. The following definitions, based on pathogenic processes, are used in clinical practice:

1. **Malformation**, a primary morphologic defect of an organ or body part resulting from an intrinsically abnormal developmental process (e.g., cleft lip, polydactyly).

- 2. Dysplasia, a primary defect involving abnormal organization of cells into tissue (e.g., vascular malformation).
- 3. **Sequence**, a primary defect with its secondary structural changes (e.g., Pierre Robin sequence, a disorder in which a primary defect in mandibular development produces a small jaw, secondary glossoptosis, and a cleft palate).
- 4. **Syndrome**, a pattern of multiple primary malformations with a single etiology (e.g., trisomy 13 syndrome).
- 5. **Deformation**, alteration of the form, shape, or position of a normally formed body part by mechanical forces; usually occurs in the fetal period, not in embryogenesis; a secondary alteration; can be extrinsic, as in oligohydramnios (reduced amniotic fluid), or intrinsic, as in congenital myotonic dystrophy.
- 6. **Disruption,** a morphological defect of an organ, part of an organ, or a larger region of the body resulting from the extrinsic breakdown of, or interference with, an originally normal developmental process; a secondary malformation (e.g., secondary limb defect resulting from a vascular event).

Note that malformations and dysplasias are primary events in embryogenesis and histogenesis, whereas disruptions and deformations are secondary.

When evaluating a child with a congenital malformation, the most important question is whether the abnormality represents a single, isolated anomaly or is instead one component of a broader, organized pattern of malformation (i.e., a syndrome). An example is given by the evaluation of a baby with a cleft lip. If a baby has an isolated, nonsyndromic cleft lip and no other malforma-

TABLE 14.2 Causes of Malformations Among Affected Infants

Genetic cause	Number*	Percentage
Chromosome abnormalities	157 (45)	10.1
Single mutant genes	48	3.1
Familial	225 (3)	14.5
Multifactorial inheritance	356 (23)	23.0
Teratogens	49	3.2
Uterine factors	39 (5)	2.5
Twinning	6 (2)	0.4
Unknown cause	669 (24)	43.2
Total	1,549 (102)	

*Values in parentheses denote therapeutic abortions; of the 69,277 infants studied, 1,549 had malformations, for an incidence of 2.24%. From Nelson K, Holmes LB (1989) Malformations due to spontaneous mutations in newborn infants. N Engl J Med 320:19–23.

tions, the discussion of natural history, genetics, prognosis, and management is markedly different than if the baby's cleft lip is one feature of the trisomy 13 syndrome (see Chapter 6). The former condition can be repaired surgically and has a relatively low recurrence risk (see Chapter 12) and few associated medical problems. Trisomy 13 is a serious chromosomal disorder. In addition to oral-facial clefts, these infants often have congenital heart disease and central nervous system malformations. More importantly, 50% of children with trisomy 13 die in the newborn period, and 90% die before 1 year of age.

Another example is a child with cleft lip who also has pits or fistulas of the lower lip. The combination of oralfacial clefts and lip pits signifies an autosomal dominant condition called the van der Woude syndrome. Although the natural history of this condition differs little from that of nonsyndromic cleft lip, the discussion of genetic recurrence risks is much different. In the evaluation of a child with van der Woude syndrome, it is very important to determine whether one of the parents carries the gene. If so, the sibling recurrence risk is 50%. This is much greater than the 4% sibling recurrence risk usually given for nonsyndromic cleft lip. Because van der Woude syndrome has highly variable expression and frequently is manifested only by lip fistulas, it is quite commonly overlooked. Thus, a careful physical examination, combined with a knowledge of the genetics of isolated malformations and syndromes, is necessary to determine accurate recurrence risks.

The most important question to ask when evaluating a child with a congenital malformation is whether the defect is isolated or part of a syndrome pattern.

Increasing knowledge of the pathogenesis of human congenital defects has led to a better understanding of the developmental relationship of the defects in multiple congenital anomaly patterns. Some well-established conditions that appear to be true syndromes at first glance are really a constellation of defects consisting of a primary malformation with its secondary effects (i.e., a sequence). In a sequence, the pattern is a developmental unit in which the cascade of secondary pathogenic events is well understood. In contrast, the pathogenic relationship of the primary malformations in a syndrome is not as well understood, although pathogenesis may be clarified when the syndrome is the result of the pleiotropic effects of a single gene (e.g., Marfan syndrome; see Chapter 4).

One of the best examples of a sequence is the so-called Potter phenotype or oligohydramnios sequence. It is currently believed that any significant and persistent condition leading to oligohydramnios can produce this sequence, whether it be intrauterine renal failure due to kidney malformations or chronic leakage of amniotic fluid. The fetus will develop a pattern of secondary growth deficiency, joint contractures, facial features, and pulmonary hypoplasia (Fig. 14-5). Before the cause of these features was understood, the phenotype was termed the "Potter syndrome." Now, with the understanding that all of the features are secondary to oligohydramnios, the disorder is more properly called the oligohydramnios sequence. As with any malformation, the renal defect can occur by itself, or it can be a part of any number of syndromes in which renal malformations are component features (such as autosomal recessive Meckel-Gruber syndrome or the more common nonsyndromic disease, bilateral renal agenesis). Distinguishing between syndromes and sequences can often improve understanding of the underlying cause of a disorder. www

It is important to distinguish between a sequence, which is a primary defect with secondary structural changes, and a syndrome, which is a collection of malformations whose relationship to one another tends to be less well understood.

Clinical Teratology

A **teratogen** is an agent external to the fetus's genome that induces structural malformations, growth deficiency, and/or functional alterations during prenatal development. Although teratogens cause only a small percentage of all birth defects, the preventive potential alone makes them worthy of study. Table 14-3 lists the wellestablished human teratogens.

It is important to understand the reasoning process that leads to the designation of a substance as a teratogen. This process is based on an evaluation of epidemiologi-

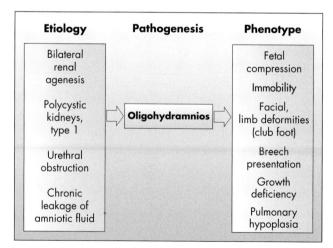

FIGURE 14.5 The oligohydramnios sequence. Oligohydramnios can arise from a number of distinct causes. It produces a constellation of secondary phenotypic features.

Drug	Potential defect	Critical exposure period	% of those exposed who are affected
Angiotensin-converting enzyme (ACE) inhibitors	Renal dysgenesis; oligohydramnios; skull ossification defects	Second to third trimester	NE
Alcohol, chronic	Craniofacial and central nervous system anomalies; heart defects	<12 wk	10-15
	Low birth weight; developmental delay	>24 wk	NE
Aminopterin	Spontaneous abortion Craniofacial anomalies; limb defects; craniosynostosis; neural tube defects Low birth weight	<14 wk First trimester >20 wk	NE
High-dose androgens/ norprogesterones	Masculinization of external female genitalia	>10 wk	0.3
Carbamazepine	Spina bifida	<30 days after conception	≈1
Carbimazole/methimazole	Hypothyroidism; goiter	NE	NE
Cocaine	Abruptio placentae Intracranial hemorrhage; premature labor/ delivery	Second to third trimester Third trimester	NE
Diethylstilbestrol	Uterine abnormalities; vaginal adenosis; vaginal adenocarcinoma; cervical ridges; male infertility	<12 wk	NE
Fluconazole (high-dose)	Limb and craniofacial defects	First trimester	NE
Isotretinoin	Fetal death; hydrocephalus; central nervous system defects; microtia/anotia; small or missing thymus; conotruncal heart defects; micrognathia	>15 days after conception	45-50
Lithium	Ebstein abnormality	<8 wk	<1
Methotrexate	Craniosynostosis; underossified skull; craniofacial dysmorphology; limb defects	6–9 wk after conception	NE
Penicillamine	Cutis laxa, joint contractures	NE	NE
Phenytoin	Craniofacial anomalies; hypoplastic phalanges/nails	First trimester	10-30
Solvents, abuse (entire pregnancy)	Small size for gestational age; developmental delay		NE
Streptomycin	Hearing loss	Third trimester	NE
Tetracycline	Stained teeth and bone	>20 wk	NE
Thalidomide	Limb deficiencies; ear anomalies	38–50 days post-LMP	15-25
Thiouracil	Spontaneous abortion Stillbirth Goiter	First trimester >20 wk	NE
Trimethadione	Developmental delay; V-shaped eyebrows; low-set ears; irregular teeth	First trimester	NE
Valproic acid	Spina bifida Craniofacial anomalies; preaxial defects	<30 days after conception First trimester	<1
Warfarin	Nasal hypoplasia; stippled epiphyses Central nervous system defects secondary to cerebral hemorrhage	6–9 wk >12 wk	NE

TABLE 14.3 Well-Established Human Teratogens*

*Other established teratogens include maternal infections (rubella, cytomegalovirus, toxoplasmosis, varicella, Venezuela equine encephalitis, syphilis, parvovirus), maternal disease states (diabetes mellitus, phenylketonuria, systemic lupus erythematosus, Graves disease), and ionizing radiation. NE, not established; post-LMP, after last menstrual period. Adapted from Martinez LP, Robertson J, Leen-Mitchell M (2002) Environmental causes of birth defects. In: Rudolph CD, Rudolph AM, Hostetter MK,

Lister G, Siegel NM (eds) Rudolph's Pediatrics, 21st ed. McGraw-Hill, New York, pp 774–779.

cal, clinical, biochemical, and physiological evidence. Animal studies may also help to establish whether an agent is teratogenic.

Some of the issues involved in determining whether an agent is teratogenic are summarized in Clinical Commentary 14-4. A key clinical point is that it is common for families to ask their doctors questions about the risks of certain exposures during pregnancy. When faced with such a question, the physician has a number of options. One is to review the literature on particular exposures in humans, make a judgment regarding the degree of risk, and then provide counseling. An alternative is to refer the patient to a teratology information service or to a clinical genetics unit. Because of the complexity of these issues, teratology information services have sprung up throughout the United States, Canada, and Europe.

Teratogens are external agents that cause a small but important proportion of congenital malformations. It is often difficult to prove conclusively that a substance is teratogenic.

CLINICAL COMMENTARY 14.4

The Bendectin Saga

Bendectin, or doxyclamine, was an agent introduced in the 1960s for "morning sickness" (nausea and vomiting during pregnancy). The agent was particularly efficacious, and during the 1970s about one third of American women took Bendectin at some time during their first trimester of pregnancy.

Bendectin has probably been studied more than any other individual pregnancy medication. Several epidemiological studies have found no conclusive evidence of an increased risk of congenital malformations with use of Bendectin during pregnancy. The few studies that have demonstrated weak associations between Bendectin and birth defects did not reveal any consistent patterns. Animal studies also indicate no association. Despite these data, a number of lawsuits were filed in the 1980s against the company that marketed Bendectin. As a result, the company removed the drug from the market.

The reasoning process used to determine causation in such cases is complex. Before judgments about etiology are made, a critical review of the literature is required. The available epidemiological studies must be evaluated in terms of their methodology, design, and biases. Up-to-date knowledge of the etiology and pathogenesis of congenital malformations must be included in the design of the study. The basic principles of teratology must be applied. This includes an evaluation of the critical period (i.e., did exposure occur during the period of pregnancy in which the malformed fetal structures were developing?). Clinical evidence includes the search for a pattern of defects (i.e., a specific syndrome), because all well-established teratogens produce consistent patterns (see Table 14-3). Animal models never prove causation in humans but can provide supportive evidence and information about pathogenesis. In addition, the proposed effect of the agent should be biologically plausible.

A review of the evidence regarding Bendectin shows that it meets none of these criteria. Indeed, because of its extensive testing, Bendectin satisfies standard criteria for "safety" as well as any known medication. What, then, could have produced this litigation? An important part of the answer to this question involves the coincidental occurrence of congenital malformations and Bendectin exposure. Considering that 3% of infants will be diagnosed with a major congenital malformation by 1 year of age and that about one third of women were taking Bendectin in the first trimester of pregnancy, then about 1% (1/3 \times 3%) of all pregnancies in the 1970s would have experienced the co-occurrence of these two events by chance alone. Because about two thirds of congenital malformations have no known cause, it is not surprising that many families of children with these disorders (and their lawyers) would attribute them to Bendectin use.

Bendectin was removed from the market in 1983. Since then, the proportion of babies born with congenital malformations has remained the same, and the number of women admitted to hospitals for complaints of morning sickness has doubled.

It is very difficult to prove epidemiologically that any exposure is "safe." The statistical power of such studies does not permit an absolute statement that there is no effect. All that can be demonstrated is that there is no definitive evidence that a particular agent (in this case, Bendectin) causes an adverse outcome. Blanket reassurance or absolute statements of complete safety are not appropriate. On the other hand, when the evidence is relatively conclusive, as in the case of Bendectin, it is clinically appropriate to have a reassuring tone in discussing exposure in the pregnancy setting.

Prevention of Congenital Malformations

Because the majority of structural defects have no obvious cause, their prevention presents a challenge. An example is fetal alcohol syndrome, one of the more common preventable causes of human malformation (Clinical Commentary 14-5). The institution of rubella immunization programs and, more recently, the preconceptional administration of folic acid are both examples of successful prevention (Clinical Commentary 14-6).

Preconceptional counseling is a model for primary prevention. Women who have diabetes mellitus, phenylketonuria, or systemic lupus erythematosus (an autoimmune disorder involving production of autoantibodies that affect multiple organs) can decrease their risk of producing an infant with a structural defect through appropriate preconceptional management. Secondary and tertiary levels of prevention occur, respectively, with newborn screening and with the provision of quality medical care for infants and children with congenital malformations. The institution of appropriate guidelines for health supervision and anticipatory guidance can decrease some of the complications of these disorders. Also important is public education regarding the limitations of scientific knowledge and the emotional difficulties of families in which a child has a congenital defect. Such information has the potential to diminish anxiety, improve the family's coping process, and reduce the stigma that surrounds congenital malformations and genetic disorders.

BIOETHICS AND MEDICAL GENETICS

With new discoveries and advances in medical technology come new choices for patients, families, and society. As medical genetics came to be defined as a medical specialty during the last four decades, a number of new issues in bioethics also emerged. Because of the significance and complexity of these issues, a significant portion

CLINICAL COMMENTARY 14.5

Fetal Alcohol Syndrome

Among the human teratogens, one of the most common and potentially preventable exposures is excessive alcohol consumption. Women who are chronic alcoholics are at significant risk of bearing a child with the fetal alcohol syndrome (FAS). This condition consists of prenatal and postnatal growth deficiency, microcephaly (small head), a wide range of developmental disabilities, and a constellation of facial alterations (Fig. 14-6). The more distinctive and consistent facial features include short palpebral fissures, low nasal root, upturned nose, simple/flat philtral folds, and a thin upper lip. Although most of these signs are not specific for FAS, their mutual occurrence in the context of maternal alcohol abuse allows the clinician to make the diagnosis. www

In addition to these findings, infants and children with FAS are at risk for a number of structural defects, including congenital heart defects, neural tube defects, and renal malformations. Most children with FAS have a mild degree of developmental delay, ranging from mild mental retardation to learning disabilities.

There are still many unanswered questions regarding alcohol use in pregnancy. These include the extent of genetic predisposition to FAS, the risk of binge drinking, the role of moderate and social drinking, and the safe level of alcohol in pregnancy. While there is no conclusive evidence that light to moderate drinking in early pregnancy is harmful, avoidance of alcohol during pregnancy is the most prudent approach.

FIGURE 14.6 A 2-year-old child with fetal alcohol syndrome. Note the low nasal root, short palpebral fissures, smooth philtrum, and thin upper lip.

CLINICAL COMMENTARY 14.6 Folate and the Prevention of Neural Tube Defects

The primary prevention of congenital malformations is an important goal of clinical genetics. Because the ultimate cause of most congenital malformations is currently unknown, there are relatively few opportunities for primary prevention. A recent approach to the prevention of congenital malformations is the periconceptional use of folate and multivitamin regimens to prevent the occurrence and recurrence of neural tube defects (NTDs).

NTDs consist of malformations of the developing neural tube and express themselves as anencephaly, encephalocele, and spina bifida (see Chapter 12). Their impact is serious: anencephaly is invariably fatal, and the medical complications of spina bifida (lower limb paralysis, hydrocephalus, urinary obstruction) are significant. Because of the potential influence of nutritional elements on embryogenesis, a series of epidemiological studies were performed in the 1970s and 1980s. With one exception, they demonstrated that the use of vitamins and folate in the periconceptional period reduced the recurrence risk of spina bifida and anencephaly in families that had previously had a child with one of these conditions. In 1991 the Medical Research Council of the United Kingdom published a double-blind study* in which 4 mg of folate with or without vitamins was administered to women who had had a child with an NTD. The group receiving folate alone experienced a 70% reduction in the recurrence of these malformations in their offspring. In 1992, a Hungarian group demonstrated the usefulness of vitamins and folic acid in preventing the initial occurrence of NTDs. In this study, two groups of women, one receiving vitamins and folic acid and the other not, were followed for the duration of their pregnancies. The vitamin/folic acid regimen significantly decreased the occurrence of NTDs.

While it is still not clear whether the purported protective effect is due to folic acid or a combination of folic acid and other vitamins, these data suggest that periconceptional vitamin use is an effective prevention strategy. The mechanism for the apparent effect remains unknown. Nonetheless, the encouraging results of these studies have prompted the Centers for Disease Control and Prevention to publish two recommendations regarding the use of folate. The first is that all women who have previously had a child with an NTD should take 4 mg/day of folic acid if they are planning to become pregnant. The second recommendation is that all women of reproductive age should take 0.4 mg/day of folic acid (the amount available in a typical multivitamin tablet) throughout their reproductive years. The latter recommendation is prudent in light of the fact that approximately half of pregnancies in the United States are unplanned. These recommendations have led to the folic acid fortification of wheat and other grain products in the United States.

of the budget of the Human Genome Project has been devoted to the "Ethical, Legal, and Social Implications" (ELSI) of human genetics. Some of these implications have been touched upon previously in this textbook (e.g., genetic testing, gene therapy, embryonic stem cell research). Our goal here is not to provide an exhaustive treatment of these issues but instead to present a sampling of the major chical questions currently confronting the genetics community.

The combination of advances in prenatal diagnosis (e.g., ultrasound, amniocentesis), the ability to determine the human karyotype, and the option of pregnancy termination set the stage for the rise of prenatal diagnosis as a clinical service in the 1970s. By that time, most tertiary medical centers in developed nations offered amniocentesis for various indications, most commonly advanced maternal age (see Chapter 13). In the early discussions of the ethics of prenatal diagnosis, the central controversy involved a woman's (or couple's) right to terminate a pregnancy. In the 1990s, the issue took on a new dimension with the concern that persons with disabilities may be devalued by society when prenatal diagnosis can lead to the selective termination of fetuses with a disability. Similar concerns revolve around the issue of withdrawal of support for newborns with severe birth defects (e.g., trisomy 13, some neural tube defects). The main principles guiding decisions about these issues are to consider the interests of the child and to provide genetic counseling so that the parents can make an informed decision.

Ethical concerns have arisen about other types of genetic testing, including carrier testing and presymptomatic testing (see Chapter 13). Genetic tests differ from other types of medical testing because genes (including mutations that predispose to disease) can be shared in families. Thus, a genetic test performed in one individual may reveal risk information about a relative who may not wish to know about his or her risk (e.g., testing of a young adult for an autosomal dominant disease may indi-

^{*}A **double-blind** study is one in which, during the treatment phase of the study, neither the subjects nor the investigator knows which subjects are receiving an active ingredient and which are receiving placebo.

cate that one of the parents must have transmitted the gene). In addition, many people perceive that their genetic inheritance is very much an intrinsic part of themselves (and their families). Genetic risk is often misperceived as "unchangeable." All of these factors can lead to unfair stigmatization of individuals, families, and even whole populations. To help counter this, care providers must be sensitive to the needs and concerns of individuals and their families. They should avoid making value judgments that could lead to or reinforce stigmatization. They should dispel notions of genetic determinism, making it clear to families that genes are but one part of disease causation. Nongenetic factors, which often can be altered, can also play an important role. As with all medical information, privacy and confidentiality must be respected.

More recently, preimplantation genetic testing (see Chapter 13) has been the focus of ethical debates. For example, this form of testing could be used to determine the sex of an embryo. Indeed, an early application was to avoid implanting male embryos that had an increased risk of carrying an X-linked recessive mutation. Many scientists and ethicists believe that preimplantation diagnosis solely for sex selection is inappropriate, and the practice is currently banned in the United Kingdom. Preimplantation diagnosis could also be used to select preferentially for embryos that do carry disease-causing mutations. For example, an embryo that is homozygous for mutations causing autosomal recessive deafness could be selected to match the phenotypes of deaf parents (a recent case was reported in which deaf parents deliberately conceived a deaf child by artificial insemination). Such applications may put the interests of the parents and the interests of the child in conflict. Another controversial application of preimplantation diagnosis was in the selection of a human leukocyte antigen (HLA)matched embryo that could later provide bone marrow cells for an older sibling who had Fanconi anemia. Such individuals could feel that their life was devalued because they had been selected partly on the basis of their suitability as a bone marrow donor.

Questions have arisen about the genetic testing of children. When such testing can lead to useful diagnostic measures or interventions, it may be warranted. An example would be the genetic testing of children at risk for inheriting a mutation in the adenomatous polyposis coli (*APC*) gene. As discussed in Chapter 11, colonoscopy should begin in gene carriers by age 12 years and is potentially life-saving. In contrast, childhood diagnosis of Huntington disease provides no preventive or therapeutic benefits and serves only to increase the potential for anxiety and stigmatization. A consensus has emerged that childhood genetic testing should not be pursued unless it provides an avenue to clinically beneficial intervention.

Genetic testing also raises the specter of discrimination on the part of insurance companies or employers. Insurance companies have long collected information about family history as a means of assessing risk. In some cases (e.g., an individual at risk for inheriting a BRCA1 mutation), a genetic test can provide a much more accurate measure of disease risk. At-risk individuals are understandably concerned about the possibility of losing their insurance benefits or their employment because of the outcome of a genetic test. A paradoxical result is that some choose not to be tested, even when it could lead to a potentially life-saving intervention. Insurance providers and employers reason that it is in the general interest to hold costs to a minimum. Others respond that, unlike lifestyle choices such as cigarette smoking or exercise, one does not choose one's genes, so it is unfair to discriminate on the basis of genetic tests. Many states in the United States have passed legislation to prevent discrimination based on genetic tests, and federal legislation has also been proposed.

Intense controversy has surrounded the issues of cloning and embryonic stem cell research (see Chapter 13). It is important to repeat the distinction between reproductive cloning and therapeutic cloning. Because of the high failure rate of reproductive cloning in other mammals, and because the benefits of reproductive cloning are unclear, the scientific community is nearly unanimous in its opposition to the creation of human beings through reproductive cloning. The use of cloning to create embryonic stem cells for therapeutic purposes (e.g., pancreatic islet cells for patients with diabetes or neurons for those with Alzheimer disease) is more controversial and, like pregnancy termination, involves highly charged questions about the definition of human life and the limits of medical intervention. As noted in Chapter 13, these issues require informed and thoughtful input from the scientific community and from patient advocacy groups, ethicists, philosophers, legal scholars, the clergy, and others.

The science of genetics is no stranger to controversy and even to abuse. The **eugenics** movement (Greek, "good birth"), popular in the United States and some European countries in the early part of the 20th century, advocated both "positive eugenics" (preferential reproduction of those deemed to be genetically more fit) and "negative eugenics" (the prevention of reproduction of those thought to be genetically less fit). Eugenics, in concert with the political thinking of the times, led to a series of abuses that culminated in the atrocities of Nazi Germany. These events are a sobering reminder of the potential for misuse of genetic information. Geneticists must help to ensure that their science is used for maximum benefit while adhering to the time-honored maxim, *primum non nocere* ("first, do no harm").

SUGGESTED READINGS

Aase J (1992) Dysmorphologic diagnosis for the pediatric practitioner. Pediatr Clin North Am 39:135-156

- Allanson JE, Cassidy SB (eds) (2000) Management of Genetic Syndromes. John Wiley, New York
- Baker DL, Schuette JL, Uhlmann WR (1998) A Guide to Genetic Counseling. John Wiley, New York
- Biesecker BB (2001) Goals of genetic counseling. Clin Genet 60:323-330
- Biesecker BB, Peters KF (2001) Process studies in genetic counseling: peering into the black box. [Special issue on genetic counseling.] Am J Med Genet 106:191-198
- Brent RL (1983) The Bendectin saga: an American tragedy. Teratology 27:283-286
- Carey JC, Viskochil DH (2002) Status of the human malformation map: 2002. Am J Med Genet 115:205-220
- Clarke A (2002) Ethical and social issues in clinical genetics. In: Rimoin DL, Connor JM, Pyeritz RE, Korf BR (eds) Emery and Rimoin's Principles and Practice of Medical Genetics, 4th ed. Vol 1. Churchill Livingstone, New York, pp 897-928
- Cohen MM (1997) The Child with Multiple Birth Defects. Oxford University Press, New York
- Daly LE, Kirke PN, Molloy A, Weir DG, Scott JM (1995) Folate levels and neural tube defects: implications for prevention. JAMA 274:1698-1702
- Donnai D (2002) Genetic services. Clin Genet 61:1-6
- Epstein CJ (1995) The new dysmorphology: application of insights from basic developmental biology to the understanding of human birth defects. Proc Natl Acad Sci U S A 92:8566-8573
- Friedman JM, Polifka JE (1994) Teratogenic effects of drugs: a resource for clinicians (TERIS). Johns Hopkins University, Baltimore
- Gorlin RJ, Cohen MM, Hennekam RCM (2001) Syndromes of the Head and Neck, 4th ed. Oxford University Press, New York
- Hall BD (1982) The 25 most common multiple genetical anomaly syndromes. In: Kaback MM (ed) Genetic Issues in Pediatrics and Obstetrics. Practice Yearbook, Chicago
- Harper PS (1998) Practical Genetic Counselling, 5th ed. Butterworth Heineman, Oxford
- Hodge SE (1998) A simple, unified approach to Bayesian risk calculations. J Genet Counseling 7:235-261
- Hunter AG (2002) Medical genetics: 2. The diagnostic approach to the child with dysmorphic signs. CMAJ 167:367-372
- Jones KL (1997) Smith's Recognizable Patterns of Human Malformation, 5th ed. WB Saunders, Philadelphia
- Koren G, Pastuszak A, Ito S (1998) Drugs in pregnancy. N Engl J Med 338:1128-1137
- Mahowald MB, Verp MS, Anderson RR (1998) Genetic counseling: clinical and ethical challenges. Annu Rev Genet 32:547-559
- Martinez LP, Robertson J, Leen-Mitchell M (2002) Environmental causes of birth defects. In: Rudolph CD, Rudolph AM, Hostetter MK, Lister G, Siegel NM (eds) Rudolph's Pediatrics, 21st ed. McGraw-Hill, New York, pp 774-779

- Nelson K, Holmes LB (1989) Malformations due to presumed spontaneous mutations in newborn infants. N Engl J Med 320:19-23
- Nowlan W (2002) Human genetics: a rational view of insurance and genetic discrimination. Science 297:195-196
- Polifka JE, Friedman JM (2002) Medical genetics: 1. Clinical teratology in the age of genomics. CMAJ 167:265-273
- Ptacek JT, Eberhardt TL (1996) Breaking bad news: a review of the literature. JAMA 276:496-503
- Rothenberg KH, Terry SF (2002) Human genetics: before it's too late—addressing fear of genetic information. Science 297:196-197
- Schneider KA (2001) Counseling About Cancer: Strategies for Genetic Counselors, 2nd ed. John Wiley, New York
- Walker AP (2002) Genetic counseling. In: Rimoin DL, Connor JM, Pyeritz RE, Korf BR (eds) Emery and Rimoin's Principles and Practice of Medical Genetics, 4th ed. Vol 1. Churchill Livingstone, New York, pp 842-874
- Weil J (2000) Psychosocial Genetic Counseling. Oxford University Press, New York
- Weiss JO, Mackta JS (1996) Starting and Sustaining Genetic Support Groups. Johns Hopkins University Press, Baltimore
- Winter RM (1996) Analysing human developmental abnormalities. BioEssays 18:965-971
- World Health Organization (1998) Proposed International Guidelines and Ethical Issues in Medical Genetics and Genetic Services. (Document WHO/HGM/GL/ETH/18.1)

INTERNET RESOURCES

Gene Clinics (reviews of genetic diseases and laboratories that perform them)

http://www.geneclinics.org/

Genetic Alliance (descriptions of genetic conditions, information on health insurance, and links to lay advocacy groups) *http://www.geneticalliance.org/*

Genetic and rare disease lay advocacy groups (links to lay advocacy groups for a large series of genetic disorders) http://www.kumc.edu/gec/support/

Genetic Interest Group (alliance of organizations, with a membership of more than 120 charities that support children, families, and individuals affected by genetic disorders) http://www.gig.org.uk/

London Dysmorphology Database (paid subscription required) http://www.oup.co.uk/ep/prodsupp/medical/ldd/

National Institutes of Health Office of Rare Diseases (information on more than 6,000 rare diseases) http://rarediseases.info.nih.gov/

POSSUM (computer-aided diagnosis of genetic disorders and other syndromes; paid subscription required) http://www.possum.net.au/

325

STUDY QUESTIONS

- Allen, a 40-year-old man, comes to your office because he is concerned about his family history of heart disease. His father had a fatal myocardial infarction (MI) at 45 years of age, and his paternal grandfather had a fatal MI at age 47 years. Allen's father had two brothers and two sisters. One of the brothers had an MI at age 44 years, and one of the sisters had an MI at age 49 years. Allen's mother had a brother and sister, both of whom are still alive. Allen's mother's parents both survived into their 80s and died of "natural causes." Draw a pedigree summarizing the information you have taken about Allen's family, and make a recommendation for further study and/or treatment.
- 2. Mary's two brothers and her mother's brother all had Duchenne muscular dystrophy (DMD) and are now dead. Based on only this information, what is the probability that Mary is a heterozygous carrier for this disorder? What is the probability

that she will produce affected offspring? Suppose Mary has a serum creatine kinase (CK) test and is told that her level is above the 95th percentile for homozygous normal individuals. Approximately two thirds of DMD carriers have CK levels above the 95th percentile. Given this information, use Bayes' theorem to calculate the probability that Mary is a carrier and the probability that she will produce affected offspring.

3. Bob's father had Huntington disease and is now deceased. Bob is now 51 years old and has no symptoms of Huntington disease. Age-of-onset curves show that approximately 85% of individuals with an affected father show symptoms by this age (the percentage is slightly lower, about 80%, if the mother is affected). Based on this information, use Bayes' theorem to estimate the probability that Bob inherited the Huntington disease mutation from his father.

Answers to Study Questions

CHAPTER 2

- 1. The mRNA sequence is: 5'-CAG AAG AAA AUU AAC AUG UAA-3' (remember that transcription moves along the 3'-5' DNA strand, allowing the mRNA to be synthesized in the 5' to 3' direction). This mRNA sequence is translated in the 5' to 3' direction to yield the following amino acid sequence: Gln-Lys-Lys-Ile-Asn-Met-STOP.
- 2. The *genome* is the sum total of our genetic material. It is composed of 23 pairs of nuclear *chromosomes* and the mitochondrial chromosome. Each chromosome contains a number of *genes*, the basic unit of heredity. Genes are composed of one or more *exons*; exons alternate with introns. Exons encode mRNA *codons*, which consist of three *nucleotides* each. It is important to remember that DNA coiling patterns also produce a hierarchy: chromosomes are composed of 100-kb chromatin loops, which are in turn composed of solenoids. Each solenoid contains approximately six nucleosomes. Each nucleosome contains about 150 DNA base pairs and may or may not include coding material.
- 3. Approximately 55% of human DNA consists of repetitive sequences whose function is unknown. Single-copy DNA includes protein-coding genes, but it consists mostly of extragenic sequences and introns that do not encode proteins. Because individual cells have specialized functions, most make only a limited number of protein products. Thus only a small percentage of the cell's coding DNA is transcriptionally active at any given time. This activation is controlled by elements such as transcription factors, enhancers, and promoters.
- 4. Mitosis is the cell division process whereby one diploid cell produces two diploid daughter cells. In meiosis, a diploid cell produces haploid cells (gametes). Meiosis produces haploid cells because the centromeres are not duplicated in meiosis I and because there is no replication of DNA in the inter-

phase stage between meiosis I and meiosis II. Another difference between mitosis and meiosis is that the homologous chromosomes form pairs and exchange material (crossing over) during meiosis I. Homologs do not pair during mitosis, and mitotic crossing over is very rare.

- 5. Each mitotic division doubles the number of cells in the developing embryo. Thus the embryo proceeds from 1 to 2 to 4 to 8 cells, and so on. After n cell divisions, there are 2^n cells. For example, after 10 divisions, there are 2^{10} , or 1,024 cells. We want a value of *n* that satisfies the simple relationship $2^n = 10^{14}$. One way to our answer is simply to "plug in" values of nuntil we get 10¹⁴. A more elegant approach is to take the common logarithms of both sides of this equation, yielding $n\log(2) = 14\log(10)$. Since the common logarithm of 10 is 1, we obtain the relationship n = $14/\log(2)$. Thus, n = 46.5. It should be emphasized that this result, approximately 46 to 47 cell divisions, is only an average value. Some cell lineages divide more times than others, and many cells are replaced as they die.
- 6. A total of 400 mature sperm and 100 mature egg cells will be produced. Each primary spermatocyte will produce four mature sperm cells, while each primary oocyte will produce only one mature egg cell (the other products of meiosis are polar bodies, which degenerate).

- 1. Mutation 1 is a nonsense mutation in the fourth codon, which produces premature termination of translation. Mutation 2 is a frameshift mutation in the third codon, and mutation 3 is a missense mutation in the second codon.
- Transcription mutations generally lower the production of a gene product, but often they do not eliminate it completely. Transcription mutations in the

 β -globin gene usually produce β^+ -thalassemia, a condition in which there is some production of β -globin chains. β^+ -Thalassemia tends to be less severe than β^0 -thalassemia. Missense mutations alter only a single amino acid in a polypeptide chain and, when they occur in the β -globin chain, can produce β^+ -thalassemia. (However, keep in mind that sickle cell disease, which is relatively severe, is also caused by a missense mutation.) In contrast, frameshift mutations alter many or all codons downstream from the site of the mutation, so a large number of amino acids may be changed. Frameshifts can also produce a stop codon. Nonsense mutations produce truncated polypeptides, which are often useless (especially if the nonsense mutation occurs near the 5' end of the gene, eliminating most of the polypeptide chain). Donor/acceptor mutations can delete whole exons or large portions of them. This can substantially alter the amino acid composition of the polypeptide. Nonsense, frameshift, and donoracceptor mutations all tend to produce the more severe β^0 -thalassemia, in which no β -globin chains are present.

- 3. In thalassemia conditions, one of the chains, α or β globin, is reduced in quantity. Most of the harmful consequences are caused by the relative excess of the chain that is produced in normal quantity. If both chains are reduced in quantity, there may be a rough balance between the two, resulting in less accumulation of excess chains.
- 4. Restriction site polymorphisms (RSPs) reflect the presence or absence of a restriction site. They thus can have only two alleles. They are detected with the use of RFLP technology. VNTRs are also a type of RFLP, but here the polymorphism is in the number of tandem repeats that lie between two restriction sites, rather than in the presence or absence of a restriction site. Because the number of tandem repeats can vary considerably, VNTRs can have many different alleles in populations. VNTRs are found in minisatellite regions. Microsatellite repeat polymorphisms consist of variations in the number of shorter microsatellite repeats (usually dinucleotides, trinucleotides, and tetranucleotides). They are usually detected with the use of the polymerase chain reaction (PCR). RSPs and VNTRs can also be detected using PCR (instead of Southern blotting technology), provided that the DNA sequences flanking the polymorphism are known. The autoradiogram represents a microsatellite repeat polymorphism. This is indicated by the fact that there are multiple alleles (distinguishing it from an RSP) and by the fact that the various alleles differ in size by only 4 bp (recall from Chapter 2 that the tandem repeat units in minisatellite regions are generally 20 to 70 bp long).

5. Because the disease mutation destroys a recognition site, those who have the disease allele will have a longer restriction fragment. This fragment will migrate more slowly on the gel and will be seen higher on the autoradiogram. Individual A has only the longer fragment and thus has two copies of the disease mutation. This individual has α_1 -antitrypsin deficiency. Individual B has only the short fragment and is genetically and physically unaffected. Individual C has both fragments and is thus a clinically unaffected heterozygote.

- 1. In this sample of 100 individuals, there are 88×2 HbA alleles in the HbA homozygotes and 10 HbA alleles in the heterozygotes. There are thus 186 HbA alleles in the population. The frequency of HbA, p, is 186/200 = 0.93, and the frequency of HbS, q, is 1 - 0.93 = 0.07. The genotype frequencies in the population are 88/100 = 0.88, 10/100 = 0.10, and 2/100 = 0.02 for the HbA/HbA, HbA/HbS, and HbS/HbS genotypes, respectively. Assuming Hardy-Weinberg proportions, the expected genotype frequencies are given by p^2 , 2pq, and q^2 , respectively. This yields expected genotype frequencies of $(0.93)^2$ $= 0.865, 2 \times 0.93 \times 0.07 = 0.130, \text{ and } (0.07)^2 = 0.005,$ respectively. In this population, the observed and expected genotype frequencies are fairly similar to one another.
- 2. For an autosomal recessive disease, the prevalence (1/10,000) equals the recessive genotype frequency, q^2 . Thus the PKU gene frequency, q, is given by $\sqrt{q^2} = \sqrt{1/10,000} = 1/100 = 0.01$. The carrier frequency is given by 2pq, which is approximately 2q, or 0.02 (i.e., 1/50).
- 3. Because this is an autosomal dominant disorder, and because affected homozygotes die early in life, the man is a heterozygote and has a 50% chance of passing the disease gene to each of his offspring. The probability that all four will be affected is given by the product of each probability: $(1/2)^4 = 1/16$. The probability that none will be affected (1/16) is obtained in exactly the same way.
- 4. The probability that the offspring will inherit the retinoblastoma susceptibility gene is 0.50, since familial retinoblastoma is an autosomal dominant disease. However, we must also consider the penetrance of the disorder. The probability of both inheriting the disease gene (0.50) and expressing the disease phenotype (0.90) is given by multiplying the two probabilities together: $0.90 \times 0.50 = 0.45$.
- 5. Since the woman's sister had Tay-Sachs disease, both parents must be heterozygous carriers. This means that, at birth, one fourth of their offspring will be

affected, one half will be carriers, and one fourth will be genetically normal. However, note that the woman in question is 30 years old. She cannot possibly be an affected homozygote because affected individuals die by age 6 years. There are thus three equally likely possibilities: (1) the disease allele was inherited from the mother and a normal allele was inherited from the father; (2) the disease allele was inherited from the father and a normal allele was inherited from the father and a normal allele was inherited from the father and a normal allele was inherited from the mother; (3) normal alleles were inherited from both parents. Because two of these three possibilities lead to the carrier state, the woman's probability of being a heterozygous carrier is 2/3.

- 6. The probability that the woman's disease gene is transmitted to her offspring is 1/2, and the probability that this offspring in turn transmits the disease gene to his or her offspring (i.e., the grandchild) is again 1/2. Thus, the probability that one grandchild has inherited the disease gene is $1/2 \times 1/2$, or 1/4. Similarly, the probability that the other grandchild has inherited the gene is 1/4. The probability that *both* grandchildren have inherited the gene is $1/4 \times 1/4 = 1/16$.
- 7. This is explained by genomic imprinting. For normal development, differential expression of genes inherited from the father and mother is necessary. If the expression pattern from only one parent is inherited, the embryo cannot develop normally and dies. The experiment works in amphibians because genomic imprinting does not occur in these animals.
- 8. The coefficient of relationship is 2^6 , or 1/64. This gives the probability that the second member of the couple carries the PKU gene. The probability that two carriers will produce an affected offspring is 1/4. The overall probability that this couple will produce a baby affected with PKU is given by multiplying the probability that the mate also carries the gene (1/64) by the probability that the couple both transmit the gene to their offspring (1/4): $1/64 \times 1/4 = 1/256$. This demonstrates that the probability of producing an affected offspring in this consanguineous mating is actually quite small.
- 9. The frequency of the heterozygote genotype in the general population is given by 2pq, according to the Hardy-Weinberg law. Thus, the frequency of the first genotype in the general population is predicted to be $2 \times 0.05 \times 0.10 = 0.01$. Similarly, for the second system, the frequency of heterozygotes in the general population is $2 \times 0.07 \times 0.02 = 0.0028$. The perpetrator was a homozygote for the third system; the frequency of the homozygote genotype in the general population is given by p^2 , or $0.08^2 = 0.0064$. If we can assume independence of the three VNTR systems in the general population, we can then multiply the frequencies of the three genotypes together to get the probability that a randomly chosen indi-

vidual in the general population would have the same genotypes as the perpetrator. We thus multiply $0.01 \times 0.0028 \times 0.0064$ to obtain a probability of 0.000000179, or 1/5,580,357. This probability can be made smaller by typing additional systems.

10. As in question 9, we assume independence of the four microsatellite systems. In this case, we multiply the four allele frequencies together to get the probability: 0.05 × 0.01 × 0.01 × 0.02 = 0.0000001 = 1/10,000,000. Notice a key difference between question 9 and question 10: in the paternity case, the father has contributed only half of the baby's genotype at each locus, the other half being contributed by the mother. Thus, we examine only a single allele for each locus. In contrast, the rapist has contributed both alleles of each genotype to the evidentiary sample, so we include both alleles in the analysis.

- 1. There are four Barr bodies, always one less than the number of X chromosomes.
- 2. This is most likely a result of X inactivation. The heterozygotes with muscle weakness are the ones with relatively large proportions of active X chromosomes containing the mutant allele.
- 3. The disease frequency in males is q, while in females it is q^2 . The male/female ratio is thus q/q^2 or 1/q. Thus, as q decreases, the male/female ratio increases.
- 4. Since the male's grandfather is affected with the disorder, his mother must be a carrier. His father is phenotypically normal and therefore does not have the disease gene. Thus, the male in question has a 50% risk of developing hemophilia A. His sister's risk of being a heterozygous carrier is also 50%. Her risk of being affected with the disorder is close to zero (barring a new mutation on the X chromosome transmitted by her father).
- 5. Male-male transmission can be observed in autosomal dominant inheritance, but it will not be observed in X-linked dominant inheritance. Thus, males affected with X-linked dominant disorders must always have affected mothers, unless a new mutation has occurred. Males and females are affected in approximately equal proportions in autosomal dominant inheritance, but there are twice as many affected females as males in X-linked dominant inheritance (unless the disorder is lethal prenatally in males, in which case only affected females are seen). In X-linked dominant inheritance, all of the sons of an affected male are normal, and all of the daughters are affected. In X-linked dominant diseases, heterozygous females tend to be more mildly affected than are hemizygous males. In autosomal dominant inheritance, there is usually no

difference in severity of expression between male and female heterozygotes.

- 6. In mitochondrial inheritance, the disease can be inherited *only* from an affected mother. In contrast to all other types of inheritance, *no* descendants of affected fathers can be affected. Note that males affected with an X-linked recessive disease who mate with normal females cannot transmit the disease to their offspring, but their grandsons can be affected with the disease.
- 7. Since Becker muscular dystrophy is relatively rare, it is reasonable to assume that the woman is a normal homozygote. Thus, she can transmit only normal X chromosomes to her offspring. Her male offspring, having received a Y chromosome from the father and a normal X from the mother, will all be unaffected. The female offspring of this mating will receive a mutated X chromosome from the father and will all be heterozygous carriers of the disorder.
- 8. If the man is phenotypically normal, his X chromosome cannot carry a Duchenne muscular dystrophy mutation. The female will transmit her mutationcarrying chromosome to half of her offspring, on average. Thus, half of the sons will be affected with the disorder, and half of the daughters will be heterozygous carriers.
- 9. The boys' mother must be a heterozygous carrier for a factor VIII mutation. Thus, one of the mother's parents must also have carried the mutation. Consequently, the probability that the mother's sister is a carrier is 1/2.

CHAPTER 6

- 1. Euploid cells have a multiple of 23 chromosomes. Haploid (n = 23), diploid (n = 46), and polyploid (triploid and tetraploid) cells are all euploid. Aneuploid cells do not have a multiple of 23 chromosomes and include trisomies (47 chromosomes in a somatic cell) and monosomies (45 chromosomes in a somatic cell).
- 2. Conventional FISH analysis involves the hybridization of a fluorescently labeled probe to denatured metaphase chromosomes and is most useful in detecting aneuploidy, deletions, and chromosome rearrangements. FISH can also be extended to use multiple differently colored probes, allowing the detection of several different aneuploidies simultaneously. Spectral karyotyping is an extension of FISH in which each chromosome can be visualized as a different color. This enables accurate and easy characterization of aneuploidy, loss or duplication of chromosome material, and (especially) chromosome rearrangements such as translocations. CGH is particularly useful in detecting the gain or loss of chro-

mosome material, but it cannot detect balanced rearrangements of chromosomes, such as reciprocal translocations. This is because, despite the rearrangement, the test sample and the reference sample each have the same amount of DNA from each chromosome region.

- 3. A normal egg can be fertilized by two sperm cells (dispermy, the most common cause of triploidy). An egg and polar body can fuse, creating a diploid egg, which is then fertilized by a normal sperm cell. Diploid sperm or egg cells can be created by meiotic failure; subsequent union with a haploid gamete would produce a triploid zygote.
- 4. The difference in incidence of various chromosome abnormalities reflects the fact that embryos and fetuses with chromosome abnormalities are spontaneously lost during pregnancy. The rate and timing of loss vary among different types of chromosome abnormalities.
- 5. A karyotype will establish whether the condition is the result of a true trisomy or a translocation. If the latter is the case, the recurrence risk in future pregnancies is greatly elevated. A karyotype will also help to establish whether the patient is a mosaic. This may help to predict and explain the severity of expression of the disorder.
- The ranking, from lowest risk to highest, would be: (1) 25- year-old female with one previous Down syndrome child (approximately 1%); (2) 25-year-old male carrier of a 21/14 translocation (1% to 2%); (3) 45-year-old female with no family history (approximately 3%); (4) 25-year-old female carrier of a 21/14 translocation (10% to 15%).
- 7. Nondisjunction of the X chromosome can occur in both meiosis I and meiosis II. If these two nondisjunctions occur in the same cell, an ovum with four X chromosomes can be produced. If this is fertilized by an X-bearing sperm cell, the zygote will have the 49,XXXXX karyotype.
- 8. The meiotic error must have occurred in the father, since his X chromosome carries the gene for hemophilia A. Because the daughter has normal factor VIII activity, she must have inherited her single X chromosome from her mother.
- 9. Since a loss of genetic material usually produces more severe consequences than does a gain of material, one would expect the patient with the deletion (46,XY,del(8p)) to be more severely affected than the patient with the duplication.
- 10. A translocation may place a proto-oncogene near a sequence that activates it, producing a cancercausing oncogene. It may also interrupt a tumorsuppressor gene (see Chapter 11), inactivating it. Because these genes encode tumor-suppressing factors, their inactivation can also lead to cancer.

- 1. In consanguineous matings, a higher proportion of genes in the offspring are identical by descent. The identical proportion is measured by the coefficient of relationship. The carrier frequency of autosomal recessive inborn errors of metabolism such as alkaptonuria decreases as the prevalence of the disorder diminishes. Thus, the carrier frequency of very rare disorders is very low. If a child is diagnosed with alkaptonuria, it would be reasonable to suspect that parents who might be related are more likely to share an individual's alkaptonuria gene than two individuals chosen at random from the population.
- 2. Many metabolic reactions can proceed in the complete absence of an enzyme. For example, a hydroxide ion can combine with carbon dioxide to form bicarbonate. Yet this reaction occurs much more efficiently in the presence of a catalyst, in this case the enzyme carbonic anhydrase. Although many reactions in the human body would continue in the absence of an enzymatic catalyst, they would not do so at a rate high enough to support normal metabolism and physiology.
- 3. Although most inborn errors of metabolism are rare, in aggregate they contribute substantially to the morbidity and mortality of children and adults. Additionally, understanding the pathogenetic basis of rare metabolic disorders has the potential to help physicians and scientists understand similar processes that contribute to common diseases. For example, by understanding how mutations in glucokinase cause hyperglycemia, we may better understand the pathogenesis of diabetes mellitus.
- 4. Metabolic disorders have been classified in many different ways. In Chapter 7, we categorized them by the types of metabolic processes that are affected. Some examples include carbohydrate metabolism (e.g., galactosemia, hereditary fructose intolerance, glycogen storage disorders); amino acid metabolism (e.g., PKU, MSUD, tyrosinemia); lipid metabolism (e.g., MCAD, LCAD); degradative pathways (e.g., Hurler syndrome, OTC deficiency, Gaucher disease); energy production (e.g., OXPHOS defects); and transport systems (e.g., cystinosis, cystinuria).
- 5. Mutations in *GAL-1-P uridyl transferase* are the most common cause of galactosemia. However, mutations in genes encoding other enzymes necessary for the metabolism of galactose, such as galactokinase and uridine diphosphate galactose-4-epimerase, can also result in galactosemia. This is an example of genetic heterogeneity. That is, indistinguishable phenotypes may be produced by mutations in different genes. Other examples of metabolic disorders that are genetically heterogeneous include hyperphenylalaninemia, MSUD, and cystinuria.

- 6. The prevalence rates for many inborn errors of metabolism vary widely between ethnic groups. In many instances this is due to founder effect and genetic drift (see Chapter 3). For example, in Finland more than 30 autosomal recessive disorders are found at an unusually high prevalence compared with closely related populations. A similar scenario partly explains the finding of only a single or few disease-causing mutations in Ashkenazi Jews (lysosomal storage disorders), Mennonites (MSUD), and French Canadians (tyrosinemia type 1). In other cases, it appears that there may be a selective advantage for carriers of a recessive allele (remember that heterozygotes for recessive disorders are unaffected). This may explain the varying frequency distribution of LAC*P, which confers persistent lactase activity and may have been advantageous in populations in which dairy products were a valuable nutritional source.
- 7. Although the mitochondrial genome is inherited only from the mother, most of the proteins in the mitochondria are encoded by genes in the nuclear genome. Thus, disorders of mitochondrial fatty acid oxidation are inherited in an autosomal recessive pattern. Given the age of this young woman, it is unlikely that she is affected with a mitochondrial fatty acid oxidation disorder, so we can assume that she either is a heterozygous carrier or is homozygous for the normal allele. Consequently, the probability that she is a carrier is 0.67. The probability that her mate is a carrier is given by the carrier rate for MCAD in the general population: 1 in 70 (~0.014). In a carrier \times carrier mating, there is a 25% chance of having an affected child (probability of two gametes bearing mutant alleles uniting); then the woman's risk of having an affected child is $0.67 \times$ $0.014 \times 0.25 = 0.002$ or 1/500. Note that her risk of being a carrier (0.67/0.014) is 48 times higher than in the general population.
- 8. Five different enzymes control the urea cycle pathway. Deficiencies of four of these enzymes (AS, ASA, arginase, and CPS) are inherited in an autosomal recessive pattern. OTC deficiency is an X-linked recessive condition. Most women who are carriers for an X-linked recessive disorder are not symptomatic. However, there are at least two explanations for a symptomatic female. First, one X chromosome is normally inactivated (lyonized) at random in each somatic cell. Sometimes, inactivation is skewed, with more normal than abnormal X chromosomes being inactivated, and the woman becomes symptomatic. Testing for skewed inactivation is not commonly performed in diagnostic laboratories. A second possible explanation is that only a single X chromosome is present in each somatic cell (Turner syndrome; see Chapter 6). Thus, X inactivation does not take place

because each cell must contain one functional copy of the X chromosome. If this X chromosome contains a mutated gene (e.g., *OTC*), a woman will be symptomatic. The simplest test to confirm this diagnosis would be a karyotype.

- 9. A functioning OXPHOS system is necessary to metabolize pyruvate aerobically. Defects of the OXPHOS system cause pyruvate to be metabolized anaerobically into lactate, increasing the level of circulating lactate. Thus, an elevated concentration of circulating lactate may signal the presence of a disorder of energy production. Increased levels of lactate are also produced by decreased tissue oxygenation due to decreased circulation (e.g., strenuous exercise, shock). Often there are other biochemical abnormalities that suggest a defect of OXPHOS; however, the diagnosis can be challenging.
- 10. Polymorphisms in the genes controlling the metabolism of drugs (e.g., *CYP2D6*) may affect a patient's therapeutic response as well as the profile of side effects. Natural foods contain thousands of chemical compounds, many of which have pharmacological properties similar to, but less potent than, contemporary drugs used by health care providers. Thus, polymorphisms in the genes may have enabled some groups of hunter-gatherers to utilize resources that other groups found inedible. Over time this may have been enough of a selective advantage that the size of one group grew more quickly than others.

CHAPTER 8

- The affected male in generation II inherited the disease allele and marker allele 1 from his affected father, and he inherited a normal allele and marker allele 2 from his mother. Therefore, the disease allele must be on the chromosome that contains marker allele 1 in this male (linkage phase). Because he married a female who is heterozygous for marker alleles 3 and 4, we expect to observe allele 1 in the affected offspring under the hypothesis of linkage. Individual III-5 has the 2,4 marker genotype but is affected, and individual III-7 has the 1,3 genotype but is normal. They both represent recombinants. Thus, there are two recombinations observed in cight meioses, giving a recombination frequency of 2/8, or 25%.
- 2. For marker *A*, the affected mother in generation II must carry allele 2 on the same chromosome as the Huntington disease allele. Under the hypothesis that $\theta = 0.0$, all of her children must also inherit allele 2 if they are affected. Marker *A* shows a recombinant with the disease allele in individual III-5 and thus produces a likelihood of zero for a recombination frequency of 0.0. The LOD score is $-\infty$ (the logarithm of 0). For marker *B*, the disease allele is on the

chromosome bearing marker allele 1 in the affected mother in generation II. All offspring inheriting allele 1 also inherit the disease allele, so there are no recombinants. Under the hypothesis that $\theta = 0.0$, the affected mother can transmit only two possible haplotypes: the disease allele with marker allele 1 and the normal allele with marker allele 2. The probability of each of these events is 1/2. Thus, the probability of observing six offspring with the marker genotypes shown is $(1/2)^6 = 1/64$. This is the numerator of the likelihood ratio. Under the hypothesis that $\theta = 0.5$ (no linkage), four possible haplotypes can be transmitted, each with probability 1/4. The probability of observing six children with these haplotypes under the hypothesis of no linkage is then $(1/4)^6 = 1/4,096$. This is the denominator of the likelihood ratio. The ratio is then (1/64)/(1/4,096) = 64. The LOD score is given by the common logarithm of 64, 1.8.

- 3. The table shows a maximum LOD score, 3.5, at a recombination frequency of 10%. Thus, the two loci are most likely to be linked at a distance of approximately 10 cM. The odds in favor of linkage at this θ value, versus nonlinkage, are 3,162 (or $10^{3.5}$) to 1.
- 4. Linkage phase can be established in both families, and no recombinants are observed in either family. Thus, the estimated recombination frequency is 0.0. The LOD score for $\theta = 0.0$ in the first family is given by $\log_{10}(1/2)^5/(1/4)^5 = \log_{10}(32) = 1.5$. In the second family the LOD score for $\theta = 0.0$ is $\log_{10}(1/2)^6/(1/4)^6 = \log_{10}(64) = 1.8$. These two LOD scores can then be added to obtain an overall LOD score of 3.3.
- 5. These matings allow us to establish linkage phase in individuals II-2 and II-3, the parents of the individuals in generation III. The disease allele is on the same chromosome as marker 4 in individual II-2, and on the same chromosome as marker 5 in individual II-3. Under the hypothesis of linkage, we would predict that offspring who inherit markers 4 and 5 will be homozygous for the disease allele and thus affected, offspring who inherit either 4 or 5 will be heterozygous carriers, and offspring who inherit neither 4 nor 5 will be homozygous normal. Note a key difference between autosomal recessive and autosomal dominant pedigrees in estimating recombination frequencies: here, both parents in generation II contribute informative meioses because both parents carry a disease-causing allele. Thus, we can evaluate all 10 meioses contributing to generation III for recombination between the disease and marker loci. No recombinations are seen in the first four offspring; however, individual III-5 is homozygous normal but has inherited allele 5 from his mother. Thus, one recombination in five meioses has occurred in the mother, and no recombinations in five meioses have occurred in the father. One recom-

bination in 10 meioses yields a recombination frequency of 1/10 = 10%.

- 6. These matings allow us to establish linkage phase in individual II-1. Under the hypothesis of linkage, she carries the disease-causing allele (labeled D) on the same chromosome as marker allele 1. Her haplotypes are thus D1/d2. Based on her haplotypes and on those of her unaffected mate, we can predict that the offspring who inherit the 1,1 genotype will be affected, while those who inherit the 1,2 genotype will not be affected. We see that this is the case for all but one of the offspring (III-5). This means that the likelihood that $\theta = 0.0$ is zero, so the LOD score for this recombination frequency is $-\infty$. To assess the LOD score for $\theta = 0.1$, we consider that the probability that the father passes each recombinant haplotype (D2 or d1) is $\theta/2 = 0.45$. The probability that he transmits each nonrecombinant haplotype (D1 or d2) is $(1 - \theta)/2 = 0.05$ (see Box 8-1 for the details of this reasoning process). There is one recombinant and seven nonrecombinants among the offspring. The probability of observing these eight events is $0.05 \times 0.457 = 0.00019$. This is the numerator of the likelihood ratio. For eight offspring, the probability that $\theta = 0.5$ is $(1/4)^8 = 0.000015$. This is the denominator of the ratio. The logarithm of the odds ratio is given by $\log_{10}(12.2) = 1.09$. This is the LOD score for $\theta = 0.1$.
- 7. The mating in generation II is uninformative because the father is a homozygote for the marker allele. It will be necessary to type the family for another closely linked marker (preferably one with more alleles) before any risk information can be given. At this point the only risk information that can be given is that each child has a 50% risk of inheriting the disease gene from the affected father.
- 8. Synteny refers to loci that are on the same chromosome. Linkage refers to loci that are less than 50 cM apart on a chromosome; alleles at such loci tend to be transmitted together within families. Linked loci are thus syntenic, but syntenic loci are not necessarily linked. Linkage disequilibrium is the nonrandom association of alleles at linked loci, observable when chromosome haplotypes are examined in populations. Association indicates that two traits are observed together in a population more often than expected by chance; the traits may or may not be genetic. Association thus does not necessarily have anything to do with linkage, *unless* we are referring to linkage disequilibrium.
- 9. Linkage disequilibrium can arise when a disease mutation occurs on a specific chromosome. If there are multiple disease mutations, they are likely to occur on chromosomes with different marker alleles, and little association will be observed between the disease genotype (which actually consists of a *collec*-

tion of different mutations at the disease locus) and a specific marker allele.

10. A hybridization signal is seen consistently in clones that include chromosome 5. This indicates that chromosome 5 is the one most likely to contain the cDNA segment.

- 1. The class I molecules present peptides at the surfaces of nearly all of the body's cells. The peptide–class I molecule complex is recognized by cytotoxic T-cells, which kill the cell if the class I MHC molecule presents foreign peptide. The class II MHC molecules also present peptides at the cell surface, but only in antigen-presenting cells of the immune system (e.g., dendritic cells, macrophages, B-cells). If the class II molecule presents foreign peptides derived from an invading microbe, they are bound by the receptors of helper T-cells; this in turn stimulates appropriate Bcells to proliferate and to produce antibodies that will help to kill the microbes.
- 2. Immunoglobulins differ among B-cells within individuals, so that a large variety of infections can be combated. MHC molecules are identical on each cell surface within an individual, but they vary a great deal between individuals. This interindividual variability may have evolved to prevent infectious agents from spreading easily through a population.
- 3. T-cell receptors and immunoglobulins are similar in that they are both cell-surface receptors that bind to foreign peptides as part of the immune response. Diversity in both types of molecules is generated by multiple germline genes, VDJ recombination, and junctional diversity. They differ in that immunoglobulins are secreted into the circulation (as antibodies) and can bind directly to foreign peptide, while T-cell receptors are not secreted and must "see" foreign peptides in conjunction with MHC molecules to recognize them. Also, somatic hypermutation generates diversity in immunoglobulins but not in T-cell receptors.
- 4. Somatic recombination alone could produce $30 \times 6 \times 80 = 14,400$ different heavy chains of this class.
- 5. The probability that a sibling will be HLA-identical is 0.25. The probability that two siblings share one gene or haplotype is 0.50 (the coefficient of relationship for siblings; see Chapter 4). Then, the probability that they share two haplotypes and are HLA-identical is $0.50 \times 0.50 = 0.25$.
- 6. If a homozygous Rh-positive (*DD*) man marries an Rh-negative woman, all of the offspring will be Rh-positive heterozygotes (*Dd*) and incompatible with the mother. If the man is an Rh-positive heterozy-

gote (*Dd*), half of the children, on average, will be incompatible Rh-positive heterozygotes. However, if the couple is ABO-incompatible, this will largely protect against Rh incompatibility.

CHAPTER 10

- 1. Animals such as roundworm, fruit fly, frog, zebra fish, chick, and mouse are commonly used to model human development. Each of these organisms has a relatively short generation time and can be selectively bred, and large populations can be maintained in captivity. Furthermore, embryos from each of these animals can be manipulated either in vitro or in vivo using a variety of techniques (e.g., surgical ablation or transplantation of cells or tissues, ectopic expression of native genes or transgenes, knockouts). Of course, each organism has advantages and disadvantages that must be considered when choosing an appropriate model. In some animals, naturally occurring mutant strains have proved to be valuable models of human genetic disease. For example, mutations in murine Pax6 produce an abnormally small eye. Mutations in the human homolog, PAX6, cause hypoplasia or absence of the iris. Most of what we understand about axis determination and pattern formation has been learned from studies of nonhuman animal models.
- 2. Although identical mutations in a developmental gene may produce different birth defects, the defects are usually the same within each family. One possible explanation is that other genes may be modifying the phenotype differently in each family. In other words, the same mutation is occurring in different genetic backgrounds, resulting in different phenotypes. To date, only a few examples of different human conditions caused by identical mutations are known. However, strain-dependent phenotypic effects are well described in other organisms such as mice and fruit flies.
- 3. Transcription factors commonly activate or repress more than a single gene. Often they affect the transcription of many genes that may be members of different developmental pathways. This maintains developmental flexibility and genomic economy. These developmental pathways are used to build many different tissues and organs. Thus, a mutation in a transcription factor can affect the growth and development of many body parts. For example, mutations in *TBX5* cause defects of both the limbs and the heart in a pleiotropic disorder called Holt-Oram syndrome.
- 4. Pattern formation is the process by which ordered spatial arrangements of differentiated cells create tissues and organs. Initially, the general pattern of the

animal body plan is established. Then, semiautonomous regions are formed that will pattern specific organs and appendages. Thus, pattern formation requires that complex temporal-spatial information be available to different populations of cells at different periods during development. This information is communicated between cells by signaling molecules. Mutations in the genes encoding these signaling molecules can disrupt signaling pathways, leading to abnormal pattern formation. For example, Sonic hedgehog (SHH) is widely used in many different patterning processes, including that of the brain. Mutations in SHH can cause failure of the forebrain to divide (holoprosencephaly). Patterning defects are also produced by mutations in genes encoding transcription factors (e.g., HOX, T-box) that are activated in response to signals from other cells.

- 5. Because of the tight constraints on developmental programs, the role of some elements in developmental pathways can be played by more than one molecule. This is known as functional redundancy. Hox paralogs appear to act in some developmental pathways in just this manner. For example, mice with *Hoxa11* or *Hoxd11* mutations have only minor abnormalities, whereas *Hoxa11/Hoxd11* double mutants exhibit a marked reduction in the size of the radius and ulna. Thus, *Hoxa11* and *Hoxd11* may be able to partially compensate for one another in some developmental programs.
- 6. There are many reasons why it may be impractical to use an organism to study loss-of-function mutations by creating knockouts. For example, baboons have small nuclear families and long generation times and are expensive to maintain in captivity. A short generation time is critical, because complete loss of function is achieved by backcrossing chimeras and subsequently mating heterozygotes with a genetic modification to produce animals homozygous for a genetic modification (e.g., a knockout). One way to circumvent the problem of long generation times would be to produce sperm from the model animal (e.g., baboon) in an organism with a short generation time (e.g., mouse). In this technique, immature sperm-making cells from an infant baboon would be placed in the testicles of mice in order to make mature sperm. These sperm could be used for in vitro fertilization of eggs harvested from female baboons with a genetic modification (i.e., chimeras or heterozygotes). In this manner, the generation time would be substantially reduced. This type of experiment has not yet been successfully completed, although the technology is forthcoming.
- 7. Cells communicate with each other through many different signaling pathways. Signaling requires that a ligand bind to a receptor molecule. This generates a response that may activate or inhibit a variety of

processes within a cell. Mutations in fibroblast growth factor receptor (FGFR) genes cause a variety of craniosynostosis syndromes. However, mutations in FGFR ligands, fibroblast growth factors, have not been described. Mutations in the genes encoding endothelin-3 and its receptor, endothelin-B, cause defects of the enteric cells of the gastrointestinal tract, leading to severe, chronic constipation (Hirschsprung disease). This demonstrates that a mutation in a ligand or its receptor may produce the same phenotype.

8. There are many obstacles to treating birth defects with gene therapy. Many developmental genes are expressed early in development. Thus, the phenotype would have to be identifiable at a very early age. This is certainly feasible (e.g., via preimplantation testing) in the gametes or zygotes of a known carrier. Because many of these genes encode axis, pattern, or organ-specific information, gene therapy would have to be initiated very early in the developmental process. In addition, the therapy might have to be targeted to specific areas, at critical times during development, and at appropriate levels required for interaction with other developmental genes. Consequently, it will be challenging to develop strategies that may be useful for treating birth defects with gene therapy.

CHAPTER 11

- 1. *G6PD* is on a portion of the X chromosome that is inactivated in one copy in normal females. Thus, any single cell will express only one *G6PD* allele. If *all* tumor cells express the same *G6PD* allele, this indicates that they all arose from a single ancestral cell. This evidence was used to support the theory that most tumors are monoclonal.
- 2. The probability that a single cell will experience two mutations is given by the square of the mutation rate per cell (i.e., the probability of one mutation and a second mutation in the same cell): $(3 \times 10^{-6})^2 \approx 10^{-11}$. We then multiply this probability by the number of retinoblasts to obtain the probability that an individual will develop sporadic retinoblastoma: $10^{-11} \times 2 \times$ $106 = 2 \times 10^{-5}$. We would thus expect 2 in 100,000 individuals to develop sporadic retinoblastoma, which is consistent with observed prevalence data (i.e., retinoblastoma is seen in about 1/20,000 children, and about half of these cases are sporadic). If an individual has inherited one copy of a mutant retinoblastoma gene, then the number of tumors is given by the rate of somatic mutation (second hit) per cell times the number of target cells: $3 \times 10^{-6} \times 2$ $\times 106 = 6$ tumors per individual.
- 3. Oncogenes are produced when proto-oncogenes,

which encode substances that affect cell growth, are altered. Oncogenes usually act as dominant genes at the level of the cell and help to produce transformation of a normal cell into one that can give rise to a tumor. Tumor suppressor genes are also involved in growth regulation, but they usually act as recessive genes at the level of the cell (i.e., both copies of the gene must be altered before progression to a tumor can proceed). Because only a single oncogene need be altered to initiate the transformation process, oncogenes have been detected by using transfection and retroviral assays and by observing the effects of chromosome translocations. Such methods are less effective for uncovering tumor suppressors, because two altered copies of these genes must be present before their effects can be observed in a cell. As a consequence, most tumor suppressor genes have been detected by studying relatively rare cancer syndromes in which one mutant copy of the tumor suppressor is inherited and the second alteration occurs during somatic development.

4. Li-Fraumeni syndrome is caused by the inheritance of a mutation in the TP53 gene. The inherited mutation is present in all cells and greatly increases predisposition to tumor formation. However, because of the multistep nature of carcinogenesis, this inherited event is not sufficient to produce a tumor. Other events, occurring in somatic cells, must also take place. These somatic events are rare, so the probability of their occurrence in any given cell is small, explaining the low frequency of any specific tumor type. The involvement of many different tumor types in Li-Fraumeni syndrome is explained by the fact that normal p53 activity is required for growth regulation in many different tissues. Thus, the likelihood that an individual will develop at least one primary tumor, in one of many tissues, is very high.

- 1. Since the trait is more common in females than in males, we infer that the threshold is lower in females than in males. Thus, an affected father is at greater risk for producing affected offspring than is an affected mother. The recurrence risk is higher in daughters than in sons.
- For a multifactorial trait, the recurrence rick decreases rapidly in more remote relatives of a proband (as shown in Table 12-2). In contrast, for an autosomal dominant gene, the recurrence risk is 50% smaller with each degree of relationship, reflecting the coefficient of relationship (see Chapter 4). Recall that first-degree relatives (parents, off-spring, and siblings) share 50% of their genes, second-degree relatives (uncles and nieces, grand-

parents and grandchildren) share 25% of their genes, and so on. Thus, for a gene with 10% penetrance, the recurrence risk is obtained by multiplying the penetrance times the percentage of shared genes between relatives: 5% ($10\% \times 50\%$) for first-degree relatives, 2.5% ($10\% \times 25\%$) for second-degree relatives, 1.25% ($10\% \times 12.5\%$) for third-degree relatives, and so on. In addition, if the disease is multifactorial, the recurrence risk should increase in populations in which the disease is more common. There will be no relationship between disease frequency and recurrence risk for an autosomal dominant disease.

- 3. (1) The disease gene may have reduced penetrance.(2) A somatic mutation may have occurred after cleavage of the embryo, such that one twin is affected by the disorder while the other is not.
- 4. These results imply that shared environmental factors are increasing the correlations among siblings, since siblings tend to share a more common environment than do parents and offspring. The spouse correlation reinforces the interpretation of a shared environment effect, although it is also possible that individuals with similar body fat levels may marry preferentially.

CHAPTER 13

- The sensitivity of the test is 93% (93 of the 100 true disease cases were detected). The specificity is 99% (98,900 of 99,900 unaffected individuals were correctly identified). The positive predictive value is 8.5% (93 of the 1,093 individuals with positive tests actually had the disease). The false-positive rate is 1% (1 specificity, or 1,000 of 99,900), and the false-negative rate is 7% (1 sensitivity, or 7 of 100).
- 2. Based on the fact that individual 3 is homozygous for the 5-kb allele, we infer that the disease gene is on the same chromosome as the 5-kb allele in both parents. Thus, individual 6, who inherited both copies of the 5-kb allele, also inherited both copies of the PKU disease gene and is affected.
- 3. The *NF1* disease gene is on the same chromosome as allele *1* in the affected father. Thus, individual 6, who inherited allele 2 from his father, should be unaffected. Note that our degree of confidence in the answers to both question 2 and question 3 depends on how closely linked the marker and disease loci are.
- 4. The mating in generation I is uninformative, so we cannot establish linkage phase in the female in generation II. Thus, the risk estimate for her daughter cannot be improved from the usual 50% figure used for autosomal dominant disease genes. Diagnostic accuracy could be improved by assaying another, more polymorphic marker (e.g., a microsatellite

repeat polymorphism, which would more likely permit the accurate definition of linkage phase).

- 5. The primary advantages of amniocentesis are a lower rate of fetal loss (approximately 0.5% versus 1% to 1.3% for CVS) and the ability to do an AFP assay for the detection of neural tube defects. CVS offers the advantages of diagnosis earlier in the pregnancy and a more rapid laboratory diagnosis. The CVS diagnosis may be complicated by confined placental mosaicism, and there is limited evidence for an association between early (before 10 weeks post-LMP) CVS and limb reduction defects.
- 6. Huntington disease (HD) is a poor candidate for gene replacement therapy because it is caused by a gain-of-function mutation. Thus, simple gene insertion is unlikely to correct the disorder. It would be a better candidate for antisense or ribozyme treatment, in which the defective gene product would be disabled. An additional consideration is that this disorder affects primarily neurons, which are relatively difficult to manipulate or target. The fact that HD has a delayed age of onset, however, is encouraging because identification of the action of the HD gene may lead to drug therapy to block the gene product's effects before neuronal damage occurs.

CHAPTER 14

1. Allen's family includes several members who have had myocardial infarctions at a relatively young age. The pedigree suggests that an autosomal dominant gene predisposing family members to heart disease *may* be segregating in this family. This could be caused by autosomal dominant familial hypercholesterolemia, or possibly by another disorder of lipid metabolism. Allen should be encouraged to have his serum lipid levels tested (total cholesterol, LDL, HDL, and triglycerides). If his LDL level is abnormally high, intervention may be necessary (e.g., dietary modification, cholesterol-lowering drugs).

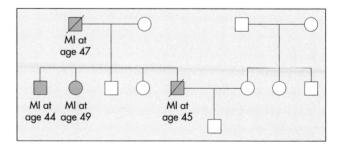

2. Based on the fact that Mary's two brothers and one uncle were all affected, we can be quite certain that her mother is a carrier of the DMD gene. (If only one of Mary's brothers had been affected, we would have to consider the possibility that he was the product of a new mutation.) If Mary's mother is a carrier, then there is a probability of 1/2 that Mary is a carrier. As we saw in Chapter 5, a female carrier will transmit the disease gene to half of her sons, on average. Thus, the probability that one of her sons will be affected with DMD is $1/2 \times 1/2 = 1/4$. The creatine kinase test contributes additional information. We can set up the Bayesian calculation as follows:

	Mary is a carrier	Mary is not a carrier
Prior probability	1/2	1/2
Conditional	2/3	0.05
probability that		
her CK is in the		
95th percentile		
Joint probability	1/3	0.025
Posterior probability	0.93	0.07

It should be clear that the conditional probability of being a carrier, given a CK level above the 95th percentile, is 2/3. The conditional probability of *not* being a carrier with this CK level must be 0.05, because only 5% of CK values in normal individuals will fall above the 95th percentile. Thus, the information derived from the CK test has increased Mary's probability of being a carrier from 1/2 to 0.93. Since the probability that she would transmit the DMD gene to her male offspring is 1/2, the probability of producing an affected male increases from 0.25 to 0.47. Currently, it is likely that additional tests, such as screening for DMD mutations and a dystrophin assay, would yield even more precise information.

3. The prior probability that Bob has inherited the gene from his father is 1/2. Because 85% of gene carriers manifest symptoms by age 51 if they inherited the gene from an affected father, the conditional probability that Bob is 51 years old and unaffected, *given* that he inherited the gene, is 0.15. The probabilities can be set up as in the table below. In this example, the incorporation of age-of-onset information decreased Bob's chance of inheriting the disease gene from 50% to only 13%. With the cloning of the Huntington disease gene, Bob would likely be given a DNA diagnostic test to determine with certainty whether he had inherited an expanded repeat mutation from his father.

Bob carries the HD gene	Bob does not carry the HD
	gene
1/2	1/2
0.15	1
0.075	1/2
0.13	0.87
	the HD gene 1/2 0.15

Glossary

NOTE: When boldface type is used to highlight a word or phrase within a definition, it signifies that the highlighted word or phrase is defined elsewhere in this glossary.

- **5' cap** A chemically modified guanine nucleotide added to the 5' end of a growing mRNA molecule.
- **acceptor site** AG sequence that defines the splice site at the 3' end of an intron.
- **acetylation** The addition of an acetyl group to a molecule (as in histone acetylation).
- **acrocentric** A chromosome whose centromere is close to the end of one arm.
- activator A specific transcription factor that binds to coactivators and to enhancers to help regulate the transcriptional activity of certain genes.
- **adaptive immune system** The portion of the immune system that is capable of changing its DNA sequence to bind foreign particles more effectively. Includes the humoral and cellular components. Compare with **innate immune system**.
- **addition rule** A law of probability that states that the probability of one event or another event occurring is derived by adding the probabilities of the two events together, assuming the events occur independently of one another.
- adenine One of the four DNA bases (abbrev.: A).
- **adeno-associated virus** A type of parvovirus sometimes used as a vector for somatic cell gene therapy.
- **adenovirus** A double-stranded RNA virus that is sometimes used in gene therapy.
- **adjacent segregation** A meiotic segregation pattern in which the pairing of translocated chromosomes leads to unbalanced gametes. Compare with **alternate segregation**.
- **affected sib-pair method** Linkage analysis method in which sib pairs who are both affected with a disease are assessed for the extent to which they share alleles at various marker loci. If alleles are shared significantly more often than the expected 50%, linkage of the disease to the marker is indicated.
- **affinity** The binding power of an antibody with an antigen (low affinity indicates poor binding; high affinity indicates precise binding).
- **allele** Conventional abbreviation for "allelomorph." Refers to the different forms, or DNA sequences, that a gene may have in a population.

- allele-specific oligonucleotide A short DNA sequence, usually 18 to 20 nucleotides, that can hybridize with either disease-causing or normal DNA sequences. Used in **direct diagnosis** of mutations.
- **alpha-fetoprotein** Albumin-like protein produced by the fetus. The level of alpha-fetoprotein is elevated in pregnancies with neural tube defects and may be decreased in pregnancies with Down syndrome.
- **alpha-satellite DNA** A type of repetitive DNA sequence found near centromeres.
- **alternate segregation** A meiotic segregation pattern in which the pairing of translocated chromosomes leads to balanced gametes. Compare with **adjacent segregation**.
- **alternative splice site** A variation in the location of intronexon splice sites in some genes that allow one gene to produce multiple different protein products.
- *Alu* family A major group of dispersed repetitive DNA sequences.
- **amino acids** The major building blocks of polypeptides. Each of the 20 amino acids is encoded by one or more mRNA codons.
- **amniocentesis** Prenatal diagnostic technique in which a small amount of amniotic fluid is withdrawn transabdominally at about 16 weeks after the last menstrual period. Fetal cells can then be tested for some genetic diseases.
- **amniocentesis, early Amniocentesis** carried out at approximately 12 to 14 weeks after the last menstrual period.
- amniocyte Fetal cell found in the amniotic fluid.
- **anaphase** One of the stages of cell division, in which sister chromatids separate and move toward opposite sides of the cell.
- **aneuploid** Condition in which the number of chromosomes is not a multiple of 23, as in trisomy and monosomy. Compare with **euploid**. (n.: aneuploidy).
- **antibody** Molecule produced by plasma cells; antibodies bind to invading antigens.
- **anticipation** A feature of pedigrees in which a disease is seen at earlier ages or with increased severity in more recent generations.
- **anticodon** A three-nucleotide DNA sequence in a tRNA molecule that undergoes complementary base pairing with an mRNA codon.
- **antigen** Molecule that provokes antibody formation (from *anti*body *generator*).
- antigen-presenting cell A cell that engulfs foreign bodies,

digests them, and then displays the foreign antigens on its cell surface for recognition by T lymphocytes.

- **antisense strand** In a double-stranded DNA molecule, the strand from which mRNA is transcribed. See **sense strand**.
- **antisense therapy** A type of somatic cell gene therapy in which an **oligonucleotide** is synthesized, which can hybridize with a mutant mRNA sequence, blocking its translation into protein.

apoptosis Programmed cell death.

- **association** The co-occurrence of two traits or events more often than expected by chance.
- **autoimmunity** Condition in which one's immune system attacks one's own cells.
- **autoradiogram** The image produced by exposing a radioactively labeled substance, such as a probe, to x-ray film (used, for example, in detecting RFLPs and in performing in situ hybridization).
- **autosomes** The 22 pairs of chromosomes excluding the sex chromosomes (X and Y).
- **axis specification** Definition, during embryonic development, of the major axes of the embryo: ventral/dorsal and anterior/posterior.
- **B** lymphocyte (also, **B** cell) A component of the adaptive immune system that produces antibodies.
- **bacterial artificial chromosome (BAC)** A recombinant plasmid inserted in bacteria that serves as a cloning vector capable of accepting DNA inserts of 50 to 200 kb.
- **bacteriophage** Virus that infects bacteria. In recombinant DNA technology, bacteriophages are used as vectors to carry inserted DNA sequences.
- **bacteriophage P1 artificial chromosome (PAC)** A cloning vector that consists of bacteriophage P1 and is inserted into a plasmid; accepts DNA inserts up to 100 kb in size.
- **bands** (1) Visibly darkened areas on **autoradiograms** that represent the location of alleles on a gel. (2) Alternating dark and light areas visible on chromosomes after certain types of stains are used.
- **Barr body** The inactive X chromosome, visible as a densely staining chromatin mass in the somatic cells of normal females. Also known as **sex chromatin**.
- **base** One of the four nitrogenous substances (adenine, cytosine, guanine, or thymine) that make up part of the DNA molecule. Combinations of bases specify amino acid sequences.
- **base analog** A substance that can mimic the chemical behavior of one of the four DNA bases. Base analogs are a type of **mutagen**.
- **base pair (bp)** A unit of complementary DNA bases in a double-stranded DNA molecule (A-T or C-G).
- **base pair substitution** The replacement of one base pair by another. A type of mutation.
- **Bayes theorem** A statistical procedure in which prior and conditional probabilities are used to derive an improved estimate of probability or risk.
- **benign** Describes a neoplasm (tumor) that does not invade surrounding tissue or **metastasize** to other parts of the body. Compare with **malignant**.
- **bivalent** A pair of intertwined homologous chromosomes seen in prophase I of meiosis. Synonymous with **tetrad**.
- **blood group** Molecules found on the surfaces of erythrocytes, some of which (ABO and Rh) determine blood transfusion compatibility.
- **body plan** The pattern and arrangement of body segments during embryonic development.

bp Abbreviation for **base pair**.

- **breakpoint** The location on a chromosome at which a translocation has occurred.
- **C-banding** A type of chromosome staining that highlights the constitutive heterochromatin that lies at and near centromeres.
- **candidate gene** A gene that, on the basis of known properties or protein product, is thought to be the gene causing a specific genetic disease.
- **capillary sequencing** A method of DNA sequencing in which DNA migrates through a thin capillary tube in order to separate DNA fragments of different lengths.
- **carcinogen** Substance that can produce cancer (adj.: carcinogenic).
- carcinogenesis The process of cancer development.
- **carrier** An individual who has a copy of a disease-causing gene but does not express the disease. The term is usually used to denote heterozygotes for a recessive disease gene.
- **catalyst** A substance that increases the rate of a chemical reaction. Enzymes are an example of a catalyst.
- **cDNA** Complementary DNA, formed by reverse transcription of mRNA purified from a collection of cells. This type of DNA corresponds only to coding sequence (**exons**).
- **cDNA library** A collection of segments of complementary DNA (cDNA) cloned into vehicles such as phages or plasmids. Compare with **genomic library**.
- **cell adhesion molecule** Cell-surface molecule that participates in the interaction of T cells and their targets.
- cell cycle The alternating sequence of mitosis and interphase.cell fate The location and function of cells, programmed during embryonic development.
- **cellular immune system** The T-cell component of the adaptive immune system.
- **centiMorgan (cM)** A unit of measure of the frequency of recombination between two loci, also known as a map unit. One cM corresponds to a recombination frequency of 1%.
- **centriole** Structure in cells that helps to pull chromosomes apart during meiosis and mitosis.
- **centromere** The region of a chromosome that separates the two arms; centromeres are the sites of attachment of spindle fibers during cell division.
- **CG islands** Unmethylated CG sequences that are found near the 5' ends of many genes.
- **chiasma** (pl. **chiasmata**) The location of a **crossover** between two homologous chromosomes during meiosis.
- **chorionic villus sampling (CVS)** A prenatal diagnostic technique in which a small sample of chorionic villi is aspirated. Usually performed at 10 to 12 weeks' gestation.
- **chromatin** The combination of proteins (e.g., **histones**) and nucleic acids that makes up chromosomes.
- **chromatin loop** A unit of DNA coiling consisting of a group of **solenoids**. Each loop is approximately 100 kb in size.
- **chromatin opener** Regulatory element that is capable of decondensing or "opening" regions of chromatin.
- **chromosome** Threadlike structure (literally "colored body") consisting of **chromatin**. Genes are arranged along chromosomes.
- **chromosome abnormalities** A major group of genetic diseases, consisting of microscopically observable alterations of chromosome number or structure.
- **chromosome banding** The process of applying specific stains to chromosomes in order to produce characteristic patterns of **bands** (example: G-banding).

- **chromosome breakage** The fracture of chromosomes; breakage is increased in the presence of **clastogcns**.
- **chromosome instability syndrome** Diseases characterized by the presence of large numbers of chromosome breaks or exchanges, such as **sister chromatid exchange** (example: Bloom syndrome).
- **chromosome-specific library** A collection of DNA fragments from a single chromosome.
- **class switching** The process in which the heavy chains of B lymphocytes change from one class, or **isotype**, to another (e.g., IgM to IgG).
- **clastogen** A substance that can induce **chromosome breakage** (example: radiation).
- **clone** (1) A series of identical DNA fragments created by recombinant DNA techniques. (2) Identical cells that are descended from a single common ancestor.
- **cloning, functional** A method of isolating genes in which a gene whose protein product's function is already known is evaluated as a **candidate gene** responsible for a trait or disease.
- **cloning, positional** The isolation and cloning of a disease gene after determining its approximate physical location; the gene product is subsequently determined. Formerly termed "reverse genetics."
- **co-activator** A type of **specific transcription factor** that binds to **activators** and to the **general transcription factor** complex to regulate the transcription of specific genes.
- **codominant** Alleles that are both expressed when they occur together in the heterozygous state (example: *A* and *B* alleles of the ABO blood group system).
- **codon** A group of three mRNA bases, each of which specifies an amino acid when translated.
- **coefficient of relationship** A statistic that measures the proportion of genes shared by two individuals as a result of descent from a common ancestor.
- **cofactors** Substances that interact with enzymes to produce chemical reactions, such as various metabolic processes (examples: dietary trace elements, vitamins).
- **colcemid** or **colchicine** A spindle poison that arrests cells in metaphase, making them easily discernible microscopically.
- **comparative genomic hybridization** Cytogenetic technique in which a mixture of DNA from a test source (e.g., a tumor) and a normal control are differentially labeled, mixed, and hybridized with normal metaphase chromosomes. Differences in color reveal chromosome losses or duplications in the test DNA.
- **complement system** A component of the immune system, encoded by genes in the class III MHC region, that can destroy invading organisms. The complement system also interacts with other components of the immune system, such as antibodies and phagocytes.
- **complementary base pairing** A fundamental process in which adenosine pairs only with thymine and guanine pairs only with cytosine. Also sometimes known as "Watson-Crick pairing."
- **compound heterozygote** An individual who is heterozygous for two different disease-causing mutations at a locus. Compare with **homozygote**. Compound heterozygotes for recessive disease mutations are usually affected with the disorder.
- **concordant** Refers to two individuals who have the same trait (e.g., monozygotic twins may be concordant for a disease such as diabetes). Compare with **discordant**. (n.: concordance).

- **conditional probability** The probability that an event will occur, *given* that another event has already occurred. Conditional probabilities are used, for example, in **Bayes theorem**.
- **confined placental mosaicism** A form of **mosaicism** that is observed in the placenta but not in the fetus.
- congenital Present at birth.
- **consanguinity** The mating of related individuals (adj.: consanguineous).
- **consensus sequence** A sequence that denotes the DNA bases most often seen in a region of interest. The sequences that are found near **donor** and **acceptor sites** are a type of consensus sequence.
- **conservation** The preservation of highly similar DNA sequences among different organisms; conserved sequences are usually found in functional genes.

conserved See conservation.

- **constitutional** or **constitutive** Pertaining to DNA in normal cells of the body, usually used in contrast to tumor DNA.
- constitutive heterochromatin See heterochromatin, constitutive.
- **contig map** A physical map of a chromosome region constructed by isolating overlapping (contiguous) DNA segments.
- **contiguous gene syndrome** A disease caused by the deletion or duplication of multiple consecutive genes. See also **microdeletion**.
- cordocentesis See percutaneous umbilical blood sampling (PUBS).
- **cosmid** A phage-plasmid hybrid capable of accepting larger DNA inserts (up to 40 to 50 kb) than either phage or plasmids.
- **costimulatory molecule** Cell-surface molecule that participates in the binding of T-cell receptors to MHC-antigen complexes.

cross Mating between organisms in genetic studies.

- **cross-reaction** The binding of an antibody to an antigen *other* than the one that originally stimulated antibody formation. Such antigens are usually very similar to the original antibody-generating antigen.
- **crossing over** or **crossover** The exchange of genetic material between homologous chromosomes during meiosis (also occurs rarely during mitosis); produces **recombination**.
- **cryptic splice site** Site at which intron-exon splicing may occur when the usual splice site is altered.
- **cyclin-dependent kinases** Enzymes that form complexes with specific **cyclins** to phosphorylate regulatory proteins (such as pRb) at specific stages of the cell cycle.
- **cyclin-dependent kinase inhibitors** Proteins that inactivate **cyclin-dependent kinases**. Many of these are tumor suppressors (examples: p16, p21).
- cyclins Proteins that interact with specific cyclin-dependent kinases to regulate the cell cycle at specific stages.
- **cytogenetics** The study of chromosomes and their abnormalities. Combines cytology, the study of cells, and genetics.
- **cytokine** Growth factor that causes cells to proliferate (example: interleukins).
- **cytokinesis** Cytoplasmic division that occurs during mitosis and meiosis.

cytosine One of the four DNA bases (abbrev.: C).

cytotoxic T lymphocyte A type of T lymphocyte that destroys a cell when the cell presents a complex of MHC class I molecule and foreign peptide. Part of the cellular immune system.

- **daughter cells** Cells that result from the division of a parent cell.
- **deformation** Alteration of the form, shape, or position of a normally formed body part by mechanical forces (example: oligohydramnios sequence).
- **deletion** The loss of chromosome material. May be terminal or interstitial. Compare with **duplication**.
- **deletion, interstitial** Deletion that removes part of the interior of the chromosome.
- **deletion, terminal** Deletion that removes part of a chromosome, including one telomere.
- denaturing gradient gel electrophoresis (DGGE) See electrophoresis, denaturing gradient gel.
- **derivative chromosome** A chromosome that has been altered as a result of a translocation (example: derivative 9, or der(9)).
- **dideoxy method** A technique for sequencing DNA in which dideoxynucleotides, which terminate replication, are incorporated into replicating DNA strands.
- diploid Having two copies of each chromosome. In humans, the diploid number is 46. Compare with haploid, polyploid.
- **direct cDNA selection** Method of exon detection in which a genomic DNA fragment inserted into a vector such as a YAC is hybridized with cDNA; hybridization and selection identify the regions of the genomic DNA fragment that correspond to cDNA (i.e., exon-containing DNA).
- **direct diagnosis** A form of DNA-based disease diagnosis in which the mutation itself is examined directly. Compare with **indirect diagnosis**.
- **discordant** Refers to two individuals who do not share the same trait. Compare with **concordant**. (n.: discordance).
- **dispermy** Fertilization of a single ovum by two sperm cells.
- **dispersed repetitive DNA** A class of repeated DNA sequences in which single repeats are scattered throughout the genome. Compare with **tandem repeat**.
- **disruption** Morphological defect that results from the breakdown of an otherwise normal developmental process (example: limb reduction defect resulting from poor vascularization).
- **dizygotic** A type of twinning in which each twin is produced by the fertilization of a different ovum. Synonymous with "fraternal" twin. Compare with **monozygotic**.
- **DNA (deoxyribonucleic acid)** A double-helix molecule that consists of a sugar-phosphate backbone and four nitrogenous bases (A, C, G, and T). DNA bases encode **messenger RNA (mRNA)**, which in turn encodes amino acid sequences.
- **DNA-binding motifs** Portions of transcription factors that allow them to interact with specific DNA sequences (examples: helix-loop-helix motif, zinc finger motif).

DNA chips See microarrays.

- **DNA looping** The formation of looped structures in DNA; sometimes permits the interaction of various regulatory elements.
- **DNA mismatch repair** A type of **DNA repair** in which nucleotide mismatches (i.e., violations of the G-C, A-T complementary base-pairing rule) are corrected by specialized enzymes.
- **DNA polymerase** An enzyme involved in DNA replication and repair.

- **DNA profile** A series of DNA polymorphisms (usually VNTRs or microsatellites) typed in an individual. Because these polymorphisms are highly variable, the combined genotypes are useful in identifying individuals for forensic purposes.
- **DNA repair** A process in which mistakes in the DNA sequence are altered to represent the original sequence.
- **DNA sequence** The order of DNA bases along a chromosome.
- **DNA sequencing, automated** DNA sequencing techniques in which automated procedures such as computer-guided laser scanning are used to provide more rapid, accurate DNA sequence results.
- **dominant** Allele that is expressed in the same way in single copy (heterozygotes) as in double copy (homozygotes). Compare with **recessive**.
- **dominant negative** A type of mutation in which the altered protein product in a heterozygote forms a complex with the normal protein product produced by the homologous normal gene, thus disabling it.
- **donor site** GT sequence that defines the splice site at the 5' end of an intron.
- **dosage compensation** Situation in which, as a consequence of X inactivation, the amount of X chromosome–encoded gene product in females is roughly equal to that in males.
- **dosage mapping** A technique for mapping genes in which excess or deficient gene product is correlated with a chromosomal duplication or deletion.
- **dosage sensitivity** Condition in which alteration of the level of a gene product (e.g., a **deletion** resulting in 50% expression or a **duplication** resulting in 150% expression of the gene product) causes a substantial alteration of the phenotype (including disease).
- **double helix** The "twisted ladder" shape of the double-stranded DNA molecule.
- **double-stranded DNA breaks** A type of DNA breakage in which both strands are broken at a specific location.
- **duplication** The presence of an extra copy of chromosome material. Compare with **deletion**.
- dysmorphology The study of abnormal physical development.
- **dysplasia** A defect in which cells are abnormally organized into tissue (example: bone dysplasia).
- **ectopic expression** Expression of a gene product in an abnormal location or tissue type.
- **electrophoresis** A technique in which charged molecules are placed in a medium and exposed to an electrical field, causing them to migrate through the medium at different rates, according to charge, length, or other attributes.
- electrophoresis, denaturing gradient gel (DGGE) A method of mutation detection in which DNA fragments are electrophoresed through a gel in which there is a changing denaturing factor, such as temperature.
- **empirical risk** Risk estimate based on direct observation of data.
- **endocytosis** Process in which molecules are transported into the interior of cells.
- **enhancer** Regulatory DNA sequence that interacts with **specific transcription factors** to increase the transcription of genes. Compare with **silencer**.
- **equational division** The second major cycle of meiosis: meiosis II. Compare with **reduction division**.

equatorial plane The middle of the cell's spindle, along

which homologous chromosomes are arranged during metaphase.

- erythroblast A nucleated red blood cell; precursors of erythrocytes.
- erythrocyte A red blood cell.
- **euchromatin** Chromatin that is light-staining during interphase and tends to be transcriptionally active. Compare with **heterochromatin**.
- **eugenics** The use of controlled breeding to increase the prevalence of "desirable" genetic traits (positive eugenics) and to decrease the prevalence of "undesirable" traits (negative eugenics).
- eukaryotes Organisms whose cells have true nuclei.
- **euploid** Refers to cells whose chromosome number is a multiple of 23 (in humans). (n.: euploidy).
- **exons** Portions of genes that encode amino acids and are retained after the primary mRNA transcript is spliced. Compare with **intron**.
- **exon trapping** Method for isolating exons in a fragment of genomic DNA by using an in vitro cell system to artificially splice out the introns.
- **expanded repeat** A type of mutation in which a tandem trinucleotide repeat increases in number (example: Huntington disease).
- **expressed sequence tag (EST)** Several hundred bp of known cDNA sequence, flanked by PCR primers. Because they are derived from cDNA libraries, these sequences represent portions of expressed genes.
- **false negative** A test result in which an affected individual is incorrectly identified as being unaffected with the disease in question. Compare with **false positive**.
- **false positive** A test result in which an unaffected individual is incorrectly identified as being affected with the disease in question. Compare with **false negative**.
- **fetoscopy** A fetal visualization technique in which an endoscope is inserted through the abdominal wall. Sometimes used in prenatal diagnosis.
- fiber FISH See fluorescence in situ hybridization, fiber.
- fibrillin Connective tissue component; mutations in the fibrillin gene can cause Marfan syndrome.
- **flow cytometry** A technique whereby chromosomes can be individually sorted.
- **fluorescence in situ hybridization (FISH)** A molecular cytogenetic technique in which labeled probes are hybridized with chromosomes and then visualized under a fluorescence microscope.
- **fluorescence in situ hybridization, fiber (fiber FISH)** A version of the **FISH** technique in which fluorescent probes are hybridized to interphase chromosomes that have been manipulated so that the chromatin fibers are stretched, allowing high-resolution visualization and mapping.
- **founder effect** A large shift in gene frequencies that results when a small "founder" population, which contains limited genetic variation, is derived from a larger population. Founder effect can be considered a special case of **genetic drift**.
- **frameshift mutation** An alteration of DNA in which a duplication or deletion occurs that is not a multiple of three base pairs.
- **fusion gene** A gene that results from a combination of two genes, or parts of two genes.

gain of function A class of mutations that results in a protein

product that either is increased in quantity or has a novel function. Compare with **loss of function**.

- gamete The haploid germ cell (sperm and ova).
- gametogenesis The process of gamete formation.
- **gastrulation** Embryonic stage in which cells of the blastula are arranged to become a three-layer structure consisting of endoderm, mesoderm, and ectoderm.

gene The fundamental unit of heredity.

- gene-environment interaction A mutual phenotypic effect of a gene and an environmental factor that is greater than the single effect of either factor alone (example: the effect of α_1 -antitrypsin deficiency and cigarette smoking on pulmonary emphysema).
- **gene family** A group of genes that are similar in DNA sequence and have evolved from a single common ancestral gene; may or may not be located in the same chromosome region.
- **gene flow** The exchange of genes between different populations.
- **gene frequency** In a population, the proportion of chromosomes that contain a specific gene.
- **gene therapy** The insertion or alteration of genes to correct a disease.
- **gene therapy, germline** Gene therapy that alters all cells of the body, including the germ line. Compare with **gene therapy, somatic cell**.
- gene therapy, somatic cell Gene therapy that alters somatic cells but not cells of the germ line. Compare with gene therapy, germline.
- genetic code The combinations of mRNA codons that specify individual amino acids.
- **genetic counseling** The delivery of information about genetic diseases (risks, natural history, and management) to patients and their families.
- **genetic drift** An evolutionary process in which gene frequencies change as a result of random fluctuations in the transmission of genes from one generation to the next. Drift is greater in smaller populations.
- **genetic engineering** The alteration of genes; typically involves **recombinant DNA** techniques.
- **genetic mapping** The ordering of genes on chromosomes according to recombination frequency. Compare with **physical mapping**.
- **genetic screening** The large-scale testing of defined populations to identify those who are at increased risk of having a disease-causing gene.
- **genetic testing** The analysis of DNA, RNA, or proteins to test for the presence of differences that may cause a genetic disease.
- genome The totality of an organism's DNA.
- **genome scan** A gene mapping approach in which markers from the entire human genome are tested for linkage with a disease phenotype.
- **genomic library** A collection of DNA fragments from an organism's entire genome. Includes cDNA as well as non-coding DNA. Compare with **cDNA library**.
- **genomic instability** Abnormal condition in which there is a substantial increase in mutations throughout the genome. It can occur, for example, when a DNA repair system is disabled.
- genotype An individual's allelic constitution at a locus.
- **genotype frequency** The proportion of individuals in a population that carry a specific genotype.

germ line Cells responsible for the production of gametes.

- Giemsa A type of staining that produces G-bands in chromosomes.
- **globin** Major component of the hemoglobin molecule. Globin is also found in the vertebrate myoglobin molecule.
- **growth factor** A substance capable of stimulating cell proliferation.
- **growth factor receptor** Structure on cell surfaces to which growth factors can bind.
- guanine One of the four DNA bases (abbrev.: G).
- guanosine diphosphate (GDP) Partially dephosphorylated form of guanosine triphosphate.
- **guanosine triphosphate (GTP)** A molecule required for the synthesis of peptide bonds during translation.
- **haploid** Refers to cells that have one copy of each chromosome, the typical state for gametes. In humans, the haploid number is 23.
- **haploinsufficiency** Describes the situation in which 50% of the normal level of gene expression (i.e., in a heterozygote) is not sufficient for normal function.
- **haplotype** The allelic constitution of multiple loci on a single chromosome. Derived from "haploid genotype."
- **Hardy-Weinberg principle** Specifies an equilibrium relationship between gene frequencies and genotype frequencies in populations.
- heavy chain A major structural component of an antibody molecule, having a higher molecular weight than the other major component, the light chain. There are five major types of heavy chains in the human: γ , μ , α , δ , and ϵ .
- helper T lymphocyte A type of T lymphocyte whose receptors bind to a complex of MHC class II molecule and foreign peptide on the surfaces of antigen-presenting cells. Part of the cellular immune system.
- **heme** Iron-containing component of the hemoglobin molecule; binds with oxygen.
- **hemizygous** Refers to a gene that is present in only a single copy (hemi = "half"). Most commonly, refers to genes on the single male X chromosome but can refer to other genes in the haploid state, such as the genes homologous to a deleted region of a chromosome.
- **heritability** The proportion of population **variance** in a trait that can be ascribed to genetic factors.
- **heterochromatin** Dark-staining chromatin that is usually transcriptionally inactive and consists mostly of repetitive DNA. Compare with **euchromatin**.
- heterochromatin, constitutive Heterochromatin that consists of satellite DNA; located near centromeres and on the short arms of acrocentric chromosomes.
- heterodisomy The presence in a cell of two chromosomes derived from a single parent and none from the other parent (disomy). In *hetero*disomy, the two chromosomes are the nonidentical homologous chromosomes. Compare with isodisomy.
- **heterogeneity, allelic** Describes conditions in which different alleles at a locus can produce variable expression of a disease. Depending on phenotype definition, allelic heterogeneity may cause two distinct diseases, as in Duchenne and Becker muscular dystrophy.
- heterogeneity, locus Describes diseases in which mutations at distinct loci can produce the same disease phenotype (examples: osteogenesis imperfecta; retinitis pigmentosa).
- **heteromorphism** Variation in the microscopic appearance of a chromosome.

- **heteroplasmy** The existence of differing DNA sequences at a locus within a single cell. Often seen in mitochondrial genes.
- **heterotetramer** A molecule consisting of four (*tetra*) subunits, at least one of which differs from the others. Compare with **homotetramer**.
- **heterozygote** An individual who has two different alleles at a locus. Compare with **homozygote**.
- high-resolution banding Chromosome banding using prophase or prometaphase chromosomes, which are more extended than metaphase chromosomes and thus yield more bands and greater resolution.
- **histone** The protein core around which DNA is wound in a chromosome.
- **holandric** Refers to Y-linked inheritance; a transmission exclusively from father to son.
- **homeodomain** A DNA-binding portion of transcription factor proteins that are involved in embryonic development.
- **homologous** (1) Refers to DNA or amino acid sequences that are highly similar to one another. (2) Describes chromosomes that pair during meiosis, one derived from the individual's father and the other from the mother.
- **homologs** Chromosomes that are **homologous**.
- **homotetramer** Molecule consisting of four (*tetra*) identical subunits. Compare with **heterotetramer**.
- **homozygote** An individual in whom the two alleles at a locus are the same. Compare with **heterozygote**.
- **housekeeping genes** Genes whose protein products are required for cellular maintenance or metabolism. Because of their central role in the life of the cell, housekeeping genes are transcriptionally active in all cells.
- **human artificial chromosome** A synthetic chromosome consisting of an artificial centromere and telomeres and an insert of human DNA that can be 5 to 10 Mb in size.
- human leukocyte antigen (HLA) Older term for major histocompatibility complex (MHC).
- **humoral immune system** The B-cell component of the adaptive immune system, termed humoral because antibodies are secreted into the circulation.
- **immunodeficiency disease** A class of diseases characterized by insufficiencies in the immune response (example: severe combined immune deficiency).
- **immunodeficiency disease, primary** Disorder of the immune system that is caused directly by defects (usually genetic) in components or cells of the immune system.
- **immunodeficiency disease, secondary** Disorder of the immune system that is a consequence of an agent or defect that originates outside the immune system (e.g., infection, radiation, drugs).
- **immunogenetics** The study of the genetic basis of the immune system.
- immunoglobulin Receptor found on the surfaces of B cells. When secreted into the circulation by B cells that have matured into plasma cells, immunoglobulins are known as antibodies.
- **imprinting, genomic** Describes process in which genetic material is expressed differently when inherited from the mother than when inherited from the father.
- in situ hybridization Molecular gene mapping technique in which labeled probes are hybridized to stained metaphase chromosomes and then exposed to x-ray film to reveal the position of the probe.
- in vitro fertilization (IVF) diagnosis A form of genetic

diagnosis in which DNA from a single embryonic cell (obtained by IVF) is amplified by **polymerase chain reaction** so that disease-causing mutations can be tested.

- **incest** The mating of closely related individuals, usually describing the union of first-degree relatives.
- **independence** A principle, often invoked in statistical analysis, indicating that the occurrence of one event has no effect on the probability of occurrence of another (adj.: independent).
- **independent assortment** One of Mendel's fundamental principles; dictates that alleles at different loci are transmitted independently of one another.

index case See proband.

- indirect diagnosis A form of genetic diagnosis in which the disease-causing mutation is not directly observed; usually refers to diagnosis using linked markers. Compare with direct diagnosis.
- **induction** The influence or determination of development of one group of cells by a second group of cells.
- innate immune system Portion of the immune system that does not change its characteristics to respond to infections. Major part of the initial immune response. Compare with adaptive immune system.
- **insert** A DNA sequence that is placed into a vector, such as a plasmid or cosmid, using recombinant DNA techniques.
- **interphase** Portion of the cell cycle that alternates with **meiosis** or **mitosis** (cell division). DNA is replicated and repaired during this phase.
- **intraclass correlation coefficient** A statistical measure that varies between -1 and 1 and specifies the degree of similarity of two quantities in a sample or population.
- **intron** DNA sequence found between two **exons**. It is transcribed into primary mRNA but is spliced out in the formation of the mature mRNA transcript.
- **inversion** A structural rearrangement of a chromosome in which two breaks occur, followed by reinsertion of the chromosome segment, but in reversed order. May be either paracentric or pericentric. See also **inversion**, **paracentric** and **inversion**, **pericentric**.
- **inversion, paracentric** An inversion that does not include the centromere.
- **inversion, pericentric** An inversion that includes the centromere.
- **isochromosome** A structural chromosome rearrangement caused by the division of a chromosome along an axis perpendicular to the usual axis of division; results in chromosomes with either two short arms or two long arms.
- **isodisomy** The presence in a cell of two identical chromosomes derived from one parent and none from the other parent. Compare with **heterodisomy**.

isotype Classes of immunoglobulin molecules (e.g., IgA, IgE, IgG), determined by the type of heavy chain present in the molecule.

joint probability The probability of two events *both* occurring. **karyotype** A display of chromosomes, ordered according to length. **kilobase (kb)** One thousand DNA base pairs.

knockout Animal model in which a specific gene has been disabled.

lentivirus A type of **retrovirus** that can enter nondividing cells.

light chain A major structural component of the antibody molecule, consisting of either a κ or a λ chain. The light chain has a lower molecular weight than the other major component, the heavy chain.

- **likelihood** A statistic that measures the probability of an event or a series of events.
- **LINEs (long interspersed elements)** A class of dispersed repetitive DNA in which each repeat is relatively long, up to 7 kb. Compare with **SINEs.**
- **linkage** Describes two loci that are located close enough on the same chromosome that their **recombination frequency** is less than 50%.
- **linkage disequilibrium** Nonrandom association of alleles at linked loci in populations. Compare with **linkage** equilibrium.
- **linkage equilibrium** Lack of preferential association of alleles at linked loci. Compare with **linkage disequilibrium**.
- **linkage phase** The arrangement of alleles of linked loci on chromosomes.
- **liposome** A fat body sometimes used as a vector for somatic cell gene therapy.

locus The chromosome location of a specific gene (pl.: loci).

- **locus control region** DNA sequence in the 5' region of the globin gene clusters that is involved in transcriptional regulation.
- **LOD score** Common logarithm of the ratio of the likelihood of linkage at a specific recombination fraction to the likelihood of no linkage.
- **loss of function** A class of mutation in which the alteration results in a nonfunctional protein product. Compare with **gain of function**.
- **loss of heterozygosity** Describes a locus or loci at which a deletion or other process has converted the locus from heterozygosity to homozygosity or hemizygosity.
- **Lyon hypothesis** A proposal (now verified) that one X chromosome is randomly inactivated in each somatic cell of the normal female embryo (lyonization).
- **macrophage** A type of **phagocyte** that ingests foreign microbes and displays them on its surface for recognition by T-cell receptors.
- **major gene** A single locus responsible for a trait (sometimes contrasted with a polygenic component).
- **major histocompatibility complex (MHC), class I** A membrane-spanning glycoprotein, found on the surfaces of nearly all cells, that presents antigen for recognition by cytotoxic T lymphocytes. Compare with **MHC class II**.
- major histocompatibility complex (MHC), class II A membrane-spanning glycoprotein, found on the surfaces of **antigen-presenting cells**, that presents antigen for recognition by helper T cells.
- **malformation** A primary morphologic defect resulting from an intrinsically abnormal developmental process (example: polydactyly).
- **malignant** Describes a tumor that is capable of invading surrounding tissue and metastasizing to other sites in the body. Compare with **benign**.
- **manifesting heterozygote** An individual who is heterozygous for a recessive trait but displays the trait. Most often used to describe females who are heterozygous for an X-linked trait and display the trait.
- **markers** Polymorphisms, such as RFLPs, VNTRs, microsatellite repeats, and blood groups, that are linked to a disease locus.

mass spectrometry Analysis of the mass/charge ratio of molecules; can be used to sequence DNA and detect mutations.

mass spectrometry, tandem A form of mass spectrometry in

which two mass spectrometry machines are used, the first of which separates molecules according to mass, and the second of which assesses the mass and charge of the molecules after they have been fragmented.

- **maternal serum alpha-fetoprotein (MSAFP)** Alphafetoprotein present in the serum of pregnant women; used in prenatal screening for fetal disorders such as neural tube defects and Down syndrome.
- **mature transcript** Describes mRNA after the introns have been spliced out. Prior to splicing, the mRNA is referred to as a **primary transcript**.
- **maximum likelihood estimate** A statistical procedure in which the likelihoods of a variety of parameter values are estimated and then compared to determine which likelihood is the largest. Used, for example, in evaluating LOD scores to determine which recombination frequency is the most likely.
- megabase (Mb) One million base pairs.
- **meiosis** Cell division process in which haploid gametes are formed from diploid germ cells.
- **meiotic failure** Aberrant **meiosis** in which a diploid gamete is produced rather than the normal haploid gamete.
- **memory cells** A class of high-affinity-binding B cells that remain in the body after an immune response has ended; they provide a relatively rapid, high-affinity response should the same disease antigen be encountered a second time.
- **mendelian** Referring to Gregor Mendel, describes a trait that is attributable to a single gene.
- **mesenchyme** Tissue that forms connective tissues and lymphatic and blood vessels during embryonic development.
- messenger RNA (mRNA) RNA molecule that is formed from the transcription of DNA. Before intron splicing, mRNA is termed a primary transcript; after splicing, the mature transcript (or mature mRNA) proceeds to the cytoplasm, where it is translated into an amino acid sequence.
- **metacentric** A chromosome in which the centromere is located approximately in the middle of the chromosome arm.
- **metaphase** A stage of mitosis and meiosis in which homologous chromosomes are arranged along the equatorial plane, or metaphase plate, of the cell. This is the mitotic stage at which chromosomes are maximally condensed and most easily visualized.
- **metastasis** The spread of malignant cells from one site in the body to another (v.: metastasize).
- **methylation** The attachment of methyl groups; in genetics, refers especially to the addition of methyl groups to cytosine bases, forming 5-methylcytosine. Methylation is correlated with reduced transcription of genes.
- **MHC restriction** The limiting of immune response functions to MHC-mediated interactions (e.g., the binding of Tcell receptors is MHC restricted because it requires the presentation of antigen by MHC class I or MHC class II molecules).
- **microarrays** Arrangement of large numbers of DNA sequences, such as oligonucleotides consisting of normal and mutated sequences, on glass slides or silicone chips (DNA chips). These oligonucleotides can be hybridized to labeled DNA from subjects to test for sequence variants, to sequence DNA, or to analyze gene expression patterns.
- **microdeletion** A chromosome deletion that is too small to be visible under a microscope (examples: DiGeorge syndrome;

Prader-Willi syndrome). See also **contiguous gene syndrome**.

- **microsatellite** A type of **satellite DNA** that consists of small repeat units (usually 2, 3, 4, or 5 bp) that occur in tandem.
- microsatellite repeat polymorphism A type of genetic variation in populations consisting of differing numbers of microsatellite repeat units at a locus. Also known as short tandem repeat polymorphisms (STRPs).
- **minisatellite** A type of **satellite DNA** that consists of tandem repeat units that are each about 20 to 70 bp in length. Variation in the number of minisatellite repeats is the basis of VNTR polymorphisms.
- **mismatch** The presence in one chain of double-stranded DNA of a base that is not complementary to the corresponding base in the other chain. Also known as mispairing.
- **mismatch repair** DNA repair process in which mismatched nucleotides are altered so that they become complementary.
- **missense** A type of mutation that results in a single amino acid change in the translated gene product. Compare with **nonsense mutation**.
- **mitochondria** Cytoplasmic organelles that are important in cellular respiration. The mitochondria have their own unique DNA.
- mitosis Cell division process in which two identical progeny cells are produced from a single parent cell. Compare with meiosis.
- **mobile elements** DNA sequences that are capable of inserting themselves into other locations in the genome.
- **modifier gene** A gene that alters the expression of a gene at another locus.
- **molecular genetics** Study of the structure and function of genes at the molecular level.
- **monoclonal** Refers to a group of cells that consist of a single clone (i.e., all cells are derived from the same single ancestral cell).
- **monogenic** Describing a single-gene, or mendelian, trait.
- **monosomy** An aneuploid condition in which a specific chromosome is present in only a single copy, giving the individual a total of 45 chromosomes.
- **monozygotic** Describes a twin pair in which both members are derived from a single zygote. Synonymous with "identical" twin. Compare with **dizygotic**.
- **morphogenesis** The process of development of a cell, organ, or organism.
- **mosaic** The existence of two or more genetically different cell lines in an individual.
- **mosaic, germline** A type of **mosaic** in which the germ line of an individual contains an allele not present in the somatic cells.
- **multifactorial** Describes traits or diseases that are the product of the interactions of multiple genetic and environmental factors (example: neural tube defects).
- **multi-hit concept of carcinogenesis** The principle that most tumors arise from a series of errors, or "hits," occurring in a cell.
- **multiplication rule** A law of probability that states that the probability of co-occurrence of two or more independent events can be obtained by multiplying the individual probabilities of each event.
- **multipoint mapping** A type of genetic mapping in which the recombination frequencies among three or more loci are estimated simultaneously.

mutagen A substance that causes a mutation.

- **mutation** An alteration in DNA sequence.
- **mutation, induced** A mutation that is caused by an exogenous factor, such as radiation. Compare with **mutation, spontaneous.**
- **mutation, spontaneous** A mutation that is not known to be the result of an exogenous factor. Compare with **mutation, induced**.
- **natural killer cell** A type of lymphocyte that is involved in the early phase of defense against foreign microbes and tumors and is not MHC restricted.
- **natural selection** An evolutionary process in which individuals with favorable genotypes produce relatively greater numbers of surviving offspring.
- **negative predictive value** In disease screening, the proportion of individuals with a negative test result who truly do not have the disease. Compare with **positive predictive value**.
- **neoplasm** or **tumor** A group of cells characterized by unregulated proliferation (may be **benign** or **malignant**).
- **neurofibromin** The protein product of the neurofibromatosis type 1 gene.
- **neurulation** Formation of the neural tube during embryonic development.
- **new mutation** An alteration in DNA sequence that appears for the first time in a family as the result of a mutation in one of the parents' germ cells.
- **nondirectiveness** Describes the genetic counseling approach in which information is provided to a family, while decisions about reproduction are left to the family.
- **nondisjunction** Failure of homologous chromosomes (in mitosis or meiosis I) or sister chromatids (in meiosis II) to separate properly into different progeny cells. Can produce **aneuploidy**.
- **nonsense mutation** A type of mutation in which an mRNA stop codon is produced, resulting in premature termination of translation, or removed, resulting in an elongated protein product. Compare with **missense mutation**.
- **Northern blotting** A gene expression assay in which mRNA on a blot is hybridized with a labeled probe.
- **nucleosome** A structural unit of chromatin in which 140 to 150 bp of DNA are wrapped around a core unit of eight histone molecules.
- **nucleotide** A basic unit of DNA or RNA, consisting of one deoxyribose (or ribose in the case of RNA), one phosphate group, and one nitrogenous base.
- **nucleotide excision repair** A type of **DNA repair** in which altered groups of nucleotides, such as pyrimidine dimers, are removed and replaced with properly functioning nucleotides.
- **obligate carrier** An individual who is known to possess a disease-causing gene (usually on the basis of pedigree examination) but may or may not be affected with the disease phenotype.
- **occurrence risk** The probability that a couple will produce a child with a genetic disease. Refers to couples who have not yet produced a child with the disease in question. Compare with **recurrence risk**.
- **oligonucleotide** DNA sequence consisting of a small number of nucleotide bases.
- **oncogene** A gene that can transform cells into a highly proliferative state, causing cancer.
- oogenesis The process by which ova are produced.
- **oogonium** The diploid germline stem cell from which ova are ultimately derived.

- organogenesis The formation of organs during embryonic development.
- **packaging cells** or **helper cells** Cells in which replicationdeficient viruses are placed so that the replication machinery of the packaging cell can produce viral copies.
- palindrome A DNA sequence whose complementary sequence is the same if read backwards (e.g., 5'-AATGCG-CATT-3').
- **panmixia** Describes a population in which individuals mate at random with respect to a specific genotype.
- **paralog** Within a species, a member of a set of homologous genes (example: *HOXA13* and *HOXD13*).
- **partial trisomy** Chromosome abnormality in which a portion of a chromosome is present in three copies; may be produced by reciprocal translocation or unequal crossover. See also **translocation, reciprocal** and **crossover**.
- **pattern formation** The spatial arrangement of differentiated cells to form tissues and organs during embryonic development.
- **pedigree** A diagram that describes family relationships, gender, disease status, and other attributes.
- **penetrance** The probability of expressing a phenotype, given that an individual has inherited a predisposing genotype. If this probability is less than 1.0, the disease genotype is said to have reduced or incomplete penetrance.
- **penetrance**, **age-dependent** Describes disease phenotypes that have a higher probability of occurrence as the age of the individual with the at-risk genotype increases (examples: Huntington disease, familial breast cancer).
- **percutaneous umbilical blood sampling (PUBS)** Prenatal diagnostic technique in which fetal blood is obtained by puncture of the umbilical cord. Also called cordocentesis.
- phagocyte A cell that engulfs foreign particles.
- pharmacogenetics Study of genetic variation in drug response.
- **phenocopy** A phenotype that resembles the phenotype produced by a specific gene but is caused instead by a different, typically nongenetic, factor.
- **phenotype** The observed characteristics of an individual, produced by the interaction of genes and environment.
- **Philadelphia chromosome** A reciprocal translocation between the long arms of chromosomes 9 and 22 in somatic cells; produces chronic myelogenous leukemia.
- **phosphorylation** The addition of a phosphate group to a molecule.
- **physical mapping** The determination of physical distances between genes using cytogenetic and molecular techniques. Compare with **genetic mapping**, in which recombination frequencies are estimated.
- plasma cell Mature B lymphocyte capable of secreting antibodies.
- **plasmid** Circular double-stranded DNA molecule found in bacteria; capable of independent replication. Plasmids are often used as cloning vectors in recombinant DNA techniques.
- **pleiotropy** Describes genes that have multiple phenotypic effects (examples: Marfan syndrome, cystic fibrosis). (adj.: pleiotropic)
- **point mutation** (1) In molecular genetics, the alteration of a single nucleotide to a different nucleotide. (2) In classical genetics, an alteration of DNA sequence too small to be detected under a light microscope.

- **polar body** Cell produced during oogenesis that has a nucleus but very little cytoplasm.
- **polar body diagnosis** Prenatal diagnostic technique in which DNA from a polar body is subjected to PCR amplification and assayed using molecular methods.
- **polarity** Direction (e.g., definition of anterior versus posterior in **axis specification**).
- **poly-A tail** The addition of several adenine nucleotides to the 3' end of a primary mRNA transcript.
- **polygenic** Describes a trait caused by the combined additive effects of multiple genes.
- **polymerase chain reaction (PCR)** A technique for amplifying a large number of copies of a specific DNA sequence flanked by two oligonucleotide primers. The DNA is alternately heated and cooled in the presence of DNA polymerase and free nucleotides so that the specified DNA segment is denatured, hybridized with primers, and extended by DNA polymerase.
- **polymorphism** A locus in which two or more alleles have gene frequencies greater than 0.01 in a population. When this criterion is not fulfilled, the locus is monomorphic.
- **polypeptide** A series of amino acids linked together by peptide bonds.
- **polyploidy** Chromosome abnormality in which the number of chromosomes in a cell is a multiple of 23 but is greater than the diploid number (examples are **triploidy** [69 chromosomes in the human] and **tetraploidy** [92 chromosomes in the human]).
- **population genetics** Branch of genetics dealing with genetic variation and genetic evolution of populations.
- **population screening** The large-scale testing of populations for a disease.
- **positional candidate** A gene mapping approach in which linkage analysis is used to define a gene's approximate location. Known **candidate genes** in the region are then evaluated for their possible role in causing the trait or disease being analyzed.

positional cloning See cloning, positional.

- **positive predictive value** Among the individuals identified by a test as having a disease, the proportion that actually have the disease. Compare with **negative predictive value**.
- **posterior probability** In Bayesian analysis, the final probability of an event after taking into account prior, conditional, and joint probabilities.
- **posttranslational modification** Various types of additions and alterations of a polypeptide that take place after the mature mRNA transcript is translated into a polypeptide (e.g., hydroxylation, glycosylation, cleavage of portions of the polypeptide).
- **prenatal diagnosis** The identification of a disease in a fetus or embryo.
- **presymptomatic diagnosis** The identification of a disease before the phenotype is clinically observable.
- **primary oocyte** The diploid product of an oogonium. All primary oocytes are produced in the female during prenatal development; they undergo meiosis I to produce secondary oocytes when ovulation begins.
- **primary spermatocyte** The diploid progeny cell of a spermatogonium, which then undergoes meiosis I to produce secondary spermatocytes.
- primary transcript The mRNA molecule directly after transcription from DNA. A mature mRNA transcript is

formed from the primary transcript when the introns are spliced out.

- **primer** An oligonucleotide sequence that flanks either side of the DNA to be amplified by **polymerase chain reaction**.
- **primer extension** Part of the **polymerase chain reaction** process, in which DNA polymerase extends the DNA sequence beginning at an oligonucleotide primer.
- **primitive streak** A structure formed during mammalian **gastrulation**, consisting of thickened epiblast tissue along the anterior/posterior axis.
- **prior probability** In Bayesian analysis, the probability that an event will occur, estimated *before* any additional information, such as a biochemical carrier test, is incorporated.
- **probability** The proportion of times that a specific event occurs in a series of trials.
- **proband** The first person in a pedigree to be identified clinically as having the disease in question. Synonymous with **propositus** and **index case**.
- **probe** In molecular genetics, a labeled substance, such as a DNA segment, that is used to identify a gene, mRNA transcript, or gene product (usually through hybridization of the probe with the target).
- **promoter** A DNA sequence located 5' of a gene to which RNA polymerase binds in order to begin transcription of the DNA into mRNA.
- **proofreading** The correction of errors that occur during replication, transcription, or translation.
- **prophase** The first stage of mitosis and meiosis.

propositus See proband.

- **protein electrophoresis** A technique in which amino acid variations are identified on the basis of charge differences that cause differential mobility of polypeptides through an electrically charged medium.
- **protein kinase** An enzyme that phosphorylates serine, threonine, or tyrosine residues in proteins.
- **protein truncation test** A mutation detection test in which the encoded protein product is artificially translated to reveal the presence of truncation-causing mutations (e.g., **nonsense** or **frameshift** mutations).
- **proto-oncogene** A gene whose protein product is involved in the regulation of cell growth. When altered, a protooncogene can become a cancer-causing **oncogene**.
- **pseudoautosomal region** The distal tip of the Y chromosome short arm, which undergoes crossover with the distal tip of the X chromosome short arm during meiosis in the male.
- **pseudogene** A gene that is highly similar in sequence to another gene or genes but has been rendered transcriptionally or translationally inactive by mutations.
- **pseudomosaicism** A false indication of fetal mosaicism, caused by an artifact of cell culture.
- **pulsed-field gel electrophoresis** A type of electrophoresis suitable for relatively large DNA fragments; the fragment is moved through a gel by alternating pulses of electricity across fields that are 90 degrees in orientation from one another.
- **Punnett square** A table specifying the genotypes that can arise from the gametes contributed by a mating pair of individuals.
- **purine** The two DNA (also RNA) bases, adenine and guanine, that consist of double carbon-nitrogen rings. Compare with **pyrimidine**.

- **pyrimidine** The bases (cytosine and thymine in DNA; cytosine and uracil in RNA) that consist of single carbonnitrogen rings. Compare with **purine**.
- **quantitative trait** Characteristic that can be measured on a continuous scale (e.g., height, weight).
- **quantitative trait locus methods** Methods for finding genes (quantitative trait loci [QTLs]) that underly complex multi-factorial traits.
- **quasidominant** A pattern of inheritance that appears to be autosomal dominant but is actually autosomal recessive. Usually the result of a mating between an affected homozygote and a heterozygote.
- **quinacrine banding (Q-banding)** Chromosome staining technique in which a fluorochrome dye (quinacrine compound) is added to chromosomes, which are then viewed under a fluorescence microscope.
- **radiation hybrid mapping** Technique in which ionizing radiation is used to break human chromosomes into small pieces that are then hybridized with rodent chromosomes. The physical distance between loci is estimated by assessing how frequently two loci are found together on the same human chromosome fragment.
- **radiation, ionizing** A type of energy emission that is capable of removing electrons from atoms, thus causing ion formation (example: x-rays).
- **radiation, non-ionizing** A type of energy emission that does not remove electrons from atoms but can change their orbits (example: ultraviolet radiation).
- random mating See panmixia.
- **receptor** A cell-surface structure that binds to extracellular particles.
- **recessive** An allele that is phenotypically expressed only in the homozygous or hemizygous state. The recessive allele is masked by a dominant allele when the two occur together in a heterozygote. Compare with **dominant**.

recognition site See restriction site.

- **recombinant DNA** A DNA molecule that consists of components from more than one parent molecule (e.g., a human DNA insert placed in a plasmid vector).
- **recombinase** An enzyme that helps to bring about somatic recombination in B and T lymphocytes.
- **recombination** The occurrence among offspring of new combinations of alleles, resulting from crossovers that occur during parental meiosis.
- **recombination frequency** The proportion of meioses in which recombinants between two loci are observed. Used to estimate genetic distances between loci. See also **centiMorgan**.
- **recombination hot spot** A region of a chromosome in which the recombination frequency is elevated.
- **recurrence risk** The probability that another affected offspring will be produced in families in which one or more affected offspring have already been produced. Compare with **occurrence risk**.
- **reduction division** The first stage of meiosis (meiosis I), in which the chromosome number is reduced from diploid to haploid.
- **redundancy, genetic** The existence of alternate genetic mechanisms or pathways that can compensate when a mechanism or pathway is disabled.
- **repetitive DNA** DNA sequences that are found in multiple copies in the genome. They may be dispersed or repeated in **tandem**.

- **replication** The process in which the double-stranded DNA molecule is duplicated.
- **replication bubble** Replication structure that occurs in multiple locations on a chromosome, allowing replication to proceed more rapidly.
- **replication origin** The point at which replication begins on a DNA strand; in eukaryotes, each chromosome has numerous replication origins.
- **replicative segregation** Refers to changes in the proportions of different mitochondrial DNA alleles as the mitochondria reproduce.
- **restriction digest** Process in which DNA is exposed to a restriction enzyme, causing it to be cleaved into **restriction fragments**.
- **restriction endonuclease** Bacterial enzyme that cleaves DNA at a specific DNA sequence (restriction site).
- **restriction fragment** A piece of DNA that has been cleaved by a restriction endonuclease.
- **restriction fragment length polymorphism (RFLP)** Variations in DNA sequence in populations, detected by digesting DNA with a restriction endonuclease, electrophoresing the resulting restriction fragments, transferring the fragments to a solid medium (blot), and hybridizing the DNA on the blot with a labeled probe.
- **restriction site** A DNA sequence that is cleaved by a specific restriction endonuclease.
- **restriction site polymorphism (RSP)** A variation in DNA sequence that is caused by the presence or absence of a restriction site. This type of polymorphism is the basis for most traditional RFLPs.
- **retrovirus** A type of RNA virus that can reverse-transcribe its RNA into DNA for insertion into the genome of a host cell; useful as a vector for gene therapy.
- **reverse banding (R-banding)** A chromosome banding technique in which chromosomes are heated in a phosphate buffer; produces dark and light bands in patterns that are the reverse of those produced by G-banding.
- **reverse transcriptase** An enzyme that transcribes RNA into DNA (hence "reverse").
- ribonucleic acid (RNA) A single-stranded molecule that consists of a sugar (ribose), a phosphate group, and a series of bases (adenine, cytosine, guanine, and uracil). There are three basic types of RNA: messenger RNA (mRNA), ribosomal RNA (rRNA), and transfer RNA (tRNA).
- **ribosomal RNA (rRNA)** In conjunction with protein molecules, composes the **ribosome**.
- **ribosome** The site of translation of mature messenger RNA into amino acid sequences.
- **ribozyme** An mRNA molecule that has catalytic activity. Some ribozymes can be used to cleave mRNA in somatic cell gene therapy.
- **ring chromosome** A structural chromosome that is abnormally formed when both ends of a chromosome are lost and the new ends fuse together.
- **RNA polymerase** Enzyme that binds to a promoter site and synthesizes messenger RNA from a DNA template.
- **satellite DNA** A portion of the DNA that differs enough in base composition so that it forms a distinct band on a cesium chloride gradient centrifugation; usually contains highly repetitive DNA sequences.

secondary oocyte A cell containing 23 double-stranded

chromosomes, produced from a primary oocyte after meiosis I in the female.

- **secondary spermatocyte** A cell containing 23 doublestranded chromosomes, produced from a primary spermatocyte after meiosis I in the male.
- **segregation** The distribution of genes from homologous chromosomes to different gametes during **meiosis**.
- senescent Aged (e.g., an aged, or senescent, cell).
- **sense strand** In a double-stranded DNA molecule, this is the strand from which messenger RNA is *not* transcribed. Because of complementary base pairing, the sense strand is identical in sequence to the transcribed mRNA (with the exception that mRNA has uracil instead of thymine). See **antisense strand**.
- **sensitivity** The proportion of affected individuals who are correctly identified by a test (true positives). Compare with **specificity**.
- **sequence (formerly "anomalad")** A primary defect with secondary structural changes in development (examples: oligohydramnios sequence, Pierre-Robin sequence).
- **sequence tagged sites (STSs)** DNA sequences of several hundred bp that are flanked by PCR primers. Their chromosome location has been established, making them useful as indicators of physical positions on the genome.
- sex chromatin See Barr body.
- **sex chromosomes** The X and Y chromosomes in humans. Compare with **autosomes**.
- **sex-influenced** A trait whose expression is modified by the gender of the individual possessing the trait.
- sex-limited A trait that is expressed in only one sex.
- **short tandem repeat polymorphism (STRP)** A DNA sequence that contains multiple repeated short sequences, one after another. These sequences are polymorphic because the number of repeats varies among individuals.
- **signal transduction** Process in which biochemical messages are transmitted from the cell surface to the nucleus.
- silencer A DNA sequence that binds to specific transcription factors to decrease or repress the activity of certain genes. Compare with enhancer.
- **silent substitution** DNA sequence change that does not change the amino acid sequence because of the degeneracy of the genetic code.
- **SINEs (short interspersed elements)** A class of dispersed repetitive DNA in which each repeat is relatively short. Compare with **LINEs**.
- single-strand conformation polymorphism (SSCP) A technique for detecting variation in DNA sequence by running single-stranded DNA fragments through a nondenaturing gel; fragments with differing secondary structure (conformation) caused by sequence variation will migrate at different rates.
- **single-copy DNA** DNA sequences that occur only once in the genome. Compare with **repetitive DNA**.
- single-gene disorder or trait A feature or disease that is caused by a single gene. Compare with polygenic and multifactorial.
- **single nucleotide polymorphisms (SNPs)** Polymorphisms that result from variation at a single nucleotide. Compare with **microsatellites** and **VNTRs**.
- sister chromatid exchange Crossover between sister chromatids; can occur either in the sister chromatids of a tetrad during meiosis or between sister chromatids of a duplicated somatic chromosome.

- **sister chromatids** The two identical strands of a duplicated chromosome, joined by a single centromere.
- **solenoid** A structure of coiled DNA, consisting of approximately six **nucleosomes**.
- **somatic cell** Cell other than those of the gamete-forming germ line. In humans, most somatic cells are diploid.
- **somatic cell hybridization** A physical gene mapping technique in which somatic cells from two different species are fused and allowed to undergo cell division. Chromosomes from one species are selectively lost, resulting in clones with only one or a few chromosomes from one of the species.
- **somatic hypermutation** An extreme increase in the mutation rate of somatic cells; observed in B lymphocytes as they achieve increased binding affinity for a foreign antigen.
- **somatic recombination** The exchange of genetic material between homologous chromosomes during mitosis in somatic cells; much rarer than meiotic recombination.
- **Southern transfer** (also, **Southern blot**) Laboratory procedure in which DNA fragments that have been electrophoresed through a gel are transferred to a solid membrane, such as nitrocellulose. The DNA can then be hybridized with a labeled probe and exposed to x-ray film (an **autoradiogram**).
- **specificity** The proportion of unaffected individuals who are correctly identified by a test (**true negatives**). Compare with **sensitivity**.
- **spectral karyotype** A chromosome display (**karyotype**) in which combinations of fluorescent probes are used with special cameras and image-processing software so that each chromosome has a unique color.
- **spermatid** One of the four haploid cells formed from a primary spermatocyte during spermatogenesis. Spermatids mature into spermatozoa.

spermatogenesis The process of male gamete formation.

- **spermatogonia** Diploid germline stem cells from which sperm cells (spermatozoa) are ultimately derived.
- **spindle fiber** One of the microtubular threads that form the spindle in a cell.
- **splice site mutation** DNA sequence alterations in **donor** or **acceptor sites** or in the consensus sites near them. Produces altered intron splicing, such that portions of exons are deleted or portions of introns are included in the mature mRNA transcript.
- **sporadic** Refers to the occurrence of a disease in a family with no apparent genetic transmission pattern (often the result of a new mutation).
- **stop codon** mRNA base triplets that specify the point at which translation of the mRNA ceases.
- structural genes Genes that encode protein products.
- **submetacentric** A chromosome in which the centromere is located closer to one end of the chromosome arm than the other. Compare with **metacentric** and **acrocentric**.
- **synapsis** The pairing of homologous chromosomes during prophase I of meiosis.
- **syndrome** A pattern of multiple primary malformations or defects all resulting from a single underlying cause (examples: Down syndrome, Marfan syndrome).
- **syntenic** Describes two loci located on the same chromosome; they may or may not be linked.
- **T** lymphocyte or **T** cell A component of the adaptive immune system whose receptors bind to a complex of MHC molecule and foreign antigen. There are two major classes

of T lymphocytes, helper T lymphocytes and cytotoxic T lymphocytes.

- **tandem repeat** DNA sequences that occur in multiple copies located directly next to one another. Compare with **dispersed repetitive DNA**.
- **targeted disruption** The disabling of a specific gene so that it is not expressed.
- **telomerase** A transferase enzyme that replaces the DNA sequences in **telomeres** during cell division.
- telomere The tip of a chromosome.
- **telophase** The final major stage of mitosis and meiosis, in which daughter chromosomes are located on opposite edges of the cell and new nuclear envelopes form.
- **template** A strand of DNA that serves as the model for replication of a new strand. Also denotes the DNA strand from which mRNA is transcribed.
- **teratogen** A substance in the environment that can cause a birth defect.
- **teratology** The study of environmental factors that cause birth defects or congenital malformations.
- **termination sequence** DNA sequence that signals the cessation of transcription.
- **tetrad** The set of four homologous chromatids (two sister chromatids from each homologous chromosome) observed during meiotic prophase I and metaphase I. Synonymous with **bivalent**.
- **tetraploidy** A **polyploid** condition in which the individual has four copies of each chromosome in each cell, for a total of 92 chromosomes.
- thymine One of the four DNA bases (abbrev.: T).
- **tissue-specific mosaic** A **mosaic** in whom the mosaicism is confined to only specific tissues of the body.
- **transcription** The process in which an mRNA sequence is synthesized from a DNA template.
- **transcription factor** Protein that binds to DNA to influence and regulate transcription.
- **transcription factor, general** A class of transcription factors that are required for the transcription of all structural genes.
- **transcription factor, specific** A class of transcription factors that activate only specific genes at specific points in time.
- transfection The transfer of a DNA sequence into a cell.
- **transfer RNA (tRNA)** A class of RNA that helps to assemble a polypeptide chain during translation. The anticodon portion of the tRNA binds to a complementary mRNA codon, and the 3' end of the tRNA molecule attaches to a specific amino acid.
- **transformation** The oncogenic conversion of a normal cell to a state of unregulated growth.
- **transgenic** Refers to an organism into which a gene has been introduced from an organism of another species (e.g., a transgenic mouse could contain an inserted human gene).
- **translation** The process in which an amino acid sequence is assembled according to the pattern specified by the mature mRNA transcript.
- translocation The exchange of genetic material between nonhomologous chromosomes.
- **translocation, reciprocal** A translocation resulting from breaks on two different chromosomes and a subsequent exchange of material. Carriers of reciprocal translocations maintain the normal number of chromosomes and the normal amount of chromosome material.

translocation, Robertsonian A translocation in which the long arms of two acrocentric chromosomes are fused at the centromere; the short arms of each chromosome are lost. The translocation carrier has 45 chromosomes instead of 46 but is phenotypically normal because the short arms contain no essential genetic material.

transposon See mobile element.

- **triploidy** A polyploid condition in which the individual has three copies of each chromosome in each cell, for a total of 69 chromosomes.
- **trisomy** An aneuploid condition in which the individual has an extra copy of one chromosome, for a total of 47 chromosomes in each cell.
- **true negative** Individual who is correctly identified by a test as not having a disease. See also **specificity**.
- **true positive** Individual who is correctly identified by a test as having a disease. See also **sensitivity**.
- tumor See neoplasm.
- **tumor suppressor** A gene whose product helps to control cell growth and proliferation; mutations in tumor suppressors can lead to cancer (example: retinoblastoma gene, *RB1*).
- **two-hit model** A model of carcinogenesis in which both copies of a gene must be altered before a neoplasm can form.
- **ultrasonography** A technique for fetal visualization in which sound waves are transmitted through the fetus and their reflection patterns are displayed on a monitor.
- **unequal crossover** Crossing over between improperly aligned DNA sequences; produces deletions or duplications of genetic material.
- **uninformative mating** A mating in which **linkage phase** cannot be established.
- **uniparental disomy** Condition in which two copies of one chromosome are derived from a single parent, and no copies are derived from the other parent. May be either **heterodisomy** or **isodisomy**.
- **variable expression** A trait in which the same genotype may produce phenotypes of varying severity or expression (example: neurofibromatosis type 1).
- variable number of tandem repeats (VNTRs) A type of polymorphism created by variations in the number of minisatellite repeats in a defined region.
- **variance** Statistical measure of variation in a quantity; estimated as the sum of the squared differences from the average value.
- **vector** The vehicle used to carry a DNA insert (e.g., phage, plasmid, cosmid, BAC, or YAC).
- X inactivation Process by which genes from one X chromosome in each cell of the female embryo are rendered transcriptionally inactive.
- **X** inactivation center The location on the X chromosome from which the X inactivation signal is transmitted (includes the *XIST* gene).
- X-linked Refers to genes that are located on the X chromosome.
- yeast artificial chromosome (YAC) A synthesized yeast chromosome capable of carrying a large DNA insert (up to 1,000 kb).
- zygote The diploid fertilized ovum.

Index

Page numbers followed by f refer to figures; those followed by t refer to tables; and those followed by b refer to boxes.

A

ABC1 gene, 266t ABL gene, 236t, 237 ABO blood group, 41, 41t, 205 Abortion, spontaneous, 120-122 Achondroplasia, 66-67, 67f, 212, 212f gene for, 187t, 212, 212f germline mosaicism in, 69 Acidemia glutaric, 151 lactic, 151 methylmalonic, 137t propionic, 137t Acquired immunodeficiency syndrome, gene therapy for, 296t, 301 Acrodermatitis enteropathica, 137t, 155, 155f Acromesomelic dysplasia, 214 Activators, 14, 14f Acute promyelocytic leukemia, 133t, 237 Addition rule, 58-59 Adenine, 7, 8f Adeno-associated virus vector, 298 Adenomatous polyposis coli, 2t Adenosine deaminase deficiency, 206 gene therapy in, 296t, 299 Adenovirus vector, 298 Adoption studies, 257-258 ADRB2 gene, 157t Adult polycystic kidney disease, 2t, 74, 77t gene for, 74, 187t Affected sib-pair analysis, 259b Aflatoxin B1, in liver cancer, 240 Agammaglobulinemia, X-linked, 206 Age maternal Down syndrome and, 117-118, 117f Klinefelter syndrome and, 120 paternal, mutation rate and, 40, 40f Alagille syndrome, 127t Albinism, 88, 136f, 136t, 187t Alcohol, teratogenicity of, 319t, 321, 321f Alcoholism, 2t, 256t, 261t, 273-274

ALDH2 gene, 274 Aldosteronism, glucocorticoid-remediable, 266t Alkaptonuria, 136, 136f, 137t Allele(s), 29. See also Gene(s). codominant, 59 dominant, 57, 58, 58f linkage disequilibrium of, 170, 172f linkage phase of, 162 recessive, 57-58, 58f recombination of, 161, 162f Allele-specific oligonucleotide hybridization, 54t Allelic dropout, 295 Allelic heterogeneity, 71 ALS2 gene, 267t Alternative splice site, 15 Alu repeats, 22 Alzheimer disease, 2t, 77t amyloid-β precursor protein in, 272, 273f gene for, 187t, 267t, 272-273 in trisomy 21, 115-116 prevalence of, 261t Amino acids. See also Protein(s). inborn errors of metabolism of, 137t, 142-145, 143b of genetic code, 16-17, 16t RNA translation to, 17, 18f Aminopterin, teratogenicity of, 319t Amish, Ellis-van Creveld syndrome in, 53b Amniocentesis, 288-290, 289b, 289f, 292t decision for, 290 Amyotrophic lateral sclerosis, 187t, 267t Anaphase, of mitosis, 23-24, 24f Anaphase I, of meiosis, 25f, 26 Anaphase II, of meiosis, 25f, 26-27 Anderson disease, 141f, 142t Androgens, teratogenicity of, 319t Anemia Fanconi, 133 in sickle cell disease, 34, 34f Anencephaly, 251, 252f

Aneuploidy autosomal, 112-118, 112f-114f sex chromosomal, 118-120, 118f Angelman syndrome, 77-78, 79f, 127t, 187t Angiogenesis, 228 Angiotensin-converting enzyme (ACE) inhibitors, teratogenicity of, 319t Aniridia, 211t Ankylosing spondylitis, HLA-B27 association with, 173, 173f, 173t, 202 Antibodies, 194, 198-199, 198f, 199f. See also Immunoglobulin(s). blood group, 41-42, 41t, 205-206 diversity of, 199, 199f Anticipation, 80-83, 80f, 81f Anticipatory guidance, 115 Anticodon, 17, 17f Antigen, 194, 195f Antigen-presenting cells, 194, 195f Antisense therapy, 300-301, 300f α_1 -Antitrypsin deficiency, 2t, 187t, 287 Aortic stenosis, in Williams syndrome, 126f APAF1 gene, 245 APC gene, 234t, 240-243, 242f Apert syndrome, 213, 213t Apical ectodermal ridge, 224-225, 224f APOB gene, 266t APOE gene, 272-273 Apolipoprotein B100, defects in, 264, 266t Apoptosis, 228 APP gene in Alzheimer disease, 267t, 272, 273f in trisomy 21, 115–116 Argininosuccinase deficiency, 150 Argininosuccinic acid synthetase deficiency, 137t, 150 Arthritis, 261t Association, population, 172-174, 173f Asthma, 261t Ataxia telangiectasia, 39t, 187t, 207t ATM gene, 234t Atomic bomb, mutagenic effects of, 37 ATP7A gene, 154

ATP7B gene, 154 Atrioventricular canal, in Down syndrome, 113 Autism, 250, 256t Autoimmunity, 202 Autoradiography, 46, 46f Autosome, 6 Avery, Oswald, 3 Axis, in human development, 210, 219–221, 219f–220f

B

Bacterial artificial chromosomes, 44, 182 Bacteriophage, 44 Bacteriophage P1 artificial chromosomes, 182 Baldness, male-pattern, 101 Bare lymphocyte syndrome, 206-207, 207t Barr body, 89-90, 89f Base analogs, mutagenic effects of, 36, 38 Base-pair substitution mutation, 29, 30f Bases, 6-7, 8f complementary pairing of, 10, 10f Bayes theorem, 310b-311b Beare-Stevenson syndrome, 213, 213t Becker muscular dystrophy, 97-98, 188t Beckwith-Wiedemann syndrome, 79-80, 187t, 306 Bendectin, 320 β sheets, 15t Bioethics, 321-323 Biotin-responsive multiple carboxylase deficiency, 295 Bipolar disorder, 2t, 256t, 261t, 275 Birth defects, 209, 211t. See also Human development and specific defects. Bivalent, 26 Blindness, color, 102b-103b Blood groups, 41-42, 41t, 205 Blood pressure, 266t, 267-268 regulation of, 268, 268f twin studies of, 256t Bloom syndrome, 39t, 133, 187t, 313b Blue cone monochromacy, 102b Body plan, 209 Bone marrow transplantation, in hemoglobin disorders, 36 Bone morphogenetic protein, 213-214 BORI gene, 211t Brachydactyly, 211t, 214 BRAF gene, 236t, 245 Brain tumor, gene therapy for, 296t Branched-chain amino acid deficiency, 137t, 144-145 Branched-chain α -ketoacid dehydrogenase deficiency, 137t, 144-145 Branchio-oto-renal syndrome, 211t BRCA genes, 234t, 243-244, 244f screening for, 284 Breast cancer, 77t, 133t, 269 genes for, 187t, 243-244, 244f, 246 locus heterogeneity in, 77t screening for, 284 Brittle bone disease. See Osteogenesis imperfecta. Burkitt lymphoma, 132-133, 133t

С

Café-au-lait spots, 308, 308f Calico cat, 88 Cancer, 2t, 228-247. See also specific cancers. APAF1 gene in, 245 APC gene in, 234t, 240-243, 242f BRAF gene in, 245 BRCA genes in, 234t, 243-244, 244f causes of, 229-230, 229f CDK4 gene in, 240, 245 CDKN2A gene in, 234t, 245 cell transformation in, 234 CHK2 gene in, 234t, 240 cytogenetic changes in, 132-133, 133f, 133t DNA repair genes in, 237 environmental factors in, 229-230 familial, 229, 229f, 231-232, 246-247 gene mapping in, 237, 238-246, 238f. See also specific cancers and genes. genomic instability in, 237 growth of, 230-231, 231f immortality in, 237 lifestyle and, 230 loss of heterozygosity in, 238, 238f molecular basis of, 246 MSH genes in, 234t, 243 multifactorial inheritance in, 261t, 268-270 NF1 gene in, 234t, 238-239, 239f nonfamilial, 231-232 oncogenes in, 234-237, 235t, 236t presymptomatic diagnosis of, 246 RET gene in, 245-246 retroviruses in, 235-236 telomerase in, 237 TP53 gene in, 234t, 239-240 transfection experiments in, 236-237 tumor suppressor genes in, 232-234, 233f, 234t, 235f, 235t Candidate genes, 187, 187t-188t Carbamazepine, teratogenicity of, 319t Carbamyl phosphate synthetase deficiency, 137t, 150 Carbimazole, teratogenicity of, 319t Carbohydrate metabolism, inborn errors of, 137t, 139-142, 140f, 141f, 142t Carcinogenesis, 228, 228f. See also Cancer. multi-hit concept of, 231 two-hit model of, 231-232 Carcinoma, 228 Cardiomyopathy, 264-265, 266t Carrier heterozygous, 62, 66 in X-linked recessive inheritance, 94, 94f obligate, 69, 69f psychosocial implications of, 284 Cartilage-derived morphogenetic protein 1, 213-214 Catalyst, 139 β-Catenin, in colorectal cancer, 242-243 C-banding, 110 CDK4 gene, 236t, 240, 245 CDK inhibitors, 234, 236f CDKN2A gene, 234t, 245 cDNA library, 180b–181b Celiac disease, 204t

Cell(s) anatomy of, 6, 7f daughter, 24, 24f, 26 diploid, 6 germline, 29 haploid, 6 somatic, 6, 29 Cell cycle, 22-27, 23f. See also Meiosis; Mitosis. regulation of, 232-233, 235f CentiMorgan (cM), 161 Centrioles, 7f, 23 Centromere, 23, 26, 26f Cervix, squamous cell carcinoma of, 204t CFBA1 gene, 226 CG dinucleotide, methylation of, 40, 40f, 90 CG islands, 184 Charcot-Marie-Tooth disease, 30-31, 77t, 188t Chediak-Higashi syndrome, 207t Chemicals, mutagenic effects of, 36, 38 Chernobyl nuclear power plant accident, 37 Chiasma, 26, 26f CHK2 gene, 234t, 240 Cholesterol, defects of, 146-147, 146f Chordin gene, 220-221, 224f Chorionic villus sampling, 290-291, 291f, 292t CHRNA4 gene, 267t CHRNB2 gene, 267t Chromatin, 6, 8, 9f, 15 Chromosome(s), 6, 7f abnormalities of, 2t, 3, 107-133 cancer and, 132-133, 133t, 237 clinical impact of, 4-5, 4t nomenclature for, 107-108, 109t numerical, 111-120, 112f-114f, 116f-118f, 120f phenotype and, 130-132 pregnancy loss and, 120–122 prevalence of, 122t structural, 122-130, 122t, 123f-126f, 127t, 130f, 131f acrocentric, 107, 108f adjacent segregation of, 123, 125f alternate segregation of, 123, 125f aneuploidy of, 112-118, 112f-114f, 116f, 117f balanced rearrangement of, 122, 123, 123f banding of, 108-110, 109f breakage of, 122, 124-127 C-banding of, 110 comparative genomic hybridization of, 111, 111f crossover of, 161-163, 162f, 163f deletions of, 124-127, 126f, 127t, 128 in physical gene mapping, 174, 175f derivative, 123, 123f double crossover of, 161, 163f duplications of, 129 fluorescence in situ hybridization of, 110, 110f, 122 Giemsa banding of, 109, 109f heteromorphic, 174 high-resolution banding of, 110

Chromosome(s) (Continued) homologous, 6 instability of, 133 interstitial deletion of, 124 inversions of, 129-130, 131f iso-, 130, 132f karyotype of, 107, 108, 108f, 109t in chromosomal abnormalities, 132b in spontaneous abortion, 121-122 long arm of, 107-108, 108f low copy repeats of, 127 metacentric, 107, 108f microdeletions of, 126-127, 126f, 127t, 128 monosomy of, 112, 112f, 118-119, 119f nomenclature for, 108, 109t nondisjunction of, 112, 112f NOR stains of, 110 normal karyotype of, 108, 108f, 109t paracentric inversion of, 130 pericentric inversion of, 129-130, 131f Philadelphia, 132, 133f polyploidy of, 111-112 quinacrine banding of, 109 reciprocal translocation of, 122, 123, 123f, 129 reverse banding of, 109 ring, 129, 130f Robertsonian translocation of, 122, 123-124, 124f, 125f segregation of, 57, 58 sex, 6. See also X chromosome(s); Y chromosome(s). short arm of, 107-108, 108f spectral karyotyping of, 110-111 staining of, 108-110, 109f submetacentric, 107, 108f subtelomeric rearrangements of, 127 terminal deletion of, 124 tetraploidy of, 111, 112 translocation of, 122-124, 122t in cancer, 132-133, 237 in physical gene mapping, 175 triploidy of, 111-112 trisomy of, 112-118, 112f-114f, 116f, 117f, 120 unbalanced rearrangement of, 122 visualization of, 107-108, 108f Chromosome 8, 130, 131f Chromosome 9, 167f Chromosome 17, 110, 110f Chromosome 22, 128 Chromosome instability syndromes, 133 Chromosome-specific library, 180b Chronic granulomatous disease, 207, 207t Chronic myelogenous leukemia, 132, 133f, 133t Chronic progressive external ophthalmoplegia, 105 Cigarette smoking, cancer and, 230 Clastogens, 122 Cleft lip, 2t, 256t Cleidocranial dysplasia, 82t, 226 Clinical genetics, 305-316. See also Genetic counseling. accurate diagnosis in, 305, 307 client evaluation in, 315-316, 315b family history in, 308, 315, 315b

Clinical genetics (Continued) in Beckwith-Wiedemann syndrome, 306 programs in, 316b referral for, 316b Cloning, 44b-45b, 302b ethics and, 323 functional, 179 positional, 179-187. See also Positional cloning. Club foot (talipes equinovarus), 2t, 256t Co-activators, 14, 14f Cocaine, teratogenicity of, 319t Cockayne syndrome, 39t Coefficient of relationship, 84b Cofactors, in metabolism, 152 COL2A1 gene, 211t Collagen, type I, in osteogenesis imperfecta, 19-21, 20f, 77f Color vision, 102b-103b Colorectal cancer, 269 APC gene in, 241-243, 241f, 242f, 269 environmental factors in, 230 familial, 229, 229f MSH genes in, 243 PMS genes in, 243 STK11 gene in, 269 Comparative genomic hybridization, 111, 111f Complement, 193 Concordance rate, in twin studies, 256-257, 256t Confined placental mosaicism, 290 Congenital adrenal hyperplasia screening for, 281, 281t treatment of, 295-296 Congenital heart defects, 2t Congenital malformations, 258, 261t, 316-321, 317t prevention of, 321 Consanguinity, 66, 83-85 mortality and, 85, 85t Consensus sequence, 21 Contig map, 179 Contiguous gene syndrome, 126 Copper, disorders of, 137t, 152, 154-155, 189t Cordocentesis, 291-292 Cori disease, 141f, 142t Coronary artery disease, 2t, 258, 261, 261t, 264, 265, 266t gene therapy for, 296t, 301 lipoprotein genes in, 265t twin studies of, 256t Cosmid, 44 Costimulatory molecules, of antigenpresenting cells, 194, 195f Cousin marriage, 85, 85t Cowden disease, 244, 269 Craniosynostosis syndromes, 213, 213t, 223-224 Cranium, development of, 221, 223-224 Creatine kinase, in Duchenne muscular dystrophy, 280f Crick, Francis, 3 Cri-du-chat syndrome, 124 Crossing over, 26, 26f Cross-reaction, in autoimmunity, 202, 204 Crouzon syndrome, 213, 213t

Cyclin-dependent kinases, 23 CIT2C9 gene, 157t CYP2D6 gene, 156, 157t Cystic fibrosis, 2t, 60-61, 60f, 61f gene for, 60-61, 188t gene therapy for, 61, 296t prevalence of, 59, 60 screening for, 282, 283, 283t Cystic fibrosis transmembrane regulator, 60-61 Cystinosis, 137t, 151-152 Cystinuria, 137t, 151 Cytochrome C oxidase deficiency, 137t Cytogenetics. See Chromosome(s). Cytokines, T lymphocyte secretion of, 194 Cytokinesis, 23 Cytomegalovirus infection, 203 Cytoplasm, 7f Cytosine, 6, 8f methylation of, 40, 40f

D

Darwin, Charles, 3 Daughter cells, 24, 24f, 26 DAX1 gene, 121 Deafness, nonsyndromic, 188t Debrisoquine hydroxylase, in drug metabolism, 156 Dejerine-Sottas syndrome, 31, 55, 55f Denaturing gradient gel electrophoresis, 53, 54t Dendritic cells, 194, 195f, 196–197 Dentatorubral-pallidoluysian atrophy (Haw River syndrome), 82t Denys-Drash syndrome, 211t Deoxyribonucleic acid (DNA), 6-10 antisense strand of, 12, 13f automated sequencing of, 50-52 bases of, 6-7, 8f coiling of, 8, 9f composition of, 6-7, 8f computer analysis of, 184-185 consensus sequences of, 21 conservation of, 182-183 dideoxy sequencing of, 50, 51f dispersed repetitive, 22, 22f double helix of, 7, 8f heteroplasmic, 103 microarrays of, 55, 55f, 185-186 mismatch cleavage of, 53, 55 mismatch repair of, 38, 237 mitochondrial, 101, 103-105, 104f mutation screen of, 185 nucleotide excision repair of, 38 nucleotide of, 7 polymerase chain reaction for, 48-50, 49f proofreading of, 10 recombinant, 44b-45b repair of, 38, 237 defects in, 38, 39, 39t repetitive, 22, 22f replication of, 8, 10, 10f, 11f restriction fragment length polymorphisms of, 43-44, 46-47, 46f, 47f satellite, 22, 22f

Deoxyribonucleic acid (DNA) (Continued) α -satellite of, 22 sense strand of, 13, 13f sequencing of, 50-53, 51f short tandem repeat polymorphisms of, 47 - 48single-copy, 21, 22f single-strand conformation polymorphisms of, 53, 54f, 54t structure of, 6-7, 8f, 9f, 17, 19f, 21-22, 22f tandem repeat polymorphisms of, 47, 47f transcription of, 11-13, 13f transcription factors in, 13-15, 14f, 15f, 15t types of, 21-22, 22f Depression, 261t Dermatoglyphics, 256t Deuteranomaly, 102b-103b Deuteranopia, 102b-103b Development. See Human development. dHAND gene, 220 DHCR7 gene, 146, 211t Diabetes mellitus, 2t, 137t, 141, 270-271 gene for, 188t, 267t, 270-271 maturity-onset, 271 prevalence of, 261t twin studies of, 256t type 1, 270-271, 271t type 2, 271, 271t Dideoxy DNA sequencing, 50, 51f Diet, in inborn errors of metabolism, 143b Diethylstilbestrol, teratogenicity of, 319t Digenic inheritance, 171 DiGeorge anomaly, 128, 207-208, 207t Diploid cell, 6 Direct cDNA selection, 184 Disomy, uniparental, 78-79, 128-129, 129f Dispermy, 111 Dispersed repetitive DNA, 22, 22f DMD gene, 96-98 DNA. See Deoxyribonucleic acid (DNA). DNA library, 180b-181b DNA microarrays (DNA chips), 54t, 55, 55f, 185-186 DNA mismatch cleavage, 54t, 55 DNA polymerase, 10, 10f in polymerase chain reaction, 49, 49f DNA profile, 48b DNA repair genes, 237 BRCA genes as, 243-244, 244f defects in, 38, 39, 39t DNA-binding motifs, 14-15, 14f, 15f, 15t Dominant disorders autosomal, 63-64, 63f, 64f, 66-67, 66t, 67f age-dependent penetrance of, 69, 71, 71f germline mutation and, 68-69, 68f locus heterogeneity in, 74, 77 new mutation in, 68 Punnett square for, 63-64, 63f recurrence risks for, 64, 66t reduced penetrance in, 69, 69f transmission of, 64, 66t vs. recessive disorder, 66-67 X-linked, 95, 95f, 98t

Dominant negative mutation, 32-33 Dosage compensation, 88 Dosage mapping, 175 Doxyclamine, 320 DPC4 gene, 234t Drugs, metabolism of, 155-158, 157f, 157t Duchenne muscular dystrophy, 2t, 96-98, 96f, 97f creatine kinase levels in, 280f gene for, 13, 96-97, 188t gene mapping in, 175 gene therapy for, 296t germline mosaicism in, 69 DYRK gene, in trisomy 21, 115 Dysmorphology, 316-321, 317t prevention of, 321 principles of, 317-318 Dystrophin, 97, 97f

E

EcoRI, 43, 43f Ectodactyly, 211t Ectoderm, 218f EDN3 gene, 215-216 EDNRB gene, 215-216 Edwards syndrome (trisomy 18), 116, 116f E2F, 70 eHAND gene, 220 Ehlers-Danlos syndrome, 188t Elastin, 214 in Williams syndrome, 127 Electron transfer flavoprotein, defects in, 151 Electron transfer flavoprotein-ubiquinone oxidoreductase, defects in, 151 Electrophoresis gel, 53, 54f protein, 42, 42f Ellis-van Creveld syndrome, 188t, 211t Embryo, 210. See also Human development. EMX2 gene, 211t Encephalocele, 251, 253f Endoderm, 217-218, 218f Endoplasmic reticulum, 7f Energy, production of, 150-151 Enhancers, 14, 14f Enzyme catalyst function of, 139 restriction, 43-44, 43f, 44f, 46-47, 46f Epilepsy, 261t, 267t twin studies of, 256t Equatorial plane, of cell, 23 ERBA gene, 236t ERBB gene, 236t Erythrocytes, in sickle cell disease, 34, 34f Euchromatin, 15 Eugenics, 323 EvC gene, 211t Ewing sarcoma, 133t Exon, 15, 16f, 19f, 21 Exon trapping, 184, 184f Expanded repeat mutation, 31 Expressed sequence tags, 185 Extracellular matrix proteins, 214, 216

 \mathbf{F}

F5 gene, 157t 1F10 marker, 162-163, 164f, 165b-166b Fabry disease, 149t Factor VIII gene, 92-93 FAH gene, 144 Familial adenomatous polyposis, 240-243, 241f Familial hypercholesterolemia. See Hypercholesterolemia, familial. Familial polyposis coli, gene for, 188t Family history, in clinical genetics, 308, 315, 315b Fanconi anemia, 39t, 133 Fetal alcohol syndrome, 321, 321f Fetal cell diagnosis, 294-295 Fetal hemoglobin, hereditary persistence of, 33 α-Fetoprotein, measurement of, 293-294, 294f FGFR1 gene, 213, 213t FGFR2 gene, 213, 213t FGFR3 gene, 212-213, 212f, 213t, 218 Fiber FISH, for gene mapping, 176-177 Fibrillin-1, 214 Fibrillin, in Marfan syndrome, 76 Fibroblast growth factor receptor, defects of, 212–213, 212f, 213t First-cousin mating, 83, 84b, 85, 85t FISH (fluorescence in situ hybridization) fiber, 176-177 for chromosome visualization, 110-111, 110f, 122 for gene mapping, 176-177 Fisher, Ronald, 3 Flow cytometry, 180b Fluconazole, teratogenicity of, 319t Fluorescence in situ hybridization (FISH) fiber, 176-177 for chromosome visualization, 110-111, 110f, 122 for gene mapping, 176-177 FMR1 gene, 100-101 Folate, 322 Folic acid, 252-253 Food, phenylalanine content of, 143b Forensic genetics, 48b FOS gene, 236t Founder effect, 53b Fragile X E, 82t Fragile X site (FRAXE), 100 Fragile X syndrome, 2t, 82t, 98-101, 99f, 100f gene for, 100, 188t Frameshift mutation, 30, 30f Friedreich ataxia, 82t, 188t Fructokinase deficiency, 137t, 140, 141f Fructose, metabolism of, 141f Fructose 1,6-bisphosphatase deficiency, 140, 141f Fructose intolerance, hereditary, 137t, 140, 141f Fructosuria, 137t, 140, 141f Fumarylacetoacetate hydrolase deficiency, 136f, 137t, 144 Functional cloning, 179

357

G

GABRG2 gene, 267t Gain-of-function mutation, 31 Galactokinase deficiency, 140, 140f Galactose, metabolism of, 139, 140f Galactosemia, 137t, 139-140, 140f gene for, 139, 140, 188t screening for, 140, 282t Galactose-1-phosphate uridyl transferase deficiency, 137t, 139-140, 140f Galton, Francis, 3 Gamete, 6 Gametogenesis, 25f, 27 Gastrulation, 216-217, 218f Gaucher disease, 149, 149t, 296t GCK gene, 267t Gel electrophoresis, 53, 54t Gene(s). See also specific genes. candidate, 187, 187t-188t CG islands of, 184 dosage sensitivity of, 31 family of, 22 frequencies of, 52b, 59, 62, 62f holandric, 101, 101f housekeeping, 13 locus of, 29. See also Loci. modifier, 71 mutation in. See Mutation(s). pleiotropic, 74 polymorphic, 29 size of, 40 structural, 6 structure of. See Deoxyribonucleic acid (DNA). vs. trait, 67 Gene blocking therapy, 300-301, 300f Gene counting, 59 Gene expression ectopic, 209 tests for, 185-187, 186f Gene flow, 53b Gene frequency, 52b, 59, 62, 62f Gene mapping, 160-174, 160f. See also Linkage analysis; Physical mapping. Gene replacement therapy, 296-300, 297f Gene splicing, 15-16, 16f, 32f Gene therapy, 296-302, 296t blocking, 300-301, 300f fetal, 295-296 for noninherited disease, 301 germline, 301, 302b in noninherited disease, 301 replacement, 296-300, 297f somatic cell, 296 Genetic code, 16-17, 16t Genetic counseling, 307-313 definition of, 307 delivery of, 313-315, 314b for reproductive decision making, 312 nondirectiveness in, 307, 309 principles of, 307, 309, 312-313 probability concepts and, 58-59 recurrence risk and, 64, 66, 66t, 310b-311b, 312 Genetic counselor, 313-314, 314b

Genetic disease, 3-4, 4f. See also specific disease. clinical impact of, 4-5, 4t mortality and, 4, 4t prevalence of, 2t, 4-5, 5t Genetic drift, 52b-53b Genetic engineering, 44b-45b Genetic enhancement therapy, 302b Genetic mapping. See Linkage analysis; Physical mapping. Genetic redundancy, 223b Genetic screening, 278. See also Population screening. Genetic testing allele-specific oligonucleotides for, 285-286, 286f direct diagnosis for, 285-287, 285t, 286f ethics and, 321-323 indirect mutation analysis for, 284-285, 285f, 285t limitations of, 288b linkage analysis for, 284-285, 285f, 285t. See also Linkage analysis. mass spectrometry for, 287 of heterozygote, 281-282, 283b, 283t of newborn, 281, 282t positive predictive value in, 281, 281t prenatal, 288-295. See also Prenatal diagnosis. presymptomatic, 282, 284 psychosocial aspects of, 284 sensitivity of, 279, 279t, 281, 281t specificity of, 279, 279t, 281, 281t tandem mass spectrometry for, 287 types of, 279b Genome, 3 Genome scan, 259b-260b Genomic imprinting, 77-80, 78f, 79f Genomic instability, 237 Genomic library, 180b-181b Genotype, 29, 57, 58f frequency of, 59, 62, 62f in autosomal dominant inheritance, 63-64, 63f in autosomal recessive inheritance, 65, 65f in X-linked recessive inheritance, 94, 94f Germline mosaicism, 68-69, 68f Germline therapy, 301, 302b Giemsa banding, 109, 109f GLI3 gene, 211t, 223-224 Glioma, 228 α-Globin, 33, 33f in thalassemia, 35 β-Globin, 33, 33f in sickle cell disease, 34 in thalassemia, 35-36 Glucocorticoid-remediable aldosteronism, 266t Glucose, metabolism of, 140-141, 141f Glucose-6-phosphate dehydrogenase deficiency, 156 Glycogen storage disorders, 137t, 141f, 142, 142t Gm3 absence, diabetes and, 174 Golgi apparatus, 7f Gordon syndrome, 266t Gorlin syndrome, 213

Graves disease, 204t Grebe chondrodysplasia, 214 Greig syndrome, 211t, 223–224 Growth factors, in cancer, 230–231, 231f Guanine, 7, 8f

Η

Hair, abnormalities of, 226 Haldane, J. B. S., 3 Hand-foot-genital syndrome, 211t, 225 Haploid cell, 6 Haploinsufficiency, 31-32 Haplotype, 161 Hardy-Weinberg principle, 59, 62, 62f Heart disease. See Coronary artery disease. Heavy chains, of immunoglobulin, 198, 198f Hedgehog family, of paracrine factors, 211, 213 Height, twin studies of, 256t Helix, double, 7, 8f Helix-loop-helix motif, 14-15, 14f, 15f, 15t Helix-turn-helix motif, 15t HELLP (hemolysis, elevated liver function tests, low platelets) syndrome, 146 Hemizygosity, 88 Hemochromatosis, hereditary, 2t, 137t, 153-154, 153f, 204t gene for, 153-154, 173, 188t Hemoglobin disorders of, 33-38, 33t, 34f, 35f, 46, 46f genes for, 33, 33f, 46, 46f in sickle cell disease, 34, 46, 46f in thalassemia, 35-36 Hemoglobin H disease, 33t Hemophilia A, 2t, 91-93, 91f, 92f gene for, 92-93, 188t germline mosaicism in, 69 in female, 95 Hemophilia B, 93, 188t, 296t Hemosiderin, 153f Hereditary nonpolyposis colorectal cancer, 2t, 39t, 77t, 188t, 243 Hereditary persistence of fetal hemoglobin, 33 HERG gene, 265, 266t Hernia, diaphragmatic, prenatal treatment of, 296 Hers disease, 142t Heterochromatin, 15 constitutive, 110 Heterodisomy, 128 Heterotaxy, 219-220, 219f Heterotetramer, 35 Heterozygote, 29 compound, 36 frequency of, 62, 62f manifesting, 95 screening of, 281-282, 283b HFE gene, 153-154 HGO gene, 136 Hirschsprung disease, 188t, 211t, 215-216, 245 Histone, 8, 9f acetylation of, 15 HLA-A3, hemochromatosis and, 173

Index

HLA-B27, ankylosing spondylitis and, 173, 173f, 173t, 202 HLA- $DQ\beta$, diabetes and, 173 HNF1A gene, 267t HNF4A gene, 267t Holandric gene, 101, 101f Holoprosencephaly, 211t, 216, 217f Holt-Oram syndrome, 211t, 225, 225f Homeodomain, 220, 221f Homeotic gene complex, 220, 221f Homocystinuria, 137t Homogentisate 1,2-dioxygenase, deficiency of. See Alkaptonuria. Homologs, 6 Homotetramer, 35 Homozygote, 29 frequency of, 62, 62f Housekeeping genes, 13 HOX (Hox) genes, 220, 221f, 225 HOXA13 gene, 211t HRAS gene, 236t 11β-HSD2 gene, 266t HST gene, 236t Human artificial chromosome, 44, 300 Human development, 209-226 animal models of, 210t, 222b-223b anterior/posterior axis in, 219-220 axis specification in, 210, 219-221, 219f-220f craniofacial region in, 221, 223-224 dorsal/ventral axis in, 220-221 embryonic, 210 endoderm in, 217-218 extracellular matrix proteins in, 214, 216 gastrulation in, 216-217, 218f limb in, 224-226, 224f, 225f mesoderm in, 217-218 neurulation in, 217 organ formation in, 226 organogenesis in, 221 paracrine signaling molecules in, 210, 213-214 pattern formation in, 216-226. See also Pattern formation. transcription factors in, 214 Human Genome Project, 3, 183b Human immunodeficiency virus infection, 203 Hunter syndrome, 147t, 148-149 Huntington disease, 2t, 69, 71, 72, 72f age of onset of, 69, 71f gene for, 72, 186, 188t presymptomatic diagnosis of, 284 Hurler syndrome, 147-148, 148f, 149 Hurler/Scheie syndrome, 147t Hybridization fluorescence in situ, 110-111, 110f, 122, 176-177 in situ, 175-177, 176f somatic cell, 177-178, 177f, 178f, 178t Hydrops fetalis, 33t Hypercholesterolemia, 266t familial, 2t, 262-264, 262f, 263f gene for, 188t, 262, 264 gene therapy for, 296t

haploinsufficiency in, 31-32

Hyperglycemia, 140-141, 141f

Hyperphenylalaninemia, 142–144, 143b. See also Phenylketonuria. Hypertension, 266t, 267–268 Hypochondroplasia, 212, 212f Hypolactasia, 137t, 141 Hypothyroidism, congenital, screening for, 282t

I

Iduronate sulfatase deficiency, 147t, 148 - 149Iduronidase deficiency, 147-148, 147t, 148f IGF2 gene, 80 IHH gene, 211t Immune system, 193-198 adaptive, 193-194 blood groups and, 41-42, 41t, 205-206 cellular, 194, 196-197, 197-198, 197f humoral, 194-196, 195f, 197-198 immunoglobulins of, 194, 195f, 198-199 innate, 193, 197-198 major histocompatibility complex of, 200-205, 201f, 204t T-cell receptor of, 200, 200f, 204t Immunodeficiency disease, 203, 206–208, 207t Immunogenetics, 193-208 Immunoglobulin(s), 194, 195f, 198-199 class switching of, 198 diversity of, 199, 199f genes for, 199, 204t somatic hypermutation of, 199 somatic recombination and, 199, 199f structure of, 198, 198f, 204t In situ hybridization, for gene mapping, 175-177, 176f Incest, 85 Incontinentia pigmenti, type 1, 95 Independent assortment, principle of, 57 Index case, 63 Induction, in embryogenesis, 210 Insulin gene, 270 Insulin promoter factor 1, 226 Intelligence quotient, twin studies of, 256t Interphase, 23 of mitosis, 24f Interphase I, of meiosis, 26 Interphase II, of meiosis, 26 Intron, 15, 16f, 19f, 21 Ionizing radiation, mutagenic effects of, 36 IPF1 gene, 267t IRF6 gene, 211t Iron, disorders of, 153-154, 153f Isochromosomes, 130, 132f Isodisomy, 128 Isolated growth hormone deficiency, 67 Isotretinoin, teratogenicity of, 319t

J

Jackson-Weiss syndrome, 213, 213t Jervell-Lange-Nielsen syndrome, 265 Junctional epidermolysis bullosa, 216 Juvenile intestinal polyposis, 269

K

Karyotype, 109t in chromosomal abnormalities, 132b in Down syndrome, 114f in spontaneous abortion, 121-122 spectral, 110-111 Kayser-Fleischer ring, 152 KCNE1 gene, 265, 266t KCNE2 gene, 157t, 265, 266t KCNQ2 gene, 267t KCNQ3 gene, 267t Kerns-Sayre syndrome, 2t, 105 Kilobase, 8 KIT gene, 211t, 236t Klinefelter syndrome, 2t, 119-120, 120f Knockout mouse models, 222b-223b Krabbe disease, 149t KRAS gene, 236t KVLQT1 gene, 265, 266t

L

Lactase deficiency, 141-142 Lactase-phlorizin hydrolase, 141 Lactose, metabolism of, 141 Lactose intolerance, 141 LAMC2 gene, 216 Langer-Giedion syndrome, 127t Lay advocacy group, 314-315 LCT gene, 141 LDL receptor, 262-264, 263f LDLR gene, 262, 264, 266t Leber hereditary optic neuropathy, 2t Lentivirus vector, 298 Leptin, in obesity, 272 Leucine zipper, 15t Leukemia, 133t, 228, 237 Leukocyte adhesion deficiency, 207t Liability distribution, for multifactorial disease, 249, 249f Liddle syndrome, 266t Lifestyle, cancer and, 230 Li-Fraumeni syndrome, 187t, 234t, 240 Light chains, of immunoglobulin, 198, 198f Likelihood ratio, 164, 165b-166b Limb, development of, 224-226, 224f, 225f LIMK1 gene, 127 Linkage analysis, 161-174. See also Physical mapping. in genetic testing, 284-285, 285f, 285t in neurofibromatosis type 1, 162-163, 164f, 165b–166b in retinitis pigmentosa, 171 LOD scores in, 163-164, 165b-166b, 169-170 marker loci for, 166-168, 167f Linkage dysequilibrium, 170, 172f Linkage phase, 162 Lipid metabolism, inborn errors of, 137t, 145-147, 145f, 146f Liposome vector, 300 Lithium, teratogenicity of, 319t LMX1 gene, 211t

Loci, 29 distance between, 161, 163 linked, 161-163, 161f, 172. See also Linkage analysis. marker, 163, 166-168, 167f, 168f, 169f gene mapping with, 166-170, 167f-169f syntenic, 162 Locus control region, 33f, 35 Locus heterogeneity, 74, 77t in retinitis pigmentosa, 171 LOD score, 163-164, 165b-166b, 169-170 Long interspersed elements, 22 Long QT syndrome, 265, 266t drug therapy in, 156 gene for, 188t Long-chain acyl-coenzyme A dehydrogenase deficiency, 137t, 146 Loss of heterozygosity, 238, 238f Loss-of-function mutation, 31-32 Low-copy repeats, 127 LQT genes, 266t Lungs cancer of, 296t, 301 in cystic fibrosis, 60, 61f Lymphocyte gene therapy, 299 Lymphocytes B, 194-196 T. 194 cytokine secretion by, 194 cytotoxic, 196 killer, 196 receptors of, 200, 200f, 204t Lymphoma, 228 Lyon hypothesis, 88-90 Lysosomal storage disorders, 147-150, 147t, 148f Lysosome, 7f

M

Macrophages, as antigen-presenting cell, 194, 195f Major gene, 254 Major histocompatibility complex, 200-205, 204t class I, 200-201, 200f, 201f in cellular immune system, 196, 197f class II, 200f, 201–202 in humoral immune system, 194, 195f, 196f class III, 200f, 202 disease associations with, 202, 204t, 205 of fetus, 203 Malaria, 204t Male-pattern baldness, 101 Manifesting heterozygote, 95 Maple syrup urine disease, 137t, 144-145 Marfan syndrome, 2t, 75-76, 75f, 214 gene for, 74, 76, 188t paternal age and, 40, 40f Marker loci, 163, 166-168, 167f, 168f, 169f 1F10, 162-163, 164f, 165b-166b gene mapping with, 166-170, 167f-169f Maroteaux-Lamy syndrome, 147t

Mass spectrometry, 54t Maternal age, chromosome abnormalities and, 117-118, 117f Mating first-cousin, 83, 84b, 85, 85t random, 59, 62 uninformative, 168, 168f Maturity-onset diabetes of youth, 137t, 141, 188t McArdle disease, 142t MECP2 gene, 95 Medical genetics, 1, 2t bioethics and, 321-323 historical perspective on, 1, 1f, 3 Medium-chain acyl-coenzyme A dehydrogenase deficiency, 137t, 145-146 diagnosis of, 138 Meiosis, 6, 25-27, 25f, 26f, 58 Meiotic failure, 112 Melanocortin-4 receptor, 272 Melanoma, 77t, 188t, 244-245 gene therapy for, 296t, 301 MELAS (mitochondrial encephalopathy, lactic acidosis), 2t, 105 Memory cell, 196 Mendel, Gregor, 1, 1f, 3, 57-58 Mendelian Inheritance in Man (McKusick), 3-4.57 Mendelian trait. See Single-gene disorders. Meningioma, 133t Meningomyelocele, 251f Menkes disease, 137t, 152, 154-155 Mental retardation in fragile X syndrome, 98 in trisomy 21, 113, 115 incest and, 85 MERRF (myoclonic epilepsy and ragged red fiber disease), 2t, 105 Mesoderm, 217-218, 218f MET gene, 236t Metabolism, inborn errors of, 136-158, 136f, 137t. See also specific disorders. classification of, 139 diagnosis of, 138 dietary management of, 143b in pharmacogenetics, 155-158 inheritance of, 139 of amino acids, 137t, 142-145, 143b of carbohydrates, 137t, 139-142, 140f, 141f, 142t of lipids, 137t, 145-147, 145f, 146f of oxidative phosphorylation system, 150-151 of transport systems, 151-155, 153b-154b, 155f of urea cycle, 150, 150f prevalence of, 136-139 sudden infant death syndrome and, 138, 139 Metachromatic leukodystrophy, 149t Metaphase, of mitosis, 23, 24f Metaphase I, of meiosis, 25f, 26 Metaphase II, of meiosis, 25f Metastasis, 228 Methimazole, teratogenicity of, 319t Methotrexate, teratogenicity of, 319t Methylation, of cytosine, 40, 40f Microarrays, DNA, 55, 55f, 185-186

Microdeletion syndromes, 125-127, 126f, 127t, 128 Microsatellite DNA, 22 Miller-Dieker syndrome, 127t Mineralocorticoid excess, syndrome of, 266t Minisatellite DNA, 22 Missense mutation, 29, 30f MITF gene, 211t Mitochondria, 7f amino acids of, 16-17 DNA of, 101, 103-105, 104f Mitochondrial disorders, 2t, 3, 105 pedigree for, 104f Mitochondrial encephalopathy, lactic acidosis (MELAS), 2t, 105 Mitosis, 6, 23-24, 24f Mitral valve prolapse, in Marfan syndrome, 75-76 MLH1 gene, 234t MLH3 gene, 243 Mobile element, 31 Mobile element mutation, 31 Modifier genes, 71 Monogenic traits. See Single-gene disorders. Monosomy, 112 Morquio A syndrome, 147t Morquio B syndrome, 147t Mosaicism germline, 68-69, 68f in trisomy 21, 115 MSH genes, 234t, 243 MSTII, 46, 46f MSX1 gene, 211t, 226 Mucopolysaccharidoses, 147-150, 147t, 148f Muller, H. J., 3 Multifactorial inheritance, 2t, 3, 248-250 adoption studies and, 257-258 basic model of, 248 clinical impact of, 4-5, 4t empirical risk in, 250 heritability of, 257 in alcoholism, 261t, 273-274 in Alzheimer disease, 261t, 267t, 272-273, 273f in amyotrophic lateral sclerosis, 267t in arthritis, 261t in asthma, 261t in bipolar disorder, 261t, 275 in breast cancer, 269 in cancer, 261t, 268-270 in colorectal cancer, 269 in congenital malformations, 258, 261t in depression, 261t in diabetes, 261t, 267t, 270-271, 271t in epilepsy, 261t, 267t in heart disease, 258, 261, 261t, 264, 265, 265t, 266t in hypertension, 266t, 267-268 in infantile autism, 250 in multiple sclerosis, 261t in neural tube defects, 251-253, 251f, 252f in obesity, 261t, 271-272 in Parkinson disease, 261t, 267t in prostate cancer, 269-270 in psoriasis, 261t in pyloric stenosis, 249-250, 250t in schizophrenia, 261t, 274-275, 274t

Multifactorial inheritance (Continued) in stroke, 266-267 liability distribution in, 249, 249f recurrence risks and, 250, 250t, 253-254, 254t threshold model of, 249-250, 249f twin studies and, 255-257, 255f, 256t vs. single-gene inheritance, 254-255, 254f, 275-276 Multiple endocrine neoplasia, 245-246 Multiple sclerosis, 204t, 261t twin studies of, 256t Multiple sulfatase deficiency, 149t Multiple synostoses, 211t Multiplication rule, 58-59 Multipoint mapping, 166b Mutagens, 36 Mutation(s), 6, 29-40. See also Multifactorial inheritance; Single-gene disorders. age-related effects on, 40, 40f base-pair substitution, 29, 30f causes of, 36-38 chemical-induced, 36, 38 constitutional, 232 deletion, 30 detection of, 53-55, 54f, 54t, 55f dominant negative, 32-33 duplication, 30-31 expanded repeat, 31 frameshift, 30, 30f gain-of-function, 31 hot spots for, 40, 40f in DNA repair genes, 38, 39, 39t induced, 36-38 insertion, 30 loss-of-function, 31-32 missense, 29, 30f mobile element, 31 molecular effects of, 31-33 new, 68 nonsense, 29, 30f promoter, 31 radiation-induced, 36, 37 rates of, 38, 40 screening for, 185 silent substitution, 29 splice site, 31, 32f spontaneous, 36 types of, 29-31, 30f Myasthenia gravis, 204t MYB gene, 236t MYBPC gene, 266t Myelomeningocele, prenatal treatment of, 296 MYH7 gene, 266t Myoclonic epilepsy and ragged red fiber disease (MERRF), 2t, 105 Myoclonus epilepsy, gene for, 189t Myotonic dystrophy, 2t, 82t anticipation in, 80-83, 80f, 81f gene for, 188t

N

NADH-CoQ reductase deficiency, 137t Nail-patella syndrome, 211t

Narcolepsy, 204t NAT2 gene, 157t Natural killer cells, 193 Natural selection, 52b Neoplasm, 228. See also Cancer. NEU gene, 236t Neural crest, developmental defects of, 215-216, 215f Neural tube defects, 2t, 251-253, 251f, 252f, 253f α-fetoprotein measurement in, 293–294, 294f prevention of, 252-253, 322 Neuroblastoma, 133t NEUROD1 gene, 267t Neurofibromatosis, 73-74, 73f type 1, 2t, 238-239, 239f gene for, 74, 189t germline mosaicism in, 69 linkage analysis in, 162-163, 164f, 165b-166b variable expression of, 71, 73 type 2, gene for, 189t Neurulation, 217 Newborn screening, 281, 282t NF1 gene, 74, 234t, 238-239, 239f NF2 gene, 74, 234t Niemann-Pick disease, 149t NMYC gene, 236t NOG gene, 211t Noggin gene, 214, 220-221, 224f Nondisjunction, meiotic, 112, 112f Nonionizing radiation, mutagenic effects of, 36 Nonobese diabetic mouse, 270-271 Nonsense mutation, 29, 30f Norprogesterones, teratogenicity of, 319t Northern blotting, 185, 186f NTBC (2-(nitro-4-trifluoromethylbenzoyl)-1,3-cyclohexanedione), in tyrosinemia, 144 Nuclear envelope, 7f Nucleolus, 7f Nucleosome, 8, 9f Nucleotide, 7 Nucleus, 7f

0

Obesity, 261t, 271-272 twin studies of, 256t Oculocutaneous albinism, 136f, 137t, 187t Oculopharyngeal muscular dystrophy, 82t Okihiro syndrome, 211t Oligodontia, 211t Oligohydramnios sequence, 318, 318f Oligonucleotides, 49, 49f Omenn syndrome, 207t Oncogenes, 234-237, 235t, 236t 1F10 marker, 162-163, 164f, 165b-166b Oocytes, 25f, 27 Oogenesis, 25f, 27 Organogenesis, 210, 221, 226 Ornithine transcarbamoylase deficiency, 137t, 150 Osteoblasts, 226

Osteogenesis imperfecta, 2t, 19–21, 19f, 20t germline mosaicism in, 68–69 locus heterogeneity in, 74, 77, 77f, 77t variable expression in, 71 *OTC* gene, 150 Ovum, 27 Oxidative phosphorylation (OXPHOS) system, 150–151

P

Palindromes, 44 Pallister-Hall syndrome, 211t, 224 Pancreas, in cystic fibrosis, 60, 60f Panmixia, 62 Paracrine factors, in development, 210-214 Paralogs, 220 PARK1 gene, 267t PARK2 gene, 267t PARK5 gene, 267t Parkinson disease, 189t, 261t, 267t Patau syndrome, 116-117, 117f PATCHED gene, 213 Pattern formation, 210, 216-226 anterior/posterior axis in, 219-220 axis specification in, 219 craniofacial development in, 221, 223-224 dorsal/ventral axis in, 220-221, 224f endoderm in, 217-218 gastrulation in, 216-217, 218f limb development in, 224-226, 224f mesoderm in, 217-218 neurulation in, 217 organogenesis in, 221, 226 PAX6 gene, 209, 211t PAX genes, 211t PCR (polymerase chain reaction), 48-50, 49f Pearson syndrome, 105 Pedigree, 63, 63f coefficient of relationship and, 84b for Angelman syndrome, 79f for autosomal dominant disorder, 64f, 168f, 169f for autosomal recessive disorder, 65f for familial colon cancer, 229f for first-cousin mating, 84f for fragile X syndrome, 100f for hemophilia A, 91f for mitochondrial disorders, 104f for myotonic dystrophy, 81f for neurofibromatosis type 1, 162-163, 164f for Prader-Willi syndrome, 79f for retinoblastoma, 69, 69f for X-linked dominant disorder, 95, 95f for X-linked recessive disorder, 93-94, 93f for Y-linked trait, 101f Pemphigus vulgaris, 204t Penetrance age-dependent, 69, 71 reduced, 69, 69f Penicillamine, teratogenicity of, 319t Percutaneous umbilical blood sampling, 291-292

Index

361

Peripherin/RDS gene, 171 Peutz-Jeghers syndrome, 269 Pfeiffer syndrome, 213, 213t Phagocytes, 193 Pharmacogenetics, 155-158, 157f, 157t Pharmacogenomics, 156 Phenotype, 62-63. See also Genotype. in chromosomal abnormalities, 130-132 Phenylalanine in foods, 143b metabolism of, 136f, 142 Phenylketonuria, 2t, 136f, 142-144, 143b gene for, 137t, 142, 189t mental retardation in, 62 prevalence of, 137t screening for, 280, 282t, 283t treatment of, 143b Phenytoin, teratogenicity of, 319t Philadelphia chromosome, 132, 133f Physical mapping, 174-189 CG islands in, 184 chromosome deletions in, 174, 175f chromosome translocations in, 175 computer-assisted, 184-185 dosage mapping in, 175 exon identification in, 184, 184f heteromorphisms in, 174 in situ hybridization in, 175-177, 176f mutation screening in, 185 positional candidate approach in, 187 positional cloning in, 179-182, 182f radiation hybrid mapping for, 178-179, 179f somatic cell hybridization for, 177-178, 177f, 178f, 178t zoo blot in, 182-183 Piebaldism, 211t Pima, type 2 diabetes in, 174 Plasma cells, 194 Plasmid, 44 Pleiotropy, 74 PMP22 gene, 31 PMS1 gene, 243 PMS2 gene, 243 Polar body diagnosis, 295 Polarity, in embryogenesis, 210 Poly-A tail, 13 Polydactyly, 211t postaxial, 64, 64f Polygenic trait, 248 Polymerase chain reaction, 48-50, 49f Polymorphism, 29 forensic applications of, 48b restriction site, 43-44, 43f, 44f, 46-47, 46f short tandem repeat, 47-48 tandem repeat, 47, 47f Polyploidy, 111-112 Pompe disease, 142t Population, associations in, 172-174, 173f Population genetics, 52b-53b, 59 Hardy-Weinberg principle and, 59, 62 Population screening, 278-284. See also Genetic testing. cutoff values for, 279-281, 280f definition of, 278 in heterozygotes, 281-282, 283b in newborns, 281, 282t

Population screening (Continued) principles of, 278-281 psychosocial implications of, 284 results of, 279-281, 280f, 281t Positional cloning, 179-187, 180b-181b, 182f, 187t-189t candidate genes for, 187 CG island identification for, 184 computer DNA sequence analysis for, 184-185 cross-species conservation analysis for, 182-183 direct cDNA selection for, 184 exon trapping for, 184, 184f gene expression tests in, 185-187, 186f mutation screening for, 185 Postaxial polydactyly, 64, 64f Potter phenotype, 318, 318f Prader-Willi syndrome, 77, 78-79, 78f, 79f, 127t microdeletions in, 125-126 mother's perspective on, 79b Pregnancy acute fatty liver of, 146 hyperphenylalaninemia in, 143b, 144 Rh incompatibility in, 205-206 Preimplantation diagnosis, 294-295 ethics and, 323 Prenatal diagnosis, 279b, 288-295 amniocentesis for, 288-290, 289b, 289f, 292t chorionic villus sampling for, 290-291, 291f, 292t cordocentesis for, 291-292 fetal cells for, 294-295 α-fetoprotein measurement for, 293-294, 294f percutaneous umbilical blood sampling for, 291-292 preimplantation, 294-295 ultrasonography for, 292-293, 292b, 293f Presymptomatic diagnosis, 282, 284 Primers, 49, 49f Primitive streak, 217, 218f Probability, 58-59 Proband, 63 Probe, 43, 44f Progressive myoclonic epilepsy, type 1, 82t Proofreading, in DNA replication, 10 Prophase, of mitosis, 23, 24f Prophase I, of meiosis, 25f, 26 Prophase II, of meiosis, 26 Propositus (proposita), 63 Prostate cancer, 269-270 Protanomaly, 102b-103b Protein(s) electrophoresis of, 42, 42f gain of function of, 31 loss of function of, 31-32 production of, 11-17, 12f amino acid sequences in, 16-17, 16t gene splicing in, 15-16, 16f posttranslational modification in, 17 transcription in, 11-15, 13f, 14f, 15f, 15t translation in, 17, 17f, 18f Protein kinases, in cancer, 230-231, 231f

Protein truncation method, 54t PS1 gcnc, 267t, 272 PS2 gene, 267t, 272 Pseudomosaicism, 290 Psoriasis, 261t Psoriasis vulgaris, 204t PTC gene, 234t PTEN gene, 234t, 244, 269 Pterygium, popliteal, 211t Punnett square, 57, 58f in autosomal dominant inheritance, 63-64, 63f in autosomal recessive inheritance, 65, 65f in X-linked recessive inheritance, 94, 94f Purine nucleoside phosphorylase deficiency, 207t Purines, 7, 8f Pyloric stenosis, 2t, 249-250, 250t Pyrimidines, 6, 8f dimers of, 36, 38f Pyruvate carboxylase deficiency, 137t Pyruvate dehydrogenase complex deficiency, 137t, 151

Q

Quantitative trait, 248, 249f Quantitative trait loci, 259b–260b Quasidominant inheritance, 66 Quinacrine banding, 109

R

Radiation, mutagenic effects of, 36, 37 Radiation hybrid mapping, 178-179, 179f Radon, mutagenic effects of, 37 Random mating, 59, 62 RAS gene, 236-237, 236t RB1 gene, 232–234, 233f, 234t **Recessive** disorders autosomal, 65-67, 65f, 66t consanguinity and, 83, 84b, 85, 85t Punnett square for, 65, 65f recurrence risks for, 66, 66t transmission of, 65-66, 66t vs. dominant disorder, 66-67 consanguinity and, 83 X-linked, 90-95, 93f, 94f, 98t, 102b-103b Recombination, 161, 162f hot spots for, 163 Recombination frequency, 161 estimation of, 162, 164f Recurrence risk, 64, 66, 66t, 310b-311b, 312 Relationship, coefficient of, 84b Replication, of DNA, 8, 10, 10f, 11f Replication bubble, 10, 11f Replication origin, 10, 11f Restriction endonucleases, 43, 43f, 46, 46f Restriction fragment length polymorphisms, 43-44, 43f, 44f, 46-47, 46f

RET gene, 215, 236t, 245-246 Retinitis pigmentosa, 77t, 171, 189t Retinoblastoma, 2t, 70, 70f, 133t, 232-234, 234f genes for, 189t, 232-233, 233f, 234t reduced penetrance in, 69, 69f, 232 two-hit hypothesis of, 231-232, 233f Retroviral vector, 297-298, 297f Retroviruses, 235-236 Rett syndrome, 95, 189t Reverse banding, 109 Reverse transcriptase, 180b Reye syndrome, vs. urea cycle defect, 138-139 Rh blood group, 41-42, 205-206 Rheumatic fever, 202, 204 Rheumatoid arthritis, 204t Ribonucleic acid (RNA), 11-17, 12f 5' cap of, 13, 13f messenger (mRNA), 11-13, 12f, 13f splicing of, 15-16, 16f poly-A tail of, 13 ribosomal (rRNA), 17, 17f, 18f termination sequence of, 13 transfer (tRNA), 17, 17f, 18f Ribosomes, 7f, 17 Ribozyme therapy, 301 Rickets, hypophosphatemic, 95 RIEF1 gene, 211t Rieger syndrome, 211t RNA. See Ribonucleic acid (RNA). RNA polymerase, 11-13, 13f RNASEL gene, 269-270 Robertsonian translocation, 123-124, 124f, 125f Robinow syndrome, 211t Rod monochromacy, 102b ROM1 gene, 171 Romano-Ward syndrome, 265 ROR2 gene, 211t Rubinstein-Taybi syndrome, 127t

S

SALL1 gene, 211t SALL4 gene, 211t Sandhoff disease, 149t Sanfilippo A syndrome, 147t Sanfilippo B syndrome, 147t Sanfilippo C syndrome, 147t Sanfilippo D syndrome, 147t Sarcoma, 228 Satellite DNA, 22, 22f Schindler disease, 149t Schizencephaly syndrome, 211t Schizophrenia, 2t, 261t, 274-275, 274t twin studies of, 256t SCN1B gene, 267t SCN5A gene, 265, 266t SCNN1B gene, 266t SCNN1G gene, 266t Screening. See Population screening. Segregation, principle of, 57, 58 Senescence, cell, 237 Sensitivity, of screening test, 279, 279t, 281, 281t Sequence tagged sites, 179, 182f

207t gene therapy in, 296t, 299 Sex-influenced trait, 101 Sex-limited trait, 101 Sex-linked disorders, 90-101. See also X chromosome(s); Y chromosome(s). X-linked dominant, 95, 95f, 98t recessive, 90-95, 93f, 94f, 98t, 102b-103b Y-linked, 101, 101f SGCB gene, 266t SGCD gene, 266t Sherman paradox, 98-100 SHH gene, 211t, 216 Short interspersed elements, 22 Short tandem repeat polymorphisms, 47-48 SHOX gene, in Turner syndrome, 119 Shprintzen syndrome, 127t, 128 Sickle cell disease, 2t, 33t, 34, 34f gene flow and, 53b gene for, 46, 46f, 47, 189t gene frequencies in, 52b screening for, 282t, 283t Sickle cell trait, 67 Signal transduction, in cancer, 230-231, 231f Silencers, 14, 14f Silent substitution mutation, 29 Single nucleotide polymorphisms, for drug-response profiles, 156, 157f Single-gene disorders, 2t, 3, 57-85 age-dependent penetrance of, 69, 71, 71f anticipation in, 80-83, 80f, 81f, 82t clinical impact of, 4-5, 4t consanguinity and, 83-85 dominant autosomal, 63-64, 63f, 64f, 66-67, 66t, 67f X-linked, 95, 95f, 98t genomic imprinting and, 77-80, 78f, 79f germline mosaicism and, 68-69, 68f locus heterogeneity and, 74, 77t mitochondrial, 101, 103-105, 104f new mutations in, 68 occurrence risk for, 64 penetrance of, 69, 69f, 71 pleiotropy and, 74 recessive autosomal, 65-67, 65f, 66t consanguinity and, 83 X-linked, 90-95, 93f, 94f, 98t, 102b-103b recurrence risk for, 64, 66, 66t reduced penetrance of, 69, 69f variable expression of, 71 X-linked dominant, 95, 95f, 98t recessive, 90-95, 93f, 94f, 98t, 102b-103b Y-linked, 101, 101f Single-strand conformation polymorphisms, 53, 54f, 54t SIS gene, 236t Situs ambiguus, 219-220, 219f Situs inversus, 219-220, 219f

Severe combined immune deficiency, 206,

Situs viscerum, 220 Skeleton, formation of, 226 SLC genes, 151 SLC39A4 gene, 155 SLO (Δ 7-sterol reductase) deficiency, 137t Sly syndrome, 147t Smith-Lemli-Opitz syndrome, 146-147, 146f, 189t, 211t Smith-Magenis syndrome, 110, 110f, 127t SNCA gene, 267t SOD1 gene, 267t Solenoid, 8, 9f Solvents abuse, teratogenicity of, 319t Somatic cell, 6, 29 Somatic cell hybridization, for gene mapping, 177-178, 177f, 178f, 178t Somatic cell therapy, 296, 296t Southern blotting, 43, 54t in somatic cell hybridization, 177, 178f SOX genes, 211t, 214 Specificity, of screening test, 279, 279t, 281, 281t Spectral karyotyping, 110-111 Sperm cells, FISH studies of, 122 Spermatids, 25f, 27 Spermatocytes, 25f, 27 Spermatogenesis, 25f, 27 Sphingolipidoses, 149, 149t Spina bifida, 251-253, 251f prenatal treatment of, 296 twin studies of, 256t Spinal and bulbar muscular atrophy, 82t Spindle fibers, 23 Spinocerebellar ataxia, 82t Splenomegaly, in thalassemia, 35, 35f Splice site mutation, 31, 32f Squamous cell carcinoma, cervical, 204t SRY gene, 121, 121f, 214 Stargardt disease, 189t Sticker syndrome, 211t Stop codon, 16, 16t Streptomycin, teratogenicity of, 319t Stroke, 2t, 266-267 Sudden infant death syndrome, metabolic disorders and, 138, 139 Sunlight, mutagenic effects of, 36 SUR1 gene, 157t Synapsis, of meiosis, 26 Synpolydactyly, 82t, 211t, 225 Syntenic loci, 162 Systemic lupus erythematosus, 204t

Т

Tandem repeat polymorphisms, 47, 47f Tangier disease, 266t *TAP2* gene, 206 Tarui disease, 141f, 142t Tay-Sachs disease, 2t, 149t, 189t screening for, 282, 283t *TBX3* gene, 211t *TBX5* gene, 211t *TBX22* gene, 211t *TBX22* gene, 211t *TBX* genes, 211t, 225 T-cell receptors, 200, 200f, 204t *TCF2* gene, 267t

Index

TCOF1 gene, 211t Telomerase, 237 Telomere, 107 Telophase, of mitosis, 24, 24f Telophase I, of meiosis, 25f, 26 Telophase II, of meiosis, 27 Template, 10, 10f Teratogen, 318-320, 319t Teratology, 316-321, 317t Termination sequence, 13 Testing. See Genetic testing. Testosterone, in Klinefelter syndrome, 120 Tetracycline, teratogenicity of, 319t Tetrad, 26 Tetraploidy, 111, 112 Thalassemia, 2t, 33t, 35-36, 35f, 67 α-Thalassemia, 187t, 283t β-Thalassemia, 187t, 282, 283t Thalidomide, teratogenicity of, 319t Thanatophoric dysplasia, 212, 212f, 218 Thiouracil, teratogenicity of, 319t Thymine, 6, 8f Thyroid gland, papillary carcinoma of, 245 Thyroidectomy, in multiple endocrine neoplasia, 245 TNNT2 gene, 266t Townes-Brocks syndrome, 211t TP53 gene, 234t, 239-240 TP63 gene, 211t TPMT gene, 157t Trace elements, 152 Trait(s) association of, 172-174, 173t polygenic, 248 sex-influenced, 101 sex-limited, 101 vs. gene, 67 Transcription factors, 13-15, 14f, 211t, 214 DNA-binding motifs of, 14, 15f, 15t in cancer, 231, 231f Transfection experiment, 236-237 Transforming growth factor-B, 213 Transgenic mouse, 222b Translation, 17, 17f, 18f Treacher Collins syndrome, 211t Trimethadione, teratogenicity of, 319t Trinucleotide repeat expansions, 82t, 83 in Huntington disease, 72, 82t in myotonic dystrophy, 80-81, 82t, 83 Triple screen, 294 Triploidy, 111-112 Trisomy, 112, 112f Trisomy 13 (Patau syndrome), 2t, 116-117, 117f

- Trisomy 18 (Edwards syndrome), 2t, 116, 116f, 312b
- Trisomy 21 (Down syndrome), 2t, 113–116, 113f
- anticipatory guidance in, 115
- counseling for, 309
- α-fetoprotein measurement in, 294, 294f

Trisomy 21 (Down syndrome) (Continued) genes for, 115-116 karyotype for, 114f maternal age and, 117-118, 117f mosaicism in, 115 Robertsonian translocation and, 123-124, 125f Trisomy X, 120 Tuberous sclerosis, 77t, 189t Tumor, 228. See also Cancer. Tumor suppressor genes, 232-234, 233f, 234t, 235f, 235t APC gene as, 234t, 240-243, 242f in retinoblastoma, 70 NF1 gene as, 234t, 238-239, 239f RBI gene as, 232-234, 234f, 234t TP53 gene as, 234t, 239-240 Tumorigenesis, 228 Turner syndrome, 2t, 118-119, 118f Twin studies, 255-257, 255f, 256t in bipolar disorder, 275 in diabetes, 270 in schizophrenia, 274, 274t Tyrosine aminotransferase deficiency, 144 Tyrosinemia, 136f, 137t, 144

U

Ulnar-mammary syndrome, 211t, 225, 225f Ultrasonography, prenatal, 292-293, 292b, 293f Ultraviolet radiation in xeroderma pigmentosum, 39 mutagenic effects of, 36 Umbilical cord, blood sampling from, 291-292 Uniparental disomy, 78-79, 128-129, 129f Unverricht-Lundborg syndrome, 189t Urea cycle, 150, 150f defects in, 150 Uridine diphosphate galactose-4-epimerase deficiency, 140, 140f Usher syndrome, 189t

V

Validity, of screening test, 279 Valproic acid, teratogenicity of, 319t Van der Woude syndrome, 211t Variable number of tandem repeats, 47, 47f Vas deferens, congenital absence of, 60, 61 Vector, 44 Velocardiofacial syndrome, 127t, 128 Ventricular septal defect, in Down syndrome, 113 *VHL* gene, 234t Von Gierke disease, 141f, 142t Von Willebrand disease, 93, 189t

W

Waardenburg syndrome, 189t, 211t WAGR (Wilms tumor, aniridia, genitourinary abnormalities, and mental retardation), 126 Warfarin, teratogenicity of, 319t Watson, James, 3 Werner syndrome, 39t Williams syndrome, 126-127, 126f, 127t Wilms tumor, 189t Wilson disease, 137t, 152, 154-155, 189t Wiskott-Aldrich syndrome, 207t, 208 WNK1 gene, 266t WNK4 gene, 266t Wnt genes, 213, 224-225 Wolf-Hirschhorn syndrome, 124, 126, 126f Wright, Sewall, 3 WT1 gene, 211t, 234t

X

X chromosome(s), 6 aneuploidy of, 118-120, 118f, 120f dominant disorders of, 95, 95f, 98t in Klinefelter syndrome, 119-120 in Turner syndrome, 118-119 inactivation of, 88-90, 89f iso-, 130, 132f monosomy of, 118-119, 118f recessive disorders of, 90-95, 93f, 94f, 98t, 102b-103b trisomy of, 120 47,XYY karyotype and, 120 Y crossover with, 121, 121f X inactivation center, 89-90 Xeroderma pigmentosum, 39, 39f, 39t, 237 XIST gene, 90 X-linked agammaglobulinemia, 206, 207t X-linked chronic granulomatous disease, 207

Y

Y chromosome(s), 6 genes of, 101, 101f pseudoautosomal region of, 121, 121f X crossover with, 121, 121f Yeast artificial chromosomes, 44, 179, 182, 182f

Z

Zap70 kinase deficiency, 207t ZIC3 gene, 220 Zinc, 152 malabsorption of, 155, 155f Zinc finger, 15t Zoo blot, 183 Zygote, 22